A HISTORY OF PHOTOGRAPHY
AT THE UNIVERSITY OF NOTRE DAME

A HISTORY OF PHOTOGRAPHY

AT THE UNIVERSITY OF NOTRE DAME

Twentieth Century

DAVID ACTON

UNIVERSITY OF
NOTRE DAME

g

The Snite Museum of Art, University of Notre Dame
In association with D Giles Limited

Snite Museum of Art at the
University of Notre Dame
David Acton, Milly and Fritz Kaeser
Curator of Photographs

© 2019 University of Notre Dame

First published in 2019 by GILES
An imprint of D Giles Limited
66 High Street,
Lewes BN7 1XG, UK
gilesltd.com

Library of Congress Control
Number: 2019908363

ISBN: 978-1-911282-40-2

For D Giles Limited
Copy-edited and proof-read
by Jodi Simpson
Designed by Alfonso Iacurci
Produced by GILES, an imprint of
D Giles Limited
Printed and bound in China

All measurements are in inches
and centimeters

Front cover:
Elliott Erwitt, American, born
in France in 1928
South Carolina (detail), 1962
(Cat. no. 70)

Back cover:
Edward Steichen, American, 1879–1973
Moonrise, The Pond (detail), 1904
(Cat. no. 4)

Frontispiece:
Jerry N. Uelsmann,
American, born in 1934
Untitled (detail), 1969
(Cat. no. 81)

Page 4:
Fritz Kaeser, American, 1910–1990
André Roch Skiing (detail), 1948
(Cat. no. 55)

Page 6:
Eugène Atget, French, 1857–1927
Saint-Cloud (detail), 1926
(Cat. no. 20)

Page 14–15:
Paul Caponigro, American, born in 1932
*Running White Deer, County Wicklow,
Ireland* (detail), 1967
(Cat. no. 78)

Page 416:
Ernest Knee, American, born in
Canada, 1907–1982
*Capilla de Santo Niño de Atocha, La
Manga* (detail), 1941
(Cat. no. 44)

Page 446:
Maurice Loewy, French, born in Austria-
Hungary, 1833–1907, and Pierre-Henri
Puiseux, French, 1855–1928
Posidonius – Aristotle – Pôle Nord (detail), 1901
(Cat. no. 1)

Page 450:
William Garnett, American, 1916–2006
Four-Sided Dune, Death Valley (detail), 1954
(Cat. no. 62)

Page 454:
Nickolas Muray, American, born in
Hungary, 1892–1965
Untitled (Still Life with Coffee)
(detail), about 1951
(Cat. no. 56)

CONTENTS

FOREWORD

The Snite Museum of Art takes great pleasure and pride in publishing this catalogue that celebrates and interprets highlights of the Museum's photography collection, which contains treasures from the earliest history of the medium to the present day. Curator of Photography David Acton organized the two-volume publication so that it might serve as an introductory textbook for the history of photography.

The present volume focuses on 20th-century photographs—a subject of great interest to Notre Dame students, whose real worlds and virtual lives are overburdened with photographic images. It is critical that they understand the history and power of the medium so that they might understand how photographic images shape contemporary perceptions of reality. The second volume will focus on 19th-century photography, which is well represented at the Snite Museum due to the generosity of Janos Scholz. The Janos Scholz Collection was the focus of the 2002 exhibition *A Gift of Light: Photographs in the Janos Scholz Collection* and the book of the same name by Stephen Roger Moriarty with Morna O'Neill.

To begin his work on this publication, Dr. Acton first examined thousands of photographs within our collection. While the initial charge was to publish a book of 100 highlights, Acton quickly realized he would need to represent at least 200 artworks to have any hope of suggesting the riches of the Museum's photography collection. The result is this handsome, thoughtfully organized and informative history of photography that benefits from Acton's keen eye, his encyclopedic knowledge of the medium, his rigorous research, and his unique ability to describe techniques and media in ways that are accessible and enjoyable to both layperson and scholar. Careful observers will also be rewarded by Acton's sense of humor.

We thank the benefactors who gave photographs, or funds to purchase photographs, featured within this publication: Edward M. Abrams and Family Endowment; Dr. Douglas Barton (ND'86); Walter R. Beardsley Endowment; Rev. Ferdinand Brown (ND'38,'45,'47), C.S.C.; Dr. M. L. Busch; Mr. and Mrs. Tom Christian; Arthur J. Decio; Engart LLC; Elliot Erwitt; Mr. and Mrs. Harry Fein; Mrs. Lorraine Gallagher Freimann; Laura Gilpin; Dr. and Mrs. Norval Green; Harry Heppenheimer (ND'52); Humana Foundation Endowment for American Art; Fritz Kaeser; Milly Kaeser; Milly and Fritz Kaeser Endowment for Photography; Eric, Rosser, and Dana Knee; Mike Madden (ND'58); Robert B. Mayer; Dr. William McGraw (ND'65); Jamie Niven; Mr. and Mrs.

Robert E. (ND'63) and Beverly (SMC'63) O'Grady; Dr. and Mrs. Dean A. Porter; Charles Rosebaum; John C. Rudolf (ND'70); Dr. and Mrs. Charles Sawyer; Samuel J. Schatz; Jack B. Smith Jr; Frank M. (ND'58) and Joan Smurlo Endowment; Dr. George Violin; The Andy Warhol Foundation for the Visual Arts; Douglas Wetmore (ND'79); and Arthur Wiesenbeger.

Special thanks are due to late benefactors Milly and Fritz Kaeser, who during their lifetimes generously donated photographs and funds to acquire photographs and through their estate established the Milly and Fritz Kaeser Endowment for Photography, which has provided resources not only for photography acquisitions and exhibitions, but also for design and printing costs associated with this book. Fritz Kaeser was an accomplished photographer who is represented within this volume, and his work was the focus of Stephen Roger Moriarty's 1998 exhibition, accompanied by the monograph *Fritz Kaeser: A Life in Photography*. The Kaesers also established a Snite Museum endowment for liturgical art and served on our Advisory Council.

I am particularly proud of this collection catalogue because it so elegantly fulfills the mission of the Snite Museum. All Museum artistic programs are founded on the principle that art is essential to understanding individual, shared and diverse human experiences and beliefs. We encourage close looking and critical thinking to stimulate inquiry, dialogue and wonder, and we value and celebrate diverse cultures, ideas and audiences.

Charles R. Loving
Director Emeritus, Snite Museum of Art

ACKNOWLEDGMENTS

Charles R. Loving, Director Emeritus of the Snite Museum of Art, first conceived a project to publish a selection of works from the Museum's noted photography collection. When he and I confronted the challenge of making a selection from over 10,000 objects, it became clear that expanding the project could bring attention to the quality and scope of the Museum's holdings and provide a teaching resource for faculty and students. Chuck enthusiastically supported strategic acquisitions to achieve a more sensible arc from which to approach the complexities of photographic history. His successor as Snite director Joseph Becherer has taken up that spirit, supporting and enhancing the project to share our treasured but little-known collection. To a significant extent, its scope and quality are due to the generosity of the late Milly and Fritz Kaeser, whose endowment to the photography program was just one aspect of their generous support of the Snite Museum and the University of Notre Dame.

An endeavor of this scope is not possible without the effort and support of many colleagues at the Snite Museum of Art and the University of Notre Dame. Ann Knoll has been essential to the project, drawing upon her institutional memory and arcane details of working within the university. Catalogue photography was done by Michael Rippy, who also assisted with digital management; Morgan Wilson and Meg Burns helped arrange photographic rights; Laura Rieff helped to keep the project on track in many ways; Elizabeth Zapf helped to manage the budget; Marsha Stevenson provided research guidance and helped to acquire study materials. Colleagues Shelly Langdale at the Philadelphia Museum of Art and Liz Siegel and Mark Pascale at the Art Institute of Chicago generously assisted with particular problems of research. I am also grateful to Snite Museum colleagues Bridget O'Brien Hoyt and Cheryl Snay, who helped refine the conception of the project to one with teaching at its core as much as research. Jodi Simpson edited the manuscript, and Alfonso Iacurci provided the book's elegant design. At D Giles Limited, I particularly wish to thank editorial assistant Louise Parfitt; production manager Louise Ramsay; and especially project manager Allison McCormick, who guided the intransigent author with astounding patience and grace. Most of all I am indebted to the photographers who shared their memories, ideas and vision with me, and to the supportive families of artists no longer with us.

David Acton

USE OF THE CATALOGUE

This catalogue is organized to provide a historical discussion in a roughly chronological arrangement. The titles are those assigned by the artists, identified by inscription or by reference to published reproductions. When such identification has not been possible, representational photographs are given brief descriptive titles. The dates given indicate the exposure of the original photographic negative. Undated works have been assigned approximate dates, the basis for which can be found in the entry. Many of the photographs were printed later. When the date of a print can be determined by inscription, or by technical comparison with dateable examples, this is given in the notes. Inscriptions and marks on the objects are described in the notes. Height precedes width in the metric and imperial measurements provided. Sheet sizes refer to the support upon which the image is printed, photographically or by other means.

INTRODUCTION

A History of Photography at the University of Notre Dame presents a brief introduction to modern photographic history in works drawn from the permanent collection of the Snite Museum of Art at the University of Notre Dame. Its goal is to share a fragile, archival segment of the collection with students, faculty and the wider community, and to make the Museum's distinguished holdings better known. The collection spans from the beginnings of photography to the present day, and this volume focuses on works from the twentieth century. A companion volume with a selection of the Museum's 19th-century photographs will follow. Each image is identified and discussed in relation to the circumstances of its creation, complemented by a biographical snapshot of the photographer. Stylistic trends are introduced and techniques and processes are described.

In the six decades between its introduction and the turn of the 20th century, photography rapidly evolved from a scientific curiosity to a universally accessible way to understand the wider world. From ancient times, philosophers observed and described the phenomenon of light reflected into a darkened room. In the fifth century B.C.E., the Han Chinese scholar Mozi wrote of an upside-down image coming through a pinhole into a "treasure house," and Aristotle described the round image of the sun passing through a tiny hole into a shaded wicker basket. During the Renaissance, Leonardo da Vinci understood that such enclosures function like an eye, and in 1604 Johannes Kepler first used the term *camera obscura* to describe the dark chamber. By the 18th century, portable cameras obscura had become artists' tools for recording topography, used by painters Canaletto and Sir Joshua Reynolds, who had a small camera obscura disguised as a book.

An apparatus of this kind was adapted by Joseph Nicéphore Niépce in his studies of light-sensitive chemistry. In 1816 he used a camera obscura to capture an image on paper coated with silver chloride, but without a way to arrest the oxidation his image disappeared in darkness. Niépce experimented with small sheets of pewter coated with brown bitumen varnish. In 1826 he loaded one in his camera obscura and pointed its lens out a window on a sunny day. After about eight hours' exposure, Niépce washed this plate with lavender oil to remove the soluble varnish and reveal a legible, negative image of the scene outside. He exposed the plate to fumes of heated iodine to reverse its tones and heighten contrasts, creating what is thought to be the world's first permanent photograph. Soon thereafter Niépce met Louis-Jacques-Mandé Daguerre, proprietor

of the Paris Diorama, who was always searching for new visual effects for his theater. Building upon Niépce's work, Daguerre developed a process for capturing a detailed image on a sheet of copper, plated with silver and sensitized with iodine. After exposing his plates in a camera with a focusing lens, he developed the images with vapor from heated mercury. He announced his invention, the daguerreotype, to the French Academy of Sciences on January 7, 1839.

Daguerre's announcement surprised William Henry Fox Talbot in England, who had independently developed a different photographic technique. During the 1830s he exposed sheets of writing paper, sensitized with silver iodide, in a camera. By this method he created his first negative on paper, the shadowy image of an oriel window at his Wiltshire home, in August 1835. After developing the sheet with gallic acid and silver nitrate, Talbot placed the paper negative in contact with another sensitized sheet, then laid it in the sunshine to print out the first of multiple photographs from the same negative. This negative-positive system became the foundation for chemical photography through the 20th century.

In the next generation, the first professional artist-photographers merged traditions of painting with evolving photographic technology. In Paris, Gustave Le Gray, a painter turned photographer, taught negative-positive photographic techniques to over 50 students and wrote a popular studio manual. He understood that fine detail and tonal subtlety depended upon the transparent support of negatives, and he advocated glass as the substrate. In Lille, the entrepreneur and inventor Louis Désiré Blanquart-Evrard also worked to refine Talbot's process, creating more sensitive paper negatives by immersing them in potassium iodide and silver nitrate. Next, Blanquart-Evrard used albumen, the clear liquid of a hen's egg, to bind the silver salts to the surface of his printing papers and create photographic prints with heightened clarity.

At that time too, a new explosive matériel was being produced from cellulose nitrate dissolved in ether and alcohol. Modified to varied uses this clear syrup acquired the name *collodion*, from the Greek word for "gluey." In 1851, the Englishman Frederick Scott Archer used collodion to bind light-sensitive silver salts to polished glass. Together the collodion glass-plate negative and the albumen print created photographs of exquisite clarity and detail. However, the process was complex and inconvenient, since the chemistry required that the negative be prepared and sensitized in the dark, exposed, and then processed in the dark before the collodion dried. Aside from the camera and tripod, photographers who worked in the field had to carry materials, developing chemicals, and a portable darkroom into the field to complete their negatives onsite.

In the portrait studio, the wet-plate collodion negative technique brought an end to daguerreotypy. In 1854 André Adolphe-Eugène Disdéri opened a photography studio in Paris where he streamlined a process for producing affordable miniature portraits. He divided a single glass-plate negative into 8, and later 10, different segments. In a camera with multiple lenses, Disdéri exposed each segment individually without having to change the glass plate negative. All eight images could be developed and printed at once, then cut into separate photographs, each mounted on a card the size and shape of traditional *cartes-de-visite*. The economical images made photographic portraiture accessible to a huge new audience.

The American Civil War was the first major conflict to be photographed comprehensively. Mathew Brady, a leading portraitist, decided to document

events of the war, and arranged for his staff to accompany the troops. Long exposure times and the demands of the wet-plate collodion technique prevented them from documenting combat itself. However, their images of marching and bivouacked armies and the aftermath of battles were rapidly transformed into wood-engraved illustrations for newspapers and magazines. When the war ended in 1865, several battlefield photographers, including William Bell, Timothy O'Sullivan and William Henry Jackson, joined government-sponsored scientific and military surveys of the American West. Their photographs, along with the work of Californian photographers Carleton E. Watkins and Eadweard Muybridge, informed Americans in the East and in Europe of the grandeur of the American West.

In 1872, former California governor Leland Stanford hired Muybridge to help settle a wager about how horses move at a trot. The project led the photographer to extensive studies of animals in motion. He collected and edited thousands of his photographs as collotype illustrations for the portfolio *Animal Locomotion: An Electro-Photographic Investigation of Connective Phases of Animal Movements*. This photomechanical process made it possible to mass-produce precise photographic images. The method was contemporary with the practical refinement of the halftone process, which translated photographic images to intaglio plates for commercial printing in conjunction with rotary presses. Photographic imagery began to vie with hand-drawn illustration in popular newspapers and magazines, subtly and gradually transforming the public notion of visual naturalism.

During the 1870s gelatin came into use as a medium for binding light-sensitive silver salts to negatives. Dry-plate negatives could be prepared in advance, and eliminated the need for immediate, onsite developing. Rapid advances made negatives more sensitive, as exposure times shortened and new, more immediate and more topical subjects interested photographers. Sensitized gelatin emulsions on glass, paper and eventually celluloid became affordable, sized for a variety of camera models. In 1879 George Eastman developed a machine for coating paper and celluloid dry plates. In 1888 he registered the trade name Kodak, and introduced the No. 1 camera. A hardwood box, covered with embossed black paper, it had a 57 mm $f/9$ wide-angle lens, and no viewfinder. The operator pulled a string to cock the shutter, and pushed a button for an exposure of $\frac{1}{20}$ second. The camera held a long strip of film on a spool, with emulsion on a paper back. When 100 frames were exposed, the user sent the camera to the factory in Rochester, New York, where the film was processed and printed. The photographs were returned to the customer by mail, along with the camera reloaded with film. This innovative combination of product, service and consumables established an industry and made photography accessible to a huge new audience in the United States. The stage was set for a new century in which photography became ever present. Scientists, engineers, travelers, photojournalists and amateurs developed their own specialized photographic genres. Amidst them, creative photographers struggled to establish their legitimacy as artists.

CATALOGUE

MAURICE LŒWY

French, born in Austria-Hungary, 1833–1907

and PIERRE-HENRI PUISEUX

French, 1855–1928

Posidonius – Aristotle – Pôle Nord

1901
from *Atlas photographique de la lune*, vol. VI, plate XXXV
Photogravure on cream wove paper
70 × 55.8 cm (27½ × 22 in.) Plate
80.5 × 60.2 cm (31¾ × 23¾ in.) Sheet

Milly and Fritz Kaeser Endowment for Photography, 2014.019.003

In 1900, to celebrate the arrival of a new millennium, the Exposition Universelle—a world's fair—was held in Paris. It was an opportunity for the French Third Republic to showcase its stature and cultural achievements, along with those of exhibiting countries from around the world. The hall of the Ministère de l'Instruction Publique was decorated with huge plates of the first lunar atlas illustrated with photographic images assembled side by side to create an image nearly two meters in diameter. These were plates from the pioneering *Atlas photographique de la lune*, a collaboration of Maurice Lœwy and Pierre-Henri Puiseux, astronomers who had each begun their careers as mathematicians, and came to their partnership by very different paths.

Maurice Lœwy, the elder of the two, was born in 1833 in the Bohemian town of Mariánské Lázne.[1] He moved with his parents to Vienna when he was eight years old. A mathematical prodigy, he attended the Polytechnic School and the University of Vienna. He went on to study astronomy at the Imperial Vienna Observatory under director Karl von Littrow, and later became Von Littrow's assistant. Lœwy's mentor was mindful of the prejudices that limited Jews in the institutions of Austria-Hungary, and helped secure a position for his student at the Paris Observatory. There, under the direction of Urbain Le Verrier,

Lœwy continued his investigations of the orbits of asteroids and comets, and also became interested in optics. He was comfortable in Paris; he became a naturalized French citizen in 1864, and even served on the city's ramparts during the Siege of Paris. Lœwy designed an improved mounting for Meridian Circle telescopes, and developed a simplified method for calculating solar orbits. These achievements prompted his election to the Bureau des Longitudes in 1872 and to the Académie des Sciences in 1873.

In 1882 Lœwy adapted the angled refractor principle of German telescopes to the design of a new instrument known as the Equatorial Coudé.[2] Lœwy's telescope used a mirror at the top to bend an optical beam along an angled, or elbow-shaped, tube. He mounted the enormous instrument in a masonry cradle, with a small building for the observer, which avoided the necessity of a more costly dome. This design enabled the astronomer to sit in one place while the telescope oscillated before and beneath him around the optical axis. In 1889 the Royal Astronomical Society in London presented Lœwy with its gold medal for his design of the Equatorial Coudé and his calculations of the constant of aberration. The construction of an Equatorial Coudé in Paris was funded by the banker and philanthropist Raphaël Louis Bischoffsheim, overseen by Lœwy, and

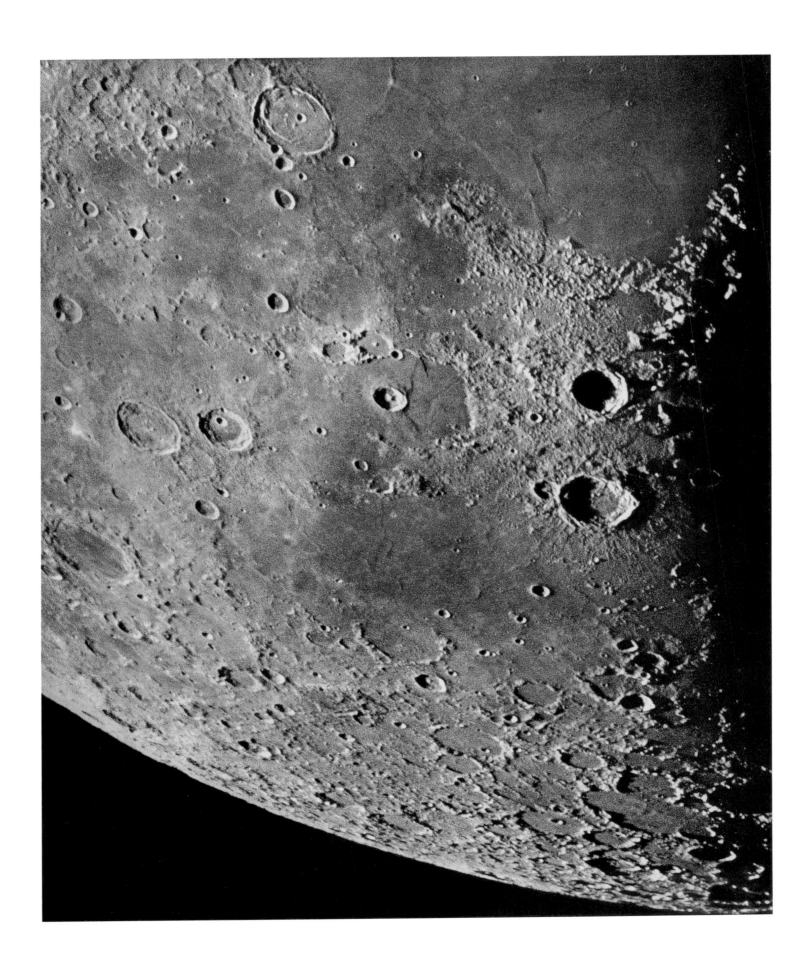

the unique telescope, with its 60-centimeter objective and 18-meter focal length, came into service in 1891. The astronomer began using the Equatorial Coudé to search for comets, and installed a camera at the focus refractor. He also engaged the brilliant young Pierre-Henri Puiseux to assist him in this work.

Puiseux was another natural mathematician. Born and raised in Paris, he was the son of Victor Puiseux, a professor of celestial mechanics at the Sorbonne.[3] He attended the prestigious Lycée Saint-Louis and then the École Normale Supérieure. He was also an expert mountaineer and made first ascents of several of the peaks in France, Switzerland and Italy. He often published articles on mountaineering in such journals as *Annuaire du Club Alpin Français* and *Montagne*. Indeed, Puiseux was best known as an alpine mountaineer for much his life. He received his doctoral degree in 1879 and taught at the University of Paris during the 1880s. He also worked at the Paris Observatory, where he was promoted to associate astronomer in 1885. It was his interest and expertise as a mountaineer that prompted his research into lunar geology at the observatory.

In 1888 Lœwy and Puiseux published their ideas for potential use of the telescope, followed in 1891 by a thesis on how their plan for comparative photographs, taken at different lunar phases, could provide precise measurements of the moon's topography and allow calculation of the effects of aberration and refraction of light.[4] They began collecting photographic images of the moon's surface using the Equatorial Coudé around 1892. The telescope was sophisticated enough to overcome atmospheric blurring and to capture remarkable detail in images of seven inches (17.8 cm) in diameter on dry photographic plates. Lœwy and Puiseux photographed the moon over about 500 nights, exposing over 6,000 photographic plates, documenting most of the moon's surface visible from Earth. Usually, fewer than 60 nights each year were clear enough to expose negatives, with Lœwy and Puiseux using a hand-operated shutter instinctively to limit exposure of the negatives from the brightest areas of the moon's surface. Therefore, just a handful of useable plates were produced on each of those rare evenings. The finest plates could be optically enlarged 8-15 times to transfer detailed images to large, atlas-scaled photogravure plates.[5]

The astronomers sent their best negatives to the printing house of Heuse, Gaultier & Schutzenberger in Paris, where the images were transferred to enlarged photogravure plates, printed, and bound.[6] Five photogravure plates were published in 1896, in the first of 12 fascicles, which also included descriptive text and a mirror-image line-drawn diagram opposite each photographic image, identifying major geological features on the lunar surface. The plates were organized in pairs, each showing the same region of the moon during the waxing and waning phase; each pair showed the moon's surface illuminated from the east and west respectively, revealing the shape, position and relative apparent topography of each feature. Serial publication of the atlas continued in 11 more fascicles with six plates each, to comprise a total of 71 enlargements, and 11 contact plates as title vignettes.

The present image, photographed in Paris on March 26, 1901, at seven hours eight minutes, is identified by the prominent lunar craters of Posidonius and Aristotle, and the North Pole of the moon, located in the lower-right corner of the image.[7] The tonal range of the photogravure image provides a

palpable sense of the topographical, even sculptural, quality of the moon's surface. The perception of objects from such a distance was unusual, and these images astounded viewers at the turn of the century. The immense scale of this view is emphasized by the passage of rich black at the bottom of the plate. The juxtaposition of vast, empty space also indicates the substance of the moon's geography. With no antecedent to gauge the images against, and lacking knowledge of astronomy or geology, most viewers of the day must have been impressed by the stark, abstract beauty and the mysteries of nature reflected in these plates.

The completed *Atlas photographique de la lune* was the first great photographic publication of the 20th century and offered a glimpse of the promise of scientific photography through the era. Lœwy died in 1907, nine years after his appointment as director of the Paris Observatory. The achievements of his career as an astronomer were honored when a lunar crater, lying along the eastern rim of Mare Humorum in the southwest part of the moon's near side, was named for him. Puiseux continued their project, now assisted by Charles le Morvan in the photography and publication of the last three folios.[8] The *Atlas photographique de la lune* remained the standard tool for visual study of the moon until the 1960s, when NASA's Lunar Orbiter Probe Atlas of the Moon (LOPAM) finally obtained superior photographs.

LEWIS WICKES HINE
American, 1874–1940

Albanian Woman from Italy, Ellis Island

1905
Gelatin silver print
17.8 × 12.7 cm (12 × 5 in.) Image
17.8 × 12.7 cm (12 × 5 in.) Sheet

Dr. and Mrs. Charles Sawyer Fund, 1975.078

The sociologist and documentarian Lewis Wickes Hine dedicated much of his photographic career to revealing the realities of life for the underprivileged in the United States. He built upon the legacy of John Thomson and Jacob Riis, and became a potent example for American documentarians. Hine was born and raised in Oshkosh, Wisconsin, where his father had a café.[1] After his father's accidental death, Hine had to go to work to support his family, while struggling to stay in school. At the Oshkosh State Normal School he took courses in drawing and sculpture. In 1900 Hine enrolled at the University of Chicago, but could only afford to attend for a year. At that time, it seems, he taught himself photography. Frank A. Manny, once an Oshkosh State Normal School teacher, had become director of the Ethical Culture School in New York, and hired Hine to teach primary and secondary students. This position made it possible for him to continue his studies at New York University, where he completed his master's degree in sociology in 1904, then married and began a family. Hine came to know the leaders of New York's reform community, including Professor Felix Adler, the colleague of Jacob Riis.

Manny suggested that Hine take his students to Ellis Island to observe and photograph arriving immigrants.[2] He took the first field trip in 1904, and over the next five years Hine exposed over 200 of his own plates. He was drawn to the spectacle of these hopeful immigrants on their way to cities, factories and farms. Hine wanted to document the appearance of immigrants in the United States. The tabloid press described hoards of disease-ridden, deformed and degenerate arrivals, but Hine saw them as 20th-century descendants of the Pilgrim asylum seekers. He was fascinated by their gallantry, spirit and variety.

This portrait of an Albanian woman, even though it was taken with a glass plate camera, appears to have been captured at a moment's notice. It is a powerful composition. The subject's direct gaze is sincere and cooperative, yet dignified. Her distinctive costume creates a stable pyramidal shape, close to the picture plane. A series of receding horizontals in the background presses the figure forward. The strongest of these is a metal bannister or the crest rail of a fence, which visually suggests that the woman has now passed into a protecting enclosure, and into a new nation. The opposing chevrons of the woman's costume—the edges of her head scarf, and her angled neckline and shoulder straps—immediately pull the attention to her face. For Hine, a distinctive quality of this subject was her costume, especially her head scarf, a Balkan version of the hijab, a hair and

neck covering traditionally worn by Muslim women in the presence of men outside their immediate family. This soft, modest garment is worn by country women in Albania, where about half the country's population are Sunni Muslim. Hine's photograph captures the woman's ethnic character, the sincerity of her personality, and her willingness to endure this immigrants' queue. Patient and cooperative, she appears eager to complete the formal process for which she has journeyed far, with great anticipation. It almost seems as though the woman believes Hine's photography to be part of her intake process.

In 1907 the Russell Sage Foundation recruited Hine to photograph the mills and works of Pittsburgh, and to provide images to supplement the statistics and analyses of its report on the steel industry. Most of Hine's photographs represent frontal portraits of the workers. He also provided straightforward, descriptive and impersonal captions identifying their jobs and national origin. In January 1909, 10 pages of these photographs were published in *Charities and the Commons*, the journal of philanthropy that later became *Survey*. The following year, the Russell Sage Foundation published six volumes of the Pittsburgh findings, which promoted corporate reform.[3] Hine had by that time been staff photographer for the National Child Labor Committee for two years. This private, nonprofit agency observed the well-being and advanced the rights of American children. The organization understood the power of photography, how images of child labor could muster support, and that Hine was uniquely suited to the task.[4] He left teaching to travel around the country, collecting images of children at work. His photographs were published in pamphlets, posters and other campaign media, and were projected in lectures. He began by

exploring textile mills in the Carolinas, where he found children loading and operating looms and other machines. In unstudied but formal group portraits, Hine lined children up outside the mills, and captioned the images with the children's names, ages, occupations and wages. After repeated threats from mill operators, he began posing as a fire inspector or bible salesman. For a decade Hine investigated American child labor, photographing children at work all over the country, from Pennsylvania coal mines to Gulf Coast canneries.[5]

In 1917 Hine settled in Hastings-on-Hudson, New York, with his wife and young son. At the outbreak of World War I, he found a position with American Red Cross, then run by the social welfare advocate Homer Folks, whom he admired. Hine traveled to France to photograph conditions faced by civilians affected by the war.[6] He also continued to make images of people at work, emphasizing their skill and craft. These "work portraits" would evolve into a much longer project; some were published in 1921 in *Survey Graphic*. Photography now provided Hine with only an intermittent income. He worked for *Western Electric News*, the magazine of the Western Electric Company in New York, which aimed to encourage employee morale in the early 1920s. Later he published pictures that emphasized the harmony of worker and machine, worker and company.

In 1930 Hine was commissioned to photograph the construction of the Empire State Building. He carried his camera in a specially modified sling as he scaled the structure with the workers. In 1932, Hine's photographs of workers welding steel girders high over the New York streets were exhibited and then published in a book for young people, *Men at Work*.[7] During the Great Depression

Hine worked on government-sponsored projects through the Tennessee Valley Authority and the Rural Electrification Administration. Later he was appointed chief photographer for the Works Progress Administration's National Research Project, which studied changes in industry and employment.

In early 1939, a retrospective exhibition of Hine's photographs was presented by the Riverside Museum in New York. The show renewed appreciation for his early work, especially among the new generation of concerned photographers at the Photo League. In Hine's needy final years, the Russell Sage Foundation asked him to assemble a definitive collection of his life's work. He selected 100 photographs, made new prints, and mounted and captioned them systematically. The series began with *The Immigrants' Gateway to America* of 1905, and concluded with *The School Nurse* from 1920. The Albanian woman is among this selection.

ROBERT DEMACHY

French, 1859–1936

Plains of Holland

about 1910
Gum bichromate print on cream laid paper
16.2 × 16.9 cm (6⅜ × 6⅝ in.) Sheet
27.5 × 24.5 cm (10⅞ × 9⅝ in.) Mount

Milly and Fritz Kaeser Endowment for Photography, 2015.061

While documentarians and scientists expanded their use of photography at the turn of the 20th century, others wished for their work to be recognized as fine art. Since the 1880s, mountains of kitschy, commercial stereographs and postcards had given photography a tawdry reputation. This was an era when the practice of photography had become more accessible as a popular hobby. Camera clubs emerged across Europe and the United States. Most amateurs wanted accurate visual documentation of cherished people and events. By contrast, aesthetic photographers studied the principles of academic painting; they carefully planned their exposures, and lavished negatives and prints with meticulous attention.

In the vanguard of this trend was Robert Demachy, whose work combined photographic imagery with vigorous hand work, attracting both admiration and censure.[1] He was the son of Charles-Adolphe Demachy, founder of the burgeoning Banque Demachy, and later regent of the Banque de France.[2] Robert grew up in privilege at the family's Paris mansion and, during the summer, at their villa near Villers-sur-Mer in Normandy. Around 1870 he and his siblings moved with their mother and English nanny to Brussels, to escape threats of the Franco-Prussian War. The Banque Demachy helped finance resistance efforts during the Paris Commune.

After fulfilling his military service, the 18-year-old Demachy had the freedom of youth and affluence. He gravitated to the bohemian counterculture of Paris, befriending artists and musicians, whom he sketched at city cafés and private salons. Demachy took up photography around 1880, and became a regular contributor to Paris photography exhibitions, submitting landscapes, portraits and nude studies. In 1882 he was elected to the Société Française de Photographie (SFP), though some of its more conservative members objected to the experimentation and sensuality of his work. Demachy would react to their disapproval by joining with Maurice Bucquet to form the Photo-Club de Paris in 1888.[3] He helped to edit the organization's journals, the *Bulletin du Photo-Club de Paris* and the *Revue de Photographie*, and contributed hundreds of articles on technique and aesthetics. At the Exposition Universelle of 1889 his photographs were awarded a bronze medal. While visiting the fair, Demachy met Julia Adelia Delano, the heiress to an industrial and banking family in Detroit. They married in spring 1893 and settled on one floor of the Hôtel Demachy in the rue François Premier.[4]

In 1894 Demachy became enthralled by the gum bichromate prints submitted to the Photo-Club exhibition, and the way they melded photographic

imagery with a draftsman's touch.[5] He began his own experiments, using an emulsion of light-sensitive potassium dichromate crystals suspended in gum arabic and tinted with watercolor. Demachy applied the solution to writing paper, then exposed the dried sheet to sunlight under a photographic negative. When the sensitized sheet was washed, areas of emulsion that had been protected dissolved, allowing the tone of the paper to shine through. By selectively painting emulsion onto the sheet, and repeating the developing process, the artist added layers of pigment to give the image a sketchy, expressive quality. Demachy was one of several photographers who exhibited gum bichromate prints at the London Salon in 1894. After seeing the show Alfred Stieglitz (Cat. no. 7) began to promote gum printing in America, as did Hugo Henneberg and his colleagues in Vienna soon thereafter.

The gum bichromate prints that Demachy exhibited in the Second Salon of the Photo-Club de Paris in 1895 were figural photographs reflecting the influence of Symbolism. Their sense of spiritual longing and eroticism was comparable to the paintings of Eugène Carrière or Pierre Puvis de Chavannes. In 1897 Demachy published a technical manual, which promptly appeared in translation with the title *Photo-Aquatint, or the Gum-Bichromate Process.*[6] It described techniques for creatively altering photographic images by hand. "A work of art must be a transcription, not a copy, of nature …," Demachy wrote. "If a man slavishly copies nature, no matter if it is with hand and pencil or through a photographic lens, he may be a supreme artist all the while, but that particular work of his cannot be called a work of art."[7]

These ideas were antithetical to the English circle of Naturalist photographers. Their champion,

Peter Henry Emerson, condemned Demachy's work as poorly composed and theatrical. The adversaries debated feverishly in the photographic press. However, Demachy's images attracted enthusiastic audiences in Britain. A solo exhibition of his work at the Royal Photographic Society in 1904 included 80 gum bichromate prints. It was one of several major shows of his work in London in the first decade of the century. The following year, Demachy was elected to the Brotherhood of the Linked Ring and named an honorary member of the Royal Photographic Society. The society invited him, and his colleague Constant Puyo, to select the French entries that year for the London Photographic Salon. The following October, Stieglitz exhibited his work at the gallery 291 in New York. With Puyo, Demachy published *Les procédés d'art en photographie.*[8] This technical manual, illustrated with photogravure and halftone plates, described techniques that the authors posit were not used 12 years before, including platinum and gum bichromate processes, as well as the more rarified methods of Rawlins oil printing and Ozotype.

Plains of Holland is one of a handful of landscapes that Demachy made after a journey to the Netherlands shortly before 1910. The work exemplifies his combination of photographic image and painterly hand work. A few of Demachy's Dutch photographs represent windmills as picturesque structures looming over flat fields. Here, two windmills rise over the landscape in static attention, their sails furled. The buildings occupy the lower-left diagonal half of this image, while at the upper right is open sky. Cattle graze beneath the windmills, each seeming to follow her own nose through lush grass. The fields recede, but seem to terminate below the horizon, which may represent dikes in the background, or even the

distant sea. There are no sharp lines in the image, and the few hard edges are described by dark forms silhouetted against light. The soft modeling of form and space and the subtle tonal shifts resemble mezzotint. To sustain this effect, Demachy selected a laid paper of the kind that might have been used for an old master drawing or print, giving this gum bichromate print a gravitas that photographs of the time often lacked. To emphasize the effects of light and atmosphere, and to create mood, the artist altered the photographic negative. Deep shadows below a luminous sky give this image a sense of muted peace. This is an image of rural serenity, in which life goes on in tune with nature, much as it has for centuries. In the collection of the Rijksmuseum in Amsterdam there is a gum bichromate print by Demachy representing the grain mill of Eendracht, Gouwsluis, near Alphen aan den Rijn, which is closely comparable in size and paper to the present print.[9] It also carries a similar inscribed signature. Both seem to have been made from a negative collected on Demachy's tour of South Holland, between Leiden and Utrecht, before 1910.

EDWARD STEICHEN
American, 1879–1973

Moonrise, The Pond

1904
Photogravure on white Rives BFK wove paper
26.5 × 32.3 cm (10⅜ × 12¾ in.) Plate
40 × 50.7 cm (15¾ × 20 in.) Sheet

Gift of Mrs. Norval Green, 2003.039.004

From his elegant Pictorialist photographs and indispensable contributions to the Photo-Secession, to his sweeping curatorial projects of the 1960s, Edward Steichen was a dominant figure in American photography. Born at Bivange in Luxembourg, Éduard Jean Steichen immigrated with his family to Chicago when he was two years old.[1] He grew up in Milwaukee, Wisconsin, where he apprenticed in a commercial lithography plant when he was 15 years old. Two years later his father gave him his first camera and he became enthralled by photography, but he still dreamed of becoming a painter. His watercolors and canvases of the late 1890s represent poetic landscapes in a soft, painterly style influenced by the work of James McNeill Whistler. Steichen developed his own Tonalist manner of painting landscape to explore effects of color, light and atmosphere. One of his favorite subjects was the moon low over the horizon, seen through a screen of silhouetted trees.[2] Few of his paintings of the period are extant today, but there is a rare example in the Snite Museum of Art (Fig. 1).

In 1900 Steichen went to Paris to study and begin a career as an artist. He concentrated on painting, but continued to photograph. "There are certain things," he wrote in 1902, "that can be done in photography that cannot be accomplished by any other medium, a wide range of finest tones that cannot be reached in painting."[3] He became interested in the gum bichromate process, and gained technical advice from Robert Demachy (Cat. no. 3). On a visit to Munich in 1901, Steichen also met Heinrich Kühn and was impressed by the color effects that he achieved by layering gum printing from different negatives. Steichen's expertise as a lithographer enabled him to master the gum-bichromate process himself. He knowingly submitted 10 of his prints to the graphic arts category of the Salon de Champs de Mars in 1902. They were accepted for exhibition, but when the jury discovered that they were in fact photographs, the prints were disqualified and removed.

In 1902 Steichen returned to the United States and settled in New York City. He was among the first artists whom Alfred Stieglitz (Cat. no. 7) invited to join the Photo-Secession, and he immediately became a key figure in its organization. He helped plan the journal *Camera Work*, designing its cover and its custom typeface.[4] The second issue was devoted to Steichen's work, and over 14 years of publication, *Camera Work* featured more photographs by Steichen than by any other artist. Steichen found a studio on the fifth floor of a building at 291 Fifth Avenue. He persuaded Stieglitz to rent rooms across the hall for what became the Little Galleries of the

Photo-Secession—later renamed "291." Steichen designed and installed its first exhibitions.

In August 1904 Steichen, his wife Clara, and their newborn daughter Katherine escaped from the city heat by visiting their friends Charles Caffin and Caroline Scurfield at Mamaroneck, on Long Island Sound.[5] In the woods nearby, the photographer discovered a pond very like those that had inspired his earlier Tonalist paintings. He exposed a few negatives to explore his current interest in color effects in his photographs. Steichen printed one large plate in platinum, and then superimposed layers of pigmented gum using the same negative to add soft tints of color. In a letter to Stieglitz he described "*Moonrise* in three printings; first printing, grey black plat[itnum]—2nd, plain blue print (secret), 3rd, greenish gum. It is so very dark I must take the glass off because it acts too much like a mirror."[6] Over

two months Steichen worked on the large prints, which were difficult and not always successful, and it was an expensive project. Ultimately he kept just three prints of *Moonrise*, each unique in its technique and coloration.[7] In spring 1906, a reduced photogravure of the image was made for publication in *Camera Work*.[8] He became fascinated by subtly colored moonlit images, and went so far as tinting every impression of two photogravure plates in *Camera Work* by hand. Steichen's obsession is reflected in this photogravure from an enlarged plate, made 60 years later for a portfolio of his work reprinted in photogravure. It was modeled after a unique printing of *Moonrise*, done in 1904, that Steichen later gave to Stieglitz. To achieve its coloration, the photographer directed the intaglio printer in how to ink and wipe the plate with black, blue and green inks, to approximate the effect of his early darkroom work.

Fig 1. — Edward Steichen, American, 1879–1973, *Nocturne*, about 1903, oil on canvas, Snite Museum of Art, Gift of Mrs. Frank E. Herring, 1957.007.009

In 1906 Steichen returned to Paris. His photographs of couture gowns by fashion designer Paul Poiret appeared in the magazine *Art et Décoration*. He captured the form and physicality of the garments, as well as their style, initiating a new era for fashion photography, and a new professional demesne for himself. Through his friendships with avant-garde collectors like Gertrude Stein, Steichen became Stieglitz's connection to European Modernism. He introduced artists like Auguste Rodin, Henri Matisse and Pablo Picasso to Stieglitz, and helped to organize shows at of their work at 291 in New York.

In the months before World War I, Steichen returned to the United States with his family. He finally fell out with Stieglitz over their competing sympathies with the belligerent nations. He joined the Photographic Division of the Air Service in 1917 and turned his expertise to advancing aerial photography. Steichen returned to France with the Army and eventually became head of aerial reconnaissance programs.[9] His practical military work prompted him to pursue the technical and formal concepts of straight photography after the war. He began a systematic exploration of the day's most advanced photographic technology. Over several years he would photograph a white cup and saucer against a black velvet background over a thousand times, in order to master command of this equipment. He built a state-of-the-art professional studio in New York and concentrated on commercial work. In 1923, Steichen joined the staff of Condé Nast Publications, and traveled widely to photograph fashion for *Vogue* magazine and celebrity portraits for *Vanity Fair*.[10] As the Depression deepened during the 1930s, his imagery became more dramatic, elegant and romantic, parallel to the escapist cinema of the period.

After the attack on Pearl Harbor, the Navy induced Steichen, then 63 years old, to document the American war in the Pacific. He became head of the United States Naval Photographic Institute with the rank of lieutenant commander. He photographed at sea aboard the U.S.S. Lexington, and also supervised a unit of nautical combat photographers.[11] Onshore, he also worked with the photography department at the Museum of Modern Art (MOMA) in New York, organizing traveling exhibitions to rally civilian support for the war. In 1947 Steichen became head of the MOMA Department of Photography. Over 15 years in this position, he helped build an outstanding collection and organized 50 exhibitions. Best known of these was *The Family of Man*, an international project conceived to reflect the universal human experience and the state of photographic art. The landmark show debuted at MOMA in 1955 and toured for several years thereafter, while its related book became an international best seller.[12]

GERTRUDE KÄSEBIER
American, 1852–1934

Gertrude and Charles O'Malley

1903
Platinum print
15.8 × 20.6 cm (6¼ × 8⅛ in.) Image
15.8 × 20.6 cm (6¼ × 8⅛ in.) Sheet

Humana Foundation Endowment for American Art, 2007.020

Gertrude Käsebier was among the best-known and most accomplished American photographers at the turn of the 20th century. A leading figure in the Pictorialist movement, she was a sensitive and renowned portraitist, also celebrated for her images of women, motherhood and family life. When she was eight years old, Gertrude Stanton crossed the plains with her mother in a covered wagon to join her father who had built a sawmill in Eureka Gulch, Colorado;[1] he later became the first mayor of Golden, capital of the Territory of Colorado. She enjoyed an unrestrained frontier childhood that encouraged a fierce independence. After the sudden death of her father in 1864, the family returned to Brooklyn, New York, where her mother bought a boarding house. Stanton attended the Bethlehem Female Seminary in Pennsylvania in 1866–70, and then returned to Brooklyn. She met Eduard Käsebier, a shellac importer from Germany and one of her mother's boarders. In 1874 she married this promising businessman, who was five years her senior, and they began a family of a son and two daughters.

In 1889, Gertrude Käsebier attended the Pratt Institute in Brooklyn, studying drawing, painting and photography. After completing her course at Pratt, she traveled to Europe with her daughters to paint and see the works of the old masters. "One day when it was too rainy to go into the fields to paint," Käsebier wrote, "I made a time exposure in the house, simply as an experiment. The result was so surprising to me that from that moment I knew I had found my vocation."[2] News of Eduard Käsebier's ill health brought his family back to New York. His wife contributed to supporting the family at that time, working as an assistant to Samuel Lifshey in his photographic portrait studio in Brooklyn. She produced hundreds of portraits with Lifshey, learning the proprieties of working with sitters and the business of running a studio. Soon she opened her own studio in the family home, which became so successful that she was able to move to Manhattan in 1897.[3] Käsebier used a studio camera for her portraits, with an array of lenses, and produced gelatin dry plate-glass negatives for contact prints on platinum paper, and gum prints on Japan or traditional Western papers. She turned away from the customary scenic backdrops of the era and concentrated her attention on her subject's personality. The most discerning clients of the era were among her sitters, including celebrities such as Mark Twain, Evelyn Nesbit and Booker T. Washington.

When Käsebier's photographs were shown in the prestigious Philadelphia Photographic Salon

in 1898, she met other leading photographers, including F. Holland Day and Clarence H. White (Cat. no. 8), who became lasting friends. Alfred Stieglitz (Cat. no. 7) exhibited some of Käsebier's photographs in New York, and the following year published five of her images in *Camera Notes* magazine.[4] In 1900 Day included Käsebier's work in his exhibition *New School of American Photography* in London. Later that year, she was one of 28 women photographers whose work comprised an exhibition, organized by Frances Benjamin Johnston and Zaida Ben-Yusuf, for the Exposition Universelle in Paris. In 1901, the year Charles H. Caffin devoted a chapter in his book *Photography as a Fine Art* to Käsebier's work,[5] her photographs were used to illustrate many chapters of the serialized "The Making of a Country Home" in *Everybody's Magazine*.[6] The following year, Stieglitz included Käsebier as a founding member of the Photo-Secession. Six of her photographs were published in the first issue of *Camera Work*, two of them representations of motherhood.

For years, Käsebier rented a cottage near Newport, Rhode Island, the summer retreat for the wealthiest New Yorkers. During a vacation she sometimes found commissions for summer portraits. Among her visitors in 1903 were her daughter and her first grandchild, Charles O'Malley. His birth, three years before, deepened the photographer's exploration of motherhood in her work. Käsebier was delighted when her daughter and grandson visited her New York studio. "There suddenly seemed to develop between us," she wrote of one visit, "a greater intimacy than I had ever known before. Every barrier was down. We were not two women, mother and daughter, old and young, but two mothers with one feeling: all I had experienced in life that had opened my eyes

and brought me in close touch with humanity seemed to well up and meet an instant response in her."[7]

In Newport, Käsebier made several photographs of Charles and his mother with her view camera. The images reflect her own meditations on motherhood, and the changing attitudes of her era. This image captures her daughter and grandson relaxing in the sunshine at Newport in summer 1903. Its composition and impact are surprisingly complex. Gertrude O'Malley leans toward the viewer; her outstretched legs, and those of her son, draw the viewer's attention to her lap and the open book that holds their attention. A slight breeze lifts her hair and the book's pages, but the warmth of the sunshine is palpable. O'Malley's slight smile and her young son's rapt attention signify a moment of close connection. For most viewers, this common experience of shared wonder between mother and child evokes a tender memory.

Behind the figures, a dirt road recedes diagonally into the background, interrupted by a spreading tree, with its lush foliage and the strong vertical of its darkened trunk. The road evokes the metaphor of a life's progression, paused temporarily by a fertile season. Käsebier's Newport photographs reflect the ideas of childhood educator Friedrich Fröbel,[8] whose work Käsebier had encountered while at art school. Fröbel organized and named the first kindergarten, examined relationships between play and learning, and developed the notion of child-centered education. In this image, Käsebier's daughter actively teaches her son; in other images the child gazes or moves away from his mother to investigate the world on its own, stressing the mother's responsibility for fostering the child's independence. Käsebier's representation of childhood was also informed by writer Kenneth Grahame and his collection of childhood

reminiscences *The Golden Age*.[9] Grahame framed some of his descriptions by comparison to ancient Greek culture. The children to whom he gives voice see the adults in their lives as "Olympians," who have forgotten what it is like to be young. Some of the photographs that Käsebier made of her grandson and daughter that summer—such as *The Golden Age* and *Road to Rome*—are titled after and conceptually related to Grahame's book.

Six of Käsebier's photographs appeared in *Camera Work* in 1905, and the following year she shared a joint exhibition with Clarence White at the Little Galleries of the Photo-Secession. Among the photographs in the show were several taken in the summer of 1903, including *The Golden Age* and *The Road to Rome*.

GEORGE H. SEELEY
American, 1880–1955

Girl and Dog

1904
Platinum print
23.4 × 19.4 cm (9¼ × 7⅝ in.) Image
23.4 × 19.4 cm (9¼ × 7⅝ in.) Sheet

Humana Foundation Endowment for American Art, 2016.009

In the rural isolation of New England, George Seeley created elegant Pictorialist photographs that attained international renown. He did not fare well, however, in the cutthroat politics of the art world, to which his career may have fallen victim. Seeley grew up at Linwood, the 40-acre country retreat of New York attorney Charles Edwards Butler near Stockbridge, Massachusetts, of which his father was superintendent.[1] Seeley lived with his family in a comfortable lodge on the grounds.[2] A capable student, he attended Williams Academy in nearby Williamstown, where he pursued his interest in art, and as a senior he learned the rudiments of photography. In 1897 he went to Boston to continue his studies at the Massachusetts Normal School (now the Massachusetts College of Art), where he concentrated on art education. Near the end of his course, F. Holland Day invited Seeley to visit his Boston studio, an experience that rekindled his schoolboy's enthusiasm for photography.[3]

Seeley graduated in 1902 and returned to the Berkshires with an 8 × 10 inch plate camera. He began teaching in the Stockbridge public school system, and made photographs in his spare time. He often worked in the early morning before school, taking advantage of the soft, even light. With Day as his inspiration, Seeley made costume images that often suggest ancient subjects. Like Clarence White (Cat. no. 8), Seeley relied on his family for models, especially his sisters, Lillian and Laura, posed in flowing silk robes that their mother made. In 1903 his photograph *Early Morning* won a first prize in the competition sponsored by *Photo-Era* magazine.

In 1904, soon after Seeley became supervisor of art for the Stockbridge Public Schools, he organized a private showing of 30 of his photographs at Linwood, by then the home of Helen Butler, daughter of the late Charles H. Butler. He exhibited 14 prints in the *First American Salon of Photography* at the Claussen Art Galleries in New York, sponsored by Curtis Bell's Salon Club. Critics noted Seeley's work.[4] Alfred Stieglitz (Cat. no. 7) was so insulted by Bell's effrontery in imposing on his Manhattan turf that he boycotted the show, and urged his colleagues to do so. A few ignored the admonition. "Really must write to you of the pleasure your things have given me," Alvin Langdon Coburn (Cat. no. 9) wrote to Seeley after seeing the show. "If you come to New York, I should very much like to meet you."[5] White also recognized Seeley's talent and visited him in Stockbridge. He shot a portrait of the young photographer, and they began a long friendship.

Stieglitz invited Seeley to join the Photo-Secession, but the young photographer was wary, no doubt advised by Day and Bell of this domineering

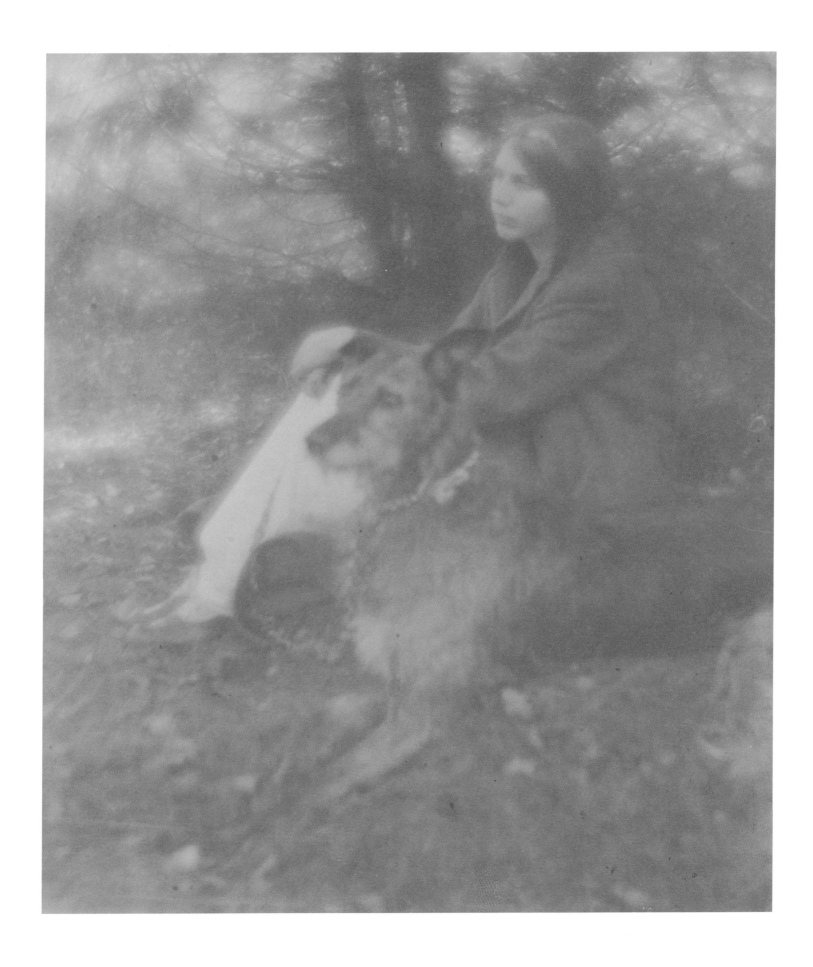

personality. Soon Stieglitz was straining for his quarry, offering Seeley the position of a fellow rather than the customary entry associate. "The fellowship," Stieglitz wrote, "is an honor not readily conferred, you know."[6] He encouraged Seeley to move to New York, closer into the orbit of his influence. The young artist preferred Stockbridge, however, with his secure job and the company of his family. After all, the photographs he made in the nearby woods, and developed in his cottage basement, continued to attract international attention. In 1905, his images and articles appeared in magazines like *Western Camera Notes*, the *Photographic Times* and *Photo-Era*. He had also begun to write essays for the local newspaper, the *Springfield Republican*.

It seems likely that Clarence White finally persuaded Seeley to join the Photo-Secession. "Before this reaches you, you will have seen Mr. White who will have given you a pretty good idea of the Secession," Stieglitz wrote on March 4, 1906. "I am much interested in your work and expect a little from you."[7] *Girl and Dog* was first exhibited in the London Salon of 1906 and became one of Seeley's best-known works. The photographer's sister Laura was his model, along with the pedigree staghound owned by Helen Butler, the owner of Linwood. With a lone beautiful figure, mysterious atmosphere and semiabstract setting, the image embodies the Symbolist style, though the overwrought sensuality of the style is absent, replaced by a more chaste, American lyricism. The feverish emotion of Symbolism is replaced by the strong and comforting sense of affection for a pet.

The girl and her staghound seem to be resting during a walk in the woods, for she holds a chain lead attached to the dog's collar. They rest in the shade on a sun-dappled forest floor, before a screen of pine boughs. The dry leaves littering the ground suggest it may be autumn. Laura Seeley wears a woolen overcoat, and a hat lies on the ground beside her. She relaxes with hands crossed on her knees, an expression of contemplation on her face. The staghound, however, whose piercing eye falls near the center of the composition, is alert, having spotted something of interest out of frame on the left. It appears to have just raised itself from the ground, head high and ears pricked. Compared to its mistress's relaxed pose, the animal is poised to spring forward, with its right foreleg raised. This detail, and the dog's focused eye, suggests a narrative for an image that seems so quiet and still at first glance. The tip of the dog's attentive right ear falls exactly at the point of its mistress's collar, a contact point of two opposing triangles that seem to tingle with communication. *Girl and Dog* was shown at the Little Galleries of the Photo-Secession in January and February 1907, in a joint exhibition of Seeley's work along with that of Baron Adolf de Meyer.

Seeley traveled to New York for the solo exhibition of his work at Stieglitz's 291 gallery in 1908. Writing later to thank Stieglitz, he mentioned that he had been particularly impressed by Steichen's work. Later, he described his admiration for the images of Heinrich Kühn and Frank Eugene, and asked whether could meet these photographers. Stieglitz had begun to organize representation of the Photo-Secession for the forthcoming *Internationale Photographische Ausstellung* in Dresden. He asked Seeley for new work, well aware of the artist's successful show at his own gallery the previous February. The photographer had few prints on hand, and wanted to save those for summer visitors to his Stockbridge studio. He wrote his regrets to Stieglitz, and encouraged him to exhibit prints from

his own collection.[8] Offended by this apparent indifference, Stieglitz mounted a campaign of persuasion and derogation. He urged Steichen to write to Seeley from Paris, encouraging him to submit prints. Stieglitz also complained to Kühn, who had oversight of the creative photography section of the Dresden exhibition.[9] He disparaged Seeley to two artists that he knew the young photographer admired.

In February 1909 Seeley served on the jury for the *International Exhibition of Pictorial Photography* at the National Arts Club, to Stieglitz's disapproval. The solo exhibition of his photographs scheduled for 291 in 1910 was canceled. Seeley's association with the Photo-Secession had come to an end. His work was selling well, however, for prices higher than most of his peers. Twenty-three of Seeley's gum prints were included in the landmark *International Exhibition of Pictorial Photography* at the Albright Art Gallery in 1910, and the museum purchased one from the show.[10] Many photographs in that exhibition reflected a shift in Seeley's style: these were atmospheric winter landscapes, so abstract that one was hung upside down.

ALFRED STIEGLITZ
American, 1864–1946

The Steerage

1905
Photogravure on cream Japan paper
33.4 × 26.7 cm (3⅛ × 10½ in.) Image
40.2 × 28.3 cm (15⅞ × 11⅛ in.) Sheet

Milly and Fritz Kaeser Endowment for Photography, 2014.011

The pivotal figure in the American campaign to establish photography as fine art, Alfred Stieglitz tenaciously pursued this goal as an artist, author, publisher and editor, gallerist and tastemaker. The eldest of six children of German-Jewish immigrants, he was born in Hoboken, New Jersey.[1] His father, Edward Stieglitz, was a successful wool merchant, who took his family back to Germany so that his children could be educated there. Alfred Stieglitz attended the Realgymnasium at Karlsruhe in 1881, and went on to the Royal Technical College in Berlin to study mechanical engineering, but it was only when he acquired a camera that Stieglitz applied himself. In the fall of 1885, he studied photochemistry with Hermann Wilhelm Vogel. When he first encountered the work of 19th-century pioneers of photography at an exhibition in Vienna in 1889, along with contemporary works by Robert Demachy (Cat. no. 3) and Heinrich Kühn, he determined to promote photography as a legitimate medium of creative expression.

Stieglitz returned to New York in 1890. His father hoped to engage his son in a practical occupation, and he purchased the Photochrome Engraving Company for him to manage. Stieglitz had no interest in business, but realized that photogravure technology could economically distribute photographic images to broad audiences. In 1893 he joined the editorial board of *The American Amateur Photographer* magazine, for which Photochrome printed photogravure illustrations. Soon he was writing most of the journal's articles and reviews. With parental encouragement, Stieglitz married Emmeline Obermeyer in on November 16, 1893. Nine years younger than Stieglitz, Obermeyer was the heiress to a brewery fortune. When Stieglitz's own family fortune was diminished in a stock market crash, he was able to depend upon his wife financially. However, the couple never became close, and Stieglitz committed himself obsessively to his work. Even after the birth of their daughter Kitty, he essentially lived apart from his family, though they remained under the same roof.

In 1895 Stieglitz organized the Camera Club of New York, merging the membership of the Society of Amateur Photographers with that of the New York Camera Club. He began *Camera Notes* magazine to promote the organization, engaging distinguished critics to write reviews and essays. He carefully selected illustrations for the magazine and supervised the production of exquisite photogravure reproductions. When 10 of Stieglitz's photographs were included in the first Philadelphia Photographic Salon in 1898, he met Gertrude Käsebier and Clarence H. White (Cat. nos. 5, 8). Shortly thereafter he met Edward

Fig 2. — Alfred Stieglitz,
American, 1864–1946,
Spring Showers, 1900,
photogravure, Gift of
Dr. and Mrs. R. Stephen
Lehman, 2006.066.004

Steichen (Cat. no. 4). After the Camera Club of New York presented a solo exhibition of 87 of Stieglitz's photographs in 1899, he left the association to found an elite group of creative photographers. The National Arts Club had invited Stieglitz to organize an exhibition of the best contemporary American photography. He curated a selection around his own work and that of others which he judged to be of comparable quality, including Steichen, Käsebier, White and a few others. He implied that the others were committed to the Photo-Secession; in fact, there was no such group until he formed it on February 17, 1902, two weeks before the National Arts Club exhibition was to open.

"The object of the Photo-Secession," Stieglitz wrote, "is to advance photography as applied to pictorial expression; to draw together those Americans practicing or otherwise interested in the art, and to hold from time to time, at varying places, exhibitions necessarily limited to the productions of the Photo-Secession or to American work."[2] Stieglitz equated his circle with European secessionist movements that broke from outdated academies and organizations, groups like the Photo-Club de Paris in 1888, the Brotherhood of the Linked Ring and the Munich Secession in 1892, and the Berliner Secession in 1898. In this secession of his own making, however, Stieglitz would not share prerogatives. He planned a new journal, *Camera Work* (Fig. 2), an elegant and expensive illustrated journal for which he functioned as editor and publisher.[3]

Stieglitz took this photograph in spring 1907, when he and his family sailed to Europe, where he planned ambitious rounds of meetings and exhibitions. They embarked at New York to sail to Bremen aboard the S.S. Kaiser Wilhelm II. Sometime after

the third day out, Stieglitz later wrote, he was strolling along the upper deck, where his family was accommodated in a first-class stateroom, when he came upon a remarkable view down into steerage, where economy passengers traveled together. The inclining mast and loading boom, a white-painted gangway bridge, and other elements of naval architecture contained a bustling city in itself. "I stood spell-bound for a while, looking and looking...," Stieglitz later wrote. "I saw a picture of shapes and underlying the feeling that I had about life."[4] He rushed back to his cabin to get his handheld 4 × 5 inch Auto-Graflex camera. He had just one prepared glass plate but was able to expose it before the scene had shifted too much.

The photographer developed the negative in Paris, then carried it back to New York in its plate holder several weeks later. He had become interested in the new Lumière Autochrome process in Paris, which began a fascination with color photography lasting years. Despite Stieglitz's later claims that he had immediately recognized the photograph as a milestone, it was not until 1910 that Max Weber reviewed Stieglitz's photographs and called attention to *The Steerage*, with its fragmented, flattened space that exemplified an abstract design, like Weber's own work and that of Arthur Dove and John Marin, which he had been exhibiting.[5] Afterward Stieglitz gave his photograph more attention. At that time Stieglitz was involved with organizing the monumental *International Exhibition of Pictorial Photography*, featuring more than 500 photographs by the Photo-Secession and related artists, for the Albright Art Gallery in Buffalo. The popular and influential show significantly advanced the acceptance of photography as an art form; however, ironically, the Photo-Secession

was dissolving. Many of its primary members had tired of Stieglitz's autocratic ways.

Stieglitz first published *The Steerage* in the October 1911 issue of *Camera Work*. The following spring the image appeared on the cover of the magazine section of the New York weekly *Saturday Evening Mail*.[6] However, the photograph was not exhibited until 1913, in a show of Stieglitz's work at his gallery, 291. This impression of *The Steerage*, printed in an enlarged format on Japan paper, was made for a special, limited edition of *291* magazine. Several of Stieglitz's friends, including Marius de Zayas, Paul Burty Haviland and Agnes Ernst Meyer, wanted to revitalize 291 and attract public attention back to the gallery. Haviland took the incentive and worked for a year on the production of *291*, conceived as a new, progressive arts journal.[7] *The Steerage* was the only image in the folio, accompanied by commentary on the photograph by Haviland and De Zayas. Its large size consciously elevated *The Steerage* to a work of fine art, meant for the gallery rather than the bookshelf. However, with the coming of World War I, Stieglitz decided that 291 could no longer be financially viable. The gallery closed with the first solo exhibition of paintings by Georgia O'Keeffe.[8] Afterward, in June 1917, the final issue of *Camera Work* was released, devoted chiefly to the work of Paul Strand (Cat. no. 66).

CLARENCE H. WHITE
American, 1871–1925

Nude Study

1909
Platinum print
24.1 × 18.8 cm (9 ½ × 7 ⅜ in.) Sheet
38.2 × 26.6 cm (15 × 10 ½ in.) Mount

Humana Foundation Endowment for American Art, 2008.034

A leading Pictorialist photographer, Clarence White began the United States' first school devoted to teaching photography as a profession, influencing American art and culture for generations to come. White was born in the village of West Carlisle, Ohio, where his father ran a grocery store and tavern.[1] His country childhood and life in a family business shaped his creative practicality. After high school he became a bookkeeper for the wholesale grocery firm of Fleck & Neal in Newark, Ohio. White married Jane Felix in 1893 and they began a family. He took up photography as a hobby, inspired in part by the images and ideas of James McNeill Whistler. The busy young father had the time and resources to expose just two plates a week. He carefully planned the photographs he would take in his scant free time at dawn, late evening or Sunday afternoons. Generally, these were figural studies of family and friends, aiming for formal balance and ethereal effects of light. White met Otto Walter Beck, a professor at the Art Academy of Cincinnati, and they worked together to establish the Newark Camera Club in 1898. He had already begun to enter his photographs in juried exhibitions, and they won an award at the first Philadelphia Photographic Salon at the Pennsylvania Academy of the Fine Arts. White served on the Philadelphia Salon jury the following year and came to know colleagues he admired, including Gertrude Käsebier (Cat. no. 5) and F. Holland Day.[2] Day encouraged the younger artist and included White's work in his New School of American Photography exhibition in London in 1900.

When Alfred Stieglitz became aware of White's work, he invited him to join the Photo-Secession and contribute to its first exhibition in 1902. Stieglitz encouraged the photographer to come to New York and pursue creative photography as a profession, and in 1906 the White family arrived in Manhattan. However, it quickly became clear that White needed to work. With Stieglitz's recommendation, Arthur Wesley Dow hired White as a part-time lecturer in photography at Columbia University Teachers College in 1907. White proved to be an effective and approachable teacher, incorporating many of the ideas of Beck and Dow.[3] Stieglitz and White worked together on experimental studies of nude models, methodically exploring the technical capabilities of their equipment and process. They tried a variety of techniques and papers, and Stieglitz introduced White to the Lumière Autochrome color process.

In the summer of 1908 White and his wife Jane took their sons to visit F. Holland Day at his summer retreat at Little Good Harbor, near Georgetown, Maine.[4] The affluent Day shared his seaside

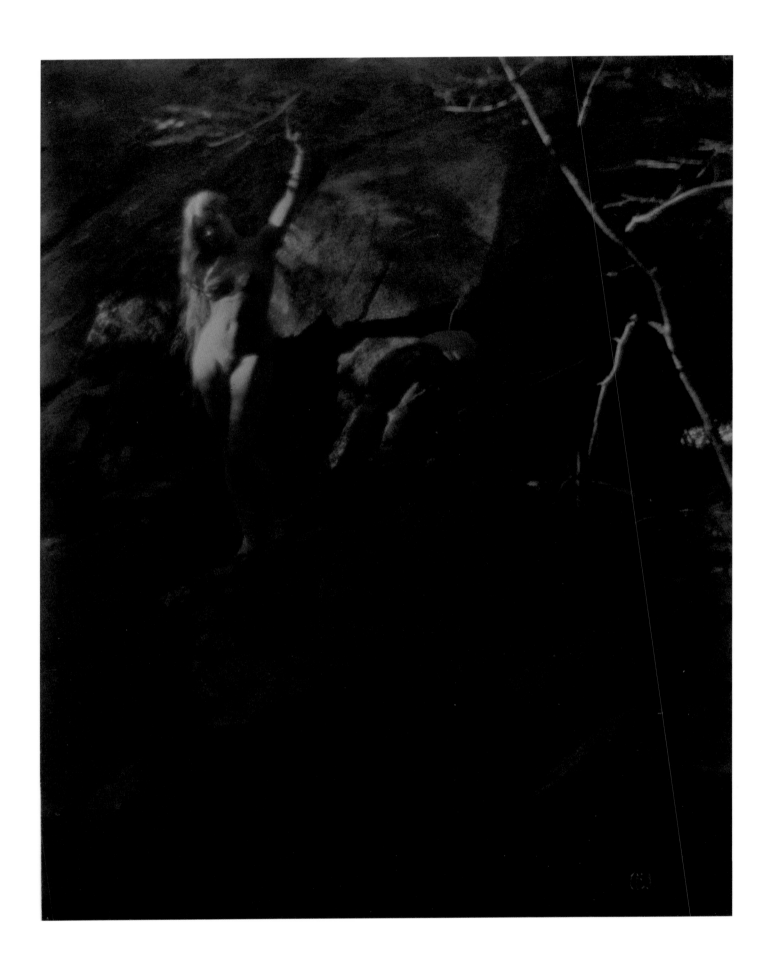

compound with friends, who became the bachelor's extended surrogate family. He often welcomed other photographers to Maine, where they modeled for each other's photographs. White's sons, too, sometimes posed in costume for images such as *The Pipes of Pan*, a few of which were published as photogravures in *Camera Work*, in the issue devoted to White's work.[5] The White family seems to have planned to return to Maine the following summer. Writing to Day on March 30, 1909, White mentioned such a possibility, and that he might bring along his "friend and pupil" Paul Burty Haviland.[6] Haviland was working with White in his new studio on 35th Street, assisting on projects like the portraits of Broadway star Maud Adams. They both photographed the artists' model Florence Peterson, each producing signed cyanotypes, platinum prints and Autochromes. Among the experiments are variations of pose, costume and illumination. Later, Haviland photographed Peterson in his own apartment, in similar costumes, poses and lighting. The number of portraits, and the expressive character of some, might suggest a personal relationship between Haviland and Peterson.[7]

This photograph also features Florence Peterson, identifiable by her physique and her long blonde hair.[8] White made other images of the model in a similar rocky landscape, but nothing so dramatic in its effect. This photograph may have been taken when the artists and model traveled together out of the city. The image is similar to White's photographs of his sons in the dappled forest sunlight in Maine. Indeed, in its style and imagery, this photograph is very like those of Day's circle, made at Little Good Harbor, where they photographed each other in classical costume. Here, the romantic figure with her long, flowing hair evokes the mythical figure of a dryad or nymph, emerging from the forest as in a vision. Light picks out the shining highlights of the woman's tresses and her round form, bringing her forward from the rocky background. White was an expert with the platinum printing process, which offered rich, saturated black passages describing the rocky background and its shadowed, craggy surfaces. The soft tone also emphasizes not only the comparative delicacy of the human figure, but her vulnerability. The artist pressed the figure into the upper-left quadrant of the composition, accentuating the feeling of her isolation. The artist balanced the inner contour of the reaching figure with an opposing diagonal, described by the thin tree leaning in from the opposite side. These diagonals create a rising chevron that directs the viewer up, away from the dark, threatening void at the bottom of the composition. This photograph also reflects White's continuing interest in the figure in a natural setting. Consciously or not, White has quoted the imagery of numerous old master paintings and prints depicting the tale of Perseus and Andromeda or Roger and Angelica.[9] This ancient myth tells the story of a damsel in distress, chained to the rocky coast to be devoured by a sea monster, and rescued by a triumphant hero. Here, the hanging position of her head and the way she drops her hip and raises one hand above her head, as if shackled to the rock, is parallel to the many representations of the legend.

White was in Maine late in September 1909 for meetings involving the purchase of an old farmhouse not far from Day's oceanside compound at Little Good Harbor. He was planning his own School of Photography, a summer course for art teachers and serious hobbyists.[10] The enterprise was part of the new "Seguinland" resort on the mid-coast of Maine

near Georgetown and Seguin Island. The project began in 1910; participants stayed at the Seguinland Hotel, where White conducted classes in its sitting rooms. Both Clarence and Jane White led groups on seaside photography outings and picnics. White's Teachers College associate Max Weber presented lectures on aesthetics and art appreciation, and Day and Käsebier gave critiques of students' work.

The success of the summer program led to the Clarence H. White School of Photography in Manhattan, which opened on East 11th Street in 1914.[11] White recognized the growing importance of commercial photography, which was rapidly supplanting other modes of illustration in newspapers and magazines. He designed the first teaching program to consolidate photographic technique with graphic design; his curriculum emphasized pictorial composition and introduced ideas of abstract design in photography. Over the years, the students at White's academy shifted from amateurs and secondary school teachers to aspirants in commercial photography and, later, photojournalists. The Clarence H. White School purchased a building at 460 West 144th Street in 1920, where it would operate for 20 years. The uptown location made it convenient for his Columbia classes, and among the students were many of the leading photographers of the following generation, including Paul Outerbridge, Dorothea Lange and Margaret Bourke-White (Cat. nos. 17, 38, 47).[12]

ALVIN LANGDON COBURN
British, born in the United States, 1882–1966

Hyde Park Corner

1908
from the photobook *London*
Photogravure
22.4 × 17.8 cm (8⅞ × 7 in.) Sheet
40.8 × 30.7 cm (16⅛ × 12⅛ in.) Mount

Gift of Dr. Douglas Barton (ND'86), Charles Rosenbaum, and Harry Heppenheimer (ND'52), 1985.073.001

As a teenager Alvin Langdon Coburn was fascinated by photography, and at the age of 20 he became a member of the Photo-Secession, contributing to the development of Pictorialism in the United States and the movement for recognition of photography as fine art. Like his mentors F. Holland Day and Alfred Stieglitz (Cat. no. 7), Coburn also exemplified the continuing influence of the wealthy and leisured, who could afford the costs of technical materials and the time required for the practice, perpetuating the lifestyle of their 19th-century predecessors. He was born in Boston, where his father operated the successful firm Coburn & Whitman Shirts.[1] Coburn was seven years old when his father died, and when he was a teenager his mother, Fannie, remarried. She was an amateur photographer and taught him the rudiments of the practice when he was a boy. On a visit to her brothers in Los Angeles, Coburn received his first camera, a 4 × 5 inch Kodak, as a gift. F. Holland Day, a distant cousin and a photographer of international renown, recognized his talent and taught him the finer points of developing and printing his work.[2] In 1899 Coburn traveled with his mother to London, where Day included nine of his works in the exhibition of contemporary American photography that he had organized for the Royal Photographic Society. The Coburns were in Paris in 1901 when the young photographer met Edward Steichen (Cat. no. 4), who introduced him to Robert Demachy (Cat. no. 3). Back in Boston in 1902, Coburn attended Arthur Wesley Dow's Ipswich Summer School of Art, where he learned Asian principles of design. Dow helped arrange for Coburn to work with Gertrude Käsebier (Cat. no. 5) at her studio in New York, in order to develop his skill as a portraitist. The first solo exhibition of his photographs was presented by the Camera Club of New York in 1903. Afterward, Stieglitz invited the young artist to join the Photo-Secession, and the first issue of *Camera Work* included a selection of his photographs.[3]

When Coburn returned to London with his mother in 1904, the Irish playwright and photographer Bernard Shaw introduced him to literary, artistic and political figures in the city, several of whom he photographed. His portraits of Henry James, G. K. Chesterton, George Meredith, H. G. Wells and others were published in the *Metropolitan Magazine*. Coburn explored the city with his 8 × 10 inch view camera, creating a series of Whistlerian views that were shown in London and in Liverpool. On a trip to Scotland he visited renowned Pictorialist photographer J. Craig Annan, who had studied photogravure with Karel Klíč 20 years before, and introduced the medium to Britain.[4] When Coburn

returned to London, he studied photogravure, set up his own press and began to print photogravures from his own negatives. He prepared the copper plates himself, exposing, etching and steel-facing. Coburn printed the etchings on various papers, experimenting until he achieved the print he desired, which was designated as a *bon à tirer* impression and the model for subsequent prints.

Hyde Park Corner is a photogravure from Coburn's first photobook, *London*, a suite of etchings printed by the photographer himself.[5] The photographs—whether showing coarse industrial areas or elegant urban spaces—present uncluttered spaces with crisp architectural forms, punctuated by people at work or leisure, usually depicted as unfocused or silhouetted figures. The folio includes images that Coburn had accumulated over five years, and they reflect his stylistic shift from the aesthetics of Pictorialism to Modernism. The later images were often taken from uncommon viewpoints and feature flattened perspective and geometric patterns. In this image, the sense of expansive space, managed environment and soft light somehow evokes a theme of urban sophistication. Tall, cultivated trees growing from the pavement diminish in scale in the receding space, while in the distance a loaded horse-drawn omnibus has stopped for passengers. Though silhouetted in the sunlight, the carriage appears soft and distant, its outlines simplified. This poetic image evokes the hazy atmosphere of a city still shrouded in smoke and fog at the turn of the 20th century, when industrial factories and millions of domestic fires burned wood and coal, contributing to a permanent pall of smoke and condensing damp air. Perhaps the most remarkable feature of this image is the soft shadow beneath the foreground tree, where dim light filters through the leaves to mottle the pavement.

Coburn returned to the United States in 1910, when 26 of his photographs were included in the landmark *International Exhibition of Pictorial Photography* at the Albright Art Gallery in Buffalo. That same year he published *New York*, a portfolio of photogravures that was a pendant to his *London* album.[6] Afterward the artist traveled to the West, visiting Arizona to photograph the Grand Canyon, and California to work in the Yosemite Valley. Coburn broke with Stieglitz, while drawing close to colleagues Max Weber and Clarence White (Cat. no. 8). Sharing ideas with Weber, Coburn made some of his most famous photographs, Cubist-influenced images of New York from elevated viewpoints. He met fellow Bostonian Edith Wightman Clement in New York, and they were married on October 11, 1912. Weeks later they sailed to England, on what would be the last of Coburn's 23 transatlantic crossings.

In London, the artist worked as a portraitist and book illustrator, producing photogravures for 25 books, including the work of his friends Chesterton, James and Wells. His book of portraits *Men of Mark* presents 33 of his portraits of authors, artists and statesmen. This was his best-known and most lucrative work, and he was prompted to produce a sequel.[7] While working on the project Coburn met expatriate American poet and critic Ezra Pound, who introduced him to a group of avant-garde writers and artists in London, including Wyndham Lewis, Henri Gaudier-Brzeska and C. R. W. Nevinson.[8] This group of Modernists came to public attention in a London exhibition of 1914, which was accompanied by a series of manifestos, published in Lewis's boldly designed journal *BLAST*. Together they forged

Vorticism, a Cubist-inspired style as dynamic and abstract as music that responded to the continental geometric imagery of Futurism. Coburn believed that it was important to keep photography relevant by responding to progressive aesthetic ideas. He made a portrait of Pound in the Vorticist style, superimposing three images in different sizes. Coburn invented an instrument that had three mirrors clamped together in a tube, which fitted over a camera lens to produced images fractured into kaleidoscopic shards. Pound called this device the Vortoscope, and the resulting photographs Vortographs.[9] Over a month or so, Coburn made about 18 of these experimental images, which are generally considered the first abstract photographs.

KARL STRUSS
American, 1886–1981

Hilda Struss, Nova Scotia

1911
Platinum print
11.4 × 9.3 cm (4½ × 3⅝ in.) Image
11.4 × 9.3 cm (4½ × 3⅝ in.) Sheet

Milly and Fritz Kaeser Endowment for Photography, 2014.020

The influences of Pictorialism and the Photo-Secession, along with an impressive level of technical understanding and skill, characterized the achievements of Karl Struss, who helped carry these ideas to American cinema.[1] He was born on the Upper West Side of New York in a house designed and built by his father Henry Struss, the successful owner of a silk mill and a bonnet-wire factory.[2] Karl was the youngest child of the family, spoiled by his mother and three older sisters. He looked up to his older brother, Will, who acquired a Polly Premo camera in 1896. Together the brothers took photographs during the family vacation on Long Island; back in the city, they developed the negatives in a makeshift darkroom, illuminated by a candle lamp covered with red glass.

In 1903 Struss contracted pneumonia. His father took him out of high school and sent him to the country, to recuperate with his aunt and uncle. After his recovery, Struss went to work at the bonnet-wire factory and dutifully stayed with the company for 11 years. In 1907, a year after the devastating death of his brother Will, Struss acquired his own camera, which he used to capture images while vacationing with his family in New Hampshire. He attended Clarence White's (Cat. no. 8) evening photography course at Columbia University Teachers College in 1908, and independently studied optics. Soon he developed a soft-focus camera lens, for which he secured a patent. Struss's photographic work was influenced by White's intuitive sense of composition. Max Weber, another Columbia instructor, exposed him to compositional ideas of the European avant-garde. Weber had painted in Paris in 1905–9, and was one of a few American artists with direct knowledge of the work of Cezanne, Matisse and Picasso. Struss also learned compositional lessons from Arthur Wesley Dow, chairman of the Teachers College art department, whose ideas and writing had revolutionized the teaching of art in the United States.[3]

In summer 1909, Struss traveled to Europe with his sisters Hilda and Lilian. He took along two Century view cameras, one fitted with his own soft-focus lens. The Strusses toured northern Italy, Dresden and Berlin, and then stayed with their mother's relatives in Cologne for a week. Struss exposed about a thousand negatives on the trip. After returning to New York, he developed, printed and enlarged some of his favorite images, experimenting with alternative printing methods and effects. The following summer, Struss and his sister Hilda vacationed with friends in Chester, Nova Scotia, a small tourist and artists' community. On the way to Canada, they stopped on the Maine coast to visit the first session of White's Seguinland School of Photography. There,

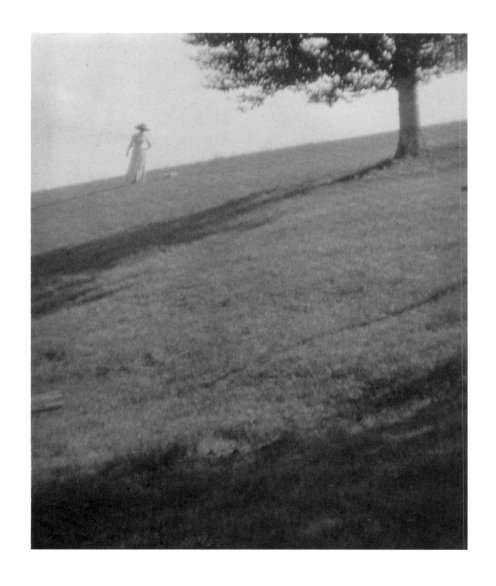

Struss met several students who would later become good friends, perhaps including Willa P. Collison. She may have joined the Strusses on their journey, for at Christmas 1910, the photographer assembled an album of Nova Scotia views for her.[4]

This is one of the photographs that Struss took that summer in Nova Scotia, an image of his sister Hilda, who was a primary school teacher in Manhattan. She looks at the photographer as she walks towards him in the sunlight, too distant, it seems, to read the expression on her face, though her casual, unposed posture gives the image a snapshot immediacy. This simple composition represents a pleasing balance of form, tone and pattern. Struss built up the image in component flat forms arranged in a manner that draws the viewer in, following White's advice to simplify composition and fill the pictorial space. The high, arching horizon, which narrows at the upper right, draws the eye up and into the distance. The shaded foreground passage shows that the photographer stood in the shade of a leafy tree and pointed his camera toward the setting sun. A soft light filters through the leaves, and a tree in the middle ground casts a long shadow. The figure of Hilda Struss appears higher and parallel with the sun. She casts a delicate, narrow shadow and seems almost to melt into insubstantiality amid light and space. The photographer captured this image with a 4 × 5 inch camera, using a long lens to obtain a wider-angle view. Struss used a 12-inch-focal-length lens, which enabled him to compose in the camera but also tended to flatten the depth of field, achieving a measure of reductive abstraction. He drew upon the ideas of Max Weber, who advised that photography was a two-dimensional art, dependent upon fundamental principles of composition, and reliant upon the selection of forms rather than their creation.[5]

In 1910 Stieglitz (Cat. no. 7) included 12 of Struss's photographs in the *International Exhibition of Pictorial Photography* at the Albright Art Gallery in Buffalo. The following summer, when Clarence White was in Maine, Struss took over White's photography course at the Teachers College, which gave him the chance to hang the first solo exhibition of his work at Columbia. Soon after Stieglitz invited him to join the Photo-Secession, he included eight of his images in the April 1912 issue of *Camera Work*.[6] Later that year, Struss's photographs were included along with White's and Coburn's in an exhibition at the Montross Gallery in New York.[7]

Struss opened his own commercial photography studio in New York in 1914. He produced his stylish images that appeared in such magazines as *Harper's Bazaar*, *Vogue* and *Vanity Fair*. He also began successfully to manufacture and market the Struss Pictorial lens. The Struss lens became the first soft-focus lens used by the motion picture industry when John Leezer used it to shoot Paul Powell's *The Marriage of Molly-O* in 1916.

Struss enlisted in the Army during World War I. After basic training in New Jersey and study at the School of Aerial Photography at Langley Field in Virginia, he taught at the School of Military Aeronautics at Cornell University. During this period of deep suspicion of German Americans, some soldiers questioned his allegiance. In December 1917, Struss was transferred to Fort Leavenworth, Kansas, with a demotion in rank. There were exaggerated rumors of his incarceration as a spy, but he remained on active duty. Military Intelligence investigated Struss, and he was exonerated of all accusations

and assigned to a clerk's job in the Department of Sociology and Psychiatry at Fort Leavenworth. Struss began officer's training a few weeks before the war ended. He was honorably discharged, but his professional reputation in New York had been tarnished by rumor. In 1919 he moved to California.

In Los Angeles, Struss was engaged by the Famous Players-Lasky Corporation, the era's leading motion picture and distribution company. Within weeks he was behind a camera working on the silent film *For Better, For Worse* for Cecil B. DeMille. While on the director's crew, he also began taking Pictorialist publicity portraits of film stars. In 1925 Struss traveled to Europe to work as a cinematographer on *Ben-Hur: A Tale of the Christ*, the epic silent film directed by Fred Niblo. After returning to Los Angeles, Struss began shooting F. W. Murnau's *Sunrise: A Song of Two Humans*, on which he and fellow cinematographer Charles Rosher worked to achieve a new aesthetic level in cinema. In 1927 Struss was a founding member of the Academy of Motion Picture Arts and Sciences, and he shared the first Academy Award for cinematography with Roscher.[8] Under contract from Paramount Studios, he worked on some of the most popular films of mid-century. In the mid-1950s he was a television cameraman in Hollywood for such early programs as *Broken Arrow* and *My Friend Flicka*.

JACQUES-HENRI LARTIGUE
French, 1894–1986

Le Grand Prix

1913
Gelatin silver print
23.5 × 34.5 cm (9¼ × 13⅝ in.) Image
30.5 × 40.8 cm (12 × 16 in.) Sheet

Gift of Jack B. Smith, Jr., 2015.045.003

The growing appeal of amateur photography in France is reflected in the early work of Jacques-Henri Lartigue, who captured remarkable images when he was a boy. When these photographs, collected in family albums, came to public attention after 60 years, he was recognized as a pioneer of the medium. Lartigue was born in the Parisian suburb of Courbevoie in June 1894, the younger of two sons of a successful financier who was one of the richest men in France.[1] Lartigue's father was a keen amateur photographer, and shared his enthusiasm with his sons. He gave seven-year-old Jacques a 13 × 18 cm view camera and tripod; the boy had to stand on a stool to reach the viewfinder. Jacques's very first photographs, of his nanny tossing a ball into the air, captured movement. Later, with a Kodak Brownie No. 2 and a handheld stereo camera, he instinctively recorded his childhood experiences.

Lartigue also became a devoted diarist as a boy, beginning a daybook that he continued throughout his life.[2] In his early photographs of family, enjoying games and sports, he demonstrated intuitive technical capability along with an innate a sense of timing. Among these images are a diver in mid-air over the water, Lartigue's cousin Bissonou leaping from garden steps, and Bissonou with Lartigue's brother Zissou skidding around a corner in a homemade pushcar. He kept all of his hundreds of exposed glass-plate negatives, and mounted his finest prints in albums, accompanied by descriptive inscriptions. In 1912, Lartigue acquired a Nettel 6 × 13 cm camera that enabled him to photograph panoramic views, and later that year his father bought a Pathé film camera. He recorded the projects that occupied him and his brother, as they progressed from go-karts and kites to automobiles and airplanes.

Youthful exuberance may have prompted the Lartigue brothers' fascination with speed and modern technology, but it coincided with the machine age and Futurism.[3] This aesthetic, literary and social movement admired new technology and its capacity for speed and efficiency. The Futurists condemned the art of the past, and advocated for science and technology to replace traditional aesthetic themes. They witnessed early flights by aviation pioneers such as Gabriel Voisin and Louis Blériot, and attended the Coupe Aéronautique Gordon Bennett gas balloon race and the Grand Prix de l'Automobile Club de France. At the velodrome, racetrack and airfield, the Lartigue brothers documented their interest in images created by chemistry and device. Quite unintentionally, they embodied the spirit of Futurism.

Lartigue's famous photograph *Le Grand Prix* was long thought to have been taken in 1912, when the annual

race was held at Dieppe. However, the car can be identified as a machine built by Th. Schneider et Cie of Besançon, which René Croquet drove in the following year's race by, accompanied by a mechanic remembered only as Didier.[4] The photograph was taken on July 12, 1913, when the Grand Prix was held in Amiens. The race that year was marred by three fatal crashes and the death of one spectator. The competitors drove 29 laps of the 19.65-mile (31.62-kilometer) race circuit on public roads. Georges Boillot won in a Peugeot EX3, in under eight hours. Croquet crossed the finish line in 10th position, with a time of 9:12:52.6.

Nineteen-year-old Lartigue is thought to have used his German ICA camera to take this remarkable photograph, using a $f/4.5$ lens to expose a 9 × 12 cm glass-plate negative.[5] He stood recklessly on the roadside to photograph the competitors as they sped by. He tried to pan to follow Croquet's car but was not quite fast enough, so the front of the car escaped the camera. However, the truncated composition captures a sense of speed, which is accentuated by the distortion of the central rear wheel into an ellipse as the automobile seems to strain forward. The angle of view shows that Lartigue held his camera low, looking down into the viewfinder from above. The distortion of the image resulted from both the velocity of the subject and the camera's slow focal-plane shutter. It opened as a slit in an upward motion, allowing light into the camera to capture different moments in time on different parts of the negative plate. The simultaneous movements of car and shutter resulted in an image in which diagonals seem to fan away from the central axis. If Lartigue could have held his camera low and stationary as the car drove by—and had used equipment fast enough

to arrest the action—the wheel would appear round, and the figures across the road from him would have been out of sight behind the car's spare tires.

Lartigue captured Croquet and Didier in the cockpit of the car. They are swathed in leather helmets, cloth masks and mufflers to protect them from the wind and road dust, and they wear goggles of metal and glass. Croquet's strong, two-handed grip on the steering wheel keeps the speeding car under control. His coat puffs up in the wind, while the fringe of a scarf and the leather strap on the spare tire flap wildly. The inherent peril in the scene is evident in the revealing detail of Didier's hand, resting on the back of the seat to steady himself during the bumpy ride.

In 1914, when Germany declared war on France, Lartigue was exempted from conscription due to poor health. Two years later, he volunteered himself and his Swiss Pic-Pic racing car (produced by Piccard-Pictet) to chauffeur doctors in the Paris hospitals. During that time he attended studios at the Académie Julian, studying painting with Jean-Paul Laurens and Émilie Desjeux. Afterwards, he considered himself a painter. He made photographs for his own amusement, but after the war his interest in machines and speed were replaced by an obsession with feminine beauty. Most of his photographs of this period represent elegant ladies parading in fashionable dress in the Bois de Boulogne, at Longchamps, and on the promenades of Deauville.

In 1918, while enjoying winter sports in the Alps, Lartigue met Madeleine Messager—known as Bibi—the daughter of the French composer André Messager and the Irish opera singer Hope Temple. Beautiful, carefree and slightly mysterious, Bibi pursued Lartigue. They were married on December

17, 1919, and enjoyed the whirl of high society, moving with the seasons from Paris, to Biarritz, to Cannes. Lartigue's photographs document their opulent lifestyle in continually growing albums. Their son Dany was born in 1921, when Lartigue was exhibiting his paintings in the Paris salons and Provençal galleries. His family life began to change, however, after the death of an infant daughter in 1924. The couple continued their social whirl, but they grew apart and eventually divorced. When the stock market failed in 1929, Lartigue's fortune was lost. He became a society portrait painter, and never seems to have considered working as a professional photographer. Even in his diminished position, Lartigue associated with the social elite. In 1930 he began a relationship with Renée Perle, a Romanian fashion model for the couturier Georges Doeuillet.[6] Lartigue's many photographs of her are stylish and elegant, but they lack the spontaneity and delight of his earlier work. Photography remained an amusing pastime, and his images of leisure and tranquility from the early 1940s seem oblivious to the horrors of war.

Lartigue's third wife Florette persuaded him that his photographs could help provide comfort in his later years. In 1962, she accompanied the 69-year-old photographer to the Manhattan offices of Rapho Guillumette Pictures, the press agency that had moved from Paris during the war. Its founder, Charles Rado, was astounded by Lartigue's albums and their detailed inscriptions. He introduced the photographer to John Szarkowski, curator at the Museum of Modern Art, who organized a solo exhibition of Lartigue's photographs.[7] In 1974, French President Valéry Giscard d'Estaing commissioned Lartigue to produce his official portrait. The following year Lartigue was named Chevalier of the Légion d'Honneur, and the first retrospective exhibition of his photographs in France was mounted at the Musée des Arts Décoratifs.[8]

UNIDENTIFIED PHOTOGRAPHER
British, 20th century

Steel-Helmeted Scots Entrenched and Awaiting a Counterattack

1917
Gelatin silver print
7.9 × 7.7 cm (3 ⅛ × 3 in.) Sheet
8.8 × 17.8 cm (3 ½ × 7 in.) Mount

Gift of Dr. and Mrs. Dean A. Porter, 1997.044.009.C

World War I was the first widespread conflict in which all adversaries used photography to support their campaigns.[1] Since 1846, photographers, hampered by slow photographic processes, had documented only the aftermath of war. The development of more efficient shutters and film chemistry made it possible to record the action of combat. Over the course of World War I, aerial reconnaissance photography became practical and contributed to battlefield tactics on all sides.[2] This conflict was so immense and long that every belligerent nation used photography to sway public information, though some were quicker to see its advantages than others.

Even before the war, Kaiser Wilhelm I of Germany recognized the power of visual propaganda and had assembled a staff of court photographers to promote his reign, documenting military maneuvers and naval fleet reviews. When the war began, German and Austro-Hungarian soldiers were allowed to photograph on the battlefield and to sell their images for censored publication.[3] This is exemplified by the experiences of André Kertész (Cat. no. 22), who took personal photographs as a private in the Austro-Hungarian Army on the Eastern Front. By contrast, in Britain and France, commanders and politicians remained wary, concerned that photography could facilitate espionage and had the potential to undermine morale. When Lord Kitchener was secretary of state for war, press and civilian photographers were prohibited access to British forces, and any serviceman caught with a personal camera faced court martial. By 1914, however, photography was a common feature of everyday life, and the halftone printing process made photographic images familiar in newspapers and magazines. The public demand for authentic images of the conflict was insatiable. Within weeks of the declaration of war, British newspaper owners began to press the government to allow the publication of official war news. The first photographs available to them were German images of the invasion of Belgium in August 1914. The newspapers purchased images from the battlefront, most of them German, and applied for release to reproduce them.

In the years before United States entered the war, American photojournalists made their way to the European battlefronts, though they were officially unwelcome. In 1914, *Leslie's Weekly* sent the experienced combat photographer Jimmy Hare to Belgium.[4] He was followed the Kansas-born freelancer Donald Thompson, who was also a filmmaker.[5] After images of the Christmas Truce appeared on the cover of the *Daily Mirror* on Friday, January 8, 1915, British and French authorities began organizing official photography in the field. Ernest Brooks was the first

British war photographer; he documented British naval attacks on Turkish forces at Constantinople, and was later wounded at Galipolli.[6] He was the only professional British photographer at the Battle of the Somme. In Paris, the French Army established the Section Photographique de l'Armée Française (French Army Photographic Section) in April 1915 to provide photographs for news, propaganda and the historical record.[7] They drafted experienced photographers from commercial studios, Jean-Baptiste Tournassoud (Cat. no. 13) among them. By far the most numerous photographers of World War I, however, were servicemen in the field and at sea. Throughout the war, newspaper and magazine publishers actively solicited their photographs, offering fees and staging competitions. In 1915, private companies in Germany collected snapshot cameras from the public to be given to soldiers at the front. Servicemen commonly included small personal cameras in their kit, from Box Brownies to more sophisticated German models by ICA and Ernemann. The folding Vest Pocket Kodak, introduced in 1912, was marketed as "The Soldier's Camera" in 1915, when nearly two million were sold.

Many soldiers' images were published, and have survived, without attribution. This photograph from the Battle of Passchendaele was probably taken by a foot soldier in the trenches.[8] The rapid development of mechanized firepower at the turn of the century had surpassed advances in troop mobility, so to protect themselves against enemy artillery and machine-gun fire, armies dug themselves into the earth.[9] They excavated broad trench systems, reinforced with lumber and deep enough to walk through in safety; some included barracks sheltered from the weather by canvas. Adversaries faced each other from their trenches along the battle lines, separated by "no man's land" and shielded from assault by barbed wire, mines and trapping pits. To gain ground, an army climbed to the surface to charge across the median on foot, hundreds of yards at a time, facing a defensive barrage that inflicted severe casualties even

Fig 3. — Unidentified photographer, British, 20th century, *Steel-Helmeted Scots Entrenched and Awaiting a Counterattack*, September 22, 1917, gelatin silver prints mounted as stereograph, Gift of Dr. and Mrs. Dean A. Porter, 1997.044.009.C

in the most successful assaults. Shellfire inflicted the most grievous injuries from a distance, and the blast of a shell explosion could kill by concussion. In an era before antibiotics, minor injuries could be fatal on the battlefield, where disease was uncontrolled and the trenches were infested with parasites and vermin. Removal or burial of the battlefield dead was irregular. The trenches often filled with rainwater, further aggravating infection, and in winter soldiers died from exposure. Most of the soldiers' time, however, was spent in monotonous waiting, in confinement and under constant threat that could cause debilitating "shell shock," or post-traumatic stress disorder, which was then poorly understood.

These disturbing facts are unapparent in this image of Commonwealth troops—Scottish soldiers attached to a South African regiment—which is dated but unattributed.[10] It reveals the devastation of the countryside near Ypres in Belgium, the once lush farmland reduced to dirt and rubble by constant bombardment since 1914. A row of blasted trees in the distance marks the position of a road that once separated farm fields. By the fall of 1917, German commanders believed that they had defeated the Flanders offensive, so they redirected forces to other fronts. However, improving weather after the rainy summer enabled the British to repair roads and resupply troops. They pressed their infantry forward, gradually taking and holding ground against counterattack by a leap-frog method of advance.

This photograph, likely taken by a soldier, captures a lull in the action. The Scots soldiers rise from cover to stretch, smoke and relax, their slouching, haphazard postures conveying exhaustion rather than military decorum. Their shallow trenches were excavated during quick advances, and the many shovels visible on the ground are evidence that digging was a constant activity; a group of mud-caked ammunition cases in the foreground provides an architectural wall that helps to shelter them. Their rifles lie close at hand with bayonets fixed. They all wear their helmets with their kilted battle dress, and each carries a gas mask on a bag across his chest. Though essentially a snapshot, this image captures the scale of the conflict on the Western Front and the soldiers' experience.

This photograph is one of a stereographic pair, mounted together with another print taken simultaneously from a slightly different angle. When perceived through a viewing device—a stereoscope—the two images create a sense of depth and dimension.[11] The geometric wooden boxes in the foreground, the tailstock of a gun carriage and the central trench receding into the distance are effects that become more dramatic in the stereoscope. During the war, stereographic cameras like the Jules Richard Vérascope and the Goerz Stereo-Pocket-Tenax were surprisingly common on the battlefield. The old-fashioned entertainment was revitalized by surging interest in visual news of the war.[12] Published without attribution in the United States and Britain during the war, this image remained in print afterward, when it was also issued in Germany.

JEAN-BAPTISTE TOURNASSOUD
French, 1866–1951

Juliette Tournassoud, The Photographer's Daughter

about 1913
Autochrome
16.1 × 10.3 cm (6⅜ × 4 in.) Image
18 × 13 cm (7⅛ × 5⅛ in.) Plate

Milly and Fritz Kaeser Endowment for Photography, 2017.015.004

When Auguste and Louis Lumière launched their practical technique for color photography in 1907, it was hailed as a milestone and compared to the introduction of the daguerreotype. Simple and affordable, the Lumière Autochrome process yielded glass-plate color transparencies meant to be viewed in transmitted light, or as still projections.[1] One of the first to embrace the medium was military officer Jean-Baptiste Tournassoud, a friend of Louis Lumière, with whom he shared discussions about and experiments in color photography. The son of a shoemaker, Tournassoud was born in the village of Montmerle-sur-Saône, near Lyon.[2] He was a capable student and an accomplished carpenter, and became interested in photography as a young man. In 1887 he was called to national service and joined an artillery battalion at Le Part-Dieu in Lyon. Military life suited Tournassoud, and he reenlisted in 1891. He received officers' training at the Army School of Artillery and Engineering at Versailles, and was assigned to a rail squadron. Later, his expertise prompted a transfer to a photography unit, where he received regular promotions and rose steadily through the ranks. He photographed military industry and documented topography for reconnaissance. In 1901, Tournassoud married and began a family of two daughters. He and his wife made friendships in Lyon society, including Édouard Herriot, the mayor of Lyon and later three-time prime minister of France; the painter Marius Mangier; and Auguste and Louis Lumière.

The Lumière Autochrome was patented in 1903, and the company began to sell its prepared plates in 1907.[3] These standard-sized glass plates were made by coating one side with a transparent adhesive—at first a mixture of pine sap and beeswax—over which microscopic grains of potato starch were cast. These dry grains had been dyed red, green or blue, before being intermingled. Pressure was applied to adhere the starch grains to the plate, flattening them slightly and making them more translucent. Lampblack was rubbed over the plate, filling the spaces between the grains, to create a mosaic luminance filter. The Autochrome plate was covered in waterproof shellac, and completed with a layer of panchromatic silver halide emulsion. Each prepared plate was packaged with a sheet of black paper to protect the delicate emulsion layer and inhibit halation. The plate was loaded into the camera with the uncoated surface facing the lens. When the black paper was removed and the plate was exposed, light passed through the colored mosaic filter before hitting the silver halide to create a negative image. Reverse-processed as a positive

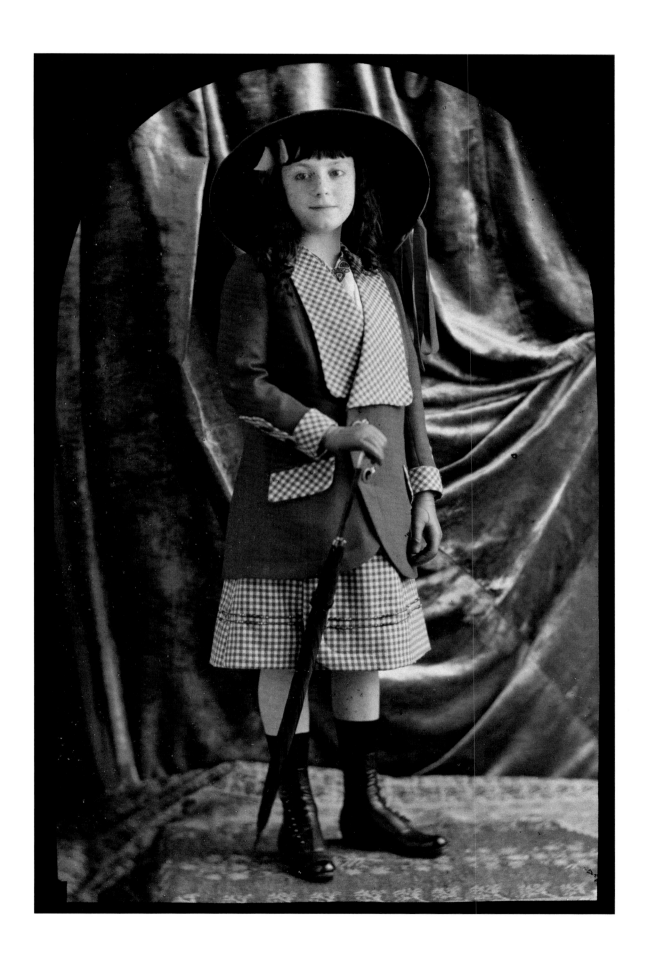

transparency, the silver halide layer on the plate worked with the starch mosaic to filter the light.

Lumière Autochromes were viewed in transmitted light. One way was to use a diascope, a portable viewer with a mirror facing a ground glass diffuser. When placed near a window or other light source, this apparatus held the plate and concentrated the light, so the image could be viewed in the mirror. An Autochrome could also be projected, like a lantern slide, on a screen or a wall. However, very bright light was required for viewing, such as a 500 watt electric bulb or even a carbon arc. The intense heat could seriously damage the color, so many surviving Autochromes have been faded or discolored.

Tournassoud's early Autochromes were portraits and genre scenes of his family.[4] He staged these images carefully, planning every detail of setting, costume and color. This is one of many portraits of his elder daughter, Juliette, one of a handful that survive from a single sitting.[5] Her age suggests that it was made just before the war. Autochromes required a long exposure, so Juliette Tournassoud would have had to hold her pose and expression for several seconds. Having grown up with a photographer father, she was an experienced model, and appears comfortable, attentive and casual. She is dressed in a brand-new outfit in autumn colors, so this portrait may have been made to celebrate a special occasion, perhaps a birthday or the first day of school. Juliette's brown wool jacket is lined in a contrasting checked fabric that matches her dress, its elegance equaled by her buttoned boots and kid gloves, and her tightly rolled umbrella.

She stands in a studio upon a Middle Eastern carpet with alternating bands of color that provide a strong visual baseline. Behind her, a blue velvet curtain is pinned up on the right, creating a curve in reverse of the arched frame. The angle of her umbrella flows toward the upper right and into the curve of her hat. These lines and curves act as a vortex, leading the viewer's eye to Juliette's face. Tournassoud posed his daughter so that the wide brim of her hat frames the perpendicular ellipse of her face, accentuated by the red ribbon encircling the brim of her hat and hanging down near her left shoulder, and the matching red edging on her coat buttons and the red bow in her hair. A red ribbon encircles the crown of the hat and hangs over the brim. This ribbon and the bow in her hair also match the bright, contrasting red edge of the brim. Even her black coat buttons are edged in red—the same hues in different proportions. This Autochrome is mounted in a frame of cut black paper (passe-partout) that sits between the emulsion surface and a protective sheet of glass. The exacting refinement of this mount marks it as the work of the R. Dechavannes Studio, a Paris framing workshop that the Lumières and Tournassoud often used.

Tournassoud was a leading figure in military photography during World War I. In the spring of 1915, the French government, in response to pervasive German propaganda, organized the Section Photographique de l'Armée (SPA). Tournassoud was transferred to the SPA at its inception, and he provided the Ministry of War with images for advertising and espionage. He made both gelatin silver prints and Autochromes for the agency.[6] Unlike the wartime images made by German photographer Hans Hildenbrand and his French contemporary Jules Gervais-Courtellemont, Tournassoud's Autochromes did not depict military action, concentrating instead on the soldiers' experiences, and he

made thousands of photographs of life at the front.[7] He shuttled between the ministries and the battlefield, working with officers and administrators of high rank. He established a trusting friendship with Georges Clémenceau, former journalist, cabinet minister and two-time prime minister of France. In the final weeks of the war, Clémenceau appointed Tournassoud director of an expanded SPA. He held the post for nearly a year, documenting such consequential events as the armistice with Germany, the Paris peace talks and the negotiation of the Treaty of Versailles. Much of Tournassoud's work from this period was funneled directly into archival collections.[8]

Tournassoud retired from the Army in 1920, and was decorated with the Légion d'Honneur and the Croix de Guerre. He settled with his family in his hometown, Montmerle-sur-Saône, where he photographed life along the river—transport, fishing and leisure. He also made Autochromes of village events, including staged scenes of local trades, folklore and such events as the electrification of the neighborhood. Later Tournassoud photographed livestock and pets. His best-known works of this period were his photographic illustrations of a book on French thoroughbred horses.[9]

E. J. BELLOCQ
American, 1873–1949

Storyville Portrait

about 1912
Gelatin silver print toned with gold chloride on printing-out paper
24.4 × 20.1 cm (9⅝ × 7⅞ in.) Image
25.3 × 20.3 cm (10 × 8 in.) Sheet

Samuel J. Schatz Fund, 1975.077

A photographic image can ignite the imagination, and it is difficult sometimes to separate the objective facts of an image from associations it provokes. Such is the case with a group of psychologically perceptive images made in New Orleans by E. J. Bellocq, photographs that seem to have survived by accident. After the Civil War and Reconstruction, New Orleans regained its former stature as an international trading port. It also reestablished itself as a cosmopolitan destination for bon vivants who enjoyed the racetrack by day and the gaming houses and bordellos at night. Sidney Story, a respected New Orleans alderman, studied the management of commercial vice in port cities around the world. He recommended that gambling and prostitution be restricted to a pleasure quarter and made illegal in the rest of New Orleans.[1] He designated a 16-block precinct, adjacent to a main railway station and near the French Quarter. When the district opened officially on July 6, 1897, it quickly became known as Storyville.

Ernest James Bellocq was 25 years old when Storyville opened, and already a professional portrait photographer.[2] His Creole father was treasurer for a wholesale merchant, but the family lived in the luxurious French Quarter mansion of his maternal grandfather, Paul Aldigé. An émigré from Bordeaux, Aldigé made a fortune in Louisiana in processing cottonseed oil.[3] His house on Conti Street combined three 18th-century buildings, close to the Théâtre de l'Opéra and the cultural center for the Creole community. Ernest—known as E.J.— was the eldest of 10 children. He and his brother Leonard, who was two years younger, both attended the College of the Immaculate Conception, a Jesuit academy in the Faubourg Sainte Marie. E.J. Bellocq went to work after graduating, while Leo enrolled at Spring Hill College in Mobile, a seminary and liberal arts academy.

E.J. Bellocq seems to have become a photographer in the mid-1890s. By 1898 he was producing portraits in the family's Conti Street home. "Mr. Bellocq . . . [is] a descendant of one of our most aristocratic Creole families," stated a newspaper advertisement featuring his halftone portrait, "and has entrée to the most exclusive of social functions."[4] Bellocq's father died in 1894, and his mother 12 years later. He seems to have stayed at Conti Street, presumably caring for his siblings; Leo was then in seminary, soon to enter the priesthood. E.J. moved his photography studio to Canal Street in downtown New Orleans, and produced local views, architectural photographs and copy work for the Louisiana State Museum. The Catholic Church was one of Bellocq's best accounts, and his shop produced photographs of church

buildings, clerical and confirmation portraits, and even views of grave plots. He produced albumen and toned gelatin silver prints typical of the period, laid down on paperboard mounts and embossed and stamped with studio marks, indicating the professional stature of his shop.

Bellocq was comfortable in Storyville, blocks from where he had grown up. He photographed opium dens in Chinatown, and made a series of intimate portraits of women, thought to be Storyville prostitutes. This photograph is one from that series, which includes images of young women clothed, in various stages of undress and nude.[5] They appear comfortable, confident and even playful before the camera. Here, the woman tips her head back slightly to gaze coolly and directly into the camera. A tight necklace emphasizes her long and shapely neck. She wears a fitted white chemise. She pulls this garment around her torso with hands held in the small of her back, accentuating her hourglass form. Her white shirt contrasts with the black stockings that reach above her knees, revealing her thighs. Her confidence, shapely figure and coiffure are reminiscent of the "Gibson Girl," an American beau ideal at the turn of the 20th century.[6] Like Bellocq's other Storyville subjects, she seems quite unselfconscious, suggesting that she may have known the photographer. This apparent ease has led many observers to speculate that Bellocq—like an American Toulouse-Lautrec—was a frequent customer of the bordello and close to these women, and photographed their friendships.[7] However, no persuasive evidence of such a relationship has been found.

Bellocq's portraits are similar to some of the images reproduced in the Storyville *Blue Book*.[8] Privately printed and published annually between 1895 and 1915, the *Blue Book* could be purchased for 25 cents on the corner of Basin and Canal Streets, and in local railroad stations, barbershops and saloons. This tourists' guidebook carried advertisements for cigar makers, tobacconists, distillers, drugstores and lawyers. Most of its pages were devoted to the Storyville houses of prostitution, describing their services and staff, indexed by name, race and address. Early issues of the *Blue Book* were illustrated with wood-engraved advertisements of the most elegant bordellos, which occupied mansions along Basin Street. Later, photographic images of lavish rooms and renowned prostitutes were printed in halftone. None of Bellocq's photographs are known to have been reproduced in the *Blue Book*, but his Storyville portraits—widely framed and clearly intended to be cropped—may have been taken for a similar purpose. The demand for erotic photographs had been ever-present in great cities beginning in the mid-19th century. Paris, where prostitution was legal, was the European center for erotic photography. Many commercial photographers produced these unsigned images, considered pornographic and illegal, as a lucrative sideline.[9] In some of Bellocq's nude portraits, the sitters' faces are hidden behind by carnival masks; in others, the faces have been scratched away from the negatives, probably while the emulsion was still wet. This may suggest that Bellocq intended the prints as erotic objects to be sold, and that he obscured the women's faces to protect them from prosecution.

New Orleans became an important military transit post during World War I, and Storyville was a popular destination for soldiers. When four were killed there early in the war, the military demanded its closure. Despite opposition from city

government, the precinct was closed on November 14, 1917. During the war, Bellocq worked for the Foundation Shipping Company, producing photographs of damaged watercraft. Afterward, his career declined for reasons that remain uncertain. Soon he was living and working in a small apartment on Dumaine Street. Bellocq acquired a reputation for eccentricity and irritability. He was no longer working, but he was always eager to discuss photography.[10]

Late in September 1949, Bellocq collapsed on Barrone Street in the French Quarter, and he was taken as a vagrant to Charity Hospital. When he was identified as the brother of Father Leo Bellocq, S.J., he was moved to Mercy Hospital, where he died. Bellocq died intestate, and the inventory of his effects does not list the Storyville portrait negatives. Since they were still considered pornographic and illegal, it is remarkable that they were not destroyed. The glass-plate negatives probably passed through several hands before 1967, when the photographer Lee Friedlander discovered them in a New Orleans antique shop.[11] He purchased them all, and made modern prints of the full negatives on printing-out paper. When a selection of Friedlander's prints was exhibited at the Museum of Modern Art in New York, the mysterious yet revealing images provoked delicious speculation, and inspired many other creative works.[12]

MARGRETHE MATHER
American, 1886–1952

Ballerina

1917
Gelatin silver print
11.9 × 15.7 cm (4¾ × 6⅛ in.) Sheet
35 × 28.2 cm (13¾ × 11⅛ in.) Mount

Walter R. Beardsley Endowment, 2016.018

In the first decades of the 20th century Margrethe Mather was a leading photographer in Southern California, and a frequent figure in the aesthetic and political circles of Los Angeles. Her strong eye for form and design influenced the work of Edward Weston (Cat. no. 16). Mather was born Emma Caroline Youngreen in Salt Lake City, one of four children of Gabriel Lundberg Youngreen and Ane Sofie Laurentzen, immigrants from the island of Lolland in Denmark, where they had converted to the Mormon faith.[1] They immigrated separately to Logan, Utah, where they met and married in 1883. Emma was three years old when her mother died in childbirth. When her father remarried she was sent to live in Salt Lake City with her maternal aunt, Rasmine Laurentzen, who was the resident housekeeper of Joseph Cole Mather, a metallurgist whose wife and daughter had died years before. Emma was recorded as a boarder in Mather's home in 1904 and 1906.[2] She worked as a physician's assistant before moving to San Francisco, drawn there in 1906 as an aide after the earthquake. Youngreen probably settled in San Francisco, though there is no documentary record of her before 1909. By that time she had adopted the name Margrethe Mather, combining her grandmother's Christian name with the surname of her childhood patron.[3]

Mather moved to Los Angeles three years later, at a time when motion picture companies were establishing themselves in nearby Hollywood. She settled in the Bunker Hill neighborhood, where many film-industry people lived, and found Elmer Ellsworth, an old friend from Salt Lake City.[4] He had worked as a writer, theater manager and vaudeville producer, and was an enthusiastic photographer. Ellsworth introduced Mather to the Los Angeles Camera Club (LACC).[5] In 1912 this organization, which promoted aesthetic photography on the West Coast, was expanding. The businessman C. J. Fox was a prominent member, and he built club facilities on the top floor of his Wright-Callender Real Estate building at 321 Hill Street, including a skylighted studio, a darkroom, developing and toning rooms, and a rooftop deck for processing printing-out paper. Mather may have joined the LACC just to find socially respectable friends in a new city. However, she discovered a facility with the camera to match her instinctive aptitude for design. The photographs she exhibited in local and regional salons quickly found admiration. One of Mather's photographs was chosen to represent the LACC in the Ninth American Salon at the Carnegie Institute in Pittsburgh in November 1912. *The Maid of Arcady* represents a female nude in a leafy setting, in a Symbolist

style that evokes the popularity of Isadora Duncan, the San Francisco–born star of modern dance, and the images of the Bay Area photographer Imogen Cunningham (Cat. no. 19).[6]

During the 1910s Mather associated with artists and designers in Los Angeles, as well as film and theater people. Notable among them were Charlie Chaplin and his girlfriend, the actress Florence Deshon; Deshon and Mather became close, and Mather photographed her often.[7] Ellsworth also introduced his friend to progressive political circles, which included Gaylord and Hanna Wilshire, T. Perceval Gerson, and Kate Crane Gantz. Mather also became acquainted with anarchist Emma Goldman, an associate of Ellsworth, who regularly lectured in Los Angeles. During an LACC outing in the fall of 1913, Mather and Ellsworth visited the studio of Edward Weston, a struggling portrait photographer in the suburb of Tropico. A few days later Mather returned to Weston's studio to pose for him. Within weeks they had begun an intimate affair, though he was married and had two children. She became Weston's studio and darkroom assistant, while continuing her own work.

Mather's fashionable, soft-focus Pictorialist style attracted noted portrait subjects, like the avant-garde writer Alfred Kreymborg and heiress and progressive patron Aline Barnsdall. Weston had never known such appreciative clients. Mather also introduced him to new ideas in illumination, pose and composition. She was an excellent printer, and passed along finer points of darkroom technique. According to Imogen Cunningham, who was friendly with both photographers at the time, it was Mather's vision and skill that dominated Weston's studio.[8] The couple joined with a small group of friends to form the Camera Pictorialists of Los Angeles, a small, select group that emphasized creativity and technique.

Mather made *Ballerina* while she and Weston were experimenting together on aesthetic studies of figures in interiors. Many of their images of the period represent half-length figures, facing away from the camera, casting dramatic shadows on the wall behind. Mather was familiar with the Japanese concept of *notan*—the interplay of dark and light, as epitomized in Arthur Wesley Dow's theory of composition—one of the most notable characteristics of modern photography and the move away from Pictorialism.[9] She had become interested in Asian—particularly Japanese—art, and the balance of form and void. Here, a figure dressed in a tutu lifts her arms gracefully, though the bottom edge of the image cuts off her lower body, leaving its position to the viewer's imagination. This is a subtle tonal image of varied textures. The ballerina is dressed in white, and stands before a white wall. Her bodice, made of glazed cotton or satin, fitting closely to her body, gives a sense of dimensional form, while the elevated skirt of tulle conveys vaporous insubstantiality. The posture of the ballerina's arms, and the turn of her head, create elegant, almost calligraphic contours, softened by the shadows behind. To further accentuate this spectrum of gray, the artist hung a large sheet of foil on the wall, which provided a positive compositional form and a varied passage of tonal reflection. A number of contemporary photographs, now in the Center for Creative Photography, demonstrate similar delicate tonality with half-length figures balanced by rectangular forms.[10]

By the spring of 1921, Mather and Weston had established an equal professional partnership, both

signing the photographs from their studio. Among their collaborations were portraits of the poet Carl Sandburg and the publisher Max Eastman, and publicity photographs for the Marion Morgan dance troupe. After a trip to New York in 1922, Weston shot a series of nude studies of Mather on the sand at Redondo Beach. By that time, however, he had begun a new affair with the Italian-born actress Tina Modotti. Modotti's husband died later in the year, and she and Weston left together for Mexico, abandoning both Mather and Weston's family.[11] Mather continued to run the studio on her own, producing stylish portraits of artists, musicians and writers, including Henry Cowell, Pablo Casals, Rebecca West and Éva Gauthier. Her spare, economical compositions often balanced a carefully posed figure with empty space and dramatic illumination. Soon she struck up a friendship with her 17-year-old neighbor, William Justema.[12] He introduced her to a circle of younger artists and musicians, and became her model for a series of photographs exploring Japanese objects and principles of design. In 1928 they applied together for a Guggenheim Foundation Fellowship for a proposal they called "The Exposé of Form." This photographic project would have explored form in sculpturesque photographs of eggs, seashells and domestic vessels. The unsuccessful application described Weston's contemporary formal studies, though Mather's image emphasized design rather than crystalline plasticity. A solo exhibition of Mather's photographs, mounted at the M. H. de Young Memorial Museum in San Francisco in 1930, included many of her recent *japoniste* images.[13]

EDWARD WESTON
American, 1886–1958

Nude on the Sand

1936
Gelatin silver print
18.5 × 24.2 cm (7¼ × 9½ in.) Sheet
33.7 × 38 cm (13¼ × 15 in.) Mount

Mr. and Mrs. Tom Christian Fund, 1975.073

Edward Weston was a pivotal figure in the transformation of American creative photography from the poetry of Pictorialism to the sharp, rigorous detail of straight photography. The formal elegance and simplicity of his precise images prompted viewers to intellectual, and even spiritual, contemplation. Edward Henry Weston was born in Highland Park, Illinois, the son of a physician.[1] His mother died when he was four years old, and his older sister May assumed a maternal role. When he was a troubled teenager, his father gave him a Bull's Eye No. 2 snapshot camera, and photography helped him find purpose. He attended the Illinois College of Photography in 1908 but left the school without a degree, convinced that he had learned all he could. Weston married grade-school teacher Flora May Chandler in 1909, and they began a family of four sons. They moved Los Angeles in 1911, where Weston worked as a retoucher while building his first studio on land owned by Flora's parents in Tropico (now Glendale).

Soon Weston developed aspirations to be a photographic artist rather than a workaday portraitist. In 1912 he shared a professional and personal relationship with Margrethe Mather (Cat. no. 15), who broadened his horizons in art, music, literature and politics. She introduced him to concepts of aesthetics and design, and they experimented together with soft focus, light and shadow, and over- and underexposure (Fig. 4). Weston described many of these experiments in his private journals, which he called his Daybooks, begun in 1915.[2] His work was frequently shown in national and international salons, and articles about his work were published in magazines such as *American Photography* and *Photo-Era*. Weston visited his sister May in Middletown, Ohio, in 1922, and took the opportunity to photograph the industrial architecture at the ARMCO Steel Plant. He found his Pictorialist style and technique inadequate to this task and decided he needed to explore a new direction in his photography, supported by Charles Sheeler, Alfred Stieglitz and Paul Strand (Cat. nos. 7, 66), whom he visited in New York after his trip to Ohio.

In 1923, Weston abandoned his wife, Flora, and his sons, his professional partnership with Margrethe Mather, and his commercial studio to move to Mexico with Tina Modotti, a model, silent-film actress and admirer.[3] Over the next three years Weston concentrated on sharply focused, unmanipulated photographs. Modotti introduced him to Diego Rivera and other artists of the mural-painting revival, who treated Weston as a serious and accomplished artist, and deepened his interest in Cubism.

The photographer methodically experimented with images of commonplace objects like the *escusado*, the porcelain commode in his apartment, striving to refine and clarify the representation of form, space and surface. "The camera should be used for a recording of life," Weston wrote in his Daybook in 1924, "for rendering the very substance and quintessence of the thing itself, whether it be polished steel or palpitating flesh."[4]

Weston returned to California in 1927 and opened a portrait studio in San Francisco with his son Brett.

Two years later he settled in Carmel-by-the-Sea, on the Monterey Peninsula. Weston made a series of close-up photographs of seashells, peppers and halved cabbages, focusing on their sculptural form and placement in spaces. By 1929 his reputation was such that he was invited to select the American photographic contribution from the West for the international Deutscher Werkbund exhibition *Film und Foto* in Stuttgart. At that time Weston became romantically involved with Sonya Noskowiak.[5] She lived with Weston and his sons in 1929–34 and worked as his student and assistant, consequently becoming a distinguished creative photographer herself. She was among a set of Weston's Northern California friends, including Willard van Dyke, Imogen Cunningham and Ansel Adams (Cat. nos. 19, 46), who shared a sharply focused, straight photographic style. In 1932 they organized an informal

Fig 4. — Edward Weston, American, 1886–1958, *George Hopkins*, 1917, gelatin silver print, Humana Foundation for American Art, 2016.029

association to promote their work, calling themselves Group *f*.64, after the smallest aperture setting on the camera.[6] Both Weston and Noskowiak contributed to the club's first exhibition at the M. H. de Young Memorial Museum in San Francisco. Weston soon withdrew from the group, however, feeling that their ideas were too restrictive.

At a concert late in 1933 Weston met Charis Wilson. Wilson visited Weston's studio a few days later; Weston was away, but Noskowiak showed Wilson his photographs and asked if she would model for Weston. After their first session in April 1934, Wilson became Weston's exclusive model for the next two years. Within months they were lovers, though Wilson had just turned 20 years old and Weston was 48. In 1935, he moved to Los Angeles to take up a project funded by the Works Progress Administration, and Wilson lived with him there. Around this time Weston began using an 8 × 10 inch view camera, which he took along when he and Wilson visited Oceano Dunes, near Pismo Beach, the largest tract of coastal dunes in California. In those days the area was isolated and lonely. It was a bright, warm day, and the photographer set up his camera to take landscape views. Wilson disrobed and playfully rolled down the face of a sand dune.[7] Though it was not her intent, she caught Weston's attention, and he tried to capture the playful spontaneity of her physical experience. This is one of the photographs taken that day at Oceano.[8] The placement of the figure in the landscape became a new focus for the photographer, a subject he explored in formal and textural studies, as he might a shell or any object. The Oceano Dunes series focuses on line and pattern, in this case the sinuous lines and rolling shapes created by the wind and tides on the sand. Weston's use of a large-format camera and small aperture settings produced both depth of field and maximum sharpness. The artist produced contact prints that combine a sparkling clarity of minute detail with tonal richness in the shadows. He created an image that is at once highly detailed yet very abstract.

Weston divorced his wife in 1937, after 16 years of separation. Wilson helped him prepare an application for a Guggenheim Foundation Fellowship, proposing a photographic expedition through the American West. It enabled the couple to travel 16,697 miles over 187 days together. With the renewal of the Guggenheim Fellowship for a second year, Weston and Wilson were able to print and organize the work. She began a narrative of her travels with Weston, which was published the next year as *Seeing California with Edward Weston*.[9] The couple were married in 1939. Soon after this, Wilson began writing the text for the photobook *California and the West*.[10] In 1941 Weston was commissioned to provide photographs to illustrate a new edition of Walt Whitman's *Leaves of Grass*, and Weston and Wilson traveled in the East and the South collecting these images, producing a volume that profoundly influenced a generation of photographers.[11] A retrospective exhibition was held at the Museum of Modern Art in New York in 1946, organized by Nancy Newhall.[12] As Weston and Wilson drifted apart, the effects of Parkinson's disease began to affect his work. It became necessary to cease darkroom work in 1948. His sons provided assistance in producing an important edition of his work, the *Fiftieth Anniversary Portfolio*.[13]

PAUL OUTERBRIDGE
American, 1896–1958

Cheese and Crackers

1922
Platinum print, mounted on cream wove paper
11.4 × 8.9 cm (4 ½ × 3 ½ in.) Sheet
35.8 × 28.1 cm (14 ⅛ × 11 ⅛ in.) Mount

Edward M. Abrams (ND'50) and Family Endowment, 2015.052

One of the most imaginative and skillful American photographers of his generation, Paul Outerbridge believed that photography was the ideal creative medium for the rapidly evolving era of scientific technology. Throughout his career he strove to synthesize aesthetic ideas in widely visible images, dissolving the boundaries between creative and commercial photography.

Born in New York, Outerbridge was the son of a noted Manhattan surgeon.[1] He attended boarding school in Pennsylvania and prep school in New York City, then studied anatomy and life drawing at the Art Students League. An impatient and adventurous young man, he joined the British Royal Flying Corps in Canada before the United States entered World War I. He was injured and discharged, and then joined the American Army, where he received training and practical experience in a Signal Corps photography unit. After the war, Outerbridge studied with Clarence White (Cat. no. 8) at Columbia University Teachers College. He learned design and technique from White, and the demanding craft of platinum printing. Also among his teachers was Max Weber, who introduced him to the aesthetic ideas of European Modernism.[2] Outerbridge worked as an assistant to the Russian sculptor Alexander Archipenko,[3] and taught at the Clarence H. White School of Photography before completing his degree.

Intending to pursue a career in commercial photography, Outerbridge began his own experiments in 1921. To refine his composition and lighting skills, and his command of platinum-palladium printing, he created a series of still-life studies. Each had a few small objects that might be subjects of advertising: a bowl of eggs, glassware, a tea set, a cracker tin. The artist employed principles of Cubism and Modernist design in arranging these objects. He framed the subjects tightly, using oblique camera angles from above to capture the freshness of a momentary glimpse. He had inherited a surgeon's precision, and combined meticulous design with exacting technique.

This print from this experimental group, *Cheese and Crackers*, depicts objects that together suggest an experience. Outerbridge's perception of commonplace subjects in novel, ordered compositions acknowledges the influence of Alfred Stieglitz's *The Steerage* (Cat. no. 7). The exacting arrangement both celebrates and abstracts the objects it represents. He "was not taking a portrait of these objects," he later wrote, "but merely using them to form a purely abstract composition."[4] Outerbridge created a Cubist composition of straight lines and contours, which cross and

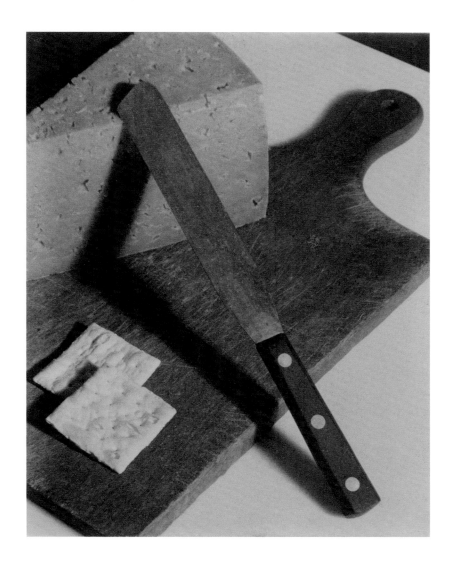

overlap to emphasize depth and intervening space. The arrangement of triangles varied in size, shape, tone and texture. He arranged opposing diagonals, creating an unstable composition that invites more careful examination. Light and dark passages complement the placement of shape and form. These tones, in turn, accent different textures, from the hard reflective steel blade, to the grainy wooden surface, to the soft, porous cheese. Outerbridge took advantage of the tonality of the platinum printing technique to emphasize the textures of the image. In the foreground, the motif of the long, diagonal knife tempts both appetite and action. The circular rivets in its handle create a ellipsis inviting us to grasp, carve and taste.

Outerbridge was committed to the superior tonal qualities of platinum paper. After World War I, this material was scarce and expensive. The artist made the investment, but he usually printed even his most successful experiments in limited quantities of five or six prints.[5] In the darkroom, he made adjustments between prints from each negative, deliberately exploring the variability of the process. Like other examples of Outerbridge's still-life studies, the present print is tipped onto a cream paper mount, with a false platemark. The artist inscribed his name and address on the verso, suggesting that he sent this print out for exhibition.[6]

Outerbridge's Cubist still-life studies earned the respect of his peers, and attracted commercial work. For his first professional assignment he created the celebrated *Ide Collar* advertisement for *Vanity Fair*. It is essentially another of his spare still-life compositions, with one plastic object isolated on a checkerboard. In an industry in which straightforward, descriptive images were the norm, Outerbridge pointed advertising photography in a different direction. He began to exhibit his photographs in 1923 at the John Wanamaker Gallery in New York, and in the International Salon of the Pictorial Photographers of America in 1923.

In 1925 the Royal Photographic Society invited Outerbridge to present his work in a solo exhibition in London. After attending, he settled for a time in Paris, where he associated with the American photographers Berenice Abbott and Man Ray (Cat. nos. 40, 50). They introduced him to artists like Pablo Picasso, Francis Picabia, Constantin Brancusi and Marcel Duchamp. The urbane, assured New Yorker thrived in café society and was energized by the Parisian avant-garde. In 1927 Outerbridge set up a large, modern photography studio in Paris for the mannequin manufacturer Maison Siegel. The following year Outerbridge went to Berlin to study film by working with the famed director G. W. Pabst.[7] His work was featured in the annual Deutscher Werkbund exhibition, and 12 of his photographs appeared in the landmark *Film und Foto* show in Stuttgart.

Outerbridge returned to New York in 1929 and opened a new studio for the production of commercial and editorial projects for leading magazines. He exhibited his creative work at the Julien Levy Gallery, the center for Surrealist art in New York.[8] It was in the early 1930s that Outerbridge began to explore color photography and carbro printing, realizing how seamlessly the technique translated to magazine process printing. Outerbridge built a studio and color laboratory at his country home in the village of Monsey, New York, north of the city. His expertise in this process kept him busy as a commercial photographer through the 1930s. He also served as

a contributing editor to *U.S. Camera* magazine. His technical manual *Photographing in Color*, published in 1940, explained the newest technology, materials and procedures with high-quality color illustrations.[9]

After World War II, Outerbridge moved to Los Angeles, where he set up a new studio in Laguna Beach and worked on commercial contracts related to the film industry. During this period he also created glamour studies of female nudes. The peculiar effect of saturated color, combined with the artist's extravagant imagination, sometimes resulted in images that could not be exhibited at the time.[10] In popular camera magazines, however, Outerbridge's glamour work found an audience among other photographers, and became quite influential. In 1945, the artist married fashion designer Lois Weir and together they formed the prêt-à-porter apparel company Lois-Paul Originals. Outerbridge took few outside projects in the coming years, though occasionally he produced photoessays for travel magazines. In 1954 he began writing a monthly column on color photography for *U.S. Camera* magazine. The following spring, a retrospective exhibition of his photographs was mounted at the Smithsonian Institution in Washington, D.C.

JOSEF SUDEK
Czechoslovakian, 1896–1976

The Veterans Home at Invalidovna, Prague

about 1924
Gelatin silver print
8.9 × 8.7 cm (3½ × 3⅜ in.) Image
14 × 9 cm (5½ × 3⅝ in.) Sheet

Walter R. Beardsley Endowment, 1998.045

Josef Sudek was a solitary man who found comfort in darkness and shadow, where he witnessed the remarkable subtleties of light and atmosphere. The son of a house painter, Sudek was born and raised in Kolín on the Elbe River in Central Bohemia.[1] At the age of 13, he became an apprentice to the Prague bookbinder František Jermann. In this workshop, a fellow assistant introduced Sudek to photography. After his apprenticeship, Sudek began an independent career as a bookbinder in the nearby town of Nymburk, but in 1915, during World War I, he was conscripted into the Austro-Hungarian Army. He served as an infantryman in Italy, where his right arm was severely injured. Later the wound became infected, and the arm had to be amputated at the shoulder. Sudek endured three years' recuperation at Invalidovna, the military hospital in Prague. His disability ended his career as a bookbinder. In 1917 he acquired a camera from the government and received a study grant to attend the State School of Graphic Art in Prague, where he was a pupil of Karel Novák.

Sudek joined the Fotoklub Praha (Prague Camera Club), where he encountered American Pictorialism through Drahomír Josef Růžička, a Czech physician who returned to Prague in 1921 after 34 years in New York. Sudek also befriended Jaromír Funke, a contemporary committed to a career as a professional photographer.[2] Funke experimented with the influences of Constructivism and Surrealism, seeking to develop the unique character of the medium. He became a member of the Fotoklub in 1924 but had little respect for its members who clung to traditional imagery and archaic methods. He was expelled from the club five months later. In 1924, Funke and Sudek, along with Adolf Schneeberger, founded the Česká Fotografická Společnost (Czech Photographic Society), to encourage progressive styles and experimental photography techniques. Sudek's own work at the time combined Funke's ideas about manipulated light and shadow with the murky atmosphere of Pictorialism.

In the mid-1920s Sudek often photographed his fellow war veterans at Invalidovna. This is one of those images. The small contact print captures a ghostly silhouette shrouded in clouds of light—a lost soul suspended in Limbo.[3] Sudek used many of the light and shadow effects he had learned from Funke, often illuminating his subjects with reflected light, shifting the perception from form to light. But where Funke created dramatic images of obscure space, Sudek's work expressed melancholy. His images often seem insubstantial and create a tranquility tinged with loneliness.

In Sudek's landscape views in the parks of his native Kolín, there are often groups of remote figures, facing away from the camera, their personalities softened by distance. They are different in mood from the advertising photographs Sudek began producing for Družstevní Práce publishing house in 1926.[4] The following year, he moved his studio to a small, wooden-frame building on Újezd Street in Prague. At that time, the artist documented the final phases of construction of Saint Vitus's Cathedral in Prague, six centuries after the building was begun, visiting the building site at dusk or nighttime. It was an ideal subject for the soft ambience of Pictorialism, but over time Sudek's photographs of Saint Vitus's became progressively more focused and precise. The photobook *Svatý Vít* (Saint Vitus's Cathedral), published in 1928, imbues the Gothic structure with Surrealist mystery.[5] After its publication, Sudek was appointed official photographer for the city of Prague. The first solo exhibition of his work was mounted in 1932 at the offices of Družstevní Práce, followed by another show in the Krasnajizba salon the following year.

During the 1930s Sudek made portraits of people he knew and cared about. Among them are portraits of Funke, the painters Emil Filla and František Tichý, and the dancer and actress Milena Vildová. Even though Sudek remained shy and isolated, he was not a recluse. He was a classical music enthusiast who amassed an outstanding collection of recordings, and in 1939 he began to welcome friends to his studio for weekly "gramophone concerts." He was especially devoted to the work of his compatriot Leoš Janáček.

When Sudek first saw a 30 × 40 cm contact print in 1940, he was astounded by its delicacy and tonal range. He became committed to large, traditional cameras, and stopped using an enlarger. His hunched figure, carrying a long wooden tripod and wooden camera, became a familiar sight for years as he trudged through the steep streets of Prague. He collected old cameras to make oversized negatives, and the technique changed his style.[6] World War II brought scarcity and increased isolation to Sudek, who turned increasingly to still life. He began with simple objects like an egg, a vase with one flower, or a glass of beer. On his nocturnal photographic expeditions in the city, he collected discarded objects for still lifes he set up next to the window looking onto his garden. Sometimes the glass became a reflective backdrop, and other times he photographed through the window, the view obscured by dew, rain drops or ice crystals. A selection of these mysterious images, taken between 1940 and 1954, was published as *The Window of My Studio*.[7] Over time, the photographer accumulated so many vessels and pieces of glassware that they began to overwhelm his living and working spaces. He photographed them in arrangements inspired by still life paintings by old masters, and later published a selection from the series as *Labyrinths*.[8]

At the end of World War II, Sudek advertised for a darkroom assistant. Sonja Bullaty arrived at his studio to apply for the job with her shaven head wrapped in a shawl, having survived captivity in the Nazi concentration camps at Auschwitz and Gross-Rosen. Sudek recognized her trauma and hired her immediately. For a year she filed negatives, helped carry his equipment through the streets of Prague and assisted him in the darkroom, learning his secrets of lighting and composition.[9] In 1947 Sudek began to venture away from Prague on summer expeditions with his friend the painter

Emil Filla, exploring the countryside northwest of the city with camera and sketchpad.

In 1952 Sudek accompanied the photographer Petr Helbich on an expedition to the Mionší forest in the Beskid Mountains of Moravia near the Polish border, to capture the mystery and majesty of the ancient trees shrouded in mountain fog.[10] Sudek was also drawn to Hukvaldy in the Moravian-Silesian Region, birthplace of his favorite composer, Leoš Janáček. Each summer for several years, he visited Hukvaldy in the summer to photograph the village and the ruins of its medieval castle, striving to capture the character of Janáček.[11] In the 1950s Sudek made use of the Kodak Panorama camera, manufactured in 1894, with a spring-driven, sweeping lens that exposed 10 × 30 cm negatives. He employed this unusual format for a stunning series of Prague views.[12]

IMOGEN CUNNINGHAM
American, 1883–1976

Magnolia Blossom

1925
Platinum-palladium print
17.9 × 22.7 cm (7 × 9 in.) Image
28 × 35 cm (11 × 13¾ in.) Sheet

Humana Foundation Endowment for American Art, 1993.011.001

Over much of the 20th century, Imogen Cunningham was a prominent photographer on the West Coast, an esteemed and influential tastemaker, and a teacher. She was born in Portland, Oregon, the fifth of 10 children in a poor, rural family.[1] She grew up on a remote farm near Seattle, but distinguished herself as a student even though she lived far from school. In 1901 she bought a 4 × 5 inch view camera by mail order, and taught herself to use it with a book from the International Correspondence Schools. Her father built a woodshed darkroom for her, covering the interior walls with tar paper to block out the light. Later, while studying at the University of Washington, her interest in photography was rekindled by seeing the work of Gertrude Käsebier (Cat. no. 5). She studied chemistry related to the medium, and earned money by photographing plants for the botany department.

After graduating from college, Cunningham worked for the photographer Edward S. Curtis in Seattle for eight years, and became an adept artisan in several photographic techniques, including the platinum printing process. In 1909, a Pi Beta Phi Graduate Fellowship enabled her to continue her study of photographic chemistry with Robert Luther at the Technical University in Dresden in 1909. On her journey home the following year, she stopped in London to visit Alvin Langdon Coburn (Cat. no. 9), and in New York City to meet Käsebier and Alfred Stieglitz (Cat. no. 7). In Seattle Cunningham began working as a portraitist; she opened a studio and went to great lengths to make it elegant and fashionable. In an essay, "Photography as a Profession for Women," she called for women to be included in all areas of the arts and industry. In modern times, she posited, women should be able to work without stigma or blame.[2]

Although her professional work concentrated on portraiture at this time, Cunningham took her camera with her friends to the forests of Mount Rainier, where they posed for each other in classical draperies or in the nude, acting out scenes from Romantic poetry. These images relate to Symbolism, which she had encountered in Germany, and demonstrate the fascination with classicism common to Bay Area artists like the dancer Isadora Duncan and the photographer Anne Brigman.[3] Cunningham may also have been inspired by the work of contemporary East Coast photographers like Käsebier or F. Holland Day. In 1915, Cunningham published a series of aesthetic photographs for which the nude model was the painter and printmaker Roi Partridge. Later that year they married, and over the next five years she raised a family of three sons.[4] In 1917 the

family moved to San Francisco, where Partridge taught at Mills College.

While Partridge was teaching or at work in his studio, Cunningham stayed at home with their boys. There, with basic equipment, she made still life photographs and developed them in an improvised darkroom. "That was when the children were small and I became interested in plant forms because I couldn't get out anywhere, and I had a garden. I didn't know plants; I just planted stuff. I had a lot of succulents. People would give them to me. I decided to do things that were around me."[5] She photographed both in the garden and indoors from cuttings in vases, during one quiet hour each afternoon when the boys were napping. She drew in closely to the leaves and flowers that were her subjects, illuminating them to describe their forms, and focusing on their varied surfaces. *Magnolia Blossom* is the most famous of these photographs.[6] She cut a closed magnolia blossom from a tree in the backyard and brought it into the house, waiting for three days as the flower opened, until she sensed the right moment. With a close vantage point and focused detail, Cunningham revealed information about the flower unapparent to the casual observer. Having worked in Dresden, Cunningham was likely aware of Karl Blossfeldt's (Cat. no. 26) enlarged studies of plant forms, published in Germany in 1909.[7] Although she took a similar up-close perspective on these small, organic forms, her work is very different in conception: while Blossfeldt's images are diagrammatic and taxonomic, Cunningham's are architectonic. The light directed inside the flower draws the eye through its structure as if it were a building. This delicate lighting also suggests the softness and translucence of the petals. The lines and curves of the flower's form evoke human anatomy, and the delicacy of the petals hints at a subtle sexual metaphor.

Cunningham's stylistic shift away from Pictorialism is also reflected in a series of Modernist industrial landscapes she made in Los Angeles and Oakland in the late 1920s. Edward Weston chose one of these—along with a nude and eight of Cunningham's botanical studies—for the landmark exhibition *Film und Foto*, organized by the Deutscher Werkbund in Stuttgart in 1929.[8] In 1932 she was among the founders of Group f.64, with which she consistently exhibited throughout its brief activity.[9] Like Weston and Stieglitz, Cunningham had adopted a style of crisp, sharply focused, strong contrast and a search for beauty in humble subjects. The artist also applied this approach to images of the human form, and she made a particular study of the hands of artists and musicians.[10] This work led to her employment by *Vanity Fair* magazine, for which she photographed film and theater celebrities in the early 1930s. A project with *Vanity Fair* took her to New York in 1934, having split from Roi Partridge; she would continue to work with the magazine until it ceased publication in 1936. Cunningham had by then returned to San Francisco to open her own portrait studio. She enjoyed a national reputation for her celebrity portraits, and her images of figures like Cary Grant and Martha Graham appeared in magazines such as *Vanity Fair* and *LIFE*. She supported herself with commercial work and portraiture, and also experimented with street photography. Then, in 1945, Ansel Adams (Cat. no. 46) recruited her to the faculty at the California School of Fine Arts. Cunningham taught photography to a new generation of artists, while continuing to pursue independent creative

projects in the 1950s and 1960s, often supported by grants and fellowships. She won a Guggenheim Foundation Fellowship when she was 87 years old, which she used to print some of her older work, much of which appeared in her photobook *Imogen! Imogen Cunningham Photographs, 1910–1973*. At the age of 92, the artist began a series of portraits of her contemporaries.[11]

EUGÈNE ATGET
French, 1857–1927

Saint-Cloud

1926
Gelatin silver print on printing-out paper
18.1 × 23.2 cm (7⅛ × 9⅛ in.) Image
18.1 × 23.2 cm (7⅛ × 9⅛ in.) Sheet

Gift of Milly Kaeser, in Memory of Fritz Kaeser, 2002.020

Over 30 years Eugène Atget photographed Paris and the momentous changes to the city around the turn of the 20th century, creating an enormous repertoire of negatives. For his thoughtful, methodical objectivity, he is recognized as one of the most important photographers of the epoch, though he never regarded his own work as art.

Jean-Eugène-Auguste Atget was born in 1857 in Libourne in southwestern France, the son of a carriage builder.[1] Both of his parents died when he was a child, and he was raised by an uncle in Bordeaux. He joined the merchant marine after secondary school, but cherished dreams of becoming an actor. In 1878 he passed the audition to attend the Conservatoire d'Art Dramatique in Paris. However, his studies were interrupted by a call to national service. After leaving the military, he joined a popular theater company that toured through the city suburbs and the provinces. In this troupe Atget met the actress Valentine Delafosse Compagnon, who became his lifelong companion. His stage career ended late in the 1880s, when an ailment permanently weakened his voice. He shifted his aspirations to the visual arts, but found that he had no talent for drawing. Atget took up photography, and worked to hone his skills by photographing static subjects like architecture. By 1899, he settled in Montparnasse, where he produced affordable photographic prints of buildings, plants and animals, meant for the use of artists and designers of the stage and the decorative arts. It was his city views, however, that first found a small market.

Atget worked alone in the early morning, when the light was diffuse and the streets empty. He carried his antique wooden camera, with its expanding bellows and tripod, all over Paris. He exposed 18 × 24 cm glass dry plates, releasing the mechanical shutter with a pneumatic bulb. Aiming for clarity in his images, he came to prefer soft illumination that evenly defined three-dimensional form across the middle distance. Only when he photographed people did he focus his rapid rectilinear lens on the center of interest. Atget worked with his old equipment and processes, making salt and albumen prints from glass plates. By the time he perfected his method he was in his mid-40s, so that even when his work came into steady demand he continued with his familiar equipment and techniques.

At the turn of the 20th century, with advancing industrialization and the arrival of country laborers in Paris, the city grew rapidly. Old neighborhoods were replaced by factories, and new residential districts expanded the city into the countryside, linked by expanding transportation networks. Atget

continued to photograph Paris as it changed. His long knowledge of its districts and neighborhoods enabled him to document old buildings and city squares as they slowly vanished. He photographed the buildings, streets and squares, storefronts and street merchants, and the people who lived much of their lives on the streets.[2] The Bibliothèque Historique de la Ville de Paris became a devoted collector of his documentary views of the city. By 1906 the library contracted Atget to supply a systematic survey of the old buildings of Paris, provided in bound albums.[3]

During World War I, demand for Atget's photographic prints subsided. He packed away his huge archive of negatives, and sometimes even stopped working. It was a period of economic hardship accompanied by grief, for Valentine Compagnon's son, Léon, was killed in combat. After the war, when nostalgia accompanied the impulse to rebuild, interest in Atget's work gradually reemerged. He began printing on demand from his repertoire of 10,000 negatives, and sold his photographs to a growing, diverse clientele. In the early 1920s he finally achieved a measure of financial security. At that time he was able to concentrate on aesthetic photographs, made for his own pleasure. Most of his late photographs represent deserted parks and gardens, pockets of green, open space within the city, like the Luxembourg Gardens and the parks of Versailles, Sceaux and Saint-Cloud.[4] Atget had photographed them throughout his career, but his late work is more contemplative and less precise than his earlier documentary images.

With its mysterious atmospheric resonance, this view at Saint-Cloud exemplifies that vision. About three miles west of Paris, overlooking the Seine at Saint-Cloud in Hauts-de-Seine, a royal château was erected late in the 17th century on the site of an earlier palace. The grand new edifice was built for Philippe, Duke of Orléans, younger brother of Louis XIV.[5] Its surrounding parkland was renovated in the 1660s by André Le Nôtre, the royal landscape architect who designed the geometrically ordered gardens at Versailles and Sceaux. When the chateau of Saint-Cloud was destroyed two centuries later during the Franco-Prussian War, the surrounding gardens and park were opened to the growing population of Paris.

Atget first photographed at Saint-Cloud in 1904, and the gardens became one of his favorite haunts. His made dozens of images of their manicured lawns, reflecting pools and sculpture, which captured a sense of sophisticated leisure. This is one of the last photographs that Atget made at Saint-Cloud, in the spring before his death. Advancing age affected his stamina, and he exposed just a few negatives on each outing. Atget's late images of Saint-Cloud are simpler, more poetic and serene, than his earlier photographs. The absence of human figures emphasizes the contrast of man's design and nature's compulsion for regrowth. The photographer captured a sense of scale, space and ambiance with a long exposure, creating a soft, wispy, drawn-out effect of light. Open space evokes peaceful contemplation. This view of a circular marble pool in the garden, with an *allée* of trees receding beyond, reveals basic spatial elements of the garden's design. It illustrates a visitor's dramatic experience of moving from a shady forest path into the soaring space of a manmade glade, where bright light shimmers from the reflecting pool. To emphasize the garden's architecture, Atget placed the distant, tree-lined promenade in the center of his composition. A pair of sculptural urns on tall plinths flank

the promenade's egress, and emphasize this prospect. Trees that were planted in rows in the 17th century, once closely trimmed, now grow tall and branch freely. To Atget, and the knowing viewer, the landscape evokes the encroachment of nature and the passage of time.

Atget photographed with a *trousse* of component rectilinear lenses in a long brass barrel. This inadvertently created shadowed corners in many of his exposures, including the present image, which he preferred not to trim away from the prints. At this stage of his activity, he used prepared 18 × 24 cm Lumière *extra rapide* glass plates sensitized with silver gelatin. He continued his old process of contact-printing his developed negatives in the sunshine onto commercial printing-out papers. He used glossy albumen papers as long as possible, but when manufacturing of this paper ended in 1923 he turned to gelatin printing-out paper.

In the mid-1920s, Atget's photographs attracted the attention of a younger generation of artists. Like Le Douanier Rousseau, the avant-garde painters celebrated Atget as a naive genius. His earlier images of doorways, mannequins and window reflections fascinated Man Ray (Cat. no. 50), whose studio was nearby along rue Campagne-Première. With Atget's permission, Man Ray used Atget's photograph *During the Eclipse* for the cover of the magazine *La Révolution Surréaliste*. Man Ray's young American assistant, Berenice Abbott (Cat. no. 40), was even more enchanted with Atget's photographs. She befriended the elderly photographer and promoted his work throughout her own influential career.[6]

PAUL WOLFF

German, 1887–1951

Frankfurt Station

1926
Gelatin silver print
24 × 17.9 cm (9½ × 7 in.) Image
24 × 17.9 cm (9½ × 7 in.) Sheet

Milly and Fritz Kaeser Endowment for Photography, 2011.014

Photography was transformed by the introduction of the precision handheld camera and the practice of darkroom enlargement. The concept was developed in Germany by the optical engineer Oskar Barnack in 1912–13 at the Ernst Letiz Optische Werke, at Wetzlar in Hesse. Barnack's Leica was the first practical camera to use the standard 35 mm roll film used in movie theaters. In 1923, the engineer persuaded Ernst Leitz II to manufacture prototype cameras and darkroom apparatus, for testing in the factory and by a panel of outside photographers.[1] In the mid-1920s two masterful photographers championed the new camera, Henri Cartier-Bresson (Cat. no. 60) and Dr. Paul Wolff.

Paul Heinrich August Wolff was the son of a government administrator at Mühlhausen.[2] As a teenager he used a plate camera to photograph his experiments in butterfly breeding, and earned pocket money by publishing images in scientific journals. Wolff attended medical school in Strasbourg, where he published views of the old city in his first photobooks.[3] He went on to complete a doctoral degree in medicine. During World War I, he volunteered to serve as a regiment physician, first in France and then in Russia. In Strasbourg after the war, the regnant Vichy government barred him, a German, from practicing medicine. Wolff moved with his wife and child to Frankfurt am Main in 1919 but lacked the funds to set up a medical practice. He began a career as a photographer and filmmaker, using his doctorate as a trademark. To promote his business he published photobooks like *Heidelberg* (1922), *Weimar* (1923) and *Alt-Frankfurt* (1923), several with introductory comments by the art historian Fried Lübbecke.

In 1924, Wolff was one of the 31 photographers to whom Leitz and Barnack gave prototypes of their first miniature camera.[4] The Leica camera was remarkable for its quality lenses and the watchmaker's precision of its mechanism. Because its little negatives produced small contact prints, Leitz provided a system for projecting diapositive slides onto a wall or screen, along with a comparably precise enlarger for making prints. The system required a conceptual shift that dismayed many; other critics believed that enlarging would exaggerate grain too much for legible prints. However, Wolff realized that shorter exposures and longer developing could reduce the grain of the film. Photographers who calculated their exposures for the shadows of an image struggled in the darkroom, overusing developer. Wolff exposed for highlights, and lightly developed his negatives for a short range of contrast. He demonstrated that he could make high-quality enlargements up to poster size.

The Leica camera sold well from its introduction. The company continued to send Wolff its latest cameras and lenses, and he often provided the company with images for advertising. Wolff carried his Leica with him obsessively. The camera hung from his shoulder on a strap, grasped behind his back in his right hand. The posture became a habit, and eventually he held his hand behind him even when there was no camera. "Without the aid of the Leica viewfinder," wrote his assistant, Walther Benser, "he could pick apart the surroundings with his naked eye in the search for a suitable subject and position. He invariably chose the perfect spot for taking the picture with the focal length he had already selected."[5]

In 1926 Wolff took his camera to the Frankfurt railway station, which soon became a favorite haunt. Its cavernous arrivals hall and its covered train sheds were busy theaters for changing light, protected from the wind, rain and snow, and Wolff returned at different times of day and in various weather conditions. He observed the bustling movement of groups of travelers through vast interiors pierced by shafts of light. This image of Frankfurt station exemplifies Wolff's use of natural light to delineate space with angles and orthogonals of form and shadow.[6] A man, seemingly just alighted from a train, descends a flight of steps from the arrival platform. He wears a business suit and tie, and a smart fedora with a deeply creased crown. Walking confidently down the middle of the staircase, he carries a sizeable leather case in each hand. The position of his arms indicates that the cases are heavy, suggesting his affluence. Light falls in a low angle behind him, casting a shadow over each step of the staircase, which we recognize as three-dimensional space. As he steps onto a mid-landing, the man looks directly at the

photographer, but his face is obscured by shade and distance. The figure and his attenuated shadow are the only organic forms breaking up the strictly regular geometry of this image. The immediacy of this photograph reflects the use of the Leica camera on Wolff's practice. Detailed negatives and the enlarging process enabled him to capture such minute details in his print as the pickets of the iron fence along with the shiny ceramic tiles lining the staircase walls and the marble paving its landings. The photographer was well aware of the Constructivist notion that everything is comprised of smaller components.

Preferring to work in the field, Wolff hired the Alfred Tritschler in 1927 to manage the growing commercial business.[7] Wolff explored the city and the capabilities of the Leica camera, often with a mind to publishing. In 1929 he released a photobook on the Frankfurt zoo, which was followed by volumes on ecclesiastical architecture and botany.[8] A subsequent series of illustrated European travel books stretched into dozens of titles. The company built a substantial picture archive, Dr. Paul Wolff & Co. Lichtbildvertrieb OHG, licensing images to magazines and publishers. As Germany entered the Weimar Republic, Tritschler became a full partner in the company, which had become the nation's leading industrial and advertising photography studios.

Ernst Leitz and Wolff were at then work together on a major project: an exhibition that demonstrated the capabilities of the miniature camera system. *Meine Erfahrungen mit der Leica* (*My Experiences with the Leica*), which opened in Frankfurt in 1933, featured more than 200 photographs printed as 40 × 60 cm enlargements, including portraits, genre studies, landscapes, city views and industrial studies. The exhibition was hugely successful during its two-year European tour.

The popular book that accompanied the show was meant to encourage amateur photographers.[9] By 1935, when reduced a version of *My Experiences with the Leica* was shown at Rockefeller Center in New York, there were six competing handheld cameras on the market, though the Leica remained the industry standard, unrivaled for its quality and precision.

When the National Socialist German Workers' Party came to power in the mid-1930s, Wolff and Tritschler were compelled to document the defense industry. The company profited from government contracts, but Wolff himself was never a member or supporter of the Nazi Party. Some of his photographs illustrated propaganda picture books on labor during the Third Reich.[10] In March 1936, the Reich Propaganda Ministry ordered him to photograph Adolf Hitler's speech at the national rally in the Festhalle Frankfurt, and weeks later his portrait of Hitler appeared on the cover of *TIME* magazine.[11] When the Allies bombed Frankfurt in 1944, both Wolff's and Tritschler's homes were destroyed, along with the company studios and main archives.[12]

ANDRÉ KERTÉSZ
American, born in Hungary, 1894–1985

Eiffel Tower

1929
Gelatin silver print
19.9 × 23.3 cm (7⅞ × 9⅛ in.) Image
20.4 × 25.3 cm (8 × 10 in.) Sheet

Dr. M.L. Busch Fund, 1978.047

With his eye for familiar objects and isolated events, André Kertész brought viewers to recognize significance in the commonplace. In the 1920s, his lyrical, often amicable French style of photography became popular in the day's leading magazines. The manner in which Kertész linked his printed images made him a pioneer of photojournalism. His work inspired the younger generation of French émigré photographers with a style that combined Modernist sensibility with humanity in the predominant postwar French photographic style.

Andor Kertész was born in Budapest, the middle of three sons of the bookseller Lipót Kertész and Ernesztin Hoffman.[1] After the death of his father, when he was 12 years old, his maternal uncle moved the family to his country estate at the village of Szigetbecse in Central Hungary. A successful stockbroker, Kertész's uncle paid for his nephews to attend the Academy of Commerce in Budapest. It was as a college student that Kertész first became interested in photography. After graduating in 1912 he became a clerk at the Budapest Stock Market, and used his first paycheck to buy an ICA box camera. With this, he explored the Budapest streets and the Hungarian countryside.

In 1914, during World War I, Kertész joined the Austro-Hungarian Army. He carried a lightweight Goerz Tenax camera while trooping through Central Europe, photographing life in the trenches[2] (Fig. 5). He was grievously wounded by a bullet in the chest while fighting on the front line, and suffered temporary paralysis of his left arm. He recuperated for more than a year in a Budapest hospital and at a military infirmary in Esztergom. During his convalescence he continued his photography, and in 1917 first published his work in the Hungarian news magazine *Érdekes Újság*.

When Kertész returned to the bourse in 1919, he was bored by the work and left the job during the political turmoil of the Hungarian Revolution that year. Instead he created descriptive, poetic photographs of everyday life in the country. On June 26, 1925, one of Kertész's photographs appeared on the cover of *Érdekes Újság*. Recognition gave him the confidence to join a group of Hungarian photographers in Paris, including François Kollar, Brassaï and Robert Capa (Cat. nos. 31, 49).[3] They introduced him to wider artistic circles; in turn, he encouraged Brassaï to take up photography and to explore nocturnal Paris with the camera. Changing his first name to André, Kertész divided his work between magazine commissions and creative photography through the 1920s. He forged a personal manner of photographic reportage, concentrating on the legible

experience. By spring 1927, when Kertész's first exhibition of photographs opened at Jan Slivinsky's avant-garde Galerie Au Sacre du Printemps, he had shifted from the primary use of a plate camera to a handheld miniature camera.

Eiffel Tower exemplifies Kertész's experimental work with the Leica, an instrument that revealed his remarkable ability to capture the magic of circumstance.[4] Without a stationary camera, and the need to wait for events, Kertész was able to take stock of the effects of light, anticipate events and capture them in an instant. With the light miniature camera, capable of such a fast exposure, he could crouch, reach and lean, and position the camera at odd angles, using his body to find a viewpoint, which was unorthodox at the time. Such a novel viewpoint is exemplified in this photograph, in which Kertész photographed the Eiffel Tower from inside, looking out and down. When the tower was built on the Champ de Mars in 1887–89 as the entrance to the World's Fair, it had three restaurants on its first level, along with an "Anglo-American Bar." After the fair one of the restaurants became a theater, so even more visitors were drawn up to this level, with its outside walkways and elevated view of the city. Kertész took this photograph from the interior promenade on the first level of the tower, looking down upon the esplanade 187 feet (57 m) below.

The initial impression of this image is one of interwoven geometry, with the curves of the tower's arches and their shadows contrasting with the rectilinear pavements and lawns. Parked automobiles draw the viewer's attention to street level and the activities in the park under the tower. Illuminated by a setting sun, figures cast long shadows as they stroll across the plaza, gather in groups to chat, and rest on benches and chairs to observe passersby. A man on his bicycle leans on the curb to speak to a

Fig 5. — André Kertész, American, born in Hungary, 1894–1985, *Transport*, 1918, gelatin silver print, Gift of Patrick J. Kealy (ND'65), 1981.108.M

friend. Behind him a family crosses the street, the father leading a child and following a dog on a leash, while the mother strides behind. It is easy to identify with these ordinary events, taking place amidst many others, within a larger urban environment, itself circumscribed by city and country. This is a society of culture, peace and wellbeing.

Kertész's photographs were shown in the landmark *Film und Foto* exhibition at Stuttgart in 1929, and struck visitors as more affable than the Russian and German avant-garde images. The following year, Kertész visited his family in Hungary and reconnected with his former girlfriend, Elizabeth Salomon. She followed him back to Paris, where they were married in June 1933. At that time, Kertész associated with the Surrealists, and his photographs appeared in the magazines *Bifur, Variétés* and *Minotaure*. A commission gave rise to his *Distortions* series of female nudes contorted by an assortment of parabolic mirrors to create fanciful, sometimes sensual images.[6] In the same year Kertész also published *Enfants* (Children), a photobook of candid images representing the innocence, drama and enchantment of childhood.[7]

In the mid-1930s, however, André and Elizabeth Kertész became increasingly uncomfortable. They sensed danger in the rise of fascism across Europe, and unconcealed anti-Semitism. A contract from the Keystone news agency enabled them to spend a year in New York City, beginning in October 1936. They settled into a hotel in Greenwich Village, but Kertész found the Keystone studio work uninspiring. He missed Paris and his friends, and his poor command of the English language isolated him further. Nevertheless, when the project was over, the comparative safety of the United States prompted the couple to remain. Elizabeth Kertész and a Hungarian friend had developed a cosmetic compounding business, Cosmia Laboratories. A solo show of Kertész's photographs was presented by the PM Gallery in New York in 1937, but he found it frustratingly difficult to sell his work to American editors. During World War II, Kertész and his wife were registered as enemy aliens, and he was prohibited from photographing on the street.

Early in 1944, the Kertészes became citizens of the United States. The photographer concentrated on the publication of *Day of Paris*, a photobook of images from the early 1930s, which brought his work to a new American audience.[8] In 1946, Kertész signed a long-term contract as a staff photographer for *House and Garden* magazine. The position enabled him to travel, and over the next 15 years thousands of his images appeared in Condé Nast publications. In 1952 Kertész and his wife moved to a 12th-floor apartment near Washington Square Park, where they would live for the rest of their lives. From this high vantage, the artist often observed the city, as in a series representing the square covered in snow, with disorienting angles creating an abstraction similar to his *Eiffel Tower*.

ALEXANDER RODCHENKO
Russian, 1891–1956

Balconies

1925
from the series *The House on Myasnitskaya Street*
Gelatin silver print
7.9 × 6.1 cm (3⅛ × 2⅜ in.) Image
7.9 × 6.1 cm (3⅛ × 2⅜ in.) Sheet

Milly and Fritz Kaeser Endowment for Photography, 2014.041.003

In the first years after the Soviet Revolution, when an ambitious Communist government searched for practical means for mass communication, Alexander Mikhailovich Rodchenko was among a small cadre of progressive artists devoted to building a visual cultural foundation, and he embraced photography as an accessible medium of social progress. Rodchenko was born in Saint Petersburg, the son of a theater props manager and a washerwoman.[1] In 1905 the family moved to Kazan, and Rodchenko attended the Kazan School of Fine Arts in Odessa, where he was instructed in styles popular at the turn of the century. At art school Rodchenko met fellow student Varvara Fedorovna Stepanova, who became his wife and lifelong collaborator (Fig. 6).[2] In 1914, the couple moved to Moscow where Rodchenko studied art and art history at the Stroganov Institute and associated with Vladimir Tatlin and Kazimir Malevich. Figures disappeared from his paintings and were replaced by geometric forms before featureless fields of white.[3] His experiments were encouraged by his work as Tatlin's assistant. Rodchenko created a series of drawings with ruler and compass in a technical style, which Tatlin included in the exhibition *The Store* in March 1916.

During World War I, Rodchenko served in the military as operations manager on a hospital train.

After his discharge in December 1917, he found that many of his former colleagues had emigrated after the October Revolution. Rodchenko and Stepanova devoted themselves to the Bolshevik government, which welcomed their support. In his paintings, the artist refined abstraction to its essentials. "I reduced painting to its logical conclusion," he later reflected, "and exhibited three canvases: red, blue, and yellow. I affirmed: it's all over."[4] When his monochrome canvases were first exhibited in Moscow in 1921, these paintings encouraged the Constructivist movement. Rodchenko meant to declare the end of easel painting and replace the medium with photography and film.

Rodchenko and Stepanova were assigned to the Visual Arts Section of the People's Commissariat for Education and assigned considerable powers. In March 1920, Rodchenko and Stepanova participated in the Institute of Artistic Culture (INKhUK), a committee of artists and aesthetes who worked to set principles for a new art. In 1920 Rodchenko also became director of the Museum Bureau and Purchasing Fund, an agency that organized works of art confiscated from the bourgeoisie and placed them in public museums throughout Russia. By 1922 this bureau had distributed over a thousand works of art to 30 provincial museums. By that time, Rodchenko

had joined the faculty of the Higher State Artistic and Technical Studios (VKhUTEMAS).[5] At first he taught composition and headed the metalwork shop. By training a new generation of artist-technicians, the academy strove to create a progressive visual environment. Art should not be a unique commodity, they declared, but fine, accessible design should permeate every phase of daily life. Like the contemporary Bauhaus in Weimar and Dessau, VKhUTEMAS intended to produce and promote well-designed, utilitarian objects for everyday living.

Rodchenko turned from abstract painting and began to concentrate on graphics and typography, creating designs for use as visual propaganda in publications and urban kiosks. Rodchenko was impressed by the photomontage of the German

Dadaists, and experimented with the form. At first he clipped printed photographic images from magazines and newspapers and glued them to colored card. One of these accompanied the publication of Vladimir Mayakovsky's poems in 1923. Rodchenko began taking his own photographs, beginning with portraits of his mother, his wife and friends, and used the images in his graphic designs (Fig. 6).[6] He progressed rapidly to reportage, and to abstract photographs. Many of Rodchenko's first photographs were meant for use in cover designs for *LEF*, the journal of Mayakovsky's Left Front of the Arts. Rodchenko designed the covers for the group's magazines, *LEF*, published in 1923–25, and *Novyï LEF*, published in 1927–28.

This photograph, taken in the fall of 1925, is one from a series titled *The House on Myasnitskaya Street*.[7] The images represent buildings of Yuskhov House, a historic mansion in Moscow at 21 Myasnitskaya Street. The mansion was built in 1780 for Lieutenant General Ivan Yushkov, and is notable for its corner rotunda with a semicircular balcony and colonnade. In the 19th century the general's heirs rented the house to the Moscow Arts Society for drawing classes; eventually it became the headquarters of the leading school for Russian academic art. After the Bolshevik Revolution, the Free State Art Studios (*SVOMAS*) occupied Yushkov House. Its surrounding gardens

Fig 6. — Alexander Rodchenko, Russian, 1891–1956, *Varvara Fedorovna Stepanova*, 1924, gelatin silver print, Snite Museum of Art, Milly and Fritz Kaeser Endowment for Photography, 2014.047.001

were uprooted and its historic outbuildings razed, to be replaced by modern structures built in the international style. This is an image of the main modern tower, housing faculty and student apartments, classrooms and an auditorium. After *VKhUTEMAS* officially replaced *SVOMAS* in 1920, Rodchenko and Stepanova lived in the new, modern buildings, as did Mayakovsky and other artists, poets, sculptors and musicians associated with the academy. To the Bolshevik art establishment, Yushkov House had become a symbol of the proletariat expropriation of Russian culture.

In his photographs of *VKhUTEMAS* headquarters, Rodchenko ignored the well-known 18th-century facade of Yushkov House and concentrated on the modernist structure in the courtyard behind. The high-rise block of simple, solid geometry provided identical apartments to many residents. This modular design made visible the notion of social equity, even between students and ranking officials. Rodchenko took his camera though the building to examine its form from different angles, looking down from the highest stories and up from the street in sharp angles. Several of his photographs concentrate on its identical balconies, projecting into space.

Rodchenko took his Leica miniature camera into the streets to shoot photographs as visual notes of design elements. Striving to make the familiar seem unusual, he searched for unusual viewpoints and confused perspective, and shot close-ups and multiple exposures. He intended to shock his viewers with unfamiliar aspects, postpone their recognition and accentuate underlying geometry. The elemental quality of these forms also prompts comparison to natural geological and biological forms, like a microscopic image of crystals. Photographs from Rodchenko's

series were first published in the magazine *Sovetskoe kino* in 1926, and continued in further issues. A cropped version of this image was central to the photomontage that Rodchenko designed for the cover of the inaugural issue of *Novyï LEF* in 1927.[8] Despite his innovative sculpture, and his influential teaching and graphic design, it was as a photographer that Rodchenko became best known during the 1920s. His photojournalism appeared in several Soviet magazines, including the photography and film journals *Kino-Fot* and *Kinpravda*. His creative photographs were exhibited all over the world.

In 1930 Joseph Stalin closed *VKhUTEMAS*. Rodchenko fell from favor as the Communist Party actively suppressed Constructivism, promoting instead the accessible figurative propaganda of Socialist Realism. The artist fell back upon photojournalism and made a speciality of sports, physical culture and dance, and also documented parades and circuses. He created epic photographs of the Soviet transformation of agriculture and industry. Rodchenko and Stepanova were fortunate to survive Stalin's Great Purges. In the mid-1930s they collaborated on the design of photobooks for Izogiz publishers, including *Fifteen Years of Soviet Cinema* and *Ten Years of Uzbekistan*. During World War II, the artists were evacuated to the Molotov region. Rodchenko stopped photographing in 1942 and fell into obscurity. In later years he gradually returned to abstract painting, keeping the works private since they openly flouted officially sanctioned aesthetics.

JOOST SCHMIDT
German, 1893–1948

Sculptural Effects in Tin

about 1930
Gelatin silver print
7.3 × 9.8 cm (2⅞ × 3⅞ in.) Image
7.3 × 9.8 cm (2⅞ × 3⅞ in.) Sheet

Milly and Fritz Kaeser Endowment for Photography, 2015.043

In Germany between the wars photography occupied a reverberating position between the fine and applied arts. In 1919 Walter Gropius founded the Bauhaus in Weimar, when the Grand Ducal Saxon School of Arts merged with the Weimar Academy of Fine Art.[1] He envisioned a new guild of versatile artisans, freely operating without the barriers between craftsmen, fine artists and architects. He called the academy the Bauhaus in reference to the Bauhütte, a premodern guild of stonemasons. For its faculty, Gropius hired the painters Johannes Itten and Lyonel Feininger, along with sculptors Gerhard Marcks and Oskar Schlemmer. Soon after, the painters Paul Klee and Wassily Kandinsky joined the staff. It was Itten, whose pedagogical vision—based upon the ideas of Franz Cižek and Friedrich Wilhelm August Fröbel—first shaped the school's curriculum. Itten communicated these principles in a foundation course, or *Vorkurs*, which was required for all new students.

Joost Schmidt was born at Wunstorf near Hannover on January 5, 1893, and he and his two siblings endured a difficult upbringing.[2] But he managed to gain admission to the Grand Ducal Saxon School of Arts in 1910, and earned a diploma in painting four years later. He studied briefly with the representational painter Max Thedy before joining the German Army during World War I. Schmidt

served in the infantry; he was wounded in action and taken prisoner, and contracted malaria during his imprisonment. After the war, Schmidt was among the advanced students in the first Bauhaus class. He studied in the sculpture workshop, in his first year, taught by Itten and Schlemmer. He also demonstrated his understanding of the academy core principles and evolving style in graphic design, to which he shifted in 1922. His poster design was chosen to advertise the first Bauhaus exhibition. It melds the contemporary geometric abstraction of Cubism, Constructivism and De Stijl—forms derived from mechanical engineering that evoke the disciplines of industrial design. With a versatility typical of the academy, Schmidt also developed a pantomime for the Bauhaus exhibition, which was performed at the municipal theater in Jena. His continuing interest in theater led to his design for a mechanical stage. In 1922–28 he was an instructor in graphic design at the Bauhaus, and in 1925–31 he also taught lettering and calligraphy.[3] Schmidt designed printed matter, posters, journal covers and advertisements for the academy.

In 1925, the year Schmidt married Bauhaus student Helene Nonné, he was offered the position of head of the sculpture department at the State Academy of Crafts and Architecture in Weimar. However, Gropius did not want Schmidt to leave the

Bauhaus, and arranged for him to join the senior faculty once he had passed his Weimar crafts union journeyman's examination. He began teaching at the Bauhaus at its new location in Dessau. Schmidt became chairman of the Plastic Arts Workshop, and soon afterward was also assigned to head the Advertising, Typography and Printing Workshop as well. This program included the nascent photography program, and for the first time all students received some photographic training. Some were influenced by the experimental work of László Moholy-Nagy and his colleagues.

This photograph was made at that time, and reflects not only the multidisciplinary environment of the Bauhaus, but also its playful interrogative attitude toward the medium.[4] Two sculptural maquettes—presumably the record of a project created in the school's Plastic Arts Workshop—stand on a table. The models are fabricated from sheets of unfinished gray metal, probably tin, which have been folded so that they can stand freely on their own. Schmidt placed the sculptures side by side, so that their shadows nearly touch, and he closely cropped the edge of the image to create an abstract geometric composition. He took advantage of the reflective quality of the tin, the geometric passages that seem both to project and recede in space. The composition appears to oscillate. This photograph of the horizontal tabletop, shown as taken with receding shadows, carries pencil inscriptions on its verso suggesting that it was meant as a more abstract, vertical composition.

The intentional ambiguity of space in this image is similar to experimental photographs by Schmidt's Bauhaus colleagues László Moholy-Nagy and Herbert Bayer (Cat. nos. 25, 37). At that time they were exploring photography as an independent creative enterprise, both on its own and in conjunction with their work in other media. In 1928, after Moholy-Nagy and his wife left the Bauhaus, Schmidt taught introductory photography classes, as well as life and figure drawing classes for advanced students. The following year he appointed Walter Peterhans as the only formal specialist on photography at the Bauhaus. Peterhans's own work was strongly influenced by the realistic style of the Neue Sachlichkeit. Peterhans organized a broad course on technique and materials that influenced graphic designers and photojournalists. In 1929 Schmidt designed and supervised construction of the Bauhaus theater, and the Junker stand for the *Gas und Wasser* exhibition in Berlin.

In 1931 the National Socialist German Workers' Party of Adolf Hitler closed the Bauhaus in Dessau. When the academy reopened the following year in Berlin under the direction of Ludwig Mies van der Rohe, Schmidt elected to remain on the faculty. The following year he invented a font for Uhertype, and designed the company's exhibition stand for the Leipzig Fair, where the typeface was introduced. In 1933, Hitler's Social Democratic government again closed the Bauhaus. Schmidt had to lean upon his Bauhaus colleagues to find work. He collaborated with Gropius in 1934 on the design and production of the stand for Nichteisen-Metall-Industrie company at the *Deutsches Volk: Deutsche Arbeit* trade fair in Berlin. In 1935, Hugo Häring, director of Kunst und Werk (formerly the Reimann-Schule), a primary-secondary art school, recruited Schmidt to the faculty. The government blocked this appointment, however, because of Schmidt's connections to the Bauhaus. He took private students for a time, until the Nazis prevented him from teaching altogether. Schmidt was able to

support himself during the war with design work for Alfred Metzner Verlag and other publishers.

In November 1943 the artist's Berlin studio was destroyed in an Allied air raid. Most of his creative work was lost, including his photographs. His activity and achievements as a photographer, therefore, are difficult to assess. In the later, desperate stage of the war, Schmidt was conscripted into the German military, though he was over 50 years old. The physical demands placed upon him prompted a relapse of the malaria he had contracted during World War I. After hospitalization, he was assigned to the Nazi war map headquarters at Saalfield. After the war, Schmidt became a professor at the University of Visual Arts in Berlin, where he taught the preliminary architecture course. He worked on design of the exhibition *Berlin Plant/Erster Bericht* in 1946, which featured plans for postwar reconstruction of the city, a project he shared with former Bauhaus colleagues.[5]

LÁSZLÓ MOHOLY-NAGY
American, born in Hungary, 1895–1946

Lapperman, Petsamo, Finland

1930
Gelatin silver print
24 × 16.4 cm (9½ × 6½ in.) Image
24 × 16.4 cm (9½ × 6½ in.) Sheet

Milly and Fritz Kaeser Endowment for Photography, 2014.057.002

"It is not the person ignorant of writing," predicted László Moholy-Nagy, "but the one ignorant of photography who will be the illiterate of the future."[1] He formulated the concept of the New Vision (Neues Sehen) to describe a creative, experimental approach to a previously documentary medium. László Weisz was born in Bácsborsód, a farming village in southern Hungary where his father, Lipót Weisz, was probably a Jewish farm worker.[2] Lipót left his family when his two sons were young, and their mother took them to Mohol, now in northern Serbia. László distinguished himself as a student, and by the age of 10 he was living at Szeged with his maternal uncle, Dr. Gustav Nagy, and attending Szeged Gymnasium. As a teenager, perhaps in retaliation against his absent father, he dropped the Jewish name of Weisz and adopted his uncle's surname, as well as his Calvinist faith.

In 1913 Nagy enrolled in law school at the Hungarian Royal University of Sciences in Budapest. His studies were interrupted by World War I, when he enlisted in the Austro-Hungarian Army, eventually to be posted as an infantryman to the front lines in Galicia, near the Russian border. There, on July 1, 1917, Nagy's left hand was badly wounded, requiring long convalescence and rehabilitation. Finally discharged in October 1918, he returned to his studies in Budapest. He gravitated to a circle of intellectuals and artists gathered around the progressive writer Lajos Kassák, who published the avant-garde journal *MA* (*Today*). Nagy learned about Socialist ideals of art as a vehicle of social and political change. Now he had adopted a new name—Moholy-Nagy—to recognize his Magyar hometown. He and his colleagues supported the cultural revolution in Hungary and the Bolshevik takeover led by Béla Kun in March 1919. When the Communist government opposed artists and writers of the avant-garde as decadent and bourgeois, he moved with Kassák and his followers to Vienna.

In early 1920, Moholy-Nagy moved again, to Berlin, where his painting gradually evolved from representation to geometric abstraction. He met Lucia Schulz, a Czech writer working as an editor and writing radical literature under the pseudonym Ulrich Steffen.[3] They married on her birthday in January 1921. The following year Moholy-Nagy shared a joint exhibition with fellow Hungarian László Péri at Galerie der Sturm. Among the visitors to that show was Walter Gropius, director of the Bauhaus at Weimar, who invited the young artist to join the faculty of the innovative academy. At the age of 27, Moholy-Nagy became head of the Bauhaus metal workshop, and soon he took over the foundation course (*Vorkurs*) from Johannes Itten. Lucia Moholy learned the fundamental techniques

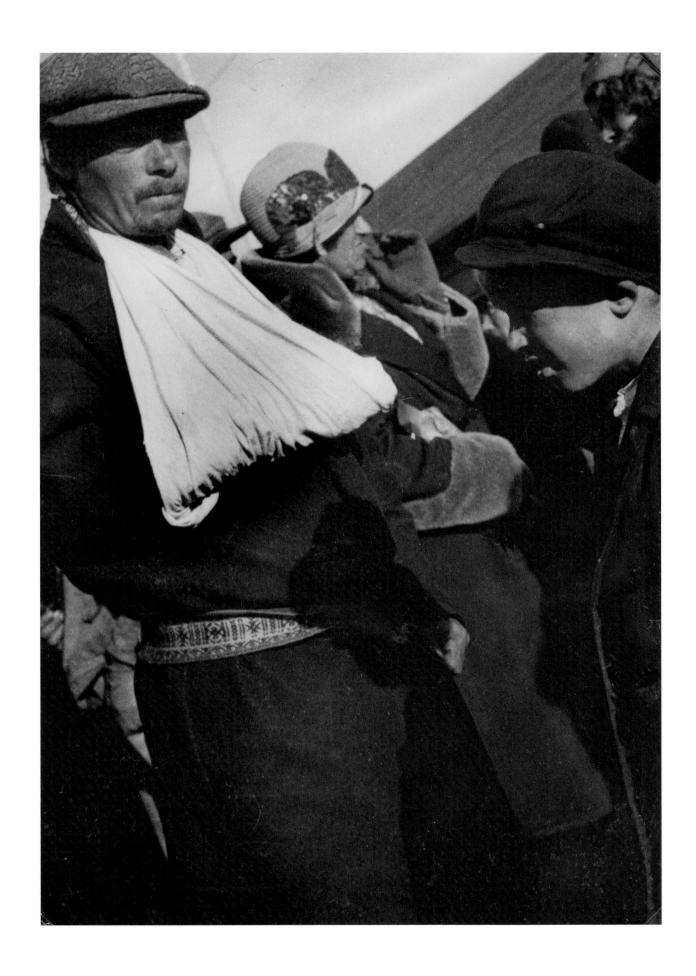

of photography in Otto Eckner's studio, and went on to advanced studies at the Leipzig Academy for Graphic and Book Arts. She set up a darkroom in the Bauhaus faculty quarters in 1926, and became the academy's first unofficial documentary photographer. She photographed its facilities, products, community and personalities, documenting its products, premises and social events. Lucia Moholy also documented the creative output of teachers and students, and her images helped to establish the school's reputation. Lucia Moholy excited and guided her husband's interest in photography.[4] Over their five years together at the Bauhaus, they forged new stylistic directions and collaborated in experiments with multiple exposures, photograms and photocollage. With the camera and darkroom they explored new ways of seeing, using confused perspective and extreme close-ups, striving for unexpected views of the familiar. On outings to the mountains or the beach, the couple frequently shared their experiments with Herbert Bayer (Cat. no. 37) and his wife Irene Hecht, both serious photographers.

These ideas are set out in Moholy-Nagy's book, essentially a collaboration with Lucia Moholy, *Painting, Photography, Film* (*Malerei, Fotografie, Film*), among the 14 volumes through which Gropius published the Bauhaus achievement.[5] This work presented the pedagogical approach Moholy-Nagy taught in the Bauhaus *Vorkurs*. It relates how he sought to revolutionize modes of perception, using new creative tools and media to clarify the perplexities of modern technology. Moholy-Nagy believed that photography should provide a major contribution to a whole new way of seeing that surpassed the human eye, a notion he described as *Neues Sehen*—New Vision.[6]

László and Lucia Moholy-Nagy stayed at the Bauhaus when it relocated to Dessau, but left when political pressures induced Marcel Breuer, Gropius and Bayer to resign as well. The Moholys returned to Berlin where Moholy-Nagy operated his own commercial design office for the next five years. He built a versatile and prolific studio, employing such artists as István Sebők, György Kepes and Andor Weininger. Moholy-Nagy made an enormous contribution to the landmark *Film und Foto* exhibition, organized by the Deutscher Werkbund, which opened in Stuttgart in May 1929. It was the first comprehensive presentation of modern photography in Europe and the first major show there of modern American photography. Moholy-Nagy designed the show's first gallery, which introduced the role of modern and avant-garde photography. His own work and Lucia Moholy's were prominent. That was the year, however, that the couple separated, soon to divorce.

After *Film und Foto*, and perhaps to escape the turmoil of his personal life, Moholy-Nagy made an automobile tour of Northern Europe in 1930–31. He traveled with Ellen Frank, a German actress and dancer, who was Walter Gropius's sister-in-law. In their wanderings they drove to the province of Petsamo in the far north of Finland, traveling a recently opened road from Sodankylä to Liinakhamari, which provided the only access to the Barents Sea by car.[7] Decades in construction, this highway provided access to the lands of the indigenous Sami people, fabled to be a dark region of mystery and romance. This photograph is one of several that Moholy-Nagy made on that trip.[8] Its confusing perspective is typical of Bauhaus photography in the late 1920s, and the notion that unusual angles could shake conventional habits of

seeing the world. The artist snapped the image of fellow passengers aboard ship, tilting his camera to disorient the viewer. Moholy-Nagy organized the shot so that the Laplander, who is the primary subject, slants diagonally from one corner of the image to the opposite. The white sail in the background, which blocks the sea beyond at an acute angle, further confuses our sense of verticality. The artist emphasized this effect with the repeating white triangles of the white fabric sling over the Laplander's arm and the ship's sail.

Moholy-Nagy settled in Berlin and reopened his design studio. He married the writer and teacher Sibyl Pietzsch in 1932, and they began a family of two daughters. With the Social Democratic Party in power, however, Moholy-Nagy was prohibited as a foreign national from working in Germany. He took his family to Amsterdam in 1933, and followed Gropius to London two years later. In 1937, the Association of Art and Industry in Chicago invited Moholy-Nagy to organize and direct a new interdisciplinary academy based on the Bauhaus. With *The New Vision* as its manifesto, this academy operated for one academic year on Prairie Avenue in Chicago. In 1939, Walter Paepcke, chairman of the Container Corporation of America, funded the reopening of the institution as the Chicago School of Design. In 1944, it became the Institute of Design, which became part of the new the Illinois Institute of Technology five years later. Photography remained integral to its curriculum, and such prominent artists as György Kepes, Harry Callahan and Aaron Siskind (Cat. nos. 61, 63) taught there.[9] Moholy-Nagy continued his prolific creative activities in his later years. Among them was the book *Vision in Motion*, an account of his

pedagogical ideas, published after his death, which became influential to the teaching of art and design education worldwide.[10]

KARL BLOSSFELDT
German, 1865–1934

Asclepias syriaca (Cornuti): **Silkweed Flower Enlarged Eighteen Times**

1928
from the book *Urformen der Kunst: Photographische Pflanzenbilder*
Photogravure
26 × 19.6 cm (10 ¼ × 7 ¾ in.) Image
31.3 × 24.6 cm (12 ⅜ × 9 ¾ in.) Sheet

Museum Projects Fund, 1997.033.002

Conceived as teaching materials for artists, Karl Blossfeldt's naturalist photographs became popular and influential in the era of the Neue Sachlichkeit (New Objectivity), and remain so today. He was neither a botanist nor a trained photographer, but he unintentionally became a celebrated modern artist. Blossfeldt was born in the village of Schielo in the Harz Mountains of Central Germany, the son of a farmer who was also a church beadle and the village bandmaster.[1] When he was about 15 years old, Blossfeldt began an apprenticeship in a foundry at Mägdesprung im Selketal, learning the processes of sculptural casting and the production of wrought-iron gates and grilles. In 1886, a grant made it possible for him to study at the School of the Museum of Decorative Arts in Berlin.

Blossfeldt became a student of Moritz Meurer, a professor of ornament and design. Charged with developing a new drawing curriculum, Meurer began to compile a visual archive of plant images as study models. With a grant from the Prussian Board of Trade he traveled to Rome with six assistants, one of whom was Blossfeldt. In Italy, Blossfeldt's expertise in sculptural modeling was put to task in creating three-dimensional plaster casts of botanical specimens. The young artist traveled beyond Italy for Meurer's project, gathering and casting botanical images in Greece and North Africa. After returning to Berlin, Meurer developed his visual archive into several publications, most notably *Vergleichende Formlehre des Ornaments und der Pflanze* (Comparative Morphology of the Ornament and the Plant), which compared organic and architectural form.[2]

In 1898, Blossfeldt joined the faculty of the Charlottenburg School of Arts and Crafts, where he also served as assistant to the director. Soon he offered the course "Modeling from Living Plants," integrating his knowledge of natural form and his skills as a sculptor. He began his own photographic archive of botanical images, and continued to gather, select and arrange natural specimens to photograph. He built his own camera and began a succession of refinements. With a bellows around 3 feet (nearly 1 m) long, he could magnify the tiniest and most delicate specimens by 30 times.[3] He exposed glass-plate negatives of about 7 × 5 inches in both horizontal and vertical orientations. Blossfeldt developed a system for arranging the specimen flowers, buds, branched stems, clusters and seed capsules before the lens and a background of white or gray cardboard. For soft, diffuse illumination, he placed his subjects precisely, so that natural, northern light fell over them from one side. He usually exposed his negatives for eight to 12

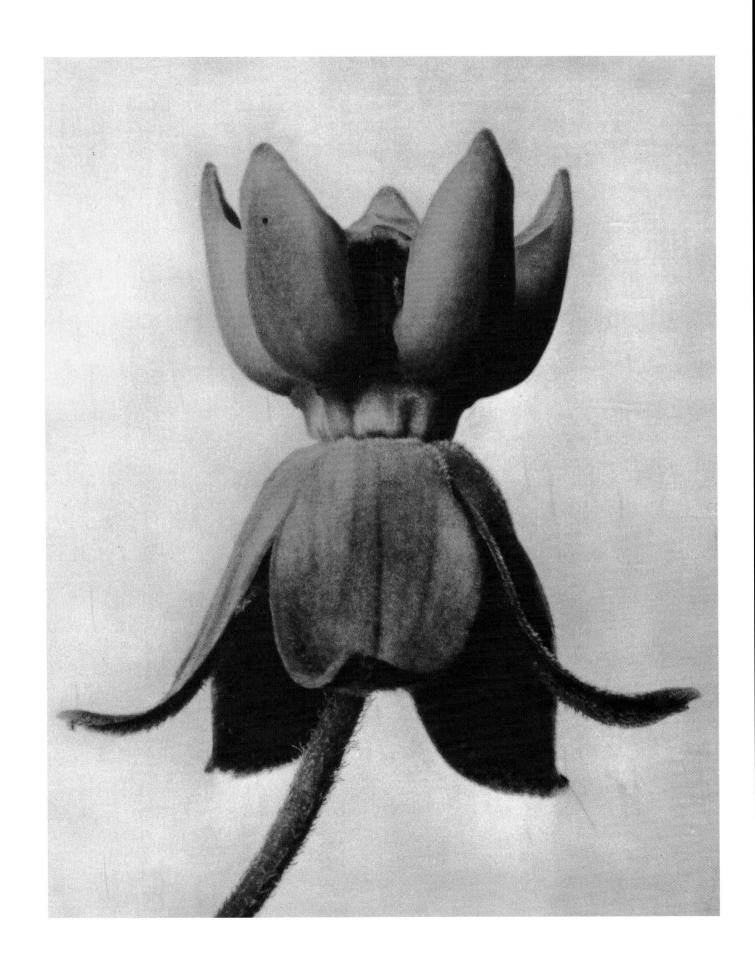

minutes. At first Blossfeldt processed his developed negatives as transparencies, which he projected in the class room for lectures. In the darkroom, he chemically intensified the images' density, aiming for dark, legible images. The artist used pencil and wash applied with a brush to modify his negatives and transparencies, and his retouching skills were remarkable. He reinforced outlines, and sometimes even modified form extensively.

By 1906 Blossfeldt had produced over a thousand negatives and at least 210 enlarged prints. Over the course of his career, his oeuvre would grow to more than 1,600 prints made with exceptional precision and uniformity in order to reveal similarities and differences between plant structure and form. In a letter to the director of the School of the Museum of Decorative Arts, Blossfeldt described his achievement in a plea for funding to complete his project: "Plants are a treasure trove of forms . . . ," he wrote, "carelessly overlooked only because the scale of shapes fails to catch the eye, and sometimes this makes the forms hard to identify."[4] The artist reported that his photographs were made by enlarging tiny specimens, and that he was only able to print slowly from his already voluminous negative archive. Blossfeldt wished for the material to be used as models for students, in classes, exhibitions or libraries. To facilitate formal comparison of his subjects, he mounted his contact prints in typological collages glued to sheets of gray cardboard. Decades after the artist's death, a group of 61 previously unknown collages, gathering more than a thousand of his contact prints, were discovered in his estate. The artist seems to have used these collages to study formal relationships in typological organization. Blossfeldt inscribed notations on some of the collages, and cropping lines on others. The collages cast fresh light on the systematic approach Blossfeldt used in his photographic studies.[5]

This image shows Blossfeldt's enlargement of one flower of the plant known to Americans as milkweed or silkweed, the favorite of monarch butterflies.[6] Scores of these flowers bloom in spherical clusters a few inches (about 8 cm) in diameter. To examine closer one of the tiny flowers, half an inch (1.3 cm) tall, presents an unfamiliar perspective. The two tiers of petals often occur in different bright colors, to attract pollinators; however, Blossfeldt's black-and-white image forces us to concentrate on the plastic form of this miniature sculpture. The flower is suspended on a slender, hairy stalk. Illuminated in this way, the crownlike form of the upper tier of petals, actually enlarged anthers of the stamen, appears architectural. The corolla, the lower tier of suspended petals that appear thick and fuzzy on one side, looks like thick sueded leather.

The School of the Museum of Decorative Arts purchased 30 of Blossfeldt's prints in 1920, an acquisition made in conjunction with the artist's promotion to professor at Charlottenburg the following year. Soon after, the school merged with other institutions in the Combined State Colleges of Applied Arts. A selection of Blossfeldt's photographs was exhibited there, which is where the banker, collector and gallery owner Karl Nierendorf probably first saw them. The following year, he paired Blossfeldt's photographs with African sculpture in an exhibition at his avant-garde Galerie Nierendorf in Berlin. Thus Karl Blossfeldt, at the age of 61, was discovered as a modern artist. Nierendorf promoted the work, and probably arranged funding for publication of a selection of the images in the photobook *Urformen der Kunst* (Art Forms in Nature), for which he wrote

the introduction.[7] The volume became a popular success, perhaps because of the lingering popularity of the style of Art Nouveau. Blossfeldt's rarefied vision, however, and his compulsion to organize the images typologically, reflect the logic and organizational principles of the Neue Sachlichkeit. These ideals were similar to those of such German photographers as Albert Renger-Patzsch and August Sander (Cat. no. 27).

Blossfeldt's photographs were included in the Stuttgart and Berlin venues of the pivotal *Film und Foto* exhibition in 1929. *Urformen der Kunst* rapidly became an international bestseller, and Blossfeldt became an unlikely celebrity. The following year, the artist retired from teaching to concentrate on the sale of his work and the organization of his photographs into the selection for a second photobook, *Wundergarten der Natur* (Magic Garden of Nature), published in 1932.[8] Blossfeldt died that same year, and a decade later another selection of Blossfeldt's photographs was published posthumously in the book *Wunder in der Natur* (Magic in Nature).[9]

AUGUST SANDER
German, 1876–1964

Boxers, Cologne

1929
from the series *Menschen des 20. Jahrhunderts*
Gelatin silver print
30.5 × 23.8 cm (12 × 9⅜ in.) Image
30.5 × 23.8 cm (12 × 9⅜ in.) Sheet

Samuel J. Schatz Fund, 1976.23.04

In the 1920s, the Cologne photographer August Sander conceived a grand project to describe the full spectrum of German society in photographic portraits. His ambitions became the model for a recurrent fascination with photographic typology. Born in the village of Herdorf, near Cologne, Sander was the son of a carpenter who worked in the mining industry.[1] As a teenager he became a *Haldenjunge*, or slag-heap boy in the mines. Around 1892 the mining company sent a photographer to document its operations, and the young Sander was assigned to assist. He befriended the photographer, who sent him books on photography. Soon he acquired a camera and processing equipment, and persuaded the local physician to teach him the necessary chemistry. After completing his military service in Trier in 1899, he drifted from job to job in studios and darkrooms in Berlin, Magdeburg and Halle.

In 1901 Sander began working in a portrait studio in Linz, Austria. The workshop employed all the fashionable trappings, including painted backdrops and architectural props. Sander became a partner in the studio, and later purchased it. He married and began a family that would include four children. In 1906 the first solo exhibition of his photographs was presented at the Landhaus Pavillion in Linz. Three years later Sander took his family to a suburb of Cologne and established a new studio in nearby Lindenthal. He strove for a new simplicity and naturalness in his photographs, purchasing equipment that enabled him to create studio-quality portraits in the sitter's home. He loaded his camera and tripod onto his bicycle and rode to nearby towns and villages to find new clients. On Sundays, he often ventured out into the country, and on the rural roads of Westerwald he met farmers and country people, often dressed for church, whom he photographed. He came to regard these country people as the very foundation of society, and he conceived a project to represent Germany through its people. During World War I he served in the local militia and photographed the effects of the war upon Cologne. In 1920, Sander turned away from the labor-intensive gum-printing technique then preferred for portraits, and began printing on glossy paper used for architectural and industrial photographs.

In the first decades of the 20th century, studies of science in Germany were dominated by typology, and Sander began to see his portrait images as a gathering of sociological data. The organization and analysis of this data, he believed, could lead to overarching sociological and anthropological conclusions. Around 1925 Sander sorted the portraits he had made—many of them anonymous—to reflect the order of German

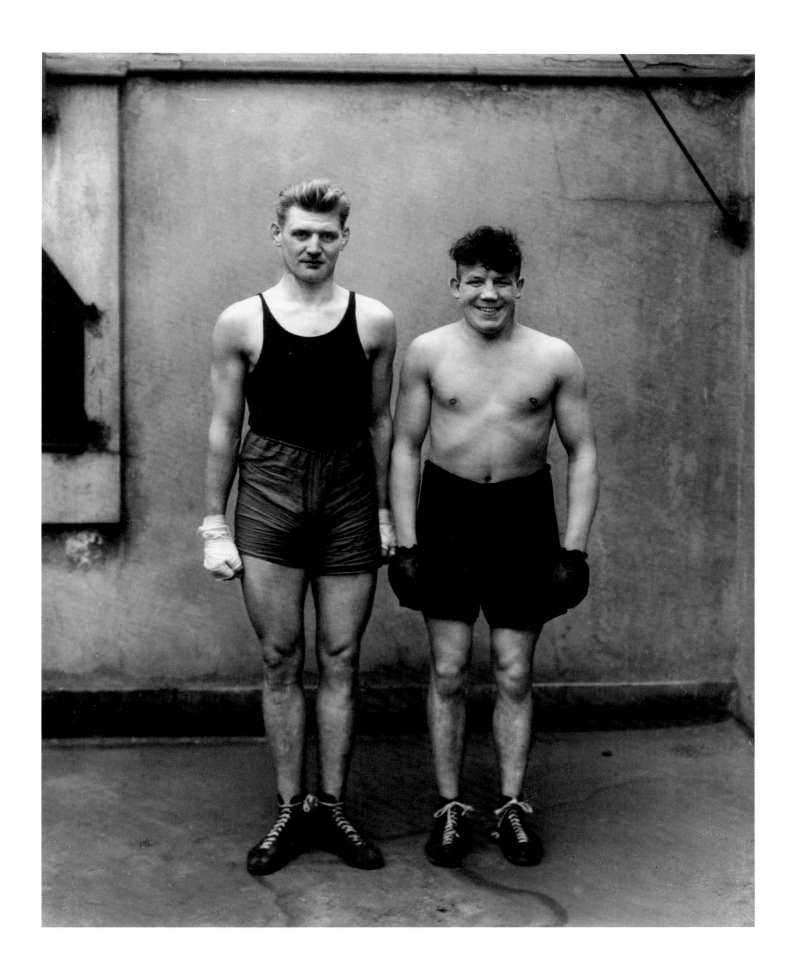

society as he saw it. He organized seven groups of German subjects, from citizens who worked with the soil to craftsmen and professionals, to those involved at the most elevated levels of the sciences, arts, religion and the nobility, as well as vagabonds, gypsies and other marginalized groups. Sander imagined a publishing project consisting of 44 series, with 12 photographs in each, making up *Menschen des 20. Jahrhunderts* (People of the 20th Century), an encyclopedic visual survey of the German people in the late Wilhelminian era and the Weimar Republic. He set out to issue the photographs one folio at a time.

This photograph is one of Sander's best-known images from *Menschen des 20. Jahrhunderts*, perhaps because of its handsome, genial subjects.[2] Boxing was one of the most popular sports in Weimar Germany. Here two pugilists, presumably sparring partners, stand side-by-side before a workout or match. They pose in a gym, positioned between the suspension cable for a heavy punching bag and a backstop on the wall for a speed bag. On the left is Paul Röderstein, cruiserweight champion of the district. The tall, blond Teutonic figure has a serious mien. By comparison, his partner, Hein Hesse, is shorter and stouter, and endearing with his wide smile and tousled hair. They are friends in the gym, not opponents, for their arms touch comfortably as they pose for the camera. They appear to be two healthy, good-natured young men, and honorable athletes. Together they represent German youth, warm-hearted and amusing, but serious and capable when necessary. Sander pictured them full length, hands by their sides, facing and acknowledging the camera, a mode typical of much of the series. He often photographed people in couples, further accentuating the theme of comparison.

The publication of Sander's photobook *Antlitz der Zeit* (The Face of Our Time) in 1929 brought him to public attention.[3] The selection of 60 portraits, taken over decades, was accompanied by an introductory essay by the novelist Alfred Döblin. The images were organized to reflect the strength of a venerable society, a theme that resonated strongly with Sander's contemporaries. The style and technique of the portraits established Sander as an advocate for straight photography at a time when the new perspectives of the Neues Sehen (New Vision) dominated most exhibitions of creative photography. He declared in his lectures on the "Nature and Development of Photography" on Cologne radio in 1931 that the subjects of documentary photography are more important than form and composition. The rise of the National Socialist German Workers' Party brought hardship to Sander and his family. After the Nazi Party came to control in Germany in 1933, *Antlitz der Zeit* was withdrawn from publication and the printing plates for the book were destroyed. Sander's perception of German society as varied in ethnic background and economic status contrasted with the vision of racial purity and prosperity promulgated by the party. Through the 1930s Sander refocused his activities, and used his repertoire in a more circumspect manner; he published a series of five books entitled *Deutsche Lande, Deutsche Menschen* (German Lands, German People), each focused on a different part of the country and its inhabitants. The word *Volk* was used instead of *Menschen* in the titles of the last three books in the series—a possible capitulation to Nazi taste.[4] In 1933–39, Sander worked on a series of photographs of the German landscape.[5] His son Erich, a member of the opposing Left Socialist Workers' Party of Germany, was

prosecuted by the Nazis and sentenced to incarceration, and died in prison. His business hobbled, Sander moved to Kuchhausen in the Westerwald in 1942, taking much of his archive of negatives and prints with him, thus saving it from wartime destruction. About three-quarters of his negatives remained in the city; they survived the war only to be destroyed in an accidental fire started by looters in 1946. In 1951, a solo exhibition of Sander's photographs was mounted at the Photokina in Cologne, and two years later the Stadtmuseum purchased his archive of city views taken between 1935 and 1945.[6]

LAURA GILPIN
American, 1891–1979

White House, Canyon de Chelly

1930
Gelatin silver print
45.2 × 36.4 cm (17¾ × 14 × ⅜ in.) Sheet
56 × 45.7 cm (22 × 18 in.) Mount

Gift of the artist, 1977.103.002

Over a long and prolific career, Laura Gilpin photographed the American West and its indigenous people, making images that also captured the extraordinary nature of the bright, arid Southwestern light. Gilpin was the daughter of a Western cattle rancher and a cultivated urban Midwesterner, born in Colorado Springs and raised on the western slope of the Rocky Mountains.[1] Her father took her and her younger brother hiking, riding and camping, and instilled in her a love of the outdoors, while her mother introduced her to the more refined and cosmopolitan culture of the East. She particularly encouraged her daughter's talent and interest in music. The great landscape photographer William Henry Jackson was an acquaintance of Frank Gilpin's, so photography was a serious pursuit within the family. When Gilpin was 12 years old, her parents gave her the gift of a Kodak Brownie camera and darkroom kit.

In 1905 Gilpin's mother took her children to New York City, where they had portraits taken by Gertrude Käsebier (Cat. no. 5). Fellow daughters of Colorado, photographer and subject seem to have felt a bond, and Gilpin would later consider Käsebier a mentor. She stayed in the East to attend boarding schools until 1909 but returned to Colorado to finish high school. Then Gilpin spent a year at the New England Conservatory of Music in Boston, though she decided against a music career. Käsebier advised Gilpin to study at the Clarence H. White School of Photography (see Cat. no. 8) in New York. So she returned to Colorado and built a turkey farm on the family ranch, which became a lucrative operation. By 1916 she had the funds to move to New York. At the White School she learned about the newest photographic techniques and acquired a foundation in design. However, her second year at the school was cut short when she fell ill in an early phase of the influenza pandemic. Gilpin returned to Colorado to recuperate, and her mother hired a nurse, Elizabeth Warham Forster, to care for her. The two young women became close friends and later life partners. Excepting separations for work, they would remain together until Forster's death in 1972.

In 1922, Gilpin and Forster visited Europe, an experience that motivated the photographer to explore the landscape of her home. She opened her own studio in 1924 in Colorado Springs where she concentrated on portraits and architectural images. She pursued landscape on her own, and in 1926 she published *The Pikes Peak Region*, a small photobook of views conceived for sale to tourists at Western hotels and train stations.[2] The following year she produced a folio of images of Mesa Verde National Park. Later, in efforts to expand the business, she made

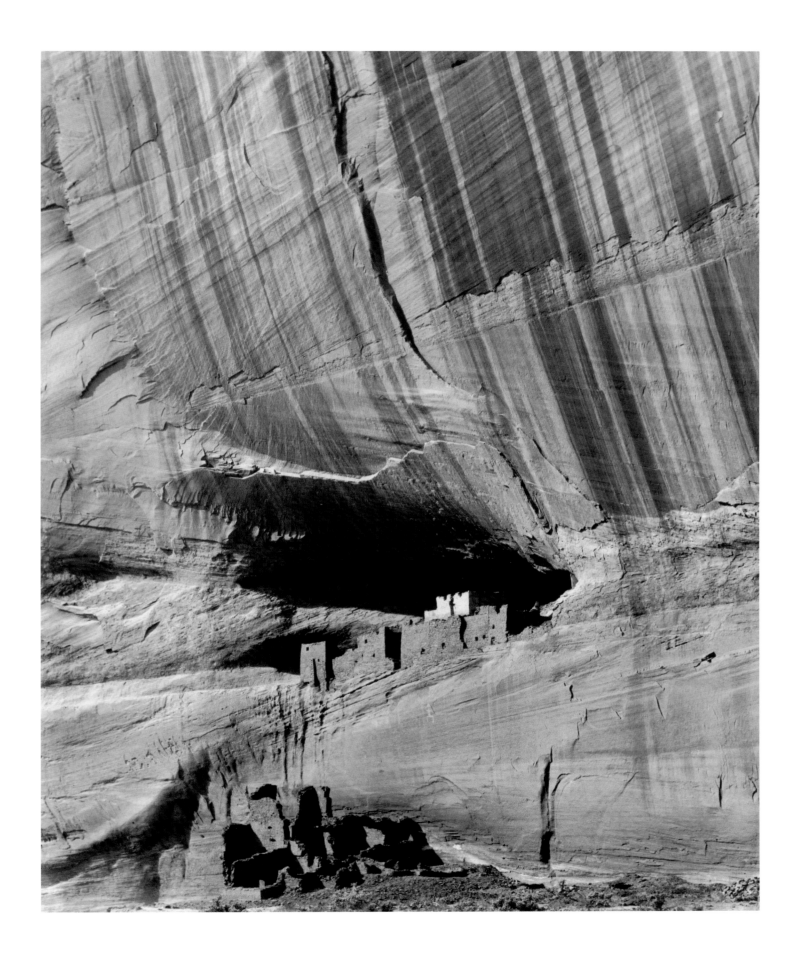

photographic postcards of Western landscapes, and lantern slides of archaeological subjects. In 1930, Gilpin and Forster were exploring the country near the Colorado-Arizona border when they ran out of gas in a remote part of the Navajo reservation. Local residents came to the rescue and welcomed the women into their homes. The women were enchanted not only by the Native Americans' generosity, but also by their simple, pastoral way of life. The Navajo community lived much as their forebears had done, working as farmers, shepherds, weavers and artisans. They had no indoor plumbing or electricity, and few

spoke English. The following year, the New Mexico Association on Indian Affairs hired Forster as a visiting nurse on the reservation at Redrock, in Grant County, New Mexico. Gilpin often visited Forster and accompanied her on her rounds, meeting and eventually photographing the people. Forster and Gilpin established deep friendships in the Navajo community, and studied their culture and history with earnest commitment. During the Depression Forster's nursing position was terminated, but the couple maintained their friendships at Redrock and Gilpin continued to photograph on the reservation. She came to understand how intimately Native Americans' history was intertwined with the land. When other Western photographers promoted natural preservation, Gilpin rejected the very notion of wilderness, for she understood how the West had been continuously inhabited for millennia.

Fig 7. — Laura Gilpin, American, 1891–1979, *Navajo Woman, with Child and Lambs*, 1932, gelatin silver print, Gift of the artist, 1977.103.001

This photograph represents the White House, the ruin of cliff dwellings built by Ancestral Pueblo peoples at Canyon de Chelly in northeast Arizona.[3] Set in a cave high above the canyon floor, the White House takes its name comes from the white plaster used to coat the long back wall in the upper dwelling. Nestled in the ancient rift in the rock, the buildings were naturally sheltered from the weather, including intense sunshine over much of each day. The site was inhabited from about 1060 C.E. to 1275 C.E., when prolonged drought prompted most of the Ancestral Pueblo to migrate away from the canyon.[4] For this photograph, Gilpin knowingly found a viewpoint similar to that used by the expeditionary photographer Timothy O'Sullivan in 1873.[5] However, she raised the angle of her camera slightly, to include most of the sheer, thousand-foot wall above the ruins. The image concentrates less on the buildings than on the remarkable geology sheltering them.

Gilpin organized her composition with the cave just below the horizontal center. She took this photograph at the moment when the two towers of the White House are illuminated by the sun, standing out against the darkness of the cave behind them. The horizontal fault in the rock curves down to the left, bringing the attention to the ancient ruins in the foreground. Gilpin's photograph reveals the vertical stains of iron oxidation carried by water down the sandstone rock wall above the White House and also captures the varied textures on the surface of the cliff, layered with the sediment of prehistoric seas. Visually interweaving the relics of ancient culture with the geology of the landscape, the artist conveys how intricately they are interrelated.

Gilpin's photobook *The Pueblos: A Camera Chronicle* was published with national distribution in 1941,

establishing her reputation as a photographer, even with the onset of World War II.[6] At that time, Gilpin worked as a photographer at the Boeing Aircraft Company in Wichita, Kansas. She returned to Colorado after the war to pursue new projects. In *Temples in Yucatán: A Camera Chronicle of Chichén Itzá*, Gilpin's images of jungle archaeological sites revealed a little-known history of native peoples in Central America.[7] For her next book, *The Rio Grande: River of Destiny*, she concentrated on the landscape, exploring how the river shaped the lives of people over centuries.[8] Gilpin worked for many years on a project on the Navajo people, a subject which had become closest to her heart. Her book *The Enduring Navaho* revealed the breadth and history of native culture, and their deep connections to the natural environment, with images made over 30 years.[9] The book includes many images of Native American women and families, whom she portrayed with tender strength (Fig. 7). Photographs of women dominate both *The Pueblos* and *The Enduring Navaho*; they reveal the character of indigenous culture, seldom described so authentically. Gilpin identified deeply with these capable women, their achievements as artisans, their family relationships and their intimate connections to the land of the undeveloped West. They provided powerful inspiration for her as a proud Westerner, and for her position as a woman in a male-dominated, Eurocentric profession.[10] In 1972, at the age of 81, Gilpin was awarded a Guggenheim Foundation Fellowship for a project to photograph the ruins of Canyon de Chelly.

DORIS ULMANN
American, 1882–1934

A Quilter

about 1930
from the book *Roll, Jordan, Roll*
Photogravure on cream CHARTA laid paper
23.8 × 17.7 cm (9⅜ × 7 in.) Plate
28.6 × 20.2 cm (11¼ × 8 in.) Sheet

Gift of Milly Kaeser, in Memory of Fritz Kaeser, 2002.012.013

The urbane Doris Ulmann distinguished herself as an elite portraitist in New York City, but followed her own inspiration to explore the American heartland in an era before the Farm Security Administration. She was born and raised in an affluent and cultured Jewish home on the Upper West Side of Manhattan.[1] As a girl she learned the fundamentals of photography from her father. After graduating from public high school Ulmann attended a two-year teacher training program at the Ethical Culture Fieldston School. She went on to Columbia University Teachers College, planning for a career teaching psychology. In 1914, at the age of 32, Ulmann married Dr. Charles H. Jaeger, an orthopedic surgeon at Columbia University Medical School. He had studied with Clarence H. White (Cat. no. 8) and encouraged his wife to take White's classes. She refined her technical skills and learned concepts of design and composition from teachers like Max Weber and Paul L. Anderson. Early in 1916 Ulmann, along with White, Gertrude Käsebier (Cat. no. 5) and a few other dedicated amateurs, met in Dr. Jaeger's medical office to form the Pictorial Photographers of America (PPA).[2] This organization was intended to advance photography as fine art, in a coterie more cordial and inclusive than the Photo-Secession. White was elected to head the association, and Dr. Jaeger was named treasurer. Both he and Ulmann contributed to the first formal PPA exhibition, mounted in October 1916 at the National Arts Club in New York.

In 1918, Ulmann opened a photographic portrait studio on the Upper West Side of Manhattan, under her maiden name. For rather formal portraits she used a traditional view camera with a soft-focus lens to expose 8 × 10 inch glass-plate negatives, working intuitively without a light meter or shutter. Her method was to chat with her sitter while setting up each exposure, establishing a comfortable rapport. Ulmann photographed many of her husband's professional colleagues, and in 1920 she published a selection in the book *The Faculty of the College of Physicians and Surgeons*, which was followed two years later by a series of doctors from Johns Hopkins.[3] By that time, the photographer had separated from her husband.

Ulmann lived on Park Avenue, and she was known for her style and elegant mien. She exhibited her work in several New York galleries, and her sensitive portraits of celebrities like W. B. Yeats, Rabindranath Tagore, Anna Pavlova and Lillian Gish appeared in national magazines. Ulmann published her third collection, *A Portrait Gallery of American Editors*, in 1925, but wished to expand beyond her rarified clientele.[4] She took her camera into the country, and in New York State and Pennsylvania she found inspiring

subjects in religious communities like the Shakers, Mennonites and Dunkard Brethren. Back in Manhattan, Ulmann met the young musical folklorist John Jacob Niles.[5] In 1927 they traveled together to eastern Kentucky, where Niles collected folk songs and Ulmann photographed the musicians and their neighbors. Some of her portraits from this expedition appeared in *Scribner's Magazine* in 1928.[6] Ulmann and Niles would continue their collaborative trips for the following six summers.

In 1929 Ulmann met the Southern novelist Julia Mood Peterkin, whose third book, *Scarlet Sister Mary* (1928), would soon win a Pulitzer Prize.[7] While growing up in the home of her grandfather, a Methodist minister and former Confederate, Julia Mood had learned the Gullah dialect from her African American nursemaid, and came to know the attitudes, customs and folkways of the black community.[8] She earned a master's degree and became a teacher in the village of Fort Motte, South Carolina. There, in 1903, Mood met and married William George Peterkin, heir to the historic Lang Syne, one of the state's richest plantations. For nearly 20 years, Julia Peterkin lived the life of a plantation mistress and raised a son. She wrote about the people of Lang Syne, descendants of 18th-century plantation slaves, describing African American characters of courage and integrity—tinged, however, with sentimentality and disdain obvious to today's readers.[9] In 1929 Ulmann made an extended visit to Lang Syne. She photographed the plantation workers, bereft and without opportunity, living much as their enslaved forebears had. Yet Ulmann's images also represent sociability, generosity, and repose.

A Quilter is one of several of Ulmann's Lang Syne images that present her subject's occupation as integral to her personality. In this sense, the photographs reflect a tradition of occupational portraits dating back to the era of the daguerreotype. Here, a woman sits on a porch before a horizontal pattern of clapboards and slatted window blinds that stabilize the closely cropped composition, giving a feeling of peace and wisdom. By contrast, the sitter is filled with energy, despite her obvious age. She gazes directly into the camera, confronting the viewer through thick spectacles and heavy eyelids. The curl of her brow—echoing the serpentine rail and splat of her chair—expresses an amiable resignation. Her slight smile conveys the wisdom of experience and endurance. The quilting on her lap suggests an analogue between character and artisan's skill—possibly influenced by John Jacob Niles's interest in regional craft. This image, like many of Ullman's other photographs of the Gullah people, shows an individual of dignity and accomplishment, sharing the responsibilities of their community.[10] Several others depict farm laborers working together in active groups. Ulmann's photographs from Lang Syne have little of Peterkin's self-assured superiority of the Jim Crow era. These images seem to maintain a respectful distance, isolated from Peterkin's presumptuous familiarity.

After years of doubt over how to publish these powerful photographs, Ulmann decided to combine a selection with an anthology of Peterkin's writing about African American life in the South.[11] *Roll, Jordan, Roll* was named after an 18th-century Anglican hymn, embraced by the African American community.[12] A trade edition of the book, published in December 1933, included 72 of Ulmann's photographs reproduced as offset-lithographs. *A Quilter* is one of the prints from the deluxe, limited edition of *Roll, Jordan, Roll*, issued in spring 1934 with 90

photogravure illustrations, produced directly from Ulmann's glass-plate negatives.[13]

When *Roll, Jordan, Roll* was published, Ulmann had already begun organizing her negatives of Appalachian folk arts at the behest of Allen Hendershott Eaton.[14] Years before, Clarence White had introduced Ulmann to Eaton, who was impressed by her conviction that her work should serve a social purpose. He believed that her images were an ideal complement to his study of Appalachian handicrafts, supported by the Russell Sage Foundation. She redoubled her journeys with Niles, and in the summer of 1934 they traveled to the mountains of the western Carolinas. Ulmann settled into a hotel in Asheville, North Carolina, venturing out to photograph rural craftspeople at work spinning, weaving and throwing pots. On this, her last photographic expedition, Ulmann exposed two thousand negatives, from which Eaton selected illustrations for his book *Handicrafts of the Southern Highlands*.[15]

ILSE BING
American, born in Germany, 1899–1998

Self-Portrait with Mirrors

1931
Gelatin silver print
26.3 × 29.8 cm (10⅜ × 11¾ in.) Image
27.9 × 35.6 cm (11 × 14 in.) Sheet

Gift of Robert E. O'Grady (ND'63) and Beverly O'Grady (SMC'63), 2011.028

One of the most versatile photographers to emerge in the Weimar era, Ilse Bing built a wide-ranging career in fields as disparate as photojournalism, architectural photography, and fashion and theater. Ernest Leitz acknowledged and made use of her devotion to his Leica miniature camera. Born into an upper middle-class Jewish family in Frankfurt am Main in 1899, Bing studied music and art during a privileged childhood.[1] She began as a mathematics major at the University of Frankfurt in 1920, but soon shifted to art history. In 1924 she began research for a doctoral thesis on the Neoclassical German architect Friedrich Gilly. To collect images of the architect's drawings for study, Bing bought a Voigtländer camera in 1928 and taught herself to use a darkroom. Soon she was enthralled by photography and the way that a mechanical device could divulge visual experience. She began to notice substance and surface anew, and to perceive effects of light and architectural space. The camera became a tool for exploring physics and mathematics. Bing bought a Leica miniature camera and began to photograph the city. She sold photographs to *Das Illustrierte Blatt*, a monthly supplement of *Frankfurter Illustrierte* magazine. Bing also worked for the Dutch architect Mart Stam, photographing his housing projects in Frankfurt. He introduced her to progressive art circles in the city,

and to such artists as El Lissitzky, Kurt Schwitters and Hannah Höch. Through them, Bing became aware of the work László Moholy-Nagy (Cat. no. 25) and other Neues Sehen (New Vision) photographers. Their influence is reflected in her experimental use of her handheld Leica camera, shooting from unusual viewpoints and tilted angles.

In 1930 Bing moved to Paris, the center of avant-garde photography, finally abandoning her academic career. The German journalist Heinrich Guttmann gave her the use of his darkroom, and she provided photographs to illustrate his newspaper articles.[2] Bing's creative work at that time combined geometric studies of light and deep shadow with available light, softened by the human and lyrical qualities suggested by the photographs of André Kertész and Henri Cartier-Bresson (Cat. nos. 22, 60). She developed a mature style characterized by strong diagonals and an overhead axis, reflective surfaces, focused pools of light, clarity of textures, and regrouping of real objects out of their context. Her photographs convey a strong sense of time continuing, rather than frozen moments. Her dominant aesthetic is grounded in Constructivism, but in Paris she forged this with a sensibility learned from the Surrealists, Dadaists and Neoromantics. She continued to publish her photographs in such

leading French journals as *L'Illustration, Le Monde Illustré* and *Regards*. In 1931, Bing's photographs of dancers at the Moulin Rouge were shown in the window of the newly established publishers La Pléiade. Later that year, her photographs were included in the 26th Salon Internationale d'Art Photographique, organized by the Société Française de Photographie.

Self-Portrait with Mirrors is one of a handful of photographs taken in one session.[3] It shows not only the artist's fascination with the physics of reflected light, but also her relationship to her Leica, the mechanical tool of her visual creativity. The camera appears in this image just as the brush, palette, canvas and easel appear in painters' self-portraits—images made using mirrors, which allow artists to observe and depict themselves making direct eye contact with the viewer, in a tradition that stretches back to the Renaissance. *Self-Portrait with Mirrors* is a complex image in which the artist has photographed herself and her trademark Leica in one mirror, while the profile of both is reflected in another. The large button on her cuff disturbs the play between full face and profile, while the objects at the bottom of the frame lend a certain informality to an otherwise highly contrived set-up. The soft velvety curtain behind introduces a further element of rich tactility. The play between black, white and shades of gray softens and enriches the overall image. Bing could have activated the shutter remotely, or used the Leica's timer for a self-portrait like that of Bill Brandt (Cat. no. 32); her use of the mirror must be a commentary on the technique and the concept of self-portraits. On the left of her image Bing has the mirror which reveals the mechanics of the process, fully dispelling any pretense about how this art is created. Our view of her, and her gaze out at us, is obstructed by the camera; she and it become inextricably linked.

In 1932, Julien Levy began to exhibit Bing's photographs in New York. Bing was working more frequently for Parisian fashion designers such as Elsa Schiaparelli. She also became increasingly involved with fashion photography, and her images appeared in French *Vogue* and the American *Harper's Bazaar*. In 1933, the painter and set designer Pavel Tchelitchew hired Bing to photograph the ballet *Errante*. Ernst Leitz, maker of the Leica and well aware of Bing's preference for the camera, began to send her prototypes of the company's new wide-angle and telephoto lenses for her experimentation and review.

In 1936 Bing visited New York, where a solo exhibition of her photographs was presented at the June Rhodes Gallery; her work was also included in an exhibition at the Museum of Modern Art. She stayed for three months with her friend the journalist Hendrik Willem van Loon, and made photographs in Manhattan and Connecticut that reflect the influence of American Social Realist painting. In an interview in the *New York World Telegraph*, Bing compared the skyscrapers of Manhattan to Alpine crystals. The photographer was impressed by the modern city, the energy of jazz, and the impetuosity of the American character.[4]

When Bing returned to Paris in 1937 she married the German pianist and composer Konrad Wolff, whom she had met in 1933 when she lived in the apartment below his.[5] A commission for a series on the Glyndebourne opera took her England the following year, and the couple moved to an apartment on the boulevard Jourdan. From her balcony there, she photographed the city looking towards Sacré Coeur, some of the last images that she made

before the Nazis occupied Paris in 1940. As German Jews, Bing and Wolff were interned by the Vichy government. Afterward they fled to Marseilles and waited nine months for visas to enter the still-neutral United States. Carmel Snow, editor of *Harper's Bazaar*, helped secure the papers, and the couple sailed to New York in June 1941. Bing found it challenging to re-energize her photojournalism career in New York. She fell back on portraiture, specializing in children, using a Rolleiflex camera in the studio. Bing visited Paris in 1947 and 1952, making more images of the city; however, the *douceur de vivre* common in her earlier work seems absent from these photographs, tainted with memories of war. In 1957 Bing took up color photography, and her work reflected her characteristic technical mastery. But in 1959 she turned away from photography to concentrate instead on abstract drawing and making photomontages of her earlier images.[6] In 1985, the New Orleans Museum of Art organized a retrospective exhibition of Bing's photographs, which traveled to the International Center of Photography in New York; this was followed by significant retrospective exhibitions in Paris and Aachen.[7] Though she never went back to photography, she remained creative and active in her later years. She wrote poetry in German, French and English, and took up motorcycling as a hobby when she was a septuagenarian.

BRASSAÏ

French, born in Romania, 1899–1984

Bal Musette des Quatre Saisons, Rue de Lappe, Paris

1932
Gelatin silver print
29.9 × 23.2 cm (11¾ × 9⅛ in.) Image
29.9 × 23.2 cm (11¾ × 9⅛ in.) Sheet

Samuel J. Schatz Fund, 1977.038

One of a remarkable group of Hungarian-born photographers working in Paris between the wars, Brassaï ultimately distinguished himself as a photoessayist. He was fascinated with the complexity of social relationships, and captured the events and interactions that pass unnoticed in daily life. His great achievement was a series of photobooks celebrating life in Paris, in images of penetrating insight into French culture.

Gyula Halász was the son of a French Literature professor, born in the small town of Brassó in the Transylvanian Alps.[1] When he was 17 years old, his studies at the Academy of Fine Arts in Budapest were interrupted by World War I. He served in the Austro-Hungarian cavalry regiment and remained on duty until the end of the war. In 1920 Halász went to Berlin to work as a journalist for the Hungarian papers Keleti and Napkelet. He also returned to the study of art at the Berlin-Charlottenburg Academy of Fine Arts (now the Berlin University of the Arts). When Halász moved to Paris in 1924 he intended to become a painter, but supported himself as a freelance journalist. He was enlivened by the art community, and met painters Pablo Picasso and Joan Miró, and writers Léon-Paul Fargue and Jacques Prévert. In 1929, André Kertész (Cat. no. 22) arrived from Budapest, and the two countrymen became friends. Halász was

inspired by Kertész's creative work, and bought a folding Voigtländer Bergheil plate-back camera with a 105 mm Heliar lens. Soon he began to submit his own photographs to newspapers to illustrate his articles. To distinguish his photographs from his work as a painter, he credited them to Brassaï, a name derived from his hometown.

In 1932, the art patron and publisher Tériade commissioned Brassaï to photograph Pablo Picasso for the first issue of Edward James's Surrealist-oriented journal Minotaure. The two artists became lasting friends, and over 150 of Brassaï's photographs would appear in the first nine issues of James's magazine.[2] The photographer was a founding member of Charles Rado's Rapho agency in 1933. Over much of the decade he made ends meet by photographing reenactments of crimes and scandals for tabloid magazines like Scandale, Detective and Paris-Magazine. He became fascinated by the unseen margins of Paris. "I was eager to penetrate this other world," Brassaï wrote, "this fringe world, the secret, sinister world of mobsters, outcasts, toughs, pimps, whores, addicts, inverts."[3]

Brassaï was a night owl. He slept much of the day, and at night he carried his cumbersome view camera and tripod into the streets, exposing gelatin silver dry-plate negatives. Night photography

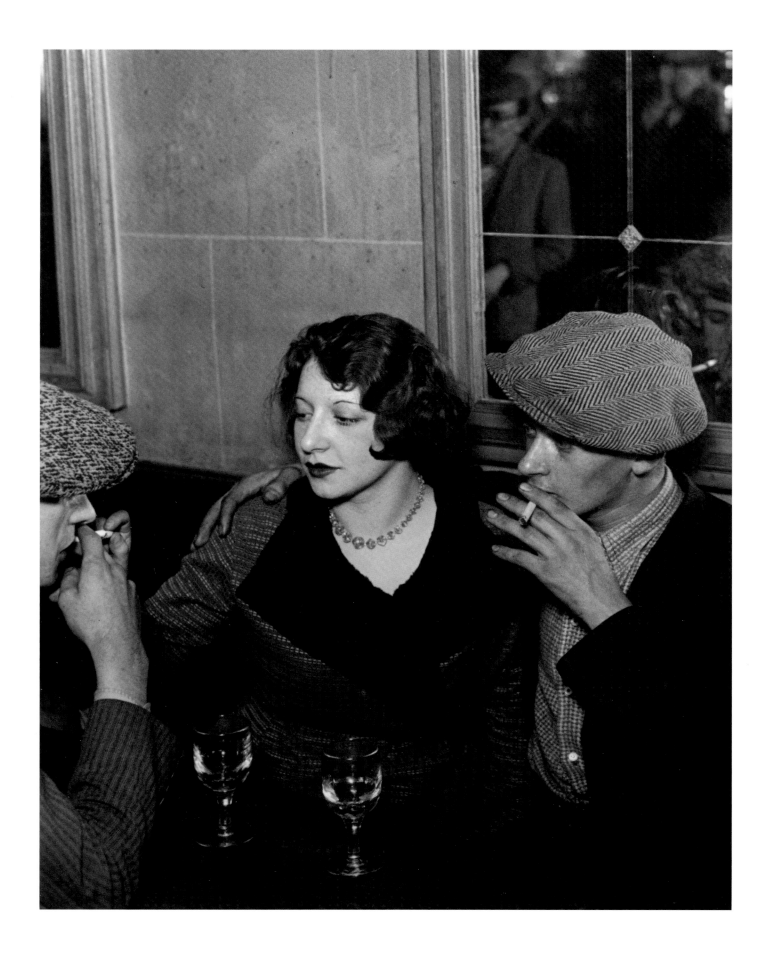

posed technical challenges, and he developed his own methods, working with the limitations of his antiquated equipment. Brassaï created mysterious images of darkened streets, contrasting shadowy architectural masses with deserted open space. He worked in light levels so low that he could uncover his lens and move in front of the camera, serving as his own model. He perfected a technique of using a burning cigarette to measure long exposures: "A Boyard is thicker than a Gauloise, so it takes longer to burn."[4] Brassaï also photographed in meeting places—coal-bars, bals musette and music halls. When he arrived with his bulky equipment, and often an assistant, candid photography was impossible. "There is something like complicity . . . I had to be familiar with the people and it was difficult at that time. I didn't have a lot of money and I had to make friends and buy drinks . . . I had to invent a technique so that people . . . never knew when I was going to take their picture, or when they knew, I didn't take it."[5] After gaining the confidence of his subjects, Brassaï set up his equipment, including a handheld pan for magnesium flash powder, with his assistant at the side holding a powder screen and reflector, and waited for a consequential moment. The explosions of the flash were so brilliant, loud and noisome that Picasso nicknamed Brassaï "the terrorist."

This photograph is one of many that Brassaï took in bals musette along the rue de Lappe of the Roquette district of Paris.[6] In the 19th century, scrap metal was collected along this short street on the city's edge. The neighborhood was a cheap place for newcomers from Brittany to settle. To accommodate them, simple shops sold both wine and heating fuel, advertised by signs announcing *Vins et charbons* (wine and coal).[7] These coal-cafés grew into gathering places where traditional music was performed on a Breton bagpipe called the musette. When new waves of migrants arrived from the Auvergne, the musette was gradually replaced by the diatonic accordion, and patrons danced the bourrée, the waltz and the Parisian java. Bals musette took over the rue de Lappe. Each had its own distinctive clientele, but their decor was similar, with red patent-leather banquettes lining the walls, behind tables bolted down so they could not be thrown. Dim light was cast from hanging globes, often festooned with paper streamers, and mirrors lining the walls made small rooms seem larger.

In this flash photograph, French viewers of the 1930s would recognize the coarse subjects by their dress. The men wore jackets, mufflers and flat caps that never came off indoors, and women dressed in skirts and satin blouses, with bobbed coiffures and spit-curls, and meticulous makeup. Here, three young people sit close together at a table, casually sharing conversation and a cigarette. The woman is the center of the composition, drawing attention with her pale complexion, pointed face and the inverted chevron of her neckline, which echoes her sharp jawline. Only she is recognizable, with her stylish hair and maquillage—her companions seem to prefer their anonymity. There are provocative hints of sexuality here: one man rests his arm around her shoulder, and she passes the light from her cigarette to the other man's.

Brassaï also recorded the nightlife of the Parisian bourgeoisie and upper classes. He photographed at the Folies Bergère and the Casino de Paris, and upper-class friends provided access to the ballet and the grand opera. A chastened selection of Brassaï's images were published in 1933 in the photobook *Paris de nuit*, named for the tourist busses offering

nighttime tours around the city.[8] The book begins and ends with images of darkened paving stones. Looming architecture and street lights provide the setting for a parade of fascinating Parisians. The images were printed as full-page bleeds, and the book is designed so that composition and tonal range lead the reader from page to page. *Paris de nuit* was the first of over a dozen books that Brassaï published over the course of his career.

When the Germans occupied Paris during World War II, Brassaï refused a photographer's permit and was prohibited from shooting on the street. He returned to drawing and sculpture, and began writing poetry. His passport became void after the war when his hometown of Brassó was absorbed by Romania, and he remained stateless until he married the French woman Gilberte Boyer. Brassaï's postwar photographs continued the themes and techniques of his earlier work, now influenced by the fashion for humanist photography.[9] In 1968, Brassaï received broader international recognition when a solo exhibition of his photographs was mounted at the Museum of Modern Art in New York.[10] It was only when *The Secret Paris of the 30s* was published in 1976, revealing the breadth of the artist's perception of Parisian nightlife between the wars, that his achievement as a photographic pioneer was fully understood.[11]

BILL BRANDT
English, born in Germany, 1904–1983

Self-Portrait

1934
Gelatin silver print
12.9 × 10.2 cm (5⅛ × 4 in.) Image
13.1 × 10.4 cm (5¼ × 4⅛ in.) Sheet

Milly and Fritz Kaeser Endowment for Photography, 2014.057.001

Bill Brandt took the scrupulous perception of the Neue Sachlichkeit (New Objectivity) to England, where his unusual status as an elite foreigner enabled him to navigate the full compass of the stratified society. He documented the country's people, its writers and artists, and its landscape with curiosity and wit. Brandt's was a long-established German family of merchant bankers. His grandfather worked in the London branch of the family bank during the mid-19th century, and Brandt's father, Ludwig Walther Brandt, was born in England.[1] Bill (born Hermann Wilhelm Brandt) and his brother Rolf were born in Hamburg, but inherited their father's dual citizenship. As a child Bill was stricken with tuberculosis, and spent two and a half years in a sanitarium in Davos, Switzerland. He took up photography as a therapeutic pastime. When he was in Vienna in 1927, he made photographic portraits of such celebrities as Ezra Pound, George Antheil and Arnold Schoenberg. He worked as a laboratory assistant, where he met another young assistant, Eva Boros, who later became his first wife. Brandt went to Paris in 1929 to work in the photography studio of Man Ray (Cat. no. 50), an arrangement that may have been a paid apprenticeship. In Paris Brandt witnessed the heyday of Surrealist film and photography. He also met the Hungarian photographers

André Kertesz and Brassaï (Cat. nos. 22, 31), and experimented with their influences.

In April 1934 Brandt and his brother Rolf moved to England along with their wives. They settled in Belsize Park, a North London neighborhood inhabited by many refugees from Nazism. Two uncles, his father's elder brothers, were prosperous partners in London branch of William Brandt & Sons bank.[2] They had remained well established in business and in upper-middle-class society, each with a London house and neighboring country properties in Surrey. They heartily welcomed their young nephews and their wives.

The photographer perceived England and its stratified class system with an outsider's eye—often sympathetic to its proprieties, but also aware of its absurd contradictions. He was able to photograph both extremities, from the indigent Docklands to the elegant Café Royal. In 1936 Brandt published a selection of these images in *The English at Home*.[3] The photographs reveal the conventions and inequities of the culture, and suggest some qualities of the English character. The small, hardcover volume contains 63 photographs that contrast upper- and lower-class society, and rural and city life. On the front cover is a crowd of affluent racegoers at Ascot, while on the back a miner's wife and children crowd into their

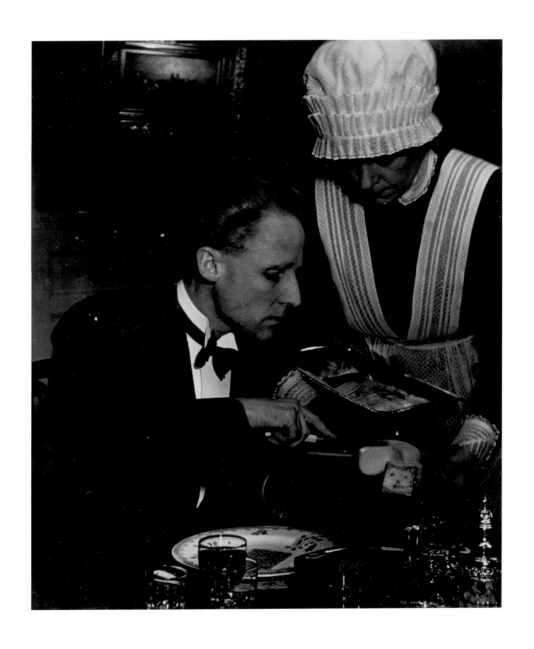

meager living quarters. Brandt took this notion of juxtaposition, so appropriate to the polarities of English society, from the German magazine *Der Querschnitt* (The Cross-Section), which often organized photoessays around pointed contrasts. The *English at Home* is designed in contrasting double-page spreads that represent the comfortable lives of the upper class on the left, facing events of working-class experience on the right. Brandt overlooked the large, relatively content middle-class segment of English society.

Brandt took this photograph while collecting images for *The English at Home.*[4] It is one of several made at his uncle Henry's house in the exclusive London borough of South Kensington. Another photograph taken that evening, *Dinner Is Served* is one of the best-known images from *The English at Home*. It shows tense anticipation as the stern parlormaid stands beside her apprehensive young assistant as guests seat themselves for dinner. Here, in a shot snapped with the automatic timer of Brandt's Leica, the maid waits upon Brandt himself, serving the cheese course later in the same meal. The puffy form of the maid's starched white cap dominates the composition. Along with her lacy collar, cuffs and apron, it is characteristic of a very expensive costume that proclaims her station. The young man wears a parallel uniform: a dinner jacket, boiled shirt and silk tie. Their customary, formal interchange takes place at a table set with porcelain, crystal and polished silver, while an oil painting glitters in electrified light behind them. This realm of privilege is also one of strict order.

Ostensibly these photographs reflect the decorous, solemn relationships between servants, employers and guests. In fact, Henry Brandt's head parlor maid, known to all as Pratt, was a beloved and indispensable member of the family. Despite her imposing demeanor, by all accounts she was affectionate and nurturing. Her employer, his family and friends esteemed her as sensible, eminently capable and warm. When Bill Brandt first met Pratt in 1928, he wrote, "Can you say what was the most important encounter of your life? To what extent did or does this encounter give you the impression of happening by chance, or by necessity?"[5] He recognized a turning point, it seems, perhaps realizing that he should concentrate on the English as the subject of his work. A few of Brandt's photographs of Pratt were used in *The English at Home*, including an image of her in uniform drawing a bath, and another as a "A Resident of Putney," in civilian clothes with a tightly rolled umbrella.

In 1939 Brandt organized his photographs of Pratt into a photoessay, "The Perfect Parlourmaid," which appeared in *Picture Post* magazine.[6] Twenty-one photographs over five pages followed Pratt's activities from morning to night. The accompanying story accentuated her exaggerated autocracy: "Pratt directs the other maids like a general in charge of an army," it relates. "Nothing escapes her dark and inscrutable eyes. Everything about her is impeccably correct. Grown-ups are frightened to misbehave in front of her."[7] "The Perfect Parlourmaid" includes a larger cropping of the present photograph, with the image extended to the right, where a bouquet of fresh flowers occupies the center of the table.

Brandt's second photobook, *A Night in London* (1938), is a nod to Brassaï's *Paris de nuit*, but is pictorially quite different due to Brandt's use of flash photography.[8] During World War II, however, Brandt photographed London under blackout, darkened to hinder the siting of German bombers. Street lights were extinguished and windows blocked from the

inside. Brandt tried to capture the eerie glow and deep shadows of the city illuminated by moonlight, reminiscent of the 18th century. When the Germans bombed the city in September 1940, the Ministry of Information engaged Brandt to document the Blitz. His images reflected the emotions and personal exchanges of people in a trying, frightening situation. The most famous photograph of this project represents evacuees in the safety of an underground railway tunnel, sleeping side by side on the Elephant and Castle station platform.[9]

In 1941 *Lilliput* magazine commissioned Brandt to photograph contemporary authors. He tried to capture their essential personalities by working in silence, not speaking and barely looking at his subjects. He tried not to isolate their faces or expressions to accentuate their personalities by context. Brandt's "Gallery of Literary Artists" appeared in *Lilliput* magazine in November 1949, including portraits of Dylan Thomas, Robert Graves and Graham Greene.[10] By the end of the war Brandt had lost his enthusiasm for documentary photography. He turned to landscape, and a new practice: now he envisioned his images in detail beforehand. On site, he watched patiently for the scene he had imagined. Brandt waited years to achieve the photograph of Stonehenge under snow that appeared on the cover of *Picture Post* on April 19, 1947. He traveled to locations associated with English poets and novelists, combining landscapes with some of his authors' portraits in the photobook *Literary Britain*.[11]

During the 1940s, Brandt also experimented with a sturdy, old, institutional camera made for recording crime scenes. Built of mahogany and brass with a wide-angle lens, it enabled him to place a figure in the foreground before an expansive setting. "Instead of photographing what I saw," Brandt wrote, "I photographed what the camera was seeing. I interfered very little, and the lens produced anatomical images and shapes which my eyes had never observed."[12] He posed nude models in the empty rooms of high-ceilinged London flats. Distorted by the lens, the anatomical forms are bereft of eroticism. The images reveal the photographer's understanding of the work of Pablo Picasso and Henry Moore. In these photographs Brandt explored creative use of the darkroom for the first time, and he considered these works to be major artistic statements of his career.[13]

ALFRED EISENSTAEDT
American, born in Germany, 1898–1995

Premiere at La Scala, Milan

1933
Gelatin silver print
44.8 × 31.8 cm (17⅝ × 12½ in.) Image
51.4 × 40.6 cm (20¼ × 16 in.) Sheet

Gift of Dr. William McGraw (ND'65), 2009.047.023

Alfred Eisenstaedt helped to formulate the practice of photojournalism in a career that spanned much of the 20th century. He strove to record events factually in a straightforward, understandable manner, always seeking to reveal the humanity of the moment. Eisenstaedt was born at Dirschau, West Prussia (now Tczew, Poland), one of three sons of a department store owner.[1] When he was eight years old, his family moved to Wilmersdorf in Berlin, where he attended the local Hohenzollern Gymnasium. For his 14th birthday, an uncle gave him an Eastman Kodak No. 3 Folding Camera, and he began taking photographs. After graduating from school he became an apprentice in a retail store at Gera in Thuringia, the first step to following in the family business. However, in 1916, during World War I, he was drafted into the German Army and assigned to an artillery regiment. Two years later, in the Battle of the Lys, he was wounded by shrapnel in both legs. During a long recovery, he studied the history of art and visited the art museums of Berlin.

Postwar inflation affected Eisenstaedt's family circumstances. When he returned to the trade, it was as a wholesale salesman of belts and buttons. Nevertheless, he took up photography again with a Zeiss Ikon Ideal camera that exposed glass-plate negatives. It was only when a friend introduced the process of enlarging that Eisenstaedt appreciated the possibilities of his work.[2] In 1927, on a visit to Czechoslovakia, he photographed a woman playing tennis, with long shadows cast over the court by early evening sun. He sold the photograph to *Der Weltspiegel*, the illustrated weekly of the *Berliner Tageblatt*, and began a new career. Among his first widely published photographs were images of actress Marlene Dietrich in her role from the film *Der blaue Engel* (The Blue Angel).

Gradually, over the next few years, Eisenstaedt turned from sales to freelance photography. He took assignments from the *Berliner Illustrierte Zeitung* and the Berlin branch of the American Pacific and Atlantic Photo Agency. One of his first major projects was to document Thomas Mann receiving the Nobel Prize for literature at Stockholm in 1929. Rather than imposing his own style, Eisenstaedt tried to let personalities and events speak for themselves. He photographed many celebrities, including champion boxer Max Schmeling, composers Sergei Rachmaninoff and Richard Strauss, and musicians Nathan Milstein and Vladimir Horowitz. He often worked alongside his colleague, the photojournalist Erich Salomon, who offered technical advice and loaned him a Leica miniature camera. Eisenstaedt began working with an Ermanox, and eventually adopted the Leica himself. He earned a reputation

for being considerate to his subjects, and for using minimal equipment. When he was sent to Italy in 1933 to cover the first meeting of fascist leaders Adolf Hitler and Benito Mussolini, his unobtrusive manner enabled him to observe the two dictators at arm's length.

Eisenstaedt's restraint and his ability to blend with his subjects is apparent in this famous photograph taken at La Scala opera house in Milan. The famous theater was constructed in 1776–78 on the location the church of Santa Maria alla Scala, from which the theater gets its name. With its large house and stage, the opulent theater immediately became one of the premiere venues for European opera. Originally, the orchestra was located on the main floor, in full sight of standing spectators, for there were no seats for the most affordable tickets. Better sound and views were available from the 678 boxes, occupying six tiers around the house perimeter. The sale of these boxes funded the construction of the theater. Each was decorated by its owners, so in the 18th century, La Scala became an important place for the upper classes of Milan to display their wealth. Ornamented with stucco relief and completely gilded, the rows of boxes appear luxurious in the glow of the house lights, originally oil lamps, then gaslights, and then electrical.

In this photograph, Eisenstaedt strove to capture this opulence, the astounding scale of the theater, and the excitement of an opening night.[3] The composition is dominated by the theater's interior— the impressive sweep of the tiered boxes, and the theater's vertical expanse. The photographer located his camera so as to capture a view that ranges from the main floor seats to the shaded *loggione* under the ceiling. This vertiginous height is complemented in this image by an indication of horizontal space, suggested by the diminishing scale of the sweeping colonnades and the figures they contain. This photograph was made in 1933 on the night of the gala premiere of Nicolai Rimsky-Korsakov's opera *The Legend of the Invisible City of Kitezh and the Maiden Fevroniya* at La Scala.[4] That fact, however, is not as intriguing as the audience member who provides a point of access into Eisenstaedt's image. Dressed in lacey evening clothes, chatting with her companion, she faces the viewer. She is immaculately turned out and attractive but relatable, not too elegant. Her opera glasses and evening bag balance on the velvet balustrade before her, as she turns from the stage to face her hidden companion, who holds up an open program. Her expression is impossible to read; she may be deeply interested in gossip or enthralled by the romance of the opera. The photographer excites our speculation about her mysterious companion, their conversation and their relationship.

In September 1933, when Eisenstaedt took his camera to the League of Nations meeting in Geneva, he captured an ominous image of Joseph Goebbels, the propaganda minister of Nazi Germany, with a threatening frown before the camera of a Jewish photographer.[5] The photographer went to Ethiopia in 1935, before the Italian invasion of the country. He brought back 3,500 negatives depicting life in eastern Africa, the court of Emperor Haile Selassie, and the Ethiopian military preparing for war. No longer comfortable in Germany, Eisenstaedt moved to the United States in 1935. His portfolio, with photoessays on the Graf Zeppelin and Ethiopia, and portraits of royalty, artists and entertainers, easily attracted freelance assignments from *Harper's Bazaar*, *Vogue*, *Town and Culture* and other magazines. Then, in

April 1936, Henry R. Luce invited Eisenstaedt to join the staff of the newly founded illustrated weekly *LIFE* magazine. Over the course of his career, Eisenstaedt covered over 2,500 assignments for the magazine, and photographed 92 covers.

Eisenstaedt traveled around the world as a *LIFE* photographer, covering social and cultural events, politics and sometimes war. Charming and unaffected, prudent and deliberate, the photographer put his subjects at ease. He documented notable personages and historic events, including the funeral of President Franklin Delano Roosevelt, and the destruction of Hiroshima and Nagasaki by American bombs in World War II. His constant search, however, was for events that revealed universal aspects of human nature. Relatable feelings are at the heart of his most famous images, such as the photograph of a young soldier spontaneously kissing a nurse in Times Square on V-J Day in 1945.[6]

In 1966, *Witness to Our Time* was published, the first book of his images selected from his work for *LIFE* magazine over 30 years, which accompanied a touring exhibition first shown at the Time-Life Building in New York. It was followed in 1969 by *The Eye of Eisenstaedt*, a book consisting of a more personal selection of images reviewing his career, to complement his reminiscences.[7] When *LIFE* temporarily suspended publication in 1972, the company exhibited several collections of Eisenstaedt's pictures, and published *Eisenstaedt: People*, an selection of his portraiture.[8] In 1979 Eisenstaedt returned to Germany for the first time since his emigration, to visit and photograph the places of his youth, and see what his homeland had become. Some of his photographs were combined with his photojournalism from the Weimar period in the exhibition *Eisenstaedt: Germany*.[9]

BARBARA MORGAN
American, 1900–1992

Martha Graham, Lamentation (oblique)

1936
Gelatin silver print
25.4 × 26.7 cm (10 × 10½ in.) Image
25.4 × 26.7 cm (10 × 10½ in.) Sheet

Humana Foundation Endowment for American Art, 2016.025

"The best pictures . . . ," wrote Barbara Morgan, "are portraits of energy; energy of imagination, generating motor energy and transfixed by light energy."[1] She understood light and movement as essential components of material existence, and she used her camera to capture and make them visible. As an infant, Barbara Brooks moved with her family from Kansas to Southern California.[2] She grew up on a peach farm, where her father taught her to see the energy and rhythms of nature. At UCLA Brooks studied art in a department built by students of Arthur Wesley Dow, a leader of the American Arts and Crafts Revival. After graduating, she joined the faculty and strove to advance its conservative curriculum. She helped professor Annita Delano to organize an exhibition of photographs by Edward Weston (Cat. no. 16) for the university art gallery.

In 1925 Brooks married Willard Detering "Herc" Morgan, a freelance journalist who provided his own photographs to illustrate his articles.[3] He used the Leica miniature camera, and the quality of his published photographs compelled the Ernst Leitz Company to provide him with equipment. Each spring, when classes ended, the couple drove together to the Southwest, to paint and photograph in the mountains and deserts. Barbara Morgan was impressed by the immensity of geologic time she saw at the Grand Canyon and Monument Valley. She was also moved by Native American culture, and its identification with the environment.

In 1930, the couple moved to New York City. The artist set up a studio on East 23rd Street, overlooking Madison Square, where she painted and made prints that were shown at the prestigious Weyhe Gallery. In New York she also concentrated on learning the techniques of photography and the darkroom. In 1935, she attended a performance of Martha Graham's *Primitive Mysteries*, and appreciated its inspiration in Southwestern Native American dance.[4] Soon afterward, the filmmaker Julien Bryan introduced Morgan to Graham. The two women found immediate rapport and agreed immediately to work together on a book of dance photographs. To prepare for the project, Morgan watched performances of each of Graham's choreographed works several times, identifying moments that epitomized the context or style of each piece. At that point, the two artists met alone in an empty studio or theater to capture these selected movements on film. They considered the photography sessions to be collaborative. When the negatives were developed, they met again to choose together which images to print.[5] Morgan always allowed Graham to use her images without charge.

This photograph represents a moment from *Lamentation*, a dance solo that Graham choreographed to a piano composition by Zoltán Kodály.[6] The piece was first performed at Maxine Elliott's Theatre in New York in January 1930, and remained in the dancer's repertoire through the decade. In less than four minutes, she tried to express the anguish of modern life. In early program notes, *Lamentation* was subtitled *Dance of Sorrow*—"not the sorrow of a specific person, time or place but the personification of grief itself."[7] Through the entire performance Graham was seated on a bench, designed by her friend the sculptor Isamu Noguchi. A spotlight illuminated her upper body. She wore a purple costume of her own design, an enveloping, tubular cowl of purple jersey fabric. Only Graham's face, hands and feet protruded from the loose garment. Some observers were reminded of a nun's habit, while others saw the mantle of the Virgin of Sorrows.[8] When the music began, Graham slowly moved her head from side to side, then gradually began to shift her torso, arms and legs in rhythm. She took angular poses, revealing her form from inside the garment, extending its stretchy fabric into geometric shapes. For emphasis she held some positions at slightly exaggerated rests in the score. As the volume and tempo of the music increased, Graham broadened her movement, while her face remained in a vacant, faraway gaze. In a final spasm she held the edge of her mantle in a fist above her head, before settling onto the bench and dropping her head between her knees.

To represent this convulsive misery, Morgan used subtle illumination. Her photograph of the piece expressed the sculptural form of which dance is capable. In this composition—subtitled *oblique*—Graham's upper body emerges from the darkness. The position of the dancer's legs can be discerned in the shadows, as well as the long, elliptical shape of Noguchi's bench. The dancer stretches her head into the light, facing out of the darkness at the apex of a triangular form. Her costume defines linear and formal shapes, as she strains the fabric from inside with her arms and legs. This tension contrasts with the soft modeling of tone and space. Graham's fists clench, while her face is set in a stoic cast.

In 1936 Barbara Morgan helped organize the American Artists' Congress, a division of the American Communist Party that aimed to use the visual arts to oppose fascism. She was also an early member of the Photo League, a parallel organization of Left-leaning photographers in New York.[9] Many of its members were professional photographers, but the organization also offered basic technique and darkroom classes. In 1941, Morgan finally published the book *Martha Graham: Sixteen Dances in Photographs*, and the present photograph was one of eight representing *Lamentation*.[10] The book included a similar number of images for each of Graham's works of choreography. This book was the first publication of Morgan & Morgan, an imprint that the photographer and her husband founded in order to retain control of every phase of book design, production and publishing. By that time, Willard Morgan was the first picture editor of *LIFE* magazine. He left that imposing position in 1943 to become founding director of the photography department at the Museum of Modern Art. A solo exhibition of Barbara Morgan's photographs was mounted in 1945 at Black Mountain College in North Carolina; the following year, she taught in the first Summer Arts Institute at Black Mountain.

An image from *Lamentation* was among the photographs included in a solo exhibition of dance

photographs shown at the Museum of Modern Art in 1945. "As a photographer," Morgan wrote of these photographs, "I have had the joyful responsibility of capturing and communicating these phenomena of the human spirit, which otherwise would not endure beyond performance. The pictures were composed in action while the dancers performed especially for my modern speed cameras and lights. I continually sought to discover the fluid relationships of light-time-motion-space-spirit by which I could release—not the mere record—but the essence of dance into the photographic image."[11]

During the 1940s, the era of Abstract Expressionism, Morgan created innovative "light drawings" by opening the shutter of her camera in a darkened studio and drawing in space with a flashlight, images of energy and motion inspired by Asian calligraphy. Later, she experimented with photomontage, encouraged by her acquaintance with László Moholy-Nagy (Cat. no. 25).[12] Her broad experiments were meant to capture the speed and turmoil of modern American life. In 1952, Barbara Morgan was among a group of colleagues who founded *Aperture* magazine. Unlike the journals for amateur photography enthusiasts, *Aperture* concerned itself with the imagery and style of creative photography.[13] Morgan and Graham continued their friendship for 60 years. "It is rare that even an inspired photographer," wrote the choreographer, "possesses the demonic eye which can capture the instant of dance and transform it into timeless gesture."[14]

MANUEL ÁLVAREZ BRAVO
Mexican, 1902–2002

Portrait of Eternity

1935
Gelatin silver print
24 × 19 cm (9½ × 7½ in.) Image
25.4 × 20.4 cm (10 × 8 in.) Sheet

Gift of John C. Rudolf (ND'70), 1979.123.001.C

A profound connection to the land of Mexico, its culture and its history distinguishes the photographs of Manuel Álvarez Bravo, the leading Central American photographer of the century. The son and grandson of painter-photographers, he was a child when the Mexican Revolution took place and he remembered hearing the gunfire and seeing dead bodies in the streets. Álvarez Bravo was 13 years old when his father died, and he left school to go to work as a clerk in a textile factory.[1] He began to study accounting at night, but shifted to art classes at the Academy of San Carlos.

After meeting Hugo Brehme in 1923, Álvarez Bravo became interested in photography; he bought a camera and taught himself how to use it. In 1925, he married Dolores (Lola) Martinez de Anda, and they moved to Oaxaca, where Álvarez Bravo worked as an accountant in the Federal Treasury Department.[2] He shared his understanding of the camera and the darkroom his wife, and when the couple returned to Mexico City in 1927, they set up a photography studio and gallery in their home. The following year, Álvarez Bravo's work was included in the First Salón Mexicano de la Fotografía in 1928. Álvarez Bravo taught photography at the Central School of Plastic Arts (now part of the Academy of San Carlos), when Diego Rivera was director in 1928–29.

At that time Álvarez Bravo made friends with Tina Modotti, protégé of Edward Weston (Cat. no. 16). When she was deported from Mexico for political activities in 1930, he helped her pack and saw her off from the station. She left him her camera, and recommended him for her job at *Mexican Folkways* magazine. Its editor, Frances Toor, assigned Álvarez Bravo to document the work of the first generation of artists after the Revolution, mural painters such as Diego Rivera, José Clemente Orozco, David Alfaro Siqueiros and others who worked to forge a national identity by representing indigenous culture and history in their public wall paintings.[3] In his own work, Álvarez Bravo joined them in the pursuit of *mexicanidad* (Mexican identity) in personal imagery that combined poetic observation with allusions to ancient myth, folklore and ritual. He employed a straightforward style to appeal to a broad range of his countrymen, who understood the iconography and cultural significance of his images. The titles of his photographs often are based on Mexican myth and culture. In 1931, the year Álvarez Bravo left his Treasury Department job to concentrate on photography, the Museum of Modern Art in New York acquired his work. While teaching for another academic year in 1932–33 at the Academy of San Carlos, Álvarez Bravo also worked as a cameraman

for Soviet filmmaker Sergei Eisenstein on his production *¡Que Viva México!*[4] This project was never finished, but it began a new direction in the photographer's career. In 1933 he met photographer Paul Strand (Cat. no. 66) on the set of his film *Redes*, and worked with him briefly.

Portrait of Eternity (*Retrato de lo eterno*) is one of Álvarez Bravo's photographs of the early 1930s that is distinctly Mexican in its style and imagery.[5] It represents a young woman dressed in a traditional Tehuana native costume. The model for this photograph was Isabel Villaseñor, known to friends like Manuel and Lola Álvarez Bravo by the diminutive nickname Chabela.[6] She was a noted beauty of the day, but she was also a visual artist, poet, musical composer and singer. Villaseñor was a sculptor, having studied with Francisco Díaz de León at the Santiago Rebull Popular Painting School and with the school's founder, Gabriel Fernández Ledesma. She was one of only two women whose work was included in the seminal *Mexican Arts* exhibition at the Metropolitan Museum of Art in New York in 1930. The following year a solo exhibition of her work was presented at the National Library of Mexico. At that time, Angelina Beloff—the wife of Diego Rivera—described Villaseñor as "a girlfriend of Gabriel (Ledesma). . . . She was a petite woman with indigenous features. She sang Mexican folk songs beautifully."[7] However, Villaseñor was respected by her post-revolutionary colleagues as an outspoken advocate of the political left. She met Álvarez Bravo when both were working on Eisenstein's *¡Qué viva México!* Villaseñor starred as María in the unfinished film.

In this photograph, the young woman sits on a wooden floor, leaning against a wall as she brushes her long, luxuriant black hair. In the dark interior, her face is illuminated by sunlight, as she turns her head to look into a small hand mirror. While her eyes are hidden in shade, she gazes at her brightly illuminated face, which appears in profile in a bright silhouette. Her raised arms and hands elegantly bracket and emphasize her delicate features. One can sense the warmth and comfort of the morning sunshine, which gives a temporary quality to this ordinary daily ritual. In Western art, a young figure gazing into a mirror symbolizes the brevity of life, which seems at odds with Álvarez Bravo's title, *Portrait of Eternity*.

The photographer and his subject were close friends, and it may be that Álvarez Bravo intended the image and its title as a personal tribute to Villaseñor. He knew that months before she had been pregnant and had lost the baby, a son whom she had carried nearly to full term. Despite her fragile and feminine appearance, Villaseñor was recognized as a woman of remarkable strength and determination, quite like the character she played in *¡Qué viva México!* In the turbulence of the 1920s and 1930s, she found strength in her ethnic roots. Álvarez Bravo had also experienced personal loss during 1934, when he separated from his wife, who moved away with their young son, Manuelito. It is possible that this quiet, elegant image was meant as a gesture of affirmation between two dispirited friends, a message to look to the native traditions of Mexico for reassurance that beauty and life are eternal forces that will prevail.

In the mid-1930s the French Surrealists became interested in the work of the Mexican mural revivalists, whose paintings appeared exotic and their unusual iconography seemed to hold psychological implications. In 1938 Álvarez Bravo met André

Breton, who commissioned the photographer to create *The Good Reputation Sleeping* (*La buena fama durmiendo*), an image at once mysterious, absurd and erotic. Breton promoted Álvarez Bravo's work in France, but the photographer was little influenced by Surrealist ideas or imagery.[8] He continued to capture distinctive images of life in Mexico. In 1938–39 he taught photography at the Central School of Plastic Arts, where many of the next generation of Mexican photographers, including Nacho López, Héctor García and Graciela Iturbide were among his students. From 1939 to 1942, he maintained a commercial photographic shop on Ayuntamiento Street, Mexico City. In 1942 he married his second wife, Doris Heyden. From 1943 to 1959, he was regularly employed as a photographer and cameraman at the Cinema Production Workers of Mexico. His first publication was in 1945, when he wrote the catalogue for an exhibition of his photographs at the Society of Modern Art in Mexico. In 1947–50, he taught photography at the Mexican Cinematographic Institute. In 1949, he collaborated with José Revueltas in an experimental film called *Coatlicue*. Two of Álvarez Bravo's photographs were included in Edward Steichen's landmark 1955 *Family of Man* exhibition at the Museum of Modern Art in New York.

In 1959 Álvarez Bravo left the film industry to become a founder, along with several other artists, of the Editorial Foundation of Mexican Plastic Arts, a publisher of fine books on Mexican art. Concentrating on this job to the detriment of his creative photography, he fell into relative obscurity. When major exhibitions of his photographs were organized in the 1970s, Álvarez Bravo was recognized as the leading creative photographer of Mexico over much of the 20th century.[9]

CLAUDE CAHUN
French, 1894–1954

E.D.M. (Sex)

1930
from the book *Aveux non avenus*
Collotype on cream wove paper
20.6 × 11.2 cm (8⅛ × 4⅜ in.) Image
21.5 × 16.5 cm (8½ × 6½ in.) Sheet

Milly and Fritz Kaeser Endowment for Photography, 2016.024

The courageous Claude Cahun examined personal identity and the psychology of self in her work as a poet, essayist, sculptor and photographer. She and her life partner and frequent collaborator, Marcel Moore, used neutral pseudonyms in their art and only their given names in daily life. Lucy Renée Mathilde Schwob was born into a prominent Jewish family in Nantes.[1] Her father, Maurice Schwob, was publisher of *Le Phare de la Loire* (Lighthouse of the Loire), the largest newspaper in Western France.[2] Her mother, Mary-Antoinette Schwob, suffered from progressive schizophrenia and was institutionalized when Lucy was four years old. Lucy was raised by her blind grandmother and an English governess. She was a brilliant student, but as an adolescent she suffered from anorexia nervosa, inhaled ether, probably experimented with other drugs and may even have attempted suicide.

At age 15, Schwob met Suzanne Alberte Malherbe, the daughter of a University of Nantes surgery professor.[3] In 1913–14 the young women collaborated on a weekly fashion column in *Le Phare de la Loire*, written by Schwob and illustrated by Malherbe. The images, which reveal the influence of the Wiener Werkstatte and Aubrey Beardsley, were signed "Marcel Moore," Malherbe's pseudonym. In 1915, the year Malherbe's father died, the two young women traveled together to the Channel Island of Jersey for the first time. Two years later, Maurice Schwob married Marie-Eugènie Rondet Malherbe, and their daughters, by now lovers, became stepsisters. They would remain a committed couple for the rest of their lives, with a publicly recognized kinship to explain their companionship. Together they moved into a fourth-floor flat in the *hôtel particulier* where the Schwob family lived and *Le Phare de la Loire* was published.

In 1918 Malherbe began studies at the School of Fine Arts in Nantes. She was already at work on illustrations for Schwob's book *Vues et visions*. When it was published, Schwob assumed the nom de plume Claude Cahun, a witty combination of her great-uncle Léon Cahun's surname with a Latin forename meaning "stuttering."[4] In 1919 she began studies in philosophy and literature at the Sorbonne. She frequented La Maison des Amis des Livres, the progressive bookshop and lending library owned by Adrienne Monnier.[5] Three years later, Shakespeare and Company, the bookstore owned by Monnier's partner Sylvia Beach, relocated across the street from La Maison des Amis des Livres and Cahun became a staff volunteer at the shop. She and Moore attended poetry readings at La Maison des Amis des Livres, lectures at the Sorbonne, performances of the Russian Ballet at the Théâtre des Champs-Elysées,

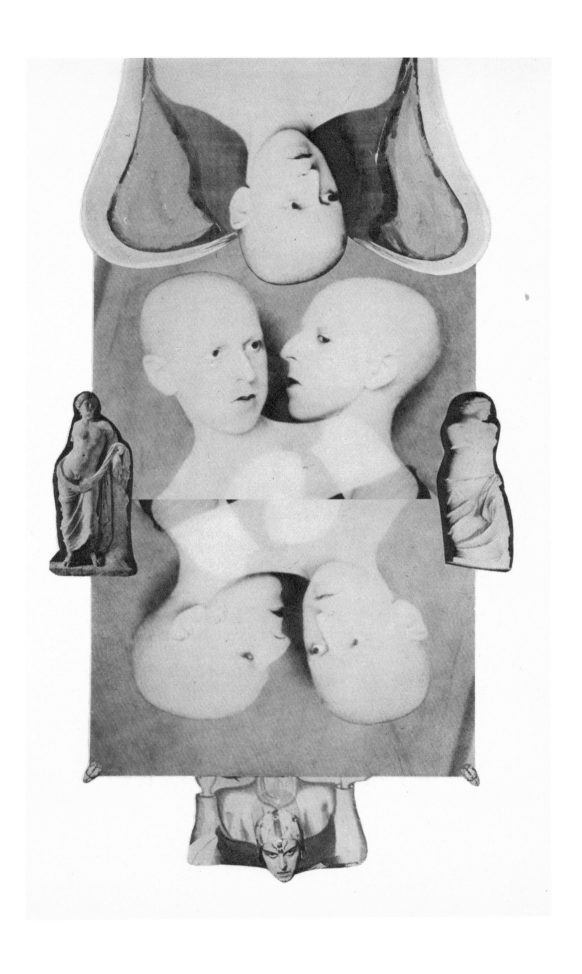

jam sessions at jazz clubs, and Hollywood movies. Cahun wrote reviews of these events for *La Gerbe*, a literary journal published by her father. In 1925 Cahun and Moore became involved with the Théâtre Esotérique, a performance art troupe founded by Berthe D'Yd and Paul Castan. The couple also joined Pierre Albert-Birot's small theater company, Le Plateau, in 1929.

In 1930 Cahun published *Aveux non avenus*, a book of her reflective writing, in a style influenced by Symbolism.[6] Organized by subject, the 10 chapters are made up of poems, aphorisms and short stories. A Surrealist photomontage precedes each, reproduced by collotype.[7] *Aveux non avenus* is personal, introspective and autobiographical, but purposely obtuse. Cahun and Moore cut up their own photographs, and others from family albums, and pasted them into montages that were rephotographed for the production of collotype plates.[8]

This photomontage heads the third chapter of *Aveux non avenus*. Self-portrait images of Cahun comprise its symmetrical design. The artist faces herself, and her image is repeated in mirror reflection at top and bottom. The shape of her shaved head, multiplied and arranged in a cloverleaf, evokes the pips on playing cards of the French suits of clovers and pikes—or clubs and spades. This cluster of bust portraits is flanked by small images of ancient sculptural figures of women. These two full-length figures are half draped, with their arms broken away, perhaps to symbolize the historic debilitation of women. Another bust of Cahun the artist hangs down from the top of the composition, with winglike shapes arching from her shoulders. Subsidiary images of the artist present her in character, dressed in costumes from her Le Plateau performances, often grimacing with exaggerated facial expressions. Several of the montages from *Aveux non avenus* are made up of figures, often in androgynous costumes and makeup, cut up and reassembled like paper dolls into decorative patterns, playfully confusing their person and cultural identity. The artist's face appears again, at the bottom of the image, dressed in a theatrical costume with a painted forehead and turban. Her head has rotated on a drawn body, so that she gazes up at the viewer like a vanquished demon under the feet of a deity. Reduced versions of these faces project like finials from the central block of the design. These dreamlike fragments, disjointed memories, puns and vagaries are Surrealist conceits that all occur in Cahun's writing as well. The cruciform typographic acrostic on the cover of *Aveux non avenus* introduces the verbal and pictorial games that feature throughout. Diametric symmetry and contrast is a recurrent theme of Cahun's imagery.

Each of the chapters has a central theme and together these themes form Cahun's brave attempt to map the complex detours of thoughts and feelings. This image precedes a chapter with a coded title, subtitled "Sex." Rather than revealing romantic or physical passion, the nine written pieces of this chapter consider the physical, procreative and emotional aspects of sex, sometimes with dispassionate indifference. Cahun's poem essays do not reconstruct her psychology or the narrative of her life; instead, they show her scrutiny of self.

In April 1932, Jacques Viot introduced Cahun to André Breton and his wife Jacqueline Lambda, and Cahun became involved with the Surrealist movement. During the 1930s Cahun's photographs and montages were shown in Surrealist exhibitions

in London and Paris. Her Surrealist still-life photographs illustrated Lise Deharme's volume of children's verse *Le coeur de pic*.[9] A special issue of *Cahiers d'Art* magazine in 1935, published to accompany a group exhibition at the Galerie Charles Ratton, includes her essay "Prenez garde aux objets domestiques" (Beware of household objects).[10] Drawn to the Surrealists, Cahun attended their meetings and contributed to their publications and exhibitions, but she never officially joined the group.

By 1937, Cahun and Moore left Paris, disillusioned by an atmosphere of political disagreement and anti-Semitism. They bought La Rocquaise, a house in the parish of St. Brélade on the Channel Island of Jersey. Recognized by their given names as stepsisters, they were well accepted by the community, though their eccentricities—like wearing trousers, walking their cat on a lead, sunbathing nude and staging photographs—were noted. Two weeks after the Nazis occupied Paris in June 1940, they invaded Jersey. Soon Cahun and Moore began a campaign of covert resistance. They listened to the proscribed BBC Radio European Service and tried to disseminate the news censored by Nazi propaganda to demoralize the German occupiers. They typed brief, informed reports of Nazi defeats on small slips of paper, signed *der Soldat ohne Namen* (the nameless soldier). They concealed these around town to be discovered by German soldiers, in such places as discarded newspapers, phone booths and park benches. A neighbor betrayed Cahun and Moore, and they were arrested by the Gestapo. They carried barbiturates, and unsuccessfully attempted suicide. Delayed prosecution probably saved them from a concentration camp. Eventually tried and convicted of espionage, they were sentenced to death, but the war was ending. On the last day of German occupation in May 1945, they were released and returned to La Rocquaise.[11]

HERBERT BAYER
American, born in Austria, 1900–1985

Still Life

1936
from the series *Fotoplastik*
Gelatin silver print
7.7 × 10.9 cm (3 × 4 ¼ in.) Image
8.4 × 13.7 cm (3 ¼ × 5 ⅜ in.) Sheet

Milly and Fritz Kaeser Endowment for Photography, 2016.035

One of the proponents of the Bauhaus integration of all arts throughout his career, Herbert Bayer had a multiform talent. His Universal alphabet became the signature typeface for the Bauhaus, where he also distinguished himself as a painter, architect and graphic designer. Bayer was born and raised in the village of Haag am Hausruck, near Salzburg, the son of government administrator.[1] After satisfying his national service, he became an apprentice in an architectural office in Darmstadt. However, Bayer aspired to the more sophisticated circles of Vienna and Berlin, and more avant-garde design. He became student at the Bauhaus in Weimar in 1921. He was inspired by the principle that fine design should derive from materials and manufacture, and be present in all phases of modern life. Bayer studied with the school's great professors, including Johannes Itten, Wassily Kandinsky, Paul Klee and Oskar Schlemmer. When the Bauhaus moved to Dessau in spring 1925, Gropius appointed Bayer to head the new Printing and Advertising Workshop. He designed Universal, a geometric sans-serif font all in lowercase, which became the standard font for all Bauhaus printing.

Like several of his Bauhaus colleagues, Bayer became interested in photography as an amusement. He came to acknowledge the notion, promoted by László Moholy-Nagy (Cat. no. 25), that photography would become more important as a modern visual medium. Moholy-Nagy and his wife Lucia, along with Bayer and his wife Irene, all serious photographers, often took photographic day trips together. Bayer experimented with confused perspective, close-ups and multiple exposures, striving for unexpected views of the mundane, and used the camera to record and explore the geometry found in natural forms.[2] In 1928, Bayer and Moholy-Nagy resigned from the Bauhaus, and moved with their wives to Berlin. Bayer was art director of the German edition of *Vogue* magazine in 1928–30. He was active as a freelance designer, and prominent among his accounts was the novel lifestyle magazine *Die Neue Linie*, published in Leipzig by Verlag Otto Beyer.

This photograph is one from a series that Bayer conceived titled *Fotoplastik*, Moholy-Nagy's name for the method of photomontage. Eight of these photographs were published together in 1937, and this set of reduced prints in postcard format the following year. Their imagery and style relate to each other as naturalistic trompe l'oeil groups of everyday objects, organic and geometric. Some of them seem to be pinned to shingled or weathered barn walls; others seem to float in deep, dreamlike landscapes. In 1937

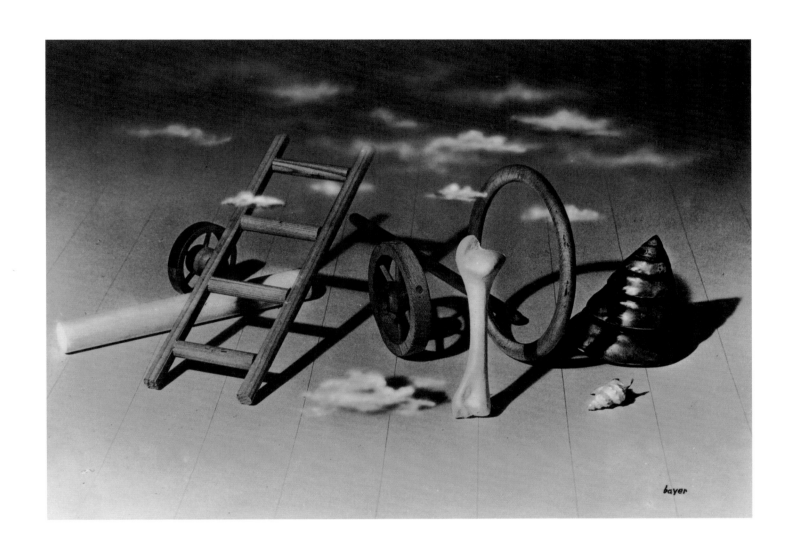

Bayer gathered eight of these experimental photographs in a portfolio entitled *Fotoplastik*.

László and Lucia Moholy-Nagy coined the term *Fotoplastik* to suggest a sort of photographic presentation parallel to Neoplasticism in painting.[3] The style was described by Piet Mondrian in an essay in the journal *De Stijl* as a manner of painting based upon pure fundamentals like pure line, geometric form and primary colors.[4] In its quest for purity, Neoplasticism aimed for abstraction instead of natural or concrete representation.

The term *Fotoplastik* may also have been meant to differentiate these experiments from the sort of Bauhaus photomontages that represented expressive, literary or political interests, such as the wide-ranging works of Hannah Höch, John Heartfield and Max Ernst. However, *Fotoplastik* never adhered to Moholy-Nagy's own work in photography, but as a result of so naming his portfolio, the term became synonymous with Bayer. Bayer gave a more sculptural and "plastic" interpretation of his colleague's term. Using a method similar to that employed in his painting and design since 1927, he created a shallow, almost trompe l'oeil tableaux in which the directly seen and the remembered or imagined merge into a landscape of the mind with that uncanny fluidity so characteristic of his Surrealist contemporaries, yet with none of their indulgence in physical distortion, or personal imagery of torture and delight. He eschewed Moholy-Nagy's concept of enhancing cutout photographs of people with spatial references, such as converging lines or foreshortened frames.

Bayer constructed the images in his *Fotoplastik* series with references to his childhood memories of alpine peasant life: farm implements on barn doors, cirrus clouds in summer skies and the sudden chancing on an unexpected vista or the skeletal remains of an animal. In his series, Bayer explored themes related to his contemporary paintings, and approached the images as experiments in representation.[5] Bayer meticulously pieced together imagery from different negatives to create a complex artificial setting in which the viewer gazes out from inside a rocky cave, beneath a sky filled with puffy clouds. Aside from the artist's favorite parallelism between pure and natural forms, this image also reflects his recurrent theme of the unstable reversals of positive form and negative space. The image incites association but defies narrative and interpretation.

In 1936, Bayer designed a brochure for the Deutschland Ausstellung, a patriotic exhibition for visitors to the Berlin Olympic Games. By that time, however, his marriage to Irene Hecht, a Jewish woman and fellow Bauhaus student, had attracted the scorn of the National Socialist Workers' Party. Soon the Nazis registered their offense to his artwork as well. In 1938 Bayer and his wife fled to Italy, and then followed Gropius to the United States. In New York, the artist found success as a freelance graphic designer, with commissions from such major clients as the advertising agency J. Walter Thompson. Alfred Barr, director of the Museum of Modern Art, selected Bayer in 1938 to design its landmark Bauhaus exhibition, as well as its catalogue.[6] In 1942 Bayer worked with Edward Steichen (Cat. no. 4), then head of the museum's photography department, to design *Road to Victory*, a show that set the course for Steichen's influential approach to photography exhibitions.[7]

Bayer and Hecht separated in 1942. Two years later he became a naturalized American citizen. He then married Joella Haweis Levy—former wife of the dealer Julien Levy—and became the father to two

stepsons. The family moved to Aspen, Colorado, in 1946 when Bayer became principal designer of the Aspen Institute for Humanistic Studies. Conceived as an adjunct to the planned mountain resort community of Aspen, this research institute provided the artist with connections to American corporate patronage, and he also became design director for the Container Corporation of America. In the mid-1950s Bayer's experiments in environmental sculpture, siting monumental geometrical forms in natural settings in a merging of sculpture, architecture and landscape, anticipated the earthworks of the 1960s.[8] In later years, Bayer and his wife sometimes wintered in Tangier, Morocco, and in Montecito, California. The artist remained prolific, painting in a geometric Modernist style, with planes and forms invoking mountainous imagery.

DOROTHEA LANGE
American, 1895–1965

The White Angel Breadline

1932
Gelatin silver print
34 × 26.6 cm (13⅜ × 10½ in.) Image
35.4 × 27.9 cm (14 × 11 in.) Sheet

Milly and Fritz Kaeser Endowment for Photography, 2004.004

A documentary photographer working in the narrative tradition of illustration, Dorothea Lange related topical stories in her images. Like leading photojournalists of her day, she documented important events through the people who experienced them. The daughter of the lawyer Henry Nutzhorn and his wife Joanna Caroline Lange, Dorothea Margaretta Nutzhorn was born in Hoboken, New Jersey.[1] As a child she contracted polio, which damaged her right leg and left her with a permanent limp. She was 12 years old when her father left the family, and later she renounced his surname and took her mother's maiden name. Lange attended the Wadleigh High School for Girls, and at the age of 18 she announced her intention to become a photographer. She began a series of apprenticeships, including one with Arnold Genthe, a fashionable society portrait photographer. Lange also briefly attended classes at the Clarence H. White School of Photography, which met at Columbia University, but abstained from class assignments.

In 1918, Lange and a friend left New York to travel around the world. They were robbed in San Francisco, where she found a job in a photography laboratory. Within months she had opened her own portrait studio; like Genthe, a former San Franciscan, Lange catered to sophisticated, often wealthy clients. Lange made friends with Bay Area artists including Roi Partridge and his wife, photographer Imogen Cunningham (Cat. no. 19), as well as Edward Weston and Ansel Adams (Cat. nos. 16, 46). In 1920 Lange met and married the artist Maynard Dixon, an illustrator of western subjects in the tradition of Frederic Remington. From this skilled illustrator she learned lessons of visual storytelling. The couple had two sons before their separation in 1929.[2]

Lange was living in her studio in central San Francisco when waves of unemployed migrants inundated the city, displaced from the Dust Bowl. The window of her upstairs studio looked down on the vacant lot in central San Francisco, opposite Pier 23, where many of the unemployed were camped. In that refuse-filled lot bounded by the Embarcadero and Battery Street, Lois Jordan, a onetime ship's cook, opened a soup kitchen.[3] She began by cooking at home and serving from her car. When she appeared each day, dressed in her cook's whites, the men began calling her the "White Angel." They helped construct an outdoor kitchen, in the form of a landlocked rescue vessel. In the vacant lot that became known as the "White Angel Jungle," trestle tables were set up where men gathered to eat according to their profession. "Mrs. Lois Jordan has petted them and scolded them, given them stamps and stationery, and bidden them to

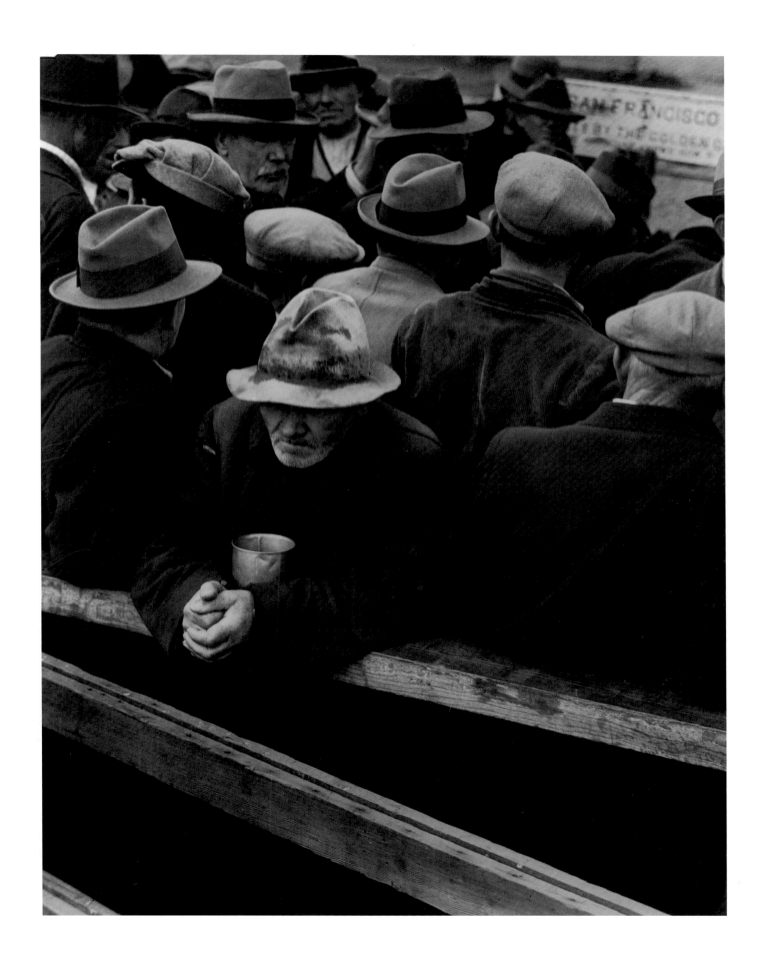

write to wives, mothers, and sisters left behind in happier and more prosperous days. It is one of the sights of San Francisco to see Mother Jordan, in a snowy white uniform, stand at the head of a line that forms twice a day for the wholesome, simple home-cooked food she dispenses."[4] Over 25 months, Jordan served more than a million meals, depending solely on private donations.

Lange was compelled to take her camera into the White Angel Jungle.[5] Her brother went along for security and encouragement on her first visit, when this photograph was taken.[6] A makeshift enclosure is crowded with men queuing for food. One older man in a stained hat is turned in the opposite direction to the rest. He is unshaven and hunched over, with a tin can between his arms and his hands clasped together. His hat shields his haggard face as he leans against a railing. Isolated from the other men, but also unbearably close to them, the man appears lost in thought—or perhaps just lost. Lange's image came to represent the Great Depression: the weariness indicated by the man's posture, the emptiness of his cup, the obscuring of his individuality by the low brim of his hat, and his isolation from others on the breadline all add up to a poignant yet respectful portrait of hopelessness and despair. By focusing on this one individual rather than the crowd that surrounds him, Lange created both a collective portrait of humanity and an individual one. Her subjects had to pose, because she used a twin-lens reflex camera. Lange held this instrument at waist level, and looked down into the ground glass in the top of the camera to organize her shot. Lange tacked a print of this photograph on the wall of her studio, and the haunting image helped crystallize her notion that her photographs might persuade viewers. She thought of this work as photojournalism that also had significance as fine art.

In 1934, Lange's friend the photographer Willard Van Dyke presented an exhibition of her documentary pictures at his small gallery in Oakland. Among the visitors was Paul Schuster Taylor, a professor of agricultural economics at the University of California, Berkeley. He thought that Lange's photographs made a fitting complement to his writing on contemporary labor issues. Taylor was studying migrant agricultural labor in a project funded by a grant from the State Emergency Relief Administration (SERA). In February 1935 he hired Lange to assist in his project by documenting the people and places they investigated. Lange and Taylor both divorced their first spouses and then married in December 1935, forming a lifelong living and working partnership. The photographer's SERA images brought her to the attention of Roy Stryker, who employed her on his Resettlement Administration and Farm Security Administration (FSA) photography projects, as his budgets allowed.[7] Lange's best-known photograph, *Migrant Mother*, was taken on one of these expeditions to the pea fields at Nipomo, near Santa Barbara. The photographer came upon Florence Owens Thompson, a widow from Oklahoma, destitute and stranded on the road amidst the fields, whose concern for her hungry children is apparent in her face. Twenty-two of Lange's photographs made for the FSA were used to illustrate John Steinbeck's "The Harvest Gypsies," a series of articles on migrant laborers commissioned by the *San Francisco News*.[8] Lange and Taylor also brought the plight of dispossessed sharecroppers and migrant farm workers to the public with their popular book *An American Exodus*.[9]

Following the attack on Pearl Harbor, the War Relocation Authority commissioned Lange to document the forced evacuation by the government of Japanese Americans on the West Coast, and their internment at Manzanar, California, at the base of the Sierra Nevada. Her empathic images were held from publication during the war.[10] In 1945, Ansel Adams hired Lange to teach photography at the California School of Fine Arts, where Imogen Cunningham and Minor White (Cat. nos. 19, 67) were among her colleagues. Lange was part of a group of photographers and scholars—including Adams, White and Barbara Morgan (Cat. no. 34)— who joined forces in 1952 to found the photography magazine *Aperture*. Lange continued to take assignments from *LIFE* magazine during the 1950s. She often traveled with her husband on study expeditions to Egypt, South America and Vietnam, supported by the Ford Foundation and the United States Information Agency. She traveled with her son, Daniel Dixon, to Ireland, and her photoessay "Irish Country People" appeared in *LIFE* in spring 1955. In the months before Lange's death in 1965, she helped to select and prepare the photographs for a retrospective of her work at the Museum of Modern Art in New York.[11]

WALKER EVANS
American, 1903–1975

Farmhouse, Westchester, New York

1931
Gelatin silver print
10.1 × 17 cm (4 × 6¾ in.) Image
40.4 × 35.7 cm (15⅞ × 14 in.) Mount

Mr. and Mrs. Harry Fein Fund, 1975.094

Widely considered to have been the leading American documentarian of the 20th century, Walker Evans developed a personal style of photography inspired by American literature and informed by painting in the 1930s. He was born in Saint Louis, the son of an advertising copywriter.[1] When his parents separated in 1918, he attended boarding school in Massachusetts, then went on to Williams College, where he developed a deep love of literature. After his freshman year, Evans used a small family allowance to go to Paris in 1926–27, intending to deeply explore French literature and become a writer. He strove to speak only French, and audited courses at the College of France and the Sorbonne. When Evans returned to New York, his literary aspirations remained. He took odd jobs on Wall Street to maintain himself, and became interested in photography as a means of support. He met Iago Galdston, a psychiatrist and amateur photographer, who introduced him to fine points of the camera and the darkroom. Evans studied the history of photography at the New York Public Library, and was especially impressed by the work of Eugène Atget (Cat. no. 20). He conceived of a mode of photographic imagery to capture the prosaic facts of contemporary life without sentimentality or political implication, in the tradition of writers Walt Whitman, Herman Melville and Henry David Thoreau.

Living in Greenwich Village, Evans associated with writers and artists. He made friends with James Agee, Hart Crane and Lincoln Kirstein.[2] Galdston introduced Evans to the painter Ben Shahn. The son of Lithuanian Jews who had been condemned for their revolutionary activities, Shahn studied art at City College and the National Academy of Design. He visited Europe in 1924, but was unsatisfied with Modernism. Shahn wanted to forge an accessible painting style to express his social consciousness. This tough, aggressive populist fascinated Evans, a Midwesterner who had enjoyed privilege and opportunity. "We had a great attachment to each other Shahn and I," Evans later said. "He was an overpowering man. . . . He was too strong for me. But I knew I was getting educated."[3] For a time, Evans lived in the basement below the apartment where Shahn lived with his wife and two children. Later they shared a studio on Bethune Street in Manhattan. Evans sparked in Shahn a new interest in photography, as a way to collect sketches for his paintings.

Farmhouse, Westchester is one of the photographs that Evans made while exploring the countryside near New York, looking for the substance of American life.[4] It exemplifies his direct and plainspoken style,

influenced by American literature and by Shahn. Evans confronted his subjects with an observant gaze. He claimed that he did not consciously think about composition, but that he was "very aware of it unconsciously, instinctively."[5] This instinctive understanding of composition is borne out by his recognition that a tree, an automobile and a farmhouse could be aligned in such a way as to create a perfectly balanced arrangement. The dramatic interplay of geometry is the most striking feature of this photograph of an early Ford parked alongside a farmhouse. Three rooflines dominate the composition and create a series of horizontal planes. The main building's siding underscores the horizontals, while the siding on a single-story extension balances these with some verticals. Two brick chimneys flanking the ends of the farmhouse and curtains hanging on the

lower story's windows extend the sense of verticality. A tall tree, spreading its bare branches throughout the upper half of the image, enlivens the composition, juxtaposing nature's irregular patterns with the farmhouse's formal structure. This is the direct viewpoint, a diagrammatic side view that Evans preferred, without complex angles or enhanced lighting. With clear black and white, and shades of gray, he intended clearly to capture a moment in time. Searching for a straightforward, personal vision, he combined his own ideas with intuition. "I was doing that instinctively because I thought that was the way I ought to be doing," he later recalled, "but without thinking very much about it: detachment, lack of sentimentality, originality."[6]

In the mid-1930s Evans supported himself with commissions, sailing to Tahiti as the photographer aboard a private yacht, and providing images to illustrate Carleton Beals's book *The Crime of Cuba*.[7] He photographed works of art for New York galleries and for the Museum of Modern Art. He also explored the American South by automobile with

Fig 8. — Walker Evans, American, 1903–1975, *Floyd Burroughs, A Cotton Sharecropper, Hale County, Alabama*, 1936, gelatin silver print, Gift of Milly Kaeser, in Memory of Fritz Kaeser, 2000.044

his camera. In June 1935 Evans found a job with the publicity office of the Resettlement Administration (RA), a New Deal agency dedicated to finding new homes for impoverished farmers on arable lands. He drove through West Virginia, Pennsylvania and the Deep South. Evans continued as a photographer in the Farm Security Administration (FSA) when that program superseded the RA.[8] He refused to keep the expense records required by government bureaucracy, and defiantly ignored specific field assignments. He had little admiration for the FSA's chief, Roy Stryker, who was exasperated by his disdain. He granted Evans's request for a leave of absence in June 1936.

The photographer went South with his friend James Agee, who had an assignment from *Fortune* magazine to write about the plight of tenant farmers during the Depression. They lived with sharecropper families in Hale County, Alabama, sharing their poverty and distress. Evans photographed the gaunt, careworn faces and their humble shacks set in dusty yards, where time seems to pass slowly (Fig. 8). He used an 8 × 10 inch view camera with a triple converter lens to compress depth of landscape and architectural views. Agee made voluminous notes on their subjects and his experience of their world. When *Fortune* magazine rejected the piece, the artists worked to publish their work independently as a book.

In 1938, a solo exhibition of Evans's work was mounted at the Museum of Modern Art, the institution's first for a photographer.[9] Soon he turned to a project that he and Agee had discussed on their travels. He concealed a miniature camera in his coat while riding the New York subway, with the lens protruding between the buttons and the shutter release cable running down his sleeve.

Practice helped him calculate the distance across a subway car. In this way, Evans photographed fellow passengers in unguarded, albeit public, moments. He meant these images of mundane life as true portraits, documents of character and experience. Evans collected over 600 such photographs, and Agee wrote an introduction. However, during World War II, when their Alabama photoessay was published as the book *Let Us Now Praise Famous Men* and received little recognition, the project was delayed. A Guggenheim Foundation Fellowship enabled Evans to continue working as a freelancer on magazine photoessays and book portfolios. In 1943 he began working as a writer for *TIME* magazine as a film, book and art critic. Two years later he became staff photographer at *Fortune* magazine, and later associate editor.[10] Evans created and usually wrote the text for 36 photographic portfolios for the magazine, much of it in color.

When *Let Us Now Praise Famous Men* was reissued in 1960, Evans received new praise as an American master.[11] Ironically, the book also led to a new appreciation of the FSA photographic archive, and the growth of a collectors' market for photographs. In 1965 Evans joined the faculty of the Yale School of Art, and was surprised to find satisfaction in teaching. The following year a selection of his subway portraits was exhibited at the Museum of Modern Art, and the book *Many Are Called* was finally published.[12] In 1971, the first definitive retrospective of Evans's photographs was mounted at the Museum of Modern Art.[13]

BERENICE ABBOTT
American, 1898–1991

West Street Row: I

1936
Gelatin silver print
16.2 × 24 cm (6⅜ × 9½ in.) Image
16.2 × 24 cm (6⅜ × 9½ in.) Sheet

Mike Madden (ND'58) Fund, 1979.044

As an American bohemian in Paris during the 1920s, Berenice Abbott made memorable psychological portraits of the era's artists and writers. Her most influential work, however, was the photographs she made in New York during the 1930s reflecting a complex era of American transformation. Abbott was born in Springfield, Ohio, the youngest of four children.[1] She was a toddler when her parents divorced, and she moved with her mother to Cleveland, living apart from her father and siblings. She attended the Ohio State University, where she fell in with a group of progressive students. At the end of World War I, she left college without a degree and went with them to New York, planning to pursue a career as a sculptor. The journalist Djuna Barnes was among her roommates, and she met artists Man Ray and Marcel Duchamp (Cat. nos. 50, 55). In 1921 Abbott went to Paris to study art. She associated with expatriate lesbian intellectuals including Barnes, Natalie Clifford Barney, Romaine Brooks, Janet Flanner and Solita Solano. Two years later, Abbott became an assistant to Man Ray, who taught her the techniques of photography and the darkroom, and introduced her to wider artistic circles in Paris. Among them was the photographer Eugène Atget (Cat. no. 20), whom she came to admire. She opened her own portrait studio, and her clientele included wealthy art patrons, artists and writers of the Rive Gauche scene, including Jean Cocteau, André Gide and James Joyce.[2] Their portraits comprised the first solo exhibition of her photographs presented at the Galerie Au Sacre du Printemps in 1926. Later Abbott persuaded Atget to allow her to photograph him, but when she returned to his studio with the proofs she found he had died. She borrowed money to purchase thousands of his glass-plate negatives and prints from his executor, André Calmette.

In 1929 Abbott sailed to New York, hoping to find a publisher for a book on Atget. After an absence of eight years, she found the city much changed, skyscrapers quickly displacing 19th-century landmarks. She decided to document this transformation, as Atget had recorded the evolution of Paris a century before. Aspiring to his precision, she acquired a view camera like the old instrument Atget had used. This meant working with a tripod and ungainly equipment, which slowed her process. Instead of fleeting images of bustling American life, Abbott created deliberate, thoughtful images of urban architecture and topography. Over a decade she collected a methodical body of photographs that record the changing form and function of American urban buildings. Her images of the gleaming Woolworth Building contrast with photographs of automats, hot

dog carts and East River tugboats. Despite her fear of heights, Abbott understood the visual impact of the city from above, and she valued the opportunity to gaze down from tall skyscrapers. She encountered unforeseen challenges and worked out her own technological solutions to such problems as clear focus in wide-angle shots, and the sway of tall buildings in the wind. Abbott tried unsuccessfully to find a sponsor for her project. While supporting herself with portraits, magazine assignments and teaching, she resolutely devoted one day a week to her New York project.

Some of Abbott's New York photographs were shown at the Museum of the City of New York in 1934. This exposure aided her application to the Federal Art Project (FAP) of the Works Progress Administration, which supported her in providing a selection of her photographs to the Museum of the City of New York. Abbott formally joined the faculty of the New School for Social Research in 1935, where she built one of the first academic photography programs in the country. In that year she befriended Elizabeth McCausland, an art historian and critic who had written favorably about Abbott's work in the *New Masses* and *Trend*.[3] Soon they began a lifelong relationship, and Abbott moved in to McCausland's loft on Commerce Street in Greenwich Village.

This print was made for Abbott's FAP project, one of a number of photographs that Abbott took

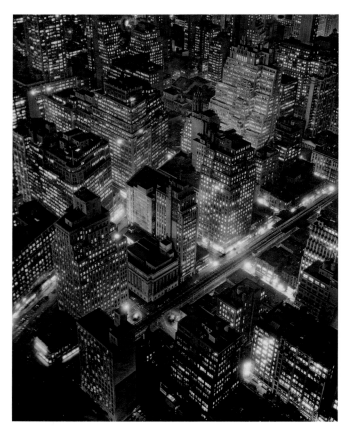

Fig 9. — Berenice Abbott, American, 1898–1991, *New York at Night*, 1936, gelatin silver print, Mike Madden (ND'58) Fund, 1977.012

of the same subject on different days.[4] Methodical inscriptions note the subject and the date of exposure. Standing with her back to the Hudson River, Abbott photographed this row of buildings with the afternoon sun warming their facades. A porch covers the sidewalk before the storefronts, which include an Italian restaurant, the Erie Cafeteria and the Susquehanna Hotel at the corner of Chambers Street. Despite the absence of people, the activity of these businesses is suggested by the deliveries waiting along the curb. A carter delivers boxes of rayon to L. Goldman & Son or the Firestein Company; the produce delivery truck from Anderson in Patterson, New Jersey, indicates the presence of a grocer, along with the empty wooden-slat bushel baskets that are stacked on the sidewalk. Above the row of shops are apartments and some rooms to let, indicated by the trellis of exterior fire escapes. Horse-drawn vehicles share the street with mechanized delivery trucks and automobiles. A traffic officer, who glances at the photographer, automatically waves cars along. In the background, the pinnacles of skyscrapers are visible, hinting at the obsolescence of this row. With foresight, Abbott placed a delivery truck at the center of this composition. Over the following decade, motor vehicles would drastically transform this neighborhood of Tribeca. Today, the street is the West Side Highway, with six busy lanes of speeding traffic. Steel and glass skyscrapers stand in place of the storefronts, and tall, international-style red-brick apartment towers face over the Hudson.

This image was one of those shown in an exhibition of the Changing New York project at the Museum of the City of New York in 1937, fulfilling a requirement of Abbott's FAP grant (Fig. 9). It included 97 of the 300 photographs that she turned over to the museum, complemented by descriptive labels written by McCausland. Two years later, when the New York World's Fair attracted a broad new audience to the city, E. P. Dutton published the photographs in a book.[5] Hoping to appeal to a range of fair visitors, the publisher cut McCausland's commentary on the photographs. Another exhibition was mounted; the book was well reviewed, but failed to attract the expected audience. By 1940 the government had reduced FAP funding, and Abbott turned away from architectural imagery. She began organizing her ideas and experiences of teaching photographic technique into clear, accessible studio manuals, which became standard references for the period.[6] Abbott had been inspired by current advances in science, and sensed a need for visual interpretation for wider audiences. Perhaps encouraged by Neues Sehen (New Vision) ideology, and the work of Harold Edgerton (Cat. no. 43), she began independently to photograph images of physics and biology. Her expertise led to a position as picture editor of *Science Illustrated* magazine in 1944–49. She often had to devise her own techniques and equipment, and was granted several patents for devices such as the distortion easel, which corrected or exaggerated proportions in the enlarger, and the autopole, a telescopic lighting support. In 1958, a study group at the Massachusetts Institute of Technology recruited her to assist in the design of a new high school physics curriculum, and her photographs illustrated their textbook, *Physics*.[7]

ARTHUR ROTHSTEIN
American, 1915–1985

Dust Storm, Cimarron County, Oklahoma

1936
Gelatin silver print
7.7 × 7.9 cm (3 × 3⅛ in.) Image
25.4 × 19.7 cm (10 × 7¾ in.) Sheet

Samuel J. Schatz Fund, 1975.031.004

The Farm Security Administration (FSA) was created as part of the Franklin Delano Roosevelt administration's New Deal during the 1930s, designed to help relieve the suffering of the rural poor during the Great Depression.[1] One way that it pursued this goal was through its information programs, responsible for providing materials to the press to make the wider public aware of the hardships of fellow Americans. As a staff photographer for the government agency that preceded the FSA, Arthur Rothstein was essential to the group of famous Depression-era photographers fostered by the FSA project, including Dorothea Lange, Walker Evans and Gordon Parks (Cat. nos. 38, 39, 54).

Rothstein was a New Yorker. Born in the Harlem section of northern Manhattan, he grew up in the North Bronx.[2] He was fascinated by technology as a boy; he built a crystal radio, and constructed a basement darkroom to develop his own photographs. While a student at Stuyvesant High School, he began to exhibit his work in photographic salons. A King's Crown Scholarship enabled Rothstein to study at Columbia College, where he majored in physics and chemistry, planning to attend medical school. He continued his hobby as a photographer for the college newspaper, the *Jester*, and photographic editor of the yearbook, the *Columbian*. He also established the Columbia University Camera Club.

As a college senior, Rothstein worked for economics professors Rexford G. Tugwell and Roy Stryker, copying, printing and organizing photographs for their historical studies of American agriculture. In 1935, the Roosevelt administration appointed Tugwell to head the Resettlement Administration (RA), which was to relocate struggling rural families to underutilized farmland and new communities as part of the New Deal.[3] Stryker was tasked with recording the agency's ongoing history. Rothstein was pleased with the opportunity to go to Washington with Stryker, for medical school had become unaffordable during the Depression. At age 20, he was charged with building a photography department, ordering equipment, setting up studios and a laboratory, and organizing the department's management. Stryker sent Rothstein into the field on a photographic expedition to the Blue Ridge Mountains of Virginia. He found inhabitants of the hills and the hollows living much as their ancestors had for generations, less than a hundred miles from Washington, D.C. He spent a several weeks documenting the lives of these Americans, soon to be displaced to make way for Shenandoah National Park.

Within the year, some members of Congress took exception with the RA and its vision of the troubled country. Tugwell resigned, and in December 1936 his agency was transferred to the Department of Agriculture, given a more conservative mandate and renamed the Farm Security Administration (FSA). Stryker remained committed to the potential of his documentary project and fought to continue within the FSA. Soon he recruited Walker Evans to the department, joining Rothstein among the 44 photographers who would work in the FSA Historical Section over three years. Rothstein would be influenced by his colleagues, both stylistically and through their concern for social justice. The FSA headquarters remained in Washington, with its developing and printing facilities, archives and offices, supplying its photographers with cameras, film, flashbulbs and travel allowances. Stryker assigned projects, describing his goals in "shooting scripts," which directed photographers how to synchronize their images with the work of local FSA agents. The photographers sent their exposed film back to Washington to be developed and printed, and later provided identifying captions. Stryker reviewed the printed contact sheets and selected images for the official archive. He punched a hole through the middle of rejected negatives, which remain part of the archive in the Library of Congress. The government made the selected FSA images freely available and they were published widely, in newspapers and magazines, government pamphlets, reports and advertising. The photographs publicized the facts of rural poverty, and government and private efforts to improve the lives of suffering Americans.

In April 1936, Stryker dispatched Rothstein to explore the Dust Bowl in Oklahoma, Kansas and Texas.[4] His assignment was to document this ecological and agricultural crisis, occurring simultaneously with the economic crisis of the Depression. Months of severe drought in 1934 were followed by wind storms in the prairies of the central United States and Canada. There, farmers had used mechanized equipment for generations, displacing the deep-rooted native grasses that trapped moisture and held the soil. The wind dried and eroded the topsoil, carrying it away as dust, blowing in huge clouds that sometimes blackened the sky. In April 1935, Edward Stanley, an Associated Press news editor in Kansas City, in a report from Oklahoma, coined the term "Dust Bowl" to describe the area affected by the phenomenon.[5] Tens of thousands of families in this region were unable to produce crops or pay mortgages, and many were forced from their land. In his 1939 novel *The Grapes of Wrath*, John Steinbeck imagined the story of such a displaced Oklahoma family, attracted to California by rumors of thriving agriculture only to discover more poverty.[6]

As Rothstein explored the devastated region in 1936, he photographed every day but found it difficult to convey the fury and destruction of a dust storm. He was driving through barren countryside in Cimarron County, Oklahoma, 14 miles south of Boise City, when he happened upon Art Coblel and his two young sons, still on their land. They chatted for several minutes, and then the wind came up and Rothstein ran to his car. "I could hardly breathe because [of] the dust," the photographer later wrote. "It was so heavy in the air that the land and the sky seemed to merge until there was no horizon. Strong winds raced along the flat land, picking up the sandy soil and making my hands and face sting."[7] Glancing back to wave, the photographer glimpsed Coble and

his boys, bending into the wind as they ran for shelter, and snapped a single shot. The horizon divides this composition in half, though it is scarcely visible as the gray, sandy dust lifts from the ground and fills the sky. With his dark coat and curved silhouette, the figure of Coble stands out against the even tone of the image. He and his older son glance at one another as they run forward. Straggling behind, the younger boy holds his hat before his face to block the stinging wind. The posture of his tiny figure reflects his struggle and evokes the urge to help him. His head falls along the horizon, and he is further emphasized by a position at the apex of a triangle formed by tilting fence posts, stripped by the wind of their rails and their utility. This one image encapsulates a typical family's struggles against nature, and the danger, especially to the weakest member. Rothstein's image from Coble Farm conveyed the reality of the Dust Bowl to millions of Americans as verbal descriptions could not. The ecological disaster that prompted so many to leave their homes became understandable.[8] This became the defining image of the FSA.

In 1940 Rothstein began working for *Look* magazine, while continuing to edit pictures for Stryker at the Office of War Information. He helped to found the American Society of Magazine Photographers, and began a wider career in photojournalism. During World War II he served with the Army Signal Corps as a photographic trainer at Astoria, New York. Rothstein published nine books, including *Photojournalism: Pictures for Magazines and Newspapers*, published in nine editions.[9]

HELEN LEVITT
American, 1913–2009

Boy Leaning on a Hydrant

1940
Gelatin silver print
15.9 × 20.8 cm (6¼ × 8¼ in.) Image
15.9 × 20.8 cm (6¼ × 8¼ in.) Sheet

Walter R. Beardsley Endowment, 2000.022

Helen Levitt brought a compassionate personal touch to street photography, using the vocabulary of social documentary for more creative means. Her photographs of children translate their play into a visceral, shared language. Rather than political statement, her candid images often reflect events of sociability without commentary, or moments of quiet introspection. Levitt was born in New York, where her Russian-Jewish father operated a wholesale knit-goods business.[1] She was born with Meniere's disease, an inner-ear disorder that can cause imbalance, vertigo and tinnitus. While growing up in Bensonhurst, Brooklyn, she became interested in the visual arts, and left school in to take a job in the studio of J. Florian Mitchell, a commercial portrait photographer in the Bronx. In 1935 Levitt was impressed by an exhibition of photographs by Henri Cartier-Bresson (Cat. no. 60) at the Julien Levy Gallery. When the photographer visited New York, she found an opportunity to meet him and tagged along while he photographed at the Brooklyn waterfront. The experience prompted Levitt to buy her own Leica camera and to concentrate on making images of the city around her. Rather than using Cartier-Bresson's sophisticated method of anticipating behavior, she adopted the equipment that Paul Strand (Cat. no. 66) had used decades before. Levitt

fitted her camera with a right-angle lens and viewfinder, so that when she focused on a subject she seemed instead to be concentrating on another, seeking to capture New Yorkers unawares.

When Levitt ventured into the streets, she quickly found that life in the affluent neighborhoods of upper Manhattan took place behind secure doors. So she took her camera to Yorkville, the Lower East Side, Harlem and Spanish Harlem. During the Depression, before air conditioning and television attracted people indoors, the streets there teemed with summer activities. Tenement dwellers found the front stoops of their buildings to be shady places to escape the summer heat, to observe the comings and goings of neighbors, and to gossip and socialize. Levitt strolled along with her camera; when she noticed a likely subject, she would stop briefly, raise her camera in a perpendicular direction, and quickly snap a photograph, usually before her subjects noticed her at all. Working rapidly, she captured the elderly passively watching, adults busy in routine tasks, and children at play. She worked as a children's art teacher in 1937, and was intrigued by her students' behavior. Once, when working with chalk, the children drew on the brick walls and concrete pavement, and she later documented their work.[2] She photographed children on the street, playing alone or in

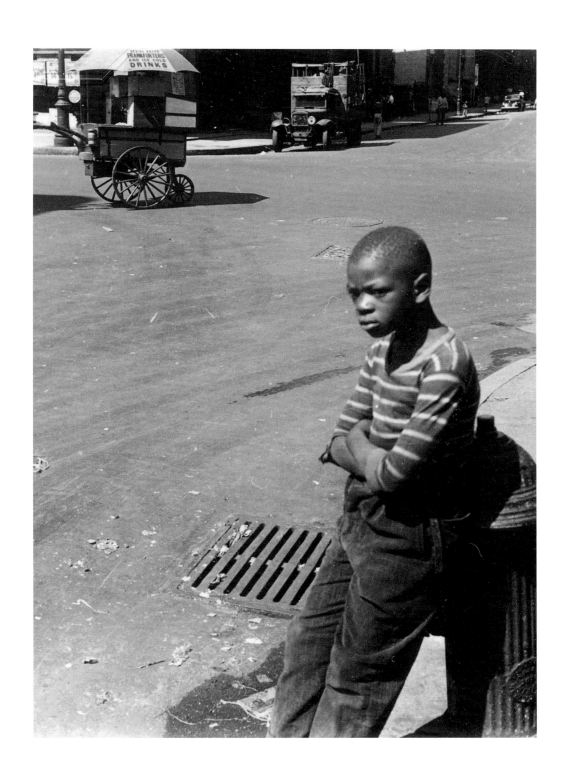

groups on sidewalks or stoops, which appear in many of her images as a stagelike platform.

In 1937, Levitt met Walker Evans (Cat. no. 39) and they shared a darkroom. His influence is apparent in the clarity and depth of field of her photographs. He was working in the subway at that time, and needed a companion to ride along with him while he photographed fellow riders. In 1939 Evans introduced Levitt to Janice Loeb, who became a good friend even though she was a decade older. Trained as an artist and historian at Harvard, she had studied in London and Paris, where she met many leading artists and intellectuals while working at the Café de Flore coffee shop in Saint-Germain-des-Prés. Later Loeb worked for Christian Zervos's art magazine Cahiers d'Art. Rumors of war in Europe drew Loeb back to New York in 1937, and she began working in the film industry. She helped Levitt get her first film job as an assistant to an editor for Luis Buñuel.

This contact print of an African American boy on the street is typical of Levitt's photographs. It seems simple and straightforward: the young man appears to be 11 or 12 years old, clean and well presented, with a recent haircut and a T-shirt and dungarees that are typical of a boy his age—but the overly long belt suggests that his clothes may be handed down. He leans on fire hydrant at a sunny street corner, perhaps waiting for a friend. Relatively deserted streets give a sense of loneliness; even the hot-dog cart beyond seems abandoned. The figure is pressed into the lower corner of the image, allowing a view up the distant street behind him, where our glance is directed by the parallel diagonal lines of the sewer grate in the street. This drain has attracted waste paper and pavement debris to the corner. A garbage truck at the opposite corner and over the

boy's shoulder also suggests shabbiness. Although there are people and activity in the distance, the boy is alone. He crosses his arms before him in a closed, defensive posture and gazes past us down the street, and seems to focus on a specific subject. Could his knitted brows reflect concern over what he sees, or is he consumed by personal matters?

From her time in Paris, Janice Loeb knew Alfred Barr, director of the Museum of Modern Art, and helped Levitt to show photographs like this to curator Nancy Newhall, who organized the first solo exhibition of Levitt's work at the museum in 1943. In the coming years Levitt's photographs regularly appeared in magazines such as Fortune, Cue and TIME. Three years later, a museum fellowship enabled her to organize the material that would become her book A Way of Seeing, with an essay by James Agee.[3] At the time Levitt lived with Janice Loeb in an apartment on the Upper East Side of Manhattan. Each of them bought a secondhand movie camera, which they took to East Harlem, one of Levitt's favorite locations. Using Levitt's techniques, the roommates collected footage of children playing and fighting on the streets. They edited this material into the 18-minute film In the Street. When the movie was released in 1952, it won awards at the Venice and Edinburgh Film Festivals. Levitt and Loeb joined the filmmaker Sidney Meyers to establish the commercial company Film Documents. They developed Loeb's idea for a docudrama into a second film, The Quiet One. It tells the story of a 10-year-old emotionally disturbed boy, plagued by difficulties in expressing himself. Rejected by his family, he is adopted by the staff of the Wiltwyck School.[4] In 1947 The Quiet One won a Venice Film Festival award and two Academy Award nominations. The Film Documents partners

intended produce feature films, but their personal lives distracted them. Janice Loeb married Levitt's older brother, Bill.

Helen Levitt worked in the film industry for nearly 25 years, but she continued to photograph on the streets. In the 1950s she noticed the children had disappeared from the streets; she sought out activity in the garment district, and the subjects of her photographs gradually shifted to the bustle of New York commerce. A Guggenheim Foundation Fellowship in 1959–60 enabled Levitt to study color photography, and she made thousands of Kodacolor 35 mm slides, from which a selection were printed for her solo exhibition at the Museum of Modern Art in 1963.[5]

HAROLD E. EDGERTON
American, 1903–1990

Wes Fesler Kicking a Football

1934
Gelatin silver print
24.2 × 19.6 (9½ × 7¾ in.) Image
25.5 × 20.7 (10 × 8⅛ in.) Sheet

Milly and Fritz Kaeser Endowment for Photography, 2014.037

As a research scientist and professor of electrical engineering at the Massachusetts Institute of Technology (MIT), Harold "Doc" Edgerton developed ultra-high-speed stroboscopic photography. His work broadened the capabilities of high-speed photography, demonstrating the limitations of the human eye and visual comprehension, and even shifting common understanding of time.

Edgerton was born in Fremont, Nebraska, the son of a lawyer and a writer.[1] He began making his own photographs as a high school student, and built a darkroom in his home. He studied electrical engineering at the University of Nebraska–Lincoln and while working for the Nebraska Power and Light Company, where he was exposed to the problems that engineers faced when attempting to diagnose malfunctioning generators while their motors were still running. In 1926–28 he attended graduate school at the Massachusetts Institute of Technology, and set out to build a light source that would flash fast enough that he could photograph the moving parts of a motor and examine them as if they were still. Edgerton developed an electronic flash that could be discharged very quickly and repeatedly, and the project became the subject of his doctoral thesis. He engineered a light bulb filled with inert gas, and connected it to a battery. Releasing a jolt of current excited the gas molecules, producing an instant of bright light. The scientist developed the circuitry to control the flash, and over a decade he improved the bulbs, replacing mercury vapor with argon and then xenon, which made for shorter, brighter flashes from smaller tubes.

Edgerton refined his stroboscope to emit 60 flashes of light per second, each a burst of 10 microseconds, a thousand times faster than the best mechanical shutters of the day. This made it possible to capture extremely rapid phenomena on film. During his dissertation research, professor Charles Stark Draper suggested that he photograph everyday objects with his electronic flash. The first of these experiments were photographs of a stream of water from a faucet. Edgerton completed his doctoral degree in 1931 and joined the MIT faculty. To demonstrate the capabilities of his high-speed strobe system to the wider scientific community, Edgerton began taking his own photographs of laboratory and sports subjects (Fig. 10).

Wes Fesler Kicking a Football is one of Edgerton's earliest photographs, taken in Cambridge in 1934.[2] Wesley Eugene Fesler was a sports superstar in the late 1920s, and an all-around college athlete. He was a consensus first-team All-American in 1928–29, and the following year he was voted the Most

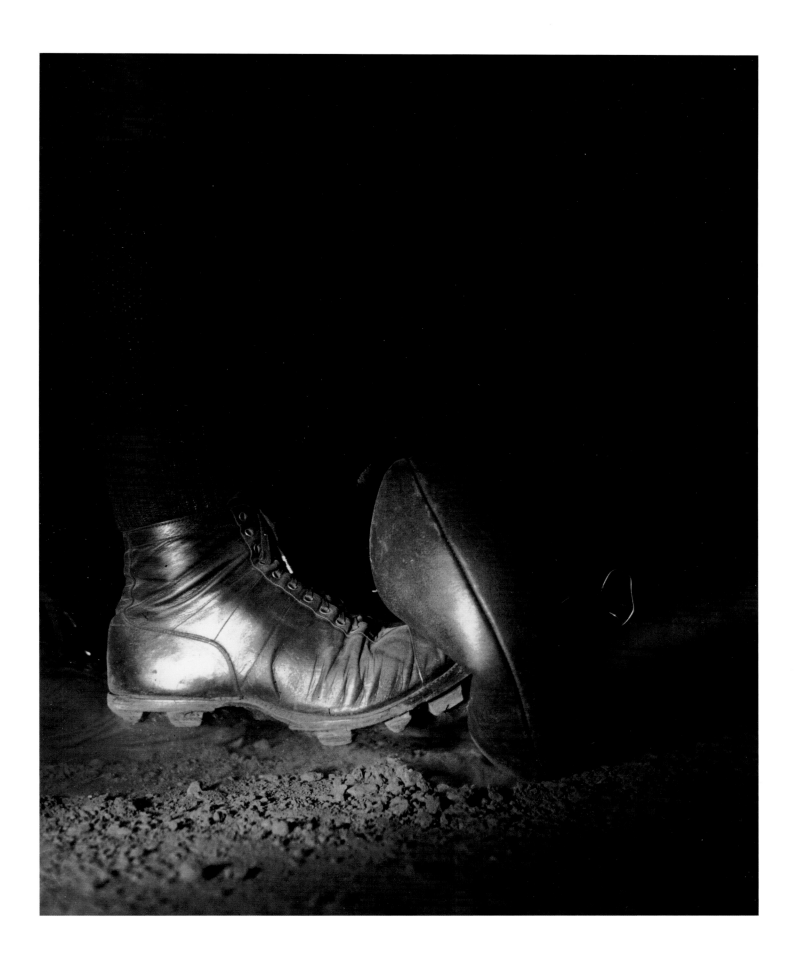

Valuable Player in the Big Ten conference. Since we see little of the athlete himself, his name stands for the precision, power, and speed of this placement kick. In this early experiment, Edgerton used a simple synchronizing method to capture the action. When Fesler kicked the ball, he completed a circuit between two wires affixed to the ball and its tee, firing the strobe light and activating the electronic shutter. The high-speed photographic exposure is so clear, we can see how deeply Fesler's boot sinks into the ball with the force of the kick, and the layer of dust dislodged from the top seam of the ball suspended in mid-air. "After leaving the foot, the ball pulsates," Edgerton explained, "swelling and contracting as it recovers its usual contour."[3]

Stroboscopic photography was a breakthrough technology for scientists, often revealing the dynamics of complex phenomena. Particle physicists were able to photograph the tracks made by subatomic particles through bubble chambers. Engineers and physiologists could view machines or animals in stop-motion or controllable slow motion. With multiple strobe flashes in sequence, Edgerton was able to expose composite images of several phases of movement. This technique was particularly revealing to athletes. Among Edgerton's students at MIT was Gjon Mili. He went on the work as a research engineer for Westinghouse, but employed Edgerton's system to photograph stop-action images of figures in motion. After one of these appeared

Fig 10. — Harold E. Edgerton, American, 1903–1990, *Tennis Forehand Drive, Jenny Tuckey*, 1939, gelatin silver print, Estate of Ronald K. Gratz, 2018.002.030

in *LIFE* magazine in 1939, Mili developed a new career as freelance photographer specializing in action shots of dance, sports and theater, sometimes using multiple cameras to image the same event from different angles. Mili's photographs were widely published in picture and fashion magazines. Some of his most memorable images capture the gestures of Picasso as he rapidly draws figures in space with a flashlight.[4]

During World War II, Edgerton worked with the Army Air Force, developing powerful flash units for nighttime aerial reconnaissance. His flash system was later employed in photographs that were essential in the planning of landing zones for Allied paratroopers during the Normandy invasion. After the war, the strobe became more widely used in photography. The National Geographic Society used the system to reveal secrets of the natural world.[5] Edgerton's laboratory continued to create photographs of phenomena too rapid to be seen and understood: drops of liquid creating elegant geometric patterns, objects pierced by speeding bullets, and insects in mid-flight. These images were extensively published and exhibited, and represent a postwar understanding of the effects of science upon modern life.

The Atomic Energy Commission contracted Edgerton's company to develop systems for photographically documenting nuclear weapons tests. Mechanical shutters are too slow to limit the immediate and intense burst of light produced by a nuclear explosion and prevent overexposure of film. Edgerton and his technical team devised the Rapatronic (rapid action electronic) camera capable of an exposure as brief as 10 nanoseconds, which used the light from a nuclear explosion to activate a photoelectric cell that triggered the camera. This made it possible to photograph American atomic tests on Eniwetok (now Enewetak) Atoll in 1952, revealing otherworldly orbs of igniting gas.

In the 1950s Edgerton applied his expertise to equipment for oceanography and archaeology. He began by designing watertight camera and electronic flash systems, thus helping to reveal unprecedented views of the deepest oceans. The National Geographic Society arranged for Edgerton to work with French oceanographer Jacques Cousteau. They became great friends and collaborators. Edgerton made 10 voyages on Cousteau's research vessel, *Calypso*, and contributed to oceanographic and archaeological expeditions.[6] Between 1939 and 1966, Edgerton obtained 45 patents, in addition to his original stroboscope design, most for control circuitry, bulbs, camera components and related electronic modifications.

ERNEST KNEE
American, born in Canada, 1907–1982

Chapel of the Holy Child of Atocha, La Manga

1941
Gelatin silver print
26.7 × 20.4 cm (10½ × 8 in.) Image
27.9 × 21.7 cm (11 × 8½ in.) Sheet

Gift of Eric, Rosser, and Dana Knee, 1996.043.002

A prolific photographer of the American Southwest, Ernest Knee had a truly extraordinary career. He was born in Montreal, one of three brothers descended from a long line of Canadian sea captains, fishermen and provisioners.[1] He became interested in photography and acquired his first camera—a Vest Pocket Kodak—when he was 19 years old. He was captivated by the sea, and after high school he signed on as a steward aboard the freighter Canadian Fisher, bound for the West Indies. In 1930, stricken with tuberculosis, Knee moved to Tucson, Arizona, for his health. There he met Virginia "Gina" Schnaufer, a visiting painter from the East.[2] They explored canyons and deserts together, sketching and photographing. In spring 1931 they moved to Santa Fe, New Mexico. Knee bought an 8 × 10 inch view camera, outfitted a studio on Canyon Road and began to build a career as a professional photographer. The couple met Mabel Dodge, a Chicago heiress and patroness at the center of the local arts community, and she introduced them to the artists of the northern New Mexico colonies.[3] In 1933 Schnaufer and Knee married and settled in Santa Fe, joining the close and amiable circles of painters, musicians, writers and other artists. Knee often photographed artwork for his friends and colleagues. In 1934, the painter Willard Nash introduced Knee to Edward Weston

(Cat. no. 16), and they became good friends. The following year Weston visited Santa Fe, and the two photographers worked side by side, influencing each other in style and technique. For Official Films, a producer of theatrical documentary and cartoon shorts for movie theaters, Knee shot the film *Navajoland*, and was the first to photograph the Devil Dancers of Zia Pueblo.

In 1937 the Knees built a home at Tesuque, north of Santa Fe, specially designed with a north-facing painting studio and a darkroom. When the house was completed, in the spring of 1937, Weston came for a month's visit. "Ford gave [Weston] a car when he worked for them," Knee recalled. "We would drive all over the countryside, stop, get out of the car at the same time, and always stand back to back, shooting in opposite directions."[4] Both worked intuitively, without meters, filters or manipulation. Weston usually focused on a single object, while Knee contextualized his images with setting. In 1938, the year Knee became a naturalized American citizen, he also returned to filming Pueblo dances and fiestas. He created three short documentaries: *Indian Rhythm* (Taos Pueblo dances), *Navajo Fair at Shiprock* and *Santa Fe Area Celebrations*.

This photograph of the Chapel of the Holy Child of Atocha (Capilla de Santo Niño de Atocha) at La

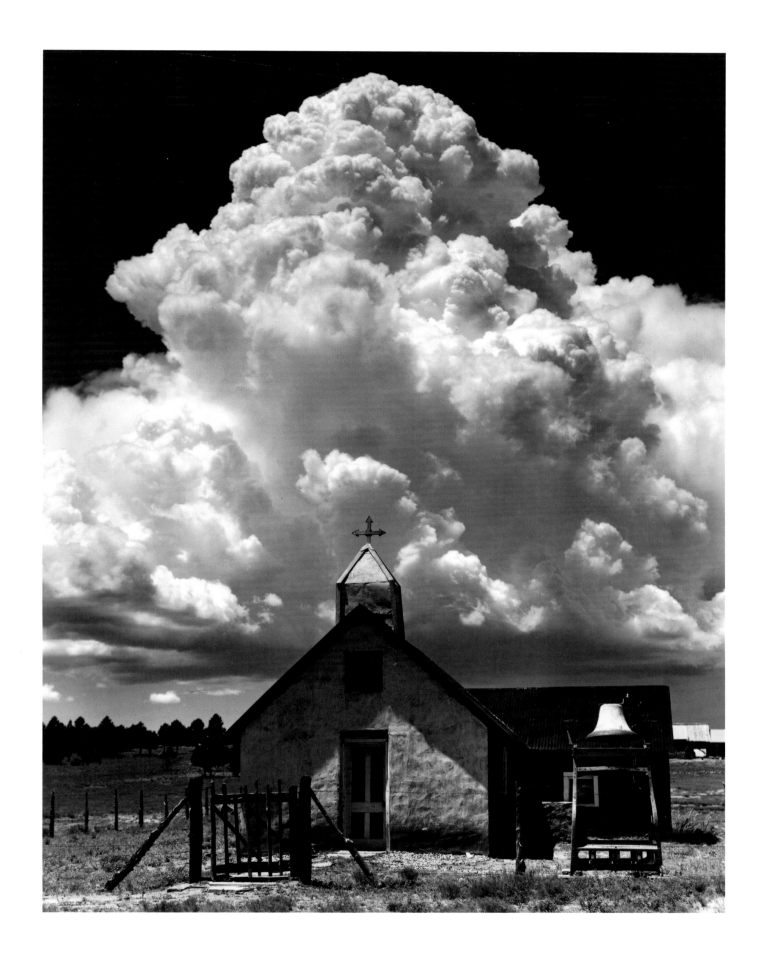

Manga is among the best-known images from Knee's series of New Mexican churches.[5] It is one of many that the artist collected in the mid-1930s, when he ventured in to the countryside in his Hudson automobile in ever increasing journeys, photographing the churches of northern New Mexico. His choice of these subjects and the organization of his composition were influenced by the popular style of American Scene regional art. Knee wanted to capture the unique appearance of the New Mexican countryside, the peace and sense of tradition embodied by local colonial missions or village chapels. This tiny shrine was erected in 1932, at La Manga in the foothills north of Las Vegas, New Mexico. When the resident farmer, Juan B. Ortega, fell ill, his older brother David prayed, pledging to build a chapel if Juan were to recover. His brother did regain his health, and David Ortega gathered fellow villagers to build the little chapel using traditional adobe construction methods and folk carving. In a churchyard behind the building is the sanctified Tecolote cemetery, which became the resting place of the extended Ortega family. Knee's image captures the humble but much-loved shrine, here glorified by nature with bright, cloudy Southwestern skies. The building remains much the same today, with the addition of a front porch, a new roof and green trim.

The chapel at La Manga is dedicated to the Holy Child of Atocha, a popular figure of devotion for the Hispanic community since colonial times.[7] His legend began in Moorish Spain during the Caliphate of Córdoba near Madrid. In the 10th century, the ruling Muslim sultan imprisoned Christians. Their own families had to provide food for them in captivity. During a period of heightened persecution, the sultan decreed that only relatives under the age of

12 could deliver to the prison, so prisoners without young children suffered all the more. Local women prayed before a statue of Our Lady of Atocha, and soon a little boy, dressed in pilgrims' garb, was seen coming to the prison each night with a basket of bread and a gourd of water for the neglected prisoners. The worshipers noticed that the clothes on the statuette of the Christ Child on the altar became tattered, and his shoes began to wear. They believed that the Holy Child went out every night to help those in need. Spanish colonists brought worship of Our Lady of Atocha and her Holy Child to the village of Plateros, Mexico, where a shrine was dedicated in 1554. Similar miracles were reported in the surrounding countryside, where the child was believed to aid the incarcerated, the poor and the sick. Worshipers have also left many photographs of children, prayers for the Holy Child's intervention on their behalf, gifts such as little pairs of new shoes to replace those worn out in the Holy Child's nighttime wanderings, and plaster figures of the Virgin and other saints.

Following the invasion of Pearl Harbor in 1941, Knee worked as a War Department munitions instructor in Santa Fe and Albuquerque. In October 1942, he and his family moved to Southern California, where he worked as a defense-plant photographer. Early in 1943, Howard Hughes recruited Knee to organize a photography department at Hughes Aircraft Company in Glendale.[8] He built studio and laboratory facilities, provided new equipment and authorized the photographer to hire as many staff as required. At that time, the company developed airplanes, weapons and ordnance for the American military. Among Knee's projects at Hughes was documentation of the development and testing of

the famous H-4 Hercules aircraft, nicknamed "The Spruce Goose."[9] Gradually Knee was called upon more and more to serve as Hughes's personal photographer, documenting parties of Hollywood socialites and even producing publicity stills for RKO Studios.

Soon after Knee and his family returned to New Mexico in 1947, the Princeton University Film Center and National Geographic Society invited the photographer to join an expedition to locate Angel Falls in the jungles of Bolívar State in Venezuela.[10] Fifteen years before, the American aviator Jimmie Angel had first glimpsed the waterfall during a geological survey flight. Later he tried to land and explore the site, but no modern surveyors or scientists had visited. The Princeton/National Geographic expedition aimed to locate and document the waterfalls, survey surrounding geology, and provide social and political context of contemporary Venezuela. The team that assembled in Caracas late in 1948 included a surveyor, a radio engineer, Knee as cameraman, and the writer Ruth Robertson. No local scouts knew the best route to the site, for the falls descend from a tableland 50 miles (80.5 km) wide, divided by several river valleys. In mid-April 1949, the team set out in dugout canoes up the Orinoco River, then hacked their way through deep jungle to the Amazon. On Knee's birthday, May 16, 1949, they first saw Angel Falls—Kerepakupai Merú or Parekupa Vená in the Pemon language—the highest uninterrupted waterfall in the world. Angel Falls plunges over the edge of the Auyán-tepui mountain, and sloped cascades descend to the Talus River, 3,211 feet (979 m) below. Over three days, Knee made the first photographs and film of the Angel Falls from the ground.[11]

WRIGHT MORRIS
American, 1910–1998

Panama, Nebraska

1947
Gelatin silver print
18.8 × 24.4 cm (7⅜ × 9⅝ in.) Image
20.3 × 25.4 cm (8 × 10 in.) Sheet

Milly and Fritz Kaeser Endowment for Photography, 2015.015.001

Celebrated as a novelist of the 20th-century American experience, Wright Morris also depicted life on the vast Midwestern prairies in his photographs. He experimented with melding his writing and his photography, searching for a more effective medium. Morris's mother died soon after his birth in Central City, Nebraska.[1] His father worked on the road for the Union Pacific Railroad, leaving nurses and neighbors to bring up his son. Then, when Morris was nine years old, his father brought home a new, teenaged wife, who was more a friend than an authority for him. When he was a boy, Morris spent two influential summers with his Uncle Harry and Aunt Clara at their farm near Norfolk, Nebraska. Morris's young stepmother left the family when he was 13 years old, and he moved with his father to Omaha. Before long, he moved on his own to Prohibition-era Chicago, where he attended high school while working as an attendant at a YMCA. Morris reunited with his father in 1924, for a road trip across the country.[2] In 1930 he attended Pomona College in Claremont, California, where he discovered a passion for literature. Morris began writing short stories about his personal experiences, including observations of Chicago gangsters. He took a year off from college in 1933 to tramp on his own through France, Germany, Austria and Italy. In Vienna he purchased his first camera, a Zeiss Ikon Kolibri, and began to photograph his journey.[3]

When Morris returned to California in 1934, he was determined to pursue a career as a writer. After graduating he married Mary Ellen Finfrock, and they moved to Connecticut where she had a teaching job. He wrote short fiction based on his travels and continued his photographic hobby, creating a series of a cloud studies in 1935. He traveled through New England, taking notes on his experiences and making photographs influenced by the work of Walker Evans (Cat. no. 39) using his first view camera, a 3¼ × 4¼ inch Graflex. Morris submitted his work to a photography contest at the Museum of Modern Art in 1940, and two of his prints were purchased for the permanent collection. At that time he conceived the notion of combining his original photographs with brief excerpts of prose to create interdependent works of art. Some of these "phototexts" were shown in New York at the New School for Social Research, and they were first published in the *New Directions in Prose and Poetry* collections in 1940 and 1941.

Morris's first novel, *My Uncle Dudley*, was based on his automobile trip with his father in 1924.[4] The book introduced an enduring theme for the author, that of a misdirected character searching for meaning on

the American highway. The author proved himself to be a perceptive observer of American character, using sharp details, subtle irony and multiple perspectives to explore obliquely the idiosyncrasies and frustrations of people living in isolated prairie towns. *My Uncle Dudley* helped Morris to win a Guggenheim Foundation Fellowship in 1942, which he used to continue his travels, from the East Coast to California and back, via Nebraska.

The Inhabitants, published in 1946, was Morris's first published phototext, featuring original photographs paired across page spreads with brief sections of prose.[5] Most of the photographs represent deserted and time-worn buildings of the Plains, with remnants of past activity. There is no sequential narrative. The texts do not describe the accompanying images or offer a symbolic equivalent; rather, each element is independent and self-contained. Instead of describing the inhabitants of the places represented, Morris suggests their imagined existence through his texts but leaves the photographs of buildings, interiors and the humble objects of rural life to speak for their absent owners. The absence of figures intensifies the isolation of these buildings as sculptural form, which is emphasized by their intense light and shade; in this way, many of Wright's photographs of this project are reminiscent of Charles Sheeler's photographs of architectural form and surface texture from the 1910s. Morris's published phototext pairings were

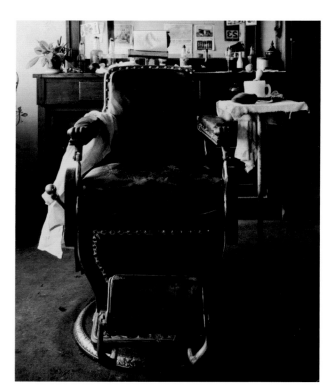

Fig 11. — Wright Morris, American, 1910–1998, *Cahow's Barber Shop, Chapman, Nebraska*, 1942, gelatin silver print, Milly and Fritz Kaeser Endowment for Photography, 2015.015.002

innovative in the breadth of their associations, and in their disjunctive nature. The work supported a renewal of his Guggenheim Fellowship, which made it possible for him to drive across the country again in May and June of 1947, now working with a 4 × 5 inch view camera.

In *The Home Place*, published in 1948, Morris adapted his phototext format into a more integrated narrative.[6] The book relates Clyde Muncy's day-long visit to his familial home at Lone Tree in central Nebraska. The story grew from Morris's memories of his childhood time spent with his aunt and uncle, and includes the unidentified photographs of them and their farm. Muncy's journey of discovery reflects the man he has become and what he has left behind, presented in the objects, rooms, buildings and landscapes represented by Morris's photographs (Fig. 11). The story has a clear plot, setting and characters, but there is no direct connection between image and text in most of the pairings in Morris's format.

This photograph, taken during Morris's expedition to Nebraska in May and June of 1947, is a variant of a horizontal shot in *The Home Place*,[7] representing a station building from a closer point slightly to the right, pushing the building off center and higher in the frame, with the roof cornice parallel to the edge of the sheet. The building, now in the middle distance, is balanced by an old, empty baggage cart on the right. The edge of the railbed follows the receding diagonal of the railroad tracks into the distance, but the static composition denies the rails' attraction the cart's capability of movement.

Morris's unusual books were influential in publishing, and they established Morris more as a photographer than a writer. *The Home Place* was unprecedented in its design and concept and might be said

to anticipate the artists' books that emerged in the 1960s. His publisher declined to include photographs in Morris's 1949 novel, *The World in the Attic*. Although Morris intended to incorporate photography into his third project in 1954, for which a Guggenheim grant funded a trip to Mexico, the resulting book, *The Field of Vision*, was a novel rather than a phototext.[8] It tells the tale of a group of Nebraskans who meet at a bullfight in Mexico City and assess their common past. This was Morris's 10th novel, and it won the National Book Award. In 1963, after visiting Italy and marrying his second wife, Josephine Kantor, Morris joined the faculty of San Francisco State College; he taught there for 11 years.

In 1967, Morris returned to phototexts. Over the next 20 years he produced two new phototexts, *God's Country and My People* (1968)—its publication spearheaded by John Szarkowski at the Museum of Modern Art in New York[9]—and *Love Affair: A Venetian Journal* (1972); he provided the words for a third phototext, *Picture America* (1982), to accompany the photographs of Jim Alinder. After his retirement from teaching, Morris published a final novel, *Plains Song: For Female Voices* (1980), which traced three generations of a Nebraska farm family. He also published several essays and books on photography, including *Photographs & Words* (1982) and *Time Pieces: Photographs, Writing, and Memory* (1983). Morris's photography, and his phototexts, enjoyed new recognition when a retrospective exhibition was presented by the San Francisco Museum of Modern Art in 1992.[10]

ANSEL ADAMS
American, 1902–1984

Winter Sunrise, Sierra Nevada, from Lone Pine, California

1944
Gelatin silver print
37 × 49.1 cm (14⅝ × 19⅜ in.) Sheet
55.5 × 71.4 cm (21⅞ × 28⅛ in.) Mount

Lorraine Gallagher Freimann Fund, 1975.066

Nature enthralled Ansel Adams, and he worked to capture its beauty and energy in his photographs. The fleeting shifts of light and weather and the endless change of geology are often present in Adams's images. He strove to communicate the profound beauty of the American West, to share this beauty and to champion its conservation. He became the leading photographic technician of his generation, and his combination of expressiveness and precision resulted in images that perpetuate his popularity as an artist.

Adams was born in San Francisco, the only child of older parents, and grandson of a wealthy timber baron.[1] He was the only child growing up in a big house amid the dunes around the Golden Gate, treasured by his parents, a maiden aunt and his maternal grandfather. He was home-schooled and became a shy, serious boy. He came to love nature while playing in the dunes, along Lobos Creek, and on Baker Beach. When he was 12 years old, he taught himself to play the piano and read music. The talent he displayed provided contact with outside teachers, and music studies instilled discipline, structure and substance in his youth.

In 1916 Adams first visited Yosemite with his family, and he returned every year of his life. When his parents gave him a Kodak No. 1 Brownie camera, he used it to document his outdoor adventures.

Adams joined the Sierra Club in 1919, and he made friends with the leaders of America's nascent conservation movement. Over four summers, he was resident manager of the club's LeConte Lodge in Yosemite Valley. He first published his photographs and writings in the *Sierra Club Bulletin* in 1922. Over the course of the 1920s, he shifted his professional ambitions from music to photography. In 1928, the year that the first solo exhibition of his photographs hung at the Sierra Club headquarters in San Francisco, he married Virginia Best, whom he had met in Yosemite. Together they raised two children.

Around 1930, Adams met Edward Weston and Paul Strand (Cat. nos. 16, 66). Their influence led to a style of optimal clarity and detail. He joined with several other California photographers in Group *f*.64, an informal association to promote their work, in 1932.[2] Named for the smallest aperture setting on a large-format camera, these photographers shared a style of sharp focus from foreground to middle distance. In 1931 they exhibited together in San Francisco at the M. H. de Young Museum, where Adams's first solo show in a museum was held the following year. He met Alfred Stieglitz (Cat. no. 7) in New York and began a correspondence and business relationship that led to a solo exhibition at An American Place. By that time, Adams

had published a series of technical articles in *Camera Craft* magazine, and his first widely distributed book, *Making a Photograph*.[3]

Adams, along with Fred Archer, formulated the Zone System as a technique for determining optimal film exposure and development, based on the late-19th-century sensitometry studies of Hurter and Driffield. The Zone System allowed photographers to define the relationship between their visualization of a subject and the final printed image.[4] This method for planning a photograph involved translating the hues, forms and light effects of a subject at hand into the monochromatic shapes and tones in a black-and-white print. To accomplish this precisely, Adams recommended the use of a densitometer—an expensive and technically complex device—to measure the tonal value of color saturation. Later the photographer used the developing process and other tools of the darkroom to achieve a print to match that conception. Adams often made an analogy between a photographic negative and a musical score, and between a print and interpretation through performance.

Adams strove to communicate the pristine beauty of the American West, and he was a great champion of its conservation. He photographed the California landscape in all seasons, in many conditions and at different times of the day, exploring the varied densities and effects of light. By representing nature without the presence or effects of man, he wished to provide the viewer with a personal experience. *Winter Sunrise, Sierra Nevada, from Lone Pine* is view that Adams knew long before he photographed it.[5] Sometimes he drove along Highway 395, north to Mono Lake, to see the vista of the Sierra from the east. He determined to photograph that view illuminated by the rising sun. On four successive mornings Adams drove out to the site before sunrise, and in the cold and darkness he climbed onto the platform mounted on his car roof to set up his tripod and view camera. Back in the car, he waited for the first rays of sun behind him to fall over the meadow. On the fifth morning, he finally observed the effects he had imagined: "I finally encountered the bright, glistening sunrise," Adams later wrote, "with light clouds streaming from the southeast and casting swift moving shadows on the meadow and dark rolling hills."[6]

Adams's careful attention to natural light while shooting, as well as his work in the darkroom, showcases a full spectrum of values and highlights. He captured a moment when the angle of the sun flooded the distant mountains with light but had not yet risen high enough to shine down upon the hills of the middle ground. The foothills are blanketed by a dark shadow that Adams manipulated to remove any details. One can almost the sense movement of the morning sunshine as it crosses the foreground meadow, warming the flanks of grazing horses. Beyond, the light shines on a row of leafless trees, picking out their feathery forms. The flashing light and dark of Adams's composition accentuates the varied scale, form and detail of natural beauty.

Adams became recognized as the preeminent darkroom technician of his day. Weston and Strand consulted him for technical advice, and he served as a technical adviser to the Polaroid and Hasselblad corporations. During the 1940s, his work often appeared in *LIFE*, *Fortune* and *Arizona Highways* magazines, and he acquired commercial accounts with Kodak, Zeiss, IBM, AT&T and the U.S. National Park Service. In 1946 Adams organized a photography department at the progressive California

School of Fine Arts in San Francisco. By the time the program of studies was suspended in 1952, Adams had marshaled a group of colleagues—including photographers Barbara Morgan, Dorothea Lange and Minor White (Cat. nos. 34, 38, 67) and scholars Beaumont and Nancy Newhall—to found the photography magazine *Aperture*. Adams supported the Newhalls' curatorial activities at the Museum of Modern Art in New York. During the 1950s and 1960s, he worked with Nancy Newhall on several exhibitions and books, including *This Is the American Earth*, a book that helped to launch the first broad-based citizen environmental movement.[7] Adams was among the founders, in 1975, of the Center for Creative Photography at the University of Arizona in Tucson, a research facility and archival repository, to which he bequeathed his personal archives and negatives.

MARGARET BOURKE-WHITE
American, 1904–1971

Beveling Armor Plate for Tanks, Gary, Indiana

1943
Gelatin silver print
33.7 × 43.2 cm (13¼ × 17 in.) Image
41.2 × 50.9 cm (16¼ × 20 in.) Sheet

Humana Foundation Endowment for American Art, 2016.007.003

A fascination with industry and labor propelled Margaret Bourke-White from a career as a documentarian into photojournalism. She was among the most intrepid Western photographers to record the events of World War II, and those of the world it left behind. Margaret White was born in New York City, the daughter of an engineer and a school teacher.[1] Throughout her life she remembered girlhood visits to industrial printing plants with her father, who supervised the installation of rotary presses. "A foundry represented the beginning and end of all beauty," she later wrote. "This memory was so vivid and so alive that it shaped the whole course of my career."[2] Her father, who died when she was 17 years old, also taught her the basics of photography. She attended Rutgers, and then Columbia University, and also studied photography with Clarence H. White (Cat. no. 8) in 1922. She began working as a freelance photographer for architects, advertisers and magazines to finance her further education.

White joined her mother in Cleveland in 1927, and added her maiden name—Bourke—to her own surname. She worked as a photographer for the Museum of Natural History and the Otis Steel Mill. She was delighted to be working in the factory, and aimed to capture and convey its scale and energy. Her dramatic photographs brought her to the attention of

publisher Henry Luce, who recruited her to work on his new business magazine.[3] Bourke-White's photographs illustrated *Fortune* magazine in its first years, and in 1929–33 she also served as associate editor. She photographed a wide range of American business and industrial subjects, and even visited Russia to document the transformation of Soviet society through industry. A selection of the diverse images that she made there were published as her first book, *Eyes on Russia*.[4] In 1934, an assignment for *Fortune* took Bourke-White to the American Midwest to document the plight of impoverished farmers during the Great Depression, and her imagery reflected a growing interest in character.

In 1936 Luce acquired the long-running American serial *LIFE*, which he intended to recast as a weekly forum for photojournalism. Bourke-White became one of its first photographers, and she was dispatched to Montana to photograph the construction of the monumental Fort Peck Dam. Her image of its architecture became the first cover of *LIFE* in November 1936, and her photoessay its lead article. As the first all-photographic American news magazine, *LIFE* dominated the market for more than 40 years. At its height, the magazine sold over 13.5 million copies each week. Bourke-White helped to develop the magazine's candid narrative style, and assignments

took her around the world. She photographed some of the most influential people of the era, from Joseph Stalin to Pope Pius XI, but her portraits often assert character traits that she perceived.

When Bourke-White photographed the Dust Bowl in the mid-1930s, she met the journalist and novelist Erskine Caldwell. They collaborated on the popular photobook *You Have Seen Their Faces*, a book about southern sharecroppers that sparked controversy for its perceived bias, and for the photographer's ambush-style methods.[5] Photographer and writer were married in 1939–42. They traveled together in the Soviet Union during World War II, when Caldwell was a correspondent for CBS Radio and Bourke-White was on assignment for *LIFE*. In summer 1941, defying commands from hotel wardens to flee to shelters, she photographed the nightly German air raids over Moscow. The following year she was the first woman photographer accredited by the United States Air Force.

In 1943, Bourke-White was sent to the steel mills of Gary, Indiana, to photograph women who had taken industrial jobs in place of men drafted into the service. Her image of Ann Zarik cutting thick steel plate with an acetylene torch appeared on the *LIFE* cover in August 1943. "Only the rising need for labor and the diminishing supply of manpower has forced this revolutionary adjustment," the magazine told its readers. "The women are recruited from Gary and nearby East Chicago. A minority has drifted in from agricultural areas. They are black and white, Polish and Croat, Mexican and Scottish. . . . The women steel workers at Gary are not freaks or novelties. They have been accepted by management, by the union, by the rough, iron-muscled men they work with day after day. In time of peace they may return once more to home and family, but they have proved that in time of crisis no job is too tough for American women."[6]

This photograph is one from Bourke-White's visit to Gary, where she made images of the workers in

Fig 12. — Margaret Bourke-White, American, 1904–1971, *Buchenwald Prisoners, Germany*, 1945, gelatin silver print, Humana Foundation Endowment, 2016.007.003

dirty, perilous jobs, in boiler suits and gas masks. Editors noted the similarity of these images to those that she had taken of Soviet workers, published two years before.[7] In this photograph, a strong composition of a line of welders projects a sense of industrial scale. Rows of similar or identical objects was a favorite trope for Bourke-White, who often used similar compositions of identical products in exact rows to convey manufactured efficiency in her *Fortune* assignments, such as the rows of plow blades photographed at the Oliver Chilled Plow Company in South Bend in 1929.[8] Here, each of the women concentrates on her task with professional competence and military precision. They are distinguished by their uniforms, but their individual characteristics are disguised: their hair is identically bound tightly to their heads, and their eyes are hidden beneath goggles of black glass, their hands in heavy leather gauntlets. The raw steel plate lying out before them plots a strong diagonal, balanced by the line of workers who diminish in size as they recede into the distance. One woman, at the center, reaches forward to create a visual fulcrum for this balanced collaborative process.[9]

Bourke-White's pictorial may have impelled the Office of War Information to launch its "Women at Work Cover Promotion" in September 1943, urging other journals to call women to the war effort with the slogan "The More Women at Work the Sooner We Win."[10] Between 1940 and 1944, the number of women working in the United States rose from 12 million to 20 million. Most of the wartime jobs they performed were away from the factory floors, but the dauntless industrial workers emboldened recruits. Contemporary with Bourke-White's photographs of the Indiana welders was the popular song "Rosie the

Riveter," a hit by the Four Vagabonds, with the chorus: "All the day long / Whether rain or shine, / She's a part of the assembly line. / She's making history, / Working for victory: / Rosie . . . the Riveter."[11]

In the closing weeks of World War II, Bourke-White was back in Europe, traveling with the forces of General George Patton when they discovered the concentration camp at Buchenwald (Fig. 12). After the war, she continued to document equally momentous events. She was in India during the independence campaign led by Mahatma Gandhi, whom she photographed hours before his assassination. In South Africa, she photographed labor and racial unrest in diamond and gold mines in 1949–50. She was a United Nations war correspondent to the Korean War in 1952, recording the conflict from the perspective of the Koreans rather than the American troops. Bourke-White worked on the staff of *LIFE* magazine until 1957, and remained a contributor afterwards. She became a celebrity in her own right, a symbol of women's capabilities and achievement. Courage and independence were apparent in her last project for *LIFE*. Over 19 years, as Bourke-White battled Parkinson's disease, she arranged for her colleague Alfred Eisenstaedt (Cat. no. 33) to photograph her experiences, through brain surgery and rehabilitation, for publication in *LIFE*.[12]

W. EUGENE SMITH
American, 1918–1978

Saipan

1944
Gelatin silver print
33 × 25.1 cm (13 × 9⅞ in.) Sheet
50.6 × 40.6 cm (19⅞ × 16 in.) Mount

Gift of Milly Kaeser, in Memory of Fritz Kaeser, 2005.011

In 1936, W. Eugene Smith enrolled as a freshman at the University of Notre Dame. His brief college experiences helped to crystallize his aspirations as a photographer and demonstrated qualities that shaped his career. Smith was the son of a grain farmer, born in Wichita, Kansas.[1] His mother was a photographer who shared her hobby with her son as he grew up. As a teenager Smith was interested in aviation and combined his interests in aerial photographs that appeared in his high-school newspaper, *The North Star*. These accomplishments helped him win a place at Notre Dame and a scholarship for work as a student photographer.

Smith's brilliant prospects dimmed in the weeks before his matriculation when his father, distraught over impending bankruptcy, shot himself to death. This enormous trauma must have colored Smith's arrival in South Bend. His feelings and ideas are reflected in letters he wrote to his mother, messages of excitement, homesickness and the exaggerated trivialities of a typical freshman.[2] He dedicated more energy to his photography than to his studies. He wrote of rising early to photograph the football team and its student supporters, and of his pictures of a papal delegate visiting the university. Soon a sense of purpose coalesced. "My station in life is to capture the action of life," Smith wrote to his mother, "the

life of the world, its humor, its tragedies, in other words, life as it is, a true picture, unposed and real."[3] Photographing live sports, as opposed to formal team pictures, taught Smith the power and immediacy of the active moment.

After the holidays, in January 1937, Smith returned to campus, but his enthusiasm had faded. Soon he decided that he was unsuited to college and belonged at the New York Institute of Photography. His letters describe failed tests and a nagging concern over poor grades, though, in fact, Smith then carried a 79.33 grade point average, which was good enough to continue his financial assistance. He wrote a string of letters imploring his mother to declare his formal withdrawal and transfer family funds so that he could go to New York. She encouraged him to persist. It surprised her when Smith cabled on February 17, 1937, to say that he had left the university without her permission and was on his way to New York. The final humiliation, he claimed, was a grade of 76, which should have been 96, on a history test. A week later, another telegram informed his mother that he was in New York and desperately needed money. Smith's first extant letter from Manhattan declares triumphantly that he had passed history after all, and his grade had been confused with that of another student who shared his common surname. "If it hadn't been

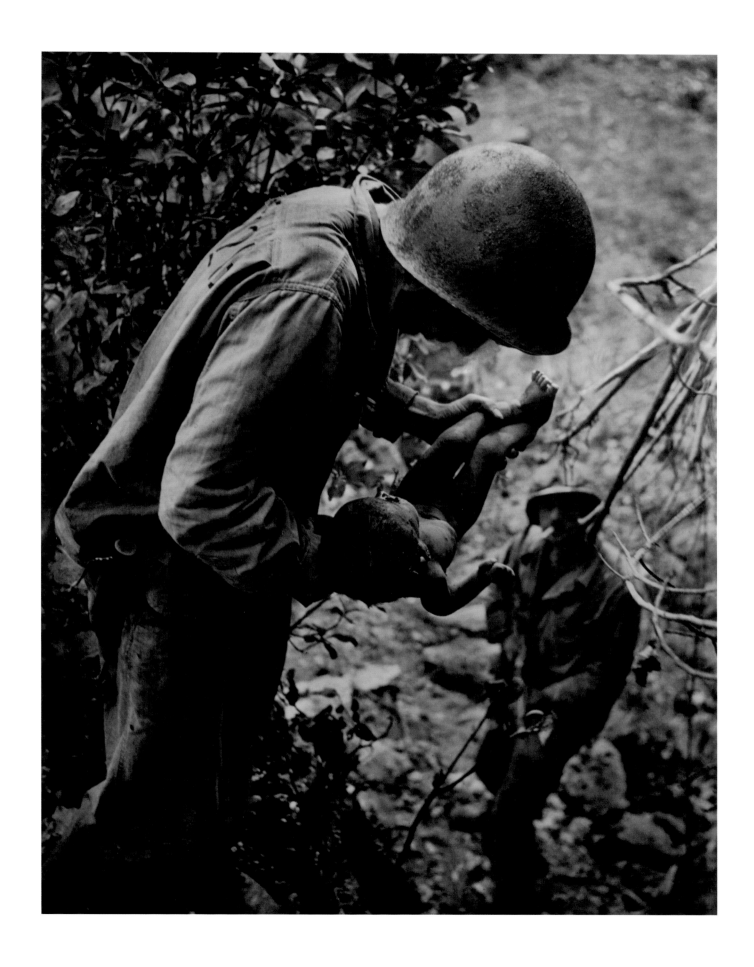

for the mixup," he wrote, "I would have still been at N.D. So I'm just as glad that it happened."[4] Smith's letters reveal his contempt for institutional structure, his disregard for rules and his inclination to blame others, characteristics that would shape his future career. Yet he seems to have proven to himself that he had an acute visual sense, the reflexes to capture action and an instinct for storytelling.

Smith completed the academic year at the New York Institute of Photography as a student of Helene Sanders. Afterwards he joined the staff of *Newsweek* magazine, but he soon lost the job for using incompatible equipment. Through the Black Star Agency, his photographs were published in magazines like *Collier's*, *Harper's Bazaar* and *Flying*. In 1939 he began working for *LIFE* magazine but again flouted rules and requirements. Despite his youth and inexperience, he arrogantly demanded editorial control, and thus began a succession of suspensions, resignations and probationary contracts. He could be conceited and rude, and he was unpopular among colleagues, but his visual sensibility often enabled him to capture brilliant images (Fig. 13). When Ziff-Davis Publishing sent Smith to the Europe during World War II, he was impassioned by patriotism. Soon he was assigned to the Pacific theater, to accompany American forces in their Japan offensive. Smith photographed at Tarawa, Bougainville

Fig 13. — W. Eugene Smith, American, 1918–1978, *Len Knight Sterilizing Suit,* from the photoessay "Life without Germs," published in *LIFE*, September 26, 1949, gelatin silver print, Laboratory of Bacteriology, University of Notre Dame (LOBUND), 1986.032.002

and Guam; on the first carrier raid over Tokyo; and on Iwo Jima and Okinawa. Smith often carried four or five small 35 mm cameras at a time, hanging on straps from his neck and shoulders. He photographed prodigiously, striving to capture American soldiers' experience of peril, terror and discomfort.

Smith accompanied the United States Marines when they landed on Saipan on June 15, 1944. This Japanese possession in the Northern Mariana Islands was 1,500 miles (2,414 km) from Tokyo, making it an ideal staging ground for an American attack. When bombardment preceded the landing, the Japanese civilians fled into the jungle, having been told that the invaders would slaughter them all. Rather than face capture, many civilians committed suicide en masse. The ferocious battle continued for nearly a month and cost many American lives, for the Japanese fought as guerrillas, taking full advantage of the rocky terrain and heavy jungle.

This is Smith's most famous photograph from Saipan, taken during a two-day mission when the Marines methodically searched out Japanese soldiers and civilians, from caverns on Mount Nafutan.[5] They slowly combed the area in squads, looking for caves amidst the undergrowth. It was a grisly task: one chamber after another was filled with bodies, and the dead decomposed rapidly in the heat and humidity of the jungle, attracting clouds of insects. As they inched along one ravine, the Marines heard a whimper. They discovered a hole in the ground, covered by a rock, where an infant boy had been hidden by his fleeing mother. The baby's head was misshapen, his body was covered in scratches, and insects swarmed over his eyes, which were encrusted with tears and pus—but he was alive. The men carefully conveyed the helpless infant hand-to-hand up the ravine, until Paul White—in the distance with a cigarette—passed him to Johnny Popham at the top. Smith photographed Popham gently but securely holding the child. The baby was carried to a Jeep and then rushed to a hospital. This print is carefully cropped so that the child's head falls in the middle of the composition, visually sheltered by the two Marines. A mirror image of this photograph was published in *LIFE* in summer 1944, illustrating an article on the Saipan operation.[6] The image has become the model for the recurrent trope in war photography of the warrior nurturing the child of an enemy, implying generosity to the vanquished.[7] Such an image of compassion in war makes a righteous, powerful propaganda symbol.

By the time he had reached Saipan, Smith's battlefield experiences had turned him against war. "Each time I pressed the shutter release," he wrote at the time, "it was a shouted condemnation hurled with the hopes that the pictures might survive through the years, with the hope that they might echo through the minds of men in the future—causing them caution and remembrance and realization."[8] Ten months later, Smith was on Okinawa, at work on a photoessay about the experiences of a single ordinary infantryman, Private First Class Terry Moore of F Company, 184th Regiment, 7th Infantry Division. When the company encountered mortar fire and fell to the ground as trained, Smith remained standing, aiming and shooting his camera. He was struck in face by a shell fragment. Carl Mydans's image of the bandaged photographer in a Guam hospital was included in Smith's photoessay.[9]

ROBERT CAPA
American, born in Hungary, 1913–1954

The Last Man to Die

1945
Gelatin silver print
24.2 × 16.3 cm (9½ × 6⅜ in.) Image
25.5 × 20.7 cm (10 × 8⅛ in.) Sheet

Milly and Fritz Kaeser Endowment for Photography, 2013.023.0032

The handsome and daring Robert Capa came to be known in the West as the most resourceful combat photographer of the mid-20th century. He was born Endre Ernö Friedmann in Budapest, where his Jewish parents ran a fashionable dressmaking salon.[1] As a teenager he became a committed social activist. In 1929 he met the Socialist artist and writer Lajos Kassák, whose journal *Munka* was often illustrated with photographic reportage. When Capa was still a Gymnasium student, he was arrested during pro-union and anti-fascist demonstrations. As soon as Friedmann passed his university-qualifying exams in 1931, he moved to Berlin, with a plan to study journalism. During the International Depression, however, his parents could no longer support his education. Friedmann decided to pursue photojournalism and began working as a darkroom assistant for the Dephot agency, where he learned the finer points of procedure and technique. His friend and fellow Hungarian émigré György Kepes loaned him a Voigtländer camera, and he began to photograph in Berlin. The weekly newsmagazine *Der Weltspiegel* gave Friedmann his first serious assignment: to photograph a public appearance by the exiled Russian Revolutionary Leon Trotsky at Copenhagen in 1932.

When Hitler came to power in Germany in February 1933, Friedmann moved to Paris, where several other Hungarian photographers were at work. He soon befriended André Kertész, Brassaï (Cat. nos. 22, 31), François Kollar and others, who aided his efforts to rebuild his freelance career. Friedmann also met Gerta Pohorylle, a German Jew from Leipzig, known as Gerda Taro. She became his agent, and he taught her the techniques of photography. Together they became Gerda Taro and Robert Capa.[2] French editors understood that Capa was an accomplished American cameraman—likely confusing him with Frank Capra—while American editors thought he was French, so Friedmann was able to command higher fees from both. Soon the relationship between Capa and Taro became intimate. In 1936 the couple traveled to Barcelona to chronicle the Spanish Civil War for *Vu* magazine. Both shot copiously, creating photographs that embody the brutality, courage and kind generosity of war.[3] Capa's image of a Loyalist militiaman on the battlefield near Córdoba, photographed at the moment of his death from an enemy bullet, was widely published.[4] The young couple thrust themselves into the heat of battle, and Taro was killed during fighting near Brunete in July 1937.[5] Capa struggled to continue working and became a staff photographer for *Ce Soir* magazine. After the fall of Barcelona in October 1937, he followed the fleeing Loyalist soldiers and

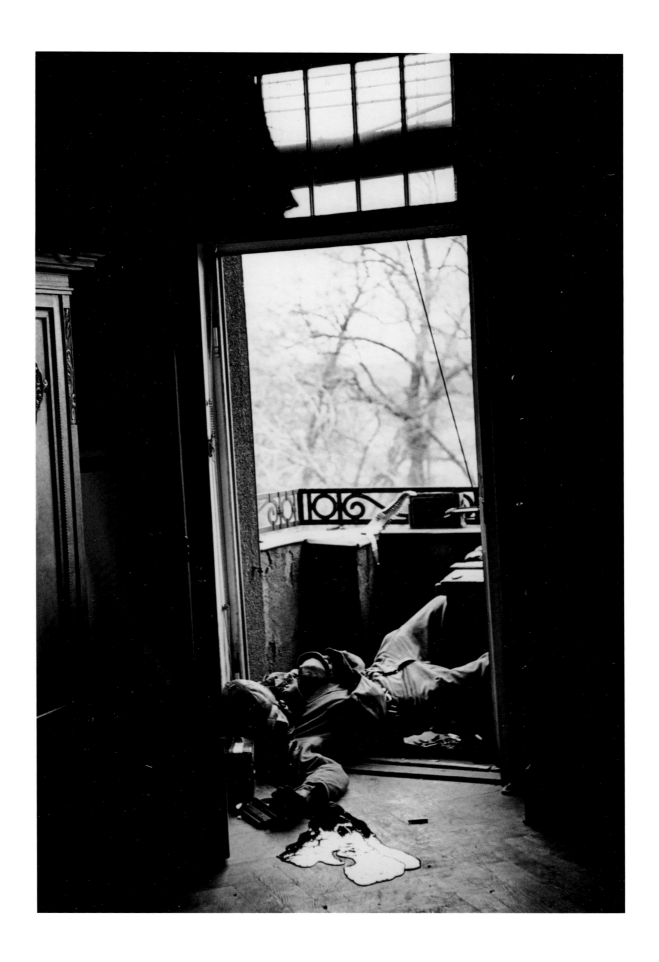

refugees to France, where he photographed the internment camps.

With war imminent across Europe, in August 1939 Capa traveled to New York, where his mother and brother, Cornell, had settled. He began working for *LIFE* magazine and established legal status in the United States in 1940. Capa's visa was about to expire and he faced deportation, so he made a marriage of convenience with the fashion model Toni Sorel. They never lived together and soon divorced, but he had lawful American credentials. He returned to Europe as a civilian photographer for the American press. On D-Day, June 6, 1944, Capa landed on Omaha Beach with the first wave of American troops. While riding a landing vehicle ashore, and wading through the surf under fire, he exposed four rolls of film. These were airlifted to London where, tragically, all but 11 of the negatives were destroyed in darkroom accident. The surviving images, unfocused and obscured by choppy seas and shrapnel smoke, evoke the peril, chaos and bravery of soldiers under fire.[6]

In the latter days of the war, Capa parachuted into Germany with the 17th Airborne Division. On April 18, 1945, he accompanied American troops as they entered Leipzig, facing heavy fire as they fought their way across the Zeppelin Bridge over the Weisse Elster Canal.[7] They found refuge in a tall apartment building overlooking the bridge. Capa mounted the stairs, hoping for a view of Leipzig in the last minute of the fighting. On the fourth floor, he found the door open to a bourgeois apartment, where a heavy-weapons company of the 2nd Infantry were preparing to cover the advance over the bridge. Two soldiers were loading a .30-caliber Browning heavy machine gun on the apartment balcony. One of them

was a fresh-faced corporal, 21-year-old Raymond J. Bowman from Rochester, New York, wearing a looted Luftwaffe sheepskin helmet as he loaded the machine gun. Capa instinctively found a viewpoint and raised his camera.[8]

"I stepped out onto the balcony," Capa recalled, "and standing about two yards away, focused my camera on his face. I clicked my shutter, my first picture in weeks." Seconds later Bowman's body relaxed, and he fell backward into the doorway, amid a litter of shell casings. His head came to rest on an ammunition box that propped the door open. "His face was not changed except for a tiny hole between his eyes."[9] Another soldier moved in behind the gun, and Capa backed into the room, shooting a sequence of photographs. Bowman's companions move quickly about his body as his blood slowly spreads across the floor into a growing pool. The sequential series captures the chaos of the event, and the contrast between the vital young soldiers and the lifeless corpse reflects its horror and finality. When the images were wired back to New York for publication in *LIFE* on May 14, 1945, the young gunner's face was blocked to respect the privacy of his family. Capa remembered the gallantry of the event: "It was a very clean and somehow a very beautiful death," he commented, "and I think that's what I remember most from this war."[10] Inside the apartment to the right of the balcony door—too dark to read in the present print—stood a tall-case clock. Brighter exposures from the photographic sequence show that Bowman died at 3:15 p.m. He was the last casualty in Capa's sector, the last death of hundreds that the photographer witnessed in World War II. When the photographer later selected a single print from his series, he chose this image. Its vertical orientation

emphasizes the lifeless slump of the body, and with the other soldiers who were in the apartment out of frame, the photograph emphasizes the finality and isolation of death, even amidst a great war. It was Capa who titled this photograph "The Last Man to Die."[11]

Capa legally changed his name when he became a naturalized American citizen in 1946. After the war he joined old friends and colleagues to accomplish a long-shared dream: the organization of the Magnum picture agency.[12] Capa was the founding director of an agency that enabled photographers to maintain copyright for their own work. Working closely with Henri Cartier-Bresson and David Seymour (Cat. nos. 60, 61), he established offices in New York and Paris. Capa also continued his own photographic work, traveling to the Soviet Union with the novelist John Steinbeck and collaborating on a book about their experiences.[13] He socialized with, and made portraits of, Hollywood stars and visited artists in the South of France. In 1948, the Israeli war for independence drew Capa back to the battlefield. His photographs of Jewish refugees arriving in Israel, and of fighting in Palestine, later illustrated the book *Report on Israel* by Irwin Shaw. Capa managed the Paris office of Magnum from 1950 to 1953. In 1954, he took an assignment from *LIFE* magazine to investigate the French Indochina War. There, while photographing French maneuvers on the Red River delta, Capa stepped on a land mine and was killed.

MAN RAY
American, 1890–1976

Le mirage

1944
from the portfolio *Objects of My Affection*
Gelatin silver print
19.9 × 12.3 cm (7⅞ × 4⅞ in.) Sheet
35.6 × 28 cm (14 × 11 in.) Mount

Walter R. Beardsley Endowment, 2016.006

The avant-garde artistic style of Dada responded to the uncertainties of life after World War I, when the emergence of psychology also prompted artists to look to their subconscious and dreams for inspiration. These concepts fascinated Man Ray and influenced his art. He was born Emmanuel Radnitsky, the son of Russian-Jewish immigrants to Philadelphia.[1] When he was seven years old the family moved to Brooklyn, where his father worked as a tailor. Around 1912 they signaled their American assimilation by changing their surname. Melach Radnitsky became Max Ray, his wife Manya became Minnie, and their aesthetic son insisted on one two-part name: Man Ray. A scholarship enabled Man Ray to study architecture at New York University. He supported himself during his studies as a graphic designer, while painting brightly hued landscapes influenced by Fauvism. In 1915, he met the French painter and sculptor Marcel Duchamp (Cat. no. 55), in exile from the war. Duchamp had adopted some ideas from Dada; he believed that modern art should replace visual interest with intellectual stimulation, and that by simply choosing and isolating a common object, the artist performed the fundamental creative act. Man Ray adopted Duchamp's concept of "found" objects as legitimate creative sculpture. To document this work, he taught himself the techniques of photography.

In 1921, Man Ray followed Duchamp to Paris, where they joined a circle of progressive artists and poets, including Francis Picabia, Tristan Tzara, André Breton and Paul Éluard. To support himself, Man Ray became a studio photographer, portraying new acquaintances, such as Pablo Picasso and Gertrude Stein, with the panache and instigation of Dada. These photographs attracted other aesthetes and intellectuals to his studio, and then socialites and fashion designers.[2] He also experimented with creative photography with his girlfriend, Alice Prin, as his subject. She was a nightclub singer who performed as Kiki de Montparnasse, and Man Ray gained a reputation for provocative photographs of her, such as *Le violon d'Ingres* in which he transformed her nude body into a musical instrument by adding *f*-holes to her back.

Along with Duchamp and other friends, Man Ray also experimented with filmmaking. When Tzara planned a Dada artists' ball in 1923, he asked Man Ray to create a short film for the gala.[3] Man Ray sprinkled salt and pepper on one length of sensitized film and scattered pins on another, then spliced these with shots of a twirling paper mobile, fairground lights, and Kiki's nude torso in the striped shadow of a Venetian blind. The abstract movie, *Le retour à la raison* (The Return to Reason), sparked controversy

at Tzara's ball, even among the Dada artists. The dispute was a contributing factor in the publication of Breton's "First Surrealist Manifesto" and Man Ray's association with the Surrealists. In 1929, Lee Miller became the photographer's studio receptionist and darkroom assistant.[4] They became a couple and creative collaborators. During their three years together, Man Ray developed a method for solarized prints. He arranged objects on light-sensitive paper, anticipating the shadows that combs, keys, tacks, paper coils and other small objects would cast

when the darkroom lights were flashed on (Fig.14). He called these works "Rayograms."[5]

During World War II, Man Ray returned to New York carrying just one suitcase. He moved on to Southern California, hoping to find work in the film industry. His avant-garde reputation was unknown in Hollywood, and though the West Coast intelligentsia appreciated his presence, they could not provide a comfortable income. Man Ray had no record of his artistic development or achievement during his time in France; many of his early works were

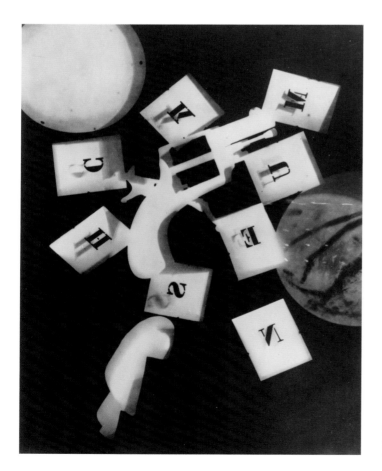

Fig 14. — Man Ray, American, 1890–1976, *Untitled*, from the portfolio *12 Rayographs*, 1921–28, 1924, gelatin silver print, Milly and Fritz Kaeser Endowment for Photography, 2016.006

lost, and others were documented only in obscure Surrealist magazines. The artist decided to reconstruct his oeuvre, and even recreate some of his lost works. He gathered notes, studies, photographs and cuttings in a ring binder that came to be known as "The Hollywood Album." He began a more refined selection of pivotal works, which he catalogued in a portfolio of photographs titled *Objects of My Affection*.[6] The album was displayed in a solo exhibition of Man Ray's work at the Circle Gallery in Hollywood in September 1944, shown simultaneously with a retrospective at the Pasadena Art Institute.

Le mirage is one of the photographs from *Objects of My Affection*.[7] It documents a construction that Man Ray made from repurposed mechanical components: "Transplanted to the home," states a typescript caption mounted on illustration board alongside the photograph, which may suggest that an earlier version of this piece was meant for the gallery or public exhibition. It is a peculiar mechanism, mounted off-center on a laminated plywood base, hanging on the wall like a clock. In this photograph, Man Ray located the plywood precisely within the frame, so that the near edge and far shadow reveal the depth of his construction. Projecting from the wooden base at a right angle is a dark cylindrical post, apparently mounted in a set of ball bearings in a race, so that the axle can swing freely. A bicycle mirror hangs like a pendulum mid-way along the post. Casting both shadow and reflection, the mirror exists in a deep, complex space. Man Ray traced and painted the mirror's shadow on the base, so that if it were to swing, its resting position would appear constant. A string is tied to a screw eye in the end of the axle, from which a painted cube or die, with a different number on each face, hangs before the mirror. When the entire apparatus moves, the cube will twist and the mirror will reflect different numbers to the viewer. Also mounted on the screw eye is a pair of doll's eyes. Hanging on a short cord from the screw eye is a tiny hemispherical bell—a toy sleigh bell or jingle bell—with a detached clapper inside. If Man Ray's machine were set in motion by swinging the pendulous mirror, the numbered cube would twist and the eyes would jiggle together and glance about unfocusedly, while the tiny bell below might sound an intermittent tinkle. Even at rest, however, the construction suggests to the viewer the potential effects of motion, a sense of expanding or contracting space, of gravity and change itself. The implied motion also suggests a passage of time: the duration of the imagined swinging and jiggling.

Man Ray made this gelatin silver print for a layout maquette, one of a set of captioned photographs meant for presentation. The artist found it difficult to find a publisher for *Objects of My Affection* as a photobook. After being shown at the Circle Gallery in fall 1944, the series was shown at Galerie Aronowitsch in Stockholm. That exhibition consisted of 26 sheets from a disbound spiral notebook, presenting 37 objects in gelatin silver prints glued to perforated pages, with inscriptions in the artist's own hand.[8] This print comes from a later version, for over the years Man Ray gradually added objects and images to the series. When *Objects of My Affection* finally appeared in print, it included 119 objects dating from 1917 to 1968.[9]

WEEGEE
American, born in Poland, 1899–1968

Tire Inspection

1940
Gelatin silver print
32.2 × 27.2 cm (12⅝ × 10¾ in.) Image
35.8 × 28.5 cm (14⅛ × 11¼ in.) Sheet

Humana Foundation Endowment for American Art, 1993.009.001

The tabloid photojournalist Arthur Fellig created sensational images of dramatic events in New York City under the pseudonym Weegee. His methods prefigured the celebrity paparazzi of the 1950s, and his style contributed to the cinematic style of film noir. He was born Usher Fellig, in the city of Złoczów, in Lviv province of Poland.[1] In 1908, his father Barnard Fellig immigrated to the United States, where he worked as a pushcart vendor on the Lower East Side of Manhattan, resolutely saving to bring his family to the United States. When they arrived at Ellis Island, immigration officials are said to have registered the 11-year-old boy as Arthur. He learned English in the neighborhood before enrolling in grammar school in the fifth grade, a year behind his contemporaries. He contributed to the family by working as a newsboy and by selling candy to burlesque-theater patrons. Fellig dropped out of school at age 14 and left home four years later. One of many odd jobs he had was as an assistant to a street photographer who used a pony to attract children to pose for portraits.

In 1924 Fellig became a darkroom technician for the photography agency ACME Newspictures.[2] Soon he was filling in as a photographer at night or on emergency stories. He had no professional credentials, but he realized that by monitoring the teletype he could be first on the scene at urgent events around the city. Policemen, reporters and rival photographers chaffed him over his seeming prescience. Fellig played upon this reputation with the nickname "Weegee," a phonetic spelling of the popular fortune-telling game Ouija.[3] A distinctive figure, with his downtown accent, gravelly voice and disheveled appearance, he was disconcertingly comfortable at a crime scene, often chomping on a cigar.

Weegee hunted for sensational images that he could sell to tabloid newspapers and true-crime magazines. He claimed to have photographed thousands of murder victims, but his best images capture human nature without judgment. Weegee used a press photographer's Folmer Graflex Speed Graphic camera with a flash attachment to expose 4 × 5 inch negatives. He set the focal distance at 10 feet and then simply tried to get near his subject; he framed his images and adjusted composition in the enlarger. The flash flattened and highlighted the subjects, darkening the background, but the high-contrast images were well suited to the heavy inking of tabloid presses. To get his photographs to the newspapers first, Weegee often developed his negatives in a makeshift darkroom in the trunk of his 1928 Ford sedan. This workspace became

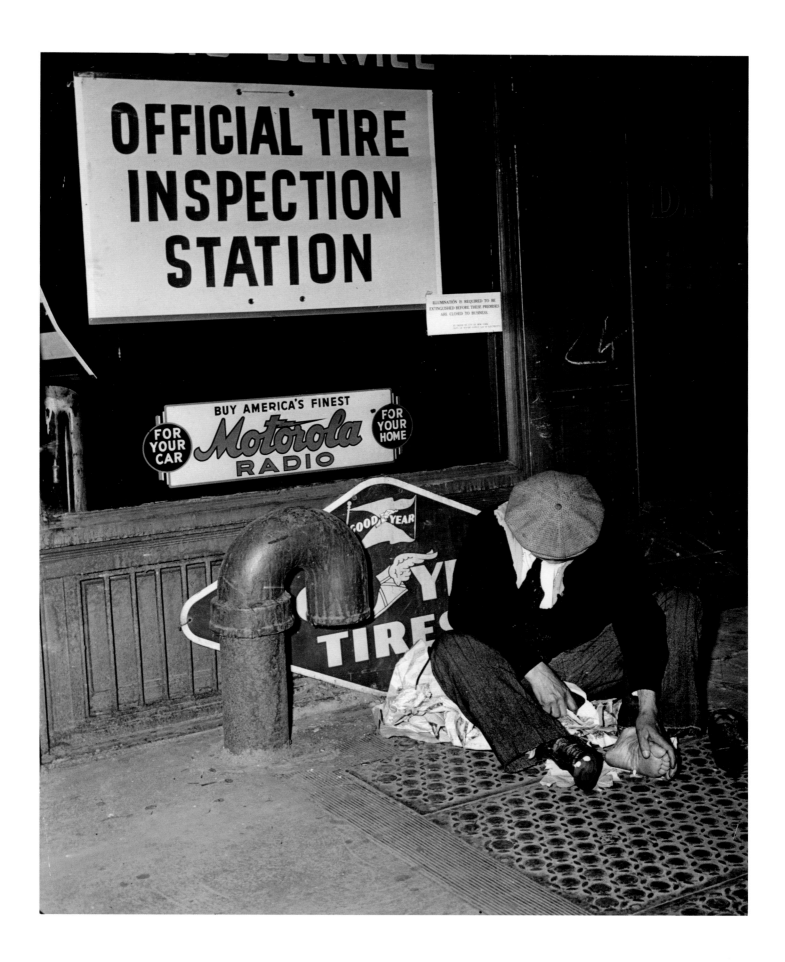

legendary for its disorder, with enlarger, typewriter, flashbulbs and documents jumbled together with prints. Indeed, many of Weegee's authentic prints are characterized by folds, scratches and dents. Such is the case with the present print which, apart from its rough condition, is inscribed with cropping marks and size notations for publication.[4] In 1935 Weegee acquired one of the first police radios licensed to a civilian. He installed it in his car, ensuring even faster arrival on scene. This enabled him to resign from ACME and establish a freelance career on the street.

Tire Inspection is typical of Weegee's work of the late 1930s—a facetious take on Depression-era images of the city's dispossessed, contemporary with Social Realist painting and the work of the Photo League.

This homeless man settles for the night on the pavement outside A. C. Schwarz Automotive on 59th Street, the northern border of Hell's Kitchen. This was a rough area of the city; millions of refugees crowded there after the Civil War, followed over generations by violent youth gangs and organized crime. There Weegee often found pathetic subjects, like this destitute man sitting on a mat of crumpled paper. Dressed in dirty, tattered clothes, he has removed a shoe and a sock to massage his foot, presumably sore from walking the streets all day. His head is tipped forward and his features are hidden under his flat cap. The light color and round shape of the cap, along with the light color of his shirt and jacket lining, balance the large standpipe that emerges from the sidewalk. The highlighted arch of the pipe

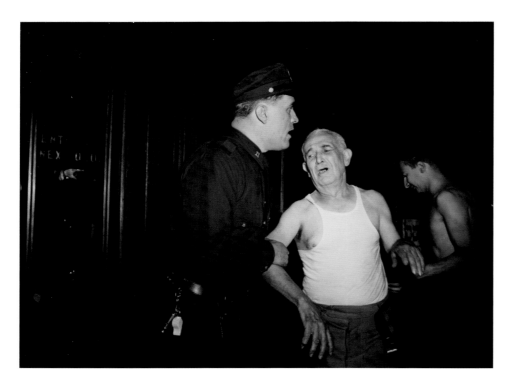

Fig 15. — Weegee (Arthur Fellig), American, born in Poland, 1899–1968, *The Crying Landlord*, 1941, gelatin silver print, Humana Foundation for American Art, 1993.009.002

makes a visual pun on the exhausted slump of the figure. The unfortunate man is like the city's plumbing, the very infrastructure of New York. He sits in a shallow space, bounded by walls and pavement, before the windows of the closed shop advertising products and services wildly beyond his reach. Weegee often titled his photographs with the wit and irony of the tabloid headline. Since the subject sits directly beneath the Official Tire Inspection Station sign, it seems likely that the photographer hired him, and posed him here to make a cruel visual joke.

In 1940 Weegee joined the staff of the progressive *PM* magazine. He made facetious images of bohemians and intellectuals in Greenwich Village, and captured glimpses of high society on uptown streets. In 1943 his work was included in the exhibition *Action Photography* at the Museum of Modern Art, which acquired five of his photographs for its permanent collection. Advertising and editorial projects for magazines followed, including assignments for *LIFE* and *Vogue*. William McCleery, the editor of *PM*, helped Weegee organize and publish the photobook *Naked City*.[5] The photographer traveled to California on a book tour, and he was predictably intrigued by Hollywood. He sold the rights to the title *Naked City* to a movie producer, and something of his visual style appears in the feature film of the same name.[6] Weegee's photographic style contributed to the film noir genre, Depression-era crime dramas with a dark, ominous appearance.

In Los Angeles, Weegee created the photobook *Naked Hollywood*.[7] He made experimental distortion photographs during the 1950s, lectured, taught clinics and wrote an autobiography. In 1957, after developing diabetes, Weegee settled down in New York with Wilma Wilcox, a Quaker social worker and old friend. He continued his involvement with the film industry, and in 1964 he was a special effects consultant and credited still photographer for Stanley Kubrick's film *Dr. Strangelove, or: How I Learned to Stop Worrying and Love the Bomb*. Weegee's gruff New York accent and his eccentric personality influenced Peter Sellers's development of the film's title character.[8]

ARNOLD NEWMAN
American, 1918–2006

Yasuo Kuniyoshi

1941
Gelatin silver print
38 × 46.3 cm (15 × 18¼ in.) Image
40.3 × 50.5 cm (15⅞ × 19⅞ in.) Sheet

Arthur Wiesenberger Fund, 1980.003

As a prominent celebrity portraitist for three decades, Arnold Newman created many of the images by which we remember historical figures of mid-century. These portraits also reflect social and cultural circumstances of their time. Newman was born in New York, where his parents worked in the hotel industry.[1] While growing up, he was accustomed to seasonal moves between hotels in Miami Beach and Atlantic City. In 1936 he won a scholarship to study art at the University of Miami, Coral Gables, but could only afford to stay for two years. Returning to the New Jersey coast, Newman found work in a Philadelphia portrait studio, where he became a skillful photographic technician. As a boy Newman had seen a photograph of President Teddy Roosevelt surrounded by big game trophies, an image that projected a memorable sense of the man's personality. The photographer reasoned that a thoughtfully devised portrait set in the subject's own milieu could help express their personality. He pursued this notion in portraits of artists whom he venerated. In New York he photographed the respected Russian-born painter Raphael Soyer and his twin brother, Moses, in their studios. The brothers sent the photographer to the painter Chaim Gross. Other references followed, and Newman enjoyed an adventure that helped refine his portrait style.

One of the artists he met was Yasuo Kuniyoshi, a widely admired colleague among the downtown New York artists. Born and raised in Japan, Kuniyoshi began to study traditional craft.[2] However, in the years after the Russo-Japanese War, prospects for an artisan's career were poor. The teenager joined thousands of Japanese migrants to the United States in search of economic opportunity. In 1906, Kuniyoshi made his way to Los Angeles, where he attended public high school and went on to study painting at the Los Angeles School of Art and Design. Kuniyoshi went to New York in 1910 and eventually found a home at the Art Students League. Kenneth Hayes Miller became a mentor and a powerful influence on Kuniyoshi's imagery, style and leftist political leanings. Miller introduced Kuniyoshi to printmaking, but to support himself the young artist learned the techniques of photography and found modest commercial projects.[3] Among his friends were Reginald Marsh, Peggy Bacon, Katherine Schmidt—his first wife—and others who depicted everyday life in the city.

Kuniyoshi lived frugally so that he could take the summer off and travel with his friends to Maine. They painted landscapes and still lifes, while living in fishing shacks on the docks and beaches, enjoying seafood and evening bonfires. They explored barns

and junk shops, and bought inexpensive antiques and folk art. Along with artist friends such as Elie and Viola Nadelman, and Marguerite and William Zorach, Kuniyoshi collected theorem paintings, as well as weathervanes and decoys, well-made objects of utility. The artists shared this hobby with such New York tastemakers as Holger Cahill, Juliana Force and Abby Aldrich Rockefeller, laying the foundations of modern appreciation of American folk art.[4] In the 1920s, along with the downtown artists, Kuniyoshi shifted his summer destination to Woodstock, New York, where an art colony established itself. At that time his expressive style was influenced by Cubism. He combined observation and imagination, synthesizing concepts from Japanese and Western art. In 1929, Kuniyoshi's work was included in the exhibition *Nineteen Living Americans* at the Museum of Modern Art, but racism provoked complaints about his inclusion. This surprised and offended the artist, who for 35 years had considered himself a proud, hard-working American. In the 1930s Kuniyoshi taught at the Art Students League and the New School for Social Research, and he was active in both the painting and printmaking New York divisions of the Federal Arts Program of the Works Progress Administration. In 1935 he won a Guggenheim Foundation Fellowship that enabled him to work in Mexico, and then at Taos, New Mexico.

Arnold Newman photographed Kuniyoshi in the painter's 14th Street studio on September 6, 1941. This is the best known of several images from a session in which the artist is surrounded by pieces from his collection of American folk art.[5] Kuniyoshi reclines on a camelback settee, leaning on his elbow in a relaxed posture that is emphatically American in its casual confidence.[6] The pose follows the undulous contour of the settee, a 19th-century form, like the antique candlestand. The ascending angle of the sofa back leads up to the left of the image, to crest at the artist's thoughtful expression and his glance outside the frame. Kuniyoshi is nattily dressed in his normal garb of the day: a coat and tie, sweater and penny loafers. Careful observation of the portrait also reveals the details of an old New York apartment: a baseboard plumbing valve and a light switch cord weighted with an old hinge. To capture this detailed atmosphere, Newman used a large-format camera and tripod, which required long exposures to keep both subject and background in sharp focus. His sitters had to remain motionless for several seconds, sacrificing a momentary expression for a settled one.

Newman created this calm, peaceful image just weeks before world events upset Kuniyoshi's life. The Japanese attack on Pearl Harbor on December 7, 1941, which drew the United States into World War II, unleashed seething racial animosity. On December 12, "An American Group" of 62 painters, sculptors and graphic artists published an open letter declaring the loyalty of its members, including two born in Japan: Kuniyoshi and Chuzo Tamotzu. Kuniyoshi was also one of seven who identified themselves as the "Committee of Japanese Artists Resident in New York City," and sent their own commitment of loyalty to the mayor, the governor, and President and Mrs. Roosevelt.[7] Nevertheless, at the end of the year, Kuniyoshi was classified as an "enemy alien" by the American government. The support of the New York art world may well have saved him from imprisonment.[8] However, despite his supporters' opinions, and his own feelings of assimilation, he had to declare and identify himself as a patriotic American. Kuniyoshi was

compelled to join discussions concerning democratic American ideals in the public media. He wrote and recorded two war propaganda speeches to be broadcast in Japan over shortwave radio. The artist also executed pro-American images, such as the posters he designed for the Office of War Information. After these experiences, his personal work became more arcane, concealing hidden meaning.[9]

In 1944, Arnold Newman had to register for the draft in his home state of Florida. Remaining for possible induction, he took over the management of a chain portrait studio in West Palm Beach. He was living in Florida when the Philadelphia Museum of Art mounted the solo exhibition of his photographs, *Artists Look Like This*. Its success provided the momentum for Newman's return the following year to New York, and regular editorial commissions followed. He opened his own studio in the city, producing portraits for magazines like *Harper's Bazaar*, *Fortune* and *LIFE*. Newman's photographs became a conspicuous reflection of the confident rebuilding of postwar American culture. Late in the 1970s, he began to publish collections of his portraits in a succession of popular books.[10]

N. JAY JAFFEE
American, 1921–1999

Learning to Skate, Livonia Avenue East New York, Brooklyn

1949
Gelatin silver print
19.4 × 16 cm (7⅝ × 6¼ in.) Image
35.6 × 27.8 cm (14 × 11 in.) Sheet

Gift of Jamie Niven, 1980.122.001.BB

After profound experiences as a soldier in World War II, N. Jay Jaffee found solace in photography. The camera helped him to concentrate his attention, express his feelings of melancholy and reconnect with other people. Nathan Jaffee was born in Brownsville, Brooklyn, the son of Jewish immigrants from Russia and Poland.[1] Yiddish was spoken in their home. Jaffee's childhood was sometimes difficult. His father worked as a cutter in the garment industry, but his mother was asthmatic and the family moved several times in search of a suitable home for her. When Jaffee was seven years old, an older brother was killed in an industrial accident. In 1932, the family settled at the western edge of Crown Point, Brooklyn. Nearby was the Prospect Place Market. This bustling district, the center of a thriving, diverse community of immigrants from Eastern Europe, was the gathering place for Jaffee and his friends during his adolescent years. He attended secondary school at the New York School of Printing and was trained as a pressman, layout artist and typesetter.

Jaffee's mother died when he was 15 years old. He left school and began working as a typesetter. Soon both his father and older brother moved away from New York City, leaving him on his own. Eventually he found camaraderie and political kinship in the Wholesale and Warehouse Workers Union, Local 65,

headquartered at Tom Moony Hall, on Astor Place in the East Village, where Jaffee met his future wife.

Jaffee was a printing-plant foreman when he was drafted into the Army in 1942. He served three years in the 104th Infantry Division and became a squad leader in the 415th Infantry Regiment, the Timberwolves, a unit trained for night fighting. They were involved in heavy combat on the Northern Front over six months. In late October and early November 1944, the 415th Infantry Regiment were involved in the Battle of the Scheldt, fighting in rain and snow alongside Anglo-Canadian allies.[2] They suffered many casualties in order to recapture the Scheldt Estuary and open the port of Antwerp so the Allied offensive in northwest Europe could be resupplied. With other members of his regiment, Jaffee was awarded a Bronze Star for distinguished service in this campaign. Dismayed by military power structures and suffering from the trauma of combat, he was haunted by his wartime experiences, but like many combat veterans he seldom spoke of those events or their effects on him.[3]

Jaffee had married on leave in 1945, and after the war he and his wife Isabel were eager to settle and begin a family. They rented the top floor of a duplex in Brooklyn and painted the apartment in lively colors. Jaffee had no desire to return to the

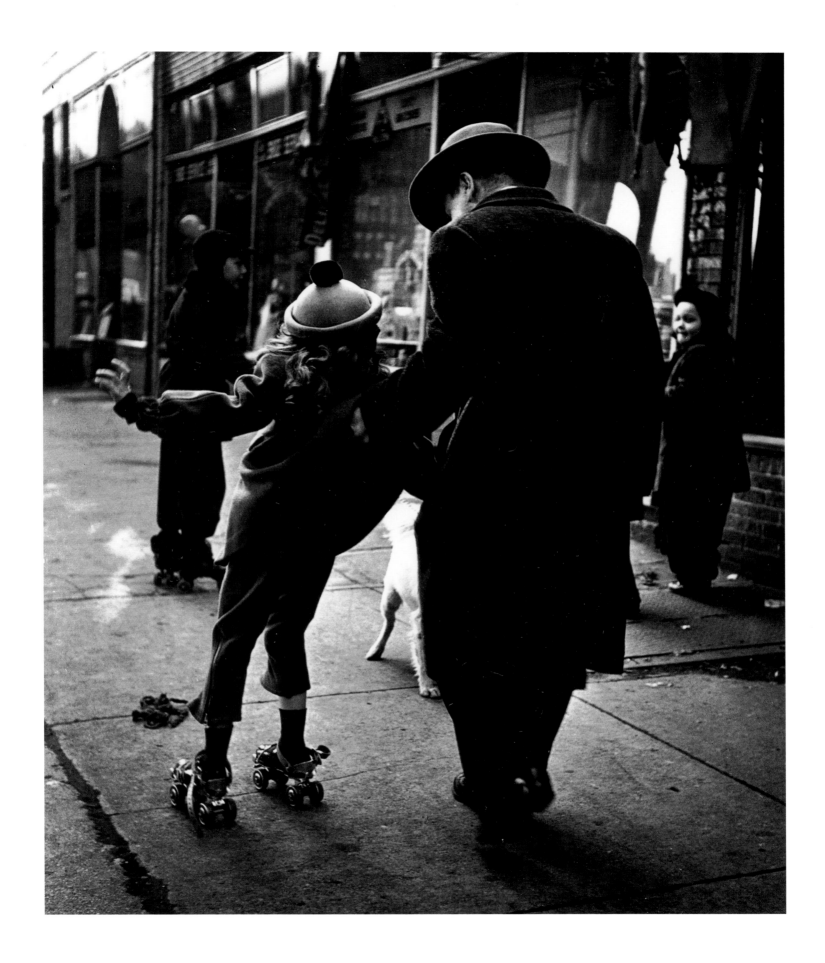

printing plant and eventually found a career as a salesman of commercial printing.[4] The return to civilian life was challenging; Jaffee suffered with post-traumatic stress disorder and feelings of melancholy, and he had lost some of his prewar memories. When his brother took up photography as a hobby he followed suit, wanting his children to have clearer memories of their early lives than he had. Jaffee bought a Kodak Monitor folding camera and began to photograph his home, his neighborhood and the city. Some of his photographs convey a sense of despondency and dread—images of isolated figures in overwhelming cityscapes of looming, darkened buildings and rubble-strewn vacant lots surrounded by wire fences. However, he also photographed pleasant human interactions. A few blocks from home he discovered the Blake Avenue Market. There, while focusing his camera on everyday life, Jaffee found relief from feelings of dread.

In 1948 Jaffee signed up for a 10-week photography course at the union hall in Astor Place, taught by Sid Grossman. This noted documentarian recognized Jaffee's talent and offered encouragement and advice about equipment and technique.[5] Jaffee also began to visit the Photo League, a membership organization in Manhattan where amateur and professional photographers combined resources to finance shared facilities.[6] Modest dues supported the maintenance of darkrooms, meeting rooms, a gallery and classes, at a time when photography was not taught in trade or art schools. Most League members were very like Jaffee: first-generation New Yorkers who had been educated in public schools. Many were well read, with wide knowledge of history, music and art. Their politics leaned to the left. Nearly a third of the Photo League members were women, many serving as club officers. These photographers chronicled urban life with a sense of social consciousness. Monthly meetings at the League often featured presentations by leading photographers, critics and historians. Jaffee attended lectures by W. Eugene Smith, Paul Strand (Cat. nos. 48, 66) and others. After about 18 months, with increasing family responsibilities, and the intention of building his own darkroom, he stopped visiting the Photo League. He had been guided and encouraged by colleagues he met there, and had learned that he was part of a historical lineage of photographers.

This remarkably tender photograph taken on the street reflects Jaffee's acute perception, his skill at capturing a powerful moment and his gift for storytelling.[7] When he noticed this girl skating haltingly forward, supported by her father, Jaffee artfully framed his image: the concrete sidewalk seams plot a recession into the distance, while on the right, diminishing vertical mullions between tall storefront windows reinforce the processional effect. The young girl teeters on the roller skates strapped on her shoes. The adjustable straps hang down in long tails, showing how small she is. Her father—larger, visually darker and stable—slowly steps forward, supporting her by lifting her waistband, which raises her slacks and exposes her socks and narrow ankles, accentuating her insecurity. The angle of his head suggests a meaningful glance at the girl, emphasized by a chevron of light pointing up from the pavement, even though his face is not visible. A dog can be seen in the gap between father and daughter, its feathery tail at the apex of the triangle. The girl seems to be distracted by animal, reaching out toward it with her hidden right hand. The arms of father and daughter cross near the center of the photograph, suggesting a

bond of reassurance and trust that seems also to be a visible symbol of affection. Another child beyond, perhaps an older brother, is confident enough on his skates to chat with friends. He and his friends are bundled up. The young girl wears a wool coat and a felt hat topped by a yarn bobble. It must be winter, and the girl may be trying out a holiday present. What appears to be a pair of knitted gloves lie on the sidewalk in front of her—another obstacle from which she must be protected. Jaffee often photographed people from the back, bringing the viewer into a scene with him. These images reveal how expressive posture can be, and the photographer's sensitivity to people and events.

In 1950 Edward Steichen purchased three of Jaffee's photographs for the Museum of Modern Art and included them in the exhibition *Photographs by 51 Photographers*. One of these, *Bryant Park*, has received wide attention. It represents five businessmen sunning themselves on the stone steps of the William Cullen Bryant monument.[8] Despite their proximity, these men ignore each other, preferring a quiet, personal lunchtime moment. The theme of New Yorkers striving to preserve some personal space is common in Jaffee's photographs; so is the subject of loneliness and alienation in the city.[9]

GORDON PARKS
American, 1912–2006

Red Jackson, Harlem Gang Leader

1948
Gelatin silver print
26.3 × 19.4 cm (10 3/8 × 7 5/8 in.) Image
35.5 × 28 cm (14 × 11 in.) Sheet

Humana Foundation Endowment for American Art, 2007.008.002

Aside from his achievements as a photojournalist and fashion photographer, Gordon Parks was an author, a poet, a musician, a composer and a filmmaker—a leading interpreter of the African American experience in the mid-20th century. Parks was born in the prairie town of Fort Scott, Kansas, the youngest of 15 children of a subsistence farmer.[1] His mother died when he was 15 years old and he went to live with his married sister in Saint Paul, Minnesota. Conflict with his brother-in-law drove him from the house after a few weeks, and he was on his own. He sustained himself by working as a waiter, a janitor and a barroom pianist, among other things, while remaining in school. He became captain of the basketball team at Central High School in Saint Paul but left in 1928 before graduating.

Parks was working as a porter on the Northern Pacific Railway when he saw photographs of migrant workers in old issues of *LIFE* magazine left on the train. At the next stop, in Seattle, he bought an old Voigtländer Brillant camera in a pawnshop. He taught himself the techniques of photography and began taking portraits. By 1937 Parks was taking pictures of neighbors, which he provided to local weekly newspapers without charge to advertise his activity as a portraitist. In February 1938, a group of his photographs was displayed in the windows of the Eastman Kodak store in Minneapolis, which helped him secure a job producing fashion photographs for a women's clothier in Saint Paul. Parks then moved to Chicago, where he found access to a darkroom at the South Side Community Art Center. An exhibition of his photographs of the neighborhood there in 1941 won him a Julius Rosenwald Fellowship.

The prestigious award enabled Parks to go to Washington, D.C., in 1942 to work with Roy Stryker at the Farm Security Administration (FSA).[2] Among the first photographs that Park submitted to Stryker was a series representing Ella Watson, a black custodian in their government building. Parks posed her before the American flag hanging in the lobby, gazing directly at the camera and holding her upturned mop and broom. He titled the photograph *American Gothic*, in reference to Grant Wood's famous painting, focusing attention on the divisions of race and class in Washington. By this time, the FSA had been reassigned to the Office of War Information, and Stryker assigned Parks to photograph the 332nd Fighter Group, the first composed entirely of African American pilots. In 1943 Stryker took Parks along when he moved to the Standard Oil Company, where the photographer made portraits of executives and views of rural America for public relations. In 1946 *Ebony*, the African American monthly

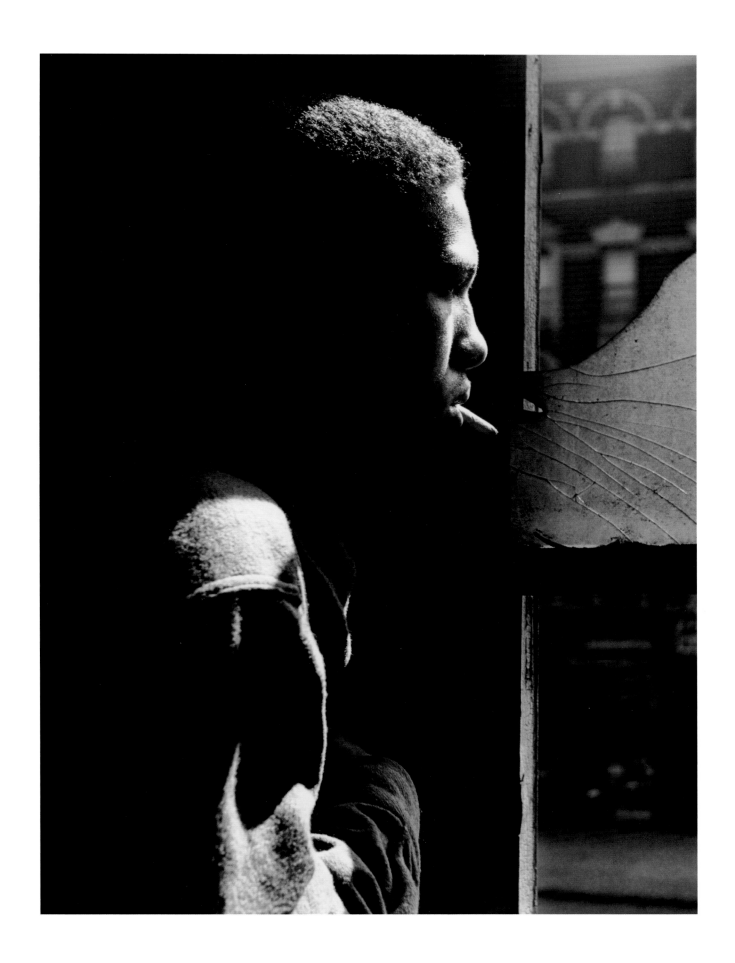

news and culture magazine, commissioned Parks to create a photoessay on the Northside Testing and Consultation Center in Harlem. To illustrate the programs of this mental health clinic, Parks used amateur models to represent fictional scenarios, one of which was the story of a gang leader. The photographer also worked for *Vogue* magazine and published his first books, two technical photography manuals, around this time.[3] Over the course of his career, Parks would publish more than 20 books, including novels, essays, poetry, biography and autobiography. He was also a talented musician and composer who wrote music in a range of styles, from pop songs and movie scores to symphonic pieces.

In 1948, Parks walked into the New York headquarters of *LIFE* magazine without an appointment, receiving a gruff reception from picture editor Wilson Hicks.[4] He was astute enough to appreciate Parks's work, however, and the photographer came away with a fashion assignment and the chance to pursue his own proposal for a photoessay on teen gang warfare in Harlem. Parks found that it was more difficult to work his way into the criminal underworld than it had been to pitch his idea. A detective at the 125th Street police precinct finally pointed him to Leonard "Red" Jackson, the 17-year-old leader of the Midtowners gang.[5] Parks offered to chauffeur Jackson and his "warlords" in his Buick Roadmaster automobile, and gradually he built a relationship with Jackson, who allowed him to accompany the Midtowners in all of their activities over several weeks. Parks witnessed petty crimes, street fights and diplomatic meetings over gang turf, but he also photographed Jackson relaxing at home and the Midtowners opening a fire hydrant to cool the neighborhood children on a sweltering day. When a Midtowner was killed by a

rival gang, the Sabers, Parks accompanied Jackson and his comrades to the view the body at the funeral home. As they were leaving, the Sabers attacked. The Midtowners retreated to the second floor of an empty building and readied themselves for defense. "Red knocked out a window," Parks later recalled, "reached for his .38 and prepared to start firing. From a dark corner I photographed him. It was that photograph that made him known throughout the world."[6]

Red Jackson, Harlem Gang Leader is one of the 21 images in Parks's photoessay, published in *LIFE* in November 1948, the first piece in the magazine by an African American photographer.[7] According to professional practice, images were selected, cropped and manipulated in the editorial process.[8] The editors declined photographs of Jackson washing dishes for his mother and playing with children, preferring more sensational images of gang violence. Parks understood the narrative of crisis imposed by this process and how it perpetuated stereotypes. He adamantly refused to let *LIFE* publish one of his photographs of Jackson holding a smoking gun as the magazine cover—its use might have sent Jackson to prison. The photographer went to the lab, retrieved the negative and cut it into pieces.[9] When the photoessay appeared, *LIFE* received letters of both praise and scathing criticism; publisher Henry Luce sent Parks a personal note of congratulations. Parks's work on the Harlem gang photoessay helped earn him a permanent position as a staff photographer for *LIFE*, and for years he traveled around the world on pictorial assignments. He also became a celebrity portraitist for the magazine, photographing, among others, author Langston Hughes, composer and musician Duke Ellington and actress Ingrid Bergman. During the 1950s Parks was a European correspondent. After returning to New

York, he focused his efforts on documenting the Civil Rights Movement.[10]

In 1961 Parks was named Magazine Photographer of the Year by the American Society of Media Photographers for his photoessay on Flavio da Silva, a boy in the slums of Rio de Janeiro, a project he adapted into a documentary film. The artist worked extensively in film during the 1960s, narrating, writing screenplays and directing. In 1963 he published *The Learning Tree*, an autobiographical novel about his childhood in Kansas.[11] The story was later dramatized as a feature film, the first in the United States to be written, directed and scored by an African American. In 1968, for a special *LIFE* magazine section on race and poverty, Parks made a selection of his own photographs of Harlem, Chicago and Brooklyn, which were published along with his own prose and verse. In the 1970s he cofounded and became the editorial director of the magazine *Essence*, dedicated to fashion, lifestyle and beauty for African American women. The most commercially successful of Parks's motion pictures was *Shaft*, the story of a black private detective that initiated the popular blaxploitation genre.[12]

IRVING PENN
American, 1917–2009

Marcel Duchamp, New York

1948
Gelatin silver print
24.4 × 18.8 cm (9⅝ × 7⅜ in.) Image
25.2 × 19.8 cm (9⅞ × 7¾ in.) Sheet

Milly and Fritz Kaeser Endowment for Photography, 2016.031

Over a career of nearly 70 years, Irving Penn remained a preeminent American photographer, known for his work in fashion, his celebrity and ethnographic portraits, and his Spartan still lifes. Born in Plainfield, New Jersey, he was the son of a watchmaker and a nurse.[1] He attended public schools, along with his younger brother Arthur, who would become a celebrated film director and producer.[2] In 1934, Irving Penn studied painting, along with industrial and graphic design, at the Philadelphia Museum School of Industrial Art. His most influential teacher was Alexey Brodovitch, a Russian émigré who came to the United States from Paris, bringing knowledge of Modernist aesthetics and haute couture to his work for *Harper's Bazaar* magazine.[3] Impressed by Penn's talent and nonchalant efficiency, Brodovitch engaged him as an unpaid assistant at the magazine for two summers.

After graduating in 1938, Penn moved to New York to become art director of *Junior League* magazine. The job enabled him to buy a Rolleiflex camera, with which he explored and photographed the city. After a few years in New York, Penn spent a year painting in Mexico and came to understand the limits of his capabilities with the medium. He returned to New York in 1943 and became the assistant to Alexander Liberman, art director of *Vogue*.[4] Assigned to supervise magazine covers, Penn arranged and photographed a still life that became his first *Vogue* cover, published on October 1, 1943, and began his career as a professional photographer. Working for the publisher Condé Nast provided opportunities to work in state-of-the-art studios and laboratories, with guidance from the professional staff. During World War II, Penn joined the American Field Service and drove ambulances in India and Italy. He met the painter Giorgio de Chirico on the street in Rome, and his photographs of the painter were the first in a remarkable oeuvre of celebrity portraits.[5] In 1946, as a *Vogue* staff photographer, Penn developed a personal style in his fashion and portrait imagery, centered on a distinctive profile or arresting motif.

Soon Penn was regularly shooting portraits for magazine features, concentrating on the face in an empty shaded space. Then, in order to photograph in the full figure, he arranged two vertical flats in his studio to form a variable niche in which he placed his subjects. He meant for this device to disrupt the comfort of sitters who were used to being photographed. "This confinement, surprisingly, seemed to comfort people, soothing them," he wrote. "The walls were a surface to lean on or push against. For me the picture possibilities were interesting, limiting the subjects' movement seemed to relieve me of part

of the problem of holding on to them."[6] Many celebrities of the 1950s posed for full-length portraits in Penn's claustrophobic corner—authors, actors, musicians and artists—but Marcel Duchamp was among the first.[7] Here, unperturbed by the set, the elegant Duchamp leans back into the corner, appropriated for his own comfort while waiting for the photographer to complete his work. He gazes directly into the lens, with a confident defiance.

When Penn made this photograph in 1948, Duchamp was extolled for having transformed modern art.[8] He had challenged the very definition of creativity during the 1910s by selecting common, mass-produced objects and presenting them as original works of fine art, which he called "readymades." The selective act, as opposed to fabrication by hand, had sweeping implications for what a legitimate work of art must be—a notion that continues to reverberate in conceptual art today. Duchamp studied perspective, optics and visual psychology, but ultimately he was less concerned with visual beauty than with formal and associative meaning. With his friends and collaborators Man Ray (Cat. no. 50) and Francis Picabia, Duchamp brought the ideas of Dada to the United States, but he never joined a formal movement. After World War II, when this portrait was taken, Duchamp was prominent in the art worlds of both Paris and New York, dividing his time between Montparnasse and Greenwich Village. He had become more instigator than exhibitor and claimed to have forsaken art for chess. Yet in Duchamp's New York studio, he was secretly crafting his last major artwork: *Étant donnés*, now at the Philadelphia Museum of Art.[9] It is a haunting diorama, glimpsed by the viewer through a peephole in a wooden door; beyond, on the ground outside, is the body of a nude woman, still and seemingly lifeless. However, one of her hands is raised, holding a gas lamp in the air before a distant landscape.

It was in 1948 that Penn first traveled to France to photograph the Paris fashion collections for *Vogue*. After several hectic days, he went to Peru, where he rented a photographer's studio in Cuzco. Over two weeks he took about 200 portraits of local subjects, which became the first in an occasional series of ethnographic portraits from around the world. These images of human nature and personality were quite different from his figural studies of 1949–50, when he created a suite of posed female nudes, focusing exclusively on their torsos. When printing these images he used bleach and other chemicals to eliminate skin tones, making the flesh appear harsh and marmoreal.[10]

In 1950, Penn married the Swedish model Lisa Fonssagrives, who had become a favorite subject of his fashion work, such as the famous image of Fonssagrives in Jerry Parnis's Harlequin Dress.[11] Over the next two decades, he continued as staff photographer at Condé Nast, while also operating an independent New York studio for commercial work. Among his own ongoing creative projects was a series of portraits of laborers and tradespeople, ever present but little noticed. The images are reminiscent of photographs by August Sander (Cat. no. 27), but instead of finding his subjects in their workplace, Penn brought them into the studio in their everyday clothes and invited them to carry implements of their occupation. They confront the camera directly, like Duchamp, with dignity and pride that seems comparatively sincere.

Penn seems to have been unsympathetic to high fashion of the 1960s, when a youthful spirit replaced

elegance. Fonssagrives's modeling career ended and she concentrated on her work as a sculptor, and Penn likewise turned more of his attention to creative work. He built a portable studio with which he traveled the world in the late 1960s, portraying local subjects in Dahomey, Nepal, Cameroon, New Guinea and Morocco. Native dress defines these subjects, as had the tools of Penn's workers, but the images reveal a common humanity within the cultural diversity.[12]

In the mid-1970s, Penn created close-up still-life views of modest objects found on city sidewalks— old gloves, wilting flowers and even cigarette butts. Presented in dramatic, large-scale platinum prints, these humble objects were cast as the visual records of precious artifacts. A selection of these oversized prints made up the exhibition *Street Material*, shown at the Metropolitan Museum of Art in 1977.[13] Still-life compositions dominate Penn's late creative work, sculpturesque images of such objects as steel blocks and bleached animal skulls, precisely composed and printed on oversized sheets of aluminum coated with a platinum emulsion. A retrospective exhibition of Penn's diverse oeuvre was presented by the Metropolitan in 1984, the first of several exhibitions at major American museums to celebrate his achievement over the following decade.[14]

FRITZ KAESER
American, 1910–1990

André Roch Skiing

1948
Gelatin silver print
23.2 × 30.2 cm (9 ⅛ × 11 ⅞ in.) Image
27.8 × 35.5 cm (11 × 14 in.) Sheet

Gift of Milly Kaeser, 1997.041.005.R

In an era when nature photography was popular, Fritz Kaeser represented his deep relationship to the American West in photographs of alpine meadows and arid deserts.[1] Born in Greenville, Illinois, Frederick Kaeser inherited his nickname Fritz from his grandfather, who was one of a group of immigrants who founded the Helvetia Milk Condensing Company in 1885.[2] These Swiss farmers were the first to package evaporated milk in cans—a shelf-stable consumer product that sustained pioneers in the West and American soldiers in World War I. Kaeser grew up in Madison, Wisconsin, where his father was Midwest manager for Helvetia, which was renamed Pet Milk in 1923. It provided the family with such affluence that Kaeser and his brother were able to pursue any occupation, travel or hobby that interested them. As well as indulging a family enthusiasm for skiing, Fritz began making photographs as a boy. In 1928 he attended the University of Wisconsin in Madison to study industrial arts. Soon his interest shifted to fine art, and he transferred to the School of the Art Institute of Chicago.

In 1931 Kaeser went to Laguna Beach, California, to work for a year as assistant to William Mortensen, a leading still photographer for the film industry.[3] Famed for his dramatic, Pictorialist style that evoked the movement and special effects of cinema,

Mortensen had often worked for director Cecil B. DeMille. He also made creative photographs of extravagant sentimentality and eroticism that attracted a devoted following, working in a style calculated for printed reproduction in halftone.[4] In Mortensen's shop, Kaeser learned about photographic reproduction, refined his darkroom skills and even shot publicity stills for movie stars.

Kaeser returned to Madison in 1933 and opened his own studio and camera store. Later in the year, on a blind date, he met Milly Tangen, a University of Wisconsin dance student and member of Orchesis, a performance troupe organized by modern dance pioneer Margaret H'Doubler. The couple was married in 1934. They built a home in Madison with a large dance studio and darkroom, and the house became a gathering place for area dancers, artists and architects.[5] Kaeser made creative photographs of dance, landscape views and images of Wisconsin lakes, which were shown in national salons during the 1930s.

In 1938 Milly Kaeser attended the Perry-Mansfield Dance Camp at Steamboat Springs, Colorado. Fritz accompanied her, photographing rehearsals and performances, and making figural portraits of dancers, including José Limón, Hanya Holm and Martha Graham (see Cat. no. 34). Afterward the Kaesers

went on to Aspen, Colorado, for a skiing vacation. They were enchanted by the area and bought a plot of land at the crossing of Conundrum and Castle creeks, where they built a log cabin. Each winter they returned for an extended visit, and Kaeser took his camera into the surrounding wilderness. He met André Roch, a Swiss mountaineer, champion skier and avalanche expert, who was in Aspen to advise on the development of recreational skiing.[6] Roch made a survey of Hayden Peak and plotted ski trails; at the beginning of World War II, he settled in Aspen and worked as a ski instructor when work on the ski resort was suspended for the duration.

In the spring of 1943 Kaeser enlisted in the Army, joining the 10th Mountain Division Light Infantry, and was sent to Europe as the ski troopers' photographer.[7] His battalion saw action in the mountains of Italy, beyond the Resia Pass in Austria, and later in Yugoslavia. Kaeser photographed their engagements and experiences, and many of his images were published in the battalion newspaper, The Blizzard. By trial and error, he developed methods for photographing in challenging alpine conditions. This work required legible, reproducible images, and he adapted his style to a sharply focused manner over a wide field of vision. After leaving the Army in 1945, Kaeser sold his Madison studio and traveled with his wife through Central and South America for a year. In 1946 they returned to Aspen, where Kaeser opened his second studio, K2—so named in reference not only to his own name but to the world's second-highest mountain, Mount Godwin-Austen, or Chhogori, in the Himalayas, to indicate his specialty in outdoor photography.[8]

André Roch Skiing exemplifies Kaeser's work after the war and his skills as both photographer and skier.

He photographed in wilderness locations accessible only on cross-country skis and used carefully selected equipment, and his own refined techniques, to achieve high-altitude action photographs unusual at the time. "My attempts at photography in the high mountains on skis," Kaeser wrote, "have led me to use a small outfit which fits into a canvas bag over one shoulder. This allows for reasonably fast downhill skiing with fair safety. A Plaubel wide-angle lens, along with other accessories are carried on a skiers belt. The whole assortment has been worked out for a one day climb."[9] Kaeser carried a Graflex Speed Graphic camera and a Kodak Ektar lens, exposing $3\frac{1}{4} \times 4\frac{1}{4}$ inch negatives, often using a yellow filter to shoot on reflective snowy slopes beneath intensely bright skies. He exposed by meter and made fine adjustments in the darkroom to compensate for the wide range of value.

Here, the photographer contrasts the diagonal hillside with the vertical pine trees in the distance. He took a position in the shade, with the sun to the side and above him, and anticipated Roch's route and manoeuver, catching the skier with his shadow cast downhill. The ski pole in Roch's right hand accentuates the obtuse angle of descent, while his left pole drags on the surface of the snow, sending up floury plumes that seem to rise and merge with the clouds in the sky. Despite the high-key tonality of the image, the details of Roch's goggled face and belted parka are still visible in the shadows. By contrast, icy crystals twinkle in the blanket of undisturbed snow. This masterful photographic achievement was acknowledged in 1948 as winner of the Graflex World-Wide Photo Contest.

In 1950, Fritz and Milly Kaeser built a house east of Tucson, Arizona, near Saguaro National Park.

According to the seasons, they divided their time between the Colorado Rockies and the Arizona desert. The photographer opened a studio in Ash Alley, a colonial-era district of adobe buildings with dirt floors in Old Tucson.[10] Kaeser also befriended Frederick Sommer (Cat. no. 68), who lived in northern Arizona. That photographer's unusual vision and fresh ideas influenced Kaeser, who made distant landscape studies without a single focal point or visible horizon. He also experimented with close-up photographs of surface patterns found on natural objects that he collected from field, forest and mountain. In the coming years, Kaeser would also make solarized and hand-painted negatives.[11]

NICKOLAS MURAY
American, born in Hungary, 1892–1965

Untitled (Still Life with Coffee)

about 1951
Carbro print, touched with watercolor
33.7 × 44.1 cm (13¼ × 17⅜ in.) Image
50 × 59.5 cm (19¾ × 23⅜ in.) Sheet

Humana Foundation Endowment for American Art, 2015.027

Soft-spoken, debonair and handsome, Nickolas Muray was an Olympic fencer, a pilot and a distinguished art collector but made his living as a photographer. He was one of the most sought-after celebrity portraitists of the 1930s, and later became a pioneer of advertising photography. When Miklós Mandl was born in Szeged, Hungary, his Jewish parents purposely gave him a Hungarian name.[1] When he was two years old, his ambitious father moved the family to Budapest, where Mandl was able to study the graphic arts in secondary school. He became an expert in the processes of lithography, photoengraving and photography. After graduation, he moved to Berlin for advanced studies in color photoengraving, and then took a job at the Ullstein publishing company. Mandl sailed to the United States in 1913. Upon arrival at Ellis Island, he renamed himself Nickolas Muray and declared himself to be an atheist.

In New York, Muray immediately found a union job as an engraver and color separator at the Stockinger Printing Company in Brooklyn and studied English in night school. He divided his spare time between the sport of fencing and an enthusiasm for photography. Eventually, the championship fencer found his way to the New York Athletic Club, where he trained every day and regularly competed at the top level. He made friends among the athletes and dancers in New York, whom he photographed. He converted a room in his Greenwich Village apartment into a studio space and darkroom. In 1922 he created an extended series of figural and dance photographs of Desha Delteil, principal dancer of the Fokine Ballet troupe. He became a regular columnist for *Dance* magazine and joined the art and theatrical circles of New York. In 1923 Muray met Miguel Covarrubias, the Mexican illustrator, caricaturist and painter.[2] They became good friends and shared an interest in collecting. With Covarrubias's guidance, Muray amassed a remarkable collection of Mexican art.[3] He was the national fencing champion for sabre in 1928–29, and competed on the American Olympic team in the games in Amsterdam in 1928 and Los Angeles in 1932.[4]

A photography contract with *Vanity Fair* prompted Muray to move to Hollywood in 1929. There, one of his first projects was a series on Greta Garbo, then at work on Jacques Feyder's movie *The Kiss*, the last silent film produced by Metro-Goldwyn-Mayer. He shot about half a dozen negatives of the actress dressed in an unbuttoned men's white shirt. *Vanity Fair* chose not to use the images, so the photographer sold four of them to *Screenland* magazine; their publication caused a sensation, certifying his stature as a celebrity

photographer. The actors, dancers, film stars and writers whom Muray photographed often gathered at Wednesday-night soirées in his studio.[5] Helen Hayes, Langston Hughes, Gertrude Vanderbilt and Charlie Chaplin (Fig.16), were among his frequent guests.

After the stock market crash in 1929, Muray gradually turned to more reliably profitable commercial work. His extensive knowledge of printing and photographic technology compelled his interest in the color technique of carbro printing—taking its name from its chief components, carbon and bromide—which was compatible with industrial offset lithography. To create a color image, the photographer exposed three negatives of the same image, through red, blue and green filters, and produced three separate gelatin silver bromide prints. Each was chemically and physically converted into a low-relief image of pigmented carbon on transfer paper. The layers of color were then offset in superimposed layers onto the final print. Muray understood, as few other photographers did, exactly how each component image of a carbro print could be transferred to zincographic matrices and printed by mechanical presses onto paper. In 1931, Muray photographed a group of models in beachwear posed around a Miami swimming pool. He synthesized his carbro process with industrial offset lithography to produce an advertisement in *Ladies Home Journal*, the first color reproduction in an American mass-publication magazine.[6] Muray soon received a flood of editorial and advertising

Fig 16. — Nickolas Muray, American, born in Hungary, 1892–1965, *Charles Chaplin*, 1924, gelatin silver print, Dr. M.L. Busch Fund, 1979.073

contracts for photographic color images. *McCall's* magazine provided a lucrative contract for him to create color images for their homemaking and food features. He undertook a range of commercial projects, from magazine advertisements to the design and photography for color packaging. Nearly every popular American lifestyle and fashion magazine adopted the process.[7]

Muray traveled to Mexico City in 1931 to visit Covarrubias and his wife, the former dancer Rosa Rolanda. Their home, with its great art collection spanning historic Olmec and Aztec sculpture to contemporary painting, was also a gathering place for an international circle of artists and intellectuals. On this visit, Muray met Diego Rivera and Frida Kahlo, the first couple of Mexican art. Rivera's true artistic genius was matched by his imposing personality. He was a well-known roué, and Kahlo was unashamed of her indiscretions. Soon Muray began a love affair with her that lasted over the next 10 years. The intensity of their relationship is reflected in extensive correspondence and in Muray's photographic portraits of Kahlo, many made as carbro prints in tropical hues.[8]

This carbro print mock-up exemplifies the design and photography of Muray's later career, apparently conceived and created by his studio in New York City.[9] It was not intended as a creative photograph, but rather as a magazine advertisement designed to attract the eye and convey an immediate message. The artist set up the composition with opposing diagonals: while the walls of the fictive room and its perspectival window frame draw the eye to the right, a checkered tablecloth in red and white point to the left and to the distant landscape. The effect is an awareness of complex depth, but a focus of attention on the center of the image, where a stream of coffee pours into a cup. Close inspection reveals that the patterned tablecloth is not woven or printed but made up of ribbon stretched in a grid over a white cloth, typical of Muray's practice of creating props in the studio from art materials.

Muray and his studio used brilliant color to visually evoke all the senses. The cozy familiarity of an American interior on a sunny autumn day provides a congenial setting. This warmth is enhanced by a range of tactile surfaces, from the hard, smooth china, gleaming in white light, to the knobby kernels of Indian corn, wrapped in their brittle husks. The stream that falls through the middle of the composition evokes the babbling sound of liquid filling the cup. Swirling bubbles on the surface of the hot coffee call up the aroma that must fill the air. Sensations of appetite are strengthened by the sight of the fresh apple and cheese. All of these details frame our imagined experience. Muray often exaggerated the scale of some elements in his advertising compositions to enhance their visual impact, and this technique is used to great effect here to emphasize the allure of the product: Muray pulls the hand, the coffee pot and the cup right up to the picture plane, printing them in a higher key. The image is designed to convey its message immediately and forcefully, during the brief, unconscious turn of a magazine page.

ROBERT DOISNEAU
French, 1912–1994

Conquest of the Skies

1950
Gelatin silver print
24 × 32.3 cm (9½ × 12¾ in.) Image
30.2 × 40 cm (11⅞ × 15¾ in.) Sheet

Robert B. Mayer Fund, 1976.023.003

Robert Doisneau's intentionally familiar imagery exemplifies the work of a generation of Parisian photographers who favored positive images of human interest. He was one of a group of photographers described as the French Humanists, artists who expressed in their work the ambition that their country might regain the strength and egalitarianism that it enjoyed before World War II.[1] Many in the group supported the political values of the French Front Populaire of the mid-1930s, and some belonged to the Communist Party. Their approach and imagery grew in large part from the poetic realism of Hungarian photographers such as André Kertész and Brassaï (Cat. nos. 22, 31). Many represented traditional elements of French culture, reidentifying and celebrating what it was to be French.

The son of a plumber, Robert Doisneau was born the Parisian suburb of Gentilly, Val-de-Marne.[2] He was raised by an unloving aunt after his father was killed in World War I and his mother remarried. As a teenager he attended the Estienne School in Gentilly, where he trained for a career in the book industry. He was fascinated by the visual arts and studied figure drawing and graphic design, along with traditional printing technology. Doisneau graduated in 1929, only to discover that he had become a journeyman in an antiquated industry. He worked as a draftsman

at Atelier Ullmann, where he learned the techniques of photography, which was being promoted as the upcoming illustrative medium for advertising and reportage. Then, in 1931, he became an assistant to the photographer André Vigneau. Doisneau developed his style and technique by exploring the streets of suburban Paris with his camera. His first photographs to be published—a series on a neighborhood flea market—appeared in *Excelsior* magazine in 1932.

After completing his military service, Doisneau took a job as a photographer at the Renault automobile plant at Boulogne-Billancourt. In his own time he continued to shoot on the streets, selling his anecdotal photographs to French picture magazines. In 1934 he met Pierrette Chaumaison, who was bicycling through a suburban village where he was on holiday with his camera; they married two years later. Doisneau lost his job at Renault for chronic tardiness in 1939. Charles Rado recruited him to the Rapho agency as a freelance photojournalist, and many of the images he created were sold to the thriving French postcard industry. At the beginning of World War II, Doisneau re-enlisted and briefly served in the infantry before being transferred to a photography unit. Discharged from active duty in 1940, he joined the Resistance. His skills as an engraver, photographer and printer made him a valuable to

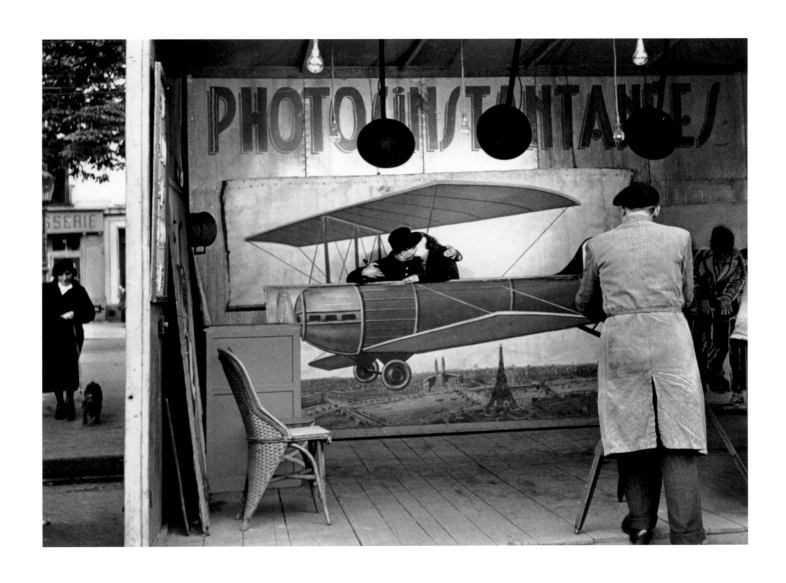

the group as a counterfeiter of passports and documents. He continued to photograph the people and places around him, including the Resistance's illicit basement printing shop. Doisneau's photographs of the liberation of Paris in 1944 are images of personal relief rather than crowds or mass celebration. Having begun a family, Doisneau worked to rebuild his career as a freelance advertising photographer and photojournalist, working for Pierre Betz, publisher of the magazine *Le Point*, and selling his work through the Alliance Photo Agency. In the distressing years of postwar reconstruction, he strove to create uplifting images. He meandered through Paris with his camera, photographing the old places and thriving people that gave the city its identity and celebrating the suburbs of Gentilly and Montrouge when they were still working-class communities represented in the realist films of Julien Duvivier and Marcel Carné. He never moved from the Parisian suburbs.

In 1946 Doisneau rejoined Rapho, his photographs regularly appearing magazines like *L'Album du Figaro* and *Le Point*. He declined an invitation to join Magnum—perhaps out of loyalty to Rapho's Raymond Grosset, perhaps out of inertia. Doisneau worked as a fashion photographer for French *Vogue* during the era of the New Look; he was good at the job, loquacious and pleasant to work with, but he preferred the inelegance of reality to beautiful models in unobtainable settings.[3]

In 1947, the year Doisneau won the Prix Kodak, he met the writers Jacques Prévert and Robert Giraud. Two years later, his photobook *La banlieue de Paris* was published and quickly became a model for French humanist photography.[4] He began a regular series of photobooks, combining his images on a given topic with an introduction or related verse by his friends, such as Blaise Cendrars and Jacques Prévert. Doisneau credited Prévert with giving him the confidence to photograph the everyday street scenes that most people simply ignored. Among the photographer's favorite subjects in the early 1950s were the street fairs, sideshows and carousels that circulated among the parks and neighborhood squares of the city—contemporary manifestations of medieval traditions, attracting a wide variety of local residents for entertainments that were special, yet familiar. Doisneau was so drawn to these street fairs that he befriended many of their vendors and entertainers, and photographed them often. A particular favorite was the Wagner Family Flea Circus, which he first photographed in Montparnasse in 1951.

This image of a photographer's novelty portrait booth was taken at one of the unassuming street fairs that Doisneau loved.[5] A variety of painted comic backdrops can be seen stacked against the walls of his canvas booth, but the present customers, a couple, have chosen to be photographed together as if they were flying in a biplane over the streets of Paris. He wears the uniform and cap of a postman or police officer, while she appears fashionably dressed and coiffed. Like his colleague, Doisneau snapped them as they kiss for the camera—indeed, kissing couples were a favorite subject of Doisneau. Here they occupy the center of the image, standing out in the bright spotlights, while their photographer faces them to operate his view camera, looking very much the part in his stained smock and beret. This image is cropped from a larger negative, titled *Photographie aérienne*, which shows more of the photo booth, beneath a sign advertising "Quick Photographer—Comic Photographs—Immediate Delivery, postcards, identity and passport photos." The larger image shows

that this booth is one of several in a line at a street market or fair, located in the shade of a spreading tree. A woman walking her dog is visible at left, in the gap between two booths. This image shows a shared interlude from the ordinary—memorable but, as emphasized by the dog walker, not all that remarkable. These are comfortable and reassuring images.

In 1951–52 Doisneau's work was included in the exhibition *Five French Photographers*, organized by Edward Steichen for the Museum of Modern Art in New York.[6] In the 1950s he was active in Group XV, an organization of photographers devoted to improving both the artistry and technical aspects of photography. He broadened the scope of his work, tending toward more ironic or humorous subjects. Doisneau produced scores of photobooks, which always generated respectable sales, along with travel books depicting French cities and regions. A raconteur and writer, he enjoyed rich and creative friendships with writers, musicians and artists. He had a convivial talent for portraiture and photographed many artists, including Alberto Giacometti, Jean Cocteau, Fernand Léger, Georges Braque and Pablo Picasso.[7] A retrospective exhibition at the Museum of Modern Art, Oxford, introduced a new generation to his work in 1992, two years before his death.[8]

WYNN BULLOCK
American, 1902–1975

Barbara

1956
Gelatin silver print
24.5 × 13.4 cm (9⅝ × 5¼ in.) Image
24.5 × 13.4 cm (9⅝ × 5¼ in.) Sheet

Samuel J. Schatz Fund, 1977.006

With the conviction that photography was the principal visual medium of his time, Wynn Bullock tried to capture the mystery and exhilaration of the universe, creating enchanting images that can be mysterious and baffling. The artist experimented with photographic techniques to express his ideas, and developed his own methods of solarization. Bullock was born in Chicago but grew up in South Pasadena, California, where his divorced mother attended law school, later to become a judge and the first woman to sit on the bench of the Superior Court of California.[1] He was a talented singer as a boy, and after graduating from high school he studied music in New York. He found a place in the chorus of Irving Berlin's *Music Box Revue* on Broadway in 1923 and became understudy to the lead tenor.[2] A major role followed in the Music Box Review Road Company. During the mid-1920s, Bullock was in Europe, studying voice and performing in Germany, Italy and France. In Paris, he was enchanted by the paintings of the Impressionists and intrigued by the contemporary photographs of László Moholy-Nagy and Man Ray (Cat. nos. 25, 50). He bought his first camera in Paris and used it to photograph his European travels.

Back in the United States, Bullock left his music career to marry Elizabeth McCarty in 1925; they settled near her parents in West Virginia and began a family. Bullock took some prelaw courses at West Virginia State University and continued to photograph in his spare time. In 1938 he moved his family back to Los Angeles, with a plan to study law. Bullock enrolled at the University of Southern California but was soon attracted to the nearby Art Center School. His most influential teacher at that time was Edward Kaminski, who encouraged his students to explore Modernist styles and experimental techniques. Taking Man Ray's photograms as his point of departure, Bullock experimented with solarization and accidental darkroom effects. He was a voracious reader, and the writings of Albert Einstein, Alfred North Whitehead and Lao Tzu influenced his work. He graduated from art school in 1940 and became a commercial photographer in Los Angeles. The first solo exhibition of Bullock's creative photographs was mounted at the Los Angeles County Museum of Art in 1941. At that time, he was immersed in the ideas of Alfred Korzybski, a semanticist who suggested that our understanding of the world is limited by our senses and the languages we have invented to communicate.[3]

Bullock separated from his wife in 1941, and they divorced. He enlisted in the service early in World War II and was assigned to work as an industry photographer at Lockheed Aircraft, and then

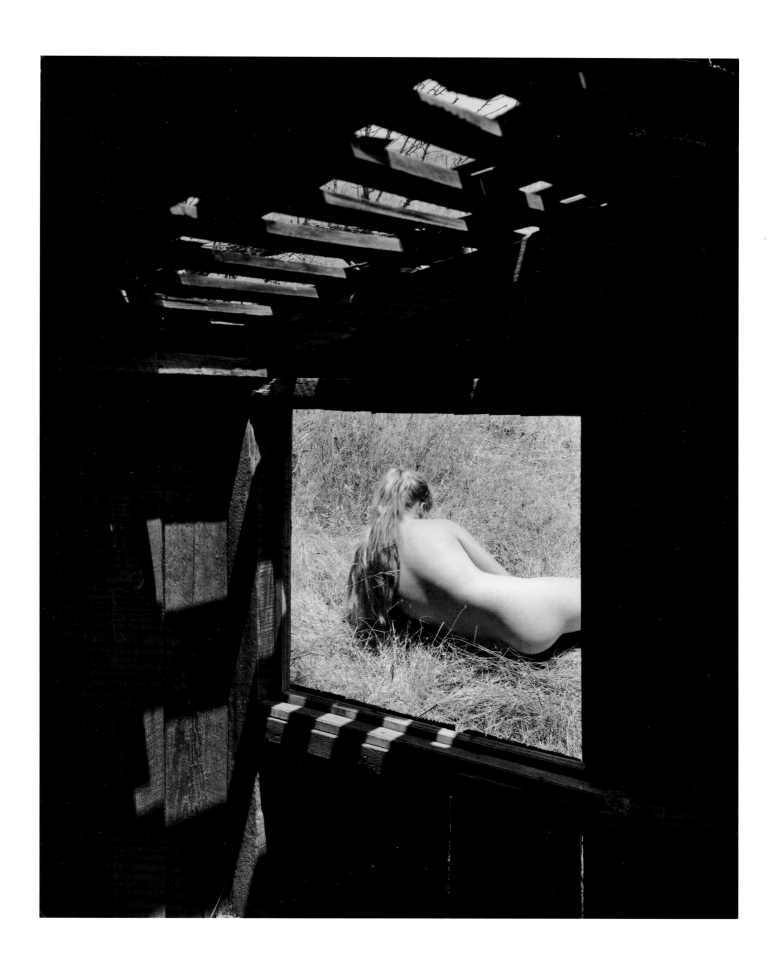

at Connors-Joyce Corporation. He married Edna Jeanette Earle in 1943 and began a second family. Bullock developed a technique for creating solarized linear effects, for which he was awarded a patent. Korzybski's ideas led Bullock to ideas of replacing imprecise language and old mythology with new, all-embracing cultural symbols. In 1946, he was awarded the photographic concession at the Fort Ord Army base, and he moved with his family to nearby Monterey. The artist used extended and multiple exposures, and inverted and negative printing in the darkroom, to create still lifes and landscape views.

In 1948 Bullock met Edward Weston (Cat. no. 16) and had the opportunity to study Weston's work. He began to produce clearer, more sharply focused images of nature. This clarity of detail made Bullock's mystical imagery appear more baffling. He wanted visually to suggest that there is more of existence than is humanly perceptible. Gradually, the artist began to conceive of his images as representations of events rather than objects or places. Two of his polysemantic photographs were included in Steichen's *Family of Man* exhibition in 1955, broadcasting his stature as a masterful creative photographer.

Barbara is one from a series of Bullock's photographs centered around a window. In thoughtful compositions he combined two separate, detailed images on one negative.[4] Like Minor White's (Cat. no. 67) doorway photographs, Bullock's compositions are metaphors for concealed realms beyond subjective human experience, the window functioning as a portal between two dimensions. Bullock was instinctively drawn to the beauty of the natural world, where trees and flowers manifest the cyclic forces of life; the human body and sensual experience are also of this realm. Many of his photographs contrast these vital motifs with old, decayed buildings returning to nature. Bullock conceived of his photographs as space-time events, in the Einsteinian sense.

Here, ruins of a weathered wooden shack, its roof disintegrating, are pierced by a view of the back of a youthful nude woman reclining on the sunlit ground, the long, blonde hair falling down her back complementing the surrounding grass in form and tone. She faces away, perhaps concentrating on a book. The photograph conveys the warmth of the sun on her skin and accentuates the tactile suggestion of the textures around her. No less tactile are the dark recesses of the weathered lumber of the foreground ruin. The perspectival recession of the square window frame seems to clash with the angles of the slanted roof beams to create a confusing, discordant space. Compared to the prospect of sunshine and germinal youth, the ruins suggest the preceding experience of time, hopes and dreams gone by. Bullock's emphasis on sensuality in this image speaks to the momentary experiences and, by extension, the temporal nature of human life. The visual effect of this photograph depends upon the technical achievement of maintaining the bright accents and dark tonalities simultaneously. Bullock opened and closed the lens over several minutes to capture subtle shifts of light. He wanted his images to attract viewers and provoke them to confront the secrets of the universe, like philosophers who seek answers to the questions of existence.

To express his ideas Bullock often used alternative photographic techniques, such as long exposures, and inverted and negative printing. Early in the 1960s, he became interested in the quickly evolving techniques of color photography and created experimental "Color Light Abstractions."[5] He

constructed an open wooden frame, slotted to hold several sheets of glass horizontally, each separated by several centimeters. He spread refractable materials like water, oil, solvent or pigments on the glass, then layered them in the frame, lighted them from the sides, and photographed them from above with Kodachrome film. Opening and closing the lens over several minutes, the artist captured changing effects of light and color. Bullock intended that these images reveal light as an animating force in the universe. He projected his color transparencies to illustrate his lectures, but he was never satisfied with the imprecise, expensive and unstable color prints of the day. He abandoned the project after about three years, and only after his death were some of his color transparencies printed as dye imbibition prints. In 1975, Bullock joined Ansel Adams, Harry Callahan, Aaron Siskind and Frederick Sommer (Cat. nos. 46, 62, 64, 68) as one of the founders of the Center for Creative Photography at the University of Arizona, where his archives reside.[6]

HENRI CARTIER-BRESSON
French, 1908–2004

Lisbon

1955
Gelatin silver print
44.7 × 29.7 cm (17⅝ × 11¾ in.) Image
50 × 40 cm (19⅝ × 15¾ in.) Sheet

Gift of Arthur J. Decio, in memory of Rev. Theodore M. Hesburgh, C.S.C., 2015.039

When the miniature handheld camera became the basic instrument for photographers in the field, Henri Cartier-Bresson established himself as master of candid photography, He developed a knack for photographing people without their knowledge. His most remarkable talent, however, was for capturing the moment when the essence of an event coincided with a compelling visual composition.

Cartier-Bresson was the eldest of five children of a leading textile manufacturer, whose thread was included in every French sewing kit.[1] He grew up in Paris in the care of a governess who taught him both French and English. He had a Kodak Brownie camera as a boy and took snapshots of his family. He loved to draw, and his talented uncle Louis—who was killed in World War I—taught him to paint. After graduating from the prestigious Condorcet High School in Paris, Cartier-Bresson continued his art study with the portraitist Jacques Émile Blanche. In 1927 he worked in the studio of André Lhote, the influential Modernist painter who taught how Cubism shared fundamental compositional principles with classical and Renaissance art. The young artist socialized with the Surrealists, who gathered at Café Cyrano in the Place Blanche in Paris to discuss the subconscious mind as a source of inspiration, and how ordinary photographic images, taken from their context, could provide revelatory meaning.[2]

In 1928–29 Cartier-Bresson was in England, studying language and art at the University of Cambridge. Afterward he presented himself for national service at Le Bourget near Paris. In the Army he met Harry Crosby, an American expatriate who gave him his first miniature handheld camera. They explored Paris together, taking photographs and then developing their films. After completing his service, Cartier-Bresson bought a 35 mm Leica rangefinder camera, with a 50 mm lens and rapid black-and-white film ideal for taking candid photographs. The photographer covered the metal parts of his miniature camera with black tape to make it more unobtrusive and keep his process as stealthy as possible. He never used a flash, which he considered impolite. He was inspired by the photographs of André Kertész (Cat. no. 22), and also tried to incorporate formal lessons from Post-Impressionist painting in his images, while Brassaï's work (Cat. no. 31) prompted him to capture the psychology of his subjects. Cartier-Bresson found the darkroom tedious and organized his practice in order to reduce the time he needed to spend there. He composed his images in the viewfinder to avoid using the enlarger, and, as a rule, he printed his negatives in full-frame,

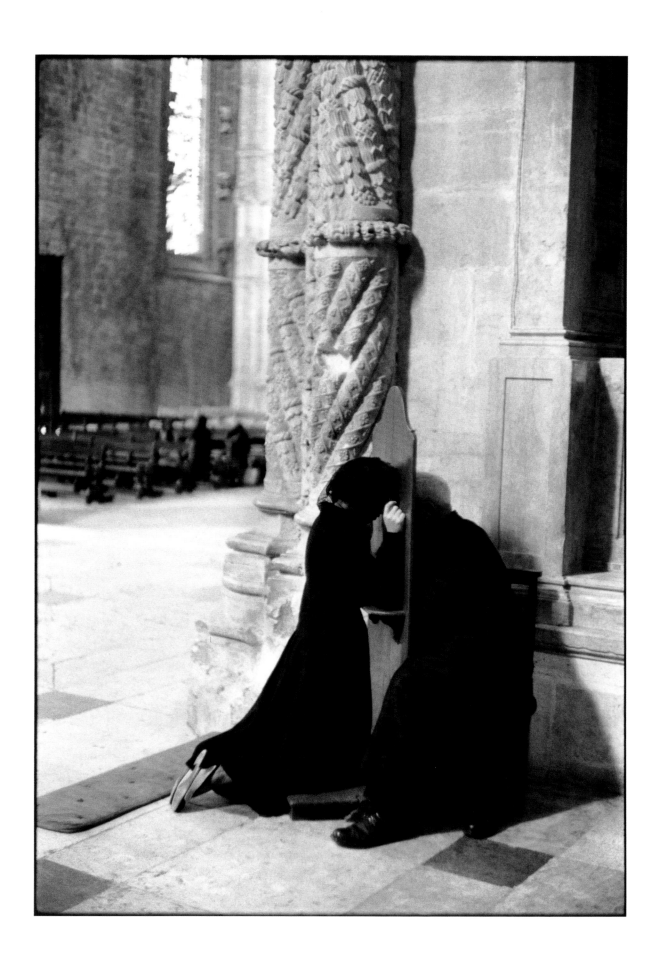

without cropping or other manipulation. To demonstrate this, he usually included a few millimeters of unexposed negative around the image area in the developed print as a thin frame of black.

In 1932, Cartier-Bresson began to publish his photographs in *Voilà* and other pictorial magazines. Frustrated by the transience of these printed media, he imagined creating more enduring photobooks, but none of his proposals found a publisher. He shared these efforts and frustrations with his friends, the photojournalists Robert Capa and David "Chim" Seymour (Cat. nos. 49, 61), who all briefly shared an apartment. In 1934 Cartier-Bresson visited to New York to attend an exhibition of his work at the Julien Levy Gallery. Carmel Snow, the editor of *Harper's Bazaar*, gave him an opportunity to try fashion photography. He also studied documentary cinema with the Nykino film cooperative, led by Paul Strand (Cat. no. 66).

After returning to Paris, Cartier-Bresson became a production assistant to filmmaker Jean Renoir (Cat. no. 85) and worked with Herbert Kline on *Victoire de la vie* (Return to Life), a documentary film on medical relief to the Republicans in the Spanish Civil War.[3] At the outbreak of World War II, he joined the Army and became a battlefield photographer. He was captured by the Germans at the Battle of France at Saint-Dié in June 1940. For two and a half years he endured forced labor as a prisoner of war. On his third attempt, Cartier-Bresson escaped and found refuge at a farm in Touraine, where the Resistance supplied him with forged papers. He retrieved the Leica camera that he had buried near the battlefield in the Vosges Mountains and assisted in the production of counterfeit documents. After the war, the U.S. Office of War Information commissioned

Cartier-Bresson to create *Le retour* (The Return), a documentary film about released French prisoners and war refugees.[4]

In 1947, the Museum of Modern Art mounted a retrospective exhibition of Cartier-Bresson's photographs. By that time, he had joined with his old colleagues Chim and Capa—along with George Rodger and William Vandivert—to establish Magnum Photos, a cooperative picture agency.[5] This bureau quickly became a leading international distributor of images to newspapers, magazines and publishers. For nearly a decade, Cartier-Bresson worked for Magnum in Asia. His photographs at this time generally concentrated more on the humanity of his subjects than overall design. He photographed Gandhi's funeral in India in 1948, the last stage of the Kuomintang administration in China, and the first six months of the Maoist People's Republic.[6] In 1952 Cartier-Bresson finally published his first book of photographs. His Greek-born French publisher Tériade chose the French title *Images à la sauvette*; in English the book was called *The Decisive Moment*.[7] The book included 126 images, photographed over two decades, with an original cover designed by Henri Matisse. "To me," Cartier-Bresson famously wrote, "photography is the simultaneous recognition, in a fraction of a second, of the significance of an event as well as of a precise organization of forms which give that event its proper expression."[8]

The present photograph was taken in Portugal in the summer of in 1955, when Cartier-Bresson was working for Magnum in Lisbon.[9] He photographed views of the old port and its bustling nightlife and captured informal street portraits of the celebrated singer Amália Rodrigues, the "Queen of Fado." He also visited Jerónimos Monastery near the shore of the

parish of Belém. Built in the 16th century, when the New World spice trade made Portugal one of Europe's greatest sea powers, this monastery and the nearby Tower of Belém exemplify the Late Gothic Manueline style of architecture. While exploring the main monastery church of Santa Maria, Cartier-Bresson witnessed this scene. Along the north wall of the nave were simple, open, *prie-dieu*-style confessionals. At the corner of the transept, he saw a woman kneeling in the sacrament, with a priest behind a panel. The two figures made a striking composition: the woman appears slim and willowy, while the priest seems to possess a visual heft, and the pyramidal shape of their combined forms points heavenward. Their encounter appears all the more intimate and solemn against the soaring space of the open nave behind them. The solid panel between confessor and priest is thin, but the column rising precisely from its peak is robust, accelerating the upward visual thrust of the figures. The orthogonal lines of the floor tiles and walls accentuate this vertical impetus. Perhaps the most poignant detail of this visual sacrament, however, is the young woman's white hand, standing out near the center of the composition, pointing tentatively heavenward. Having been raised in the Church, Cartier-Bresson was comfortable in its sanctified spaces. When he photographed there, he always concentrated on worshipers, not the monumental buildings or opulent icons.

DAVID SEYMOUR

American, born in Poland, 1911–1956

Earthquake Refugees, Zante, Greece

1953
Gelatin silver print
24.5 × 19.7 cm (9⅝ × 7¾ in.) Image
25 × 20.3 cm (9⅞ × 8 in.) Sheet

Milly and Fritz Kaeser Endowment for Photography, 2017.015.003

David Seymour considered himself to be a documentarian and strove to tell compelling visual stories. He meant his images for immediate reproduction, and photojournalism became his life's work. Seymour was born Dawid (Didek) Szymin in Warsaw, a son of the city's leading publisher of Hebrew and Yiddish books.[1] His family's bookstore was a center of Jewish intellectual life. In this stimulating environment, the young Szymin became a skilled pianist and an able student, especially adept with languages. After graduating from the Jewish Ascolah Gymnasium in 1929, he went to Leipzig to study the printing arts at the State Academy of Graphic and Book Arts, intending to expand the family's publishing activities. However, as the National Socialist regime gathered power, Szymin became uncomfortable in Germany. He went to Paris, where he studied physics and chemistry at the Sorbonne. He also worked with David Rappaport, a family friend who ran the small photographic agency Rap. Szymin had no formal training in photography, but his knowledge of science, design and printing technology provided a strong foundation. He explored Paris with a borrowed camera and found himself drawn to scenes of human interaction. Rappaport readily placed the images in French illustrated magazines and newspapers.

In Paris, Szymin was drawn to a circle whose shared cultural and political backgrounds had instilled a common concern for social justice. Among them were two young photographers, Endre Friedmann—and Henri Cartier-Bresson—soon to be known as Robert Capa (Cat. nos. 49, 60). Szymin became close friends with them, and the three briefly shared an apartment together. As Szymin established himself as a photojournalist, he began to stamp his prints CHIM—inscribed in capitals—a phonetic abbreviation of his surname that could be easily pronounced in French. His photographs regularly appeared in Léon Moussinac's weekly magazine *Regards*, which became associated with the anti-fascist Front Populaire.[2] In summer 1936, Chim covered the Spanish Civil War from the Republican side. He worked alongside Capa and Gerda Taro, who dauntlessly pursued their images into the fighting.[3] Chim, however, concentrated on more intimate events behind the lines. Twenty-five of his photoessays from Spain appeared in *Regards*.

In 1939 Chim photographed the voyage of the Spanish Republican government to exile in Mexico aboard the S.S. Sinaia. He was working in New York City when Germany invaded Poland in September of that year. Later he was drafted into the United States Army and had the opportunity to become

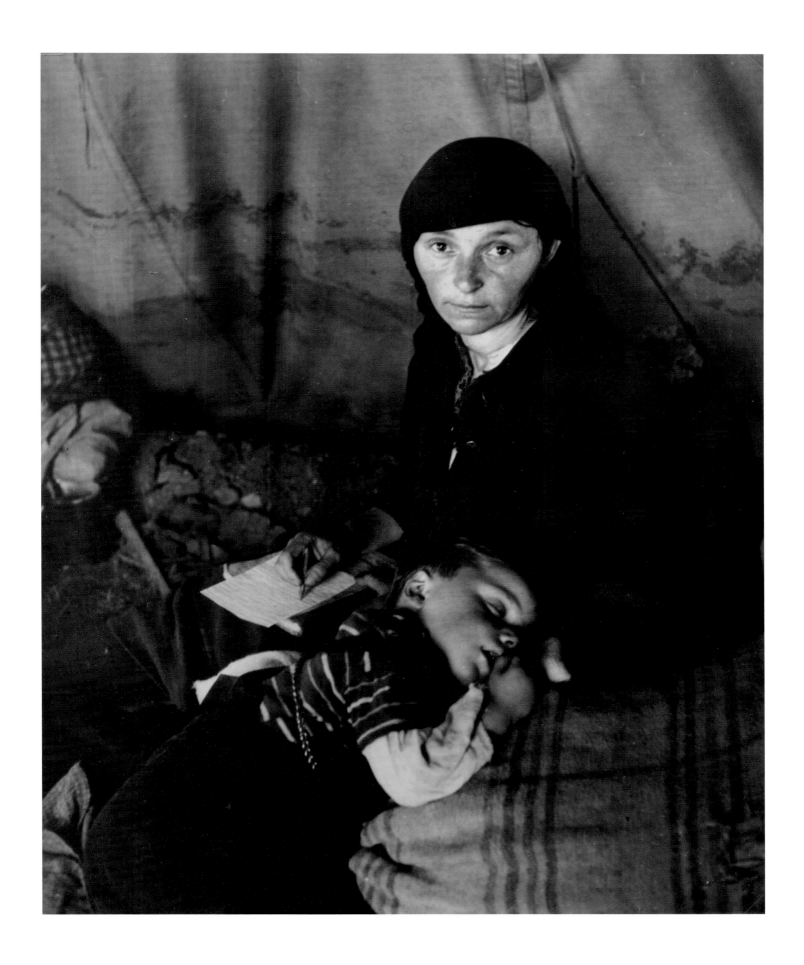

a U.S. citizen. Fearing that his family in Poland might suffer for their association with an enemy soldier, he changed his name to David Robert Seymour. He was trained in military intelligence, and later he served in England and France as a reconnaissance-photo interpreter. When hostilities ended, he returned to Poland in search of his family. He made photographs while searching the Warsaw ghetto and found that his family's summer retreat at Otwock had become an orphanage. Only later did he discover that his parents had been killed in the Holocaust.

In Paris, before the war, Chim and his friends had dreamed of their own publishing cooperative. They had imagined a system in which photographers would control their own work instead of editors or business managers. Instead of assigned projects, they would pursue stories and images that compelled them. Most importantly, the agency would allow photographers to retain copyright and the monetary potential of their own images. This scheme became reality in April 1947, when the photographer joined Capa, Cartier-Bresson, George Rodger and William Vandivert to establish Magnum Photos, Inc.[4] Capa was founding president and Chim the first vice-president. Before the advent of television, newspapers and pictorial magazines conveyed world events visually to a growing audience. Magazines like *LIFE* and *Look* became ubiquitous in the United States, while *Paris-Match* and *Stern* were popular in Europe, and *Ogonyak* and *Sovetskoe Foto* were widely distributed in the Soviet Union. Following the example of earlier agencies like the Associated Press and United Press International, Magnum collected members' exposed film at offices in New York and Paris to be printed, captioned and distributed all over the world.

Chim prepared carefully for his Magnum projects, studying cultural context and related news events before traveling. To avoid costly spur-of-the-moment decisions, he even envisioned what his ideal subjects and images might be. He carried a Leica miniature camera, but, unlike his colleagues, he preferred to work with the twin-lens Rolleiflex, which produced 6 cm square negatives that captured extraordinary detail. Rather than peering through a viewfinder, the photographer framed the image by looking down into the ground glass in the top of the camera, which he held at waist level; this technique required him to stop and compose images with deliberation. It suited Chim's working method, for he liked to speak to his subjects, earning a measure of trust. His quiet confidence and forthright working method resulted in the sympathy and authenticity reflected in his most arresting photographs.

On the morning of August 12, 1953, Chim was at work on a Magnum portrait session with Frederica of Hanover, queen consort of Greece, when an earthquake struck the southern Ionian Islands. The event measured 7.2 on the Richter scale, causing damage across the region, especially to islands of Zante (Zakynthos) and Kefalonia, which the quake raised 24 inches (61 cm) above sea level. Chim hurried to the Aegean and arrived at Zante on the first ship carrying aid to the island. He found nearly all of the buildings of the capital city destroyed as aftershocks continued. Some of his photographs pictured this devastation but, as usual, he focused his attention chiefly on the people.[5]

In this powerful image from Zante, the photographer captured a young woman, presumably a mother, with a sleeping child, sheltering in a refugee tent.[6] She is bundled in traditional costume, the folds of

which are echoed in the flimsy cloth walls of the tent behind her. While tending to the child curled in her lap, she looks up from a letter she is writing, pen in hand. She may be writing to share news of the tragedy, of her safety and that of her child. The fact that the woman can read and write marks her as an urban dweller in this era. To put himself in the momentous events he photographed, Chim made use of lighting and depth of field. Many of his images are sharp from the immediate foreground to the distant background, indicating setting with detailed information. This image is unusual among Chim's photographs, in that the subject gazes directly into the lens of his camera. The image relates a small but comprehensive story, revealing ways in which human beings meet the challenges of crisis or conflict.

When Robert Capa was killed in 1954, Chim took over as Magnum president. He proved to be a capable administrator, reorganizing the Paris office and refurbishing its financial accounting. He drew upon his knowledge of industrial printing to improve agency products for mass reproduction. In 1956 he helped arrange for the first international exhibition of Magnum photographs at the *Photokina* trade fair in Cologne. "There is a great affinity among Magnum photographers," Chim wrote for the show, "in terms of their photographic integrity and respect for reality, their approach to human interests and search for emotional impact, their preoccupation with composition and layout, and their awareness of narrative continuity."[7] Later in the year he was killed in Egyptian Sinai while photographing the Suez Crisis for *Newsweek* magazine.

HARRY CALLAHAN
American, 1912–1999

Chicago

1958
Gelatin silver print
18.2 × 18.6 cm (7⅛ × 7⅜ in.) Sheet
50.9 × 38.1 cm (20 × 15 in.) Mount

Gift of Dr. and Mrs. Norval Green, 1993.041.001

Understanding the functions of the camera and darkroom, and the ways in which photographs differ from human perception, were central to Harry Callahan's approach to the medium. He believed that this understanding could enhance the way he saw the world and make him a better, more expressive artist. At a time when straight photography and naturalism dominated the field, he introduced notions of abstraction long prevalent in other art forms.

Harry Morey Callahan was born in Detroit, the son of a farmer turned factory worker, whose work in the automobile industry helped provide his family with a middle-class lifestyle.[1] He attended Michigan State University in 1934 to study chemical engineering. In 1936 he married Eleanor Knapp and began working as a shipping clerk at the Chrysler Motor Parts Corporation in Detroit. Callahan joined the company-sponsored camera club and took up photography; soon he also became an active member of the Detroit Photo Guild. While his colleagues pursued aesthetic subjects with the clarity of straight photography, Callahan's curiosity and scientific orientation prompted him to experiment. While photographing the stuff of ordinary life, he fearlessly tried all the settings of his camera and enlarger.

Callahan created an experimental series of abstract images of light reflected on the water. After attending a workshop with Ansel Adams in 1941, he followed Adams's advice and experimented with sequential images, such as a series of people climbing an exterior staircase in Highland Park. Callahan visited New York in 1942 and met Alfred Stieglitz (Cat. no. 7). He was impressed by the emotion and design combined in Stieglitz's portraits of Georgia O'Keeffe, and he began to portray his wife, Eleanor, in a series that he continued for decades. He took a job as a processor in the photography lab at General Motors in 1944 and deepened his technical experience. Among his friends was the Detroit photojournalist Arthur Siegel, a former student of László Moholy-Nagy (Cat. no. 25). In 1945, Moholy-Nagy hired Siegel to head the newly formed photography department at the Institute of Design in Chicago (ID), where he helped develop its pioneering course, "New Visions in Photography."[2]

In 1946, Siegel brought Callahan to teach at the the ID. Callahan's understanding of the camera and the photographic process was well suited to the academy, founded on Moholy-Nagy's machine aesthetics. Siegel, Callahan and their colleagues led students to familiarity with the camera and encouraged them to explore different techniques, such as varied shutter speeds, X-rays and photomontage. Often Callahan provided an example of simplicity in

elegant, evocative designs, such as his high-contrast images of dry weeds against the sky or snow that look like Picassoesque line drawings. He often photographed his wife and young daughter, Barbara, at Lake Michigan and amidst the Chicago architecture in view-camera "snapshots," their compositions dominated by geometry. The dominance and verticality of Chicago architecture, and its effect on space and light, shifted Callahan's awareness of visual perception and design. His work was influenced by the Neues Sehen (New Vision) and its foundation in geometric Modernism. Callahan was impressed by architect Ludwig Mies van der Rohe, his colleague at the ID, who was uncompromising in his ambition to simplify form and design. This influence is apparent in the photographer's multiple-exposure photographs of architectural subjects. Callahan had begun to attract national attention, and in the summer and fall of 1946 his work was included in the exhibition New Photographers at the Museum of Modern Art in New York. The first solo exhibition of his photographs was presented at 750 Studio in Chicago in 1947.

Callahan succeeded Siegel as head of the photography department in 1949, the year that the ID became part of the new Illinois Institute of Technology university system. Three years later he hired Aaron Siskind (Cat. no. 64) to teach at the ID. Siskind was a photographer whose process was comparatively spontaneous, oriented to Abstract Surrealism and the New York School. The cross-influences of these two photographers was powerful, and together they began a distinctive school of photography at the ID.[3] Callahan often took his students onto the streets of Chicago to make candid photographs amid the effects of light and shadow created by skyscrapers. In the mid-1950s he made a series of close-up photographs

of women shoppers that captures the singularity and humanity of anonymous strangers,[4] calling to mind Walker Evans's (Cat. no. 39) images of nameless subway riders. A Graham Foundation Award in 1957 enabled Callahan and his family to live in France for a year. Callahan found that Aix-en-Provence was a more traditional, earthbound city than Chicago and encouraged experiments of an organic nature, and he produced double-exposure images of Eleanor enmeshed in the Provençal landscape.

Callahan's Chicago reflects his experience of urban life in the 20th century.[5] Rather than a disheartening experience of alienation, it is a stunning visual adventure. This is a geometric image, strikingly abstract in its initial appearance but quite typical of modern life for the city dweller. From a street-level viewpoint, the photographer observed buildings of steel and glass, so tall that they extend well above the frame. Callahan framed his composition so that none of the angles appear plumb. In fact, from this angle, the two skyscrapers appear to rise from the ground at different angles. The facades of both buildings are structured by crosshatchings: horizontal bands accentuate the near building, while verticals dominate its neighbor. Through the windows of the far building, a pattern of fluorescent ceiling lights can be seen, illuminating the vast offices on each floor; the windows of the near building show the reflection of another skyscraper. Three vertical flagpoles shine in the morning light, providing linear accents that emphasize the upward sweep of the buildings, the angle of the grid work in the building behind and the geometry of the design. On the left is a slice of bright sky and fleecy clouds, as well as a view along the receding street. A woman in white strides towards the entrance to the near building. From the

center of the photograph, her mirror image moves toward her; Callahan has captured her reflection in the sheets of glass hidden underneath the darkened porch. Further to the right, deeper in the facade of the building, is a second smaller, dimmer reflection, which reveals the complexity of the space around her. The technical brilliance of this print, its saturated black and gleaming highlights, is essential to its success. The image was thoughtfully made, and is best appreciated with careful looking.

Callahan left the ID in 1961 for the Rhode Island School of Design in Providence. There he established a new photography program that soon gained a national reputation for its sophistication and graduate-level teaching. The breadth of Callahan's popularity in the mid-1960s is reflected in the solo exhibition of his photographs at the Museum of Modern Art.[6] In 1971 Siskind joined him in Providence, and many of their students went on to establish photography departments in schools across the country. In 1976, the Museum of Modern Art presented a retrospective exhibition of Callahan's photographs on the eve of his retirement from teaching.[7] Despite thousands of undeveloped black-and-white negatives in his archive, he quickly turned to an investigation of color photography, taking up the new technical and formal challenges of Kodachrome transparencies. Later in the decade, selections were produced as dye imbibition prints for exhibition.[8] In 1978 Callahan was the first photographer to represent the United States at the prestigious Venice Biennale.[9]

WILLIAM GARNETT
American, 1916–2006

Four-Sided Dune, Death Valley

1954
Gelatin silver print
50.4 × 40.2 cm (19⅞ × 15⅞ in.) Sheet
61.1 × 55.8 cm (24 × 22 in.) Mount

Frank Smurlo (ND'58) and Joan Smurlo Endowment, 2015.062

It was Nadar, the Parisian portraitist and balloon enthusiast, who made the first aerial photographs. Later, during World War I, Edward Steichen (Cat. no. 4) was among the pioneers of aerial reconnaissance. By the end of that conflict, military photographers were collecting as many as 10,000 aerial images every day from airships and airplanes, though nearly all the photographs were destroyed after use.[1] William Garnett, in his photographs of the American West, was the first to create high-quality creative images from above.

Garnett was born in Chicago, but moved as a small child with his family to California.[2] He and his brother became interested in photography when they were teenagers, and they built a darkroom at home. He was yearbook photographer at John Muir Technical High School in Pasadena. After graduating, he attended the Art Center School in Los Angeles and studied photography with Fred Archer. After one year, however, he could no longer afford art school and went to work as a freelance commercial photographer. In 1940 Garnett found a stable position as photographer for the Pasadena Police Department, which made it possible for him to marry and begin a family. He adapted his skills to evidence and crime-scene photography, and executed the first color photomicrographs to be admitted as evidence in California courts. In 1942, when the United States entered World War II, Garnett became a darkroom technician at Lockheed Corporation. He was drafted into the Army in 1944 and assigned to the Signal Corps, where he was trained as a cinematographer, with the goal of producing staff training films in Europe. Shortly before his deployment, however, the war ended, and he was discharged on the East Coast in 1945.

To get himself back to California, Garnett hitched a ride on a military transport. "The airplane was full," he later reminisced, "but the captain let me sit in the navigator's seat so I had a command view. I was amazed at the variety and beauty of these United States. . . . So I changed my career."[3] Back in Pasadena, Garnett used his G.I. Bill benefits to attend flight school and secure a pilot's license. In 1947 he bought his first airplane and began photographing from the air, at first just shooting out the window. He invented working methods for the new specialty he imagined, but found it difficult to find customers.

In January 1950, a group of developers purchased 3,500 acres of farmland 23 miles (37 km) southeast of downtown Los Angeles. The Lakewood Park Corporation set out to transform bean fields into neighborhoods of modest homes for servicemen returning from the war, with a plan to build

17,500 houses.[4] They hired Garnett to shoot photographs from the air, for documentation and promotion. As a veteran himself in his early 30s, raising a young family, Garnett had an idea of how to appeal to his audience. Early in 1950 he photographed the concrete foundations of tract houses, 500 of which were being poured every week. Later Garnett returned to shoot thousands of houses as they were being framed, and in May 1954 he shot the houses again, this time with completed roofs. From his perspective 1,000 feet (305 m) above, he had a unique sense of the enormity of the project, which paralleled a wartime campaign. "I was hired commercially to illustrate the growth of that housing project," Garnett recalled. "I didn't approve of what they were doing . . . and there was not a tree in sight when they got through."[5] The Lakewood Park executives were delighted with his photographs and bound some enlarged prints into presentation albums. Garnett had come to understand the creative potential of his aerial images. So did his friend Edward Weston (Cat. no. 16), who encouraged him to apply for a Guggenheim Foundation Fellowship. In 1953 Garnett was awarded the first of three grants that enabled him to fly, shoot and process his own work.

Four-Sided Sand Dune, Death Valley, exemplifies Garnett's remarkable aerial imagery, looking straight down at the earth from above.[6] It demonstrates his preference for images without the straight lines imposed on the landscape by man. These photographs anticipated satellite imagery, and today it is difficult to understand their initial impact. Without the familiar, organizing horizon, Garnett's images appear abstract. In this image of the apex of a pyramidal sand dune, he employs light and shadow to define topography and texture; Even without identifying its subject, the delicate tonal modulation is tactile, even sensual. This natural design appears to oscillate between projection and recession. It is impossible to determine scale, but the contrast between the bright highlights of the sunlit side and the deep black of the one most shadowed suggests something truly massive. The delicate, sharp lines of the windblown ridges are reminiscent of rock gorges sculpted by flowing water. Garnett processed and printed most of his own work. He preferred large prints from his negatives and lavished attention on them, emphasizing a broad tonal spectrum between glaring blacks and whites. His expanded viewpoint disclosed a geological American West, with a perspective that encouraged environmental preservation.

Garnett's work received little attention until Walker Evans (Cat. no. 39) selected a group of his Lakewood images for a photoessay titled "Over California" that he designed for *Fortune* magazine.[7] Evans described the skilled composition of Garnett's images, and how they differed from reconnaissance or documentary aerial photography. The quality and graphic impact of Garnett's photographs brought him other opportunities from Time-Life, Inc., which over the next 20 years dispatched him on assignment across the United States, to Asia and to Australia. His photographs were also published in such national magazines as *LIFE*, *Reader's Digest* and *The New York Times Magazine*. In 1955 Edward Steichen included Garnett's work in the landmark *Family of Man* exhibition at the Museum of Modern Art.

In 1956, Garnett purchased a Cessna 170B airplane, which he experimentally modified for his work. He tried different methods of mounting a camera, including a port in the cockpit floor beneath

his feet, and experimented with several cameras and films. Ultimately, Garnett cut a panel out of the passenger-side floor and installed a shelf above and behind the void to hold his equipment within reach. He came to prefer two 35 mm SLR cameras, one loaded with black-and-white film and the other with color. Garnett preferred to work alone, flying early in the morning or late in the afternoon for the best light. When he located himself above the subject, he would lean over and shoot through the hole in the floor, momentarily letting go of the flight controls rather than risk dropping the camera.

Garnett logged more than 10,000 hours of flying time, during which he captured images not observable from the ground, revealing ordered patterns and ambiguous organic shapes. His extraordinary perspective on the growth of Southern California, urban sprawl and consequent air pollution alarmed early environmentalists.[8] The photographer took his family away from the city's sprawl. He searched Northern California from the air, and in 1958 he moved his family to Napa. There, he continued his commercial business for a decade, while also producing creative photographs. At the invitation of Ansel Adams (Cat. no. 46), Garnett also taught for many years in the Yosemite Workshops. His enthusiasm for teaching helped lead to an appointment in the Department of Design at the University of California, Berkeley. After retiring in 1984, Garnett grew Chardonnay grapes for local wineries on his hilltop property in Napa.

AARON SISKIND
American, 1903–1991

Broken Window, Gloucester

1944
Gelatin silver print
19.3 × 22 cm (7⅝ × 8⅝ in.) Image
20.5 × 25.4 cm (8⅛ × 10 in.) Sheet

Gift of Dr. George Violin, 1985.080.003

At a time when most employed photography as a descriptive method for documenting the world, Aaron Siskind used the medium to explore abstraction. The son of a tailor, born and raised on the Lower East Side of Manhattan, he was a bright and curious boy.[1] He explored music, poetry and literature as a student at DeWitt Clinton High School and went on to study social science at City College of New York, where he met a group of artists that included Adolph Gottlieb, Mark Rothko and Barnett Newman.[2] All three shared an Eastern European Russian Jewish background and became longtime friends who influenced each other as artists.

After graduating in 1926, Siskind began teaching middle-school English in the New York public school system. He married three years later and received a camera as a wedding gift. He taught himself the basic techniques of photography, and around 1934 he joined the Film and Photo League for access to its darkrooms and the shared expertise of its members.[3] Many in the league were first-generation Americans—erudite and socially conscious New Yorkers interested in social change. Siskind, like others in the group, concentrated on street photography, but he became frustrated by their insistent leftist politics. He quit temporarily, but was drawn back to the league's Feature Group, a film production unit. For this project, he created such independent films and photography series as *Dead End: The Bowery* and *A Harlem Document* (Fig. 17).[4]

In the early 1940s Gottlieb, Rothko and Newman were discussing the concept of "ideographic" art, a kind of imagery that would be engaging and comprehensible across time and culture. Having seen Native American pictographs in the Southwest, Gottlieb investigated their symbolic relationships to Jungian archetypes; Rothko created symbolic motifs suggested by archaic Greek sculpture, while Newman found inspiration in the traditional arts of Mesoamerica and the Pacific Northwest Coast—ideas they understood to be related to those of Abstract Surrealists like Joan Miró and André Masson. Siskind found these ideas compelling at a time when the events of World War II prompted many to reconsider the purpose of visual art. "For some reason or other," Siskind later wrote, "there was in me the desire to see the world clean and fresh and alive, as primitive things are clean and fresh and alive. The so-called documentary picture left me wanting something."[5] These intellectual pursuits continued during summer holidays, and for several years Siskind and his friends vacationed together on the beaches of New England.

Early in 1944, Siskind helped Newman by photographing Mesoamerican sculpture for the catalogue

of an exhibition that his friend Betty Parsons was organizing at the Wakefield Gallery. He found that photographing sculpture gave him a new feeling for volume, weight and surface, and he was anxious to investigate their creative implications when he went to Cape Ann on vacation in July 1944. Siskind settled into a studio that Gottlieb had found for him in East Gloucester. He set himself a goal to capture six good negatives each day. Every morning he walked in the town for two or three hours, carrying his $3\frac{1}{4}$ × $4\frac{1}{4}$ inch Linhof camera with one lens. Along with shots of the port city, he experimented with images of isolated objects, suggested by Abstract Surrealism. Usually Siskind met his friends on the beach in the afternoons, and in the evenings they gathered at Gottlieb's studio to continue their philosophical discourse and discuss their own work.

Broken Window, Gloucester is one of the photographs from that summer, when Siskind used the camera viewfinder to search for pure design.[6] Once freed from representation by the ideas of Abstract Surrealism, he began to discover engaging compositions everywhere. In several photographs, including this image, he searched for suggestive forms in the broken glass windows of empty buildings.[7] Siskind often photographed straight on, aiming his camera perpendicularly at walls and floors. This viewpoint removed the surrounding context and denied spatial

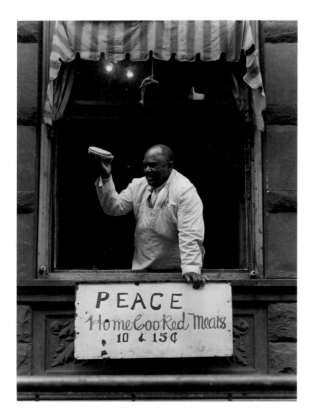

Fig 17. — Aaron Siskind, American, 1903–1991, *Peace Meals*, from the series *A Harlem Document*, about 1937, gelatin silver print, Gift of Walter Lake, Jr., 1981.080.002.V

perspective. Here, Siskind's balanced forms, in a range of black and gray, can be read as a harmonious graphic design or a Miróesque fantasy, but the image does not appear immediately to be representational. This was a transformational step, as Siskind began using photography, with its mimetic capabilities, to render purely abstract form: "Pressed for the meaning of these pictures, I should answer, obliquely, that they are informed with animism—not so much that these inanimate objects resemble the creatures of the animal world (as indeed they often do), but rather that they suggest the energy we usually associate with them. Aesthetically, they pretend to the resolution of these sometimes fierce, sometimes gentle, but always conflicting forces."[8]

Along with his friends—Gottlieb, Rothko, Newman and others—Siskind participated in artists' symposia of the 1940s, including the Subjects of the Artist, Studio 35, and The Club, where the conceptual foundations of Abstract Expressionism were formulated.[9] In 1947 the photographer began to show and sell his work at the Charles Egan Gallery, where several of the New York School painters exhibited. Egan introduced Siskind to Frederick Sommer (Cat. no. 68) in 1949, and suggested that the photographer visit him in Arizona. Siskind stayed for three months.

In 1949, Siskind left his public-school position to become a photography instructor at Trenton Junior College in New Jersey. In 1951 he participated in the Black Mountain College Summer Art Institute, where he met Harry Callahan (Cat. no. 62). Soon afterwards, Callahan invited him to join the faculty of the Institute of Design (ID) at the Illinois Institute of Technology in Chicago. Together these colleagues would influence generations of great American creative photographers. In 1961 Siskind succeeded Callahan as head of the photography department at ID. A decade later, Callahan lured him away once again, to a new teaching position at the Rhode Island School of Design, where he remained for the last five years of his influential teaching career.

ELIOT PORTER
American, 1901–1990

Pool in a Brook
Pond Brook near Whiteface, New Hampshire

October 4, 1953
from the portfolio *In Wildness*
Dye imbibition print
40.6 × 32 cm (16 × 12⅝ in.) Sheet
61 × 51 cm (24 × 20⅛ in.) Mount

Milly and Fritz Kaeser Endowment for Photography, 2015.047.001

Among the creative photographers working in color at mid-century, Eliot Porter was unusual in his preference for the dye imbibition process, a complex technique that yielded richly hued prints. A scientist and naturalist, he explored the beauty of nature in his work and helped advance the environmental movement. Eliot Furness Porter was born in Winnetka, Illinois, the second of five children of a Chicago real estate manager and amateur photographer.[1] He received a Kodak Brownie camera for Christmas when he was 10 years old and used it to photograph the woods and shores of Great Spruce Head Island in Penobscot Bay, Maine, where the family spent their summers.[2] In later years, his mother helped him build a canvas blind on the island, where he and a friend photographed birds with a Graflex single-lens reflex camera. After prep school in the East, Porter followed family tradition by attending Harvard, where he majored in chemical engineering. His enthusiasm for photography continued, and he bought a Leica handheld camera. After graduating, he went on to medical school and completed his M.D. degree in 1929. Porter then became a researcher at Harvard and an instructor in bacteriology and biological chemistry.

During the 1930s, birds remained the main subject of Porter's photographs, and he acquired a 9 × 12 cm Linhof camera for his ornithological work. In 1936 he married the painter Aline Kilham and they traveled to Europe together. The first solo exhibition of Porter's photographs, mounted at Alfred Stieglitz's (Cat. no. 7) An American Place gallery, featured landscape views of Switzerland, Austria and Maine. In 1939, when the Porters were working in Santa Fe, they met Gina Schnaufer and Ernest Knee (Cat. no. 44), and natural friendships developed through their common interests.

During World War II, Porter worked in the Radiation Laboratory at the Massachusetts Institute of Technology (MIT), assisting in the development of radar. After experimenting with different photographic methods, he adopted a synchronized flash system to improve his ornithological images. Porter showed these to the Houghton Mifflin editor Paul Brooks, who insisted that they be in color to make a successful book. At that time, however, the relatively slow color film, with its complex printing requirements and prohibitive cost, made the project impractical. His photographs were sufficient, however, to earn him a Guggenheim Foundation Fellowship in 1941, which enabled him to travel across the country photographing birds. Porter developed a meticulous, macroscopic style for nature photography.[3] After the war, he and his family moved to

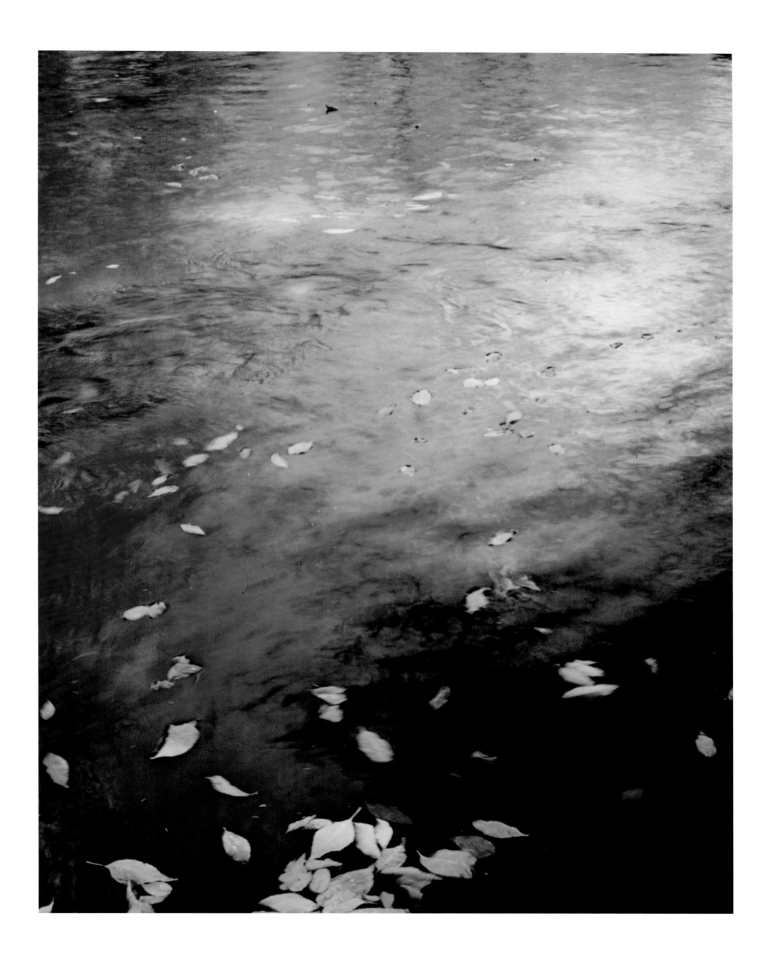

New Mexico, where they purchased the Knees' home at Tesuque, north of Santa Fe, with its darkroom and painting studio. The photographer explored the Southwest with his camera and often published his work in *Audubon* magazine.

Porter learned the dye imbibition process from Jeannette Klute of Eastman Kodak, which marketed the technique as Dye Transfer printing in 1945.[4] A skilled photographer and research scientist, Klute was a student of the physicist and vision scientist Ralph M. Evans at the Rochester Institute of Technology. She went on to head the Visual Research Studio of the Color Control Division at Kodak and worked to perfect the process. Klute and Porter shared a love of nature and concern for the environment, and she helped persuade the photographer that the color printing technique could advance his aesthetic and ethical concerns. The dye transfer process employs three separate negatives of the same subject, produced on film from a full-color transparency through red, green and blue filters. Three separate, enlarged matrices are made from these negatives and are separately immersed in water-based cyan, magenta and yellow dyes, which are absorbed—or imbibed—by the gelatin. The three saturated matrices are rolled onto a single sheet of paper under intense pressure and their images precisely registered, so that superimposed dyes combine to create a full-color print. During exposure, developing and printing, the photographer can control the hue, tone and contrast of each of the three matrices. The dye imbibition technique offered brighter, more adjustable and more accurate color than any other process of its time. However, the process demanded extraordinary skill and was time-consuming and expensive.

In the 1950s, Porter traveled around the country photographing the natural landscape in both black-and-white and color. Once, when reviewing his nature studies from New England, Aline Porter was reminded of the writing of Henry David Thoreau. The couple paired excerpts from Thoreau's essays and journals with Porter's woodland photographs, organizing a selection by seasons through the year. The series was titled with a quotation from Thoreau's *Walden*—"*In Wildness Is the Preservation of the World*"—and published as a color photobook by the Sierra Club in 1962.[5] The volume's clear, brilliant images appealed to a broad audience, and it became a best-seller. Success prompted Sierra Club director David Brower to dispatch Porter on a new project. The following year *The Place No One Knew: Glen Canyon on the Colorado* was published, expressing opposition to the indiscriminate damming of rivers in the West, with passages about canyon life and wilderness preservation by more than 30 notable authors, including Joseph Wood Krutch and Loren Eiseley.[6] In 1965 Porter joined Ansel Adams as a member of the Sierra Club board of directors, and would serve for six years. There followed a succession of books on the landscapes of Maine, Baja California, and the Appalachians, and on birds.[7]

This photograph is one from the portfolio *Eliot Porter: In Wildness*, later enlarged printings of 10 color images from "*In Wildness Is the Preservation of the World*" featuring views from Arizona, Colorado and Maine.[8] The image shows the surface of a woodland brook in autumn, the colors of the surrounding red and golden trees and the deep blue sky shimmering on the water. The long, dappled shapes of trunks and the colored foliage scattered across the pool reinforce a sense of distance, while the darkened foreground

places the photographer—and the viewer—in the cool shadow of a tall tree. The movement of the water is evident in the mottled reflections and the birch and poplar leaves that seem to swirl in a spiral toward us and down to the bottom of the composition. Autumn breezes and pond currents have left some of the birch and poplar leaves on the water's surface with their deep red tops facing up, in contrast to the delicate pink undersides of others. Some move with the flowing water and fall out of focus, while others are stationary enough to be captured in detail.

The swirling colors and silvery tones, dotted with leaves, bring to mind works of Japanese decorative art in lacquer and silver. The strong diagonal composition, melding color passages and over-layered imagery, are also reminiscent of Abstract Expressionist painting, which remained popular when this photograph was made. Indeed, through his brother, the New York painter Fairfield Porter, the photographer knew many of these painters and their work.[9] This noted image was included in the retrospective exhibition of Porter's photographs at the University of New Mexico Art Museum in 1973.[10] In 1980 Porter's show *Intimate Landscapes* was the first solo exhibition of color photographs presented by the Metropolitan Museum of Art.[11]

PAUL STRAND
American, 1890–1976

Window and Thatch, South Uist, Outer Hebrides

1954
Gelatin silver print
24.5 × 19.5 cm (9⅝ × 7⅝ in.) Image
24.5 × 19.5 cm (9⅝ × 7⅝ in.) Sheet

Milly and Fritz Kaeser Endowment for Photography, 2017.006.001

Over much of the 20th century, Paul Strand was a towering figure in American photography, and his deep commitments to social justice and cultural dignity determined the arc of his career. Born Nathaniel Paul Stransky in New York, he was the son of an immigrant from Bohemia, whose zeal to integrate prompted him change the family name to Strand in 1895.[1] When Paul Strand was 12 years old, he received a Brownie camera as a gift and began taking photographs. He attended the Ethical Culture Fieldston School in Manhattan, established to introduce poor children to principles of social justice, racial equality and intellectual freedom.[2] In 1907, with Lewis Wickes Hine's (Cat. no. 2) photography class, he visited Gallery 291 and met Alfred Stieglitz (Cat. no. 7).

After graduating in 1909, Strand worked in his father's enamelware business. He pursued photography as a hobby and showed his work in the annual exhibitions of the Camera Club of New York. Stieglitz became a mentor and encouraged him to pursue a career as a professional photographer. For a few years, Strand photographed New York architectural landmarks and produced prints that were hand-colored and sold as souvenirs. In 1913 he visited the International Exhibition of Modern Art in New York, which introduced the European avant-garde to the American public, and began to experiment with geometric cityscapes and still lifes influenced by Cubism.

However, Strand remained committed to the ethos of social justice. To reveal the lives of the underprivileged, he photographed a remarkable series of vendors and beggars on the streets of New York. The tight compositions suggest that he often composed these images through the viewfinder, cropping close to the figure so that facial features and pose expressed both personality and mood.[3] Stieglitz mounted a solo exhibition of Strand's photographs at 291 gallery in March 1916. The following October, six of the photographs from the show were reproduced in *Camera Work*. Best known among them is *Wall Street* (Fig.18), in which tiny, faceless figures scurry along the sidewalk beside the new J. P. Morgan Building, a symbol of the colossal power of the political and economic establishments.

During World War I, Strand served in the Army as an X-ray technician at Fort Snelling in Minnesota. After the war he explored filmmaking, collaborating with Charles Sheeler on *Manhatta*, an eight-minute silent documentary representing New York as Modernist geometry—the first avant-garde film made in the United States.[4] Strand bought a hand-cranked Akeley motion picture camera and established

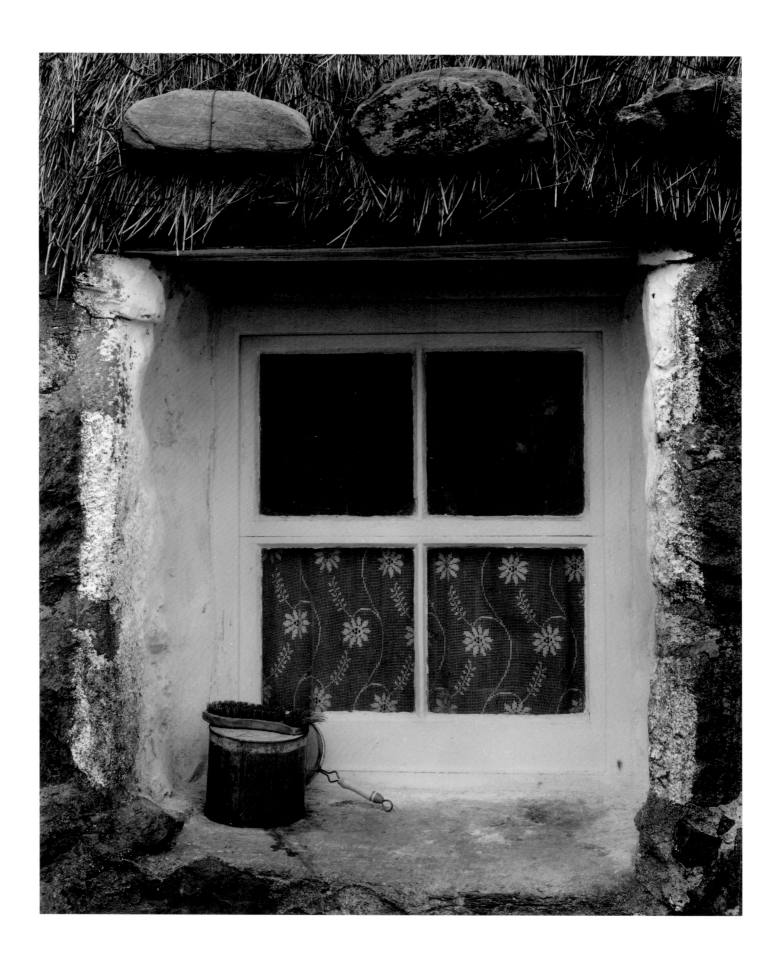

himself as a freelance filmmaker. In 1932 he went to Mexico, after finally breaking ties with Stieglitz. He explored villages in Oaxaca and Michoacán with his camera, capturing images that celebrated the dignity of common people,[5] and worked on a government filmmaking program, helping to produce *Redes* (The Wave), the story of a coastal community near Vera Cruz reclaiming control of its fishing industry from corrupt businessmen. Strand returned to New York in 1934 and joined the filmmakers who split from the Photo League to form the film group Nykino. He visited the Soviet Union the following year and met influential theater and film directors, including Sergei Eisenstein and Alexander Dovzhenko. In 1936, Strand joined Leo Hurwitz, Ralph Steiner and Pare Lorentz to organize Frontier Films in New York. He was a cinematographer on *The Plow That Broke the Plains*, a documentary for the Resettlement Administration.[6] Despite his Leftist politics, Strand made government propaganda films during World War II. His interest in still photographs revived.

After moving to Vermont in 1940, Strand photographed the farmers and workers of New England. The Museum of Modern Art presented an extensive show of his photographs in 1945, the museum's first solo exhibition of a living photographer. He also collaborated with curator Nancy Newhall on *Time in New England*, the first in a succession of photobook projects.[7] Each book presented a selection of images from a distinctive location, with commentary by a different writer familiar with its history and concerns.[8] When Strand's friend Alger Hiss was prosecuted for libel in 1950, the photographer left the country, fleeing the threats of McCarthyism. He settled at Orgeval, outside Paris, and compiled a selection of photographs of the town

Fig 18. — Paul Strand, American, 1890–1976, *Wall Street*, 1915, photogravure, Walter R. Beardsley Endowment, 1996.059

in the photobook *La France de profil*, with text by the poet Claude Roy.[9]

In the summer of 1954, Strand traveled to the Outer Hebrides, off the west coast of Scotland. He settled on the island of South Uist and photographed the island and its people over 12 weeks. The site of Scotland's largest known Viking settlement, the island was occupied by the MacDonalds of Clan Ranald, who lived off the sea in the 17th and 18th centuries. During the Highland Clearances, farmers from the Borders brought flocks of Blackface sheep to South Uist, and Strand found the islanders still making their livings by herding, along with fishing, cutting peat and gathering seaweed. Strand admired their lives lived so close to nature, and he sensed history everywhere. South Uist was one of the last surviving strongholds of the Gaelic language in Scotland. He photographed the ruggedly beautiful island, the forbidding sea and the indomitable crofting families.

This sharply focused photograph of a window in a crofter's cottage seems simple and picturesque at first glance, but its details tell much about life on the island.[10] Strand moved in close for a tight, detailed glimpse of the cottage window that emphasizes the cottage's natural mass. The stone walls are thick and window is quite small—architectural features meant to keep out the cold and damp. A white lace curtain offers further insulation and some nighttime privacy. Outside, fresh coats of whitewash on the window embrasure reflect as much light as possible to the interior. The cottage is roofed with local thatch, secured against the gales with a metal mesh weighted by a row of rocks. In convenient reach on the window ledge are a can, colander and brush, ready for the washing of root vegetables, scallops and oysters, or a dog's feet. Strand's image depicts a scene that might be from the 17th century as easily as the 20th. This is one of the photographs from South Uist that Strand later organized into the photobook *Tir a'mhurain*—"Land of the Bendy Grass" in Gaelic.[11] He chose the English journalist Basil Davidson to write commentary for what became the most acclaimed photobook of 20th-century Scotland.

Strand insisted that *Tir a'mhurain* be printed in Leipzig, in the German Democratic Republic. This may have been a political statement, for the photographer had arrived on South Uist soon after its selection as the testing site for an American-British guided nuclear missile. Island residents were concerned about the ecological effects of the project, and about an influx of strangers who might threaten their Gaelic dialect. Dealings between local opposition and government officials inspired the satirical novel *Rockets Galore* by Compton Mackenzie.[12] Strand fell from American public attention while living abroad. Late in the 1960s, European exhibitions began to revive his reputation, and a major retrospective exhibition at the Philadelphia Museum of Art restored the photographer to the canon of American photography.[13]

MINOR WHITE
American, 1908–1976

Two Barns and Shadow, Dansville, New York

1955
from the series *Sequence 10/Rural Cathedrals*
Gelatin silver print
23.8 × 30.3 cm (9⅜ × 11⅞ in.) Image
27.7 × 35.1 cm (10⅞ × 13⅞ in.) Sheet

Gift of Dr. and Mrs. Dean A. Porter, 1995.73

One of the most influential American photographers of his day, Minor White advocated photography as a means of poetic communication and self-reflection, and expressed these ideas in his work as a teacher, curator, critic and editor. Born in Minneapolis, White was the son of a bookkeeper and a dressmaker who separated when he was eight years old.[1] The child and his mother often lived with his grandparents during his years in the Minneapolis public schools. His grandfather helped him make his first photographs when he was a boy. In 1927 White attended the University of Minnesota as a biology major. He used photography to aid his studies and produced photomicrographs for the botany department.

In 1937 White began creating lyrical photographs of the northern Minnesota landscape. That summer he moved to Portland, Oregon, where he joined the Works Progress Administration as a documentary photographer, recording the cast-iron facades of old waterfront buildings then facing demolition.[2] These images dominated the first solo exhibition of his photographs, presented by the Portland Art Museum in February 1942. Two months later, during World War II, he was drafted into the Army and posted to the Pacific. White made few photographs at that time, but he wrote verse that reflected his spiritual longing. In Hawaii in 1943 he was baptized into the Roman Catholic Church. Over the following months, he saw action during in the invasion of the Philippines.

After the war White went to New York, where he attended the Columbia University Extension Division as a G.I. Bill student. In art history classes taught by Meyer Schapiro, he first learned about psychological approaches to the visual arts. White worked as an intern in the photography department at the Museum of Modern Art, where curators Beaumont and Nancy Newhall introduced him to wider circles of art photographers, including Ansel Adams (Cat. no. 46). At that time Adams was organizing a new photography program for Douglas McAgy at the California School of Fine Arts (CSFA), and he recruited White to the faculty. Adams and White shared their ideas about creative photography when they drove together from New York to San Francisco. In his teaching over the next few years, White integrated Adams's Zone System of previsualization, along with aesthetic theory from Schapiro and notions of inspiration professed by such faculty colleagues as Clyfford Still and Mark Rothko.[3] He also consolidated ideas from Christian mysticism and the teachings of the Sufi visionary G. I. Gurdjieff.

By the time the CSFA ended its photography program in 1952, White was involved with the

organization of the photography journal *Aperture*, along with Adams, Barbara Morgan, Dorothea Lange (Cat. nos. 34, 38) and Beaumont and Nancy Newhall. White became the magazine's first editor and moved to Rochester, New York, where Beaumont Newhall had become curator at the George Eastman House museum of photography and the new journal would be headquartered.[4] White found it difficult to adapt his own creative photography to upstate New York, which lacked the dramatic natural beauty of the Northern California landscape. "This land is comfortable, cultivated, cramped, and inhabited . . . ," he wrote, "rich farmland that goes soft and pretty and spiritually flat."[5] For a time he concentrated on close-up and still-life images and the symbolic motif of windows and doors. He heightened the tonal contrast of his landscape views and even used infrared film, striving to create energy and drama. Since 1946 White had organized his photographs in "sequences," grouping related images to broaden their intellectual and emotional implications. With 10, 20 or 30 photographs in a sequence, he characterized them as "cinemas of stills." Ideally, he meant for the groups to be viewed together in order to appreciate the different aspect of the underlying theme in each photograph.[6]

Two Barns and Shadow is the final photograph in White's *Sequence 10/Rural Cathedrals*, a series completed in December 1955.[7] He shot the photographs in the autumn, near the villages of Naples and Dansville, south of Rochester. In exploring the New York countryside, White had found the most provocative features to be old agricultural buildings. Two centuries of farming had transformed the region's landscape, and White realized that the barns told a story of human interaction with nature. They reflected a range of building traditions from the waves of immigrants to the region, and some were more than a century old. These functional monuments were the patrimony for farming families, stable and serviceable over generations. In this sense, and in their architectural form, White equated them with ecclesiastical buildings.

More than any photograph in *Sequence 10*, *Two Barns and Shadow* carries religious symbolism. The central doorway of the large barn conveys a sense of sanctuary and congregation with its raised earth ramp, engineered specifically to gather livestock into the barn's main floor. The replaced barn doors—built of new, unblemished wood and contrasting with the shingled roof and weathered walls—enhance this effect. White photographed this scene on a late summer evening, when the stubble of a mown hayfield provided a modulated passage of gray, contrasting with the starker tones of the buildings. He was most excited by the shadow of a utility pole, reminiscent of a Byzantine or Russian Orthodox cross. In fact, White considered the appearance of this cruciform shadow as a personal revelation. In the darkroom, the photographer burned the area of the sky to darken its appearance; he also accentuated the cross by augmenting the contrast in the image. Since arriving in Upstate New York, White had been contemplating visual perception and spiritual revelation, reading Aldous Huxley's *Doors of Perception* (1954), Eugen Herrigel's *Zen and the Art of Archery* (1948) and Evelyn Underhill's *Mysticism* (1911).[8] The photographer was fascinated by Underhill's notion of a "Mystic Way," a psychological process for connecting with the divine. He came to believe that in his struggle for inspiration he had photographed symbols of the Mystic Way without realizing it. "These sequences are

'given' as if directed by an outside force," he wrote to a friend in February 1956. "Few persons have had this experience in photography. And for this reason I feel that it is necessary, maybe even a kind of duty, to continue for a while yet in pursuing that way of photographing till it is not a hint of a way, but thoroughly set, that a lifetime devoted to it is necessary. This will give proof that this instrument can carry out the work of God as well as any other."[9]

When Newhall became director of George Eastman House in 1958, White succeeded him as curator of the museum's growing collection. He remained in this position until 1965, when he joined the faculty of the Massachusetts Institute of Technology. White taught photography and organized influential exhibitions, including some exploring the spiritual aspects of photography.[10] By the mid-1960s his interests had become fashionable, as worldwide spiritual traditions affected popular culture in the West. White published *Mirrors, Messages, Manifestations*, a selection of his images and poetry, which appeared in conjunction with a retrospective exhibition of his photographs at the Philadelphia Museum of Art in January 1970.[11]

FREDERICK SOMMER

American, born in Italy, 1905–1999

Paracelsus

1957
Gelatin silver print
34.4 × 25.8 cm (13½ × 10⅛ in.) Image
34.4 × 25.8 cm (13½ × 10⅛ in.) Sheet

Gift of Milly Kaeser, in Memory of Fritz Kaeser, 2001.002

Over a long, varied career in the relative isolation of the American Southwest, Frederick Sommer blended Surrealist influences into a compelling creative viewpoint. He was born Fritz Carlos Sommer at Angri, a small town near Naples in Italy.[1] His family moved to Brazil and he grew up in Rio de Janeiro, where his father was a successful landscape architect. When he was 16 years old, Sommer was an apprentice at Escritório Técnico Heitor de Mello, one of Rio's finest architectural firms. In 1924 he served as an assistant to Edward Gorton Davis, chairman of the landscape architecture department at Cornell University, and the following year he enrolled in the university's graduate program. Sommer learned the techniques of photography at that time as a tool for planning and documentation.

After completing a master's degree, he returned to Brazil to become a partner in the family firm. In 1928 he traveled again to Ithaca, New York, to marry his American girlfriend, Frances Watson, and bring her back to Brazil. Two years later, Sommer was stricken with tuberculosis and his wife took him to Switzerland to convalesce in a sanatorium at Arosa. This period of rest enabled him to study aesthetic theory and begin making his own creative photographs. After more than a year's recovery, the Sommers moved to the healthful climate of Tucson, Arizona, in the American Southwest. From 1931 to 1937 the artist created drawings and watercolors with a precision that grew from his meticulous method of architectural drawing.

Late in 1934 the couple moved to Prescott, Arizona, where Frances Sommer became a state social worker. Soon after, the artist met Edward Weston (Cat. no. 16), who inspired him to purchase an 8 × 10 inch Century Universal view camera. By contrast to Weston's sculpturesque images of vegetables and seashells, Sommer's large negatives were influenced by Surrealism, and were often slightly disturbing. He photographed the entrails and severed heads of chickens, the dry carcasses of coyotes taken for bounty, and a hobo's amputated foot. In November 1939 Sommer became a naturalized United States citizen, and for the next decade he drew, painted and made photographs with equal enthusiasm. When he acquired a lens with a long focal length, Sommer created *Colorado River Landscapes*, a series of distant views of the Grand Canyon in which he exploited glaring desert light to reveal fine details on faraway desert hillsides. Without a visible horizon or a single focal point, these images present broad patterns that presage the allover compositions of the Abstract Expressionist painters.

In 1946, Max Ernst and Dorothea Tanning moved to Sedona, Arizona, near Prescott, and they became close friends to the Sommers.[2] The mystery and whimsy of Ernst's Surrealist works in collage and assemblage inspired the photographer. During his walks in the desert and high forest, he collected scraps of printed paper, bits of rusted metal, discarded toys and other objects. He arranged these into Surrealist assemblages and photographed them, often adding handwork to the negatives and prints. Some of these images were included in the first solo exhibition of his photographs, presented at the Santa Barbara Museum of Art in 1946. The painter Lew Davis introduced Sommer to Charles Egan, a New York art dealer whose gallery was known for its Surrealist and Abstract artists. In 1949 Egan began to exhibit and sell Sommer's work, and he encouraged Aaron Siskind (Cat. no. 64) to visit Sommer in Arizona. Over three months in Prescott, Siskind worked side by side with Sommer in his darkroom, and the two photographers made several visits together to shoot in the ghost town of Jerome, Arizona. They shared ideas, and Siskind conveyed the concepts of Abstract Surrealism, formulated a decade before in discussions with friends such as Adolph Gottlieb, Mark Rothko and Barnett Newman. Sommer was one of six artists whose photographs were included in the exhibition *Diogenes with a Camera* at the Museum of Modern Art in 1952. His broadening reputation is reflected in the publication of his photographs in *Aperture* magazine, along with his own critical commentary.[3]

Paracelsus was printed from synthetic negative of Sommer's own invention.[4] In 1957 he began experimenting by painting on glass and using these plates as negatives in the enlarger. Then he turned to small, thin sheets of transparent cellophane on which he painted in transparent medium which was slightly tinted with brown paint. As the pigment set and its viscosity changed, Sommer manipulated the paint, working quickly to preserve the spontaneity of the image. Exposed in the enlarger, the clear portions of the sheet printed black, and the painted areas as a range of grays and white. Then he made gelatin silver prints several times larger than the handmade negatives. He did 10–20 of these extemporaneous sketches at a time. Sometimes he employed a variation of decalcomania, pressing pigment between two sheets of cellophane, then pulling them apart to create organic, dendritic patterns. The resulting images, which reveal the behavior of pigment, belong to the same school as the Abstract Expressionist paintings of such artists of the preceding decade as Jackson Pollock and Willem de Kooning. In his photographs from synthetic negatives, Sommer also experimented with Surrealist drawing techniques like *fumage* and *cliché verre*.

Sommer often allied his photographs with Surrealist tradition with his arcane, classicizing titles. He named this image for the Swiss Renaissance physician, botanist and alchemist Philippus Aureolus Theophrastus Bombastus von Hohenheim, known to history as Paracelsus.[5] Said to be among the first to diagnose an illness by physically examining a patient, Paracelsus learned from nature rather than taking his knowledge solely from ancient texts. He is credited with founding the discipline of toxicology. Sommer's image appears to represent a human torso, opened in its side and abdomen to reveal an interior, recalling the impious dissections of medieval anatomists. Brushstrokes evoke sinew, and spongy patterns made by separating sheets of cellophane suggest viscera. The absence of head and limbs on

this figure—fractured away rather than sectioned—brings to mind the ruined artifacts of ancient Greek and Roman sculpture, rephrasing a theme of historical inquiry.

After three months traveling in Europe in 1960, Sommer came home to begin photographing the model. A continuing interest in form and contour led, in 1962, to photographs of cut paper. The artist slashed sweeping arcs in sheets of heavy craft paper with a razor blade, then hung the paper so that the cut edges fell open and photographed them in carefully controlled lighting. Some of these photographs were included in a monographic issue of *Aperture* magazine.[6] They also featured in the traveling exhibition *Frederick Sommer: An Exhibition of Photographs*, organized by Gerald Nordland for the Washington Gallery of Modern Art in 1965.[7] At that time the artist was among the first professors at Prescott College, an experimental liberal arts academy in Arizona supported by a grant from the Ford Foundation. Among Sommer's students were Walton Mendelson and Stephen Aldrich, with whom he investigated moving images and experimental music. In 1971 Aldrich worked with Sommer to complete and edit *The Poetic Logic of Art and Aesthetics*.[8] Afterward they collaborated on complex collages made from Sommer's cut-up photographs and fragments of intaglio prints, many clipped from 19th-century anatomy texts to acknowledge the influence of Max Ernst. Sommer made hundreds of these collages, which became his principal medium in the last decade of his life.[9] In 1975, Sommer was one of five photographers to commit his archive to the foundation of the Center for Creative Photography at the University of Arizona in Tucson.

MARIO GIACOMELLI
Italian, 1925–2000

Scanno

1957
Gelatin silver print
30.2 × 39.9 cm (11 ⅞ × 15 ¾ in.) Image
30.2 × 39.9 cm (11 ⅞ × 15 ¾ in.) Sheet

Milly and Fritz Kaeser Endowment for Photography, 2011.015

Mario Giacomelli photographed his home town in the Marches of Italy, employing a distinctive style that reflected the intense sunlight of the Adriatic coast and the challenges of life in this region. He was a bricoleur who created haunting, poetic images with relative modest means. Giacomelli spent his life in his hometown, Senigallia, a coastal fishing and farming town in the province of Ancona.[1] His father died when Giacomelli was nine years old, and his mother struggled to support the family as a laundress in a home for the aged. Her children spent much of their early childhood in the home, where the residents became their extended family. When he was 13 years old, Giacomelli left school to become an apprentice typesetter at Tipografia Giunchedi. He became an expert in this occupation, skilled at building and dismantling words and images. In his spare time, he wrote poetry and painted images of nearby mountains and valleys, using improvised media on planks of wood.

During World War II Giacomelli enlisted in the Italian Army; he was stationed in Ancona when it was bombed in 1944. When he returned to Senigallia after the war, he found the Giunchedi printing plant destroyed by bombing. Aiding in the clean-up, he discovered copies of Il Corriere Fotografico magazine, the remains of a destroyed bindery job, which ignited his interest in photography. When the printing plant reopened, he returned to work as a typesetter and pressman. Giacomelli received an inheritance from an elderly friend in the Senigallia hospice, which enabled him and his partner, Olindo Mancini, to open their own printing company, La Tipografica, in 1950. That same year, Giacomelli and his wife traveled to celebrate the Holy Year in Rome, where he took his first photographs.

In 1953 Giacomelli bought a used Bencini Comet S roll-film camera with an achromatic 1:11 lens and synchronized flash, which he used to photograph family and friends in his small town. Giacomelli also began to frequent the Senigallia studio of photographer Lafranco Torcoletti, where he printed his photographs and experimented with the techniques he studied. Some of Giacomelli's first creative photographs were distant views of horizonless landscapes. The contours of the rolling hills around Senigallia dominate these compositions, accented by buildings and plow furrows in the earth. Giacomelli persuaded farmers to harrow grids of his design, and he emphasized those patterns in the darkroom. He returned to this open-ended series, the Paesaggi, for years to come.

In 1954, Torcoletti introduced Giacomelli to Giuseppe Cavalli.[2] This lawyer, critic and skilled

creative photographer had moved from Lucera to Senigallia during the war. His photographs reacted against the exaggerated rhetoric and imagery of the fascist era, representing still-life studies and commonplace events. Intense Mediterranean light illuminated his thoughtfully composed images, minimizing shadow. In 1947, Cavalli and Luigi Veronesi had begun the photography group La Bussola (The Compass) to share ideas. Now, striving further to build a social context for himself and to promote photography, Cavalli began a new camera club, La Misa, named for the river that runs through Senigallia to the Adriatic. Cavalli was its first president and Giacomelli was treasurer. Cavalli may also have prompted Giacomelli to attend the cinema in nearby Ancona. The Neorealist films of Luchino Visconti, Vittorio De Sica and Roberto Rossellini impressed Giacomelli, and their gritty perception of war-ravaged Italy influenced his still photographs. He brought this sensibility to his images of the Senigallia elder home residents—empathetic pictures that depict harsh reality. In February 1954 Giacomelli published his first photograph in *Ferrania* magazine, the image of a fishing scale with a hazy profile beneath.

In 1955 Giacomelli acquired a Kobell Press camera, manufactured by Boniforti & Ballerio in Milan, a versatile model that combined the 6 × 9 cm negative of the Zeiss Ikon with the compact scale and speed of the Leica. Giacomelli claimed to use just two settings on the camera, operating them from memory. This is certainly affectation, for he was masterful in his improvised darkroom, working with a ramshackle enlarger and concrete laundry tubs for developing his film. In the mid-1950s Giacomelli joined ANSA (Angenzia Nazionale Stampa Associata), the leading Italian picture agency, which made his work available to major national newspapers and magazines. The high contrast of his images and their strong graphic quality made them ideal for printed reproduction, but aesthetic rather than topical subjects limited their use. Out of necessity, the artist continued his work as a typographer.

In 1957 Giacomelli visited Scanno, a small town in the Abruzzo region of central Italy. Early in the decade Henri Cartier-Bresson (Cat. no. 60) had photographed there, fascinated by the tiered, cobbled streets of the hill town, illuminated by shifting mountain light. Giacomelli reacted instead to the pace of the traditional way of life in this impoverished village, progressing as it had for centuries. On October 19, 1957, he captured this image of a young boy emerging from the Church of Saint Anthony of Padua after the Mass.[3] Giacomelli focused his camera on the child as he walked toward the photographer, his hands in his pockets. The boy stands out among the other churchgoers for his youth and costume. Around him—both in the foreground and in the receding distance—are elderly ladies dressed in widow's black. Young and old seem oblivious to each other, incapable of sharing their presumed vigor or acquired wisdom. In the darkroom, Giacomelli pressed the setting and the women into the background, using them to frame the child.[4]

In 1958 Giacomelli met the painter and sculptor Alberto Burri, and they began a close friendship. Some works from Giacomelli's *Paesaggi* are dedicated to Burri, referencing the abstraction and poetics of the painter. Indeed, Burri's abstraction fascinated Giacomelli so much that he created hundreds of pictorial works during the 1960s, when he associated with a group of painters and sculptors in Senigallia

gathered around the dealer Mario Angelini. In 1962 Giacomelli received a commission from the local Catholic seminary to document the life of its young priests. The task was rather tedious, until snow fell one afternoon and the young men reacted playfully; Giacomelli captured their childlike reaction to the unusual weather.[5] The joyous image of exuberant seminarians chasing one another and throwing snowballs, their black cassocks contrasting starkly with the white snow, was widely reproduced and gained Giacomelli much popularity. Part of his seminary series, titled *Io non ho mani che mi accrezzino il volto* (I Have No Hands Caressing My Face) after a poem by Father David Maria Turoldo, was exhibited at Cologne Photokina in 1963.

In 1967 Giacomelli began making new, abstract images inspired by the work of American poet Edgar Lee Masters, whose *Spoon River Anthology* had been popular in Italy since its publication in translation in 1948.[6] The double exposure and layering that Giacomelli used in these images, combining figures with natural motifs of trees, flower fields and moving water, became a key stylistic technique of much of his late work. In 1978 photographs from Giacomelli's *Paesaggi* series were shown at the Venice Biennale. Although he photographed in places like Ethiopia and documented Tibetan Buddhist rituals and pilgrims at the Lourdes shrine in France, the great mystery that enthralled him was the order and disorder of life as seen in a small Italian town.

ROBERT FRANK

American, born in Switzerland in 1924

Derry

about 1958
Gelatin silver print
34.6 × 20.9 cm (13⅝ × 8¼ in.) Image
35.7 × 28 cm (14 × 11 in.) Sheet

Milly and Fritz Kaeser Endowment for Photography, 2014.027

With skepticism towards high culture and a technical nonchalance repudiating the straight photography of Edward Weston (Cat. no. 16), Robert Frank transformed American photography in the 1950s. His personal vision and persistence also helped revitalize the photobook as an independent art form. Frank was born in Zurich, the son of a German importer of Swedish radios to Switzerland.[1] To avoid the family business, however, he began a volunteer apprenticeship with the commercial photographer Hermann Segesser in 1941. This led to a job in the studio of the industrial photographer Michael Wolgensinger. In 1947, after completing his national service, Frank moved to New York to pursue a career in fashion and advertising photography. Compared to the rigid conventionality of Switzerland, postwar New York offered dizzying freedom for a young man. Frank joined the bohemian culture of Greenwich Village, where he met the jazz musicians Ornette Coleman and Charles Mingus and made friends with Beat poets like Allen Ginsberg and Peter Orlovsky, and with Abstract Expressionist painters like Alfred Leslie and Grace Hartigan.

Frank was a great admirer of Walker Evans (Cat. no. 39), and took his work to show the photographer at his *Fortune* magazine office. In 1955, Evans became a reference for his successful application for a Guggenheim Foundation Fellowship. Frank proposed to follow Evans's example and travel the United States with his camera. By chance or design, Frank avoided polite and intellectual society when he drove across the country with his English-born wife and young children. He discovered an unfamiliar, often unfriendly culture in transition. The industrial boom after World War II had produced a new abundance, with products, services and modern conveniences readily available. Old values lost their sway as a new affluence and materialism seized American life. Frank photographed doleful consumers, charmless and indolent despite their material privilege. The subjects of his selected photographs seldom look at each other. They seem obsessed with unwholesome fast food, cars and highways, telephones and radios. With more concern for their own gratification and convenience, they appear jingoistic and cruel in their disregard for poverty and infirmity. This was an America that nobody had photographed before. Frank used a 35 mm handheld camera to shoot quickly and furtively, and his photographs have an impromptu, accidental look. Instead of previsualized, carefully planned and focused, his images are spontaneous, reflexive and improvisational. So was his work later in the darkroom, and in selecting from the thousands of exposures he took on the road.

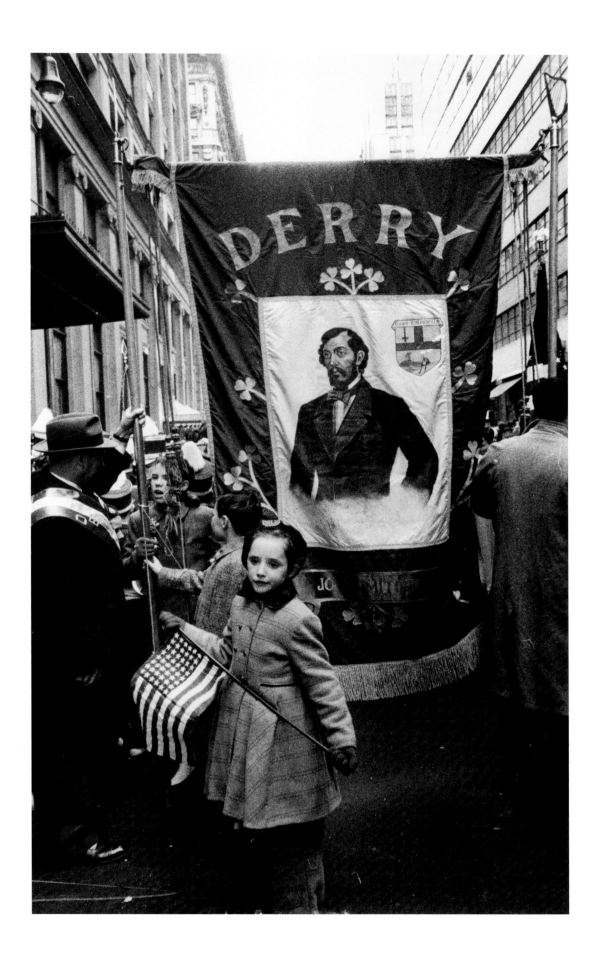

The photographer selected tilted, blurred and grainy images, retaining imperfections usually corrected in printing. To complete his Guggenheim Fellowship, Frank wanted to publish rather than exhibit a selection of his photographs. He selected 86 images that reflected not only what he had seen with his camera, but what he had experienced. It may have been the contemptuous mood of the series that made it difficult to find a publisher in the United States. Finally, Frank agreed to a French edition that merged the photographs with commentary by renowned authors and made *Les Américains* more sociology than art.[2]

Although this rare print is not dated, *Derry* was taken when Frank was working on *The Americans*.[3] The photograph depicts a group of marchers gathering before the St. Patrick's Day parade in New York City. The American flag—one of Frank's favorite motifs—visible in the image has 48 stars, indicating that this festival preceded the declaration of Alaska as the 49th state in January 1959. Frank may have attended the event for its paradoxical merging of nationalism and ethnic tribalism, or for its intersections with American history. In 1762, 14 years before the Declaration of Independence, a group of British soldiers and Irish expatriates in New York organized the first St. Patrick's Day parade. They dressed in green at a time when the practice was banned in Ireland, sang traditional songs, played the pipes and spoke the Irish language, sharing their yearning for home. Military units organized the parade in its early years. After the War of 1812, fraternal and beneficial societies of Irish expatriates took over sponsorship. Around 1851 the "Irish" Brigade of the New York 69th Infantry Regiment began leading the marchers, and the Ancient Order of Hibernians became the official parade sponsor. The regiment still leads the parade today, followed by the Irish County societies and other Irish organizations and institutions of New York, in the march from the steps of St. Patrick's Cathedral up Fifth Avenue to 79th Street.

Many of the details of this image celebrate tribal belonging within a larger American society. As they gather in Midtown Manhattan before the parade, this group congregates beneath a banner proclaiming County Derry as their home. Held aloft on standards topped with harps, the shamrock-spangled banner carries a portrait of John Mitchel, a Derry native son and famed Irish nationalist who brought his views and influence to the United States before the American Civil War.[4] Over his shoulder are the arms of the city of Londonderry, with its Irish name, Doire Colmcille. Despite their home pride, the marchers look away from the banner in excited anticipation. Amidst the scrum are men in business suits and members of a marching band with feathers festooning their hats. The Derry banner precisely blocks the vista along the canyon-like New York street, bounded on both sides by tall buildings. It is almost as if it is a symbolic doorway, through which many pass into the American experience.

Despite the reputation of the Saint Patrick's Day Parade as a festival of inebriate gaiety, Frank presents an almost solemn image of resolution. Like many of Frank's photographs, most of the subjects here seem alone in their thoughts. A little girl carrying an American flag also wears a tam with embroidered badges, identifying her with a quasi-military group. She alone turns from the parade to look at the photographer. Her receptive innocence is surrounded by details that imply the ties of restrictive social affiliation. The softly focused, grainy printing of Frank's photograph creates a dynamic, expressive effect. It

captures a fleeting, pensive moment similar to Helen Levitt's (Cat. no. 42) street photographs of children.

In 1959 Grove Press published *The Americans* in the United States, in an English-language edition that replaced the multiple glosses with a brief, stylish introduction by Jack Kerouac.[5] This photobook identified Frank with a youthful postwar counterculture and was perceived as an anti-authoritarian political statement, like the work of the artists, musicians and poets who were the photographer's friends. By that time, Frank had become a filmmaker and was at work on *Pull My Daisy*, a movie co-directed by the painter Alfred Leslie, written and narrated by Kerouac, featuring poets Allen Ginsberg and Gregory Corso, with a soundtrack by the jazz musician David Amram. Even though its creators used professional lighting and carefully rehearsed the scenes, they produced a movie that captured the same spirit and look of improvisation that characterized Frank's photographs.[6]

ELLIOTT ERWITT

American, born in France in 1928

South Carolina

1962
Gelatin silver print
30.4 × 20.6 cm (12 × 8⅛ in.) Image
35.5 × 28.1 cm (14 × 11 in.) Sheet

Gift of the artist, 1994.028.X4

Despite his broad achievements, Elliott Erwitt described photography as craft as much as art, a practice perfected by skill, experience and persistence. He was born Elio Romano, in Paris, the son of Russian-Jewish parents who met, married and lived in Western Europe.[1] He spent his early childhood in Milan, where his father worked as an architectural engineer. Italian fascism, however, prompted the family to sail to the United States in 1939. They settled in New York, where the boy attended PS 156, quickly learning the English language to match his fluency in Russian, French and Italian. When he was 12 years old his parents separated, and he accompanied his father in a drive across the country. They arrived in Los Angeles in summer 1941.

Erwitt was a student at Hollywood High School when he became interested in photography. He bought an Argos camera, taught himself to process and print his negatives from the instructions on a film box, and built a darkroom at home in the laundry. Soon he was earning money by photographing weddings and printing signed celebrity portraits for film studios. He bought a Rolleiflex camera and also began to make creative photographs of people and events he found amusing or compelling. Erwitt's father soon followed his wanderlust to the road (later in life he would

became a Buddhist monk), while Erwitt stayed on in their rented Hollywood house. After graduating from high school in 1944, he went on to study at Los Angeles City College. In 1949, he returned to New York and worked as a janitor while studying photography and film at the New School for Social Research. Soon Roy Stryker hired him to work on a project sponsored by the Allegheny Conference on Community Development.[2] Erwitt went to Pittsburgh, Pennsylvania, to photograph the city's postwar development from an industrial hub to a center for business and culture. The photographer collected hundreds of negatives of the city and its people, but after four months he was drafted into the Army during the Korean War. Erwitt was posted as a staff photographer in Europe, where he documented events ranging from meetings between genial officers to military industrial accidents. He also photographed the experiences of life on base, and entered some of his images in a *LIFE* magazine contest. His photoessay "Recruits Share Bed and Boredom" won second prize and appeared in the magazine during the holidays in 1951.[3]

After his discharge from the Army in 1953, Erwitt he returned to New York with his new Dutch-born wife Lucienne van Kam, and they began a family.[4] He joined the Magnum photo agency and became

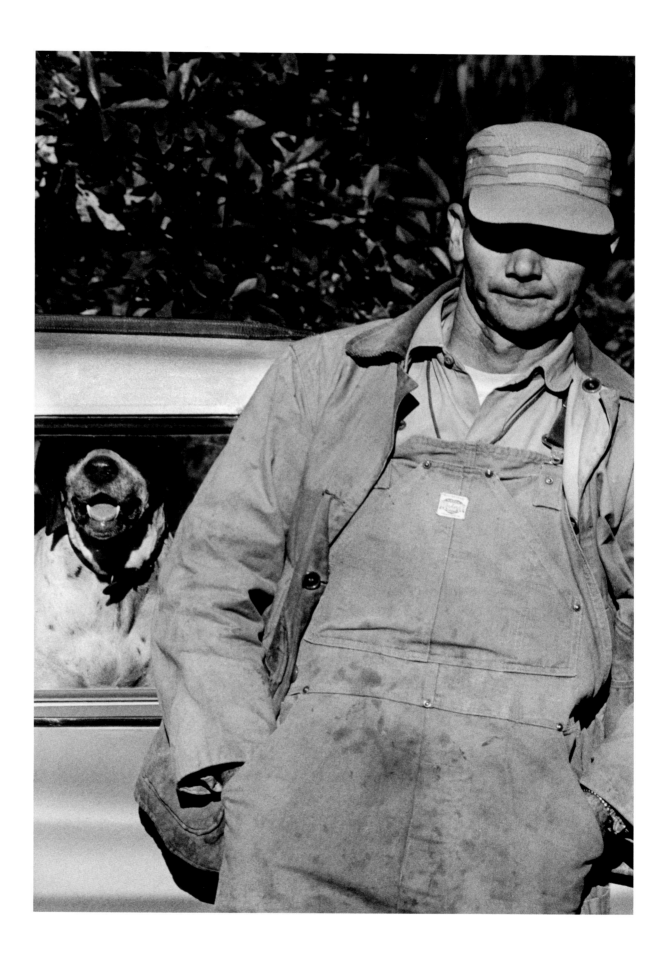

a traveling photojournalist; within a few years he had photographed in Mexico and Central America, Japan, and South Asia. The photographs Erwitt made for himself were his immediate responses to compelling events or beautiful sights, captured with his Leica miniature camera. Through Magnum, Erwitt was assigned to work as set photographer for such Hollywood films as *On the Waterfront* (1954), *The Seven Year Itch* (1955) and *The Misfits* (1961). He made a reputation with such images as Marilyn Monroe in *The Seven Year Itch*, her white William Travilla dress lifted by a draft rising from a subway grille underfoot. During the Cold War, Erwitt made several trips to the Soviet Union, where his language skills led him to images observed by no other Western photographer. In summer 1959 he covered Vice President Richard Nixon, along with Communist Party Chairman Nikita Khrushchev, on a visit to a Soviet trade fair. At the display of a modern kitchen presented by Macy's department store, Erwitt photographed Nixon prodding Khrushchev's lapel as he boasted about the superiority of American life. The photographer understood Khrushchev's expletive rejoinder, even if the vice-president could not.[5]

Dogs are Erwitt's favorite subject. Throughout his career, wherever he traveled around the world, he has observed their exploits and personalities with an enthusiasm that combines a sense of kinship with the acuity of a behaviorist. "It's simple. I like dogs," he proclaimed. "They're nice and they don't ask for prints."[6] For years, the photographer carried a small bulb horn in his pocket to attract the attention of potential subjects. Erwitt realized that dogs reveal their personalities with a clarity and directness that human beings cannot. Sometimes he descended to eye level to photograph tiny dogs, contrasting their point of view with the overwhelming presence of their owners. Other images captured dogs in embarrassing predicaments that their owners put them in. Erwitt also photographed many dogs and owners with similar appearance and personal bearing.

Such is the case in this photograph of rural partners, taken in South Carolina.[7] A screen of background foliage lends a rustic quality to this portrait of a farmer and his hound dog. The man seems friendly, if slightly shy; he leans on his car to chat, relaxed and diffident, hands in his pockets, and lips pursed. His dog looks equally unassuming, belying his sophisticated olfactory awareness of the world around him. He pants through an open mouth, conveying a sense of the warmth of the morning sunshine. Both tip their heads to shade their eyes and get a good look at the photographer. Brown spots on the hound's chest parallel the farmer's work-stained dungarees, while a lanyard around the man's neck, hidden by his overalls, appears to lead to the dogtag-like label on the front. The image presents a genial, practical cooperation between work partners whose friendship is assuring, if amusing. Somehow these two seem more intelligent than they appear. Erwitt's unusual knack for finding such reassuring complexity in the world is matched by an ability to encapsulate and share it in a single, endearing image. His love of dogs and their people is well appreciated and is the subject of several successful photobooks.[8]

Erwitt was among scores of photojournalists at the funeral of President John F. Kennedy in 1963, but his photograph of Jacqueline Kennedy, young and tragic yet elegant and dignified, clutching the flag that draped the president's coffin, is one of the most widely published images of the event. The following year, on assignment for *Newsweek* magazine,

Erwitt traveled to Cuba, where he photographed Fidel Castro and Che Guevara, representing them as self-confident and heroic revolutionaries.[9] In France, in the mid-1960s, Erwitt photographed for the first time in a nudist colony. He found the environment—where subjects exposed facets of their personality along with their bodies, often in situations of amusing happenstance—a perfect match for his sensibilities. Over the next 20 years the photographer visited nudist camps in Europe and the United States to make photographs and films.

Erwitt was president of Magnum in 1968 and worked to uphold the agency's founding principle that photographers should retain ownership and copyright of their work in order to ensure their livelihood. In 1970 the documentary film *Arthur Penn: The Director* was released, written, directed and produced by Erwitt. This began two decades of concentration on filmmaking, which included television commercials, documentaries and feature films.[10] The first major retrospective exhibition of Erwitt's photographs was mounted in 1998 at the International Center of Photography in New York.[11] Concern for the human condition, shared by Erwitt's Magnum colleagues, can be interpreted in many ways. His work demonstrates that it need not be expressed in images of misery and suffering, but can also be found in pictures of joy and fulfillment in the commonplace.

JULIUS SHULMAN
American, 1910–2009

The Stahl House, Los Angeles

1960
Gelatin silver print
61.1 × 50.2 cm (24 × 19¾ in.) Image
61.1 × 50.2 cm (24 × 19¾ in.) Sheet

Gift of Dr. William McGraw (ND'65), 2009.047.042

Architectural photography has flourished since the mid-19th century. Specialists work closely with the architects who are their patrons, providing custom images for presentation and documentation of their building projects. Julius Shulman was a remarkable member of the profession, known for his postwar work in California. He was one of five children of immigrants from Russia, born in Brooklyn.[1] When he was 10 years old, the family moved across the country to settle in Los Angeles, where his parents opened a dry-goods store. When Shulman was in the 11th grade at Roosevelt High School, he learned the rudiments of photography. He went on to study electrical engineering at the University of California, at both the Los Angeles and Berkeley campuses. Shulman helped finance his education by photographing portraits and campus buildings, selling prints in local book and department stores. In about 1932 he acquired a Vest Pocket Kodak (VPK) camera. Constructed mostly of aluminum, this miniature bellows camera folded into a compact shape measuring only 2½ × 4¾ × 1 inch when not in use. The VPK was the first miniature camera to use 127 roll film, which provided eight exposures and produced postage-stamp-sized negatives large enough to make contact prints as well as enlargements. Its fixed-focus single meniscus lens was situated behind the diaphragm and shutter.[2]

Shulman was back in Los Angeles in 1936 when he met an architectural draftsman from the office of Richard Neutra. He tagged along on a visit to Neutra's Kun House, then under construction in the Hollywood Hills. Shulman took five or six snapshots of the building with his VPK. Neutra was impressed with the photographs and purchased some to represent the project. Other assignments followed from Neutra, who introduced Shulman to some of his colleagues, effectively launching him on a new career. In March 1936, Shulman met the architect Raphael Soriano, who became a good friend and frequent collaborator.

In Shulman's early photographs of California Modernist architecture, he strove to convey not only architectural form but also the placement of a building in the landscape. An innate sense of composition enabled him instinctively to convey space. His photographs began appearing in *California Arts & Architecture* magazine in 1938. Four years later, publisher and editor John Entenza hired Shulman as staff photographer for the magazine, now called *Arts & Architecture*. As Los Angeles grew over the next decade, Shulman received commissions from the region's leading architectural firms and developed a thriving business. His architectural photographs also appeared in national magazines, including *LIFE*, *House & Garden*

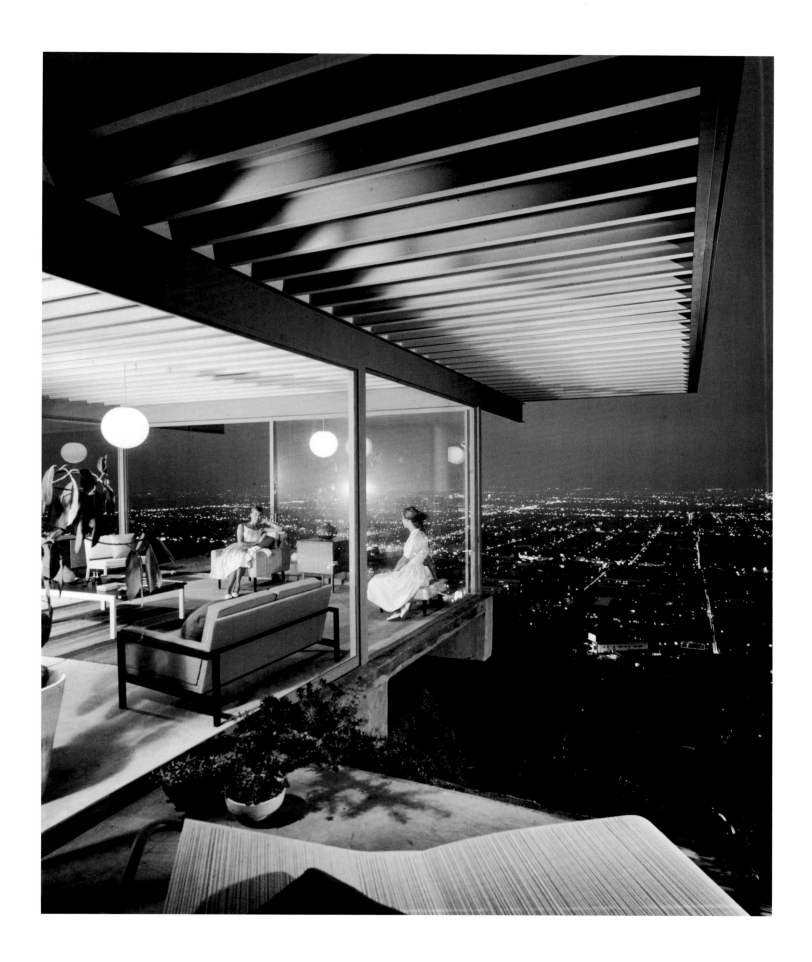

and *Good Housekeeping*. This success enabled Shulman to engage Raphael Soriano to design a steel-framed house and studio, which the photographer built in the Hollywood Hills.[3]

During World War II, in 1943–44, Shulman served in the Army as a surgical theater photographer. When he returned to Los Angeles, the photographer found that Entenza had begun a project to design and publicize affordable modern homes in preparation for service personnel returning from the war.[4] Entenza wanted to make available to veterans well-designed Modernist buildings that could be erected economically with new industrial materials and updated building techniques. He favored the International Style because of its simplicity and popularity. Among the architects recruited to design Entenza's "Case Study Houses" were Richard Neutra, Raphael Soriano, Charles and Ray Eames, Pierre Koenig, Eero Saarinen and Ralph Rapson.[5] Funds for this project were scarce, so Entenza and his staff appealed to architects, building contractors, equipment and material manufacturers, and suppliers to support the program. Thirty-six Case Study House plans were published in *Arts & Architecture*; 26 of them were eventually built in Southern California, and Shulman photographed 18 for the magazine.

This image of the Stahl House, or Case Study House #22, is one of Shulman's most famous photographs.[6] This small steel-and-glass building, designed by Pierre Koenig, exemplified the principles and aesthetics of Entenza's program. It was built for Clarence H. "Buck" Stahl, his wife Carlotta and their three children.[7] A former professional football player and car salesman, Stahl was a purchasing agent for Hughes Aircraft. In 1954 he noticed a small

vacant lot on a steep slope in the Hollywood Hills and imagined a home there with unobstructed views from the mountains to the sea. Stahl bought the lot at 1635 Woods Drive, and on weekends over the next two years he took fragments of concrete waste to the lot to shore up the retaining walls. Buck Stahl and a nephew appear in a family snapshot, taken in July 1956, sitting beside the large architectural model of a glass-and-steel house, suggesting that Stahl had already formulated the concept of a Modernist home on the hillside. Stahl approached several architects, who declined his project, perhaps because of his limited budget and insistence upon a wing without walls, providing an unimpeded a 270-degree view to the horizon.

In 1957, Pierre Koenig found Stahl's concept suited to his own style and vocabulary and took the job, adapting the design into something more rigorous, geometric and true to the Modernist aesthetic. He designed a small, two-bedroom home of 2,200 square feet (204 square meters). He moved the carport to the end of the building and substituted a flat tar-and-gravel roof for the curving butterfly roof that Stahl had envisioned. Three walls of the main living space were made of plate glass to maximize the stunning views to the ocean. In an era before tempered safety glass, Koenig used the largest sheets of glass then available for residential construction. Dramatic roof overhangs emphasize the soaring effect of the cantilevered living room, which extends 10 feet (3 m) over the hill.

Construction of the Stahl House was completed in May 1960.[8] To celebrate and promote the project, the owners of the Case Study Houses agreed to have Shulman photograph their homes and to open them to visitors. Entenza and Shulman selected this as the

leading image in the presentation of the Stahl House in *Arts & Architecture* magazine. To establish a dramatic relationship with the city beyond, Shulman photographed the house after dark. He shot this image from the pool deck, using the wide overhanging eaves of the house and its receding grid of roof rafters to draw the eye to the astounding view of Los Angeles at night. He was careful to line up the orthogonals described by the building with the grid of lighted streets beyond. Even the furniture inside is arranged along this grid, punctuated by the bright spheres of the hanging lamps. Two elegant ladies in light-colored, cinch-waisted New Look dresses converse politely in the illuminated interior. They were not family members but students that Shulman selected as models. The living-room furniture was brought in by Van Keppel-Green to decorate the house temporarily for its magazine premiere. The figures of the women and the plants in the foreground are like organic accents in a Cubist composition. In the foreground, Shulman placed a webbed sun chaise with its cords pointing into the distance at an opposing angle to emphasize the geometric recession even more. The effect exaggerates the space, making the house appear larger than it is, and its cantilevered overhang wider and more dramatic. Because of this image, the Stahl House has become a paradigm of Southern California Modernism.

LARRY BURROWS
English, 1926–1971

H-21 Helicopter, Trà Bông

1962
Dye imbibition print
45.7 × 30.5 cm (18 × 12 in.) Image
54 × 42 cm (21¼ × 16½ in.) Sheet

Milly and Fritz Kaeser Endowment for Photography, 2018.007

Over nine years, Larry Burrows assembled a remarkable photojournalistic record of the American war in Vietnam. His viewpoint changed over time, and his efforts to construct a compassionate point of view in his work reflect the moral ambiguities of his role as both photographer and witness. During the 1960s, media coverage of the war gradually shifted to television; Burrows stands out as the most innovative photojournalist in Vietnam, and his images influenced television coverage. His courage, talent as a visual artist and feel for the Vietnamese distinguished his work.

Henry Frank Leslie Burrows was born in central London, where his father was a truck driver for the railroad and his mother a housewife.[1] When he was 16 years old he left school to become a messenger at the *Daily Express* newspaper. Later he got a job at the Keystone Agency, where he learned the skills of a darkroom technician. Ironically, Burrows was exempted from military service during World War II for his poor eyesight. During the Blitz he served in the Home Guard, however, and he experienced the destruction of London by German bombing. After the war Burrows became a photographic printer in the London bureau of *LIFE* magazine, calling himself Larry, rather than Henry, to avoid confusion with an office coworker. He processed film and printed

the work of a wide variety of *LIFE* photographers, including Robert Capa (Cat. no. 49), and exposure to this work was an important influence on his own photographs.

In 1945 Burrows began his own career as a freelance photojournalist. He often had assignments from *LIFE*, but his work also appeared in magazines like *Quick*, *Stern* and *Paris Match*. The assignments took him across Europe and around the world, to Africa, the Middle East, India and Pakistan. Burrows created nature photoessays, chronicled archeological excavations and made portraits of celebrities like Winston Churchill and Ernest Hemingway. Occasionally he photographed masterworks of European art for *LIFE*, which taught him lessons of pictorial composition and the use of color. In 1961 Burrows took a position as *LIFE* staff photographer in Hong Kong. He received assignments for projects in India and New Zealand, as well as calls to cover the progressing war in Indochina. In 1962, when the photographer first visited Vietnam, a small number of American troops were advisers to the South Vietnamese Army. Burrows quickly realized that this was an ideal subject for him: an elemental clash of alien cultures, traditional and modern, played out in an exotic, beautiful land of paddies, mountains and jungles.

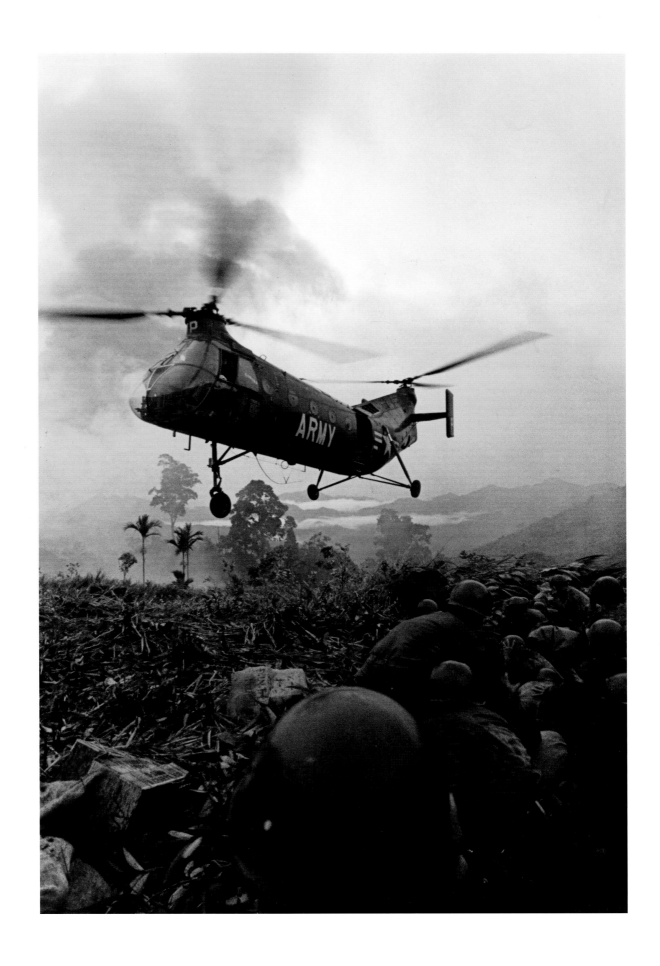

This photograph of a U.S. Army Piasecki H-21 Shawnee helicopter on a supply run was taken during one of Burrows's first expeditions in Vietnam, to Quàng Ngãi Province in the South Central Coast region. Burrows understood straightaway how important the helicopter was in the evolving conflict. To the rural Vietnamese, this was a weapon of awesome, almost otherworldly power. The H-21, known as "the flying banana" for the peculiar shape of its fuselage, became the mainstay of the American combat air assault force early in the Vietnam War.[2] Its form was adapted to its two piston engines with overlapping rotor blades, which enabled the helicopter to lift heavier loads with little concern for even weight distribution. In Vietnam the H-21s were also used for "administrative" missions such as this: resupplying Special Forces advisors with ammunition and rations, delivering mail and evacuating the wounded. American pilots soon developed tactics for evading enemy antiaircraft gunners. They frequently varied their routes to these drop sites, rapidly flying at an altitude of about 2,000 feet (610 m) until the approach to the landing zone, when they would descend to 10–20 feet (3–6 m) above the ground, flying at 100 knots. This tactic allowed the enemy little time to fire, and was an impressive and rather frightening sight from the ground.

Burrows tried to capture this impact in his photograph.[3] The huge helicopter hovers in the center of the image, above a landing zone cut into the jungle hilltop. It is likely that this is a supply mission, and that the helicopter is landing, having dropped personnel and supplies, the wooden cases of which are apparent in the foreground. Directly below the helicopter is the helmet of a South Vietnamese soldier, positioning the viewer in the scene, among the other soldiers who observe the aircraft. The curve of the aircraft appears to settle into the concave landscape. Between the dip in its fuselage and the soldier's helmet is a view into the landscape in the deep distance, where clouds float between the peaks of jungle-covered mountains. The center of the composition is open, emphasizing the astounding fact that this enormous machine hovering in midair is capable of horizontal descent and take-off. This image suggests something of the awesome scale, power, noise and psychological impact that these machines must have had on the Vietnamese. Figures shrink away from the helicopter, clutching their helmets to their heads, shielding their eyes from the dirt kicked up by the blade wash. The smoky, hazy tone of this photograph emphasizes the experience, and is different from the bright, tropical palette of many of Burrows's color photographs. Greens and browns reflect the monochromatic hues of the battlefield rather than the jungle.

H-21, Trà Bông was one of 14 photographs published in Burrows's first extended Vietnam War story in *LIFE* magazine, "In Color: The Vicious Fighting in Vietnam, We Wade Deeper into Jungle War," in January 1963.[4] The 14-page photoessay accompanied a report by Milton Orsefsky. It took Burrows almost six months to cover the material and prepare the story, which depicts the operations of South Vietnamese with their American advisors in the Mekong Delta. This was the most extensive photographic coverage of the conflict at that time in the American press. It was also the first color imagery representing the war in a major magazine, changing the ground rules for photojournalism. "We Wade Deeper into Jungle War" presents a brutal conflict against complex forces in an inhospitable,

faraway landscape, introducing a mood that continued through Burrows's work in Vietnam. Stylistically the photoessay followed the *LIFE* tradition of design, with text and images carefully laid out in each spread to complement each other, all working together to narrate the events depicted. Burrows's vibrant colors enhanced the imagery in new ways, and his jarring compositions shaped the viewer's perspective on the action and personnel. The photoessay also included images of dead enemy soldiers, while others show evidence of U.S. military involvement at a time when this was little discussed.

Working for *LIFE* magazine gave Burrows the luxury of deliberation. Most of his colleagues in the field were employed by daily newspapers or news services, and they pursued breaking news on tight schedules. Burrows had time to observe, study and plan a story, frequently over weeks and months. He was noted for his patience and composure, and worked deliberately, selecting his subjects and dictating their scenario, setting and composition on the basis of his observations of the battlefield. He often devoted several days to achieving a single image. This seems a counterintuitive approach to combat photography, but he captured many of the most memorable images of the war in Vietnam. Burrows's efforts to balance aesthetics and documentation were aimed at making events understandable to Western viewers. He experienced the war along with the soldiers. He lived in military camps, stayed on the front lines during enemy fire, and accompanied air crews on combat missions. He strove to photograph the full range of combat in Vietnam, from helicopter flights to parachute drops, the gore of battle and the evacuation of the wounded. His work often adds formal elegance to technically perfect images.

From 1963 to 1965 Burrows followed the evolving political and military developments in Vietnam, including the Buddhist revolt and the coup that overthrew Diem, the increasing activity of U.S. advisors and the arrival of U.S. combat troops in March 1965. For an in-depth story on helicopter crews and their cyclical activities on base and in the field, he accompanied them on many missions. One of these resulted in his most famous photoessay, "One Ride with Yankee Papa 13," following a single eventful mission and its effects on a young soldier.[5] His most admired photoessays covered the battle for hills in the Demilitarized Zone in the fall of 1966, the increase in U.S. activity in the Mekong Delta at the beginning of 1967, and the siege of Ke Sahn in the spring of 1968. Many of his photographs represent American soldiers involved in the ground war, reflecting their experiences and the physical and emotional effects of battle upon them. Although Burrows came to Vietnam in support of American involvement, he sensed a deep pessimism among the Vietnamese people, which affected his own opinion on war and human endeavor, expressed in his photoessay "Vietnam: A Degree of Disillusion" in 1969.[6] The invasion of Laos was imminent in February 1971, when Burrows and four other photojournalists— Kent Potter, Keizaburo Shimamoto, Henri Huet and Tu Vu—died when the South Vietnamese helicopter in which they rode was brought down by antiaircraft fire along the Laos-Vietnam border.[7]

DAN BUDNIK
American, born in 1933

Boy Peering through the Berlin Wall

1961
Gelatin silver print
34.3 × 23 cm (13½ × 9 in.) Image
35.5 × 28.2 cm (14 × 11⅛ in.) Sheet

Humana Foundation Endowment for American Art, 2015.056

The photojournalist Dan Budnik has explored the personal character of creativity in his work, and the public events of social change. He was born and raised on Long Island, New York, the son of immigrants from the Ukraine.[1] By the time he was a teenager, he had decided upon a career in the fine arts. After high school he went to join his older sister Vera, a Hollywood publicist, in Los Angeles. There Budnik met the Ukrainian-born painter Peter Krasnow and his wife, Rose, who for decades had been friendly with Edward Weston (Cat. no. 16) They had assembled a remarkable collection of Weston's photographs, and Budnik enjoyed long evenings looking at the photographs and discussing visual arts with the Krasnows.[2] This adventure was interrupted by a draft notice, which required him to return to New York to register and await induction. Back in the city, he enrolled at the Art Students League (ASL). His principal teacher was Charles Alston, a renowned painter of the Harlem Renaissance and the first African American supervisor in the Federal Arts Project of the Works Progress Administration.[3] A generous mentor, Alston and his wife often had Budnik over for dinner, and at their table he became aware of American racism and segregation from a different perspective. One evening at the Alstons' apartment, Budnik first saw Henri Cartier-Bresson's (Cat. no. 60) photobook *The Decisive Moment*. He was especially taken by the portraits of artists Pierre Bonnard and Henri Matisse, which presented them as approachable people. Another of Budnik's teachers was the painter Herman Cherry, who sometimes took him to the Cedar Tavern, where many of the Abstract Expressionists gathered. Cherry introduced Budnik to his friends, including Willem de Kooning, Franz Kline and Jackson Pollock.

In 1953, Budnik was drafted into the military. He was trained in an infantry regiment, but the Korean War ended before his deployment and he completed his service in the South. After his discharge, he returned to Manhattan. He bought a Leica camera from a pawn shop and made photographs around the city, dreaming of a career in photojournalism. Budnik met Cornell Capa, then president of Magnum, who hired him to work in the agency office, with the promise of a field assignment within three months. Budnik worked at the traffic desk and came to know both lab technicians and photographers such as Eve Arnold, Ernst Haas and Elliott Erwitt (Cat. no. 71). In this job he learned the practical realities of photojournalism; a part-time job as assistant to Philippe Halsman, a fashion and commercial photographer and a great portraitist,

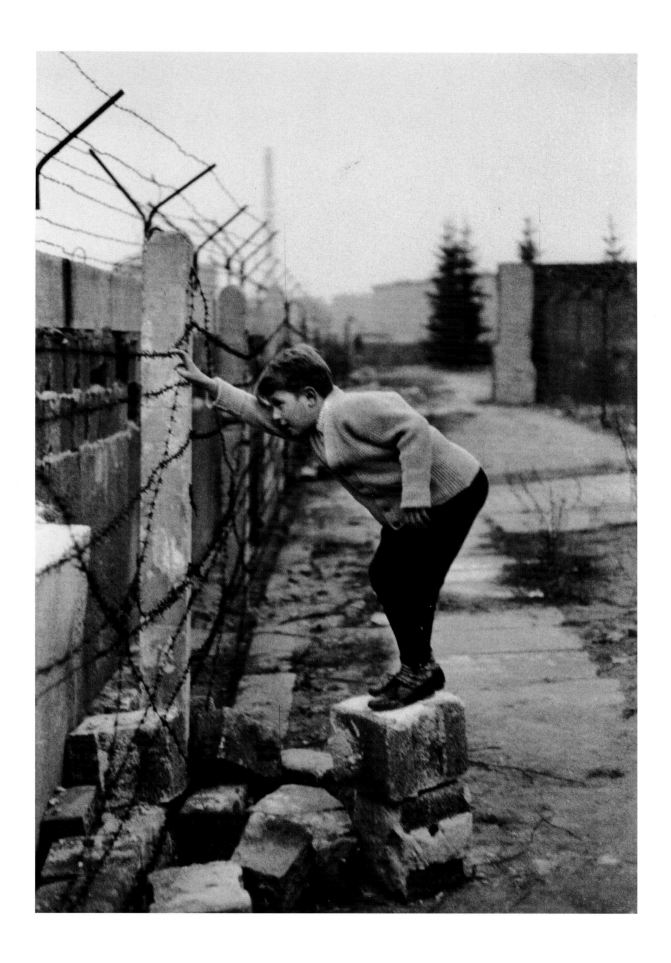

allowed Budnik to observe the work of a photographer from a more creative and aesthetic perspective.[4]

In March 1958 Budnik received his first assignment from Magnum: investigate underground opposition to dictator General Fulgencio Batista in Cuba. For six weeks Budnik lived with members of the leftist underground in Havana, sleeping in a different safe house every night. In these rough surroundings, he photographed Fidel Castro, Che Guevara and other youthful, idealistic leaders of the Cuban Revolution. When Budnik returned to New York, Charles Alston introduced him to ideas and leaders in the nascent Civil Rights Movement. Among them was the actor Harry Belafonte, who used his celebrity to bring attention to the movement. In October 1958 Budnik joined the Youth March for Integrated Schools in Washington, D.C., organized

by Belafonte, Bayard Rustin and Dr. Martin Luther King Jr. He was there when Belafonte, Rustin and a group of students delivered a petition to the White House only to be disrespectfully rubuffed.[5]

In fall 1961, Budnik took a Magnum assignment to investigate the Berlin Wall. During the night of August 31, soldiers and police in the German Democratic Republic (East Germany or GDR) had erected a guarded concrete barrier to separate their part of the city from the Federal Republic of Germany (*Bundesrepublik Deutschland*, West Germany or BRD). Years of political tension led to this event. At the end of World War II, the Potsdam Agreement had divided Germany into four occupation zones, controlled by the USSR, the United States, the United Kingdom and France. The capital city of Berlin, located about 100 miles (160 km) inside the Soviet-controlled zone, was likewise divided into four sectors. The BRD became a capitalist nation with a social market economy and a democratic parliamentary government, while the GDR became a Communist country under the sway of the USSR. Millions moved to the BRD for political reasons, and the economic stability of East Germany was threatened. In response,

Fig 19. — Dan Budnik, American, born in 1933, *Dr. Martin Luther King, Jr.*, 1963, gelatin silver print, Humana Foundation Endowment, 2015.014.001

the GDR constructed an *Antifaschistischer Schutzwall* (anti-fascist protective wall), equating West Germany and the NATO countries with fascists. Fences and barbed-wire entanglements were built along the 97 miles (156 km) encircling the three western sectors, and across the 27 miles (43 km) that divided East and West Berlin. Many Berliners who lived in the East were cut off from jobs in the West, and families and friends were divided. The GDR was able to control emigration and establish relative economic stability. However, the Berlin Wall became the visible symbol of Communist tyranny and the "Iron Curtain" forcibly dividing Europe. This was the situation that Budnik found when he arrived in West Berlin in fall 1961. He photographed the wire fences, concrete barriers and guard posts, and saw townspeople gathered in small groups along the wall hoping to glimpse or wave at loved ones on the other side. Budnik documented makeshift memorials to civilians killed trying to escape over the wall, and armed soldiers peering through binoculars into the lens of his camera. Around 5,000 people successfully escaped into West Berlin during the years of the wall, but as many as 200 were killed in their attempts to flee.

This photograph encapsulates the situation.[6] A boy in West Berlin has clambered to the top of a pile of bricks to look through a hole in the wall, perhaps hoping for a glimpse of friends or family. This child, born since the end of World War II, cannot understand the political cause of his plight. He looks more curious than frightened, but he is small and insignificant in his street clothes facing the wall of brick and the rows of barbed wire. He is surrounded by a wasteland of wire fencing, concrete and weeds left clear for a second, parallel fence to be built on the East German side. The area between the fences, known as the "death strip," offered clear fields of fire for guards on the wall. Balancing precariously on a tower of bricks, the boy grasps a strand of wire as he leans forward to see through the wall. The skies are overcast, and in the distance the shadows of factory buildings and a tall smokestack seem to suggest a grim future. Budnik printed this photograph in soft, grainy tones that support the mood of the image and approximate the coarse surfaces of concrete and mortar. Confronting the baffling political and physical barriers before him, this German boy metaphorically gazes into an uncertain life during the Cold War.

After returning to New York in 1962, Budnik photographed Willem de Kooning at his studio on Broadway, and David Smith in his foundry at Bolton Landing in Upstate New York. A photoessay on Smith appeared in *LIFE* magazine in April 5, 1963, and a selection of Budnik's photographs of Smith was exhibited at the Guggenheim Museum.[7] Soon after the photographer became an associate member of Magnum in 1963, *LIFE* sent him to the South to photograph events in the Civil Rights Movement. Late in August, Budnik covered the March on Washington. He found a place among the crush of people high on the steps of the Lincoln Memorial and was there when Dr. Martin Luther King Jr. delivered his "I Have a Dream" speech. Moments afterward, when King was being mobbed by his colleagues near the podium, Budnik snapped his famous portrait of King (Fig. 19), emotionally exhausted but still heartened by the great event.[8]

DIANE ARBUS
American, 1923–1971

Triplets in Their Bedroom, N.J.

1963
Gelatin silver print
37 × 37.6 cm (14⅝ × 14¾ in.) Image
50.6 × 40.5 cm (19⅞ × 16 in.) Sheet

Dr. M.L. Busch Fund, 1977.090

Diane Arbus's subjects included a wide range of people: middle-class families and children as well as eccentric and marginalized members of society. However, it was not Arbus's subjects that made her photographs so remarkable, but the intensity of the interchange that she exposed. Diane Nemerov was born in New York, where her father was director of Russeks Fifth Avenue.[1] This landmark Manhattan women's department store was founded as a furrier in the 1890s by her maternal grandparents, Jewish immigrants from Eastern Europe.

Diane attended the Ethical Culture School in Manhattan and the prestigious Fieldston School in the Bronx. At 13, she met Allan Arbus, a Russeks employee, and at 18 they were married. They shared a fascination with photography, and shortly after their marriage Allan gave Diane a Graflex camera. David Nemerov, her father, hired the couple to produce photographs for Russeks's newspaper ads. After the war, they opened a commercial photography studio under the name "Diane & Allan Arbus." Diane acted as art director and stylist, while Allan made the photographs. The studio became moderately successful as their work regularly appeared in magazines like *Glamour* and *Vogue*.

In 1956, Diane Arbus began studying with Lisette Model, and later that year quit the business partnership with her husband to produce her own work.[2] Using a 35 mm Nikon camera, she began to pursue photographic subjects in some of the same places where Model and Weegee (Cat. no. 51) worked, making images of transvestites, carnival performers, strippers and Coney Island bathers. Six years later, Arbus shifted to using a wide-angle Rolleiflex and then a Mamiyaflex camera, both of which produced 2 1/2 inch (6 cm) square negatives with sharper images. These twin-lens reflex cameras were held at waist level, and the photographer sited down into a ground-glass viewing screen.

Arbus's images often reflect a surprising intimacy, and in a sense the photographs may have been less important to her than the exchange they recorded. In 1959, *Esquire* magazine commissioned Arbus's photoessay "The Vertical Journey: Six Movements of a Moment within the Heart of the City," which included portraits of a Times Square sideshow performer and a Daughters of the American Revolution doyenne.[3]

In 1963 Arbus won a Guggenheim Foundation Fellowship to support her project "American Rites, Manners and Customs," which documented a range of social ceremonies, such as parties, religious ceremonies and beauty pageants. As Arbus wrote in her Guggenheim application, "I want to photograph

the considerable ceremonies of our present because we tend while living here and now to perceive only what is random and barren and formless about it. While we regret that the present is not like the past and despair of its ever becoming the future, its innumerable, inscrutable habits lie in wait for their meaning."

Triplets in Their Bedroom, N.J. 1963, shot with a Rolleiflex camera, exemplifies Arbus's straightforward, traditional mode of portraiture, similar to the work of August Sander (Cat. no. 27).[4] This style had become relatively unusual at a time when progressive photographers preferred expressive, fleeting images. The triplets lean against the head of a small bed, one of three pushed tightly together in their little room, suggesting how closely they live. They sit comfortably together, touching affectionately. They are dressed alike, with a dark skirt, white buttoned shirt, and white headband against their common haircut. The white headboards flanking the girls create a strong horizontal band, further locked by the subjects' direct gaze.

The sisters confront us as one, as if they were different aspects of one personality, simultaneously cordial, friendly and beguiling. The disconcerting effect challenges us to consider how much these three people must share, despite their different personalities. Similar genetic makeup, background and experience set them apart, and make them fascinating. They comprise a rather intimidating team. Arbus brings the viewer into a guarded, private realm, both physical and personal.

In 1965, the year Arbus taught at the Parsons School of Design, her Guggenheim grant was renewed. Thirty of her photographs were included in the exhibition *New Documents*, organized by John Szarkowski at the Museum of Modern Art in spring 1967. The show also featured work by Lee Friedlander and Garry Winogrand, and presented unsentimental observation rather than poetic documentation. As Szarkowski wrote about the artists in his introduction to the show, "Their aim has been not to reform life but to know it, not to persuade but to understand. The world, in spite of its terrors, is approached as the ultimate source of wonder and fascination, no less precious for being irrational and incoherent."[5] The show generated a fair amount of attention for Arbus.

In 1969 she prepared a limited-edition portfolio of large prints. Only four of the intended edition of 50 were sold during her lifetime. *A Box of Ten Photographs* was presented in a clear Plexiglas box that doubled as a framing device. The portfolio included several images from the *New Documents* exhibition; five of them were later published in *Artforum* magazine in May 1971, the first photographs to be featured in the bastion of late Modernism. On July 26, 1971, the artist committed suicide in her apartment. The following year, the Museum of Modern Art held a retrospective exhibition of her work, one of the most widely attended photography shows in the museum's history.[6]

DAVE HEATH
Canadian, born in the United States, 1931–2016

New York

1963
Waxed gelatin silver print
27.4 × 18.8 cm (10¾ × 7⅜ in.) Sheet
45.5 × 35.9 cm (17⅞ × 14⅛ in.) Mount

Humana Foundation Endowment for American Art, 1995.007.004

The intense photographs of Dave Heath often reveal disquieting aspects of the human condition. The artist struggled with depression, and anguish fueled his art. Born in Philadelphia, David Martin Heath was named after a maternal great-grandfather, a noted rabbi in Russia.[1] His father left the family when Heath was a toddler. Three years later his mother abandoned him on her parents' doorstep, never to be seen again. Unable to raise the boy, his grandparents placed him in care, and over the next eight years he passed through a succession of indifferent foster homes. He became introverted and unpredictable, and remained so throughout his life. When Heath was 12 years old, he entered the Association for Jewish Children orphanage in Philadelphia, where he remained for the next four years.

While he was there Heath encountered photography for the first time in Ralph Crane's photoessay "Bad Boy's Story" in *LIFE* magazine.[2] He recognized himself in these images of an orphan's life in the child welfare system and realized how moving photographic images could be. He stole two dollars from the orphanage director, bought a Falcon Miniature camera, and taught himself to use it. He learned how to print his photographs in his high school camera club. At that time Heath was also inspired by John Whiting's book *Photography Is a Language*.[3] In 1947 he

transfered to a vocational school, only to find that its photography program was restricted to G.I. Bill students. He left school and, while working in a succession of darkroom jobs in Philadelphia and New York, made the first of a series of handmade photobooks. He was drafted into the Army in 1952 and trained as an infantryman before being sent to the front lines during the Korean War. He carried his camera along, and photographed his comrades and their experiences.[4]

After his discharge from the service, Heath continued his work on unique handmade books of his photographs. He completed *No Dancing in the Streets* in 1954, and attended the Philadelphia College of Art for two terms, before moving to Chicago, and then New York in January 1955. The first solo exhibition of his photographs hung at the Seven Arts Coffee Gallery, a Beat gathering place in Greenwich Village. The artist made another unique photobook, *In Search of Self: A Portfolio*, in 1956. Three years later, Heath attended a class taught by W. Eugene Smith (Cat. no. 48) at the New School for Social Research. He was impressed by Smith's insistence that only in the darkroom did a photographer a produce a work of art. As a workshop participant at Smith's loft in 1961, he learned how to sequence images to convey a story. A solo exhibition of Heath's photographs was

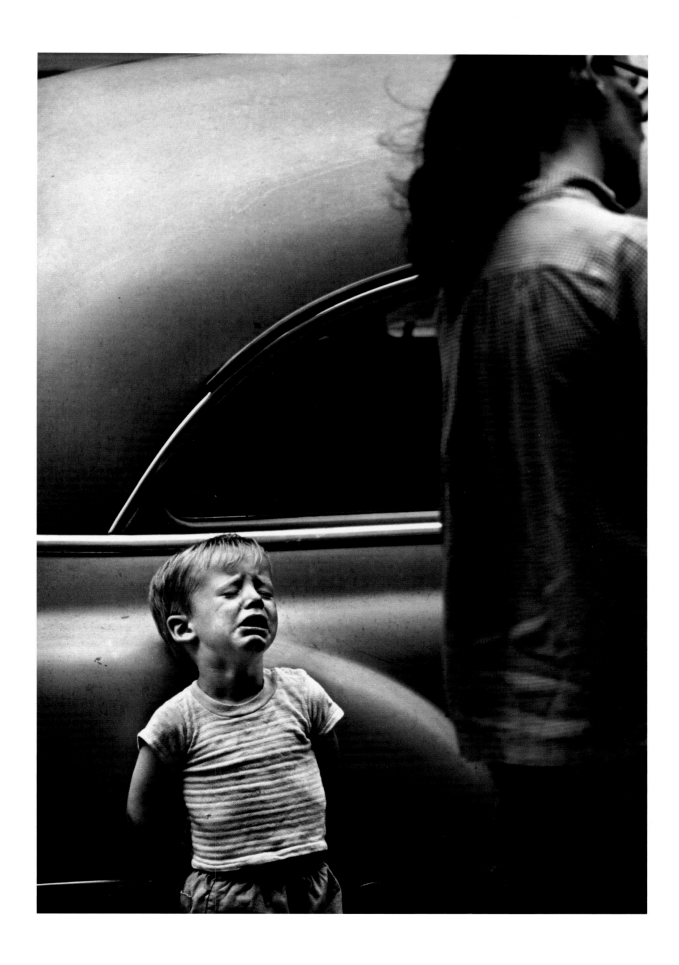

presented at the Image Gallery in Manhattan in 1961, but he still struggled to publish his work. His handmade books helped him to win a Guggenheim Foundation Fellowship in 1963, which he used to compile a printed photobook from images he had taken on city streets over a decade. Whenever possible, during slow times at the local printing plant, he worked with a commercial job printer. He designed and executed the layout himself and, supported by a renewal of the grant in 1964, he published *A Dialogue with Solitude* in 1965.[5] The book presents Heath's perception of the human condition in 82 images, arranged in 10 thematic sections, each of which is preceded by a literary epigraph. Although there are joyful images, most represent loneliness and despair, and even a sort of ennui similar to Robert Frank's *The Americans* (Cat. no. 70). Heath possessed an innate graphic sense, and in the moment he was able to identify and extract a highly organized image from events in the street. This dynamic continued in the darkroom, where he refined and clarified the designs he sensed all along.

This photograph of a frustrated child on a New York City street was made at the time of *A Dialogue with Solitude*.[6] Children were a favorite subject for Heath, perhaps for their ingenuous demonstrations of emotion. This little boy cries alone, ignored by his mother who turns her back on his displeasure. Pressed into the upper right corner of the frame, she is tall and emotionally inaccessible. Though she turns away, perhaps to chat with a friend or neighbor, her emphatic black ponytail directs our attention back down to the little boy, as does the sweep of the car's window and the curve of its fender, drawing the eye to his gathered brows. The boy's small size within the composition signals the scale of his tiny personal anguish. The visible outline of his rib cage suggests a deep intake of breath and the depth of his sobs, wracking his entire body. This sort of childhood sadness haunted Heath, and he observed and examined it, perhaps seeking to neutralize its power. To capture this emotion, he often moved in close to his subjects. In the darkroom he refined images through close cropping and centering tiny gestures, fleeting motions or expressions. In this way, he achieved a formal solemnity from his small negatives. Nearly all of his images are in some sense introspective, yet through all of his activity he seemed to find little relief from the demons of his past. This print was shown in the exhibition *Focus 23* at the Association of Heliographers, a short-lived cooperative of professional photographers.

Heath began a teaching career, with appointments at the Dayton Art Institute in Ohio and Moore College of Art and Design in Philadelphia. Curators and critics admired his photographs, but he found it difficult to exhibit and publish his work regularly in the 1960s. Instead he created presentations of his original 35 mm slides, shown by a pair of Kodak Carousel projectors. The first of these, *Beyond the Gates of Eden*, was accompanied by a tape recording of Heath reading a William Everson poem, with the music of singer-songwriter Tim Buckley. Over about 15 years, the artist created four more slide-tape presentations.

In 1970, troubled by the actions of the American government, and the war in Vietnam, Heath moved to Canada. He joined the faculty at the Ryerson Polytechnical Institute in Toronto. He became quite an effective teacher; as well as instructing students in technical darkroom skills, he encouraged them by recognizing themes in their work. The artist remained troubled by recurrent depression.

He found it difficult to maintain friendships, and his marriage in Toronto lasted less than 18 months. Often angry and moody, he disparaged colleagues and students and pushed away admirers. On his own, Heath explored antique and junk shops, collecting old family snapshots and vernacular photographs, incorporating them into journals and slideshows. He also began using the Polaroid SX-70 camera to make self-developing color prints, which he gathered in notebooks along with his own writing. He accumulated 200 volumes over the course of his activity. In 1981 a retrospective exhibition of Heath's photographs was presented at the National Gallery of Canada in Ottawa.[7]

GARRY WINOGRAND
American, 1929–1984

New York City

1964
Gelatin silver print
33.9 × 22.9 cm (13⅜ × 9 in.) Image
35.3 × 27.9 cm (13⅞ × 11 in.) Sheet

Gift of John C. Rudolf (ND'70), 1983.040.002.G

Garry Winogrand became a pivotal figure in American street photography during the 1950s. He had a knack for finding the extraordinary among the commonplace, and developed his own methods of capturing fleeting events. Like earlier visual artists of social satire, such as William Hogarth and Honoré Daumier, he was drawn to human fallibility and irony. The son of immigrants from Eastern Europe, Winogrand was born and raised in a Jewish, working-class neighborhood of the Bronx.[1] He was an indifferent student and enlisted in the Army when a recruiter told him that he could graduate from high school early. Stationed in Georgia, Winogrand learned the techniques of photography as a weather forecaster. After his discharge in 1947 he returned to New York and began to study painting at City College. When he used the support of the G.I. Bill to attend Columbia University, he discovered a student darkroom that was open 24 hours a day. This made it possible to shoot during the day, then develop and print his photographs at night in solitude. It was a rhythm of production that suited Winogrand's impatient nature, and soon he turned away from painting. He took a class with Alexey Brodovitch at the New School for Social Research and adopted that influential teacher's preference for intuitive photography over technical precision. Brodovitch also passed

along an enthusiasm for the human form in motion, and Winogrand began photographing at fight clubs and gyms around New York, and backstage at the ballet. He found these dynamic images satisfying because they were self-explanatory.

A brief contract with a New York picture agency in 1951 gave Winogrand access to a darkroom, as well as a place to meet and socialize with other photographers. He began a career as a freelance photojournalist, and his images appeared in such magazines as *Collier's* and *Sports Illustrated*. In 1952 Winogrand married the dancer Adrienne Lubow, the first of three marriages. Two of his motion photographs were included in Edward Steichen's (Cat. no. 4) landmark *Family of Man* show at the Museum of Modern Art in 1955, a distinguished exhibition debut. At that time, however, television and the accelerating pace of postwar life reduced the demand for photojournalism. Winogrand turned to commercial photography, but he was unsuited to its aesthetic refinement and technical demands. He concentrated on his creative work, spurred by other frustrations, including marital disharmony and the bleak politics of the Cold War. Searching for a compelling theme and distinctive personal style, he photographed everything that crossed his path, no matter how seemingly insignificant. Winogrand tried using a wide-angle

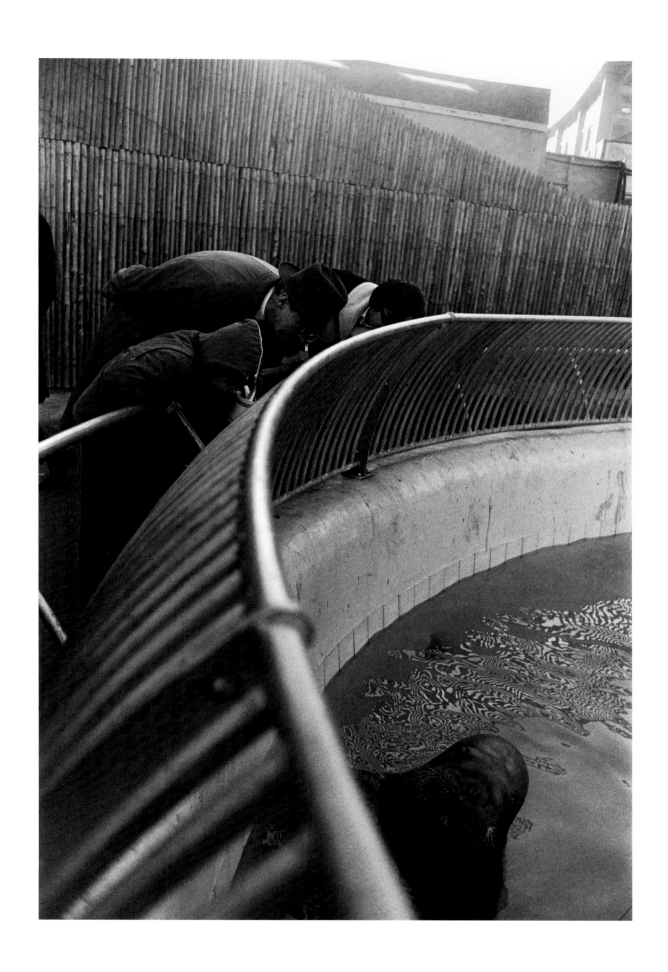

lens on his Leica miniature camera, and he exposed hundreds of rolls of film. In this way, he discovered his unusual reactivity and sense for human fallibility. He framed images instinctively, tilting the camera to control the visual distortions of the lens. To capture fleeting moments, he stopped looking through the viewfinder, often literally shooting from the hip—a responsive, improvisational practice that was the photographic equivalent of contemporary jazz music or Abstract Expressionist painting.

Winogrand began regularly to visit the Central Park Zoo in New York. He discovered that people relaxed in the presence of the animals and dropped their social defenses, leaving them exposed for his camera. When he photographed animals and people together, the creatures often appeared canny, quick and agile compared to the diverted and stupefied humans. Many of Winogrand's zoo photographs

emphasize the iron bars, concrete floors and unpleasant conditions for the animals. In this photograph, much of the composition is devoted to layer after layer of fencing.[2] Leaning together to peer through the bars, a family surveys a tank for a glimpse of a walrus, oblivious to the animal that has emerged from the surface to confront the photographer. The mammal looks directly at the camera, as if to shrug at the stupidity of its specta-tors and the absurdity of its own situation. A little boy holds a paper cup filled with silvery herring to feed the walrus, who seems almost to scoff. The animal's floating body takes an angle that echoes the curving diagonal that gives this image an energy, a sense of *espièglerie*. Life seems to fly by in Winogrand's photographs, tilted, unfocused and insecure, a viewpoint that reflects the overcapacity and alienation of the era. The photographer often

Fig 20. — Garry Winogrand, American, 1929–1984, *New York*, 1972, gelatin silver print, Gift of John C. Rudolf (ND'70), 1987.046.005.A

cropped his images in alignment with a vertical axis, rather than orienting his composition with a level horizon. Here he used the pickets of the middle background fence, emphasizing the sweep into the distance. Winogrand's skillful framing in the darkroom influenced a generation of American photographers, as did his satirical view of people and society. Although this photograph seems to present an amusing anecdote, Winogrand insisted that his images never told a story; rather, they were literal, momentary records of what his equipment could perceive and capture.

In 1964, Winogrand won a Guggenheim Foundation Fellowship that allowed him to travel and photograph in California and the Southwest. Somehow he never seemed as engaged away from overcrowded city streets. In California he exposed hundreds of frames from his car that were never printed or edited. In the mid-1960s, Winogrand's work was included in the influential shows *Toward a Social Landscape* at George Eastman House and *New Documents* at the Museum of Modern Art.[3] These exhibitions reflected how creative photography had become more casual imagery and facture, influenced by a Cold War sense of impending threat. As seen in the work of younger photographers, like Ed van der Elsken and Robert Frank (Cat. no. 70), creative photography focused on the commonplace and inconsequential in a grim, almost elegiac mode.

In 1969, *The Animals* became the first of a series of solo exhibitions of Winogrand's photographs presented at the Museum of Modern Art.[4] The artist was awarded a second Guggenheim Fellowship that year to explore the effect of the media on events. He photographed marches, press conferences, sports events, parades and parties; many of the images are crowded and complex in their webs of aversion. The photographs of Winogrand's *Public Relations* series document an era of social distress that seems to offer no relief.[5] In 1967 the photographer had begun teaching and found that he enjoyed it, holding positions at the Parsons School of Design, the School of Visual Arts and Cooper Union in New York. Over years he had been collecting pleasing and affable photographs of women on the street whom he found attractive, sometimes in candid shots and sometimes with the subject's interaction (Fig. 20). For Winogrand, the acknowledgment of sexuality revealed people—himself included—at their most vulnerable and sympathetic. His folio of original prints and the mass-market photobook *Women Are Beautiful* seemed fresh and playful to many in an era of sexual liberation.[6] Today, the photographs often seem distasteful and voyeuristic. Might this provocation have been Winogrand's intent?

In 1973 Winogrand moved with his family to Austin, where he taught at the University of Texas. The artist again explored the uneasy relationships between human culture and the animal world in photographs of livestock and their owners in his exhibition and photobook *The Fort Worth Fat Stock Show and Rodeo*.[7] When he died in 1984, Winogrand left more than 300,000 exposed negatives that were either undeveloped, unproofed or unedited. The impulse to seek and gather had entirely overtaken his interest in selection and creative presentation, it seems. A posthumous retrospective exhibition was presented by the Museum of Modern Art in 1988.[8]

PAUL CAPONIGRO
American, born in 1932

Running White Deer, County Wicklow, Ireland

1967
Gelatin silver print
19.3 × 48.5 cm (7⅝ × 19⅛ in.) Image
19.9 × 49.5 cm (7⅞ × 19½ in.) Sheet

Humana Foundation Endowment for American Art, 2015.064.020

In his work as a creative photographer, and as a musician, Paul Caponigro has searched for inspiration in the unmanifest world of spirit. He was born and raised in the Revere neighborhood of northeast Boston.[1] His father, who operated a floor-covering business, was born in Salerno, Italy, and his mother at Canicattini Bagni in Sicily. They met and married in Boston and raised a family of four children. As a child, Paul excelled in art and music, and received encouragement from his uncle, a pianist. When he was 13 years old, he bought a used Zeiss Ikon camera and taught himself to develop and print his own photographs. He volunteered to work at a local portrait studio to refine his darkroom skills, and eventually he was hired as a darkroom assistant and event photographer. He earned enough to buy a Graflex Speed Graphic camera, which he took to Nahant Beach on the North Shore of Massachusetts to photograph the seaside rocks. After graduating from high school, Caponigro attended the Boston University School of Music where he studied with Alfredo Fondacaro. His aspirations to become a classical pianist were interrupted, however, in 1953, when he was drafted into the Army during the Korean War. He was trained for combat, but the war ended before his deployment and he was posted to the Presidio in San Francisco.

In the Army photo lab, Caponigro befriended the Chinese American photographer Benjamen Chinn.[2] They spent weekends together photographing along the Bay Area seacoast, and Chinn taught Caponigro the fundamentals of Ansel Adams's Zone System. Chinn also introduced his friend to Bay Area creative photographers, including Adams, Imogen Cunningham, Dorothea Lange and Minor White (Cat. nos. 49, 19, 38, 67). After his release from the service in 1955, Caponigro stayed in San Francisco among this stimulating circle of colleagues.

In 1957 the photographer returned to Boston, where he married and began a family. Periodically he traveled to Rochester, New York, to study with Minor White, who passed along his conviction that photography can be a personal, spiritual inquiry. The first solo exhibition of Caponigro's photographs was organized by Walter Chapell for George Eastman House in 1958. The photographer Carl Chiarenza helped Caponigro to secure a part-time teaching position at Boston University and, with Ansel Adams's recommendation, he also became a technical advisor to the Polaroid Corporation. In 1966 the photographer was awarded a Guggenheim Foundation Fellowship for a project to photograph the monuments of ancient Egypt. However, political shifts in the Middle East

made the country inhospitable for an American artist and his young family, so Caponigro redesigned his project to photograph monuments of Celtic Christianity in Ireland.

In Ireland, Caponigro first encountered prehistoric megaliths, and he was bewitched. In these stones, shaped and placed in the earth thousands of years before, the artist sensed teachings from ancient fathers, believing that the sites had acquired energy that could affect human beings. He concentrated his work on the stone monuments, with an approach more emotional than intellectual, and tried to study them, but in the mid-1960s few serious archaeological or sociological studies had been published.[3] In the field Caponigro met archeologists who pointed him to records of ancient sites documented by the Board of Works, where a library of maps and reports led him to other sites and subjects for his photographs. As the months progressed, Caponigro photographed Neolithic standing stones, cairns, stone circles, avenues, dolmens, tumuli and mounds. He strove to photograph each particular stone as a sculptural entity, recording its context in groupings of stones and capturing the atmosphere of the site.

Caponigro also sensed an unusual ambiance elsewhere as he explored other uniquely Irish places, often those that combined natural beauty with evocations of history. He made this photograph in County Wicklow, when visiting a private estate where white fallow deer roamed its extensive park.[4] The artist envisioned images of the svelte, graceful animals wandering peacefully amid the trees, but he was unsatisfied with his shots of the deer scattered naturally over the sward in small groups. Caponigro enlisted the help of the estate warden and his sheepdog, intending to bring the deer closer. Concealed by a stand of trees, he set up his view camera and adjusted the lens to its widest aperture for the day's subdued light, with a slow shutter speed of one second. Caponigro waited quietly for the dog to bring about 25 deer toward him from the opposite end of a long field. In the event, the shepherd frightened the skittish deer, which bolted in a line past the photographer. Caponigro was alarmed too, but he managed to snap the shutter.

Fig 21. — Paul Caponigro, American, born in 1932, *St. Kevin's Church, Glendalough, Ireland*, 1967, gelatin silver print, Humana Foundation Endowment for American Art, 2015.064.001

Immediately afterward, a pair of swans flew directly over the photographer's head, bent before the ground glass. He took this as a good omen in what he felt to be a magical place. When he processed the negative he found this image of ghostly white deer, blurred by motion as they darted past the shady forest. By contrast, leaves on the overhanging branches remain in focus, heightening this illusion of movement. In the darkroom, Caponigro made enlargements from the 8 × 10 inch negative and cropped away the top portion to create this panoramic shape and accentuate the sensation of motion. Printing an enlargement on this scale, however, made it very difficult to retain the subtle tonalities of the negative. Each example of *Running White Deer* is a demonstration of Caponigro's virtuosity in the darkroom.

In 1967 Caponigro made his first photographs at Stonehenge, but he had exhausted his grant support. At that time, New York University had recruited John Szarkowski and Peter C. Bunnell, from the Museum of Modern Art, to teach in its film department.[5] They were encouraged to bring others to teach in the program and invited Caponigro to join them. Bunnell was especially impressed with Caponigro's recent work, and he organized an exhibition for the Museum of Modern Art that included Irish landscapes, Celtic crosses and some of the Stonehenge photographs (Fig. 21).[6] The images of Irish megaliths mystified many viewers. Those familiar with contemporary art recognized similarities between architectonic form, Minimalist sculpture and Modernist abstraction.

Late in the 1960s Caponigro moved to New York City to join a community of adherents to the teachings of G. I. Gurdjieff.[7] This group sought personal knowledge through meetings, music, sacred dance, writings, lectures and collaborative projects. Their spiritual practice influenced Caponigro's photography. The artist photographed forest landscapes and natural still lifes, publishing a succession of photobooks. When his young son, John Paul, brought him a sunflower, the artist became fascinated by its combination of spiky and soft shapes, and its archetypal solar form. He began photographing all sorts of sunflowers, along country roadsides, in gardens and in fields, and gathered some of these images in a photobook.[8] The artist moved to New Mexico in 1973, where he lived for the next 20 years at El Rancho de San Sebastian in Santa Fe County. An Artists' Grant from the National Endowment for the Arts in 1975 supported his work, and a second Guggenheim Fellowship enabled him to travel to Japan. He returned to Northern Ireland and England once again in 1978, with a grant from the Arts Council of Great Britain.[9] In 1983, the George Eastman House International Museum of Photography organized and toured an exhibition of his work.[10] In 1993 the artist moved to rural Maine, and since that time his work has become even more contemplative.

DANNY LYON

American, born in 1942

Hoe Line, Ferguson Prison, Huntsville, Texas

1967
from *Conversations with the Dead*
Gelatin silver print
22.3 × 33.2 cm (8¾ × 13⅛ in.) Image
27.8 × 35.6 cm (11 × 14 in.) Sheet

Humana Foundation Endowment for American Art, 1996.035.001

One of the most important photographers working in an immersive style of journalism in the 1960s, Danny Lyon tried to convey the viewpoint of his subjects. "As a child I had been afraid of so many things," he wrote, "but as a soon as I had a camera in my hand, I began to expose myself to the very things that were foreign to me and that I had always feared."[1] Lyon was born and raised in Brooklyn, a son of Jewish parents who had escaped from Nazi Germany.[2] He first visited Europe in summer 1959, when he bought a camera and began making photographs. He attended the University of Chicago to study history and philosophy. In the summer after his junior year, Lyon hitchhiked to Cairo, Illinois, to join a civil rights rally. A speech by John Lewis, chairman of the Student Nonviolent Coordinating Committee (SNCC), inspired Lyon, who joined the subsequent demonstration and became committed to the movement. The activist James Forman brought Lyon into the SNCC as its first staff photographer, and over the next two years Lyon documented the group's activities, helping to develop its public image. In August 1963, Lyon snuck into the Leesburg Stockade in Georgia, where 35 young African American girls were held without charge after their arrest in a civil rights demonstration. Lyon photographed them through the broken glass and barred windows of the armory and revealed the unsanitary conditions of their confinement. After their appearance in the SNCC's newsletter, *Student Voice*, Lyon's photographs were picked up by national newspapers and the girls were quickly released. These events proved to Lyon that his work could accomplish tangible results. By the time he graduated from college in 1963, he was working as a photographer for the SNCC and would be present at nearly all of the Civil Rights Movement's important events in the coming years (Fig. 22). Lyon shared his photographs with Hugh Edwards, curator of photography at the Art Institute of Chicago, who organized Lyon's first solo exhibition at the institute in 1966. Lyon's work appeared in *The Movement*, a documentary monograph on the Southern Civil Rights Movement.[3]

Aside from his deep political commitments, Lyon was also a motorcycle aficionado in the early 1960s and a member of the Chicago Outlaws Motorcycle Club. Over three years he documented their adventures and occasionally illicit exploits, and some of these images were collected in his photobook *The Bikeriders*. Lyon supplemented the images with text, including interviews, letters and fiction.[4] In New York, he photographed the urban renewal projects in Lower Manhattan in the 1960s, when rows of the

19th-century buildings were razed to make way for the World Trade Center. His portraits of residents being displaced from the neighborhood and images of structures awaiting demolition were published in *The Destruction of Lower Manhattan* in 1969.[5]

By that time, Lyon had also taken his camera into the Texas penal system. To guarantee that he could establish rapport with his subjects, he obtained permission to photograph anywhere—excepting Death Row—without a guard. Over 14 months in 1967–68, Lyon worked in seven different institutions. He met many inmates, befriended several, and strove to represent their experiences truthfully. "I was never afraid of the men," Lyon wrote. "I liked them. And I had many friends inside the system that would stand up for me, dangerous men. . . . The guards were another thing. I couldn't relate to them at all."[6] The artist strove to capture how painful imprisonment really is. *Hoe Line, Ferguson Prison, Huntsville, Texas* is one of the photographs from this project,[7] depicting a group of African American convicts at work on the prison farm in East Texas, which had opened three years before, to great promise.[8] It housed about a thousand convicts, most between the ages of 17 and 21—the same age as college students. At that time, about one-third of the inmates at Ferguson were African American and generally segregated from the white convicts at work.

This photograph is one from a sequence representing a team of black workers going out to work in the fields, watched over by armed guards on horseback and in pickup trucks. In this image they have reached the field and work as a team, preparing the soil for seasonal planting. They wear white prison uniforms and hats to protect them from the hot sun, but some of Lyon's photographs show inmates

Fig 22. — Danny Lyon, American, born in 1942, *Arrested Woman in a Police Van*, 1963, gelatin silver print, Milly and Fritz Kaeser Endowment for Photography, 2014.047.003

suffering from heat stroke. He captured this rank of men working together, standing closely side by side in a line that continues to either side beyond the frame. Their postures, and the varied positions of the dark hoe blades, convey a sensation of movement. As they hoe the soil toward them, clumps of dust and clay rise into the air against their white pants. Lyon's images of toiling African Americans, watched over by passive white officers, reflects the racial segregation of the Texas prison system and its lamentable history of slavery.

The photographer also intended that his image of field laborers, clad in cotton and working together, represent the solace of community. The visual rhythm of their labor evokes the vocal chanting of slaves at work in cotton fields, on railway gangs, in turpentine camps and in prison gangs through the centuries. Historic field hollers in four-line stanzas, alternating with choruses of matching length, maintained the cadence of work, helped pass the hours and encouraged the weak. They provided the structure for gospel music, Negro spirituals and the blues, and seeded the flowering of African American music. These men work together amid rolling prairie hills, sectioned by wire fencing, the wooden posts of which punctuate the distance. A single tree stands on the horizon in the center of the composition. Barren of leaves, the tree signals the time of year and suggests the passage of time. The horizon lies above the convicts' heads, placing them beneath the earth, as if they are digging toward a hellish underworld or are already dead themselves. The title of Lyon's book of prison photographs, *Conversations with the Dead*, proves that this association is no coincidence. Once again, the photographer combined his images with varied texts, describing the men he observed and

including excerpts from prison records, letters from convicts, and inmate artwork, which was unprecedented in the genre.

During the 1970s Lyon explored the lives of the rural poor in New Mexico and South America, both with his camera and as a filmmaker. His chief productions were the films *Llanito* (1971), *El mojado* (1974), and *Los niños abandonados* (1975).[9] He began to photograph his own family during the 1980s, and compiled unique photobooks reflecting their history and recording their lives in the late 20th century.[10] These handmade albums combine the work of many family members, in different photographic techniques and formats, with written text. Lyon also made versions of these personal chronicles for publication, including *I Like to Eat Right on the Dirt* and *Knave of Hearts*.[11]

ERNEST C. WITHERS
American, 1922–2007

I Am a Man: Sanitation Workers' Strike, Memphis, Tennessee

1968
Gelatin silver print
34.5 × 57.6 cm (13⅝ × 22⅝ in.) Image
51 × 60.8 cm (20⅛ × 24 in.) Sheet

Milly and Fritz Kaeser Endowment for Photography, 2014.023.001

The photographs of Ernest C. Withers provide a remarkable chronicle of African American life in the Southern United States during much of the 20th century. As the leading photographer in the black community of Memphis, Tennessee, he recorded the life of his city as no one else could. Withers was born in Memphis, where his parents had moved from Marshall County, Mississippi.[1] As a boy he carried a borrowed a Brownie camera to school every day, and his classmates thought of him as a photographer. Withers married his high school sweetheart, Dorothy Curry, and they began a family of seven sons and one daughter. He joined the service during World War II and was trained at the Army School of Photography. Withers was posted to Pearl Harbor, Hawaii, and then to Saipan, Northern Mariana Islands, where he spent much of the war producing identification portraits for black servicemen in a still-segregated military.

After his discharge, Withers returned to Memphis, where he became one of the city's first African American police officers. He used his G.I. benefits to open a professional photography studio with his brother, serving the African American community of north Memphis. He became a familiar figure at proms and graduations, weddings and funerals. Soon he left the police force and devoted himself

to photography full-time. Over the years, each of his seven sons worked at Ernest C. Withers & Sons Photography on Beale Street in Memphis. Soon after John H. Sengstacke began the *Tri-State Defender* in 1951, the weekly Memphis newspaper began regularly to buy Withers's photographs. The images were often shared with the progenitor *Defender* newspaper in Chicago, and his work was circulated to the broader African American press.

As a newspaper stringer, Withers often covered music and sports events in Tennessee, Arkansas and Mississippi. Memphis had become the epicenter for African American music. Local radio station WDIA was the first in the country to program entirely for African Americans in 1949, broadcasting to an audience reaching the Mississippi Delta and the Gulf Coast. The station hired local musicians as programmers and on-air personalities, including Rufus Thomas and B.B. King (Fig. 23). Radio became a unifying element in the black community, but also influenced white musicians such as Elvis Presley and Jerry Lee Lewis. For 20 years, Withers was the official photographer for the influential Stax Records label. At his studio, he made portraits of visiting musicians, including Ray Charles, Sam Cooke and Aretha Franklin, among many others.[2] On Saturday nights he took his camera into the Beale Street clubs

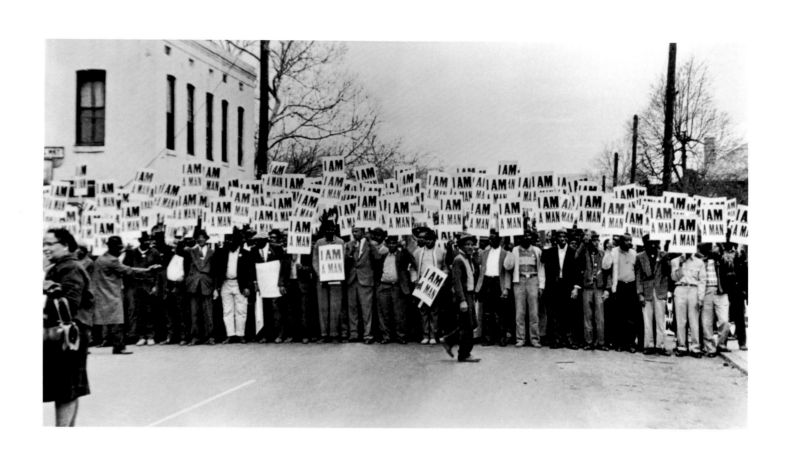

nearby. His main intent was to produce lucrative portraits of club patrons on a night out. Withers also photographed the Memphis Red Sox, the local Negro League Baseball team.[3] He loved the game but went to Martin Stadium chiefly for work as a commercial freelance photographer, documenting play and making promotional images and portraits for the team. He also found work with visiting Negro League teams like the Chicago American Giants and the Birmingham Black Barons. Among his remarkable photographs are the ballpark portraits of Satchel Paige with Withers's young sons.

In 1955 Withers traveled to Sumner, Mississippi, to cover the trial of men accused of lynching Emmett Till. One of his most remarkable images represents Till's great-uncle pointing an accusing finger at the murderers. Some of Withers's photographs appeared in the *Defender* newspapers, and later he created an illustrated pamphlet to explain the case and its implications for the African American community. In 1956 he was in Alabama to record events connected to the Montgomery Bus Boycott against the policy of racial segregation on the city's public transit system.[4] He photographed Rev. Ralph Abernathy and Dr. Martin Luther King Jr. riding together on December 21, 1956, the first day for desegregated buses in the city. The following fall he was in Little Rock, Arkansas, to document the arrival of nine black students at Central High School, the beginning of school desegregation in the South. His experiences as a police officer helped him to gauge appropriate distance, avoid confrontation and anticipate the best images.

Closer to home, Withers photographed Memphis Public Works Department employees struggling for better working conditions. In 1963, after a union

Fig 23. — Ernest Withers, American,1922–2007, *The Two Kings: Elvis Presley and B.B. King, Goodwill Review, Memphis, Tennessee*, 1957, gelatin silver print, Milly and Fritz Kaeser Endowment for Photography, 2014.023.004

organizing meeting, 33 workers were summarily dismissed by Public Works Commissioner Henry Loeb. AFSCME Local 1733 was finally organized in November 1964, but workers still labored with outdated equipment and without restrooms, uniforms or any grievance procedure. Curbside trash collectors were required to ride on the trucks' running boards, not inside the cab; in bad weather they sheltered inside the truck with the garbage. It was stormy on February 1, 1968, when two workers, Echol Cole and Robert Walker, were riding in the back of the truck. Somehow the hydraulic compactor was engaged, and both men were crushed to death. On Monday, February 12, 1,375 sanitation and sewage workers went out on strike. By that time, Henry Loeb was mayor of Memphis, and he declared the strike illegal. Refuse accumulated on the streets, and Loeb hired white strikebreakers to work with police escorts. Meanwhile, the strikers established a daily routine of meeting at Clayborn Temple, then marching peacefully downtown as the public and police openly harassed them. After one such incident, on February 24, Rev. James M. Lawson, pastor of Centenary Methodist Church, spoke to the demonstrators: "At the heart of racism is the idea that a man is not a man," he said, "that a person is not a person. You are human beings. You are men. You deserve dignity."[5]

This photograph depicts the sanitation workers gathering at Clayborn Temple early in the afternoon of March 28, 1968, before their march to downtown Memphis, carrying placards inspired by Lawson's words: "I AM A MAN."[6] Withers was deeply committed to this demonstration and had obtained the circular saw with which organizers had cut wood into the sticks supporting the picket signs.[7]

He photographed the demonstrators, all ages, shapes and sizes, varied in their dress and deportment. One man, on the left, tries to organize the group. Others in distant rows behind raise their placards high to make sure they are seen, revealing the size of the crowd. The perception of their number is increased by the photographer's viewpoint and the linear perspective suggested by the angled sides of the composition. This is the record of an event, not a group portrait. The workers project a serious mood, but their attitude is cordial, not threatening, suggestive of a social gathering rather than a combative rally. The enduring impact of this image comes from the fact that these workers had to declare their humanity in the Jim Crow era of institutionalized disadvantages for African Americans in the South.

Dr. Martin Luther King Jr. was on hand that day in Memphis to support the strike. His presence may have heightened tensions between police and marchers. Conflicting accounts describe vandalism and looting, and police response with batons, tear gas and live ammunition. A city patrolman shot and killed 16-year-old Larry Payne. The wooden sticks of the marchers' signs became weapons, and 276 were arrested. Mayor Loeb called in the Tennessee National Guard. The day after Payne's funeral, on April 2, King was back in the city to restart peaceful demonstrations to support the strike. Withers photographed his visit, and the speech in which King declared, "I've been to the mountaintop."[8] It was the following afternoon that Martin Luther King was assassinated on the balcony of the Lorraine Hotel in Memphis.

JERRY N. UELSMANN

American, born in 1934

Untitled

1969
Gelatin silver print
34.2 × 24.2 cm (13½ × 9½ in.) Image
50.8 × 40.7 cm (20 × 16 in.) Mount

Milly and Fritz Kaeser Foundation for Photography, 2017.042.002

Before digital photography allowed the effortless merging of images into fantastic visions, artists achieved similar effects with the darkroom technique of combination printing. In the 19th century, photographers such as Oscar Gustave Rejlander and Henry Peach Robinson combined their original negatives of studio tableaux into historical, literary and melodramatic compositions that approximated painting. The development of the miniature camera and enlarger provided new tools for combining negatives. Although Wynn Bullock and Frederick Sommer (Cat. nos. 59, 68) flirted with similar ideas, it was Jerry Uelsmann who elevated the film combination print into an art.

Uelsmann was born and raised in Detroit, where his father was an independent grocer.[1] He was also an amateur photographer who taught his two sons to use the camera and darkroom. With the notion of becoming a commercial photographer, in 1953 Uelsmann attended the Rochester Institute of Technology (RIT), where he learned the finer points of technique from Ralph Hattersley.[2] Aside from his skills as a craftsman and teacher, Hattersley was inspired by Abstract Expressionist ideas of psychological expression through creative process. Another of Uelsmann's teachers at RIT was Minor White (Cat. no. 67), who saw in

photography—combined with disciplines from Gurdjieff and Zen Buddhism—nothing less than a means of spiritual self-discovery. Uelsmann learned Ansel Adams's (Cat. no. 46) Zone System from White, as well as some of the basic values of Buddhism. He first published his photographs in the 1957 annual of *Popular Photography*, the year he received his BFA degree. Uelsmann then went on to graduate studies at Indiana University in Bloomington, where he became a student of Henry Holmes Smith.[3] Another prodigious thinker, Smith had experimented with high-speed flash and color photography during the 1930s, and by the late 1950s he was he was producing cameraless color photographs inspired by the Neues Sehen (New Vision). He also promoted self-discovery and experimentation, and encouraged Uelsmann's interest in combination printing. Uelsmann began by building upon the achievement of 19th-century photographers, experimenting with sandwiching negatives before printing. He progressed to combining different negatives as components of a composite image, projected on the photographic paper from separate enlargers. Uelsmann completed an MFA in photography in 1960, and soon after—with the help of Van Deren Coke—he began teaching at the University of Florida in Gainesville. He

began to achieve wide recognition when his work was included in the exhibition *Three Photographers* at George Eastman House in 1962.

In Gainesville during the 1960s, Uelsmann developed his process and built a repertoire of original component negatives. He accumulated thousands of images of figures; trees, plants and landscapes; watery surfaces; and architecture. Uelsman used these to create fantastic compositions, influenced by Surrealism, Jungian psychology and his own notions of perception, time and space. He reviewed old contact sheets, spontaneously combining and contrasting elements in free association, enabling him to see connections between seemingly quite different images. The photography department at Gainesville grew during that time, and Doug Prince, Todd Walker and Evon Streetman served on the faculty. Uelsmann worked to promote photographic education, helping to develop a college-level curriculum.

In 1967 Uelsmann was awarded a Guggenheim Foundation Fellowship for his project "Experiments in Multiple Printing Techniques in Photography," which enabled him to continue his creative work with additional equipment. He perfected methods for combining positive and negative images in one composite negative. Early in 1967, a solo exhibition of Uelsmann's photographs was presented at the Museum of Modern Art. At the time, the artist described how he remained alert to discovery and chance during the creative process, as Abstract Expressionist painters had done for decades. Ansel Adams invited Uelsmann to lecture on the West Coast, and soon he began annually to teach in Adams's workshops in Carmel and Yosemite, a role he continued for 15 years.[4]

In the 1960s, Uelsmann usually refrained from giving titles to his photographs, preferring not to direct the viewer's perception in any way. In this broad panoramic landscape, the laws of physics seem no longer to apply.[5] A tree, in full leaf with its roots unfurled, hovers over the earth, floating above an island in a mountain lake. However, closer examination suggests that island may be airborne as well, for there seems to be a reflection of its underside in the glassy water. Another smaller tree on the right seems to hover in the distance, creating the sensation that the trees may be arriving in sequence. Although this spectacle is peculiar, it seems peaceful and natural, as if it were a view of another world similar to our own. The image conveys a feeling of liberation. Close examination shows that each side of the background and the floating island is a mirror image. Uelsmann constructed this composition with several enlargers. His darkroom has seven, each with its own sinks, processing trays and chemicals. Here the artist creates his prints from three to five negatives meticulously aligned in the exposure process to make a single, composite print. By flashing and burning, or selectively blocking light from the print during exposure in each enlarger, he further adjusts tone within the image, in an active creative process.[6]

Uelsmann was promoted to full professor at the University of Florida in 1969, and the following year a retrospective exhibition of his photographs was presented by the Philadelphia Museum of Art.[7] An Artist's Fellowship from the National Endowment for the Arts in 1972 enabled Uelsmann to experiment with color photographic processes. At that time, his work often merged natural motifs with architectural elements. Writing in 1976, the photography critic A. D. Coleman described how Uelsmann had become

a leading figure in an interpretive genre in which photographs were no longer *of* something, but were instead *about* something. He argued that this impulse was present in the 19th century when Hippolyte Bayard photographed himself as a drowned man, and when Rejlander and Robinson used photography to mimic history painting. Coleman also noted the manipulation common to straight photography, and suggested correctly that "the directorial mode" would become more characteristic of creative photography.[8]

A monograph on Uelsmann's work in 1982 was a mid-career retrospective.[9] The artist is prolific and each year continues to produce scores of composite photographs, from which he chooses 10 to add to his oeuvre. In 1997 Uelsmann retired from teaching. With more time at his disposal and with the encouragement of his third wife, Maggie Taylor, who was proficient at manipulating imagery digitally, Uelsmann pursued his interest in learning the subtle capabilities of the digital process. He continues to present lectures and workshops in Gainesville, Florida, and to produce exhibitions and photobooks.[10] His work remains meticulous in its technique and visionary in its imagery.

NEIL ARMSTRONG
American, 1930–2012

Buzz Aldrin on the Moon

1969
Chromogenic print
35.5 × 28.5 cm (14 × 11 ¼ in.) Image
35.5 × 28.5 cm (14 × 11 ¼ in.) Sheet

Gift from the Congregation of the Holy Cross, Rev. Ferdinand Brown (ND'38,'45,'47),
C.S.C., 1976.002.001

The first steps of human beings on the moon were recorded by state-of-the-art still and television photography, and shared with the world. On July 16, 1969, three American astronauts, Commander Neil Armstrong, Command Module Pilot Michael Collins, and Lunar Module Pilot Edwin "Buzz" Aldrin, were launched into space from Kennedy Space Center on Merritt Island, Florida.[1] The first and second stages of a powerful Saturn V rocket propelled their Apollo 11 spacecraft out of Earth's atmosphere, then into orbit at an altitude of about 100 miles (160 km).[2] After one and a half revolutions of the earth, the third-stage engine catapulted the spacecraft on a course to the moon. Thirty minutes later Collins separated the Command Module, named *Columbia*, from the spent rocket stage, and rotated the vehicle 180 degrees to extract the Lunar Module, called *Eagle*, from the Service Module. To this point, the flight had taken about three and a half hours. For the next three days Apollo 11 coasted through space, gradually maneuvering into the moon's orbit.

On July 20, Armstrong and Aldrin climbed into the *Eagle* and separated from *Columbia*, which Collins maintained in lunar orbit. They piloted the spacecraft to the moon's surface, snapping photographs through its windows as they landed in the Sea of Tranquility. Just before Armstrong climbed down to the lunar surface, he pulled a lever near the top of the descent ladder to free the Modularized Equipment Stowage Assembly (MESA) from under the vehicle, activating a television camera inside. Thus, as he alighted on the moon at 2:56 Coordinated Universal Time (UTC) on July 21, 1969, his movements were conveyed via slow-scan television to the Parkes Observatory in New South Wales, Australia, and to the Goldstone Observatory near Barstow, California. There, a television camera captured the low-bandwidth transmission from a closed-circuit monitor and broadcast the events to an audience estimated at 530 million people worldwide.[3] Armstrong later removed the television camera from the MESA and mounted it on a tripod about 30 feet (9 m) away from the lander, where it continued to broadcast the astronauts' activities.

Before Aldrin left the *Eagle* he passed a Hasselblad wide-angle camera down to Armstrong.[4] Still photography was an important component of the Apollo 11 project, though it had a surprisingly casual beginning at NASA. In 1962 Wally Schirra bought a Hasselblad 500C at a Houston camera store and carried it on the fifth manned space flight. The photographs he took from his orbiting Gemini capsule were so successful that NASA technicians began a partnership with the Swedish camera

manufacturer. In spring 1967 they convened a study group to develop cameras for a mission to the moon. Astronauts had come to prefer the Hasselblad 500 design for its interchangeable lenses and film magazines and its ease of use inside restrictive space suits. The engineers replaced the camera's reflex mirror with an eye-level viewfinder, enlarged the shutter button, and strengthened the battery cover and hinge for use with heavy gloves. After the Apollo 1 fire of 1967, they also modified safety features of this electrical instrument for a high-oxygen environment. Four Hasselblad 500 EL cameras were carried on the Apollo 11 mission. In the Command Module was a standard 70 mm Hasselblad 500EL with a battery-powered motor-drive, and in the Lunar Module there were two manually operated cameras loaded with magazines of black-and-white and color film, along with an extra 250 mm telephoto lens. The Lunar Module also carried a more advanced instrument, the Hasselblad 500EL Data Camera for use on the moon's surface. It had a Zeiss 60 mm $f/5.6$ Biogon lens and a body of anodized aluminum, built to withstand a wide range of thermal variations, and it worked without conventional lubrication that might boil off in the atmosphere or leave condensate on the optical elements. It could be fitted on a bracket on the front of the astronauts' suits, and be operated by a trigger mounted in the camera handle. The Data Camera's anodized magazines held film for 150–200 exposures. It also had a Réseau plate, a thin sheet of glass next to the film plane, precisely engraved with a five-by-five grid of fiducials. These cross-marks, apparent in this photograph and in every negative exposed in the camera, enabled NASA analysts to determine angular distances between objects in the field of view.

Armstrong used the Data Camera to photograph Aldrin's descent from the *Eagle* and his first tentative steps in lunar gravity, one-sixth that of Earth. Both astronauts adopted a gentle loping gait and found that they had to plan their movements several steps ahead to balance under the weight of the cumbersome Portable Life Support System (PLSS) carried in their backpacks. They raised an American flag on the moon and spoke via telephone link to President Richard Nixon in the White House. However, most of their time on the moon was devoted to seismic and solar wind experiments and data gathering. They deployed a Retroreflector to rebound laser impulses from Earth observatories and collected geological material and mapping data. Using a Closeup Stereoscopic Camera attached to a walking stick, they exposed high-resolution 35 mm negatives of three-inch areas of lunar geology. After about two hours on the surface, Armstrong and Aldrin returned to the Lunar Module. They remained on the moon for 21 hours, timing their ascent to converge and dock with the orbiting *Columbia*. Apollo 11 returned safely to earth with about 50 pounds (23 kg) of moon rock and soil, along with abundant data, including nine magazines of exposed 70 mm film.

Armstrong took this photograph at 110:42:14 UTC.[5] Aldrin stands under a black sky before a barren landscape and a curved horizon—a lone, heroic figure protected by the hostile environment of space by implements of human ingenuity. Extending into the foreground from the right is the landing probe of the Lunar Module, partially covered in insulated foil. Raking light picks out soft irregularities of the moon's ancient topography, quite unlike the sharply distinct human footprints in the

foreground. Aldrin's legs appear to bend slightly, suggesting the weight of the PLSS on his back, as he lifts his left arm to read the checklist sewn onto the cuff of his glove. The visor of his helmet, plated in gold to protect his eyes from the bright sun, reflects the landing vehicle, the American flag, the television tripod, and Armstrong himself snapping the photograph. This vintage print on Kodak Ektacolor paper has faded to an orange tone, which obscures some of its original detail and the cool, blue light reflected from the ocean-covered earth.

Like all images created for NASA, the photographs from the Apollo 11 mission are in the public domain, and the present image is among those that were promptly edited and published to promote the agency's achievements. About two weeks after Apollo 11 returned, a detail of the present image appeared on the cover of a special issue of *LIFE* magazine, and the entire photograph was reproduced inside over a full spread.[6] This chromogenic print modified Armstrong's original negative, which was framed more tightly, with the top edge of the image falling just above Aldrin's PLSS backpack; for publication, NASA media editors added a passage of black at the top of the image and cropped its sides and bottom for visual balance. Since this print was made, improvements in photographic technology have enabled investigators to glean more detail from the original film negative. They digitally removed the gold cast from the reflection in Aldrin's visor and discovered a blue planet Earth in the lunar sky.[7]

LARRY CLARK
American, born in 1943

Untitled

1971
from the book *Tulsa*
Gelatin silver print
20.2 × 30.5 cm (8 × 12 in.) Image
27.9 × 35.5 cm (11 × 14 in.) Sheet

Gift of Walter Lake, Jr., 1981.080.001.OO

As a young man, Larry Clark was disturbed by the hypocrisy he saw in adults who hid their weaknesses and vices and seldom discussed them. This awareness prompted the transgressive personal photographs he made as a teenager, works that launched his career as a creative artist. Clark was born and raised in Tulsa, Oklahoma.[1] His father was a traveling salesman of books and magazines who was seldom at home and left his son feeling detested. Clark's mother was a children's portrait photographer who sold her service door-to-door. She taught her son the rudiments of photography when he was a boy, and by the time he was a teenager Clark was working as her assistant. Soon the gawky teenager, who spoke with a stutter, was searching the neighborhoods of suburban Tulsa for parents with children, hoping to get them to invite him into their homes with his camera. If he succeeded, he had to perform whatever antics were needed to get the babies to laugh and smile for a photograph, a demeaning venture for an insecure teenage boy.

Clark responded to these indignities and a sense of rejection with reckless behavior. In 1959 he and his friends, all middle-class suburban teenagers, experimented with drugs. He began injecting amphetamines, and continued every day for three years. Clark and his friends were sexually active; they often tussled aggressively and played with handguns. He always had a camera with him, and his friends were accustomed to his recording their activities, creating a visual diary of their shared self-destructive indulgences. When he printed and reviewed these photographs, he was shocked by their power, which was unlike that of any other images he had seen. At a time when this sort of behavior was never discussed, let alone shown in pictures, he understood that his photographs were unusual and compelling.

In 1961 Clark attended the Layton School of Art in Milwaukee, Wisconsin, where he studied commercial photography with Walter Sheffer and Gerhard Bakker, among others. He learned more about the work of photojournalists like W. Eugene Smith (Cat. no. 48) and realized how photographic images could relate complex stories. In 1964 Clark moved to New York City to pursue a professional career, but he almost immediately received his draft notice. He served in the Army during the Vietnam War, and for nearly two years worked in a supply unit transporting ammunition. All the while, he continued his drug use. After his discharge from the service, Clark returned to Tulsa. Soon he was living with a prostitute and had become addicted to heroin. He was incapable of returning to commercial photography, but he was able to print and organize the photographs from

his teen years. In 1971 Clark met Danny Seymour, a protégé of Robert Frank (Cat. no. 70) and friend of Ralph Gibson, who financed the printing and publication a selection of these photographs as *Tulsa*.[2]

This is one of the most striking photographs from Clark's *Tulsa*, an image of one of his friends injecting herself with amphetamine even though she is heavily pregnant.[3] The artist organized his composition so that the hypodermic needle falls in the center, picked out by light falling through the window. The young woman gazes down at the syringe, emphasizing the activity and her willful participation. The bright rectangular window emphasizes, by contrast, the rounded, organic contours of her body and the fertility that she irresponsibly violates. Shadows model her globous form, while the rest of the room is empty, with minimal furniture and no curtains. The teenagers are using a vacant neighborhood house as their suburban shooting gallery, and its emptiness is another, ironic, symbol of her disregard of motherhood, domesticity and human affection. Many of the images in Clark's *Tulsa* represent the adolescent immaturity of youth, but this stark and shocking image demonstrates the power of addiction. "When I was sixteen I started shooting amphetamine," Clark wrote in the series preface. "Once the needle goes in it never comes out."[4] Perhaps to mimic the effect of the overstimulation of the drug, Clark printed many of these photographs in a bright, grainy monochrome, as if they had been overexposed. "I do a lot of burning and dodging when making a print," Clark later stated, "and then use bleach. There's not a straight print in the *Tulsa* book. When I'm photographing I always try to shoot against the light. The film can't handle this and everything gets burned up, since I'm exposing for the shadows."[5] If Clark

began to photograph the exploits of his friends as a teenage prank, he nonetheless committed skill, energy and time to these forbidden images. He may have been defiantly proclaiming the rebellious lifestyle he was enjoying; he may have been hoping for help. In any case, Clark realized that, for all the secrecy surrounding them, these activities were not unusual, and that he depicted not only his friends but suburban America. It is difficult to imagine that he anticipated that the photographs would launch a serious career.

After the publication of *Tulsa*, Clark received a grant from the National Endowment for the Arts to support his next project. By that time, however, drug addiction had begun to take its toll. After several arrests, he was convicted of shooting a friend during a dispute and sent to the Oklahoma State Penitentiary in McAlester, where he served 19 months in 1976–77. Eventually he completed his second series, *Teenage Lust*, which confronts a similar universal and unspoken subject with uncommon candor.[6] This portfolio includes other, contextual, images, from childhood self-portraits to images of male street hustlers Clark met in Times Square in the early 1980s. *Teenage Lust* roughly chronicles the lives of the photographer and his friends over 30 years; the images would influence such filmmakers as Gus Van Sant and Martin Scorsese.[7] In subsequent photobook projects, Clark used a similar journal format to present adolescent males, confused by identity and sexuality, and the intersection of mass imagery and social behavior.[8]

In 1993, Clark directed a music video for the rock musician Chris Isaak, which ignited an interest in film. When he met Harmony Korine among teen skateboarders that he photographed in Washington Square Park, he invited the teenager to write a story

about skaters, and to include the teenage experience of HIV-AIDS. This project evolved into *Kids*, a film that chronicles 24 hours in the lives of Manhattan teenagers, filled with their irreverent sex and substance abuse.[9] Shot in the style of cinéma vérité with mostly untrained actors, *Kids* debuted at the Cannes Film Festival in 1995 and launched Clark into a new career. His films relate varied versions of stories of 20th-century adolescence and confrontations with sex, drugs, crime and violence.[10] Since the publication of *Tulsa*, many critics have condemned Clark's work as prurient and exploitive, and even as condoning self-destructive violence. While admitting his own shortcomings, the photographer maintained that these genuine social ills could not be contained, and that to ignore them was hypocrisy. The use of digital photographic technology and social media at the beginning of the 21st century, allowing teenagers freely to share uncensored images, demonstrated Clark's prescience.

MARY ELLEN MARK
American, 1940–2015

Brenda Sitting on Her Bed, Ward 81, Oregon State Hospital, Salem

1976
Gelatin silver print
33.1 × 23.2 cm (13 × 9⅛ in.) Image
35.5 × 27.9 cm (14 × 11 in.) Sheet

Scholz Family Fund, 2014.056

Like the documentary photographers of the Farm Security Administration, Mary Ellen Mark used her camera to bring attention to people whose circumstances have relegated them to the margins of society.[1] She was especially responsive to the plight of women and children who had fallen into neglect through the vagaries of fortune. Like other photographers of her generation, she shared time and living circumstances with her subjects, when possible, to capture events and experiences from their point of view.

Mark was born in Philadelphia and grew up nearby in suburban Elkins Park.[2] Like many children of her generation, she had a Brownie camera as a young girl, and photography remained a familiar pastime through her childhood. A successful student, she was head cheerleader at Cheltenham High School. At the University of Pennsylvania, Mark studied painting and the history of art. After completing her BFA degree in 1962, she went on to graduate studies in photojournalism in the Annenberg School for Communication. She received her master's degree in 1965 and set off for Europe, with the support of a Fulbright Foundation Scholarship for a project to photograph in Turkey. A selection of the photographs she made during her year abroad were later published in her first photobook, *Passport*.[3]

In 1966, Mark settled in New York City to begin a career as a photojournalist. She photographed life in Times Square, as well as demonstrations opposing the war in Vietnam and supporting the Women's Liberation Movement. In 1968, she met Pat Carbine of *Look* magazine, who provided occasional assignments. She approved Mark's proposal to cover the production of Federico Fellini's film *Satyricon* in Rome. While in Italy Mark heard about a practical drug addiction treatment program at the St. Clement's Drug Unit in London and proposed a piece to Carbine. She endorsed the idea and assigned Mary Simons to write an article;[4] Mark's accompanying photoessay proved her skill in conveying her subjects' experience in a thoughtfully sequenced narrative.

Back in the United States, Mark was engaged by United Artists as a still photographer for motion picture production. She worked on the sets of Arthur Penn's *Alice's Restaurant* in 1969, and on Mike Nichols's films *Catch-22* in 1970 and *Carnal Knowledge* the following year.[5] In the spring of 1975 she was on location for Miloš Forman's film *One Flew Over the Cuckoo's Nest*, filmed at the Oregon State Hospital, the setting of Ken Kesey's novel and screenplay.[6] Mark learned of the hospital's Ward 81, a locked security wing for women, and the only locked ward in the state. Patients considered dangerous to themselves or others lived

there. Many were regularly given electroshock ther-apy, and some had been lobotomized. Mark sensed an opportunity to unveil long-held secrets, and to bring visual reality to Kesey's fiction. It took her nearly a year to secure permission from the hospi-tal, the patients and their families to photograph. She arranged to collaborate with Dr. Karen Folger Jacobs, a writer and psychotherapist, and a friend of Mark since high school. In 1976 they spent 36 days together with the residents of Ward 81, sleeping in an adjacent quarter of the hospital. At first they casu-ally socialized with the patients, working to build comfortable, trusting relationships. Mark snapped Polaroid portraits for them to keep and share. As they

came to know her, she was allowed to polish the nails of one and take another swimming for the first time. After achieving a measure of rapport, Mark carefully introduced her 35 mm handheld cameras, although she observed and interacted with the women more than she photographed them. She found that drugs, as well as mood disorders, could produce mercu-rial emotions in the patients, and a willing subject one day could be disturbed by the camera the next. The atmosphere on the ward was often stressful, but Mark and Jacobs never felt threatened, even feel-ing accepted when the patients began to make fun of them. Mark and Jacobs strove to humanize their subjects, and Mark took pains to depict the patients as human, empathetic and apprehensible. In depict-ing the difficulties of the women's circumstances, the two reporters emphasized the ordinary over the sensational and called for compassion in dealing with people afflicted by mental illness. The women had strong personalities and formed intense rela-tionships, both friendly and antagonistic. In Mark's

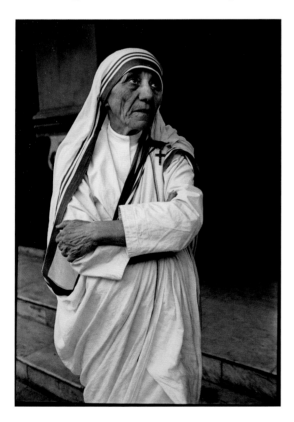

Fig 24. — Mary Ellen Mark, American, 1940–2015, *Mother Theresa, Calcutta*, 1980, gelatin silver print, Estate of Ronald K. Gratz (ND'68), 2018.002.046

photographs, some of them perform histrionically, while others shy away from the camera.

Brenda Sitting on Her Bed is one of Mark's photographs from Ward 81, a portrait that seems unremarkable at first glance.[7] A young woman sits cross-legged on her institutional steel bed, next to a radiator, in a space similar to any dormitory room. Fluorescent lighting glares from above. Brenda is an attractive teenager with long hair and fashionable dress for the period, though her esotropic gaze adds a touch of oddness to the portrait. Around her neck Brenda wears a fabric lanyard, which seems to hold a key. Like her dress, she has tried to personalize her room, with framed pictures, decorative clippings, and pictures taped to the wall; in the upper right is an image of the Mona Lisa wearing sunglasses. Prominent for its position beside her face, her name is scrawled prominently on the wall, along with the message "I wish to die." This anguished phrase prompts us to look more closely, and we realize that Brenda unashamedly displays her left arm, marked by the scars of suicide attempts and other instances of self-harm. Mark's compassionate approach, before and beyond clicking the shutter, made it possible for this young woman to share her vulnerability and something of her pain. Mark exposed 200 rolls of film at the Oregon State Hospital in just over a month. She preferred black-and-white enlarged prints, and chose not to retouch her photographs in any way. She organized a selection of her images into the photobook *Ward 81*, dismissing a narrative in favor of a mixture of subjects and moods, mimicking the lively, haphazard environment of the hospital.[8]

In 1978 Mark traveled to India, where she lived for three months in Mumbai among sex workers, many of them girls traded by their impoverished families for sustenance. Having failed to obtain access in the past, Mark approached the project by getting to know the procuresses and their charges, and learning the circumstances that had forced them into the lives they led. She shot in color, befitting the vivid, tropical hues of woven textiles, dingy curtains and peeling paint. Mark's photographs appeared in *Stern* and other magazines, and resulted in her third photobook.[9] An assignment from *LIFE* magazine took Mark to Kolkata in 1980 to visit Mother Teresa (Fig. 24). She returned to spend more time with Mother Teresa and the nuns of her Missionaries of Charity, who took her on hospital visits where she photographed their work with the sick and homeless, and with abandoned children.[10]

In 1983 Mark and journalist Cheryl McCall investigated the problem of runaway children living on the street in Seattle. Gradually they became acquainted with these vagrants, most of whom had fled abusive homes only to become targets of crime on the streets. After the publication of the photoessay "Streets of the Lost" in *LIFE* magazine, the collaborators felt that the project should continue.[11] They returned to Seattle along with Mark's husband, the filmmaker Martin Bell, and followed a group of teenagers and their struggles to take care of each other. The teens became central characters in two projects titled *Streetwise*: Bell's documentary film and Mark's celebrated photobook.[12]

RICHARD AVEDON
American, 1923–2004

Jean Renoir, Director, Beverly Hills, California

April 11, 1972
Gelatin silver print
41.7 × 39.8 cm (16⅜ × 15⅝ in.) Image
42.3 × 40.2 cm (16⅝ × 15⅞ in.) Sheet

Mr. and Mrs. Tom Christian Fund, 1976.23.01

The leading American fashion photographer of the 20th century, Richard Avedon was a protégé of Alexey Brodovitch and Carmel Snow. He was also an especially sensitive portraitist, and is equally remembered for this perceptive work. Born in New York City, Avedon was the son of a Jewish orphan from Russia, who rose from menial laborer to owner of a successful women's clothing store.[1] He attended DeWitt Clinton High School in the Bronx where, along with his classmate the future novelist James Baldwin, he was editor of the school's literary magazine. He attended Columbia University in 1941, but left school to join the United States Merchant Marine during World War II. Using his own Rolleiflex camera, he worked as a photographer over most of the next two years in port, taking identity photographs of servicemen. When Avedon left the Merchant Marine in 1945, he used his discharge pay to hire a top fashion model, whom he photographed in clothing from Bonwit Teller women's department store. The store executives were impressed with his unsolicited images and began giving him freelance work. He also took classes at the New School for Social Research with Alexey Brodovitch, the renowned art director at *Harper's Bazaar* magazine, who recognized his talent and helped him to join the magazine staff in 1946. The following year, Avedon photographed

the couture collections in Paris; this became a yearly assignment for the next 20 years.[2]

Avedon revolutionized fashion photography by directing the elegant models to behave naturally before his camera.[3] He took them out to recognizable locations in Paris and Rome, but also to farms, circuses, and the launch pads of Cape Canaveral. The work of Martin Munkácsi inspired him to work outside the studio, and to explore dynamic poses and gleeful moods.[4] Avedon kept his interesting locations in the background by urging his models to take active poses and engage the camera with teasing, theatrical facial expressions. Handsome, urbane and accomplished, Avedon also became a celebrity himself. Stanley Donen's movie *Funny Face* of 1957, starring Fred Astaire and Audrey Hepburn, was inspired by Avedon's career.[5] In 1965 Avedon joined the staff of *Vogue* magazine, and his fashion work reflected the energy and liberality of the era.[6]

Brodovitch designed the first book of Avedon's photographs, *Observations*, which included commentary by Truman Capote. Most of its images are portraits, photographed expressly for the project.[7] While Avedon's fashion and commercial work projected joy and unconventional elegance, his portraits of the 1950s and 1960s revealed unexpected aspects of character. His distinctive portrait style was

informed by the thousands of identity photographs he had taken of sailors during the war: he placed his sitters against a seamless white background and had them look directly into the camera, allowing them to assume their own expressions over the course of a session. Celebrities were eager to have Avedon photograph them, and notable among his sitters were actors Audrey Hepburn and Cary Grant, composer Igor Stravinsky, the Beatles, and artists Pablo Picasso and Andy Warhol (Cat. no. 91).[8] Some of his most powerful portraits of this period are those taken in Vietnam during the war, when he photographed American service members and burn victims disfigured by napalm attacks.

This portrait of the great French film director Jean Renoir exemplifies Avedon's balance of visual simplicity and psychological complexity.[9] A son of the Impressionist painter Pierre-Auguste Renoir, Jean Renoir grew up in Paris and Provence.[10] After fighting in the cavalry during World War I, he began working in film. In 1924 he made the first of nine silent films, financed by periodic sale of paintings inherited from his father. He made more than 40 films through the 1960s and was one of the first filmmakers to be considered an auteur. Renoir's film *La grande illusion*, of 1937, relates the attempts of French prisoners to escape from a German prison during World War I. It was the first foreign-language film to be nominated as Best Picture by the Academy of Motion Picture Arts and Sciences. *The Rules of the Game* (*La règle du jeu*), Renoir's next film, was a social satire on the moral expediency of the French in the years before World War II. When Germany invaded France in 1940, Renoir moved to the United States. In Hollywood, he directed a variety of movies, from anti-Nazi films to adaptations of romantic novels and

tales of the American South. Renoir wrote stage and screenplays, a novel and memoirs.

Avedon was a great admirer of Renoir's films, and a brief meeting in France in 1958 only increased his desire to explore the filmmaker's visage and persona.[11] The photographer visited Renoir in Beverly Hills in 1972, finding him in a home reminiscent of the South of France, filled with daylight and fresh flowers. On the wall was a portrait of Renoir as a child painted by his father, but when Avedon came to photograph him, he was in his 70s, sick and moving with difficulty. "There was something so moving about his face," Avedon recalled, "and about his life and his work and what he stood for. He was one of the last people I felt in awe of."[12] This portrait, the most famous image from the sitting, is typical of Avedon's work at the time, presenting a full-face bust, before a white background, concentrating on physiognomy and expression. The artist placed Renoir a little off center. The old man glances away from the camera, pulling the viewer's attention in the same direction and enlivening the composition. His asymmetrical face seems almost to reflect a number of different expressions at once. The wrinkle in his right brow narrows one eye and draws up one cheek, suggesting an attitude of thoughtful concern. By contrast, the other side of his face seems relaxed: his left eye is wide and dreamy, as if drifting in a contemplative reverie. He might be lamenting tragedies of the past or dreaming of a hopeful future. But it doesn't really matter what he is thinking or feeling, or indeed who he is. For Avedon's portrait—as they often do—transcends the individual to express the depths of human intellectual and emotional potential.

Renoir was one of several accomplished elderly people whom Avedon photographed in Los Angeles

that spring, including the director John Ford and the comedian Groucho Marx. The following year, in New York, he made portraits of the writers Truman Capote and William Burroughs. In Florida he photographed his aged father.[13] In 1978 a retrospective exhibition of his photographs was presented at the Metropolitan Museum of Art.[14] Soon after, the artist began to explore the American West in periodic expeditions sponsored by the Amon Carter Museum in Fort Worth, Texas. His aim was to glimpse the lives of working-class and indigent people. Over eight years, Avedon continued these expeditions, each of which lasted for months. He printed the confrontational three-quarter-length portraits in monumental scale for *In the American West*, an exhibition at the Amon Carter in 1985.[15] In 1992 Avedon became the first staff photographer for the *New Yorker* magazine. He continued to create penetrating portraits for the magazine, and also provided access to images from his own archives. Portraits comprised a major segment of the retrospective exhibition of Avedon's photographs at the Whitney Museum of American Art in 1994.[16]

CINDY SHERMAN
American, born in 1954

The Lucy Photo-Booth Shot

1975
Chromogenic print
26.8 × 21.3 cm (10½ × 8⅜ in.) Image
30.5 × 24.2 cm (12 × 9½ in.) Sheet

Walter R. Beardsley Endowment, 2018.010

A generation of artists who came of age in the 1970s, having grown up amid film and television mass media, have used photography as a mode to present their creative works in other media.[1] Cindy Sherman, who places her own image at the center of invented characters and stories, is prominent among them. She grew up in Huntington, on the north shore of Long Island, New York, where her father was an engineer for Grumman Aircraft and her mother taught remedial reading.[2] Along with her four siblings, she spent many childhood hours watching television, and old movies sparked her fascination with dressing up and make believe.

In 1972 Sherman enrolled at Buffalo State College to study art. She failed the required freshman photography class, but when she repeated the course with Barbara Jo Revelle, she was introduced to prevailing ideas about the medium. Sherman was compelled by the conceptual artist's utilitarian approach to photography. As an art student she had continued to dress in vintage apparel from thrift shops, and also collected wigs and makeup. "I'd play with makeup for a while," she later recalled, "just to see where it took me. It was like sketching."[3] In 1974, Sherman joined Robert Longo—her art-school boyfriend—Charles Clough, Nancy Dwyer, and others to establish Hallwalls Contemporary Art Center. This community of artists' studios in an old Buffalo factory building provided apartments, studios and exhibition space. Sherman had her own studio and flat, and often took her turn as Hallwalls gallery receptionist in creative new costumes. On the weekends, residents and other local artists converged for casual gatherings at Hallwalls. Sherman often arrived in a new ensemble, to the amusement and delight of her friends. She acquired a wig that reminded her of Lucille Ball in films and television comedy of the 1950s. One Saturday evening in 1975 she appeared dressed as the comedienne, and her friends were so impressed that they decided to record the costume. In his Hallwalls studio, the artist Michael Zwak had a rented photo-booth, which Sherman often used. This image is one from a strip of small negatives made by the machine that night.[4]

The photo-booth was a common feature of public spaces like post offices and bus stations in the first half of the 20th century. It was a self-contained cubicle, mostly given to the equipment for spooling film through a wet chemistry dip-and-dunk process. A seat inside faced a mirror and the lens, closed by a curtain to block out exterior light and ensure privacy. The customer inserted a coin and sat before the small mirror. Each illuminated exposure was anticipated by a light or buzzer signaling the sitter to hold a pose.

After the final shot, the mechanism developed and printed the images, one after the other, on a continuous strip of paper, usually measuring about 1 5/8 × 8 1/8 inches (4 × 20 cm). The small portraits were suitable for identity or passport photographs. The first practical photo-booth was developed in New York during the 1920s, by the Siberian immigrant Anatol Marco Josepho.[5] He introduced his patented "Photomaton" at a Broadway storefront in September 1925. For 25 cents, patrons could pose themselves for eight small prints, developed and printed in about 10 minutes. With no photographer looking on, sitters felt comfortable to pose, dissemble or clown around before the camera. The photo-booth was an immediate sensation, and its lucrative potential prompted organization of the Photomaton Company, a consortium that paid Josepho a million dollars for his invention. Within 20 years they had placed 30,000 photo-booths in operation across the country. Their use peaked during World War II, when soldiers and loved ones exchanged portraits.

Andy Warhol's (Cat. no. 91) use of photography influenced Sherman's early work. He used the camera—and the photo-booth—to grapple with the dilemma of the unearned assets of beauty.[6] In 1963 the artist became fascinated by the way that the photo-booth provided a series of related images, "designed," as it were, by the sitter. Over the next three years, he made hundreds of images of himself and his friends, and one of his first commissioned portraits. Warhol was troubled by own his personal appearance, and wore a wig in public as part of an invented persona. His use of published images of celebrities and the cultural symbolism they represented explored the quandaries of self-image. He appropriated photographic images of Marilyn Monroe, Elizabeth Taylor and Elvis Presley, printing them in lurid colors to create bolder, more iconic images.

Sherman used the photo-booth in other projects in 1975. In one, an art-school class assignment, she created *Untitled #479*, a series of 23 photo-booth portraits mounted together in an accordion fold, marking the progressive transition of her appearance from typical college student to seductress.[7] By altering makeup, hairstyle and dress, varying props, and tinting the photographs by hand, she transformed the look and attitude while maintaining the centered, frontal arrangement of an identity shot. In the present image, Sherman posed herself in a three-quarter view.[8] The glamor of this photograph suggests Lucille Ball early in her career, before the ingenue had established herself as a comedienne. Rather than displaying the empty, wide-eyed stare of her klutzy character, this Lucy glances at the camera through lowered eyelids. She is dressed in black, with lacy evening gloves correct to the period, and a short string of pearls around her neck. Sherman has darkened her eyebrows and thickened her lips with rich red lipstick, and she wears thick false eyelashes. She holds her left hand under her chin to narrow her jaw line, more closely to approximate the shape of Lucy's face. The artist captures an intelligent, savvy personality, matched with the attractive appearance of a movie star.

In summer 1977, Sherman and Longo moved together to New York City. She was fascinated by the publicity stills for low-budget films of the 1940s–60s, which were sold cheaply on the street in Midtown Manhattan, and she began photographing herself as characters from such forgotten films. Sherman worked in her own apartment, costuming herself from her thrift-store wardrobe to resemble

characters, settings and situations from film and television of previous decades. She posed in a mirror and used the camera's automatic timer to snap pictures. These are not self-portraits; the artist used her own image as a creative medium to represent invented, ambiguous characters. The first six photographs she made were intentionally grainy and unfocused, mimicking low-budget B-film production and careless industrial printing. They also evoke the stylistic mode of Robert Frank (Cat. no. 70). When Sherman exhibited six photographs selected from the first roll as *Untitled Film Stills*, they received critical admiration and marked her first recognition as an artist.[9]

In 1980, Sherman shifted to color photography in her *Rear Screen Projections* series, simulating a 1950s cinematic technique meant to represent open space and different backdrops in the studio. These photographs were printed in larger formats, and began a progression to the use of more theatrical lighting, props and costume. Over the next 40 years, Sherman photographed herself as a stunning range of characters, varying costume, makeup, pose and expression to represent different themes: haute couture models from fashion magazines, glamour fantasies in men's magazines, fairy-tale characters, the subjects of Renaissance and Baroque portraits and history paintings, clowns, Civil War soldiers, and aging 20th-century socialites. A traveling retrospective exhibition of Sherman's photographs, presented by the Museum of Modern Art in 2012, featured examples from her significant series.[10]

JOHN BALDESSARI
American, born in 1931

Throwing Three Balls in the Air to Get a Straight Line (Best of Thirty-Six Attempts)

1973
Offset lithograph on cream, clay coated wove paper
17.7 × 25.9 cm (7 × 10¼ in.) Image
24.3 × 32.3 cm (9⅝ × 12¾ in.) Sheet

Walter A. Beardsley Endowment, 2017.080.005

For conceptual artists, photography provided an accurate means of visual documentation rather than an aesthetic medium. Original and appropriated photography has often been an element in the work of John Baldessari, who acknowledges the medium as the visual language of our age. He was born and raised in National City, California.[1] His mother was a nurse, and his father was a capable and creative bricoleur who put his hand to various trades, from farm labor to construction. As a boy, Baldessari built projects with materials from his father's accumulation of scrap and salvage. In 1949 he attended San Diego State College to study art education. By the time he had completed his BA degree in 1953, his interest had shifted to art history. Over the next decade, Baldessari continued the study of art and art history at several schools in Southern California, including UCLA, the Otis Art Institute and the Chouinard Art Institute. In 1957 he received an MA degree in painting from San Diego State College, and he eventually began a career teaching art in high school.

Baldessari joined the visual arts faculty of the University of California when it opened its San Diego campus in 1968. At that time he marked a fresh start, in true California tradition, with a bonfire of his work made before 1966. He baked some of the ash

of his incinerated paintings into cookies, and sealed the rest into a book-shaped urn bearing a plaque with the dates of the destroyed artworks and the cookie recipe. This piece, titled *The Cremation Project*, exemplifies the artist's playful fusion of concept, image and word.[2] Baldessari was inspired in these ideas by Marcel Duchamp, with whom he shared a fascination with chance, and with picture and word games. In the 1960s the artist began using found photographic imagery, such as old advertisements and film stills, and introducing them to new a context in which they assume layers of association. His favorite target at that time was the rarified domain of fine arts and art criticism. His *Wrong* series, of 1966–68, used images photographically transferred to canvas, paired with text from an amateur photography book, purposely violating the basic rules the appropriated text described for a successful snapshot.[3] The artist also produced canvases empty but for a phrase from contemporary art theory, made poetic by its isolation. He further removed himself from these works by hiring sign painters to letter his words on the canvas. In 1968, the first solo exhibition of Baldessari's work was presented by the Molly Barnes Gallery in Los Angeles.

In 1970 Baldessari joined the faculty at CalArts in Los Angeles. The following year he contributed

to *PROJECTS: Pier 18*, an experimental program of the Museum of Modern Art in New York.[4] Artists proposed conceptual works to be constructed or performed on an abandoned pier in the Hudson River. They were photographed by Shunk-Kender whose images comprised the museum exhibition. Baldessari was familiar with the work of Harry Shunk and Janós Kender, and their sophisticated collaborations with Yves Klein and Christo.[5] Baldessari invented a game meant to prevent Shunk-Kender from achieving a beautiful image, instructing them to photograph a rubber ball in midair, after a bounce off the unused pier, locating its sphere in the center of the composition without cropping. The challenges of physics and timing were intended to overwhelm aesthetic refinements. Baldessari went on to explore this notion in several of his other works, tossing or propelling objects before the camera while trying, by chance, to create a geometric arrangement.[6]

Throwing Three Balls in the Air to Get a Straight Line (Best of Thirty-Six Attempts) is a one of these visual games of chance. As in Baldessari's other loosely related works, the title sets out the simple rules of the exercise. The essential role of photography is described by the phrase "best of thirty-six attempts," for this was the number of frames in a standard roll of 35 mm film for color slides that documented the exercise. These images depend upon chance, or the infinite variables of physiological effort and natural effects: the physics of flight and motion, the weather and so on.[7] In these undertakings, Baldessari worked with Carol Wixom, his wife at the time: one tossed the balls, the other wielded the camera. Even though Baldessari made up the rules, his works were were team projects that included his partner and the film processors. After the slides were developed, Baldessari reviewed the

photographs and chose images that came closest to his goal. His creative method was based as much on selection as synthesis.

The present image is one of the 12 in *Throwing Three Balls . . .* , a limited-edition series of prints conceived for dissemination to a wide audience.[8] During the early 1970s, many serious artists made affordable books and editioned objects. Baldessari worked together with the Italian gallerist Giampaolo Prearo to produce and publish his series. His original transparencies were photographically transferred through halftone screens to aluminum plates and printed in four colors by offset lithography, the principal technique of reproductive printing in the late 20th century. The 12 prints in the set are identical in size and format. They are not individually titled or numbered, suggesting that the artist intended no specific sequence or configuration for the images. Further to emphasize the impersonal, industrial quality of the series, it was produced in a quantity much larger than most artist's editions of the era.[9] In its imagery and reproductive medium, *Throwing Three Balls . . .* declares the dominance of photography in 20th-century visual culture. Indeed, the cloudless, blue skies of Southern California, its soaring fan palm trees, and these orange spheres so reminiscent of fruit evoke the kitschy color postcards of the era, recognized by many more people as "art" than rarified creative images.

In the era of NASA's Apollo space program, Baldessari's images of aerophysical objects aloft also call up the science that engaged even the popular imagination. Robin Kelsey observed how *Throwing Three Balls . . .* and Baldessari's other photographic series correlate to contemporary game theory.[10] Cold War defense contractors utilized these models

of predictive analysis to design their products, in which chance became a standard variable in modeling systems. Comparable simulations gradually spread through the social sciences and education as research methods. These ideas were close by and ever present in San Diego County where Baldessari grew up, and which was also home to military bases and defense manufacturing.[11] Baldessari's images, and the games through which he produced them, may ultimately be seen as parodies of the science of projectile weaponry.

JOEL MEYEROWITZ
American, born in 1938

Vivian's Things

1977
Chromogenic print
24.3 × 19.3 cm (9⅝ × 7⅝ in.) Image
35.4 × 27.9 cm (14 × 11 in.) Sheet

Mike Madden (ND'58) Fund, 1979.032.003

Best known as a street photographer and as a pioneer in color photography, Joel Meyerowitz has explored many photographic genres in the course of his influential career. He was born and raised in the Bronx, New York, the son of a convivial salesman of dry-cleaning supplies with customers throughout the five boroughs.[1] In 1956 he attended the Ohio State University to study painting and medical illustration. After graduation he returned to New York, where he continued to paint and studied for a master's degree in art history, while working as an advertising designer in Manhattan. For an agency project, Meyerowitz accompanied photographer Robert Frank (Cat. no. 70) on a shoot in 1962. He became fascinated by the photographer's ability to move around and among his subjects with his handheld camera, instead of having them arranged, static, before him. Meyerowitz immediately left his job, got a miniature camera and taught himself the techniques of photography. He met Tony Ray-Jones and Garry Winogrand (Cat. no. 77), who became a good friend, and they photographed on the streets of Manhattan nearly every day.[2] They searched for shafts of sunlight or skyscraper shadows to enliven images of their human subjects. While Wingorand preferred fleeting glimpses of body language, Meyerowitz looked for connections between his subjects in their lines of sight and facial expressions. The first solo exhibition of his photographs was presented at the George Eastman House in Rochester in 1966. Two years later, the exhibition *My European Trip: Photographs from a Moving Car* was shown at the Museum of Modern Art.

In 1962–62 Meyerowitz used 35 mm Kodachrome color film for his street photographs. To honor his creative experience on the street, he kept a careful log noting the colors, light and shadows of his exposures. In the darkroom, he used these notes to learn the technical limitations when producing chromogenic prints and progressively achieved unexcelled control of color processes. Meyerowitz began teaching at Cooper Union in 1971, the year he received a Guggenheim Foundation Fellowship for the project "Still Going: America during Vietnam." His second award, five years later, enabled him to buy a vintage 8 × 10 inch view camera, which he used primarily to shoot in color. The demands of the slower rhythm of working required from this equipment, as well as the cost of film, prompted Meyerowitz to reevaluate his process. It was only when he left the city for his annual summer vacation on Cape Cod that the photographer found the time and concentration to make the most of the view camera. He concentrated on the static subject of landscape, and set out to capture the extraordinary light of the northern

Atlantic coast during the course of long summer days. He eliminated figures altogether in favor of atmosphere and shifting light.

Vivian's Things, an interior, taken in the summer of 1977, is unusual among Meyerowitz's early photographs of Cape Cod.[3] It fits into his oeuvre, however, in its thoughtful investigation of light, space and color, and as a representation of the artist's interest in the descriptive power of the large camera and the technique of color photography at the time. At first glance, this appears to be straight view of a domestic interior, with wooden flooring leading straight to the rear wall. It is a small room and the beadboard paneling that lines its walls is painted white, suggesting, along with the white wicker chest and the intense light pouring through the window, that it is located in a rented beach house on Cape Cod. The bright light filters through and around a drawn window shade, creating a warm atmosphere. The hidden window must be slightly open, for a breeze lifts sheer curtains that glow with sunlight. The window is reflected from different angles in glass surfaces around the room: a framed mirror leaning on the back wall affords a glimpse of the top of the window, and the antique cheval glass shows its far side and the end of the dresser. Both mirrors are angled away from the photographer, as is the dresser's glass top, which reflects the windows, its drapes and slivers of sunlight from below. This arrangement provides a complex view of the small space. Perhaps more complex in its components is the riot of colors and patterns in the room, reminiscent of Les Nabis. Larger passages of color, in the dresser top, floor and rug, are balanced by colored fabrics of different hues and printed patterns. Folded clothing in the foreground leads the eye to a batik shawl draped over the end of the dresser. Beyond, a red towel sits on the teal-blue cushion of a painted chair. Another printed scarf drapes over the back of the chair, hanging in front of the chintz fabric covering a piece of furniture. Perhaps most important is that somehow these hues and designs all harmonize to create a cohesive mood. Meyerowitz has carefully arranged these elements by color and space, effectively creating a painting for the camera to capture.

In the fall of 1978 a selection of Meyerowitz's summer photographs in color, *Cape Light*, was exhibited at the Museum of Fine Arts in Boston.[4] Aside from the delicate, lyrical quality of these color photographs, the show demonstrated a more aesthetic side of a photographer known for dynamic street work. In 1978 the St. Louis Art Museum commissioned Meyerowitz to create a photographic document of the city. On his first visit he was captivated by the Gateway Arch, designed by Finnish-American architect Eero Saarinen in collaboration with the structural engineer Hannskarl Bandel. The enormous scale of the arch and its location on the west bank of the Mississippi River, where St. Louis was founded, made it irresistible. Meyerowitz used the sculptural form of the arch, near and far, as a motif in his photographs of St. Louis.[5] During the 1980s, Meyerowitz worked on new color projects in the summers, and he attracted a wide audience for photobooks that celebrate the distinctive beauty and informal mood of the season, books such as *Wild Flowers, A Summer's Day, Redheads* and *Bay/Sky*.[6]

Within a few days of the attacks on the World Trade Center on September 11, 2001, Meyerowitz began photographing at Ground Zero. He persistently returned to the site, documenting the painful efforts of rescue, recovery and demolition, creating a

historical and research archive in thousands of photographs.[7] Among his photographs are many images of the people who worked on recovery at Ground Zero, bringing intimate human care to a place of vast destruction. A selection became the exhibition *After September 11: Images from Ground Zero*, which traveled to 60 countries and was shown at the Eighth Venice Biennale for Architecture in 2002. Meyerowitz and his second wife, the English novelist Maggie Barrett, began to divide their time between New York and Tuscany, where they converted a barn into a home and studio. They collaborated on books that carry on the simple sophistication of Meyerowitz's earlier summer books.[8] The photographer has also used his camera to investigate new ways of understanding the art of Paul Cézanne and Giorgio Morandi.[9]

WILLIAM EGGLESTON
American, born in 1939

Untitled

1978
from the series *Jamaica Botanical*
Chromogenic print
25.8 × 38.1 cm (10⅛ × 15 in.) Image
36.5 × 43.1 cm (14 × 17 in.) Sheet

Gift of Jamie Niven, 1980.122.004.R

Although serious photographers like Ernst Haas and Eliot Porter (Cat. no. 65) had worked in color for years, and had their work collected and shown by museums, the controversy around William Eggleston's work forced a resentful acceptance of color in American creative photography. The artist approached color as a natural part of everyday life, and his photographs represented it as such. Eggleston was born in Memphis, Tennessee, and he grew up in privilege on the family cotton plantation in Sumner, Mississippi, at a time when the South was still deeply divided by race and class.[1] As a boy he learned to play the piano, beginning a passion for music that sustained him through irksome years in boarding school. Eggleston made his first serious photographs when he was a teenager, inspired by the work of Walker Evans and Henri Cartier-Bresson (Cat. nos. 39, 60). When he acquired his first Leica miniature camera in 1958, he set out to replace Evans's view of the South as an impoverished place with one of a region of modern prosperity, with all its superficiality. After high school, he drifted from Vanderbilt University to Delta State College and then the University of Mississippi, but he never completed a degree.

Eggleston worked in black and white for several years before he settled on color photography in 1965,

producing copious Kodachromes and Ektachromes. He traveled to New York in 1967 and showed his work to John Szarkowski, curator at the Museum of Modern Art, who provided encouraging comments. Eggleston met other photographers in New York, including Joel Meyerowitz (Cat. no. 88), who shared his current work with color negatives. When he returned to Memphis, he shifted to color transparency film. Like other photographers of his generation, Eggleston made a great many exposures, working improvisationally and shooting subjects from different points of view. He captured ordinary life with an instinctive sense of composition and a delight in bright color.

In 1969 Eggleston took his camera on the first of several vacation trips with his friend Walter Hopps, curator at the Corcoran Gallery of Art in Washington. They traveled from Memphis to the Mississippi Delta, through New Orleans, and out West. In New Mexico, they stopped in Los Alamos—where the Manhattan Project developed the first nuclear weapons during World War II—proceeding to Las Vegas and then to Los Angeles, Hopps's former home. Eggleston made thousands of slides during these expeditions, and with Hopps's assistance he selected 75 to present as his "Los Alamos Project," named for a typical American town with a sinister history.[2] Some of these photographs made up

Eggleston's first solo exhibition, held at the Jefferson Place Gallery in Washington, D.C., in 1974. In that year the pioneering photography dealer Harry Lunn published *Fourteen Pictures*, a portfolio of dye imbibition prints from Eggleston's transparencies. These were included in a solo show in 1975 at the Carpenter Center for the Visual Arts at Harvard University, and supported Eggleston's successful application for an Artist's Fellowship from the National Endowment for the Arts.

Szarkowski reviewed thousands of Eggleston's slides taken in Memphis around 1969–71, and chose a group for *Color Photographs by William Eggleston*, an exhibition at the Museum of Modern Art in 1976.[3] He was impressed by the artist's recognition of color all around him and the way he used it as a fundamental element of design. Eggleston perceived visual delight in mundane subjects and events; his photographs represented a particular place and time through a unique personality. Many were unimpressed by the prosaic nature of the images, and critical reaction to the show was hostile. Eggleston's subjects were condemned as banal, but his use of color exasperated the critics most. Seemingly bound by the supposition that fine-art photographs must be in black and white, they denounced Eggleston's work as garish, vulgar and inappropriate for the museum. These art critics—few then specialized in photography—may have judged the work through the cool intellectuality of the current style of Minimalism. Many of them had previously accepted the brilliant hues of Pop and Color Field painting. Later, *The New York Times* named the exhibition the most hated show of the year.

Uproar over the exhibition made Eggleston a celebrity. He moved to New York, and lived for several years at the Chelsea Hotel. He found a particularly appreciative audience in the film industry. The intense color that enraged some viewers drew directors and cinematographers to his work, which they also appreciated for its spontaneous authenticity. In 1976 *Rolling Stone* magazine commissioned Eggleston to photograph at Plains, Georgia, the hometown of presidential candidate Jimmy Carter. Although the magazine decided not to print the images he turned in, in 1977 film producer Caldecot Chubb funded the production of Eggleston's first photobook, *Election Eve*, an exclusive edition presenting a hundred images in two leather-bound volumes.[4] After the election, a selection of Eggleston's Georgia photographs was exhibited at the Corcoran Gallery of Art.

When Eggleston visited Jamaica in 1978, he was compelled by the fauna of the place. This is a photograph from his *Jamaica Botanical* series, an editioned portfolio of 20 chromogenic prints, produced and published by the artist.[5] Apart from one contextual image of a patio, the photographs present tropical vegetation from varied distance and perspectives, as if seen on a walk through a garden. Individually the images are like casual snapshots, but together they convey the environment and the interrelationship of elements. Most of them are similar in their diagonal compositions. Eggleston would seem to have taken this photograph standing over a croton plant, aiming his camera down; another image in the series represents the vivid bush from the side, before a deep landscape. Here, passages of color and tone plot strong diagonal forms from upper left to lower right. Eggleston focused on the middle ground, so that the nearest projecting leaves and the background foliage blur slightly. The colored edges of the croton leaves, and the patterns of yellow and red around their central veins, delineate a dynamic

abstract design of line and hue. The effect is like an agitated pot of colored spaghetti, swirling as it boils. Its visual impact is similar to gestural painting, with calligraphic lines and scumbled passages. Color is a key, integral component of the design.

During the 1980s, Eggleston continued to photograph throughout the American South, and on his continually broadening travels. He made two visits to Africa over the decade, and also traveled to Europe and Japan. In 1983, the Estate of Elvis Presley commissioned Eggleston to photograph the late singer's Memphis home, Graceland. He arranged a selection of his photographs into *The Democratic Forest*.[6] This volume of 150 extraordinary images of often unremarkable subjects is organized with the sensibility of a Southern novelist. Later, Eggleston photographed along the Mississippi River, capturing it as described by William Faulkner, to accompany quotations from Faulkner's novels.[7]

Filmmakers often invited Eggleston onto their sets to photograph movie projects, including *Annie*, directed by John Huston in 1982; *True Stories*, directed by David Byrne in 1986; *Eve's Bayou*, directed by Kasi Lemmons in 1997; and *Easter*, directed by Gus Van Sant in 1999. In 2000 Paramount Pictures commissioned the photographer to document its Hollywood studio lot. In the new century, documentary films on Eggleston celebrated his work and his stature as a cultural celebrity, including *William Eggleston in the Real World* by Michael Almereyda (2005), *By the Ways: A Journey with William Eggleston* by Vincent Gérard and Cédric Laty (2006), and *Stranded in Canton* by Robert Gordon (2008), a documentary created from video shot by Eggleston in 1973. In 2017, Eggleston released his first recording, *Musik*, which includes original improvisations and interpretations of tunes by Sir Arthur Sullivan and Lerner and Lowe, performed by the artist on his Korg synthesizer.

HIROSHI SUGIMOTO

Japanese, born in 1948

UA Walker Theater, New York

1978
from the series *Theaters*
Photogravure on white Rives BFK wove paper
29.2 × 37.7 cm (11½ × 14⅞ in.) Plate
43.7 × 53.9 cm (17¼ × 21¼ in.) Sheet

Humana Foundation Endowment for American Art, 2002.043

Clear perception, technical finesse and penetrating ideas characterize the provocative work of Hiroshi Sugimoto. He first became aware of photography in his Tokyo elementary school, when the teacher demonstrated the photogram process; the boy insisted that his parents buy photosensitive paper so he could continue at home.[1] When he was 12 years old, Sugimoto was given his father's Mamiya 35 mm SLR camera, and he began taking his own experimental photographs. As a teenager, he photographed Audrey Hepburn on screen as her movies played at the local theater. He studied economics at Rikkyo University, but instead of beginning a salaried job after graduating, he traveled with a backpack and his camera in the Soviet Union, Western Europe and the United States. Sugimoto settled in California to study photography at the ArtCenter College of Design in Los Angeles. He was surprised to discover the popularity of Zen Buddhism in California, and realized that his interest in foreign cultures had led him to neglect his own. He began studying Asian philosophy, Zen Buddhism in particular, and these ideas would later influence his work. Sugimoto completed his BFA degree in 1974 and moved to New York to pursue a career as a creative photographer. There, while considering a direction for his creative work, he assisted commercial photographers and worked as

a dealer of Japanese art and antiques. At that time, he also became interested Dada and Surrealism, and the ideas and writings of Marcel Duchamp (Cat. no. 55).

In 1976, Sugimoto began to work in the American Museum of Natural History, creating photographs of taxidermy mounts displayed in dioramas of the animals' natural habitats. He was fascinated by the way that remnants of living creatures were set in fictive activities, frozen in time. At first, his photographs appear to depict live animals, but close examination reveals the fallacy. These are displays created by museum designers for entertainment and information.[2] Sugimoto's series *Dioramas* challenges our cultural assumption that photography always reflects reality.

This is an image from Sugimoto's next project, the open-ended series *Theaters*, begun in 1978.[3] Illusion, concrete experience and notions of time also characterize these photographs. For nearly four decades, Sugimoto used a large-format camera to photograph movie theater interiors in the light of a projected film. He captured the lavish interior decor of American movie theaters of the 1920s and 1930s, setting up his 8 × 10 inch view camera under the projection booth on the balcony in a dark, deserted auditorium. He set the timer for an exposure as long as the length of a feature film, opened the shutter and had the

key designs to original photographs. Warhol used an instant camera and self-developing film to make preparatory studies and primary designs. He came to prefer the Polaroid Big Shot, an affordable camera designed for portraits. It was larger than most consumer cameras of the day, with a rigid plastic body shaped like a bellows, and an f/29 plastic meniscus lens. The fixed focal distance of about 39⅜ inches (1 m) required the photographer to move back and forth to find focus. In 1973, the year that the Factory moved to 860 Broadway, Polaroid discontinued the Big Shot; it is said that Warhol's assistants fanned out across New York to buy all the remaining cameras and ASA 75-100 series Packfilms.

This selection of Warhol's snapshots suggests the breadth of his later Polaroids, and their varied purposes. The earliest is *Dog*, one of many photographs of Pom, a charming Cavalier King Charles Spaniel, done in preparation for a series of prints.[4] Warhol was a devoted dog lover; when his dachshund Archie was a puppy, the artist carried him everywhere, secreting him beneath a napkin in restaurants. In 1976 the newspaper mogul Peter Brant commissioned a portrait of his Cocker Spaniel. The successful project led to a series of cat and dog paintings and prints. Warhol collected Polaroids of the animals, including portraits of his dachshunds, as well as the stuffed Great Dane, Cecil, who stood guard at the Factory. He made several photographs of Pom, at least one of which he developed into a screenprint-acrylic painting on canvas.[5]

Around 1979 Warhol's friend the fashion designer Halston commissioned an advertising campaign for his line of women's shoes, made by Garolini. He sent a large cardboard box to the Factory filled with single samples of high-heeled shoes. When they were spilled onto the floor, the artist liked the haphazard patterns they made and began shooting Polaroids. Scores followed, including this print.[6] Warhol's shoes appeared as fashion magazine advertisements, and he developed some into paintings on canvas, images that embodied the glamour of the disco nightclub Studio 54, where Warhol was an habitué. He transferred some of the shoe designs to screenprints on paper in pink and green on black backgrounds. To evoke the glitz of the dance floor, Warhol cast diamond dust over the wet ink, causing the *Diamond Dust Shoes* prints literally to sparkle.[7]

Through the 1970s Warhol attracted portrait commissions from film and rock stars, socialites and other celebrities, deriving their images from his Polaroids.[8] Usually he made scores of snapshot studies, using the camera's tight depth of field and harsh lighting to create high contrast and simplify contours. For women, Warhol increased this effect by preparing his sitters with opaque white makeup and bright lipstick, which smoothed wrinkles and reduced facial features to simple, strong design elements. Together the artist and subject usually selected the final images from the studies; these were enlarged and transferred to a silk or nylon screen with an internegative, then printed onto canvas. Color was applied through supplementary screens or by hand. The artist often made polyptychs, with identical or closely similar portraits in variant hues. In 1980 the Italian clothing marketer Gruppo Finanziario Tessile (GFT) commissioned Warhol to do a portrait of fashion designer Giorgio Armani, then a rising star in the United States.[9] The artist arranged to meet Armani at the opening of a new GFT showroom in Manhattan. Their encounter was brief, and Warhol took him to a fluorescent-lighted corridor to

make just a handful of Polaroids. Armani admired the artist, and on that night he was impressed by his decisive efficiency.[10] The present photograph is one from that group, but not one of the two close variants chosen for the canvases. Warhol created a multi-panel portrait of Armani, each canvas in his customary 40 × 40 inch (101.6 × 101.6 cm) format, one of them enhanced with diamond dust.[11] Warhol included Armani in his entourage on a typical evening's tour of New York nightspots. Both men were shy, and Armani's English was limited, so much of their time together was spent in silence.

At that time Warhol was also at work on a series of editioned screenprints, conceived to reflect and caricature 20th-century American culture through a group of national symbols. Among the 10 fictional archetypes in the *Myths* series are Uncle Sam, the personification of the American government; children's characters like Mickey Mouse; and fairy tale figures like the Wicked Witch.[12] *Santa Claus* is a Polaroid study of Warhol's version of Father Christmas from the *Myths* series.[13] This is one of his many studies of an actor dressed in the traditional white wig and beard and red costume. He is not the benign, affectionate character of author Clement Moore, illustrator Thomas Nast or artist Haddon Sundblom; rather, Warhol's Santa is the mystifying imposter that children of Warhol's generation met on holiday visits to local department stores. His mythic persona has faded like childhood wonder.

DONNA FERRATO
American, born in 1949

Scenes from a Marriage #2, Garth & Lisa

1982
Gelatin silver print
34.3 × 50.8 cm (13½ × 20 in.) Image
50.9 × 60.8 cm (20 × 24 in.) Sheet

Gift of Douglas Wetmore (ND'79), 2012.97

The photojournalist Donna Ferrato was the first to capture domestic violence in the moment, a deeply disturbing experience that changed the course of her career. Ferrato grew up with two younger brothers in Lorrain, Ohio, the daughter of a surgeon and a nurse.[1] She attended Garland Junior College in Boston in 1968, when she met and married Harvard student Mark Webb. The couple moved to San Francisco, where she worked as a legal secretary while studying photography at the California Art Institute. After divorcing Webb, she traveled to Europe with her camera in 1977, working especially in Portugal, Belgium and France. Ferrato then settled in New York City, where she aspired to a career in photojournalism. She was drawn to the subjects of love, personal freedom, and the power of romantic and sexual relationships. She photographed couples on the street, and explored places where couples meet and share moments of intimacy. Ferrato took her camera to popular nightclubs of the era, such as Studio 54 and the Mudd Club. She also found her way to stripper bars and sex clubs. *New York Magazine* gave her an assignment to photograph Larry Levenson, an owner of the notorious heterosexual swingers' club Plato's Retreat. The club was located in the basement of the Ansonia Hotel on Broadway, once the home of Continental Baths, a popular a gay rendezvous.

Ferrato's next important commission came from Japanese *Playboy* magazine, which requested a photoessay on wealthy, successful couples who shared open relationships and frequented Plato's Retreat. At the club, Ferrato met Bengt and Elizabeth Lindberg, an affluent Swedish couple who lived with their children in a spacious home in Saddle River, New Jersey. Ferrato became friendly with the Lindbergs and was often invited to stay at their home, where she shared typical family moments as well as debauched private parties. She photographed their activities in the city and at home, with plans to publish the images in Japan with assumed names. Alcohol and drugs, especially cocaine, were constant features of the revelry. Ferrato supported Elizabeth Lindberg's concerns about her husband's increasing cocaine use. One night, when she was staying at Saddle River, she was roused by shouting. She instinctively grabbed her camera and ran from her room to find the Lindbergs fighting in the master bathroom. The brightly lighted makeup mirrors illuminated the room like a movie set, and shouts and screams resounded from the marble and porcelain. Hoping to moderate her husband's drug use, Elizabeth had hidden the cocaine. In a drunken rage Bengt demanded its return. When she refused he became violent. Hoping that the camera would

subdue his rage, Ferrato recorded the following events in series of powerful photographs.

This is the second photograph that Ferrato selected from the sequence taken that night.[2] Its title carries the pseudonyms—Garth and Lisa—used when the photographs were published in an erotic context. The previous image in the series shows Bengt striking his wife, but this photograph is no less violent and reflects the depth of psychological intimidation that he wields. The wide bathroom mirror provides multiple views of the couple, amplifying the scene. Just inside the doorway, between the figures and their reflections, stands Ferrato, aiming her camera at the moment of exposure. The dark, lumbering figure of Bengt and his violence seems out of place in this spacious and neat room. Ferrato selected photographs in which his face is obscured, which for the viewer adds confusion and heightens the threat. Holding a drink in one hand, Bengt covers Elizabeth's mouth with the other, stifling her screams. He presses his face close to hers while bending her backwards over the counter. She seems to lose her balance as she leans back, closing her eyes in submission. His aggressive position standing between her legs emphasizes his dominance. Next, Bengt raised his hand to strike Elizabeth again, and Ferrato grabbed his arm. "What are you doing?" she screamed. "You are really going to hurt her." Pushing Ferrato aside, he shouted, "She's my wife. I know what my strength is but I have to teach her that she can't lie to me."[3] Ferrato was used to the adrenalin of physical and emotional intensity, but this was something quite different. She kept shooting as Bengt went on to rifle through the cabinets for his drugs.

The events of that night affected Ferrato deeply. She had never known domestic violence, or its profound psychological impact. It was shocking to realize that such events so completely destroy the sense that one's home is a safe refuge. More revealing for Ferrato was the understanding of how common problems of domestic abuse are in our culture. She committed herself to understanding this widespread problem and sharing its devastating impact through photojournalism. For the next decade, Ferrato traveled across the United States photographing stories of domestic violence. She rode with police on domestic calls, visited victims in emergency rooms, lived in women's shelters and attended legal trials of batterers. Though at first it was difficult to find journals to publish this work, when Ferrato received the W. Eugene Smith Award in 1986 editors took her project seriously. She found that this social problem is not restricted by income, education or race. Domestic violence recurs through generations of families, often ignited by the fear and insecurity that former victims had experienced. She came to the conclusion, therefore, that children suffer most profoundly from this violence. Many women can escape from these tragic events and move on with their lives; their children, however, can be deeply scarred and become batterers themselves years later. A selection of the photographs Ferrato collected was published in *Living with the Enemy* in 1991, including her photographs of the Lindbergs.[4] Along with her images, the book contains her interviews with battered women, violent men, activists and reporters. Among the most disturbing images in the book are those including children.

Ferrato still believed that women should have the choice to be sexually liberated, and in the late 1980s she published photoessays on lifestyles of sexual freedom in the *Philadelphia Inquirer* and *Stern* magazine, and

in subsequent photobooks.[5] Aside from her continuing photojournalism work on a variety of topics, in 1991 Ferrato began Domestic Abuse Awareness, Inc., a nonprofit that put on photographic exhibitions to support women's organizations. Apart from their value in fundraising, these projects provide models with which victims can identify, encouraging them to understand and escape from abusive partners, especially if there are children endangered by the relationship. Ferrato's efforts are widely admired. In 2008, the year New York City declared October 30th Donna Ferrato Appreciation Day, the photographer began publishing her street photographs of Tribeca, the Lower West Side neighborhood where she has lived since the mid-1990s.[6] She began publishing the *10013* portfolios of original prints, named for the Tribeca zip code. In 2011 she published a selection of these images in a photobook chronicling the neighborhood during the decade following the September 11, 2001, attacks on the World Trade Center.[7] Ferrato's most recent book, *Holy*, represents the struggle for women's rights from the sexual revolution of the 1960s through the Me Too movement of the 2010s.[8]

SEBASTIÃO SALGADO
Brazilian, born in 1944

Serra Pelada, Brazil

1986
Gelatin silver print
29.5 × 44.3 cm (11⅝ × 17½ in.) Image
40.5 × 50.5 cm (16 × 19⅞ in.) Sheet

Gift of Dr. William McGraw, 2009.047.031

Sebastião Salgado is distinctive among photojournalists of his time for the global scope of his activities, and for his stated commitment as a political activist. His work derives from the sensibility of an artist, the intellect of an economist and the ethos of a journalist. Salgado was born in Aimorés, in the Brazilian state of Minas Gerais, where his family were landowners and cattle farmers.[1] He attended the Federal University of Espírito Santo, in Vitória, to study economics. After graduating in 1967 he married Lélia Deluiz Wanick and they moved to São Paulo, where he completed a master's degree. Salgado took a job as an economist for the Ministry of Finance and worked on the organization and financial planning of large-scale projects for the Brazilian government.

The rule of the military junta in Brazil prompted the couple to move to Paris. In 1971, Salgado became an economist for the International Coffee Organization. As part of his job he frequently travelled to Africa for projects affiliated with the World Bank; to document the coffee industry for business presentations he began taking photographs. This activity so intrigued Salgado that he left his career as an economist to become a freelance photojournalist. He first sold his photographs through the Sygma picture bureau in Paris. In 1975 he began working with the Gamma agency and took assignments in Africa, Europe and Latin America. Salgado's understanding of international affairs prompted him to seek out the dispossessed and voiceless as the subjects of his photographs. In 1979 he joined the Magnum picture agency. A few years later he worked with the humanitarian organization Médecins sans Frontières (MSF), documenting the effects of famine in the Sudan, Ethiopia, Chad and Mali. His photographs of the starving are not pathetic; rather, they capture the dignity of those facing extreme hardship. These images were first published in a book, *Sahel, l'homme en détresse*, the proceeds of which he donated to MSF.[2] Salgado went on to investigate the plight of landless peasants in Latin America, images of which were shown in the traveling exhibition *An Uncertain Grace*.[3] Salgado resolved to chronicle such events as broadly as possible. Over six years, he visited 23 countries, exploring antiquated, sometimes inhuman methods of labor and production surviving in the modern world.

Salgado's photographs of Serra Pelada, an open-cast gold mine in the Amazon jungle, are among the most startling of this project. In January 1979 a child swimming in a jungle tributary found a nugget of gold. Afterwards, Genésio Ferreira da Silva, the farmer who owned the property in southeast Pará, 270 miles (435 km) south of the Amazon

estuary, began digging and extracted huge lumps of gold. News spread quickly and poor people of the region descended on the isolated farm. Within five weeks, 10,000 potential *garimpeiros* (gold miners) had joined an encampment that came to be known as Serra Pelada, "Bald Mountain."[4] Most were young men who dug by hand, and the discovery of more gold brought more potential miners. When news of the gold rush reached President João Figueiredo, he sent Major Sebastião Rodrigues de Moura to Serra Pelada. Moura was a member of the National Intelligence

Service who had distinguished himself by the brutal repression of the leftist guerrilla rebellion in the Araguaia region.[5] He was assigned to control violence among the miners, but also managed to extract profit for the government, and for himself. Though now a colonel, Moura became known as Major Curió, a nickname from his boxing days, referring to a small bird of the Amazon admired for its many sweet songs.

Curió's first act was to restrict access to the pit mine to official laborers; only they were allowed to live at Serra Pelada, where alcohol and prostitution

were prohibited. The miners had to register with a new Federal Savings Bank in the village, which became the sole legal buyer of extracted gold and palladium. To accommodate mine administration and commerce, and house the miners' families, Curió established Trinta, a town named for its location at kilometer-marker 30 on highway PA-275. There, bars and brothels were allowed, and the thriving district became notorious for its violence. It was the site of more than 60 murders each month during the gold rush. In 1981, the year Trinta was renamed Curionópolis, two and a half tons of gold were taken from the mine by about 80,000 miners. They dug with pickaxes and shovels in an ever widening and deepening pit. Miners each had a claim of 6½ × 10 feet (2 × 3 m), in which they broke up the rock and earth; they then carried the rubble from the pit in burlap sacks to mine officials for chemical extraction of the ore. In the sweltering rain forest, the task became much more exhausting as the pit deepened and it was necessary to climb from its depths on rickety ladders. Violence was common among the exhausted and desperate miners.

This photograph reflects the astounding scene that Salgado discovered at Serra Pelada in 1986. The mine was then nearing its ultimate extent, and its activities were reminiscent of the building of the pyramids.[6] This overview represents the scale of the project, the unforgiving rocky terrain and the treacherous work of the miners. Literally tens of thousands descended into the open pit each day, clambering out again laden with sacks of rubble and sodden earth. Any gold extracted was subject to heavy taxation. Still, these people were so poor that any success was an unimaginable boon for their families. Salgado understood the breadth of this economic exploitation, which he expressed in closer images of miners at work, practically naked in the jungle heat, their bodies soaked from sweat and frequent rain, and completely covered in red mud.

Articles and photoessays with Salgado's images from Serra Pelada solidified his reputation as a leading photojournalist.[7] The images also comprise one segment of his photobook *Workers: An Archaeology of the Industrial Age*, published in 1993.[8] The following year, Salgado and his wife formed Amazonas Images to distribute and authorize use of his work. He continued to travel, now concentrating his attention on migrant populations around the world, uprooted by famine, war, persecution and globalization. Over five years he worked in 35 countries and made thousands of photographs. A selection of these were published in his book *Migrations: Humanity in Transition*.[9] By 2000, the Salgados had begun to restore the cattle ranch owned by his father to a forest preserve. They established the Instituto Terra, dedicated to the promotion of reforestation, conservation and environmental education. A similar goal became the focus of Salgado's continued travels. In 2004 he set out to photograph the last places on earth untouched by human incursion, both as a psychic restorative and to focus attention on their protection. Many of these images were his first aesthetic landscape photographs. Salgado also explored and documented isolated people and communities living in the traditional ways of their ancestors and preserving their distinctive cultures. In his photobook *Genesis*, Salgado presented these images as a possible path to humanity's rediscovery of itself in nature.[10]

FLOR GARDUÑO
Mexican, born in 1957

Basket of Light

1989
Gelatin silver print
44.4 × 34.6 cm (17½ × 13⅝ in.) Image
50.6 × 40.8 cm (19⅞ × 16⅛ in.) Sheet

Friends of the Snite Museum of Art, 2005.060.003

The photographs of Flor Garduño straddle the threshold between the temporal world and the spiritual realm. The artist finds her imagery deep in the cultural traditions of Mexico and Central America. Although she was born in Mexico City, Garduño grew up on a farm, where she was deeply influenced by a childhood amidst nature and among animals.[1] Always intending to become a painter, she attended the Academy of San Carlos of the National Autonomous University of Mexico in 1976–78. Among her teachers was Kati Horna, the Hungarian-born photographer who had come to Mexico after the Spanish Civil War.[2] A photojournalist who explored Surrealism and Feminism in her later work, Horna encouraged the young Garduño to pursue her own personal vision. In 1979 Garduño left school to become a darkroom assistant to Manuel Álvarez Bravo (Cat. no. 35). He guided the refinement of her technical skills so she could print gelatin silver, platinum and palladium prints from his negatives. Bravo also instilled the qualities of discipline and persistence in his protégé, along with a sensibility of constructive self-criticism.

In 1981 Garduño joined a government project sponsored by the Instituto Nacional Indigenista, run by Mariana Yampolsky (Cat. no. 97), and was among a group of artists who traveled to remote areas of Mexico to collect images of native peoples to illustrate textbooks. These experiences helped crystallize her photographic style and pointed the direction of her future work. The first solo exhibition of her photographs was presented at the Galería José Clemente Orozco in Mexico City in 1982. Garduño's friend the painter Francisco Toledo encouraged her to prepare her first book, *Magia del juego eterno* (Magic of the Eternal Game) which presents a selection of images exploring the lifestyles, traditions and rituals of Mexico, Guatemala, Bolivia and Ecuador, published in 1985.[3]

In spring 1989 Garduño was working in the highlands of South Central Guatemala, at Sumpango, Sacatepéquez, a small mountain town famous for its kite festival, celebrated each year on the first of November in conjunction with the traditional Day of the Dead.[4] However, the profusion of white lilies in this photograph show that Garduño was also at Sumpango in late spring or early summer.[5] Here, a Mayan girl carries piles of flowers in a woven basket balanced on her head. The profusion of white blooms creates a burst of light, which Garduño emphasized in her exposure and further heightened in the darkroom. Standing on the edge of shadow, the girl gazes directly at the camera with a tinge of apprehension that suggests how unusual it is for her to be photographed. She is dressed in traditional Mayan

clothing, her *corte* (blouse) and *huipil* (long skirt) made from natural, handwoven fabrics in colors and designs that reflect her marital status, as well as shared meanings in the village where she lives. The flowers she carries are Madonna lilies (*Lilium candidum*), cultivated in Mexico since the conquest and cherished for their symbolism as well as their beauty and scent. Traditionally this flower was associated with the Virgin Mary and the Annunciation, when the archangel Gabriel visited the Virgin to explain that she would bear the son of God. Since the Medieval period, the white lilies were traditionally included in European representations of the Annunciation, either to mark the time of year or as a symbol of, or in connection with, the arrival of the Holy Spirit.[6] Mexican viewers of Garduño's image also recognized the similarity of this image to the painter Diego Rivera's frequent representations of Mayan women carrying and selling enormous

bunches of white calla lilies. Garduño knew Álvarez Bravo's portrait of Rivera seated before his mural of a flower seller.[7]

Garduño visited Sumpango during the 30-year Guatemalan Civil War, when the government of Guatemala opposed leftist rebel groups supported chiefly by indigenous Mayan people, long dispossessed of their land. It was an era of fear for the rural poor, with kidnappings and mass executions common. This is barely apparent in Garduño's photograph of this young girl and her fragrant harvest. Instead, her image evokes the fertile cycle of seasons, the blooms of summer, the promise of adolescence, and indigenous ways of life that have existed for centuries. Such archetypal symbols are characteristic of Garduño's imagery.

Garduño included *Basket of Light* in her photobook *Testigos del tiempo* (Witnesses of Time), a selection of images of Mexicans and Central Americans

Fig 25. — Flor Garduño, Mexican, born in 1957, *Dreaming Woman, Pinotepa, Mexico*, from the book *Testigos del tiempo*, 1991, gelatin silver print, Mary Frances Mulholland (SMC'39) Bequest, 2005.041.002

descended from indigenous ancestors in which the photographer explored the progress of human life and the passage of time (Fig. 25).[8] Other publications and numerous exhibitions soon followed, establishing Garduño's reputation beyond Mexico. For her *Mesteños* (Mustang) project, Garduño used the horse to explore the history of the New World, and the ways in which Native Americans organized their varied cultures around these animals over centuries.[9] In the mid-1990s the photographer broadened her Central American focus to include still life, nude photography and portraits. She set up a studio in a small adobe structure beside her house in Tepoztlán, where she photographed still lifes. The limited space promoted a shallow depth of field against the neutral backdrop of the cracked adobe floor and walls. She invited women friends to be her models and encouraged them to choose their own poses. Themes of fertility and eroticism emerged, as well as the iconography of Precolumbian religions and Catholicism, represented in her photobook *Inner Light*.[10]

DAVID LEVINTHAL
American, born in 1949

Untitled

1989
from the series *Wild West*
Dye diffusion transfer print
67 × 55.8 cm (26⅜ × 22 in.) Image
84 × 55.8 cm (33⅛ × 22 in.) Sheet

Gift of Engart LLC, 2017.050.043

Among the artists who used photography to present their creative work in other media during the 1970s, David Levinthal became prominent for his staged miniature scenes. His subjects first appear to be historical, but they depend upon works of art, industry, film and electronic mass media, so Levinthal is often characterized as a Postmodern artist. The son of a physicist, Levinthal was born in San Francisco, where he grew up in an accomplished Jewish family.[1] He planned to study constitutional law when he enrolled at Stanford University in 1966. However, living in the Bay Area of the late 1960s, he was understandably drawn to more creative approaches to social justice. He learned the fundamentals of photographic technique in a course at Stanford's Free University and began making street photographs of storefronts in Santa Cruz and pinball players in Palo Alto, images influenced by the work of Garry Winogrand and Joel Meyerowitz (Cat. nos. 77, 88).

In 1971 Levinthal began the graduate program at the Yale School of Art, where Walker Evans and Paul Caponigro (Cat. nos. 39, 78) were on the faculty. During his second year in New Haven, he was inspired by the work of Robert Capa (Cat. no. 49) to experiment with his own wartime vignettes. He staged these in miniature on the linoleum floor of his apartment using molded polyethylene toy soldiers, which were available in startling variety. Levinthal constructed simple sets from painted wooden blocks, basing his compositions on historic photographs and war movies. Soon he had planned a miniature recreation of the 1941 Nazi invasion of Russia. By coincidence, Levinthal's friend and classmate Garry Trudeau—who had already begun drawing his newspaper comic strip *Doonesbury*—was working on the graphic biography of a fictional Luftwaffe pilot. When Trudeau's publisher heard about the two projects, he suggested that the artists collaborate on a book. With a contract and a cash advance, Levinthal and Trudeau started work on images of the Eastern Front. They posed small plastic figures before cardboard buildings or on hillocks of potting soil. Levinthal photographed the tableaux with his Rollei camera under spotlights reflected from the ceiling. He used selective focus to create ambiguous space, softening the subjects and blurring the distance. He printed the images in sepia tones on grainy paper to give an appearance of age. When the book *Hitler Moves East: A Graphic Chronicle, 1941–43* appeared in 1977, it became an influential example of its genre.[2]

Levinthal took a hiatus from his art career to earn a management science degree from the Massachusetts Institute of Technology. He moved to New York in 1983 and returned to photography with a new project

David Levinthal 1989 1/1

inspired by the style of film noir and the paintings of Edward Hopper. He photographed miniature figures in elaborate settings, softly focused and dramatically lighted, using a Polaroid SX-70 instant camera to create 3 × 3 inch prints, and even transmitted some of the images through a cathode ray tube to capture the grainy appearance of predigital television. The *Modern Romance* series represents themes of urban courtship and coupling in the late 20th century.[3]

In 1985 Levinthal bought an extensive set of Britains Deetail toy figures, including six mounted cowboys and six on foot, along with an equal number of Sioux and Apache warriors, as well as soldiers of the Seventh Cavalry. The artist also collected figures of pioneer women in long skirts and bonnets, a toy covered wagon with a team of four horses, and a miniature building with a porch. He also seems to

have obtained some vintage Britains Swoppet toys from the 1950s or 1960s. Levinthal carefully painted the toys to create individualized characters. In designing images of the American frontier and the Indian Wars, he drew upon memories of childhood play, filtered through fiction, turn-of-the-century Wild West shows, films, television and advertising. Now the artist used more sophisticated lighting, colored, reflected and electronically modulated. In the early photographs of Levinthal's *Wild West* series the artist used an amber tint to create the appearance of age merged with recollection.[4] Later he introduced more dramatic lighting, with intense background colors. By precisely narrowing the depth of field in these photographs, he enhanced the illusion of movement. He blurred images in and out of focus to manipulate the viewer's attention, using techniques similar to those of film and television photography. The first *Wild West* photographs were small, unique dye diffusion transfer prints taken with a Polaroid SX-70 instant camera. Later he transferred some of the images onto canvas at larger scale.

Fig 26. — David Levinthal, American, born in 1949, *Untitled*, from the series *Barbie*, 1998, dye diffusion transfer print, Gift of Engart, LLC, 2017.050.002

In 1987 Levinthal began working with a Polaroid 20 × 24 inch camera. A handful of these large-format cameras, and the specialized film packs they required, were made by the Polaroid Corporation, which made them available to serious photographers by lease. They were extensive systems, designed primarily for studio work, weighing nearly 250 pounds (113 kg) and mounted on a wheeled chassis. Like consumer Polaroid instant cameras, they produced one positive print at a time. Immediately after exposure, the prints were processed when developing chemicals were squeezed between the exposed negative and a positive sheet by being drawn through set of rollers. The instantaneous results suited Levinthal's experimental process and he was delighted by the large, shiny, detailed prints. If a photograph seemed especially successful, he could reshoot to create small editions of essentially identical prints.

In this photograph Levinthal presents a glimpse of an action movie, rather than a character study.[5] Several of the images in the *Wild West* series depict a lone gunfighter. Here, he wears a wide-brimmed hat, faded red shirt, and belt and holster; a six-pointed brass badge identifies him as an officer, probably a sheriff. He has turned away, gun pointed, his left arm lifted slightly in a dancelike pose that gives the image energy and suspense. Our attention follows his to an unseen threat. We identify strongly with the character, though we cannot see his face or sense his personality. The setting of this image, framed by a darkened wooden porch, is described entirely by straight lines, and the figure stands out for its irregular, dynamic form.

To 20th-century viewers, the trope of a solitary lawman in a village gunfight is so familiar that we can anticipate the events to come. In images like this,

Levinthal prompts us to contemplate how play and mass media contribute to the formation of identity, gender roles and membership in modern culture. He understood that play is a potent means of socializing young people. Toys reflect cultural mythology and provide role models thought to be appropriate in American society. In the mid-20th century these toys, and the ideals they advanced, included messages of racial hierarchy, which were incongruously bound up with notions of honesty, fair play and justice. In 1997 Levinthal turned his attention to the toys that girls of his generation enjoyed. Barbie, the American fashion doll introduced in 1959, remains enormously significant.[6] In the 1980s she was the coveted toy for little girls, who began to imagine their dolls in adult roles (Fig. 26). Levinthal sought out early versions of Barbie dolls and costumes, which pointedly mirrored adult fashion. He approached this project like a fashion shoot, carefully selecting solid background colors for each costume and striving to capture the look of the late 1960s, like Audrey Hepburn or Doris Day films of the period.

Levinthal has continued to produce photographic series with staged figural miniatures, often concentrating on themes of sport, sex and war.[7] Through these subjects he has explored the character of 20th-century culture, history and social identity. In 2018–19, major retrospective exhibitions of Levinthal's photographs were presented by the George Eastman Museum in Rochester, New York, and by the Smithsonian American Art Museum in Washington, D.C.[8]

KENNETH JARECKE
American, born in 1963

Incinerated Soldier, Iraq-Kuwait Highway

1991
Dye imbibition print
33.7 × 48.6 cm (13¼ × 19⅛ in.) Image
39.8 × 51 cm (15⅝ × 20⅛ in.) Sheet

Gift of Milly Kaeser, in Memory of Fritz Kaeser, 2004.007

Although American editors initially declined to publish this haunting image, it became recognized as a potent symbol of the Gulf War that closed the 20th century. Its creation exemplifies the enduring impulse of photojournalists to inform and influence with their work. Kenneth Jarecke was born in Fairfax, Missouri, and grew up in Omaha, Nebraska, where he developed a native obsession with football. At age 15 he also became interested in photography and began experimenting with his father's 35 mm camera, learning to develop and print his work in the Bryan High School darkroom. Jarecke attended the University of Nebraska, where he played on the Cornhuskers football team. His experiences on the field enabled him to photograph the game with an insider's understanding.

After graduating from college, Jarecke went to New York to pursue a career in photojournalism. While striving to get commissions, he attended workshops taught by Gilles Peress, David Burnett and Robert Pledge, which led to his early membership in the photo agency Contact Press Images. Among Jarecke's first published photographs were candid shots of Oliver North at time of the Iran-Contra affair in 1986. During the administration of President Ronald Reagan, Jarecke often worked on assignment at the White House. In 1987 contracts from

LIFE magazine took him around the world, photographing elections in Haiti, an eventful IRA funeral in Belfast and the Summer Olympics in Seoul. Jarecke's photographs of the 1988 U.S. presidential campaign were widely published, and his coverage of candidate Jesse Jackson earned him a World Press Photo Award. Two years later, TIME magazine contracted the photographer to gather images for a cover story on the plight of New York City, then beset by political and social problems.[1] The magazine had proudly shifted to color illustration, but Jarecke turned in black-and-white photographs that extolled the history of New York street photography. At the time, Jarecke was working in the Manhattan darkroom of Bill Pierce, a former apprentice to W. Eugene Smith (Cat. no. 48), and learning the finer points of printing gelatin silver. Among his photographs in the TIME article was Bathers, the image of a couple in swimsuits seated on a decaying pier across the river from Manhattan. This photograph won Jarecke a second World Press Photo Award.

Meanwhile, the president of Iraq, Saddam Hussein, had launched a military invasion of Kuwait. This aggression was opposed by an American-led military coalition of nations. During the buildup of troops and matériel, Jarecke saw how the American government effectively controlled

journalism around Operation Desert Shield. He was determined to assail the system and persuaded *TIME* editors to send him to the Gulf. Jarecke arrived in Saudi Arabia on January 17, 1991, the first day of bombing in Iraq. To assure safety for the media and regulate coverage of the war, the Pentagon operated a press pool system, grouping journalists, photographers and television crews together under the supervision of public affairs officers (POAs). They organized and accompanied press junkets, keeping a close watch on their charges. For two weeks, during the bombing campaign, Jarecke and other reporters remained in Saudi Arabia. Finally he was assigned to a pool attached to the U.S. Army's 18th Artillery Corps, encamped 25 miles (40 km) inside southern Iraq. When the pool was finally driven into the desert to survey the battlefield, they witnessed little combat.

On February 28, 1991, Jarecke was traveling with his press-pool colleagues through southern Iraq in two vehicles. While driving along Highway 8, about 50 miles (80 km) from Kuwait City, they came upon a burned-out Iraqi military convoy surrounded by burned bodies. Riding alone in one truck with POA Patrick Hermanson, Jarecke grabbed his camera and jumped out as they approached the destroyed vehicles. "In one truck," he later recalled, "the radio was still wired up and faintly picking up some plaintive Arabic air which sounded so utterly forlorn I thought at first it must be a cry for help."[2] Jarecke was photographing the truck, trying to position himself for optimal lighting, when he noticed this burned figure in the empty windshield frame.[3] The soldier seems to have been about to pull himself over the dashboard when flames engulfed the truck, incinerating the body and freezing it in this position. Charred sinew in the soldier's arms and shoulders define his final effort. The eyeless, skeletal face seems to stare ahead, his mouth fixed in what appears to be a grimace of agony. The Iraqi's presence was powerful, but Jarecke tried to concentrate on the technical challenge of capturing his image. He carried a Canon EOS-1 camera, fitted with a 200 mm zoom lens. The sun shone through the rear of the destroyed truck, backlighting the subject. Between Jarecke and the subject was another burned corpse lying on the ground, so he could not move in for a close-up. The focus had to be precise, and with the exposure set at $1/60$ second at $f/2.8$, the camera had to be steady. When Jarecke had the shot he returned to the truck, where Hermanson questioned why he would even want such an image. The photographer knew that it had the potential to change the way that Americans perceived the war.

Back in Saudi Arabia, Jarecke turned in his edited film to the pool for Reuters and the Associated Press to put on the wire, but the Associated Press editor in New York deleted the image when it arrived from Dhahran. America's coalition allies, however, were not so squeamish. As Jarecke passed through Heathrow Airport in London, he found his photograph in the *Observer* newspaper under the headline "The Real Face of War," accompanied by an article by Colin Smith.[4] The following day, the image was published in Paris in the daily *Libération*. Soon afterwards, *The Guardian* in London commissioned poet Tony Harrison to observe the "Highway of Death," a 7-mile (11-kilometer) stretch of road on Highway 80 outside Kuwait City on which more than 1,500 vehicles had been destroyed in the same offensive that caught the convoy on Highway 8 that Jarecke had photographed; Harrison began his

poem "A Cold Coming" with a vivid description of Jarecke's photograph.[5]

This recognition abroad only piqued the photographer's frustration with American restrictions. "If we're big enough to fight a war," he wrote, "we should be big enough to look at it."[6] Ultimately, international recognition overcame political authority. Jarecke's photograph appeared in the year-end issue of *TIME* in 1991; Jarecke was awarded the Leica Medal of Excellence in January 1992 and later received a Pulitzer Prize nomination.[7] He worked with *TIME* until 1996, while continuing to photograph subjects of interest, including football.[8]

MARIANA YAMPOLSKY
Mexican, born in the United States, 1925–2002

On the Edge of Time

1992
Gelatin silver print
35.4 × 47.7 cm (14 × 18¾ in.) Image
40.4 × 50.9 cm (15⅞ × 20 in.) Sheet

Humana Foundation Endowment for American Art Fund, 2007.047.001

One of a remarkable group of Mexican women photographers, Mariana Yampolsky lovingly recorded her adopted country, its landscape, arts and culture, and especially its people. She was a prolific artist who made both creative and editorial photographs. "When [I] take a photograph . . . ," she told an interviewer in 1999, "it is like a personal discovery that I want to show to everybody else, not as an achievement of mine, but as something I want to share because I feel it is important."[1] Yampolsky was born in Chicago, the daughter of European Jews who immigrated to the United States to escape Nazi persecution.[2] Her mother's uncle was Franz Boas, the pioneer of anthropology. Yampolsky grew up on her paternal grandfather's farm in Illinois, in a cultured home amidst an intellectual family with leftist political convictions. Her father was a sculptor who introduced her to a range of art practices. As a young girl she helped him develop photographs in the bathtub. Yampolsky attended the University of Chicago and received a BA degree in social science in 1944, the year of her father's death. In 1945 she went to Mexico City to study art at La Esmeralda, the National School of Painting, Sculpture and Graphics. She arrived with little command of the Spanish language but soon met Pablo O'Higgins, an American-born protégé of Diego Rivera.[3]

At that time, many of the artists of the Mexican Revolution were still at work. O'Higgins introduced her to Leopoldo Méndez and the Taller de Gráfica Popular (TGP), or People's Graphics Workshop, at Nezahualcóyotl, just outside Mexico City. Founded in 1937 by Méndez, O'Higgins and Luis Arenal, this printshop produced affordable works of political art for the common people. During World War II, TGP artists rushed to the streets of Mexico City to hang their posters and broadsheets while the ink was still wet. At the TGP Yampolsky made friends, including Francisco Mora, Ángel Bracho and Alberto Beltrán, who helped her learn Spanish and encouraged her work as an artist. Her woodcut of the revolutionary leader Emiliano Zapata and his followers was included in *Estampas de la revolución mexicana* (Prints of the Mexican Revolution), a portfolio published by TGP in 1948. Over the following decade she exhibited regularly with the shop, and helped to organize several group exhibitions and international tours of its prints.[4]

Around 1948 Yampolsky began to photograph her TGP colleagues and their political activities, an interest that led her to studies with Lola and Manuel Álvarez Bravo (Cat. no. 35) at the Academy of San Carlos. Her early photographs observed the daily life of rural Mexicans, especially the descendants of native peoples. Yampolsky understood how

the people's lives and land ownership were determined by European colonial tradition, and believed that the situation, along with political corruption, perpetuated poverty. She wished to document this institutionalized destitution across the country, in communities greatly varied by race, history and circumstance. In her travels, she photographed vernacular architecture, buildings of wood, rock, adobe and thatch; she also became interested in the flora of Central America, especially cactus and succulent plants, and photographed them with fascination. In 1960, photographs from her visit to Israel and the Middle East were shown in her first solo exhibition, held at the José María Velasco Gallery in Mexico City.

In 1962, Yampolsky began working for the publishers Fondo Editorial de la Plástica Mexicana. She and her old friend and mentor Leopoldo Méndez traveled through Mexico taking photographs for book illustrations. Her images appear in books on Mexican and European painting, folk arts and the prints of José Guadalupe Posada. Sometimes Yampolsky's creative work overlapped with her activity, but each function was a discipline on its own. Her creative photographs are expressive, poetic images, personal and complex in their meaning. Her editorial photographs, on the other hand, are, by necessity, clear, descriptive and coherent. The artist became well known among friends for exploring with her camera, driving her *vochito*—Volkswagen Beetle—at a snail's pace as she scrutinized the sights.

During the 1970s, Yampolsky also worked for the Ministry of Public Education, editing and organizing the publication of primary- and secondary-school textbooks, especially titles on the humanities and natural science. She supervised publication of the beloved Colibrí Colección (Hummingbird Collection) of children's books, for which she brought

Fig 27. — Mariana Yampolsky, Mexican, born in the United States, 1925–2002, *Mazahuan Women*, 1989, gelatin silver print, Humana Foundation Endowment, 2007.047.002

together important writers, illustrators, painters, designers and photographers. Her much-loved book *Niños* (Children) presents the life of a child in historic paintings, sculpture, prints, drawings and photographs. She published 15 photobooks, especially on the subjects of rural architecture and native horticulture, most produced in collaboration with her friend, the journalist and author Elena Poniatowska. *La raíz y el camino* (The Root and the Road) and *Estancias del olvido* (Visits to Oblivion) present Yampolsky's photographs of country villages and their residents, many the descendants of indigenous Nahua peoples.[5] To mark the sesquicentennial of the invention of photography in 1989, she organized a landmark historical exhibition of Mexican photography for the Museo de Arte Moderno in Mexico City. Four years later *Mazahua*, a show of her photographs of indigenous women, was presented by the Museo Mural Diego Rivera in Mexico City.[6] Yampolsky's editorial repertoire was vast in its breadth and richness. She was prolific in this work, creating photographs to complement the cadence of writing and book design, with little interest in abstraction, optical effects or stylistic trends.

This architectural image of a decorated wall at Santa Rita, Xicotepec, in Puebla State, demonstrates Yampolsky's keen eye for intriguing suggestions of other worlds.[7] Aside from her love for architecture, her identification with indigenous cultures made her sensitive to fable, myth and allegory. When Yampolsky photographed this face carved into the corner of a building, she divided her composition in half, as if plotting the separation between two realms. Within the scalloped crescent of the carving is the face of a Mayan moon goddess, associated throughout Mesoamerica with water, both in the earth or falling from the sky, and also with menstruation, and thus with fertility and growth, sexuality and procreation, of vegetation and crops as well as human beings. The progress of the lunar calendar also linked this deity with new beginnings. So when Yampolsky placed her face at the intersection of two equal quadrants, she made an analogy between the passing of the months, and of lifetimes. She chose a cloudy day to make the photograph, so that the softly mottled sky was similar in texture to the smoothly plastered wall, but quite different in tone. Like Graciela Iturbide and Flor Garduño (Cat. no. 94), Yampolsky was noted for the mystery of her creative images, and her sensibility has been compared to Magical Realism in literature. She had the visual acuity and the knowledge of cultural tradition to recognize the mystery present in everyday life.

A major retrospective of Yampolsky's photographs was mounted in 1998 at the Centro de la Imagen in Mexico City.[8] She wished her photographic archive of more than 70,000 negatives, and that of the Colibrí Colección, to stay in Mexico. When she died in 2002 her husband, Arjeh van der Sluis, created the Fundación Mariana Yampolsky at the home in the Tlalpan borough of Mexico City that she had filled with a remarkable collection of folk art.

SALLY MANN
American, born in 1951

Sempervirens "Stricta"

1995
Gelatin silver print
19.7 × 24.8 cm (7¾ × 9¾ in.) Image
20.4 × 25.3 cm (8 × 10 in.) Sheet

Gift of Dr. William McGraw (ND'65), 2009.047.007

Through a career of photographing in the American South, Sally Mann has always remained close to home, and close to her Southern roots. Sally Munger was born in Lexington, Virginia, where her father was a physician and her mother ran the bookstore at Washington and Lee University.[1] She took up photography as a teenager at boarding school in Vermont. She went on to Bennington College and was a student there in 1970 when she met and married Larry Mann at home in Lexington. Afterwards, Mann continued her study of English at Hollins College in Virginia. She graduated in 1974 and went on to complete an MA degree in creative writing. She also began working as a photographer at Washington and Lee University. There, in the attic of the journalism building, she discovered 7,500 mammoth-plate collodion negatives made by Michael Miley, the Virginia photographer who had portrayed General Robert E. Lee.[2] These images charged her imagination. She documented the construction of Sydney Lewis Hall in the Washington and Lee Law School, and a selection of these photographs comprised her first solo museum exhibition at the Corcoran Gallery of Art in Washington, D.C., in 1977.

After the birth of Mann's first child, Emmett, in 1979, she was fascinated by his developing personality, and considered just how to photograph such progress. In a series of portraits of 12-year-old girls, she strove to capture the complex emotions of early adolescence (Fig. 28). Personal recollections of the experience merged with a mother's perspective in these images of the fraught juncture between childhood and adolescence. The photographs were exhibited in 1984–85 and collected in her photobook *At Twelve: Portraits of Young Women*, which established her as an expressive artist.[3] Mann tried to capture the childhood of her own three children—Emmett and his two younger sisters, Jessie, born in 1981, and Virginia, born in 1985—their innocence and pluck in the secure comfort of family. In the summer, the Manns lived at an isolated farm on the Maury River, and she photographed the children playing and swimming in the river beneath wooded cliffs. All three were young, under 12 years old, and they spent much of their time during the summer swelter in the water, comfortable without clothes, as the photographer had done as a child. Mann did not pose her subjects, but sometimes she asked them to hold still while she exposed a sequence of similar shots. She also kept the camera set up on its tripod in case something interesting should happen. The Mann children helped to select the images that were first exhibited in Chicago in 1990 and then published

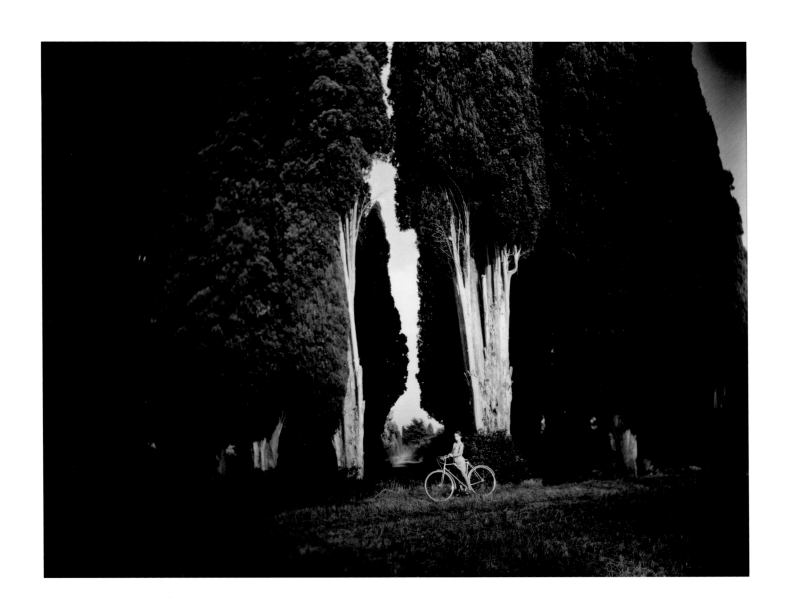

as the photobook *Immediate Family* two years later.[4] Most viewers perceived the photographs as images of childhood innocence, but others were offended by the nudity. Mann and her family were surprised and saddened by these attacks, and sometimes even alarmed by the response. She continued making these photographs for about a decade, completing around 200 pictures, most of which did not feature nude figures.

Sempervirens "Stricta" grew from Mann's *Immediate Family* series, an example of her continued documentation of her children's lives despite the controversy.[5] This photograph associates the children's experience with a sense of place, of the landscapes in which they grew up. The photograph takes its title from its setting amid the columnar "Stricta" variety of evergreen cypress, whose Latin name, *Sempervirens*, means "always flourishing." Rows of these ancient trees define the composition, while Virginia Mann stands in the center with her bicycle. The girl and her bike are thin and swift, while the burly trunks and soaring height of the trees mark their comparative antiquity. Growing in rows, they bring to mind the long-gone people who planted them. By focusing on the figure and the foreground before her, Mann allowed the trees soften into an architectural grandeur comparable to the photographs of Eugène Atget (Cat. no. 20). The warming sunshine highlights a pose from which Virginia could launch her bike and ride off at any moment. We are invited to explore with her, and to consider our own place in history.

Mann's children were discovering their independent personalities by the mid-1990s when she turned her attention to landscape, another aspect of

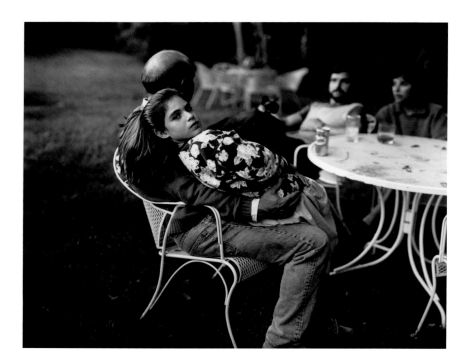

Fig 28. — Sally Mann, American, born in 1951, *Leah and her Father*, 1983–85, from the series *At Twelve*, 1988, gelatin silver print, Estate of Ronald K. Gratz (ND'68), 2018.002.045

personal experience. In fact, *Sempervirens "Stricta"* is a transitional image, in which private experiences give way to long-lived emotional memories. In the South, remnants of past intent and action are common in the landscape. Mann wanted to capture these reverberations of forgotten events, as well as the sultry, humid atmosphere of the place, and its shifting light. The High Museum in Atlanta invited Mann to join the commissioned project *Picturing the South*, and she found new inspiration in Michael Miley's glass-plate negatives that she had discovered 20 years before. Ultimately, she decided to explore Miley's traditional wet-plate collodion technique. France Scully Osterman and her husband Mark introduced Mann to the process, and to modern adaptations of traditional chemistry.[6] Mann had an 8 × 10 inch view camera modified for glass-plate holders, and she contrived a portable darkroom fitted into the back of her GMC Suburban. Many of the photographs in Mann's book *Deep South* were prints from wet-plate collodion negatives.[7] To add to the sense of history generated by the old printing technique, she used damaged lenses and physically flawed the negatives herself. The photographer collected these exposures on a solitary road trip, searching for inspiring locations and extraordinary effects of Southern light and atmosphere. By their subjects and imagery, these photographs evoke 19th-century views of Civil War battlefields, the ruins of antebellum mansions and haunted lynching sites.

After a long effort, Mann obtained permission to work at the University of Tennessee anthropological facility. In this three-acre wood, human cadavers are placed outside so graduate students of forensic science can study their decomposition in different conditions of temperature, humidity and infestation. Perhaps inspired by her physician father, Mann has a sanguine acceptance of the fact of death and its biological implications. Some of these photographs were included in her exhibition *What Remains*, which also included images of a decomposing pet and brooding photographs of the site of the Battle of Antietam, the bloodiest day of the Civil War. A nearby death was also remembered in photographs of the place on the Mann family farm where an escaped fugitive killed himself.[8] The artist expanded her consideration of organic decay and passing time in photographs of her husband over six years, cataloguing the effects of limb/girdle muscular dystrophy upon his body. Something of his vulnerability and struggle is recorded in the photobook *Proud Flesh*.[9] The artist experienced a temporary physical compromise herself after a riding accident in 2006. Confined to the studio for a time, she made a series of self-portraits using the historic ambrotype process. These photographs were first shown in the exhibition *Sally Mann: The Flesh and the Spirit* at the Virginia Museum of Fine Arts, with a catalogue united by the theme of the human body.[10] A self-portrait of a different kind was embodied in Mann's book *Hold Still: A Memoir with Photographs*, published in 2015.[11]

RICHARD MISRACH
American, born in 1949

11.1.98, 6:45 A.M.

1998
Chromogenic print
46.3 × 58.9 cm (18¼ × 23¼ in.) Image
50.7 × 60.8 cm (20 × 24 in.) Sheet

Gift of Dr. William McGraw (ND'65), 2009.047.040

In an era of environmental degradation, Richard Misrach strove to document natural splendor, and to convey messages of alarm over its well-being. During the 1970s he emerged as a pioneer of color photography as a creative medium. Misrach was born and raised in Los Angeles, where his father ran a sporting-goods business.[1] He made his first photographs as a boy with a Kodak Instamatic camera and became serious about the pursuit when he was a student at the University of California, Berkeley. He learned the techniques of photography at the Berkeley studio of the Associated Students of the University of California (ASUC), where he studied briefly with Roger Minick and William Garnett (Cat. no. 63). After graduating in 1971, Misrach joined the ASUC staff. In this era of heightened social consciousness, the young artist made nighttime photographs of the indigents living on the Berkeley streets. In 1973 an Artist's Fellowship from the National Endowment for the Arts (NEA) made it possible for him to exhibit and publish some of these images as a photobook, with which he hoped to raise funds for a homeless food bank.[2] Though the project fell short of his aspirations for aiding the community, Misrach became convinced that photography could support political change. He continued to made nocturnal landscape views in the mid-1970s, illuminating his exposures with strobe lights to produce richly toned gelatin silver prints.

Misrach took his camera into the deserts of Arizona, Southern California, and Baja California in Mexico to make nocturnal color photographs. Human figures are absent from the landscape in this open-ended series of images. In 1979, a second NEA grant and a Guggenheim Foundation Fellowship enabled Misrach to travel to Egypt to photograph ancient architectural ruins in the desert at night. He began to divide this work into an open-ended lyric suite he called *The Desert Cantos*, organizing the images into thematic essays, reminiscent of the cycles of Dante Alighieri or Ezra Pound. His austere, atmospheric landscapes imply the tensions between human activity and the natural world.[3] The artist recognized the similarities between his work and that of such 19th-century American expeditionary photographers as Timothy O'Sullivan and William Henry Jackson. They documented the state of the continent they encountered in the 1870s and the historic effects of human habitation; Misrach intended to do the same a century later. He used a Deardorff view camera to expose 8 × 10 inch color negative film, and often produced large prints. When working in the desert, the artist learned to observe his subject over time, anticipate the effects of light and atmosphere

that he wanted to capture, and then wait and watch all day for the perfect conditions. Independently, he arrived at a method of working similar to Ansel Adams's (Cat. no. 46).

After Misrach was detained for photographing near Marine Corps Air Station Yuma in Arizona, he became aware of the military presence in the deserts of the Southwest. Later he photographed on public land near Fallon, Nevada, sacred to Northern Paiute tribes, known to Navy pilots as "Bravo 20." High-explosive bombs were tested there in the 1950s, leaving vast tracts contaminated by radioactivity, along with the debris of ordinance and matériel. In Misrach set out to juxtapose the natural beauty of the area with the human devastation of the land-scape.[4] Other photographs in the *Desert Cantos* depict the reassertion of nature after irresponsible human incursions like residential sprawl, industrialization and petrochemical manufacturing. In the 1990s he contrasted these disheartening images with photographs of the sky, which serve as both docu-mentation and metaphor.[5]

In 1997 Misrach moved with his family to a home in the Berkeley hills with a view of the Golden Gate, 7 miles (11 km) away. On the front porch he marked a place where he could set up his camera to photograph the changing effects of light, weather and atmos-phere over the bay. He shot images from the same position at different times of day, throughout the year. Misrach made this exposure as the sun rose on November 1, 1998, and a bank of clouds moved across San Francisco Bay.[6] The initial impression of this photograph is one of luminous color. Its saturated, softly modulated veils of blue and gray are remi-niscent of a painting by Mark Rothko. However, in the shining band at the bottom of the image we recognize a distant landscape, and realize that it is a colored cloud bank that occupies most of the image. In the background we can see the Golden Gate, with the bridge spanning from Fort Point to the Marin Headlands. In the middle distance Alcatraz Island is visible on the left, and Angel Island on the right. Between them, the morning sun reflects off the shifting waters of San Francisco Bay, as the coastal atmosphere responds to the rising temperature and shifting light of the morning sun. Change is Misrach's theme in this and his other Golden Gate landscapes, signaled, with elegant restraint, by the date and time that title the photograph. The majesty of nature is his subject, and he entreats us to notice its beauty, covet it and conserve it. Misrach produced over 700 photographs from this viewpoint, from which 85 were selected for the book *Golden Gate*.[7]

In 1998, the High Museum of Art in Atlanta commissioned Misrach to photograph along the Mississippi River between Baton Rouge and New Orleans. This area of rich cultural history during the 18th and 19th centuries was eventually overtaken by the Industrial Revolution, and more than a hundred industrial plants and refineries introduced petro-chemical pollution to the environment.[8] In January 2002, Misrach began to photograph a Hawaiian beach, looking down on beachgoers from atop a tall building. Over three years he returned period-ically to photograph from the same spot, to create the series *On the Beach*.[9] The title of this project came from a 1950s science fiction novel and movie, which told the story of carefree visitors to a secluded beach who discover that they are the only survivors of a nuclear disaster. Misrach's referencing of this alarm-ing scenario, which may have been influenced by the World Trade Center attacks of September 11, 2001,

contradicts the splendor and repose of the images.[10] Misrach began to investigate digital photography at about this time, and when he returned to the same location in 2011, he used a digital camera and telephoto lens to capture the scene, creating faster, more detailed images that could be printed at mural scale. At the same time, he created a series of small-scale color prints taken with an iPhone camera. In 2016, Misrach published *Border Cantos*, a selection of images taken along the Mexico-United States border over 12 years. This photobook reflected the artist's collaboration with sculptor and musician Guillermo Galindo. Using discarded objects that the two artists collected from the border zone, Galindo created sculptures that function as musical instruments, with which he performed his own lyrical compositions.[11]

ABELARDO MORELL

American, born in Cuba in 1948

Camera Obscura Image of Umbrian Landscape over Bed

2000
Gelatin silver print
57.2 × 46.1 cm (22½ × 18⅛ in.) Image
60.9 × 51 cm (24 × 20⅛ in.) Sheet

Gift of Milly Kaeser, in Memory of Fritz Kaeser, 2001.063

Late in the 20th century, when digital technology had begun to change photography, many serious artists looked back to the history of the medium. A revival of early techniques included works in daguerreotype, calotype, and wet-plate collodion negative. Some photographers made their own pinhole cameras and cameras obscura. The "dark room" or camera obscura is a closed chamber with a tiny hole in one wall. When light passes through the aperture it casts an inverted "latent image" of the scene outside on the opposite wall inside.[1] Ancient philosophers and scientists described this phenomenon. Aristotle observed the precise, round image of the sun projected through the tiny holes of a wicker basket. In the fifth century B.C.E., the Han Chinese scholar Mozi wrote of a "treasure house," pierced by a pinhole or "collecting-point" from which rays of light formed an upside-down image. During the Medieval period, Arabic and European astronomers used cameras obscura to observe the solar eclipse and to conduct optical experiments. Leonardo da Vinci understood that the camera obscura functions just like an eye; his Renaissance-era notebooks contain hundreds of drawings of the apparatus and its inverted projections. In the 16th century, scientists placed a lens into the opening to focus and clarify the projected image. Artists replaced the back of the box with a sheet of oiled paper—and later with ground glass—on which the outlines of the scene could be traced. A mirror was then mounted inside the chamber to correct the transposed image on the tracing screen.

Johannes Kepler was first to use the term *camera obscura* in 1604, and many European artists used the device during the 17th century. Jan Vermeer's paintings reproduce the blurred focus and optical distortions of the device. Jean-François Nicéron, a French Minim friar, mathematician and painter, wrote of its utility for capturing convincing perspective and decried magicians who used the apparatus to produce occult apparitions for the gullible. The camera obscura became a drawing-room amusement for the wealthy in the 18th century, and portable tents were invented with a kind of periscope on the top to project an image of the surroundings down onto a tabletop. Sir Joshua Reynolds had a small camera obscura disguised as a book. Half a century later, Joseph Nicéphore Niépce, Louis Daguerre and William Henry Fox Talbot adapted cameras of this kind to create the first photographs.

In the 1990s, Abelardo Morell employed cameras obscura his teaching and in his creative work. The son of an officer in the Cuban Navy, he was born in Havana and spent his early childhood in the small

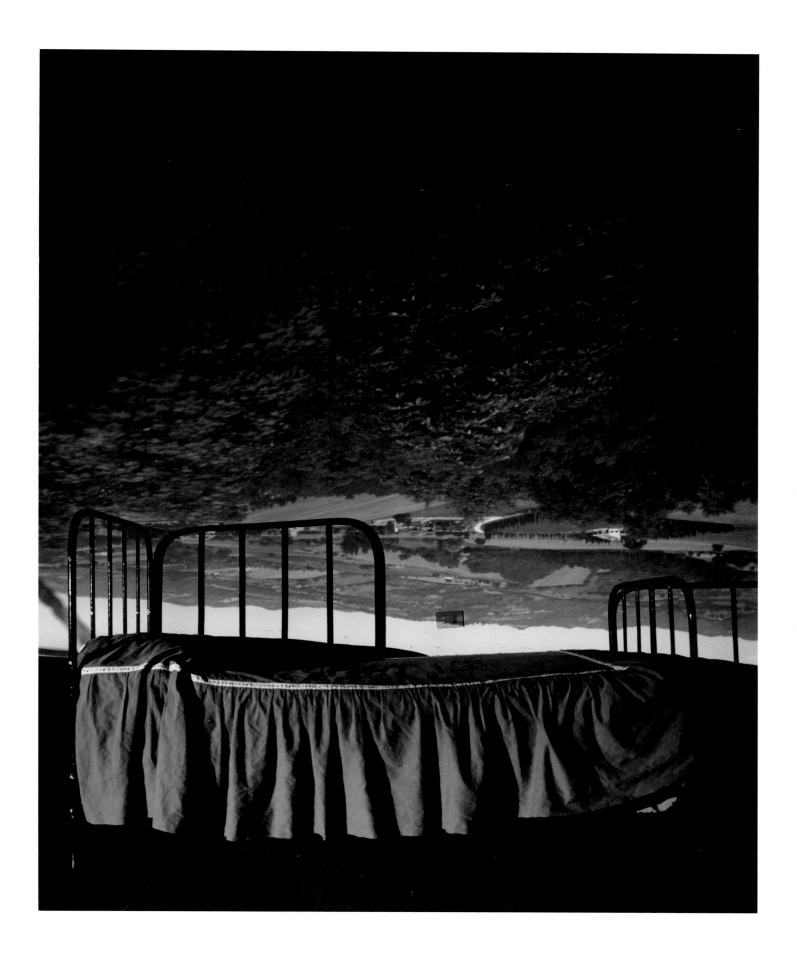

coastal town of Guanabo.[2] His family immigrated to the United States in 1962, eventually they settled in New York City. Morell's father became the superintendent of five apartment buildings on the Upper West Side, and soon his son got an after-school job as a drugstore delivery boy. His earnings enabled him to buy a Brownie camera, and he began to photograph around the city. In 1967 Morell enrolled at Bowdoin College in Maine, planning to study physics. Soon he shifted to art, concentrating on photography. He took a break from college to work and exhibit in New York, and graduated from Bowdoin in 1977. As a graduate student at Yale University, he worked in street photography, inspired by the work of Robert Frank and Diane Arbus (Cat. nos. 70, 75).

Morell completed his MFA degree in 1981, and two years later he joined the faculty of the Massachusetts College of Art (MassArt) in Boston. He married and began a family, and found that fatherhood affected his work. He photographed domestic life from the viewpoint of a child, turning his camera on interior spaces and shooting familiar objects from a level near the floor. His rhythm of working slowed, and he began using a medium-format 4 × 5 inch view camera. This reconsideration also affected Morell's teaching. He returned to basics, constructing an elementary camera from a large cardboard box. He attached a lens to one end with duct tape, and left one side of the box open. He placed an electrified lightbulb before the lens so that its inverted mirror image appeared clearly inside. Students who had always taken the camera for granted suddenly understood how it functioned.[3] Next, Morell blocked all the windows of his classroom with black plastic. He gathered the class in the darkened room, and punched a hole through the plastic. The street

outside appeared across the walls and over the ceiling, and the students realized that they were inside a camera obscura.

Morell was on sabbatical when he first decided to photograph inside a monumental camera obscura. He experimented with different rooms at his home in Quincy, Massachusetts, sharing each with his wife and son. "I remember lying in bed with them," he later recalled "watching neighbors going to work, and squirrels walking on the telephone poles."[4] Morell experimented with apertures and exposure times. He found that a ⅜ inch opening in the black-out plastic created an interior projection that could be photographed, with an exposure of six to eight hours. Morell began to travel, setting up his cameras obscura in different locations and making photographs inside them. In New York, he made images in hotel rooms of the skyscrapers that had astounded him as an immigrant teenager. He traveled to Europe and captured sites like the Uffizi in Florence and the Eiffel Tower in Paris, projected across hotel room walls.[5] This began an ongoing open-ended series of camera obscura images that contrast recognizable locations with the comparatively mundane daily lives reflected in nearby interiors.

In 1993, with the support of a Guggenheim Foundation Fellowship, Morell explored the materiality of paper and printed text. He explored collections at the Boston Public Library and the Boston Athenaeum, where he was artist-in-residence in 1995.[6] Some of these photographs were included, along with images of his home and son and camera obscura interiors, in the first monograph on his work, *A Camera in a Room.*[7] In 1996 the children's book historian and critic Leonard S. Marcus invited Morell to provide illustrations for a new edition of *Alice's*

Adventures in Wonderland. The artist combined his book still lifes with figures from John Tenniel's original illustrations of 1865, enlarged to life-size cut-outs, posed with books, teapots and other objects.[8] In 1998 Morell was an artist-in-residence at the Isabella Stewart Gardner Museum, where he explored the paintings of the collection by contrasting them with portraits of museum staff, in double exposures.[9]

In 2000, the year Morell became a United States citizen, he was awarded a fellowship at the Civitella Ranieri Foundation, an artists' community housed in a medieval castle near the Italian town of Umbertide. Philanthropist Ursula Corning began the foundation in 1995, bringing together visual artists, musical composers and writers from around the world. Morell created a series of camera obscura photographs in private homes in the neighborhood looking out onto the Umbrian countryside. In this image from the series, a humble bedroom is transformed by the camera obscura reflection of the scene outside its window.[10] The artist set his camera to photograph the rumpled bed in profile. Light streams into the room from the left, casting the bed frame in shadow and creating a fencelike grid on the wall. In contrast to this modest, prosaic space, a magnificent Umbrian landscape is spread across the wall like a dream vision. Leafy trees in the foreground rustle in the breeze, giving way to farm fields, meadows and gardens bounded by tree-lined fence rows. A river circles through the landscape, as hills roll gently into the distance. The sky seems bright and cloudless, and casts an eerie glow into the room. With strange precision, the hilly horizon crosses over the light switches on the interior wall, as if the whole project might be switched on or off at will.[11]

NOTES

1 — MAURICE LŒWY
AND PIERRE-HENRI PUISEUX

1. On Maurice Lœwy (Vienna, April 15, 1833–October 15, 1907, Paris), see *Popular Astronomy*, vol. 16, January 1908, pp. 1–9.
2. See H. M. Paul, "The Equatorial Coudé," *Science*, August 1, 1884, n.s., vol. 2, pp. 101–2; Stefan Hughes, *Catchers of the Light: The Forgotten Lives of the Men and Women Who First Photographed the Heaven*, Cyprus, ArtDeCiel Publishing, 2012, pp. 381–83.
3. On Pierre-Henri Puiseux (Paris, July 20, 1855–September 28, 1928, Fontenay, Jura), see Auguste Collard, "Un astronome français. Pierre Puiseux (1855–1928)," *Ciel et Terre: Bulletin de la Société Belge d'Astronomie*, vol. 47, 1931, pp. 60–68.
4. Maurice Lœwy and Pierre Puiseux, *Théories nouvelles de l'équatorial coudé et des équatoriaux en général*, Paris, Gauthier-Villars, 1888; Maurice Lœwy and Pierre Puiseux, *Théorie du système optique composé d'une lunette astronomique et d'un double miroir plan: Application à la mesure précise des distances en vue de l'étude de l'aberration et de la refraction*, Paris, Gauthier-Villars, 1891.
5. Ewen A. Whitaker, *Mapping and Naming the Moon: A History of Lunar Cartography and Nomenclature*, Cambridge, Cambridge University Press, 1999, p. 151; Hughes 2012, pp. 137–49.
6. The technician, whose name has come down to us as M. Fillon, created an enlarged positive transparency of each photograph, and transferred the image to a sheet of light-sensitized tissue in ultraviolet light. The tissue was then adhered to a copper printing plate in a cold water bath. The non-hardened gelatin was then washed off the plate by immersion in hot water. After the hardened gelatin had dried on the plate, a liquid hard aquatint ground was applied to each plate. It was then passed through a roller press against coarse sandpaper to create a finely stippled, grainy texture through the ground. Each plate was then etched in ferric chloride baths of decreasing concentration. The aquatint ground and gelatin were washed from the plate, which was then inked and printed by the conventional intaglio process.
7. Maurice Lœwy and Pierre Henri Puiseux, *Atlas photographique de la lune … Héliogravures d'après les clichés et les agrandissements exécutés par M. M. Lœwy et Puiseux assistés de M. le Morvan*, Paris, Observatoire de Paris and Imprimerie Nationale, 1896–1910. Published in 12 fascicles, in paper cover, 75.5 × 60 cm (29¾ × 23⅝ in.), with 71 photogravure plates and printed keys, and 11 title vignettes.
8. In 1935, a lunar crater (27.8 degrees south latitude, 39 degrees west longitude; diameter 24 kilometers) was named for Pierre Puiseux to credit his scientific achievements.

2 — LEWIS WICKES HINE

1. On Lewis Wickes Hine (Oshkosh, Wisconsin, September 26, 1874–November 4, 1940, Dobbs Ferry, New York), see Timothy J. Duerden, *Lewis Hine: Photographer and American Progressive*, Jefferson, North Carolina, McFarland & Company, 2018; Alexander Nemerov, *Soulmaker: The Times of Lewis Hine*, Princeton, Princeton University Press, 2016; Mónica Fuentes Santos and Luis Miguel García Mora, eds., *Lewis Hine: From the Collections of George Eastman House*, exhibition catalogue, New York, Distributed Art Publishers, 2012.
2. See Kate Sampsell Willmann, "Lewis Hine, Ellis Island, and Pragmatism: Photographs as Lived Experience," *The Journal of the Gilded Age and Progressive Era*, vol. 7, April 2008, pp. 221–22; Michael Torosian, ed., *Lewis Hine, Ellis Island: Memories & Meditations of Walter Rosenblum on the Life and Work of an American Artist*, Toronto, Lumiere Press, 1995.
3. Survey Associates, *The Pittsburgh Survey: Finding in Six Volumes*, 6 vols., New York, Russell Sage Foundation, 1911. The format and illustrations of this report made it a model for future studies of its kind.
4. See Verna Posever Curtis and Stanley Mallach, *Photography and Reform: Lewis Hine and the National Child Labor Committee*, Milwaukee, Wisconsin, Milwaukee Art Museum, 1981.
5. See Russell Freedman, *Kids at Work: Lewis Hine and the Crusade against Child Labor*, New York, Clarion Books, 1994.
6. Daile Kaplan, *Lewis Hine in Europe: The Lost Photographs*, New York, Abbeville Press, 1988.
7. Lewis Hine, *Men at Work: Photographic Studies of Modern Men and Machines*, New York, Macmillan Company, 1932.

3 — ROBERT DEMACHY

1. For biographical information on Robert Demachy (Saint-Germain-en-Laye, July 7, 1859–December 29, 1936, Hennequeville, Trouville-sur-Mer), see Kristina Lowis, Bruno Foucart, and Sylvie Aubenas, *Robert Demachy et l'esthétique de son temps*, 2 vols., Paris, K. Lowis, 1999; Bill Jay, ed., *Robert Demachy: Photographs and Essays*, London, Academy Editions, 1974.
2. Raymond Dartevelle, *La banque Seillière-Demachy: Une dynastie familiale au centre du négoce, de la finance et des arts, 1798–1998*, exhibition catalogue, Paris, Musée de l'Armée, Perrin, Fondation pour l'Histoire de la Haute Banque, 1999. The Banque Demachy still exists today but is no longer connected to the original family. The family mansion at 13 rue François Premier was for many years the Paris headquarters of Christian Dior.
3. On Photo-Club de Paris, see Marion Perceval, in John Hannavy, *Encyclopedia of Nineteenth-Century Photography*, New York, Routledge, Taylor & Francis Group, 2007, pp. 1072–74.
4. Their son Robert-Charles was born in 1894 and his younger brother Jacques-François four years later.
5. A. Rouillé-Ladevèze, *Sépia-photo et sanguine-photo*, Paris, Gauthier-Villars et fils, 1894.
6. Alfred Maskell and Robert Demachy, *Photo-Aquatint, or the Gum-Bichromate Process*, London, Hazell, Watson & Viney, 1897 (French edition, Paris, Gauthier-Villars et fils, 1898).
7. Robert Demachy, "On the Straight Print," *Camera Work*, no. 19, January 1907, pp. 21–24.
8. Robert Demachy and Constant Puyo, *Les procédés d'art en photographie*, Paris, Photo-Club de Paris, 1906 (reprint, New York, Arno, 1979).
9. Robert Demachy, *View of the Grain Mill de Eendracht, Gouwsluis, Alphen aan de Rijn*, 1907–14, gum bichromate print, 23 × 16.3 cm (9 × 6⅜ in.) image, 28.8 × 22.8 cm (11⅜ × 9 in.) sheet, Amsterdam, Rijksmuseum, Paul Huf Fonds/Rijksmuseum Fonds, RP-F-2002-100.

4 — EDWARD STEICHEN

1. On Éduard Jean Steichen (Bivange, Luxembourg, March 27, 1879–March 25, 1973, West Redding, Connecticut), see Todd Brandow and William A. Ewing, *Edward Steichen: Lives in Photography*, New York, W. W. Norton, 2008; Penelope Niven, *Steichen: A Biography*, New York, Clarkson Potter, 1997; Edward Steichen, *A Life in Photography*, Garden City, New York, Doubleday, 1963.
2. Anne Cohen DePietro, *The Paintings of Eduard Steichen*, exhibition catalogue, Huntington, New York, Heckscher Museum, 1985; Mary Anne Goley and Barbara Ann Boese Wolanin, *From Tonalism to Modernism: The Paintings of Eduard J. Steichen*, exhibition catalogue, Washington, D.C., Board of Governors of the Federal Reserve System, 1988.
3. Quoted in DePietro 1985, p. 17.
4. See Jay Bochner, *An American Lens: Scenes from Alfred Stieglitz's New York Secession*, Cambridge, Massachusetts, MIT Press, 2005; William Innes Homer, *Stieglitz and the Photo-Secession*, ed. Catherine Johnson, New York, Viking Studio, 2002.
5. The English-born critic Charles Caffin wrote in an accessible vernacular style for several New York journals including *Camera Work*. He had championed Steichen's work in his

book *Photography as a Fine Art: The Achievements and Possibilities of Photographic Art in America* (New York, Doubleday, Page & Company, 1901).

6. See Dennis Longwell, *Steichen: The Master Prints 1895–1914, The Symbolist Period*, New York, Museum of Modern Art, 1978, p. 94.

7. There are only three original prints from the negative, each treated differently in tone, in atmosphere and in detail. Steichen gave one of these three original prints to Stieglitz, who donated it to the Metropolitan Museum of Art in 1933 (33.43.40). The photographer kept one, which he gave to the Museum of Modern Art in 1964 (364.1964).

8. *"Road into the Valley — Moonrise," Camera Work*, Steichen Supplement, no. 14, April 1906; and *"Pastoral — Moonlight," Camera Work*, no. 19, July 1907.

9. See Christopher Phillips, *Steichen at War*, New York, H. N. Abrams, 1981; Von Hardesty, *Camera Aloft: Edward Steichen in the Great War*, New York, Cambridge University Press, 2015.

10. See William A. Ewing and Todd Brandow et al., *Edward Steichen: In High Fashion, the Condé Nast Years, 1923–1937*, Minneapolis, Foundation for the Exhibition of Photography, 2008.

11. See Edward Steichen, *The Blue Ghost: A Photographic Log and Personal Narrative of the Aircraft Carrier U.S.S. Lexington in Combat Operation*, New York, Harcourt, Brace, 1947; see also Mark D. Faram, *Faces of War: The Untold Story of Edward Steichen's WWII Photographers*, New York, Berkley Caliber, 2009.

12. Edward Steichen, *The Family of Man*, prologue by Carl Sandburg, 30th anniversary edition, exhibition catalogue, New York, Museum of Modern Art, 1983. Circulated around the world by the U.S. Information Agency, the exhibition was seen by almost nine million people in 37 countries; see Eric J. Sandeen, *Picturing an Exhibition: The Family of Man and 1950s America*, Albuquerque, University of New Mexico Press, 1995.

5 — GERTRUDE KÄSEBIER

1. On Gertrude Käsebier (Fort Des Moines, Iowa, May 18, 1852–October 13, 1934, New York), see Barbara L. Michaels, *Gertrude Käsebier: The Photographer and Her Photographs*, New York, Abrams, 1992; William Homer, *A Pictorial Heritage: The Photographs of Gertrude Käsebier*, exhibition catalogue, Wilmington, Delaware Art Museum, 1979.

2. Gertrude Kasebier, "Studies in Photography," *The Photographic Times*, vol. 30, June 1898, p. 269.

3. Arthur Wesley Dow, "Mrs. Gertrude Kasebier's Portrait Photographs from a Painter's Point of View," *Camera Notes*, no. 3, July 1899, pp. 22–23.

4. *Camera Notes*, no. 3, July 1899.

5. Charles H. Caffin, "Photography as a Fine Art: III, Mrs. Gertrude Käsebier and the Artistic-Commercial Portrait," *Everybody's Magazine*, vol. 4, May 1901, pp. 480–95.

6. J. P. Mowbray, *The Making of a Country Home*, New York, Doubleday, Page & Co., 1901. J. P. Mowbray was the pen name of the collaborative writing partnership of Andrew Carpenter Wheeler and his wife, Jennie Pearl Mowbray (Wheeler); they published four popular novels together.

7. See Mary Fanton Roberts [Giles Edgerton], "Photography as an Emotional Art: A Study of the Work of Gertrude Käsebier," *Craftsman*, vol. 12, April 1907, pp. 91–92.

8. Suggested by Barbara Michaels, *Family: Photographs by Gertrude Kasebier*, exhibition catalogue, Winchester, Massachusetts, Lee Gallery/San Francisco, Paul M. Hertzmann, 2007, p. 6; see also Michaels 1992, pp. 17–18, 82.

9. Kenneth Grahame, *The Golden Age*, London, The Bodley Head/Chicago, Stone & Kimball, 1895.

6 — GEORGE H. SEELEY

1. On George Henry Seeley (Stockbridge, Massachusetts, January 1880–December 21, 1955, Stockbridge, Massachusetts), see George Dimock and Joanne Hardy, *Intimations & Imaginings: The Photographs of George H. Seeley*, exhibition catalogue, Pittsfield, Massachusetts, Berkshire Museum, 1986.

2. Charles Edwards Butler (1818–1897) headed the prestigious Wall Street law firm Butler, Evarts, Southmayd and Choate, and other firms until his retirement from the practice of law in 1882 (*A History of Real Estate, Building and Architecture in New York City during the Last Quarter of the Century*, New York, Real Estate Record Association, 1898, pp. 247–48). He is remembered for having added to Linwood by purchasing the contiguous acreage of the Oxbow Farm from the poet Henry Wadsworth Longfellow in 1867 (see Andrew Hilen, ed., *The Letters of Henry Wadsworth Longfellow*, vol. 5, Cambridge, Belknap Press of Harvard University Press, 1982, p. 172).

3. On F. Holland Day (1864–1933), see Patricia J. Fanning, *Through an Uncommon Lens: The Life and Photography of F. Holland Day*, Amherst, University of Massachusetts Press, 2008.

4. Clausen Art Galleries, *The First American Photographic Salon*, exhibition catalogue, New York, December 5–17, 1904.

5. In a letter from Coburn to Seeley, December 6, 1905, now in the George H. Seeley Papers and Photographs, Beinecke Rare Book Library, Yale University, New Haven, YCAL MSS 459.

6. In a letter dated December 27, 1904, quoted by Weston J. Naef, *The Collection of Alfred Stieglitz: Fifty Pioneers of Modern Photography*, New York, Metropolitan Museum of Art, 1978, p. 431.

7. In a letter from Stieglitz to Seeley, March 4, 1906, now in the George H. Seeley Papers and Photographs, Beinecke Rare Book Library, Yale University, New Haven, YCAL MSS 459.

8. In a letter from Seeley to Stieglitz, April 17, 1908, now in the George H. Seeley Papers and

Photographs, Beinecke Rare Book Library, Yale University, New Haven, YCAL MSS 459.

9. In a letter from Stieglitz to Kühn, March 1, 1909, now in the George H. Seeley Papers and Photographs, Beinecke Rare Book Library, Yale University, New Haven, YCAL MSS 459.

10. Buffalo Fine Arts Academy, *International Exhibition of Pictorial Photography*, Albright Art Gallery, Buffalo, November 3–December 1, 1910, pp. 29–30, nos. 359–81.

7 — ALFRED STIEGLITZ

1. On Alfred Stieglitz (Hoboken, New Jersey, January 1, 1864–July 13, 1946, New York), see Katherine Hoffman, *Alfred Stieglitz: A Legacy of Light*, New Haven, Yale University Press, 2011; Richard Whelan, *Alfred Stieglitz: A Biography*, Boston, Little, Brown & Company, 1995.

2. *Camera Work*, no. 3, supplement, July 1903.

3. See Jonathan Green, ed., *Camera Work: A Critical Anthology*, New York, Aperture, 1973.

4. Alfred Stieglitz, "How 'The Steerage' Happened," *Twice a Year*, vols. 8–9, 1942, pp. 175–78.

5. See James Terry, "The Problem of 'The Steerage,'" *History of Photography*, vol. 6, July 1988, pp. 211–15; see also Jason Francisco and Elizabeth Anne McCauley, *"The Steerage" and Alfred Stieglitz*, Berkeley, University of California Press, 2012.

6. *Saturday Evening Mail*, April 20, 1912.

7. See Alfred Stieglitz, "291 – A New Publication," *Camera Work*, no.48, October 1916, p. 26; Sarah Greenough, *Alfred Stieglitz: The Key Set*, Washington, D.C., National Gallery of Art, 2002, vol.1, no.313.

8. See Benita Eisler, *O'Keeffe and Stieglitz: An American Romance*, New York, Doubleday, 1991; Drohojowska-Philp, Hunter. *Full Bloom : The Art and Life of Georgia O'Keeffe*. 1st ed. New York: W.W. Norton, 2004.

8 — CLARENCE H. WHITE

1. On Clarence Hudson White (West Carlisle, Newark, Ohio, April 8, 1871–July 7, 1925, Mexico City), see Anne McCauley, *Clarence H. White and his World: The Art & Craft of Photography, 1895–1925*, New Haven, Yale University Press, 2017.

2. On F. Holland Day (1864–1933), see Patricia J. Fanning, *Through an Uncommon Lens: The Life and Photography of F. Holland Day*, Amherst, University of Massachusetts Press, 2008; Pam Roberts et al., *F. Holland Day*, Amsterdam, Van Gogh Museum, 2000; Verna Posever Curtis and Jane Van Nimmen, eds., *F. Holland Day: Selected Texts and Bibliography*, New York, G. K. Hall, 1995.

3. See Arthur Wesley Dow, *Composition*, Boston, 1899; Otto Walter Beck, *Art Principles in Portrait Photography*, New York, Baker & Taylor Company, 1907.

4. Day became a close, supportive and lasting friend to the whole White family. Years later he paid for Maynard White to study at Brown University.

5. *Camera Work*, no. 23, July 1908.

6. Noted by McCauley 2017, p. 64. Paul Burty Haviland (1880–1950) was the son of Charles Edward Haviland, owner of Haviland & Co., a china manufacturer in Limoges. His mother was the daughter of art critic Philippe Burty. After graduating from the University of Paris, Haviland attended graduate school at Harvard. Afterward he became the representative of the family china firm in New York. In 1908 Haviland met Alfred Stieglitz and became interested in photography. He became a private pupil of Clarence White, and soon Stieglitz persuaded him to help support the Little Galleries of the Photo-Secession financially. In 1909, Haviland began writing regular columns for *Camera Work*, his photographs began to appear in the magazine, and in 1910 he was named associate editor. He also functioned as secretary of the gallery and helped organize many of the shows of French artists. In 1916 Haviland returned to France. The following year he married Suzanne Lalique, daughter of the glass designer René Lalique. When his father died in 1922, he concentrated on the family business. In 1925, Haviland and his wife purchased a 17th-century priory in Yzeures-sur-Creuse with vineyards and a winery.

7. Several of Haviland's early photographs of Florence Peterson are in the Haviland family archive in the Musée d'Orsay in Paris. Karl Struss (Cat. no. 10), another of White's students at that time, also photographed Peterson in this studio, which Struss later took over; see McCauley 2017, p. 221.

8. The present print is laid down onto a mount of cream mulberry-fiber paper and bears the artist's signature in graphite, under the print at lower right. The Japan paper mount is tipped onto a larger sheet of clay-coated paperboard, perhaps an album leaf.

9. Examples include Titian's *Perseus and Andromeda*, 1556, now in the Wallace Collection in London; Rubens's *Perseus Freeing Andromeda*, 1639, at the Prado in Madrid; and Ingres's *Roger and Angelica*, 1819, now in the Louvre. It is also reminiscent in subject and mood of *The Bat*, Gertrude Käsebier's photograph of Jane White from August 1902, in which the figure stands in a darkened glade, lifting her arms to spread black, mantle-like wings.

10. Years later, when the restoration was nearly complete, White wrote an account of the acquisition, move and restoration of the house ("The House that Moved to the Sea," *Woman's Home Companion*, July 1924), presumably to attract potential guests.

11. See McCauley 2017; Bonnie Yochelson and Kathleen A. Erwin, *Pictorialism into Modernism: The Clarence H. White School of Photography*, New York, 1996.

12. In 1925 White was traveling in Mexico with a group of students when he died from a sudden heart attack. Jane Felix White persevered, serving as the school's director for 15 years, though she was not a photographer. In 1940 the school moved to larger quarters on West 74th Street, but the mobilization for World War II absorbed its students and it was finally forced to close in 1942.

9 — ALVIN LANGDON COBURN

1. On Alvin Langdon Coburn (Boston, June 11, 1882–November 23, 1966, Rhos-on-Sea, Wales) see Pamela Glasson Roberts, Anne Cartier-Bresson, et al., *Alvin Langdon Coburn*, exhibition catalogue, Madrid, Fundación Mapfre, 2015; Helmut Gernsheim and Alison Gernsheim, eds., *Alvin Langdon Coburn Photographer, an Autobiography*, New York, Praeger, 1966. Coburn's autobiography and the papers he bequeathed to George Eastman House contain significant information about the photographer's working method and provide an insight of the evolution of his experimenting with materials and techniques over the years.

2. On F. Holland Day, see Pamela Glasson Roberts et al., *F. Holland Day*, exhibition catalogue, Boston, Museum of Fine Arts, 2000.

3. *Camera Work*, no. 6, April 1904.

4. On James Craig Annan and photogravure, see William Buchanan, ed., *J. Craig Annan: Selected Texts and Bibliography*, Oxford, Clio Press, 1994.

5. Alvin Langdon Coburn, *London*, foreword by Hillaire Belloc, London, Duckworth & Brentano, 1909.

6. Alvin Langdon Coburn, *New York*, foreword by H. G. Wells, London, Duckworth & Co., 1911.

7. Alvin Langdon Coburn, *Men of Mark*, London, Duckworth & Co., 1913; Alvin Langdon Coburn, *More Men of Mark*, London, Duckworth & Co., 1913.

8. See Mark Antliff and Scott W. Klein, *Vorticism: New Perspectives*, Oxford, Oxford University Press, 2013.

9. Vivien Greene, "Alvin Langdon Coburn and the Vortographs," in *The Vorticists: Manifesto for a Modern World*, ed. Mark Antliff and Vivien Greene, exhibition catalogue, London, Tate Publishing, 2010, pp. 85–91.

10 — KARL STRUSS

1. On Karl Fischer Struss (New York, November 30, 1886–December 15, 1981, Santa Monica), see Susan and John Harvith, *Karl Struss: Man with a Camera, The Artist-Photographer in New York and Hollywood*, exhibition catalogue, Bloomfield Hills, Michigan, Cranbrook Academy of Art, 1976; Barbara McCandless and Bonnie Yochelson et al., *New York to Hollywood: The Photography of Karl Struss*, exhibition catalogue, Fort Worth, Texas, Amon Carter Museum, 1995. The Amon Carter Museum holds the Karl Struss Collection of photographs, negatives, and miscellaneous papers and equipment, acquired from the artist's estate.

2. Henry Struss, the photographer's father, designed and built his house a block from the stables of the New York Riding Club, to which he was devoted. The economic depression of 1892 forced Struss's silk mill into bankruptcy. He worked hard to recover his financial stability, and in 1896 he bought back his personally designed house near the Riding Club. An accomplished mechanical engineer, Henry Struss also built and patented the first gasoline-powered automobile in New York City, and he helped edit the first automobile magazine, *Horseless Age*.

3. Arthur Wesley Dow, *Composition*, Boston, J. M. Bowles, 1899.

4. Negatives in the Amon Carter Museum collection show Karl with Hilda, one older woman approximately Hilda's age, and a younger girl who may be Willa P. Collison. For Christmas 1910, Struss constructed an album of Nova Scotia views for Collison.

5. McCandless and Yochelson et al. 1995, p. 94.

6. Eight of Struss's photographs were reproduced in *Camera Work*, no. 38, April 1912.

7. In 1913 Struss helped to found the magazine *Platinum Print: A Journal of Personal Expression*, along with Paul Anderson, Alvin Langdon Coburn, Edward Dickson and Clarence White. The editors hoped to attract readers who felt abandoned or slighted by the new editorial focus of *Camera Work*, which concentrated more on modernist painting and sculpture.

8. Struss received his next Academy Award nomination in 1934 for his work on *Dr. Jekyll and Mr. Hyde*, then again in 1942 for *The Sign of the Cross* and for *Aloma of the South Seas*. Struss was a pioneer of "stereo cinematography" in 1949, when he worked in Italy on some of the first 3-D films, though they were never released in the United States. Struss used infrared filters for the transformation scenes of *Dr. Jekyll and Mr. Hyde* in 1931. One of the photographer's last films was *The Fly* with its famous "fly's-eye view" shot of Susan Morrow.

11 — JACQUES-HENRI LARTIGUE

1. On Jacques-Henri-Charles-Auguste Lartigue (Courbevoie, June 13, 1894–September 12, 1986, Nice), see Kevin D. Moore, *Jacques Henri Lartigue: The Invention of an Artist*, Princeton, Princeton University Press, 2004; Martine D'Astier, Quentin Bajac, and Alain Sayag, eds., *Lartigue: Album of a Century*, New York, Harry N. Abrams, 2003;

Jacques-Henri Lartigue, *Mémoires sans mémoire*, Paris, R. Laffont, 1975.

2. Richard Avedon, ed., *Jacques-Henri Lartigue: Diary of a Century*, trans. Carla van Splunteren, New York, Viking Press, 1970.

3. For surveys of the style, see Lawrence Rainey, Christine Poggi, and Laura Wittman, eds., *Futurism: An Anthology*, New Haven, Yale University Press, 2009; Geert Buelens, Harald Hendrix, and Monica Jansen, eds., *The History of Futurism: The Precursors, Protagonists, and Legacies*, Lanham, Maryland, Lexington Books, 2012.

4. This identification is confirmed by a portrait of Croquet with his mechanic Didier in his Th. Schneider racing car at Amiens on July 12, 1913, by the press agency Agence Rol, a photograph now in the Bibliothèque de France, No. FRBNF40481498.

5. The present enlarged print was produced before 1986. Inscribed in black felt-tip pen in the margin on the recto, lower right: J.H. LARTIGUE; embossed with a blind stamp in the margin, lower left: J.H.L. (in signature facsimile).

6. In 2000–2001, Renée Perle's (1904–1977) descendants put 340 of Lartigue's prints to auction at Tajan in Paris; see Tajan, *Renée Perle, "Renée, un instant de ma vie" par Jacques-Henry Lartigue, 1930–1932*, exhibition/auction catalogue, Paris, December 21, 2000.

7. John Szarkowski, *The Photographs of Jacques Henri Lartigue*, exhibition catalogue, New York, Museum of Modern Art, 1963.

8. In 1979, Lartigue donated his entire photographic work to the French state, including 130 of his original albums, and some 100,000 prints, negatives and transparencies.

12 — UNIDENTIFIED PHOTOGRAPHER

1. See Mark Holborn and Hilary Roberts, eds., *The Great War: A Photographic Narrative*, London, Imperial War Museum, 2013; Jane Carmichael, *First World War Photographers*, New York, Routledge, 1990.

2. See Terrence Finnegan, *Shooting the Front: Allied Aerial Reconnaissance in the First World War*, Stroud, Gloucestershire, Spellmount, 2011.

3. See Ludger Derenthal and Stephanie Klamm, *Fotografie im Ersten Weltkrieg*, exhibition catalogue, Berlin, Museum für Fotografie, Staatliche Museen zu Berlin, 2014.

4. On James H. Hare (1856–1946), see Lewis L. Gould and Richard Greffe, *Photojournalist: The Career of Jimmy Hare*, Austin, University of Texas Press, 1977.

5. On Donald C. Thompson (1885–1947), see James W. Castellan, Ron van Dopperen, and Cooper C. Graham, eds., *American Cinematographers in the Great War, 1914–1918*, Bloomington, Indiana University Press, 2014, pp. 71–77. Thompson worked in Belgium and France in 1914–15. Late in 1916, *Leslie's Weekly* magazine sent him and reporter Florence Harper to cover the Eastern Front. Arriving in Petrograd in early 1917, they found themselves in the midst of the February Revolution. Thompson documented his experiences in still photographs and film, and wrote several books, including *From Czar to Kaiser: The Betrayal of Russia* (Garden City, New York, Doubleday, Page & Co., 1918).

6. On Ernest Brooks (1876–1957), see Carmichael, *First World War Photographers*, pp. 63–64.

7. See Hélène Guillot, *Les soldats de la mémoire: La Section photographique de l'armée, 1915–1919*, Nanterre, Presses Universitaires de Paris Nanterre, 2017.

8. On the Battle of Passchendaele, see Peter H. Liddle, ed., *Passchendaele in Perspective: The Third Battle of Ypres*, London, Leo Cooper, 1997.

9. See E. John Solano, *Field Entrenchments: Spadework for Riflemen, Hasty Fire-Cover, Fire-Trenches, Communications, Concealment, Obstruction, Shelters*, 2nd ed., London, J. Murray, 1915; John Ellis, *Eye-Deep in Hell*, London, Croom Helm, 1976.

10. A larger, untrimmed print from this negative in the Imperial War Museum in London, *Battle of Menin Road* (Cat. no. Q 11681), shows South African Scottish troops waiting in a support trench east of Fresenberg Ridge on September 22, 1917. The photograph is attributed to Northey, who may have been Captain William Brooks Northey (b. 1884). He was wounded in Mesopotamia on March 25, 1917, and seems later to have served in Europe. After the war, he obtained the rank of colonel over 20 years with the Ghurka Rifles in Nepal. See Major William Brook Northey and Captain C. J. Morris, *The Gurkhas: Their Manners, Customs and Country*, foreword by Brigadier-General the Hon. C. G. Bruce, illustrations from photographs by the author, London, John Lane, 1928.

11. Printed in 1920 or later and mounted on gray paperboard. Legend printed in letterpress on the recto: Keystone View Company / Copyrighted, Underwood & Underwood / *Manufacturers* MADE IN U.S.A. *Publishers* / 426 / Meadville, Pa., New York, N.Y. / Chicago, Ill., London, England. / V18862 Steelhelmeted Scots in the World War En- / trenched and Awaiting a Counterattack, France. Printed in letterpress on the verso: 426–(V18862) / STEEL-HELMETED SCOTS IN THE WORLD WAR, ENTRENCHED / AND AWAITING A COUN- / TERATTACK, FRANCE [sic].

12. Brothers Elmer and Bert Elias Underwood founded the stereograph company in Ottawa, Kansas, in 1881 and moved to New York a decade later. They became the largest stereograph producer, publishing as many as 40,000 titles. The company transitioned to news photography in 1910, reducing stereograph production. However, this activity increased again in the early years of World War I. During the 1910s Underwood & Underwood packaged its stereographs and lantern slides in series, marketed to educators. In 1920 the company sold its stereographic stock and rights to the Keystone View Company, which continued to print and publish the most popular stereographs. See Paul Wing, *Stereoscopes: The First One Hundred Years*, Nashua, New Hampshire, Transition Publishing, 1996.

13 — JEAN-BAPTISTE TOURNASSOUD

1. There were several experimenters with cinematic technology at the time in France, but in 1895 the Lumière brothers presented ten of their original films to a paying audience at the Salon Indien du Grand Café in Paris. This event is considered to be the birth of film as a commercial medium. On Auguste Marie Louis Nicolas Lumière (Besançon, October 19, 1862–April 10, 1954, Lyon) and Louis Jean Lumière (Besançon, October 5, 1863–June 6, 1948, Bandol), see Michel Faucheux, *Auguste et Louis Lumière*, Paris, Gallimard, 2011; Guy Borgé and Marjorie Borgé, *Les Lumière, Antoine, Auguste, Louis et les autres: L'invention du cinéma, les autochromes*, Lyon, Éditions Lyonnaises d'Art et d'Histoire, 2004.

2. On Jean-Baptiste Tournassaud (Montmerle-sur-Saône, May 3, 1866–January 5, 1951, Montmerle-sur-Saône), see Agnès Bruno and Jean-Pierre Sudre, *Jean-Baptiste Tournassoud, 1866–1951: Oeuvres photographiques*, exhibition catalogue, Musée Départemental des Pays de l'Ain, Bourg-en-Bresse, December 31, 1991–January 18, 1992.

3. See Bertrand Lavédrine et al., *The Lumière Autochrome: History, Technology, and Preservation*, Los Angeles, Getty Conservation Institute, 2013.

4. See Paul Jay, *Jean-Baptiste Tournassoud*, exhibition catalogue, Musée Nicéphore Niépce, Ville de Chalon-sur-Saône, May 15–June 28, 1981.

5. Three of Tournassoud's related Autochrome portraits, photographed in the same sitting, were on the market in Paris in 2010: *Juliette (Noeud rouge dans les cheveux)*, about 1912, Autochrome Lumière, 18.2 × 13 cm (7⅛ × 5⅛ in.), Pierre Cardin, Rémy le Fur et Associés, Paris, November 17, 2010, lot 15; *Juliette (Mains croisées sur les genoux)*, about 1912, Lumière Autochome, 27.8 × 21.5 cm (11 × 8½ in.), Pierre Cardin, Rémy le Fur et Associés, Paris, November 17, 2010, lot 16; and *Juliette (Chapeau aux cerises)*, about 1912, Lumière, Autochrome, 27.8 × 21.5 cm (11 × 8½ in.), Pierre Cardin, Rémy le Fur et Associés, Paris, November 17, 2010, lot 17. In one, the subject is seated before the blue curtain in her checked dress, without her jacket or her hat.

6. See Carl de Keyzer, *The First World War: Unseen Glass Plate Photographs of the Western Front*, Chicago, University of Chicago Press, 2015; Hélène

Guillot, "La section photographique de l'armée et la Grande Guerre," *Revue historique des armées*, no. 258, 2010, published online February 26, 2010.

7. Philippe Garner, *Jean Tournassoud: L'album-photo de la Grande Guerre*, Paris and Brussels, Elsevier-Séquoia, 1978; Pierre Argence, *Jean-Baptiste Tournassoud: La guerre, 1914–1919*, Lyon, Éditions Archat, 1920.

8. Significant holdings of Tournassoud's works are to be found in the Institut Lumière, Lyon; Musée Départemental des Pays de l'Ain, Bourg-en-Bresse; Musée Nicéphore Niépce, Chalon-sur-Saône; Musée Georges Clémenceau, Paris; and Historial de la Grande Guerre, Péronne.

9. Saint Sauveur, Dudley Gilroy, Edward Lasker, and Cynthia Lasker, *Les grands étalons de pur sang de France*, Lyon and Chantilly, 1922.

14 — E. J. BELLOCQ

1. See Al Rose, *Storyville, New Orleans: Being an Authentic, Illustrated Account of the Notorious Red-Light District*, Tuscaloosa, University of Alabama Press, 1974; Gilbert King, "The Portrait of Sensitivity: A Photographer in Storyville, New Orleans' Forgotten Burlesque Quarter," *Smithsonian*, March 28, 2012.

2. On Ernest J. Bellocq (New Orleans, 1873–October 4, 1949, New Orleans), see John Szarkowski, ed., *E. J. Bellocq: Photographs from Storyville, the Red-Light District of New Orleans*, reproduced from prints made by Lee Friedlander, introduction by Susan Sontag, New York, Random House, 1996.

3. On Raymond Paul Aldigé (1811–1881), see Frederick Converse Beach, ed., "The Cotton-Seed-Oil Industry," in *The Americana: A Universal Reference Library*, vol. 5, New York, Scientific American, 1907, pp. 226ff.

4. *The Owl*, New Orleans, 1898.

5. Stamped in gray ink on the verso: PHOTOGRAPH BY E.J. BELLOCQ / New Orleans Circa 1911–13 / COLLECTION LEE FRIEDLANDER / The print was made on Printing Out Paper / and toned in gold chloride toning bath. (A process popular in the early 1900's) / This photograph is not released for publi- / cation or for any commercial use of any kind. For / permission communicate with Lee Friedlander, / 44 So. Mountain Road, New City, N.Y. 19056.

6. See Fairfax Downey, *Portrait of an Era as Drawn by C. D. Gibson: A Biography by Fairfax Downey*, New York, C. Scribner's Sons, 1936.

7. See Rudolf Koella et al., *Toulouse-Lautrec und die Photographie*, exhibition catalogue, Kunstmuseum Bern, 2015; Georges Beaute, *Toulouse-Lautrec vu par les photographes*, Lausanne, Edita, 1988.

8. Pamela D. Arceneaux, *Guidebooks to Sin: The Blue Books of Storyville*, New Orleans, The Historic New Orleans Collection, 2017; Brooke Bergan, *Storyville: A Hidden Mirror*, Rhode Island, Wakefield, 1994.

9. On early erotic photography, see Graham Ovenden and Peter Mendes, *Victorian Erotic Photography*, London, Academy Editions, 1973; Denis Pellerin, "File BB3 and the Erotic Image in the Second Empire," in *Paris in 3D: From Stereoscopy to Virtual Reality, 1850–2000*, ed. Francoise Reynaud, Catherine Tambrun, and Kim Timby, exhibition catalogue, Paris, Museum of the History of Paris, in association with Musée Carnavalet, pp. 91–95.

10. Rex Rose, "The Last Days of Ernest J. Bellocq," *Exquisite Corpse: A Journal of Letters and Life*, no. 10, Fall/Winter 2001–2, pp. 3–4.

11. John Szarkowski, *E. J. Bellocq: Storyville Portraits, Photographs from the New Orleans Red-Light District, circa 1912*, exhibition catalogue, New York, Museum of Modern Art, 1970.

12. Chief among these is the film *Pretty Baby* (Paramount, 1978), produced and directed by Louis Malle, with screenplay by Polly Platt. Peter Everett's novel *Bellocq's Women* (London, Jonathan Cape, 2000) is a fiction novel inspired by the photographs. Natasha D. Trethewey composed a cycle of verse titled *Bellocq's Ophelia: Poems* (Saint Paul, Minnesota, Graywolf Press, 2002).

15 — MARGRETHE MATHER

1. On Margrethe Mather (Salt Lake City, March 4, 1886–December 25, 1952, Los Angeles), see Beth Gates Warren, *Artful Lives: Edward Weston, Margrethe Mather, and the Bohemians of Los Angeles*, Los Angeles, J. Paul Getty Museum, 2011.

2. Warren 2011, p. 23.

3. Years later, Mather told William Justema tales of her prostitution since childhood, perhaps one of several dubious stories teasingly related to shock and impress the listener; see Justema, "Margaret Mather: A Memoir," in *Margrethe Mather*, Center for Creative Photography, no. 11, Tucson, Center for Creative Photography, University of Arizona, 1979, pp. 6–7.

4. Ellsworth grew up in Salt Lake City, where his stepfather ran a livery stable. Disappointed in love, he began and abandoned several careers: vaudeville theater owner, traveling amusements agent, member of the Consolidated Stock (and Petroleum) exchange. In New York he became involved with Socialist politics and wrote for the national satire magazine *Judge*, where he met the anarchist Emma Goldman. In 1919 Ellsworth was working as Elliott Clawson's department chief at Universal City (*Los Angeles Herald*, no. 93, February 18, 1919, p. 23). The following year he was described as the personal representative to Charlie Chaplin (*Los Angeles Herald*, no. 103, March 1, 1920, p. B-8).

5. See Harry H. I. Forbes, "The Los Angeles Camera Club," *Los Angeles Herald*, no. 19, October 20, 1901, pp. 16–17; Warren 2011, pp. 40-41.

6. See Amelia Gray, *Isadora*, New York, Farrar, Straus & Giroux, 2017.

7. When Mather knew Deshon, the dancer and stage and screen actress was involved with Charlie Chaplin in Los Angeles. When that relationship ended, Deshon went to New York, where she performed onstage. She was accidentally killed at age 27, asphyxiated by a leak of illuminating gas in her small apartment. See Warren 2011, pp. 163–64; Ross Wetzsteon, *Republic of Dreams: Greenwich Village, The American Bohemia, 1910–1960*, New York, Simon & Schuster, 2002, pp. 64–65; *New York Times*, "Actress Dies of Poison Gas," February 5, 1922, p. 3.

8. Justema 1979, p. 9; see also Lawrence Jasud, "Margrethe Mather: Questions of Influence," in *Margrethe Mather*, Center for Creative Photography, no. 11, Tucson, Center for Creative Photography, University of Arizona, 1979, pp. 54–59.

9. See Arthur Wesley Dow, *Composition: A Series of Exercises Selected from a New System of Art Education*, Boston, A. Mudge & Son, 1900.

10. See *Charles Gerrard*, n.d. (79:017:002), and *Portrait of a Lady*, about 1917 (79:013:031) reproduced in *Margrethe Mather*, Center for Creative Photography, no. 11, Tucson, Center for Creative Photography, University of Arizona, 1979, p. 28.

11. Paolo Ferrari and Claudio Natali, *Tina Modotti: Arte e libertà fra Europa e Americhe*, Udine, Forum, 2017; Bernadette Costa-Prades, *Tina Modotti: Biographie*, Paris, Philippe Rey, 2015; Valeria Arnaldi, *Tina Modotti hermana: Passione, scandalo e rivoluzione*, Rome, Bizzarro/Red Star Press, 2016.

12. Justema 1979, pp. 12–14.

13. In the 1930s Mather became involved with the antique dealer George Lipton, an old friend from the anarchist movement. They achieved a lasting relationship, and Mather's interest in photography waned as she shared his work. In the early 1940s Mather was diagnosed with multiple sclerosis, a disease that soon became debilitating. She died on Christmas Day 1952.

16 — EDWARD WESTON

1. On Edward Weston (Chicago, March 24, 1886–January 1, 1958, Carmel, California), see Ben Maddow, *Edward Weston: His Life and Photographs, The Definitive Volume of His Photographic Work*, afterword by Cole Weston, rev. ed., Millerton, New York, Aperture, 1979; Gilles Mora, ed., *Edward Weston: Forms of Passion*, New York, H. H. Abrams, 1995.

2. Edward Weston, March 10, 1924, in *The Daybooks of Edward Weston*, vol. 1, ed. Nancy Newhall, 2nd ed., New York, Aperture, 1990, p. 54.

3. See Letizia Argenteri, *Tina Modotti: Between Art and Revolution*, New Haven, Yale University

Press, 2003; Pino Cacucci, *Tina Modotti: A Life*, New York, Saint Martin's Press, 1999.

4. Weston, March 10, 1924, in Newhall 1990, p. 132.

5. See William Johnson, *Sonya Noskowiak*, Tucson, Center for Creative Photography, University of Arizona, 1979; Donna Bender et al., *Sonya Noskowiak Archive*, Tucson, Center for Creative Photography, University of Arizona, 1982.

6. On Group f.64, see Mary Street Alinder, *Group f.64: Edward Weston, Ansel Adams, Imogen Cunningham, and the Community of Artists who Revolutionized American Photography*, New York, Bloomsbury, 2014.

7. Charis Wilson and Wendy Madar, *Through Another Lens: My Years with Edward Weston*, New York, North Point Press, 1998.

8. This later print is laid down on white ragboard. Inscribed in graphite on the verso, upper left: 237N; upper right: NUDE, 1936; stamped in black ink, center: NEGATIVE / BY / *Edward Weston* / PRINT / BY; inscribed in graphite: Cole Weston.

9. Charis Wilson, *Seeing California with Edward Weston*, Los Angeles, Automobile Club of Southern California, 1939.

10. Edward Weston and Charis Wilson, *California and the West*, New York, Duell, Sloan & Pearce, 1940.

11. Walt Whitman, *Leaves of Grass*, with photographs by Edward Weston, New York, Limited Editions Club, 1942.

12. Nancy Newhall, *The Photographs of Edward Weston*, exhibition catalogue, New York, Museum of Modern Art, 1946.

13. See Ben Maddow, *Edward Weston, Fifty Years: The Definitive Volume of His Photographic Work*, Millerton, New York, Aperture, 1973.

17 — PAUL OUTERBRIDGE

1. On Paul Outerbridge, (New York, August 15, 1896–October 17, 1958, Los Angeles), see Elaine Dines-Cox, Manfred Heiting, et al., *Paul Outerbridge: 1896–1958*, Cologne, Taschen, 1999; Elaine Dines and Graham Howe, *Paul Outerbridge: A Singular Aesthetic, Photographs and Drawings: A Catalogue Raisonné*, introduction by Bernard Barryte, Santa Barbara, Arabesque Books, 1981.

2. See Max Weber, *Essays on Art*, New York, W. E. Rudge, 1916; on Weber, see Sarah MacDougall, ed., *Max Weber: An American Cubist in Paris and London, 1905–1915*, Farnham, Surrey, and Burlington, Vermont, Lund Humphries, 2014.

3. On Alexander Archipenko, see Frances Archipenko Gray, *My Life with Alexander Archipenko*, Munich, Hirmer, 2014.

4. Paul Outerbridge, "Visualizing Design in the Common Place," *Arts and Decoration*, vol. 17, September 1922, pp. 32off.

5. Six prints of *Cheese and Crackers* are in American museums today, including the Metropolitan Museum of Art in New York, the Getty Museum in Los Angeles, the Library of Congress in Washington, D.C., the Museum of Fine Arts in Boston, the High Museum of Art in Atlanta, and the present photograph.

6. Inscribed on the recto in graphite, lower right: 4⅛ × 5¼; inscribed in pen and black ink on the verso of the mount: Property of / Paul Outerbridge, Jr., / 44 W. 74th Street, / New York City.

7. The Viennese theater and film director Georg Wilhelm Pabst (1885–1967) worked at the German Theater in New York City in 1910. He was director of the avant-garde Neue Wiener Bühne in Vienna in 1919, when Carl Froelich hired him as an assistant director. Pabst directed his first independent film, *The Treasure*, in 1923. He is known for a series of films with heroic women, including *The Joyless Street* (1925) with Greta Garbo and Asta Nielsen, and *Pandora's Box* and *Diary of a Lost Girl* (1929) with Louise Brooks. See Wolfgang Jacobsen, *G. W. Pabst*, Berlin, Argon, 1997.

8. Julien Levy, *Memoir of an Art Gallery*, New York, Putnam, 1977; Ingrid Schaffner and Lisa Jacobs, *Julien Levy: Portrait of an Art Gallery*, Cambridge, Massachusetts, MIT Press, 1998; David Travis, *Photographs from The Julien Levy Collection: Starting with Atget*, exhibition catalogue, Art Institute of Chicago, 1976.

9. Paul Outerbridge Jr., *Photographing in Color*, New York, Random House, 1940.

10. See Graham Howe, *Nudes: Paul Outerbridge*, Milan, Federico Motta Editore, 1996; Graham Howe, William Ewing, and Philip Prodger, *Paul Outerbridge: New Color Photographs from Mexico and California, 1948–1955*, Portland, Oregon, Nazraeli Press, 2009.

18 — JOSEF SUDEK

1. On Josef Sudek (Kolín, Czech Republic, March 17, 1896–September 15, 1976, Prague, Czech Republic), see Maia-Mari Sutnik, ed., *Josef Sudek: The Legacy of a Deeper Vision*, Munich, Hirmer Verlag, 2012; Sonja Bullaty and Anna Fárová, *Sudek*, New York, C. N. Potter, 1978.

2. On Jaromír Funke (1896–1945), see Antonín Dufek, *Jaromír Funke: Mezi konstrukcí a emocí*, exhibition catalogue, Brno, Moravská Galerie v Brně, 2013.

3. This contact print is on postcard stock, with lithographed rulings on the verso, along with the manufacturer: Wellington.

4. See Vojtech Lahoda, *Josef Sudek: The Advertising Photographs*, Prague, Trost, 2008.

5. Josef Sudek, *Svatý Vít*, Prague, Družstevní Práce, 1928; Sudek's, *Saint Vitus's Cathedral* (Prague, Torst, 2011) includes images not included in the 1928 photobook.

6. Among the instruments that Sudek collected were a Linhof 13 × 18 cm, a Zeiss 18 × 24 cm, a Goldmann & Hrdlička 24 × 30 cm, and Kodak 10 × 30 cm cameras.

7. See Anna Fárová, *Josef Sudek: The Window of My Studio*, Prague, Torst, 2007.

8. Daniela Hodrová and Antonín Dufek, *Josef Sudek: Labyrinths*, Prague, Torst, 2014.

9. In 1947, distant relatives found Bullaty's name on a survivors' list and paid her passage to New York. There she met Angelo Lomeo, whom she married in 1951. For five decades they shared a commercial and editorial photography studio, contributing to many publications, from travel to children's books. See Janis Bultman, "Double Visions: An Interview with Sonja Bullaty & Angelo Lomeo," *Darkroom Photography*, September 1985; "Sonja Bullaty, 76, a Photographer of Lyricism," *New York Times*, October 13, 2000.

10. See Antonín Dufek, *Josef Sudek: Mionší Forest*, Prague, Torst, 2009.

11. Josef Sudek, *Janacek/Hukvaldy*, Prague, Supraphon, 1971.

12. Ivan Lutterer, ed., *Panoramatické fotografie = Panoramic Photographs: 1984–1991*, Prague, Studio JB, 2004.

19 — IMOGEN CUNNINGHAM

1. On Imogen Cunningham (Portland, Oregon, April 12, 1883–June 23, 1976, San Francisco), see Mónica Fuentes Santos, ed., *Imogen Cunningham*, exhibition catalogue, Madrid, Fundación MAPFRE, 2012; Manfred Heiting, ed., *Imogen Cunningham, 1883–1976*, Cologne and New York, Taschen, 2001; Richard Lorenz, *Imogen Cunningham: Ideas without End; A Life in Photographs*, San Francisco, Chronicle Books, 1993.

2. Imogen Cunningham, *Photography as a Profession for Women*, Seattle, University of Washington Press, 1913. Originally published in *The Arrow* (Journal of the Pi Beta Phi), vol. 29, no. 2, January, 1913, pp. 203–9.

3. See Ann M. Wolfe, *Anne Brigman: A Visionary in Modern Photography*, exhibition catalogue, Reno, Nevada Museum of Art, 2018.

4. On Roi Partridge, see Anthony R. White et al., *The Graphic Art of Roi Partridge: A Catalogue Raisonné*, Los Angeles, Hennessy & Ingalls, 1988. Cunningham and Partridge's first son, Gryffyd, was born in 1915, and twin sons, Rondal and Padraic, followed in 1917. At age 16 Rondal became an assistant to Dorothea Lange (Cat. no. 38), and in 1937–39 he was an assistant to Ansel Adams (Cat. no. 46), before his own long career as a photographer and filmmaker.

5. Imogen Cunningham, "Imogen Cunningham: Portraits, Ideas, and Design," interview by Edna Tartaul Daniel, Berkeley Regional Cultural History Project, University of California General Library, Berkeley, 1961, p. 117.

6. This print on white Strathmore 500 wove paper was produced from Cunningham's original negative by the artist's estate in 1986. Inscribed in graphite on the verso, lower left: RP-3-200; lower right: 18, 4, 20D [underlined] / 4+ / Jan 86 / Ektachrome 500.

7. See Moritz Meurer, *Vergleichende Formenlehre des Ornamentes und der Pflanze, mit besonderer Berücksichtigung der Entwickelungsgeschichte der architektonischen Kunstformen*, Dresden, G. Kühtmann, 1909.

8. On the *Film und Foto* exhibition, see Laszlo Moholy-Nagy (Cat. no. 25) in this volume. After seeing the exhibition, the critic Franz Roh wrote an essay entitled *Foto-Auge* (Stuttgart, Akademischer Verlag, 1929; facsimile, London, Thames & Hudson, 1974) suggesting that photography had undergone a definitive change. In the same year, *Film und Foto* traveled to Zurich, Berlin, Danzig and Vienna, and in 1931 it was presented in Tokyo and Osaka.

9. On Group ƒ.64, see Edward Weston (Cat. no. 16).

10. See the photobooks edited by Richard Lorenz: *Imogen Cunningham: On the Body* (Boston, Bulfinch Press, 1998), *Imogen Cunningham: Portraiture* (Boston, Little, Brown & Company, 1997), and *Imogen Cunningham: Flora* (Boston, Little, Brown & Company, 1996).

11. Imogen Cunningham, *Imogen! Imogen Cunningham Photographs, 1910–1973*, intro. by Margery Mann, Seattle, University of Washington Press, 1974; Imogen Cunningham, *After Ninety*, intro. by Margaretta Mitchell, Seattle, University of Washington Press, 1977.

20 — EUGÈNE ATGET

1. For biographical information on Eugène Atget (Libourne, February 12, 1857–August 4, 1927, Paris), see Sylvie Aubenas and Guillaume Le Gall, *Atget: Une rétrospective*, exhibition catalogue, Paris, Bibliothèque Nationale de France, 2007; John Szarkowski and Maria Morris Hambourg, *The Work of Atget*, New York, Museum of Modern Art, 1981–85.

2. Frits Gierstberg, Carlos Gollonet, et al., *Eugène Atget: Paris 1898–1924*, Madrid, TF Editores, 2011; Suzanne Tise-Isoré, ed., *Atget: Paris in Detail*, Paris, Flammarion, 2002.

3. See Molly Nesbit, *Atget's Seven Albums*, New Haven, Yale University Press, 1992.

4. See William Howard Adams, *Atget's Gardens: A Selection of Eugène Atget's Garden Photographs*, exhibition catalogue, London, Royal Institution of British Architects, 1979; Muriel Bouchami-Paquelet, *Atget à Sceaux: Inventaire avant disparitions*, exhibition catalogue, Sceaux, Musée de l'Ile-de-France, 2008.

5. See Michel Martinez, *Saint-Cloud: Le château, le parc, la fête*, Saint-Cyr-sur-Loire, A. Sutton, 2005.

6. See Berenice Abbott, *The World of Atget*, New York, Horizon Press, 1964; Clark Worswick, *Berenice Abbott, Eugène Atget*, Santa Fe, Arena Editions, 2002. After Atget's death, Abbott purchased 1,500 of his negatives, which were later acquired by the Museum of Modern Art in New York.

21 — PAUL WOLFF

1. Ulf Richter, *Oskar Barnack: Von der Idee zur Leica*, Wetzlar, Lindemann, 2009; Knut Kühn-Leitz, *Ernst Leitz, Wegbereiter der Leica: Ein vorbildlicher Unternehmer und mutiger Demokrat*, Königswinter, Heel, 2006; Hans-Michael Koetzle, ed., *Eyes Wide Open!: 100 Years of Leica Photography*, Heidelberg, Kehrer, 2015.

2. For biographical information on Dr. Paul Wolff (Mulhouse, February 19, 1887–April 10, 1951, Frankfurt am Main), see Sylvia Böhmer, *Paul Wolff: Fotografien der 20er und 30er Jahre*, exhibition catalogue, Aachen, Suermondt-Ludwig-Museum, 2003.

3. Paul Wolff, *Alt-Strasbourg*, Strasbourg, Rasch, 1912 (2nd ed., 36 photographs, Strasbourg, Rasch, 1914).

4. Richter 2009, p. 83.

5. In *My Life with the Leica* (Steyning, West Sussex, Hove Foto Books, 1990, p. 36), Walther Benser recalled his period as Wolff's assistant.

6. Inscribed in graphite on the verso, upper right: 25; upper left: 83; left center: L/94/190; stamped in purple ink, lower left: BESTELLN. . . / DR.PAUL WOLFF / FRANKFURT AM MAIN / KAISERSTRASSE 32^IV. TEL32278. The print also carries a label from press agency AGENTUR SCHOSTAL, inscribed with a serial number from the Paris office: 59082.

7. Alfred Tritschler (Offenberg, Baden-Württemberg, June 12, 1905–December 31, 1970, Offenberg) was trained as a photographer in his home town in 1921–24, and then worked in Munich in 1924–25. When he worked in the testing laboratory of UFA in Babelsberg, he became familiar with the Leica camera. In 1927 Tritschler joined Wolff's photo agency, becoming a partner in 1934. Tritschler was aboard the airship Hindenberg on its first trip to South America in 1936. He worked with Wolff on the photobooks *What I Saw at the Olympic Games 1936* (1936), *In the Force Field of Rüsselsheim* (the first industrialized volume in color, 1939/40) and *My Experiences ... Colored* (1942). In 1939 Tritschler served in the German military with the propaganda company (PK) in France, Africa and Russia. In 1944 Tritschler's house in Frankfurt-Ginnheim was destroyed during an air raid, and his wife Hägeli was killed. With the currency reform of 1948, Wolff & Tritschler again received industrial orders, which fell to Tritschler after Wolff's death in 1951. For a couple of years the photographer Kurt Röhrig was Tritschler's partner while his nephew, Robert Sommer, was commercial director, and took over the company when Tritschler retired in June 1963.

8. Paul Wolff, *Aus zoologischen gärten*, Königstein Langewiesche, 1929; Paul Wolff and Martin Möbius, *Formen des Lebens: Botanische Lichtbildstiudien*, Königstein im Taunus, K. R. Langewiesche, 1933; Wilhelm Pinder and Paul Wolff, *Drei Kaiserdome: Mainz, Worms, Speyer*, Königstein im Taunus, K. R. Langewiesche, 1933.

9. Paul Wolff, *Meine Erfahrungen mit der Leica*, Frankfurt am Main, H. Bechold, 1934, with 192 photogravure plates.

10. For example, Paul Georg Ehrhardt, *Arbeit!*, with photographs by Paul Wolff and Alfred Tritschler, Frankfurt am Main, Hauserpresse, 1937; Wilhelm Schlaghecke, *Das Heim im Reichsarbeitsdienst*, Frankfurt am Main, Bechhold, 1937.

11. *TIME*, vol. 27, no. 15, April 13, 1936. That year, Ernst Leitz presented Wolff with the hundred-thousandth Leica off the production line.

12. When Agfa slide film became available after the war, Wolff expanded his activity into 35 mm color work. This is described in his book *Meine Erfahrungen ... farbig*, with photographs by Alfred Tritschler and Rudolf Hermann, Frankfurt am Main, Umschau-Verlag, 1942 (*My Experiences with Color Photography*, New York, Grayson/Cinephot International, 1952). By the end of 1945, he was back at work, with a commission to document the city's destruction.

22 — ANDRÉ KERTÉSZ

1. On Andor Kertész (Budapest, July 2, 1894–September 28, 1985, New York), see Michel Frizot, *André Kertész*, Paris, Editions Hazan/New Haven, Yale University Press, 2010; Sarah Greenough, Robert Gurbo, and Sarah Kennel, *André Kertész*, exhibition catalogue, Washington, D.C., National Gallery of Art, 2005.

2. Kertész carried a lightweight Goerz Tenax camera on the battlefield, but most of the photographs he made were destroyed during the violence of the Hungarian Revolution of 1919.

3. André Kertész, *Kertész on Kertész: A Self-Portrait*, New York, Abbeville Press, 1985, p. 53. Since knew little French, Kertész gravitated to the Hungarian community, which met informally at the Café du Dôme in Montparnasse. There he could have met the architect Ernö Goldfinger; artists like Lajos Tihanyi, József Csáky and Dénes Förstner; and the writer Sandor Kemeri. Photographers who visited the Hungarian table in these years included Gyula Halász (Brassaï), László Moholy-Nagy, Endre Friedmann (Robert Capa), Henri Cartier-Bresson and Germaine Krull.

4. This print was produced after 1972. Inscribed in graphite on the verso, upper right: 60 Years., Page 37; center: "Eiffel Tower" / 1929 / Paris / A Kertesz.

5. On the *Film und Foto* exhibition, see the László Moholy-Nagy entry (Cat. no. 25) in this volume.

6. André Kertész, *Distorsions*, Paris, Association Française pour la Diffusion du Patrimoine Photographique, 1933; see also Nicolas

Ducrot, ed., *André Kertész: Distortions*, introduction by Hilton Kramer, New York, Knopf, 1976.

7. *Paris vu par André Kertész* (1934), and the artist published regularly during the succeeding years. *Nos amies les bêtes* (Our Friends the Animals) was released in 1936 and *Les cathédrales du vin* (The Cathedrals of Wine) in 1937.

8. *Day of Paris: Photographs by André Kertész* (New York, J. J. Augustin, 1945), was edited by George Davis of *Harper's Bazaar*, influential fiction editor and novelist, and second husband of the Austrian singer and actress Lotte Lenya.

23 — ALEXANDER RODCHENKO

1. On Alexander Mikhailovich Rodchenko (St. Petersburg, December 5, 1891–December 3, 1956, Moscow), see Magdalena Dabrowski et al., *Aleksandr Rodchenko*, exhibition catalogue, New York, Museum of Modern Art, 1998.

2. On Varvara Fedorovna Stepanova (November 9, 1894–May 20, 1958), see Aleksandr Nikolaevich Lavrentev, *Varvara Stepanova: The Complete Work*, ed. John E. Bowlt, trans. Wendy Salmond, Cambridge, Massachusetts, MIT Press, 1988.

3. On Malevich and Suprematism, see Andréi Nakov, *Malevich: Painting the Absolute*, 4 vols., Farnham, Surrey, Lund Humphries, 2010; Aleksandra Semenovna Shatskikh, *Black Square: Malevich and the Origin of Suprematism*, trans. Marian Schwartz, New Haven, Yale University Press, 2012.

4. Quoted in Hugh Adams, "Alexander Rodchenko: The Simple and the Commonplace," *Artforum*, Summer 1979, p. 28.

5. VKhUTEMAS, the Vysshie khudozhestvenno-tekhnicheskie masterskie (Higher State Artistic and Technical Studios), was established in Moscow in 1920 as a teaching academy for industry designers and higher-education teachers. Its curriculum was similar to that of the Bauhaus. First-year students attended a foundation course, with introductions to color theory, composition, history of art and political science. Later they concentrated upon architecture, metalwork, woodwork or textiles. Rodchenko was among the original faculty, and taught composition and metalworking. See Lidija Komarova, *Il VChUTEMAS e il suo tempo: Testimonianze e progetti della scuola costruttivista a Mosca*, Rome, Edizioni Kappa, 1996; Arlette Barré-Despond and Joëlle Aubert-Yong, eds., *Vkhutemas: Moscou, 1920–1930*, 2 vols., Paris, Éditions du Regard, 1990.

6. On Rodchenko as a photographer, see Aleksandr Nikolaevich Lavrentev and Olga Sviblova, *Alexsander Rodchenko: Photography Is an Art*, trans. Kate Cook, Moscow, Interros, 2006; Aleksandr Nikolaevich Lavrentev, *Alexander Rodchenko: Photography 1924–1954*, trans.

Francis Nethercott, Edison, New Jersey, Knickerbocker Press, 1996.

7. Stamped in purple ink on the verso: ФОТО / РОДЧНГНКО.

8. *Sovetskoe kino*, no. 2, 1926; *Novyï LEF*, no. 1, January 1927 (reprint, Munich, Wilhelm Fink Verlag, 1970).

24 — JOOST SCHMIDT

1. See Roswitha Fricke, ed., *Bauhaus Fotografie*, Dusseldorf, Edition Marzona, 1982 (English edition, Cambridge, MIT Press, 1987); Jeannine Fiedler, ed., *Photography at the Bauhaus*, Cambridge, Massachusetts, MIT Press, 1990; Lutz Schöbe, *Bauhaus fotografie: Dalla collezione della Fondazione Bauhaus di Dessau*, Florence, Fratelli Alinari/Lestans, CRAF, 2002. On the Bauhaus, see Michael Siebenbrodt and Lutz Schöbe, *Bauhaus 1919–1933*, New York, Parkstone Press, 2009.

2. On Joost Schmidt (January 5, 1893, Wunstorf–December 2, 1948, Nuremberg), see Heinz Loew and Helene Nonné-Schmidt, *Joost Schmidt: Lehre und Arbeit am Bauhaus, 1919–1932*, Dusseldorf, Edition Marzona, 1984.

3. On Schmidt as a typographer, see see Friedrich Friedl, Nicolaus Ott, and Bernard Stein, *Typography—when/who/how*, Cologne, Könemann Verlags, 1998, pp. 470–71; Philip B. Meggs, *A History of Graphic Design*, 3rd ed, New York, John Wiley & Sons, 1998, pp. 279, 284–85; Joost Schmidt, "On Lettering," in Hans M. Wingler, *The Bauhaus*, Cambridge, MIT Press, 1969, p. 161.

4. Inscribed in graphite on the verso: I. / plastiche / wirkung / im weissblech / 73 [in a circle] / II. / 31.

5. Prior to his death in Nuremberg on December 2, 1948, Schmidt was working on another exhibition of works from the Bauhaus, as well as a book on the influential academy.

25 — LÁSZLÓ MOHOLY-NAGY

1. An aphorism quoted and restated by Walter Benjamin, *On Photography*, ed. and trans. by Esther Leslie, London, Redaktion, 2005, p. 25.

2. On László Moholy-Nagy (Bácsborsód, Hungary, July 20, 1895–November 24, 1946, Chicago), see Lloyd C. Engelbrecht, ed., *Moholy-Nagy: Mentor to Modernism*, 2 vols., Cincinnati, Flying Trapeze Press, 2009.

3. On Lucia Moholy, née Schulz (Prague, January 18, 1894–May 17, 1989, Zurich), see Rolf Sachsse, *Lucia Moholy*, Düsseldorf, Edition Marzona, 1985; Angela Madesani and Nicoletta Ossanna Cavedini, *Lucia Moholy (1894–1989): Tra fotografia e vita (Between Photography and Life)*, Cinisello Balsamo, Silvana Editoriale, 2012; Rolf Sachsse and Sabine Hartmann, *Lucia Moholy: Bauhaus Fotografin*, exhibition catalogue, Museumspädagogischer Dienst Berlin;

Bauhaus-Archiv Berlin, 1995.

4. On László Moholy-Nagy as a photographer, see Andreas Haus, *Moholy-Nagy: Photographs and Photograms*, New York, Pantheon Books, 1980; *László Moholy-Nagy: Photographs from the J. Paul Getty Museum*, Malibu, California, J. Paul Getty Museum, 1995.

5. László Moholy-Nagy, *Painting, Photography, Film*, trans. Janet Seligman, Cambridge, Massachusetts, MIT Press, 1969.

6. László Moholy-Nagy, "The New Vision" and "Abstract of an Artist," trans. Daphne M. Hoffman, 3rd rev. ed., New York, Wittenborn & Company, 1946.

7. A portrait of Frank, taken at this time, is now at the Art Institute of Chicago: László Moholy-Nagy, *Ellen Frank*, 1930, (gelatin silver print, 17.6 × 23.8 cm (7 × 9⅜ in.), Julien Levy Collection, Special Photography Acquisition Fund, 1979.89.

8. Inscribed in graphite on the verso, center: 7 [in a circle] e v / Lappermann / Petsamo; stamped in purple ink: foto moholy-nagy; inscribed in graphite: Finland; stamped in blue ink: Edition „Tilleul" / Paris.

9. See David Travis and Elizabeth Siegel, eds., *Taken by Design: Photographs from the Institute of Design, 1937–1971*, exhibition catalogue, Art Institute of Chicago, in association with the University of Chicago Press, 2002.

10. László Moholy-Nagy, *Vision in Motion*, Chicago, P. Theobald, 1947.

26 — KARL BLOSSFELDT

1. On Karl Blossfeldt (Schielo, Harz Mountains June 13, 1865–December 9, 1932, Berlin), see Ann Wilde and Jürgen Wilde, *Karl Blossfeldt: Meisterwerke*, with botanical commentary by Hansjörg Küster, Munich, Schirmer/Mosel, 2016; Hans-Christian Adam, *Karl Blossfeldt, 1865–1932*, Cologne, Taschen, 1999.

2. Meurer credited Blossfeldt as the photographer in his two publications: *Die Ursprungsformen des griechischen Akanthusornaments und ihre natürlichen Vorbilder* (Berlin, Druck und Verlag von Georg Reimer, 1896) and *Vergleichende Formenlehre des Ornamentes und der Pflanze* (Dresden, Verlag von Gerhard Kühtmann, 1909).

3. Blossfeldt described his "self-built camera" in technical information he submitted to the journal *Das Deutsche Lichtbild* (Berlin, Robert & Bruno Schultz, 1930, section DDL20, n.p.). Blossfeldt varied exposure time according to the subject: eight minutes for one of the images published in 1931 and 12 minutes for the other, as well as 12 minutes for the images published in 1933 and 1935. The photographer used an Aplanat lens and commercial glass-plate negatives from two different manufacturers.

4. In a 1906 letter to the director of the Berlin Museum of Decorative Arts, quoted by Claudia Schubert, in *Karl Blossfeldt —Studienzeit und Lehrtätigkeit: Quellen und Nachweise aus dem Archiv*

der Universität Berlin, Cologne, SK Stiftung, Die Photographische Sammlung, 2009, pp. 8–9.

5. See Ann Wilde, Jürgen Wilde, and Ulrike Stamp, *Karl Blossfeldt: Working Collages*, Cambridge, MIT Press, 2001.

6. Numbered in letterpress, lower right: 81.

7. Karl Blossfeldt, *Urformen der Kunst: Photographische Pflanzenbilder*, intro. by Karl Nierendorf, 120 Bildtafeln, Berlin, Ernst Wasmuth A.G., 1928.

8. Karl Blossfeldt, *Wundergarten der Natur: Neue Bilddokumente Schöner Pflanzenformen*, Berlin, Verlag für Kunstwissenschaft, 1932.

9. Karl Blossfeldt, *Wunder in der Natur: Bild-dokumente schöner Pflanzenformen*, intro. by Otto Danenberg, 120 Bildtafeln, Leipzig, H. Schmidt & C. Günther, 1942.

27 — AUGUST SANDER

1. For biographical information on Sander (Herdorf, Altenkirchen, November 17, 1876–April 20, 1964, Cologne), see Susan Lange and Manfred Heiting, *August Sander, 1876–1964*, Cologne, Taschen, 1999; Gerd Sander and Christoph Schreier, *August Sander: "In photography there are no unexplained shadows!"* exhibition catalogue, Cologne, August Sander Archive, Kulturstiftung Stadtsparkasse/London, National Portrait Gallery, 1996.

2. Blindstamped on the recto, lower left: AUG. SANDER / KÖLN / LINDENTHAL [in a circle]; inscribed in graphite on the verso, upper right: #125.

3. Alfred Sander, *Antlitz der Zeit; sechzig Aufnahmen deutscher Menschen des 20. Jahrhunderts*, intro. by Alfred Döblin, Munich, Transmare Verlag, 1929.

4. Michael Wildt, "*Volksgemeinschaft*: A Modern Perspective National Socialist Society," in *Visions of Community in Nazi Germany: Social Engineering and Private Lives*, ed. Martina Steber and Bernhard Gotto, Oxford, Oxford University Press, 2014, pp. 42–49.

5. See Olivier Lugon, *August Sander: Landschaften*, exhibition catalogue, Cologne, Mediapark, 1999.

6. See Rolf Sachsse and Michael Euler-Schmidt, *August Sander: Köln wie es war*, Cologne, Kölnisches Stadtmuseum, 1988.

28 — LAURA GILPIN

1. On Laura Gilpin (Colorado Springs, Colorado, April 22, 1891–November 30, 1979, Santa Fe, New Mexico), see Martha Sandweiss, *Laura Gilpin: An Enduring Grace*, exhibition catalogue, Fort Worth, Texas, Amon Carter Museum, 1986. Gilpin's photographic and personal archives are now at the Amon Carter Museum in Fort Worth, Texas.

2. Laura Gilpin, *The Pikes Peak Region: Reproductions from a Series of Photographs*, Colorado Springs, The Gilpin Publishing Company, 1926; see

Terence R. Pitts, *The Early Work of Laura Gilpin, 1917–1932*, Tucson, Center for Creative Photography, University of Arizona, 1981.

3. Dry-mounted on paperboard. Inscribed in graphite on mount, lower right: Laura Gilpin / 1930; printed on a label on the verso of the mount, upper center: A PHOTOGRAPH BY / LAURA GILPIN / SANTA FE, NEW MEXICO; typewritten on label: WHITE HOUSE / 1930 / Canyon de Chelly.

4. Raphäelle Rolland-Francis, *Au cœur des rochers: Anthropologie du canyon de Chelly, parc national en terre navajo*, Paris, Harmattan, 2011; Jeanne M. Simonelli, *Crossing Between Worlds: The Navajos of Canyon de Chelly*, photographs by Charles D. Winters, Santa Fe, New Mexico, SAR Press, School of American Research, 1997.

5. See Robin Kelsey, *Archive Style: Photographs & Illustrations for U.S. Surveys, 1850–1890*, Berkeley, University of California Press, 2007.

6. Laura Gilpin, *The Pueblos: A Camera Chronicle*, New York, Hastings House, 1941.

7. Laura Gilpin, *Temples in Yucatán: A Camera Chronicle of Chichen Itzá*, New York, Hastings House, 1948.

8. Laura Gilpin, *The Rio Grande: River of Destiny; An Interpretation of the River, the Land, and the People*, New York, Duell, Sloan & Pearce, 1949.

9. Laura Gilpin, *The Enduring Navaho*, Austin, University of Texas Press, 1968.

10. Jonathan Goldberg, *Willa Cather and Others*, Durham, North Carolina, Duke University Press, 2000, pp. 148–80.

29 — DORIS ULMANN

1. On Doris Ulmann (New York, May 29, 1882–August 28, 1934, New York), see Philip Walker Jacobs, *The Life and Photography of Doris Ulmann*, Lexington, University Press of Kentucky, 2001; John Jacob Niles, "Doris Ulmann: As I Remember Her," in *The Appalachian Photographs of Doris Ulmann*, Penland, North Carolina, Jargon Society, 1971; David Featherstone, *Doris Ulmann: American Portraits*, Albuquerque, University of New Mexico Press, 1985. The principal repository of Ulmann's work is at the University of Oregon Libraries' Special Collections. A significant collection of her photographs, chiefly representing Appalachian subjects, are at the art gallery named for her at Berea College, in Berea, Kentucky.

2. On the Pictorial Photographers of America, see Marianne Fulton with Bonnie Yochelson and Kathleen A. Erwin, *Pictorialism into Modernism: The Clarence H. White School of Photography*, New York, Rizzoli, 1996; Peter Bunnell, *A Photographic Vision: Pictorial Photography, 1889–1923*, Salt Lake City, Peregrine Smith, 1980.

3. Doris Ulmann, *The Faculty of the College of Physicians and Surgeons, Columbia University in the City of New York: Twenty-Four Portraits*, New York,

Hoeber, 1920; *A Book of Portraits of the Faculty of the Medical Department of the Johns Hopkins University*, Baltimore, Johns Hopkins Press, 1922.

4. Doris Ulmann, *A Portrait Gallery of American Editors*, with critical essays by the editors and an introduction by Louis Evan Shipman, New York, W. E. Rudge, 1925.

5. See Ronald Pen, *I Wonder as I Wander: The Life of John Jacob Niles*, Lexington, University Press of Kentucky, 2010.

6. Doris Ulmann, "The Mountaineers of Kentucky: A Series of Portrait Studies," *Scribner's Magazine*, vol. 83, June 1928, pp. 675–81; Doris Ulmann, "Among the Southern Mountaineers: Camera Portraits of Types of Character Reproduced from Photographs Recently Made in the Highlands of the South," *The Mentor*, vol. 16, 1928, pp. 23–32. See also Niles 1971.

7. On Julia Mood Peterkin (1880–1961), see Susan Millar Williams, *A Devil and a Good Woman, Too: The Lives of Julia Peterkin*, Athens, University of Georgia Press, 1997. Peterkin's papers are at the South Carolina Historical Society in Charleston. A photographic portrait of Ulmann and Peterkin together is in the collection of the South Carolina Historical Society in Charleston.

8. Isadora Bennett, "Lang Syne's Miss: The Background of Julia Peterkin, Novelist of the South," *The Bookman*, vol. 69, June 1929, p. 359.

9. Peterkin's earlier writings include *Green Thursday: Stories* (New York, Alfred A. Knopf, 1924) and *Black April: A Novel* (New York, Indianapolis, Bobbs-Merrill, 1927).

10. See Patricia Jones-Jackson, *When Roots Die: Endangered Traditions on the Sea Islands*, Athens, University of Georgia Press, 1987.

11. Julia Mood Peterkin and Doris Ulmann, *Roll, Jordan, Roll*, trade edition, Indianapolis, Bobbs-Merrill, 1933.

12. The volume was titled after a popular 18th-century hymn by the English minister Charles Wesley, younger brother of Methodist founder John Wesley. It was introduced during the Second Great Awakening, when planters hoped to suppress their slaves with the promises of Christianity. However, the Jordan River was understood to symbolize the Mississippi or Ohio River, watercourses to the slave-free Northern states. The Wesley brothers visited the Georgia Colony in 1735–36, but it was not until a century later that the hymn became popular at camp meetings in Virginia and Kentucky. When score and lyrics were published in 1867 as the first entry in *Slave Songs of the United States* (William Francis Allen et al., eds., New York, A. Simpson, 1867), the spiritual was described as "one of the best known and noblest . . . from South Carolina down to Florida."

13. *Roll, Jordan, Roll* was published in two editions by Robert O. Ballou in New York: a trade edition, released on December 15, 1933, with

72 of Ulmann's photographs reproduced as offset-lithographs, and a "special edition," published in 1933. Of this special edition, 350 copies, each numbered and signed by Julia Peterkin and Doris Ulmann, were printed by letterpress and copper-plate photogravure; 327 are for sale. This copy is number 98.

14. On Allen Hendershott Eaton (1878–1962), see David B. Van Dommelen, *Allen H. Eaton: Dean of American Crafts*, Pittsburgh, Pennsylvania, Local History Company, 2004.

15. On this last trip, Ulmann exposed two thousand negatives. After her death they were passed to the New York commercial photographer Samuel H. Lifshey, who developed the plates and made proof prints. Niles organized them, and Eaton selected 58 photographs to illustrate his landmark book, *Handicrafts of the Southern Highlands* (New York, Russell Sage Foundation, 1937).

30 — ILSE BING

1. On Ilse Bing (Frankfurt, March 23, 1899–March 10, 1998, New York City), see Larisa Dryansky, *Ilse Bing: Photography Through the Looking Glass*, New York, Harry N. Abrams, 2006; Hilary Schmalbach, *Ilse Bing: Fotografien 1929–1956*, exhibition catalogue, Aachen, Suermondt-Ludwig-Museum, 1996.

2. She also created illustrations for the landmark study of photographic history that Guttmann wrote in collaboration with the art historian and philologist Helmuth Theodor Bossert; Helmuth Theodor Bossert and Heinrich Guttmann, *Aus der frühzeit der photographie, 1840–70; Ein bildbuch nach 200 originalen*, Frankfurt am Main, Societäts-verlag, 1930.

3. The photographed signature in the upper left of the image marks this as a later copy print. Inscribed in graphite on the verso, center: ILSE / BING / 1931.

4. "Famous German Woman Sees Life in New York as Transitory and Wild," *New York World-Telegram*, June 8, 1936.

5. Wolff (1907–1989) continued his distinguished career in the United States as a performer, teacher and scholar; his primary written work is *Masters of the Keyboard: Individual Style Elements in the Piano Music of Bach, Haydn, Mozart, Beethoven, and Schubert* (Bloomington, Indiana University Press, 1983).

6. Athina Alvarez, *Ilse Bing: Les collages, un album photographique revisité (1968–1993)*, 3 vols., Paris, Bibliothèque Nationale de France, Paris, 2014.

7. Nancy C. Barrett, *Ilse Bing: Three Decades of Photography*, exhibition catalogue, New Orleans Museum of Art, 1985; Françoise Reynaud, *Ilse Bing: Paris, 1931–1952*, exhibition catalogue, Musée Carnavalet, Paris Musées, 1987; Schmalbach 1996.

31 — BRASSAÏ

1. On Gyula Halász (Brassó, September 9, 1899–July 8, 1984, Beaulieu-sur-Mer, Alpes-Maritimes), see Peter Galassi, Stuart Alexander, and Antonio Muñoz Molina, *Brassaï*, Madrid, Fundación Mapfre, 2018; Sylvie Aubenas and Quentin Bajac, *Brassaï: Le flâneur nocturne*, Paris, Gallimard, 2012; Serge Sanchez, *Brassaï: Le promeneur de nuit*, Paris, Grasset, 2010.

2. See Brassaï, *Picasso and Company*, Garden City, New York, Doubleday, 1966; Brassaï, *The Artists of My Life*, New York, Viking Press, 1982.

3. Brassaï, *The Secret Paris of the 30s*, trans. Richard Miller, London, Thames & Hudson, 1976, p. 8.

4. "Une gauloise pour une certaine lumiére, une boyard s'il faisait plus sombre"; Richard Klein, *Cigarettes are Sublime*, Durham, Duke University Press, 1993, p. 24.

5. Tom Marotta and Jean-Claude Gautrand, "Brassaï: A Talk with the Great French Master," *Lens*, vol. 2, September–October 1977, p. 10.

6. Stamped in black ink on the verso, lower left: Tirage de l'Auteur; lower center: © COPYRIGHT BY / BRASSAÏ / 81, Faubourg St. Jacques / PARIS 14eme / Tél. 707.23.41; inscribed in graphite, lower right: Brassaï.

7. See Claude Dubois, *La Bastoche: Bal-musette, plaisir et crime, 1750–1939; "Paris entre chiens et loups,"* Paris, Éditions du Félin, 1997.

8. Brassaï, *Paris de nuit*, intro. by Paul Morand, Paris, Éditions "Arts et métiers graphiques," 1933 (English ed., *Paris by Night*, New York, Pantheon, 1987).

9. See Brassaï, *Camera in Paris*, London, Focal Press, 1949.

10. Lawrence Durrell, *Brassaï*, exhibition catalogue, New York, Museum of Modern Art, 1968.

11. See Brassaï 1976. In his lifetime, the photographer produced more than 35,000 images. Most of his negatives, prints and contact sheets are today housed at the George Pompidou Centre in Paris. Around 450 of them were included in a retrospective exhibition at the Centre Pompidou in 2000 (Alain Sayag, Annick Lionel-Marie, et al., *Brassaï*, Paris, Éditions du Seuil, 2000).

32 — BILL BRANDT

1. On Bill Brandt (Hamburg, Germany, May 2, 1904–December 20, 1983, London), see Paul Delany, *Bill Brandt: A Life*, Stanford, Stanford University Press, 2004; Bill Jay and Nigel Warburton, *Brandt: The Photography of Bill Brandt*, New York, Harry N. Abrams, 1999.

2. Delany 2004, pp. 13–18.

3. Bill Brandt, *The English at Home: Sixty-Three Photographs*, intro. by Raymond Mortimer, London, B. T. Batsford, 1936.

4. This print is ferrotyped, with meticulously trimmed thread margins, stamped in black ink on the verso: BILL BRAND[T]. The negative and print were not spotted, and tiny white spots are prominent, perhaps suggesting that this print was not meant for distribution. The dark tones of this print suggest that it may have been printed in the 1960s.

5. "Fortuite où nécessaire—qui sait, le recontre avec Pratt m'était en tout cas fatale." See Delany 2004, pp. 300–301, nn. 4–5. Brandt paraphrased Brassaï's answer (printed in *Minotaure*, vols. 3–4, December 1933) to a question posed by André Breton and Paul Éluard in a survey sent out to 300 people. Brassaï answered "Goethe." The date given in Brandt's note cannot be right, since the Viennese residency records place him at Pension Cottage on that day. The year before, 1928, he left Vienna for his first visit to England on March 25, and it seems most likely that he met Pratt then, though a few days after the 22nd.

6. Bill Brandt, "The Perfect Parlourmaid," *Picture Post*, vol. 4, July 29, 1939, pp. 43–47.

7. Brandt 1939, p. 44.

8. Bill Brandt, *A Night in London: Story of a London Night in Sixty-Four Photographs*, intro. by James Bone, London, Country Life/Paris, Arts et Métiers Graphiques/New York, Charles Scribner's Sons, 1938.

9. Brandt's shelter photographs were published in *Horizon* in February 1942. Years later, the magazine's editor, Cyril Connolly, wrote that *Elephant and Castle 3.45 a.m.* "eternalises for me the dreamlike monotony of wartime London."

10. "Young Poets of Democracy," *Lilliput*, December 1941; "A Gallery of Literary Artists," *Lilliput*, November 1949.

11. Bill Brandt, *Literary Britain*, intro. by John Hayward, London, Cassell, 1951; see also John Hayward and Mark Haworth-Booth, *Literary Britain: Photographed by Bill Brandt*, exhibition catalogue, London, Victoria and Albert Museum, 1984.

12. Quoted in Mark Haworth-Booth and David Mellor, *Bill Brandt, Behind the Camera: Photographs 1928-1983*, Millerton, New York, Aperture, 1985, p. 62.

13. Bill Brandt, *Perspective of Nudes*, preface by Lawrence Durrell, intro. by Chapman Mortimer, London, Amphoto, 1961; see also Mark Haworth-Booth, *Brandt Nudes: A New Perspective*, preface by Lawrence Durrell, New York, Thames & Hudson, 2013.

33 — ALFRED EISENSTAEDT

1. On Alfred Eisenstaedt (Tczew, Poland, December 6, 1898–August 23, 1995, Oak Bluffs, Massachusetts), see Alfred Eisenstaedt, *Eisenstaedt on Eisenstaedt: A Self-Portrait, Photos and Text*, intro. by Peter Adam, New York, Abbeville Press, 1985; Alfred Eisenstaedt, *Eisenstaedt: Remembrances*, ed. Doris C. O'Neil, intro. by Bryan Holme,

Boston, Little, Brown & Company, 1990.

2. Eisenstaedt 1985, p. 39.

3. Inscribed in black in on the recto, lower right: 'PREMIER AT LA SCALA — MILAN / Alfred Eisenstadt / 14/50' in ink in the margin, the photographer's credit/copyright/ reproduction rights and Time Inc. stamps, with title and date in pencil, on the reverse, 1933, this print 89/250, print at Time-Life Photo Lab, 1994.

4. See Nicolai Rimsky-Korsakov, *The Legend of the Invisible City of Kitezh and the Maiden Fevronia: An Opera in Four Acts*, libretto by Vladimir Ivanovich Belsky, trans. Harlow Robinson, *The Complete Works of Nicolai Rimsky-Korsakov*, Melville, New York, Belwin Mills, 1984.

5. Ben Cosgrove, "Behind the Picture: Joseph Goebbels Glares at the Camera, Geneva, 1933," *Time*, August 2, 2014,

6. See Lawrence Verria and George Galdorisi, *The Kissing Sailor: The Mystery Behind the Photo that Ended World War II*, Annapolis, Maryland, Naval Institute Press, 2012.

7. Alfred Eisenstaedt, *Witness to Our Time*, rev. ed., New York, Penguin Books, 1980; Alfred Eisenstaedt, *The Eye of Eisenstaedt*, ed. Arthur Goldsmith, New York, Viking Press, 1969.

8. Alfred Eisenstaedt, *Eisenstaedt: People*, New York, Viking Press, 1973.

9. Alfred Eisenstaedt, *Eisenstaedt: Germany*, ed. Gregory A. Vitiello, New York, Abrams, 1980.

34 — BARBARA MORGAN

1. Quoted by Barbara Confino, "Barbara Morgan: Photographing Energy and Motion," *Saturday Review of Literature*, October 7, 1972, pp. 62–66.

2. On Barbara Morgan (Buffalo, Kansas, 1900–1992, North Tarrytown, New York), see Deba Prasad Patnaik, *Barbara Morgan*, New York, Aperture Foundation, 1999; see also Curtis L. Carter and William C. Agee, *Barbara Morgan: Prints, Drawings, Watercolors & Photographs*, exhibition catalogue, Milwaukee, Patrick and Beatrice Haggerty Museum of Art, Marquette University/Dobbs Ferry, New York, Morgan & Morgan, 1988.

3. On Willard Detering Morgan (Snohomish, Washington, May 30, 1900–September 18, 1967, Bronxville, New York), see Jennifer Steensma, "The Willard D. Morgan Archive," MFA thesis, Rochester Institute of Technology, 1992; Michael Shuter, "Willard D. Morgan," MFA thesis, Rochester Institute of Technology, 1995.

4. On Martha Graham (May 11, 1894–April 1, 1991), see Martha Graham, *Blood Memory: An Autobiography*, New York, Doubleday, 1991.

5. See Andrea Lublinski, "Photographer Recalls Martha Graham Years," *New York Times*, April 1, 1984, section 22, p. 26.

6. Zoltán Kodály, *Lamentation*, for solo piano, op. 3, no. 2, 1910.

7. Maxine Elliott's Theatre, Shubert Theatre Corp., *Martha Graham*, concert program, January 8, 1930.

8. Don McDonough, *Martha Graham: A Biography*, New York, Praeger, 1973, p. 69.

9. See Anne Wilkes Tucker, *The Radical Camera: New York's Photo League, 1936–1951*, exhibition catalogue, New York, The Jewish Museum, 2011.

10. Barbara Morgan, *Martha Graham: Sixteen Dances in Photographs*, New York, Duell, Sloan & Pearce, 1941. A new edition of the book was published in 1980 (Dobbs Ferry, New York, Morgan & Morgan), with updated comments from the artists and a chronology of Graham's dances in 1926–1980, which lists each premiere date and location, performers, music and costumes.

11. Quoted in the press release for *Exhibition 283: Modern American Dance*, New York, Museum of Modern Art, March 28–April 29, 1945. After its presentation in New York, the show toured South America with the support of the Department of State and the National Gallery of Art.

12. The exhibition *Barbara Morgan: Photomontage* was presented at George Eastman House in Rochester, New York, at the time of the publication of Barbara Morgan, *Photomontage*, Dobbs Ferry, New York, Morgan & Morgan, 1980.

13. Morgan's stature as a modern master and trusted colleague to many American photographers was celebrated in a monographic issue of *Aperture* in 1964 (vol. 11, no. 1).

14. *Aperture*, vol. 11, no. 1, 1964. A second solo exhibition at the Museum of Modern Art was presented in 1972; see Peter C. Bunnell, *Barbara Morgan: Exhibition of Photography*, exhibition catalogue, New York, Museum of Modern Art, March 8–May 31, 1972.

35 — MANUEL ÁLVAREZ BRAVO

1. On Manuel Álvarez Bravo (Mexico City, February 4, 1902–October 19, 2002, Mexico City), see Laura González Flores and Gerardo Mosquera, *Manuel Álvarez Bravo*, exhibition catalogue, Paris, Jeu de Paume/ Madrid, Fundación Mapfre, 2012.

2. See Elizabeth Ferrer, *Lola Álvarez Bravo*, New York, Aperture, 2006.

3. See Leonard Folgarait, *Mural Painting and Social Revolution in Mexico, 1920–1940: Art of the New Order*, Cambridge/New York, Cambridge University Press, 1998.

4. See Masha Salazkina, *In Excess: Sergei Eisenstein's Mexico*, Chicago, University of Chicago Press, 2009, pp. 107–9.

5. Printed in 1977. Inscribed in graphite on the verso, lower right: M. Alvarez Bravo. / Mexico. / 45/100.

6. Angelina Beloff, *Memorias*, Mexico City, Universidad Nacional Autónoma de Mexico, 2000, p. 132.

7. On Isabel Villaseñor (Guadalajara, May 18, 1909–March 13, 1953, Mexico City), see Carmen Gómez del Campo y Leticia Torres Carmona, *En memoria de un rostro: Isabel Villaseñor*, Mexico City, LOLA de México, 1997; Judith Alanís Figueroa, *Chabela Villaseñor: Exposición retrospectiva*, Exhibition catalogue, Guadalajara, Instituto Cultural Cabañas, 1998.

8. André Breton, Wolfgang Paalen and Cesar Moro, *Exposicion International del Surrealismo*, exhibition catalogue, Mexico City, Galeria de Arte Mexicano, 1940; the show included four photographs by Álvarez Bravo.

9. See Fred R. Parker, *Manuel Alvarez Bravo*, exhibition catalogue, Pasadena, California, Pasadena Art Museum, 1971 (the show traveled to the George Eastman House in Rochester, New York, and the Museum of Modern Art in New York City); Jane Livingston and Anthony Castro, *M. Alvarez Bravo*, exhibition catalogue, Washington, D.C., Corcoran Gallery of Art, 1978.

36 — CLAUDE CAHUN

1. On Claude Cahun (Nantes, October 25, 1894–December 8, 1954, St. Helier, Jersey), see Jennifer L. Shaw, *Exist Otherwise: The Life and Works of Claude Cahun*, London, Reaktion Books, 2017; Gen Doy, *Claude Cahun: A Sensual Politics of Photography*, London, I. B. Tauris, 2008. Both of Lucy Schwob's paternal great-grandfathers, Leopold Schwob and Anselm Cahun, were noted rabbis. The Mazarin Library curator and orientalist scholar Léon Cahun was a great-uncle, and the writer Marcel Schwob, a founder of the literary magazine *Mercure de France*, was her uncle.

2. See Patrice Allain, "La famille Schwob," *Europe*, no. 925, May 2006, pp. 32–49. *Le Phare de la Loire* was a daily newspaper published in Nantes from 1852 to 1944. It was the last manifestation of a publication that had begun in 1782, managed by the Mangin family and then sold to the Schwob family. It was Nantes's main daily throughout its life, though it was banned from publication in the Liberation and replaced by *The Western Resistance*. In 1876, Evariste Mangin sold the newspaper to George Schwob (1822–1892), who then passed control to his son Maurice (1859–1928).

3. See Tirza True Latimer, "Acting Out: Claude Cahun and Marcel Moore," in Louise Downie, ed., *Don't Kiss Me: The Art of Claude Cahun and Marcel Moore*, New York, Aperture Foundation, 2006.

4. Léon Cahun (1841–1900) was a traveler, writer and orientalist curator at the Mazarin Library. Elisabeth-Christine Muelsch, *Zwischen Assimilation und jüdischem Selbstverständnis: David Léon Cahun (1841–1900); Ein Journalist und Jugendbuchautor im Umfeld der Dreyfus-Affäre*, Bonn, Romantischer Verlag, 1987.

5. Cahun became a friend and admirer of

Monnier, whose activities she described in an essay in *La Gerbe*. See Adrienne Monnier, *The Very Rich Hours of Adrienne Monnier*, trans. Richard McDougall, Lincoln, University of Nebraska Press, 1996; Laure Murat, *Passage de l'Odéon: Sylvia Beach, Adrienne Monnier et la vie littéraire à Paris dans l'entre-deux-guerres*, Paris, Fayard, 2003.

6. Claude Cahun, *Aveux non avenus*, Paris, Éditions du Carrefour, 1930. The title *Aveux non avenus* does not lend itself to facile translation. While *Aveux* may be clearly understood as either "avowals" or "confessions," the addition of the phrase *non avenus*, which indicates that which has "not happened," renders the formulation opaque. Most English-speaking scholars choose to translate "non avenus" loosely as "disavowed," which contains both "avow" and its negation. This play on words captures the spirit of the title, which references, with the word "confessions," an entire autobiographical tradition while canceling it out in the next breath.

7. In the 1920s Soviet artists such as Gustav Klutsis and Valentina Kulagina, and Alexander Rodchenko (Cat. no. 23) and Varvara Stepanova, experimented with photomontage, and the first retrospective consideration of the medium was mounted in Berlin in 1931 (Curt Glaser, ed., *Fotomontage: Ausstellung im Lichthof des ehemaligen Kunstgewerbemuseums*, exhibition catalogue, Berlin, Reckendorf, 1931); see also Elza Adamowicz, *Surrealist Collage in Text and Image: Dissecting the Exquisite Corpse*, Cambridge/New York, Cambridge University Press, 1998.

8. The images of *Aveux non avenus* are usually ascribed to Cahun, though they are certainly collaborative works. It has been claimed recently that Marcel Moore either made the photocollages herself or was an equal partner in their making with Cahun (Latimer in Downie 2006, p. 56; Jennifer Shaw, "Narcissus and the Magic Mirror," in Downie 2006, pp. 33–45). It is true that the first photomontage in the book, the original of which is owned now by the National Gallery of Australia, is signed by Moore. Beyond that, it seems reasonable to accept the attribution given in the book's frontispiece: "Illustrated with Heliogravures Composed by Moore after Plans [Projets] Made by the author." If Moore had played a more significant role in the creation of the images, it seems likely that it would have been acknowledged more clearly here.

9. Lise Deharme's *Le coeur de pic* (Paris, MeMo, 1931) is a collection of 32 Surrealist children's poems accompanied by 20 illustrations by Claude Cahun; Lise Deharme, *Le coeur de pic: Trente-deux poèmes pour les enfants*, Nantes, Éditions MeMo, 2004; Andrea Oberhuber, "Claude Cahun, Marcel Moore, Lise Deharme and the Surrealist Book," *History of Photography*, vol. 31, no. 1, 2007, p. 40.

10. Claude Cahun, "Prenez garde aux objets domestiques," *Cahiers d'Art*, vol. 11, May 22–28, 1936, pp. 43, 46.

11. In 1951 Cahun was awarded the *Médaille d'argent de la reconnaissance française* for her wartime efforts. By that time her health was deteriorating, as failing eyesight accompanied kidney and respiratory problems. After her death in December 1954, Moore moved to a smaller house at Beaumont, Jersey, where she lived for nearly 20 years before her death from suicide.

37 — HERBERT BAYER

1. On Herbert Bayer (Haag am Hausruck, Austria, April 1900–September 30, 1985, Montecito, California), see Arthur A. Cohen, *Herbert Bayer: The Complete Work*, Cambridge, Massachusetts, MIT Press, 1984.

2. On Bayer as a photographer, see Beaumont Newhall, *Herbert Bayer: Photographic Works, An Exhibition*, exhibition catalogue, Los Angeles, Arco Center for Visual Art, 1977.

3. Julie Saul, *Moholy-Nagy Fotoplastiks: The Bauhaus Years*, exhibition catalogue, New York, Bronx Museum of the Arts, 1983.

4. Piet Mondrian, "De nieuwe beelding in de schilderkunst," *De Stijl*, vol. 1, nos. 1–12, 1917–18; "Neoplasticim in Pictorial Art," in *The New Art—The New Life: The Collected Writing of Piet Mondrian*, ed. and trans. Harry Holtzman and Martin S. James, New York, Da Capo, 1993, p. 37.

5. Jan Van der Marck, *Herbert Bayer: From Type to Landscape, Designs, Projects & Proposals, 1923–73*, exhibition catalogue, Hanover, New Hampshire, Dartmouth College Museum and Galleries, 1977, p. 28.

6. Herbert Bayer, Walter Gropius, and Ise Gropius, eds., *Bauhaus, 1919–1928*, exhibition catalogue, New York, Museum of Modern Art, 1938 (reprint, New York, Abrams, 1975).

7. Carl Sandberg, *Road to Victory: A Procession of Photographs of the Nation at War; Directed by Lt. Comdr. Edward Steichen, U.S.N.R.*, exhibition catalogue, New York, Museum of Modern Art, 1942.

8. See Bernhard Widder, *Architektur, Skulptur, Landschaftsgestaltung*, Vienna, Springer, 2000.

38 — DOROTHEA LANGE

1. On Dorothea Lange (Hoboken, New Jersey, May 25, 1895– October 11, 1965), see Linda Gordon, *Dorothea Lange: A Life Beyond Limits*, New York, W. W. Norton & Co., 2009; Milton Meltzer, *Dorothea Lange: A Photographer's Life*, Syracuse, New York, Syracuse University Press, 2000.

2. Lange and Dixon had two sons, Daniel Rhodes Dixon (1925–2009) and John Eaglefeather Dixon (1930–2016).

3. On Lois Bryan Jordan (1883–1949), see John Freeman, "Lois Jordan, the Shadowy White Angel," *San Francisco Bay Area Post Card Club*, vol. 23, no. 10, November 2008, pp. 2–3.

4. *San Francisco Call*, June 13, 1932.

5. Since the White Angel Jungle closed on February 19, 1933, and Lange wrote about having a print pinned on her studio wall for some weeks, it seems reasonable to speculate that the photograph was taken during 1932.

6. This print was seemingly made in the 1960s. Stamped in black ink on the verso: PHOTOGRAPHY BY / DOROTHEA LANGE / 1163 EUCLID AVENUE / BERKELEY / CALIFORNIA.

7. On Roy Stryker and the FSA, see the Arthur Rothstein entry (Cat. no. 41) in this volume. See also Howard M. Levin and Katherine Northrup, eds., *Dorothea Lange: Farm Security Administration Photographs, 1935–1939*, 2 vols., Glencoe, Illinois, Text-Fiche Press, 1980.

8. "The Harvest Gypsies" is a series of articles commissioned from John Steinbeck by the *San Francisco News* and published daily from October 5 to 12, 1936. Reporting on migrant workers in the Central Valley, they describe the hardships of the Great Depression in California. "The Harvest Gypsies" project provided Steinbeck with the source material for his novels centered around migrant labor: *Of Mice and Men* (New York, Collier, 1937) and *The Grapes of Wrath* (New York, Viking, 1939).

9. Dorothea Lange and Paul Schuster Taylor, *An American Exodus: A Record of Human Erosion*, New York, Reynal & Hitchcock, 1939. See also Jan Goggans, *California on the Breadlines: Dorothea Lange, Paul Taylor, and the Making of a New Deal Narrative*, Berkeley, University of California Press, 2010.

10. See Linda Gordon and Gary Y. Okihiro, eds., *Impounded: Dorothea Lange and the Censored Images of Japanese American Internment*, New York, W. W. Norton, 2006.

11. George P. Elliott, *Dorothea Lange*, exhibition catalogue, New York, Museum of Modern Art, 1966.

39 — WALKER EVANS

1. On Walker Evans (Saint Louis, Missouri, November 3, 1903–April 10, 1975, New Haven, Connecticut), see Clément Chéroux, ed., *Walker Evans*, exhibition catalogue, Paris, Centre Pompidou, 2017; Judith Keller, *Walker Evans: The Getty Museum Collection*, Malibu, J. Paul Getty Museum, 1995.

2. A precocious Harvard student, Kirstein hired Evans to photograph Victorian architecture to illustrate a research project. A selection of these images was shown in 1933 at the Museum of Modern Art in New York; see Lincoln Kirstein, *Walker Evans: Photographs of Nineteenth-Century Houses*, exhibition catalogue, New York, Museum of Modern Art, 1933.

3. Walker Evans, oral history interview by Paul Cummings, Connecticut, October 13, 1971, and New York City, December 23, 1971, Archives of American Art, Smithsonian Institution.

4. Printed in 1971, this photograph is mounted on ragboard, within an embossed platemark. Inscribed in graphite on the mount beneath the sheet, lower left: XIII 21/100 1936 1971; lower right: Walker Evans. It was published in the portfolio *Walker Evans* (New Haven, Ives-Sillman, 1971, edition of 100), a suite of 14 photographs printed under the photographer's supervision in 1971, and published by Yale colleagues Norman Ives and Sewell Sillman at the time of Evans's retrospective exhibition at the Museum of Modern Art. The portfolio includes a preface by Evans and an introduction by Robert Penn Warren.

5. Walker Evans, oral history interview by Paul Cummings, Connecticut, October 13, 1971, and New York City, December 23, 1971.

6. Ibid.

7. Carleton Beals, *The Crime of Cuba*, with 31 aquatone illustrations from photographs by Walker Evans, Philadelphia, J. B. Lippincott Company, 1933.

8. On the Resettlement Administration and the Farm Security Administration, see the Rothstein entry in this volume.

9. Lincoln Kirstein, *American Photographs*, exhibition catalogue, New York, Museum of Modern Art, 1938 (reprint, New York, East River Press, 1975).

10. David Campany, *Walker Evans: The Magazine Work*, Göttingen, Steidl, 2014.

11. James Agee, *Let Us Now Praise Famous Men: Three Tenant Families*, with photographs by Walker Evans, Boston, Houghton Mifflin, 1941 (new ed., Boston, Houghton Mifflin, 1961).

12. Walker Evans, *Many Are Called*, intro. by James Agee, New Haven, Yale University Press, in association with the Metropolitan Museum of Art, 2004.

13. John Szarkowski, *Walker Evans*, exhibition catalogue, New York, Museum of Modern Art, 1971.

40 — BERENICE ABBOTT

1. On Berenice Abbott (Springfield, Ohio, July 17, 1898–December 10, 1991, Monson, Maine), see Julia Van Haaften, *Berenice Abbott: A Life in Photography*, New York, W. W. Norton & Company, 2018; Gaëlle Morel, *Berenice Abbott*, Paris, Éditions Hazan, 2012; Terri Weissman, *The Realisms of Berenice Abbott: Documentary Photography and Political Action*, Berkeley, University of California Press, 2011.

2. Ron Kurtz and Hank O'Neal, eds., *Berenice Abbott: Paris Portraits, 1925–1930*, London, Thames & Hudson, 2012.

3. Elizabeth McCausland, "The Photography of Berenice Abbott," *Trend*, vol. 3, no. 1, March–April, 1935, p. 17; this was the first critical review of the photographer's work. See also Garnett McCoy, "Elizabeth McCausland: Critic and Idealist," *Archives of American Art Journal*, vol. 6, April 1966, pp. 16–20.

4. Stamped in purple ink on the verso: FEDERAL ART PROJECT / "Changing New York" / PHOTOGRAPHS BY BERENICE ABBOTT [in a rectangle]; stamped form in purple ink: Title: *West Street Row: I / 178–183 West Street, Manhattan* [in graphite] / Angle of View: / Date: *Apr 8 1936* [in graphite] / Neg.# *98* [in graphite] / Code: *I A2 & I / II C I* [in graphite].

5. Berenice Abbott and Elisabeth McCausland, *Changing New York*, New York, E .P. Dutton, 1939 (reprinted as *New York in the Thirties*, New York, Dover, 1973); see also Bonnie Yochelson, *Berenice Abbott at Work: The Making of Changing New York*, New York, New Press, Museum of the City of New York, 1997.

6. Berenice Abbott, *A Guide to Better Photography*, New York, Crown Publishers, 1941; Berenice Abbott, *The View Camera Made Simple*, Chicago, Ziff-Davis, 1948.

7. Physical Science Study Committee, *Physics*, Boston, D. C. Heath & Co., 1960; see also Berenice Abbott, *The Beauty of Physics*, New York, New York Academy of Sciences, 1986.

41 — ARTHUR ROTHSTEIN

1. On the Farm Security Administration photography program, see Roy Emerson Stryker and Nancy Wood, eds., *In This Proud Land: America 1935–1943, As Seen in the FSA Photographs*, Greenwich, Connecticut, New York Graphic Society, 1973; F. Jack Hurley, *Portrait of a Decade: Roy Stryker and the Development of Documentary Photography in the Thirties*, Baton Rouge, Louisiana State University Press, 1972.

2. On Arthur Rothstein (Harlem, New York, July 17, 1915–November 11, 1985, New Rochelle, New York), see George Packer, *The Photographs of Arthur Rothstein*, Washington, D.C., Library of Congress, 2011; "Interview: Arthur Rothstein Talks with Richard Doud," *Archives of American Art Journal*, vol. 17, no. 1, 1977, pp. 19–23.

3. See Michael V. Namorato, *Rexford G. Tugwell: A Biography*, New York, Praeger, 1988.

4. See R. Douglas Hurt, *The Dust Bowl: An Agricultural and Social History*, Chicago, Nelson-Hall, 1981; Vance Johnson, *Heaven's Tableland: The Dust Bowl Story*, New York, Farrar, Straus, 1947.

5. In mid-April 1935, the Associated Press reporter Robert E. Geiger witnessed the dust storms in Boise City, Oklahoma. He submitted his story to Edward Stanley, his editor in Kansas City, who inserted the term "Dust Bowl" in his revision of Geiger's report; see H. L. Mencken and Raven I. McDavid Jr., *The American Language: An Inquiry into the Development of English in the United States*, 4th ed., New York, Knopf, 1977, p. 206.

6. John Steinbeck, *The Grapes of Wrath*, New York, The Viking Press, 1939.

7. Hank O'Neal, *A Vision Shared: A Classic Portrait of America and Its People, 1935–1943*, New York, St.

Martin's Press, 1976, p. 21. See also Arthur Rothstein, *The American West in the Thirties*, New York, Dover Publications, 1978; Arthur Rothstein, *The Depression Years*, New York, Dover Publications, 1978.

8. The Snite Museum print is thought to have made in the mid-1970s. Inscribed in china marker below the image, lower right: Arthur Rothstein; inscribed in graphite on the verso, upper right: illus p85 / 'Portrait of a Decade' / by F.J. Hurley — plate 184 / 'In this Proud Land' / by R. Stryker; stamped in black ink, lower left: ARTHUR ROTHSTEIN / 122 SUTTON MANOR / NEW ROCHELLE, N.Y. 10805; lower center: RETURN TO / ARTHUR ROTHSTEIN; stamped in red ink, lower right: PHOTOGRAPH BY / ARTHUR ROTHSTEIN.

9. Arthur Rothstein, *Photojournalism: Pictures for Magazines and Newspapers*, New York, American Photographic Book Publishing Co., 1956.

42 — HELEN LEVITT

1. On Helen Levitt (Brooklyn, August 31, 1913–March 29, 2009, New York), see Sandra S. Phillips and Maria Morris Hambourg, *Helen Levitt*, exhibition catalogue, San Francisco, San Francisco Museum of Modern Art, 1991; Peter Weiermair, *Helen Levitt*, exhibition catalogue, Frankfurt, Frankfurter Kunstverein, 1998.

2. See Alex Harris and Marvin Hoshino, eds., *In the Street: Chalk Drawings and Messages, New York City 1938–1948*, Durham, North Carolina, Duke University Press, 1987; Helen Levitt and Geoff Dyer, *One, Two, Three, More*, Brooklyn, powerHouse Books, 2017.

3. Helen Levitt and James Agee, *A Way of Seeing*, New York, Horizon Press, 1965.

4. Bosley Crowther, "'The Quiet One,' Documentary of a Rejected Boy, Arrives at the Little Carnegie," *New York Times*, February 14, 1949, p. 15.

5. *Slideshow: The Color Photographs of Helen Levitt*, foreword by John Szarkowski, Brooklyn, powerHouse Books, 2001.

43 — HAROLD E. EDGERTON

1. On Harold Eugene Edgerton (Fremont, Nebraska, April 6, 1903– January 4, 1990, Cambridge, Massachusetts), see James L. Enyeart et al., *Seeing the Unseen: Dr. Harold E. Edgerton and the Wonders of Strobe Alley*, Rochester, New York, George Eastman House/Cambridge, Massachusetts, MIT Press, 1994.

2. Marked with cropping lines in orange pencil on the recto, in four margins; inscribed in graphite on the verso, upper right: WP 10-3; upper center: 7½" × 3¼" / 43 [in a circle]; stamped in blue ink, center: HAROLD E.EDGERTON / SEPT 12 1961 / M.I.T. CAMBRIDGE, MASS. [in a

rectangle]; stamped in black ink, lower left: © 1961 Estate of / 10.621 [in graphite] / HAROLD E. EDGERTON [in a rectangle]; inscription scribbled over in blue crayon, left center; inscribed in black ballpoint pen, lower right: please return to ; stamped in blue ink, lower right: H.E. EDGERTON / 4-405 / CAMBRIDGE, MASS.; stamped, lower right: 933026.

3. Harold E. Edgerton and James R. Killian Jr., *Flash! Seeing the Unseen by Ultra High-Speed Photography*, Boston, Hale, Cushman & Flint, 1939, p. 103; see also Estelle Jussim, *Stopping Time: The Photographs of Harold Edgerton*, New York, H. N. Abrams, 1987, p. 52.

4. See Gjon Mili, *Picasso's Third Dimension*, New York, Triton, 1970; Gjon Mili, *Gjon Mili: Photographs & Recollections*, Boston, New York Graphic Society, 1980.

5. Harold E. Edgerton, "Hummingbirds in Action," *National Geographic*, vol. 92, August 1947, pp. 220–32, was the first of these.

6. See Frederic Dumas, *30 Centuries Under the Sea*, New York, Crown Publishers, 1976.

44 — ERNEST KNEE

1. On Ernest Knee (Montreal, May 15, 1907–October 7, 1982 Santa Fe), see Dana Knee, ed., *Ernest Knee in New Mexico: Photographs 1930–1940s*, foreword by Robert A. Ewing, intro. by Catherine Williamson, Santa Fe, Museum of New Mexico Press, 2005.

2. On Gina Schnauffer Knee Brook (Marietta, Ohio, Oct 31, 1898–December 1982, Suffolk, New York), see Sharyn Rohlfsen Udall, *Inside Looking Out: The Life and Art of Gina Knee*, Lubbock, Texas Tech University Press, 1994.

3. Knee's photographs later illustrated Mabel Dodge Luhan's book *Winter in Taos* (New York, Harcourt, Brace & Company, 1935). See also Mabel Dodge Luhan, *Intimate Memories: The Autobiography of Mabel Dodge Luhan*, ed. Lois Palken Rudnick, Santa Fe, Sunstone Press, 2008.

4. Knee 2005, p. 8.

5. Inscribed in blue ballpoint pen on the verso: Ernest Knee / La Manga; inscribed in graphite: Ernest Knee.

6. Ernest Knee, *Santa Fe, New Mexico*, New York, Hastings House, 1942.

7. Juan Javier Pescador, *Crossing Borders with the Santo Niño de Atocha*, Albuquerque, University of New Mexico Press, 2009.

8. Donald L. Barlett and James B. Steele, *Howard Hughes: His Life & Madness*, New York, W. W. Norton, 2004.

9. During World War II, the H-4 was designed to transport troops and equipment in low flights to avoid submarine attack. Congress appropriated $18 million for three prototypes; Hughes Aircraft built only one before the war ended. Hughes himself piloted the Spruce Goose on its maiden flight in Long Beach Harbor on November 2, 1947. See John J. McDonald, *Howard Hughes and the Spruce Goose*, Blue Ridge Summit, Pennsylvania, TAB Books, 1981.

10. See Fausto Grisi, *Salto Angel*, Caracas, Amazonas Adventures, 1992; Ruth Robertson, *Churún Merú, the Tallest Angel: Of Jungles and Other Journeys*, Ardmore, Pennsylvania, Whitmore, 1975.

11. Ruth Robertson, "Jungle Journey to the World's Highest Waterfall," *National Geographic*, November 1949. Ruth Robertson returned to write and publish the story in *National Geographic*, and was credited with many of Knee's photographs.

45 — WRIGHT MORRIS

1. On Wright Marion Morris (January 6, 1910, Central City, Nebraska–April 25, 1998, Mill Valley, California), see Jackson J. Benson, *Haunted: The Strange and Profound Art of Wright Morris: A Biography and A Photo Gallery*, Bloomington, Indiana, Xlibris, 2013; Joseph J. Wydeven, *Wright Morris Revisited*, New York, Twayne Publishers, 1998. Aside from his three volumes of memoir, see Wright Morris, *A Cloak of Light: Writing My Life*, New York, Harper & Row, 1985.

2. Wright Morris, *Will's Boy*, New York, Harper & Row, 1981.

3. Wright Morris, *Solo: An American Dreamer in Europe, 1933–34*, New York, Harper & Row, 1983.

4. Wright Morris, *My Uncle Dudley*, Westport, Connecticut, Greenwood Press, 1942.

5. Wright Morris, *The Inhabitants: Text and Photographs by Wright Morris*, New York, Charles Scribner's Sons, 1946.

6. Wright Morris, *The Home Place*, New York, Charles Scribner's Sons, 1948.

7. Morris 1948, p. 64.

8. Wright Morris, *The Field of Vision*, New York, Harcourt, Brace, 1956. The author published five novels over the next 10 years: *Ceremony in Lone Tree* (1960), *What a Way to Go* (1962), *Cause for Wonder* (1963), *One Day* (1965) and *In Orbit* (1969). Four more appeared during the 1970s: *Fire Sermon* (1971), *War Games* (1972), *A Life* (1973) and *The Fork River Space Project* (1977).

9. Wright Morris, *God's Country and My People*, New York, Harper & Row, 1968.

10. Sandra S. Phillips and John Szarkowski, *Wright Morris: Origin of a Species*, exhibition catalogue, San Francisco, San Francisco Museum of Modern Art, 1992; Alan Trachtenberg and Ralph Lieberman, *Distinctly American: The Photography of Wright Morris*, exhibition catalogue, Stanford, The Iris & B. Gerald Cantor Center, Stanford University, 2002.

46 — ANSEL ADAMS

1. Ansel Adams (San Francisco, February 20, 1902–April 22, 1984, Monterey, California) left the manuscript of an unfinished autobiography at his death—*Ansel Adams: An Autobiography*—which was later completed by his editor: Mary Street Alinder, *Ansel Adams: A Biography*, New York, H. Holt, 1996. See also Jonathan Spaulding, *Ansel Adams and the American Landscape: A Biography*, Berkeley, University of California Press, 1995.

2. On Group *f*.64, see Edward Weston (Cat. no. 16) in this volume.

3. Ansel Adams, *Making a Photograph: An Introduction to Photography*, London, The Studio, 1935.

4. Ansel Adams and Robert Baker, *The Negative*, vol. 2 of *The New Ansel Adams Photography Series*, Boston, New York Graphic Society, 1948; Minor White, *The New Zone System Manual*, Dobbs Ferry, New York, Morgan & Morgan, 1976.

5. This is one of three Adams photographs, acquired by the Snite Museum in 1975, which were printed in or around 1968. The present print is mounted on four-ply museum board. Inscribed in graphite on the recto below the sheet: Ansel Adams; stamped in black ink on the verso, center: Photograph by Ansel Adams / Route 1 Box 181 Carmel, California 93921; inscribed in black ink: Winter Sunrise, Sierra Nevada / from Lone Pine, California.

6. Andrea Gray Stillman, ed., *Ansel Adams: 400 Photographs*, New York, Little, Brown, 2007, p. 422.

7. Ansel Adams and Nancy Newhall, *This Is the American Earth*, San Francisco, Sierra Club, 1960.

47 — MARGARET BOURKE-WHITE

1. On Margaret Bourke-White (New York, June 14, 1904–August 27, 1971, Stamford, Connecticut), see Margaret Bourke-White, *Portrait of Myself*, New York, Simon & Schuster, 1963; Vicki Goldberg, *Margaret Bourke-White: A Biography*, Addison-Wesley Publishing Company, 1986.

2. Bourke-White 1963, p. 18.

3. See Bourke-White 1963, pp. 61–66; Alan Brinkley, *The Publisher: Henry Luce and his American Century*, New York, Alfred A. Knopf, 2010.

4. Margaret Bourke-White, *Eyes on Russia*, preface by Maurice Hindus, New York, Simon & Schuster, 1931.

5. Erskine Caldwell and Margaret Bourke-White, *You Have Seen Their Faces*, New York, Modern Age Books, 1937 (reprint, New York, Arno Press, 1975). See Bourke-White 1963, pp. 122–39. In their three years together, Bourke-White and Caldwell collaborated on two other books: *North of the Danube* (New York, Viking Press, 1939) and *Say, Is This the U.S.A.?* (New York, Duell, Sloan, & Pearce, 1941).

6. "Women in Steel: They Are Handling Tough

Jobs in Heavy Industry," *LIFE*, August 9, 1943, p. 48.

7. *LIFE*, September 1, 1941.

8. Goldberg 1986, pp. 104–5.

9. Inscribed on the recto in felt-tip pen, lower left: 27/250; blindstamped on the recto, lower right, facsimile signature: Margaret Bourke-White; inscribed in graphite on the verso, upper left: Print made at Kelton Labs, 2005; upper right: © Time Inc. / All Rights Reserved; stamped in black ink, lower right: [in double rectangle] LIMITED EDITION PRINT ISSUED BY: / LIFE Gallery of Photography / in association with the / Estate of Margaret Bourke White.

10. One of the publications that responded was the *Saturday Evening Post*, with its famous cover by Norman Rockwell, representing Rosie the Riveter, published on Memorial Day, May 29, 1943. The illustrator, who worked from photographs rather than living models, hired Gene Pelham to make images of a local Vermont teenager. He set Mary Doyle in the pose of Michelangelo's prophet Isaiah from the Sistine Chapel ceiling. At the easel, Rockwell combined Michelangelo's brawny physique with the young woman's delicate features. He placed a pneumatic rivet gun across her lap, and filled the image with American allegorical details. Rockwell's original painting *Rosie the Riveter* is now in the collection of the Crystal Bridges Museum of American Art, Bentonville, Arkansas (2007.178).

11. Redd Evans and John Jacob Loeb, "Rosie the Riveter," New York, Paramount Music Corp., 1942.

12. Margaret Bourke-White and Alfred Eisenstaedt, "Famous Lady's Indomitable Fight," *LIFE*, vol. 46, June 22, 1959, pp. 101–9; Bourke-White 1963, pp. 358–80.

48 — W. EUGENE SMITH

1. On W. Eugene Smith (Wichita, Kansas, December 30, 1918–October 15, 1978, Tucson, Arizona), see Katherine Martinez, William Johnson, John Berger, et al., *Eugene Smith: The Big Book*, 3 vols., Austin, University of Texas Press/Tucson, Center for Creative Photography, University of Arizona, 2013; Jim Hughes, *W. Eugene Smith: Shadow and Substance; The Life and Work of an American Photographer*, New York, McGraw-Hill, 1989.

2. Smith's college letters to his mother are preserved in the W. Eugene Smith Archive, Center for Creative Photography, University of Arizona, Tucson. See also William Johnson, "W. Eugene Smith: 1938–1951," *Center for Creative Photography*, no. 12, July 1980, pp. 5–20.

3. W. Eugene Smith to Lettie Smith, October 25, 1936.

4. W. Eugene Smith to Lettie Smith, March 1, 1937.

5. Signed in black ink on the mount, below the sheet, lower right: W. Eugene Smith; printed on a label on the verso of the mount, lower left: W. EUGENE SMITH / A PORTFOLIO OF | TEN PHOTOGRAPHS / A portfolio of 10 original prints / by W. Eugene Smith. / A limited edition of / 25 portfolios, this being / print No. 5 / of portfolio No. 5 / Published July 1977 by / Witkin-Berley Ltd. / 34 Sherwood Lane / Roslyn Heights, N.Y., 11577.

6. Robert Sherrod, "Saipan: Eyewitness Tells of Island Fight," photographs by Peter Stackpole and W. Eugene Smith, *LIFE*, vol. 17, August 28, 1944, pp. 75–83 (variant of this image p. 78).

7. See Barbie Zelizer, "War and Conflict through Magnum's Eyes," in *Reading Magnum: A Visual Archive of the Modern World*, Harry Ransom Center Photography Series, ed. Steven Hoelscher, Austin, University of Texas Press, 2013, pp. 42–43.

8. W. Eugene Smith, "The Struggle to Save," unpublished manuscript, ca. 1945, Center for Creative Photography, University of Arizona, Tucson, p. 6.

9. W. Eugene Smith, "Americans Battle for Okinawa: 24 Hours with Infantryman Terry Moore," *LIFE*, vol. 18, June 18, 1945, pp. 18–25.

49 — ROBERT CAPA

1. On Robert Capa (Budapest, Hungary, October 22, 1913–May 25, 1954, Thái Bình, Vietnam), see Richard Whelan, *Robert Capa: The Definitive Collection*, London, Phaidon, 2001. Capa's negatives and papers are archived at the International Center of Photography, New York.

2. Jane Rogoyska, *Gerda Taro: Inventing Robert Capa*, London, Jonathan Cape, 2013; Marc Aronson and Marina Budhos, *Eyes of the World: Robert Capa, Gerda Taro, and the Invention of Modern Photojournalism*, New York, Henry Holt & Company, 2017.

3. Juan P. Fusi Aizpúrua, Richard Whelan, and Catherine Coleman, *Heart of Spain: Robert Capa's Photographs of the Spanish Civil War*; *From the Collection of the Museo Nacional Centro de Arte Reina Sofia*, New York, Aperture Foundation, 1999; Cynthia Young, *The Mexican Suitcase: The Legendary Spanish Civil War Negatives of Robert Capa, Gerda Taro, and David Seymour*, Göttingen, Steidl, 2010.

4. Richard Whelan, "Proving that Robert Capa's 'Falling Soldier' is Genuine: A Detective Story," *Aperture*, no. 166, Spring 2002, pp. 48–55.

5. Capa memorialized their war experiences in his book *Death in the Making* (New York, Convici-Friede, 1938).

6. "Beachheads of Normandy: The Fateful Battle for Europe Is Joined by Sea and Air," *LIFE*, vol. 16, June 19, 1944, pp. 25–32; see also John Morris, "D-Day / 60 Years Later: 'This Is It': How Robert Capa Got the Pictures," *New York Times*, June 5, 2004.

7. Capa recalled in a radio interview in 1947; see Alex Kershaw, *Blood and Champagne: The Life and Times of Robert Capa*, London, Macmillan, 2003, pp. 154–55.

8. Robert Capa, *Slightly Out of Focus*, New York, H. Holt, 1947, p. 241.

9. Inscribed in graphite on the verso, upper right: 12 [in a circle]; stamped in purple ink, upper center: ALL MAGAZINE RIGHTS RESERVED / MAGNUM PHOTOS, INC.; FOR ONE TIME NEWSPAPER – / REPRODUCTION ONLY; center: PLEASE CREDIT / ROBERT CAPA – MAGNUM / MAGNUM PHOTOS INC. / 15 Wes … / New York [in a rectangle]; lower center: Please credit: ROBERT CAPA — MAGNUM / COURTESY — LIFE MAGAZINE.

10. "An Episode: Americans Still Died," *LIFE*, vol. 18, May 14, 1945, pp. 40B–C.

11. Kershaw 2003, pp. 154–55; Richard Whelan, *Robert Capa: A Biography*, New York, Knopf, 1985, p. 237.

12. On Magnum, see the David Seymour entry (Cat. no. 61) in this volume.

13. John Steinbeck, *A Russian Journal*, pictures by Robert Capa, New York, Viking Press, 1948.

50 — MAN RAY

1. On Man Ray (Philadelphia, August 27, 1890–November 18, 1976, Paris), see Alain Sayag and Emmanuelle de L'Ecotais, *Man Ray*, Paris, Delpire, 2015; Serge Sanchez, *Man Ray*, Paris, Gallimard, 2014.

2. Clement Cheroux, ed., *Man Ray, Portraits: Paris, Hollywood, Paris; From the Man Ray Archives of the Centre Pompidou*, Munich, Schirmer/Mosel, 2011.

3. See Jennifer Mundy, ed., *Duchamp, Man Ray, Picabia*, London, Tate Publications, 2008.

4. Federica Muzzarelli, *Lee Miller/Man Ray: Arte, moda, fotografia*, Valsamoggia, Bologna, Atlante, 2016; Carolyn Burke, *Lee Miller: A Life*, New York: Knopf, 2005.

5. Emmanuelle de L'Ecotais, *Man Ray: Rayographies*, Paris, L. Scheer, 2002.

6. Jennifer Mundy, ed., *Man Ray: Writings on Art*, Los Angeles, Getty Research Institute, 2015, p. 221.

7. Stamped in black ink on the verso: MAN RAY / PARIS.

8. This series was acquired by the Moderna Museet in Stockholm: see Mundy 2015, no. 108, pp. 274–91. The following year a variant series was shown at the Julien Levy Gallery in New York, with a catalogue designed by Duchamp and an essay written by him: Marcel Duchamp, *Man Ray: Objects of My Affection*, 1945, photomechanical relief print, 29.4 × 23 cm (11⅝ × 9 in.) sheet, Philadelphia Museum of Art, Gift of Mme Marcel Duchamp, 1973-208-1.

9. See Man Ray, "Preface from a Proposed Book: One Hundred Objects of My Affection," in *The Art of Assemblage*, ed. William Seitz, exhibition catalogue, New York,

Museum of Modern Art, 1961, pp. 48–49.
See also *Man Ray: Objets de mon affection*, Paris,
1983, pp. 143–44, no. 39, reproduced p. 42;
Man Ray, Objects of My Affection, exhibition
catalogue, New York, Zabriskie Gallery, 1985.

51 — WEEGEE

1. On Arthur Fellig (Złoczów, Poland [now
 Eastern Ukraine], June 12, 1899–December
 26, 1968, New York), see Weegee, *Weegee by
 Weegee*, New York, Ziff-Davis, 1961 (revised
 and republished as *Weegee: The Autobiography*,
 2013); Christopher Bonanos, *Flash: The Making
 of Weegee the Famous*, New York, Henry Holt &
 Company, 2018.
2. ACME operated from 1923 to 1952,
 when it was acquired by United Press
 International. See V. Penelope Pelizon and
 Nancy M. West, *Tabloid, Inc.: Crimes, Newspapers,
 Narratives*, Columbus, Ohio State University
 Press, 2010.
3. Popularized in the 1910s, Ouija is a game in
 which players use a planchette on a printed
 board to spell out messages, supposedly sent
 from the spirit world. See John Godfrey
 Raupert, *The New Black Magic and the Truth about
 the Ouija-Board*, New York, Devin-Adair
 Company, 1919.
4. Marked with cropping lines in pen and
 blue ink on the recto in four margins;
 inscribed in pen and blue ink, upper
 center: –6 3/4–; lower center: M 20 ch2;
 inscribed in graphite on the verso, upper
 left: 5; upper center: 29 chapter 2; stamped
 in red ink, center left: PLEASE CREDIT
 PHOTOGRAPH BY [in an arc] / WEEGEE.
5. Weegee, *Naked City*, New York, Essential
 Books, 1945; *Weegee's New York*, directed by
 Weegee (Arthur Fellig), 1948, 16mm film,
 Harvard Film Archive, no. 30185. See
 also Philomena Mariani and Christopher
 George, *The Weegee Guide to New York: Roaming
 the City with Its Greatest Tabloid Photographer*, New
 York, International Center of Photography/
 Munich, Prestel, 2014.
6. Producer Mark Hellinger purchased the
 rights to the title *Naked City* for a detective
 movie about the murder of a New York
 model. Written by Malvin Wald and Albert
 Maltz, and directed by Jules Dascin, the
 successful film was released in March
 1948 and won Academy Awards for
 cinematography and film editing.
7. Weegee and Mel Harris, *Naked Hollywood*,
 New York, Pellegrini & Cudahy, 1953;
 see also Richard Meyer, *Naked Hollywood:
 Weegee in Los Angeles*, Los Angeles, Museum of
 Contemporary Art, 2011.
8. See Bonanos 2018, p. 300.

52 — ARNOLD NEWMAN

1. On Arnold Newman (New York, March
 3, 1918–June 6, 2006, New York), see
 William A. Ewing, ed., *Masterclass: Arnold
 Newman*, London, Thames & Hudson, 2012;
 Robert Sobieszek, *One Mind's Eye: The Portraits and
 Other Photographs of Arnold Newman*, Boston, D. R.
 Godine, 1974.
2. On Yasuo Kuniyoshi (1893–1953), see
 Tom Wolf, *The Artistic Journey of Yasuo Kuniyoshi*,
 London, D Giles Limited, 2015.
3. See Richard Allen Davis, *Yasuo Kuniyoshi: The
 Complete Graphic Work*, San Francisco, Alan
 Wofsy Fine Arts, 1991; Franklin Riehlman,
 Tom Wolf, and Bruce Weber, *Yasuo Kuniyoshi:
 Artist as Photographer*, exhibition catalogue,
 Annandale-on-Hudson, New York, Bard
 College Center with the Norton Gallery and
 School of Art, 1983.
4. In 1924 Juliana R. Force organized an
 exhibition of American folk art at the Whitney
 Studio Club, which helped to legitimize the
 genre; see Avis Berman, *Rebels on Eighth Street:
 Juliana Force and the Whitney Museum of American Art*,
 New York, Atheneum, 1990. Abby Aldrich
 Rockefeller established the Folk Art Museum
 in Colonial Williamsburg and the American
 Folk Art Museum in New York City; see
 Bernice Kert, *Abby Aldrich Rockefeller: The Woman in
 the Family*, New York, Random House, 1993.
5. Inscribed in graphite below the image,
 lower left: Yasuo Kuniyoshi; lower right:
 © Arnold Newman; stamped in black ink
 on the verso of the mount: © ARNOLD
 NEWMAN / THIS PHOTOGRAPH
 CANNOT BE COPIED / TELEVISED
 OR REPRODUCED IN ANY FORM /
 WITHOUT THE EXPRESSED AND
 WRITTEN / PERMISSION OF THE
 PHOTOGRAPHER. IT / CAN BE USED
 FOR EXHIBIT PURPOSES ONLY. / 39
 West 67th St., N.Y.C. 10023.
6. In another photograph from the session,
 Kuniyoshi sits in a wicker chair, with one
 of his own paintings on the wall behind
 him. The carved folk statue of an angel on
 a pedestal stands in the background, with
 other objects on the table in front and to the
 side, including a tin weathervane topped by
 a cockerel, the carved figure of a cow and a
 model of a steam locomotive.
7. ShiPu Wang, *Becoming American? The Art and
 Identity Crisis of Yasuo Kuniyoshi*, Honolulu,
 University of Hawai'i Press, 2011, p. 14.
8. In mid-February 1942, President
 Franklin D. Roosevelt signed Executive
 Order 9066, which authorized the War
 Relocation Authority to construct "relocation
 centers" in the American West. More than
 110,000 Japanese-Americans, two-thirds of
 whom were native-born American citizens,
 were forcibly removed to these camps. See
 Ansel Adams, *Born Free and Equal: Photographs
 of the Loyal Japanese-Americans at Manzanar
 Relocation Center, Inyo County, California*, New

York, U.S. Camera, 1944.
9. Kuniyoshi was the first living artist chosen to
 have a retrospective at the Whitney Museum
 of American Art; see Lloyd Goodrich, *Yasuo
 Kuniyoshi: Retrospective Exhibition*, exhibition
 catalogue, New York, Whitney Museum of
 American Art, 1948.
10. The first of these was *One Mind's Eye: The Portraits
 and Other Photographs of Arnold Newman*, foreword
 by Beaumont Newhall, intro. by Robert
 Sobieszek, Boston, D. R. Godine, 1974.

53 — N. JAY JAFFEE

1. On N. Jay Jaffee (Brownsville, Brooklyn,
 March 8, 1921–1999, Huntington, Long
 Island), see Janie Margaret Welker, *Coney
 Island to Caumsett: The Photographic Journey of N. Jay
 Jaffee*, exhibition catalogue, Huntington, New
 York, Heckscher Museum of Art, 1999. I am
 grateful to Cyrisse Jaffee, the photographer's
 daughter, for her assistance with this essay.
2. See James L. Moulton, *Battle for Antwerp*,
 London, Ian Allan, 1978; Denis Whitaker
 and Shelagh Whitaker, *Tug of War: Allied Command
 & the Story Behind the Battle of the Scheldt*, New York,
 Beaufort Books, 1984.
3. On the 50th anniversary of D-Day, Jaffee
 began to write down some of his memories of
 World War II; see "Nat" Jay Jaffee, Company
 A, 415th Infantry, "The Drive to the Roer
 River," War Stories Archive, 104th Infantry
 Division, National Timberwolf Association,
 http://www.104infdiv.org/arch4.htm#32.
4. Only in the late 1950s did Nat Jaffee become
 known as Jay. At that time he became
 employed by a company who shared his first
 name. To avoid confusion on the job he
 was asked to use another name at work, and
 began using Jay, referring to his surname
 (Welker 1999, p. 40, n. 3).
5. Welker 1999, p. 11.
6. On the Photo League, see Mason Klein,
 Catherine Evans, et al., *The Radical Camera: New
 York's Photo League, 1936–1951*, New Haven, Yale
 University Press, 2011; Anne Wilkes Tucker,
 Claire Cass, and Stephen Daiter, *This Was the
 Photo League: Compassion and the Camera from the
 Depression to the Cold War*, exhibition catalogue,
 Chicago, Stephen Daiter Gallery/Houston,
 John Cleary Gallery, 2001.
7. Printed by the photographer in 1979.
 Inscribed in graphite on the verso, lower
 center: 15/25 N Jay Jaffee.
8. Keith F. Davis, *An American Century of
 Photography: From Dry-Plate to Digital; The Hallmark
 Photographic Collection*, 2nd ed., New York,
 Harry N. Abrams, 1999, pp. 286–87;
 Howard B. Rock and Deborah Dash
 Moore, *Cityscapes: A History of New York in Images*,
 New York, Columbia University Press,
 2001, p. 298.
9. In 1976, the artist published a
 photobook, *N. Jay Jaffee: Photographs, 1947–
 1955* (New York, N. Jay Jaffee, 1976),
 which combined his own poetry with his

photographs. Five years later, the Brooklyn Museum presented a solo exhibition of Jaffee's photographs, accompanied by a catalogue by Gene Baro (*Inward Image: Photographs of N. Jay Jaffee*, exhibition catalogue, Brooklyn Museum, 1981).

54 — GORDON PARKS

1. On Gordon Parks (Fort Scott, Kansas, November 30, 1912–March 7, 2006, New York), see Gordon Parks, *Voices in the Mirror: An Autobiography*, New York, Doubleday, 1990. Parks also published several volumes of verse, illustrated by photographs, including *The Poet and His Camera* (1968), *Whispers of Intimate Things* (1971) and *Moments without Proper Names* (1975). See also Peter W. Kunhardt Jr. and Felix Hoffmann, eds., *Gordon Parks, I Am You: Selected Works, 1942–1978*, Göttingen, Steidl, 2016.
2. On the Farm Security Administration, see the Arthur Rothstein entry (Cat. no. 41) in this volume.
3. Gordon Parks, *Flash Photography*, New York, Grosset & Dunlap, 1947; Gordon Parks, *Camera Portraits: The Techniques and Principles of Documentary Portraiture*, New York, Watts, 1948.
4. Gordon Parks, *Half Past Autumn: A Retrospective*, essay by Philip Brookman, exhibition catalogue, Washington, D.C., Corcoran Gallery of Art, 1997, p. 80.
5. Parks 1997, p. 81.
6. Parks 1990, p. 110.
7. "Harlem Gang Leader: Red Jackson's Life Is One of Fear, Frustration, and Violence," *LIFE*, vol. 25, November 1948, pp. 96–106. See also Russell Lord et al., *Gordon Parks: The Making of an Argument*, exhibition catalogue, Göttingen, Steidl, 2013.
8. Inscribed in graphite on the verso, lower center: PF41532; lower right: Gordon Parks. Printed in the 1980s.
9. Parks 1997, p. 85.
10. See Gordon Parks, *Gordon Parks: Segregation Story*, Göttingen, Steidl/Pleasantville, New York, Gordon Parks Foundation, 2014.
11. Gordon Parks, *The Learning Tree*, New York, Harper & Row, 1963. After directing a film adaptation of *The Learning Tree*, Parks became a leading African American director during the 1960s and 1970s, creating 10 successful movies.
12. Gordon Parks, dir., *Shaft*, Los Angeles, Metro-Goldwyn-Mayer, 1971.

55 — IRVING PENN

1. On Irving Penn (Plainfield, New Jersey, June 16, 1917–October 7, 2009, Manhattan, New York), see Maria Morris Hambourg, Jeff L. Rosenheim, et al., *Irving Penn: Centennial*, exhibition catalogue, New York, Metropolitan Museum of Art, 2017; Irving Penn, Alexandra Arrowsmith, and Nicola Majocchi, *Passage: A Work Record*, New York, Knopf, 1991.

2. On Arthur Penn (1922–2010), see Danielle Berrin, "'Bonnie and Clyde' Director Arthur Penn Dies at 88," *Jewish Journal*, September 29, 2010; Nat Segaloff, *Arthur Penn: American Director*, Lexington, University Press of Kentucky, 2011.
3. On Alexey Brodovitch (1898–1971), see Andy Grundberg, *Brodovitch*, New York, Documents of American Design/H. N. Abrams, 1989; Allan Porter and Georges Tourdjman, *Alexey Brodovitch*, exhibition catalogue, Paris, Grand Palais, 1982.
4. Charles Churchward and Alexander Liberman, *Then: Photographs, 1925–1995*, New York, Random House, 1995.
5. Penn, Arrowsmith, and Majocchi 1991, p. 50.
6. Rosamund Bernier, "Some Early Photographs by Irving Penn," in *Irving Penn: A Career in Photography*, ed. Colin Westerbeck, exhibition catalogue, Chicago, Art Institute of Chicago, 1997, pp. 129, 135.
7. Printed in 1984, this gelatin silver print, toned with selenium, is one of an edition of 20. Inscribed on the verso: MARCEL DUCHAMP (WITH PIPE IN MOUTH) / NEW YORK, APRIL 30, 1948 [in a box]; inscribed: REF. 9262; stamped and inscribed: PHOTOGRAPH BY IRVING PENN / Copyright © 1984 by Irving Penn, COURTESY OF VOGUE / Not to be reproduced without / written permission of the / copyright owner and THE CONDE NAST PUBLICATIONS INC.; SIGNED, SILVER PRINTS OF / THIS NEGATIVE NOT EXCEEDING 20.; inscribed in pen and black ink: Irving Penn; stamped: / IRVING PENN [both in inscribed circle]; stamped: TONED IN SELENIUM; inscribed: Print made 1984. / I.P.
8. On Marcel Duchamp (1887–1968), see Calvin Tomkins, *Duchamp: A Biography*, rev. ed., New York, Museum of Modern Art, 2014.
9. See Julian Jason Haladyn, *Marcel Duchamp: Étant donnés*, London, Afterall Books/Cambridge, Massachusetts, MIT Press, 2010.
10. Maria Morris Hambourg, *Earthly Bodies: Irving Penn's Nudes, 1949–50*, exhibition catalogue, New York, Metropolitan Museum of Art, 2002.
11. See Philippe Garner, "In Vogue, 1947–50," in Hambourg, Rosenheim, et al. 2017, pp. 95–96.
12. Virginia A. Heckert and Anne Lacoste, *Irving Penn: Small Trades*, exhibition catalogue, Los Angeles, J. Paul Getty Museum, 2009.
13. Irving Penn, *Worlds in a Small Room*, New York, Grossman, 1974.
14. John Szarkowski, *Irving Penn*, exhibition catalogue, New York, Museum of Modern Art, 1984; Merry A. Foresta and William F. Stapp, *Irving Penn: Master Images, The Collections of the National Museum of American Art and the National Portrait Gallery*, exhibition catalogue, Washington, D.C., Smithsonian Institution Press, 1990; Colin Westerbeck,

ed., *Irving Penn: A Career in Photography*, exhibition catalogue, Art Institute of Chicago, 1997; Hambourg, Rosenheim, et al. 2017.

56 — FRITZ KAESER

1. On Frederick "Fritz" Kaeser (Greenville, Illinois, July 1910–1990 Tucson, Arizona), see Stephen Roger Moriarty, *Fritz Kaeser: A Life in Photography*, exhibition catalogue, Notre Dame, Indiana, Snite Museum of Art, University of Notre Dame, 1998.
2. On Fridolin "Fritz" Kaeser (1847–1916), see W. T. Norton, *Centennial History of Madison County, Illinois, and Its People, 1818–1912*, vol. 2., Chicago/New York, Lewis Publishing Company, 1912, pp. 1010–11. See also Earl Chapin May, *The Canning Clan: A Pageant of Pioneering Americans*, New York, MacMillan, 1937.
3. Mortensen wrote nine books on photographic technique in conjunction with George Dunham; see Larry Lytle and Michael Moynihan, eds., *American Grotesque: The Life and Art of William Mortensen*, Port Townsend, Washington, Feral House, 2014.
4. Halftone is a technique for printing photographic images by mass production, for newspapers, magazines, books and posters. A positive image is rephotographed through a screen, which reduces the image to microscopic dots. These dots are small and further apart in light passages, and larger and closer in dark areas. Transferred to a gravure, lithographic or even gelatin matrix, the discreet shapes can be printed by a mechanical press. The "Mortensen screen" was the photographer's own system, which employed a plastic sheet covered with thousands of short, diagonal hatched lines rather than a conventional grid of perpendicular lines.
5. This Madison neighborhood and its academic culture were described by Wallace Stegner in his novel *Crossing to Safety* (New York, Random House, 1987).
6. André Roch (1906–2002) was the son of a medical professor who later became the president of the University of Geneva. His father was an avid mountaineer who taught him to climb and ski as a boy. Roch won both the downhill and the slalom races at the 1927 Student Olympics in Italy. At age 25 he attended college in Oregon, where was among a group of three who became the first to ski down from the summit of Mount Hood in 1931. That same year, Roch made the first ascent of many in the Mont Blanc Massif. Over his career, he would make 25 first ascents in the Alps, and 27 first ascents in Asia. Roch published more than a dozen books on mountaineering. In the late 1930s Roch joined the Swiss Federal Institute for Snow and Avalanche Research, and became head of the Section on Snow and Avalanche Mechanics and Avalanche Control. He was

one of four Swiss climbers who accompanied Tenzing Norgay on an Everest expedition in 1952 (see André Roch, *Everest 1952: With the Routes of the Expedition Members*, intro. by Edouard Wyss-Dunant, Geneva, Jeheber, 1952). Two colleagues reached to within 200 meters (656 feet) of the summit before the weather forced them back. Norgay and Edmund Hillary used their route to summit Everest the following year. See André Roch, *On Rock and Ice: Mountaineering in Photographs*, London, A. & C. Black, 1947.

7. During World War II, Kaeser's Madison studio remained in operation, managed by Frederica Ritter Cutcheon (1904–1983). To support her during this time, Kaeser hired the 18-year-old university student and photographer John Szarkowski (1925–2007), who would later become the influential head of the photography department at the Museum of Modern Art in New York.

8. *Aspen Daily Times*, February 7, 1946, p. 2.

9. Tom J. Maloney, ed., *U.S. Camera: 1943*, New York, Duell, Sloan, 1943, p. 206.

10. Lucia Lewis, "Pocket of Old West Vie with Modern Spots in Tucson," *The Pittsburgh Press*, December 4, 1960, p. 63. The Ash Alley jewelers ignited Kaeser's interest in geology and gemology. He bought two enormous old water-storage tanks of redwood, and joined them to create a building for his rock shop. He combined his expertise by photographing gems and mineral specimens, which he sold by mail; see *Desert Magazine* (Palm Desert, California), vol. 17, March 1954. p. 36.

11. Late in the 1950s, the Kaesers became acquainted with Dorothy Day, Thomas Merton and other Catholic intellectuals, and developed a shared interest in liturgical art. Fritz Kaeser became member of the advisory council of the Snite Museum of Art at the University of Notre Dame in 1979. The couple endowed a studio and gallery at the museum for the resident Croatian-born sculptor Ivan Meštrović (see Maria Meštrović, *Ivan Meštrović: The Making of a Master*, London, Stacey International, 2008). Four years after the photographer's death in 1990, Milly Kaeser donated his archive of negatives and prints to the University of Notre Dame. In 1998, the Snite Museum organized a retrospective show, accompanied by a monograph on the photographer (Moriarty 1998).

57 — NICKOLAS MURAY

1. On Nickolas Muray (Szeged, Hungary, February 15, 1892–November 2, 1965, New York), see Salomón Grimberg and Thomas Bauer-Friedrich, *Nickolas Muray: Double Exposure*, exhibition catalogue, Halle, Kunstmuseum Moritzburg, 2015.

2. See Adriana Williams, *Covarrubias*, Austin, University of Texas Press, 1994.

3. Kurt Heintzelman, ed., *The Covarrubias Circle:*
Nickolas Muray's Collection of Twentieth-Century Mexican Art, Austin, University of Texas Press, 2004.

4. Muray died while fencing at the New York Athletic Club in 1965, in a studio now named for his memory. When he died, he had claimed over 60 medals and was celebrated as one of the 20 greatest American fencers in history.

5. See Marianne Fulton Margolis, *Muray's Celebrity Portraits of the Twenties and Thirties*, New York, Dover Publications, 1978; Paul Gallico, *The Revealing Eye: Personalities of the 1920s in Photographs by Nickolas Muray*, New York, Atheneum, 1967.

6. "Diverting Beach Days in Divers Colorful Ways," *Ladies Home Journal*, June 1931, pp. 20–21.

7. See Katherine A. Bussard and Lisa Hostetler, *Color Rush: American Color Photography from Stieglitz to Sherman*, exhibition catalogue, Wisconsin, Milwaukee Art Museum, 2013, pp. 52–63.

8. Salomón Grimberg, *I Will Never Forget You: Frida Kahlo to Nickolas Muray, Unpublished Photographs and Letters*, Munich, Schirmer/Mosel, 2004.

9. This print is dry-mounted on illustration board. Inscribed in red crayon on the verso of the mount: NM-31; stamped in black ink: PHOTOGRAPHY BY / MURAY ASSOCIATES / 78 EAST 48TH STREET / NEW YORK 17 N.Y.

58 — ROBERT DOISNEAU

1. See Marie de la Thézy and Claude Nori, *La photographie humaniste: 1930–1960, histoire d'un mouvement en France*, Paris, Contrejour, 1992.

2. On Robert Doisneau (Gentilly, April 14, 1912–April 1, 1994, Broussais), see Peter Hamilton, *Robert Doisneau: A Photographer's Life*, New York, Abbeville Press, 1995; Brigitte Ollier, *Robert Doisneau*, Paris, Hazan, 1996; Jean Claude Gautrand, *Robert Doisneau: 1912–1994*, trans. Chris Miller, Cologne, Taschen, 2014.

3. See Gaélle Lassée, ed., *Robert Doisneau: The Vogue Years*, trans. David Radzinowicz, Paris, Flammarion, 2017.

4. Blaise Cendrars, *La banlieue de Paris: Photographies de Robert Doisneau*, Paris, Seghers, 1966.

5. Inscribed in black felt-tip pen below the image, lower right: Robert Doisneau; inscribed in black felt-tip pen on the verso: LE CONQUÊTE DU CIEL / Tirage en Mai 1975 / RD.

6. The exhibition *Five French Photographers*, presented by the Museum of Modern Art in New York, December 18, 1951–February 24, 1952, also included works by Brassaï, Willy Ronis and Izis (Israëlis Bidermanas).

7. Doisneau gave an account of his work and his meetings with such artists as Braque, Brancusi, Léger and Picasso in *A l'imparfait de l'objectif: Souvenirs et portraits* (Paris, P. Belfond, 1989).

8. Peter Hamilton, *Robert Doisneau, Retrospective*,
London, Tauris Parke Books, 1992; see also Dominique Laudien, Francine Deroudille, and Annette Doisneau, *Robert Doisneau*, exhibition catalogue, Manderen, Château de Malbrouch, Ars-sur-Moselle, Serge Domini Éditeur, 2011.

59 — WYNN BULLOCK

1. On Wynn Bullock (Chicago, April 18, 1902 – November, 16, 1975, Monterey, California), see Brett Abbott, Barbara Bullock-Wilson, and Maria L. Kelly, *Wynn Bullock: Revelations*, exhibition catalogue, Atlanta, High Museum of Art, 2014; Barbara Bullock-Wilson, *Wynn Bullock: Photography, A Way of Life*, Dobbs Ferry, New York, Morgan & Morgan, 1973.

2. Wynn Bullock, *Wynne Bullock: American Lyric Tenor*, Tucson, Center for Creative Photography, University of Arizona, 1976.

3. Alfred Korzybski, *Science and Sanity: An Introduction to Non-Aristotelean Systems and General Semantics*, Lakeville, Connecticut, International Non-Aristotelian Library Publishing Company, 1948.

4. Stamped in black ink on the verso, lower left: WYNN BULLOCK / 155 MAR VISTA DRIVE / MONTEREY, CALIF. / ONE TIME REPRODUCTION RIGHT OFFERED; inscribed in graphite, lower right: 587.

5. Barbara Bullock-Wilson, ed., *Wynn Bullock: Color Light Abstractions*, Carmel, California, Bullock Family Photography, 2010.

6. Charles Lamb and Cynthia Ludlow, *Wynn Bullock Archive*, Tucson, Center for Creative Photography, University of Arizona, 1982.

60 — HENRI CARTIER-BRESSON

1. On Henri Cartier-Bresson (August 22, 1908–Montjustin, Alpes-de-Haute-Provence, August 3, 2004), see Pierre Assouline, *Henri Cartier-Bresson: A Biography*, trans. David Wilson, New York, Thames & Hudson, 2005; Peter Galassi, *Henri Cartier-Bresson: The Modern Century*, exhibition catalogue, New York, Museum of Modern Art, 2010.

2. See David Bate, *Photography and Surrealism: Sexuality, Colonialism and Social Dissent*, London, I. B. Tauris, 2004.

3. Henri Cartier-Bresson with Herbert Kline, dir., *Victoire de la vie*, Paris, Frontier Films for the Centrale Sanitaire Internationale, 1937.

4. Henri Cartier-Bresson with Richard Banks, dir., *Le retour*, Washington, D.C., U.S. Office of War Information, 1945.

5. On Magnum, see the David Seymour entry (Cat. no. 61) in this volume.

6. Robert Delpire, ed., *From One China to the Other: Photographs by Henri Cartier-Bresson*, New York, Universe Books, 1956.

7. Henri Cartier-Bresson, *Images à la sauvette, photographies*, Paris, Éditions Verve, 1952; Henri Cartier-Bresson, *The Decisive Moment: Photographs by Henri Cartier-Bresson*, New York, Simon & Schuster, 1952.

8. Cartier-Bresson, *The Decisive Moment*, 1952, p. 5; see also Henri Cartier-Bresson, *The Mind's Eye: Writings on Photography and Photographers*, ed. Michael L. Sand, New York, Aperture, 1999.

9. Inscribed in black felt-tip pen below the image, lower right: Henri Cartier-Bresson; blindstamped, lower right: © HENRI / CARTIER / BRESSON.

61 — DAVID SEYMOUR

1. On David Seymour (Warsaw, 1911–1956, El Quantara, Egypt), see Inge Bondi, *Chim: The Photographs of David Seymour*, Boston, Bulfinch Press, 1996; Yves Laberge, in *Encyclopedia of Twentieth-Century Photography*, ed. Lynne Warren, vol. 3, New York, Routledge, 2006, pp. 1408–11; Cynthia Young et al., *We Went Back: Photographs from Europe 1933–1956 by Chim*, Munich, DelMonico Books, 2013; Marco Minus, *La nascita di Magnum/The Birth of Magnum: Robert Capa, Henri Cartier-Bresson, George Rodger, David "Chim" Seymour*, Milan, Silvana, 2014.

2. In 1933 Léon Moussinac (1890–1964)—a writer, film critic, journalist, historian, political organizer and academic administrator—took over the magazine *Regards*, which had begun the preceding year. He transformed the journal into a Communist-oriented pictorial newsmagazine and pioneer of photojournalism, in advance of *LIFE* (1936), *Lilliput* (1937) and *Paris-Match* (1942). See Valérie Vignaux and François Albera, *Léon Moussinac*, 2 vols., Paris, Association Française de Recherche sur l'Histoire du Cinéma, 2014.

3. A large group of Seymour's negatives from the Spanish Civil War, along with those of Robert Capa and Gerda Taro, were discovered in Mexico in 1995 and acquired by the International Center of Photography in 2007; see Cynthia Young, ed., *The Mexican Suitcase: The Rediscovered Spanish Civil War Negatives of Capa, Chim and Taro*, New York, International Center of Photography, 2010.

4. Russell Miller, *Magnum: Fifty Years at the Front Line of History*, London, Secker & Warburg, 1997; Fred Ritchin and Carole Naggar, *Magnum Photobook: The Catalogue Raisonné*, London and New York, Phaidon Press, 2016.

5. "Ruinous Epilog to Homeric Drama," *LIFE*, August 31, 1953, pp. 24–28.

6. Stamped in black on the verso: PLEASE CREDIT / DAVID SEYMOUR—MAGNUM / MAGNUM PHOTOS INC / 55 WEST 8 STREET, NEW YORK CITY 11 / LONDON REPRESENTATIVE / ELIZABETH REEVE, / 185 HIGH HOLBORN, LONDON, W.C.1.

7. See Chris Boot, ed., *Magnum Stories*, London, Phaidon, 2004.

62 — HARRY CALLAHAN

1. On Harry M. Callahan (Detroit, Michigan, October 22, 1912–March 15, 1999, Atlanta, Georgia), see Dirk Luckow, Sabine Schnakenberg, et al., *Harry Callahan: Retrospektive*, Heidelberg, Kehrer, 2013; Britt Salvesen and Amy Rule, *Harry Callahan: The Photographer at Work*, exhibition catalogue, Tucson, Center for Creative Photography, University of Arizona, 2006.

2. See Arthur Siegel, *Chicago's Famous Buildings: A Photographic Guide to the City's Architectural Landmarks and Other Notable Buildings*, Chicago, University of Chicago Press, 1965.

3. See Denise J. Miller and Stephen Daiter, *When Aaron Met Harry: Chicago Photography 1946–1971*, exhibition catalogue, Chicago, Museum of Contemporary Photography (Columbia College), 1996; Stephen Daiter Gallery, *Light and Vision: Photography at the School of Design in Chicago, 1937–1952*, exhibition catalogue, Chicago, Stephen Daiter Gallery, 1994.

4. See Grant Arnold, *Harry Callahan: The Street*, exhibition catalogue, Vancouver, Vancouver Art Gallery, 2016.

5. Printed later, and mounted on four-ply ragboard. Inscribed in graphite on the mount below the sheet, lower right: Harry Callahan.

6. Sherman Paul, *Harry Callahan*, exhibition catalogue, New York, Museum of Modern Art, 1967.

7. John Szarkowski, *Harry M. Callahan*, New York, Museum of Modern Art, in association with Aperture, 1976.

8. See Robert Tow and Ricker Winsor, eds., *Harry Callahan: Color, 1941–1980*, Providence, Rhode Island, Matrix Publications, 1980; Keith F. Davis, *Harry Callahan, New Color: Photographs 1978–1987*, exhibition catalogue, Missouri, Hallmark Cards, 1988.

9. Peter C. Bunnell, *Harry M. Callahan: 38th Venice Biennial, United States Pavilion*, exhibition catalogue, New York, International Exhibitions Committee of the American Federation of Arts, 1978.

63 — WILLIAM GARNETT

1. William Langewiesche, *Inside the Sky: A Meditation on Flight*, New York, Pantheon, 1996.

2. On William Garnett (Chicago, December 26, 1916–August 26, 2006, Napa, California), see William Garnett, *William Garnett: Aerial Photographs*, intro. by Martha A. Sandweiss, Berkeley, University of California Press, 1994; William Garnett, *The Extraordinary Landscape: Aerial Photographs of America*, intro. by Ansel Adams, Boston, Little, Brown & Company, 1982.

3. John Thurber, "William Garnett, 89; Took Aerial Photography to Artistic Heights, *Los Angeles Times*, September 5, 2006.

4. See D. J. Waldie, *Holy Land: A Suburban Memoir*, New York, Norton, 2005.

5. D. J. Waldie, "Beautiful and Terrible: Aeriality and the Image of Suburbia," *Places Journal*, February 2013. In March 1954 Lakewood was incorporated as a city, the first in California since 1939. The vacant landscape Garnett photographed was now crowded with 90,000 citizens, most of whom were children under the age of 15.

6. Inscribed in graphite on the recto of the mount below the sheet, lower right: Garnett; inscribed in graphite on the verso of the mount, upper center: FOUR SIDED DUNE, DEATH VALLEY, 1954; stamped in gray ink, center: "ALL RIGHTS TO THIS PHOTOGRAPH, OTHER THAN FOR / THE PURPOSE FOR WHICH IT IS SOLD, ARE RETAINED BY / WILLIAM A. GARNETT AND HIS HEIRS, ADMINISTRATORS, EXECUTORS AND ASSIGNS. REPRODUCTION BY ANY / MEANS, IS PROHIBITED EXCEPT BY EXPRESS WRITTEN / CONSENT FOR EACH SPECIFIC USE."; inscribed in graphite, lower center: Garnett.

7. Walker Evans, "Over California: A Portfolio by William Garnett," *Fortune*, March 1954, pp. 105–12.

8. In 1960, Ansel Adams and Nancy Newhall reproduced six of Garnett's Lakewood images in their photobook *This Is the American Earth* (San Francisco, Sierra Club); they were later published in Peter Blake's *God's Own Junkyard: The Planned Deterioration of America's Landscape* (New York, Holt, Rinehart & Winston, 1964). The documentary and aesthetic quality of these photographs made them politically charged symbols of postwar environmental irresponsibility.

64 — AARON SISKIND

1. On Aaron Siskind (New York, 1903–1991, Providence, Rhode Island), see Gilles Mora, *Aaron Siskind: Another Photographic Reality*, exhibition catalogue, Austin, University of Texas Press, 2014; Deborah Martin Kao and Charles A. Meyer, *Aaron Siskind: Toward a Personal Vision, 1935–1955*, exhibition catalogue, Chestnut Hill, Massachusetts, Boston College Museum of Art, 1994.

2. See Sanford Hirsch, Mary Davis MacNaughton, and Lawrence Alloway, *Adolph Gottlieb: A Retrospective*, exhibition catalogue, Washington, D.C., Corcoran Gallery of Art, in association with the Adolph and Esther Gottlieb Foundation, 1981, pp. 168–71.

3. On the Photo League, see the N. Jay Jaffee entry (Cat. no. 53) in this volume.

4. Ann Banks, ed., *Harlem Document: Photographs 1932–1940*, foreword by Gordon Parks, Providence, Rhode Island, Matrix, 1981.

5. Aaron Siskind, "The Drama of Objects (1945)," in Kao and Meyer 1994, p. 50.

6. Inscribed in graphite on the verso, upper left: library; inscribed in blue ballpoint

pen, upper center: top; stamped in black ink: Photograph by / AARON SISKIND; inscribed in graphite, center: "Broken Window."

7. The present photograph is similar to another, now in the Metropolitan Museum of Art, in which abstract patterns are suggested by broken panes of window glass in a disused warehouse: Aaron Siskind, *Gloucester*, 1944, gelatin silver print, 19 × 23.9 cm (7½ × 9⅜ in.), Gift of Richard L. Menschel, 1977, 1977.677.58.

8. Aaron Siskind, "The Drama of Objects (1945)," in Kao and Meyer, 1994, p. 53.

9. Elaine de Kooning, "The Photographs of Aaron Siskind (1951)," in Kao and Meyer 1994, p. 58; see also Helen A. Harrison, ed., *Subject Matter of the Artist: Writings by Robert Goodnough, 1950–1965*, Chicago, Soberscove Press, 2013.

65 — ELIOT PORTER

1. On Eliot Porter (Winnetka, Illinois, December 6, 1901–November 2, 1990, Santa Fe, New Mexico), see John Rohrbach, Rebecca Solnit, and Jonathan Porter, *Eliot Porter: The Color of Wildness*, New York, Aperture, in association with the Amon Carter Museum, Fort Worth, Texas, 2001; Eliot Porter, *Eliot Porter*, foreword by Martha A. Sandweiss, exhibition catalogue, Fort Worth, Texas, Amon Carter Museum, 1987.

2. See Porter's *Summer Island: Penobscot Country* (San Francisco, Sierra Club, 1966), his photographic and prose reminiscences of Great Spruce Head Island.

3. Porter's ornithological photographs would be published in *American Birds: 10 Photographs in Color* (New York, McGraw-Hill, 1953) and *Birds of North America: A Personal Selection* (New York, E. P. Dutton, 1972). See also John Rohrbach and W. Powell Cottrille, *A Passion for Birds: Eliot Porter's Photography*, exhibition catalogue, Fort Worth, Texas, Amon Carter Museum, 1997.

4. Therese Mulligan, *Jeannette Klute: A Photographic Pioneer*, Rochester, New York, RIT Press, 2017.

5. Henry David Thoreau and Eliot Porter, *"In Wildness Is the Preservation of the World,"* San Francisco, Sierra Club, 1962.

6. See Eliot Porter, *The Place No One Knew: Glen Canyon on the Colorado*, San Francisco, Sierra Club, 1963.

7. Eliot Porter, *Forever Wild: The Adirondacks*, Blue Mountain Lake, New York, Adirondack Museum/New York, Harper & Row, 1966; Eliot Porter and Joseph Wood Krutch, *Baja California and the Geography of Hope*, San Francisco, Sierra Club, 1967; John Wesley Powell, *Down the Colorado: Diary of the First Trip through the Grand Canyon*, photographs and epilogue by Eliot Porter, foreword and notes by Don D. Fowler, New York, E. P. Dutton, 1969; Eliot Porter and Edward

Abbey, *Appalachian Wilderness: The Great Smoky Mountains*, New York, E. P. Dutton, 1970. Over a 50-year career, Porter published 25 books and continued to energize the environmental movement.

8. Inscribed in graphite on the mount below the image, lower right: Eliot Porter. Stamped in black ink on the verso of the mount, lower left: This print from the portfolio / ELIOT PORTER / IN WILDNESS / has been published in an edition / of 300. This dye-transfer print / was made by Berkey K & L, New York. / Copyright 1981 by Daniel Wolf Press, Inc., and / Eliot Porter.

9. Fairfield Porter, "Eliot Porter," *Nation*, vol. 190, January 1960, pp. 39–40. Though his own style was representational, Fairfield Porter was an affable member of the art circles of the New York School and the second-generation Abstract Expressionist painters; see Justin Spring, *Fairfield Porter: A Life in Art*, New Haven, Yale University Press, 2000.

10. The photographer bequeathed his personal archives to the Amon Carter Museum, including about 7,500 color prints, 1,800 gelatin silver prints, 84,000 slides and transparencies, 4,400 negatives and about 2,600 work prints.

11. See Eliot Porter, *Intimate Landscapes: Photographs*, afterword by Weston J. Naef, New York, Metropolitan Museum of Art, 1979.

66 — PAUL STRAND

1. On Paul Strand (New York, October 16, 1890–March 31, 1976, Orgeval, Yvelines, France), see Samantha Gainsburg, "Chronology," in *Paul Strand: Master of Modern Photography*, ed. Peter Barberie, exhibition catalogue, Philadelphia, Philadelphia Museum of Art, in collaboration with Fundación MAPFRE/New Haven and London, Yale University Press, 2014, pp. 334–47; Sarah Greenough, *Paul Strand: An American Vision*, 1990; Maria Morris Hambourg, *Paul Strand: Circa 1916*, exhibition catalogue, New York, Metropolitan Museum of Art, 1998. Strand's papers are at the Center for Creative Photography in Tucson, Arizona.

2. On the Ethical Culture Fieldston School, see Howard B. Radest, *Felix Adler: An Ethical Culture*, New York, P. Lang, 1998; Edward L. Ericson, *The Humanist Way: An Introduction to Ethical Humanist Religion*, New York, Ungar, 1988.

3. See Meir Wigoder, "Paul Strand's New York Portraits: Private Eye–Public Space," *History of Photography*, vol. 27, Winter 2003, pp. 349–62.

4. The film included intertitles with extracts from poems by Walt Whitman: "Crossing Brooklyn Ferry" (1856) and "Manahatta" (1860). See Charles Wolfe, "Paul Strand and Charles Sheeler's *Manhatta*," in *Lovers of Cinema: The First American Film Avant-Garde, 1919–1945*, ed.

Jan-Christopher Horak, Madison, University of Wisconsin Press, 1995.

5. James Krippner, *Paul Strand in Mexico*, New York, Aperture Foundation, 2010, pp. 69–100.

6. Lorentz's *The Plow That Broke the Plains*, produced in 1936, was sponsored by the government Resettlement Administration. This short documentary film described the uncontrolled agricultural farming in the Great Plains region of the United States and Canada that led to the Dust Bowl. It was written and directed by Lorentz, with original music by Virgil Thomson, orchestra directed by Alexander Smallens, and narration by the American actor and baritone Thomas Hardie Chalmers. The cinematographers included Leo T. Hurwitz, Ralph Steiner, Paul Ivano and Paul Strand.

7. Nancy Newhall, *Photographs, 1915–1945: Paul Strand*, exhibition catalogue, New York, Museum of Modern Art, 1945; Paul Strand, *Time in New England*, text selected and edited by Nancy Newhall, New York, Oxford University Press, 1950.

8. Including *Living Egypt*, commentary by James Aldridge (New York, Horizon Press, 1969); *Ghana: An African Portrait*, commentary by Basil Davidson (Millerton, New York, Aperture, 1976); *Un Paese: Portrait of an Italian Village*, with commentary by Cesare Zavattini (New York, Aperture, 1997).

9. Paul Strand, *La France de profil*, commentary by Claude Roy, Lausanne, Éditions Clairefontaine, 1952.

10. Inscribed in pen and blue ink on the verso, center: South Uist / Scotland. 1954 / Paul Strand.

11. Paul Strand, *Tir a'mhurain: Outer Hebrides*, commentary by Basil Davidson, London, MacGibbon & Kee, 1962; see also Basil Davidson, "Working with Strand," in *Paul Strand: Essays on His Life and Work*, ed. Maren Stange, New York, Aperture Foundation, 1990, pp. 211–24.

12. Compton Mackenzie, *Rockets Galore*, London, Chatto & Windus, 1957.

13. *Paul Strand: A Retrospective Monograph, 1915–1968*, exhibition catalogue, Philadelphia Museum of Art/Millerton, New York, Aperture, 1971.

67 — MINOR WHITE

1. On Minor White (Minneapolis, 1908–1976, Boston), see Deborah Klochko and Andrew E. Hershberger, *The Time Between: The Sequences of Minor White*, San Francisco, Modernbook Editions, 2015; Paul Martineau, *Minor White: Manifestations of the Spirit*, Los Angeles, J. Paul Getty Museum, 2014.

2. Fred DeWolfe, *Heritage Lost: Two Grand Portland Houses through the Lens of Minor White*, Portland, Oregon Historical Society Press, in collaboration with the Portland Art Museum, 1995.

3. See Minor White, *Zone System Manual:*

Previsualization, Exposure, Development, Printing; The Ansel Adams Zone System as a Basis of Intuitive Photography, rev. ed., Hastings-on-Hudson, Morgan & Morgan, 1968; Stephanie Comer and Deborah Klochko, *The Moment of Seeing: Minor White at the California School of Fine Arts*, San Francisco, Chronicle Books, 2006.

4. Peter C. Bunnell, ed., *Aperture Magazine Anthology: The Minor White Years, 1952–1976*, New York, Aperture, 2012.

5. From White's journal, "Memorable Fancies," July 24, 1954; see Peter C. Bunnell, "Minor White's *Rural Cathedrals*: A Reading," *Proceedings of the American Philosophical Society*, vol. 135, December 1991, p. 559.

6. See Peter C. Bunnell, "The Sequence," in *Minor White: The Eye That Shapes*, exhibition catalogue, Princeton, Princeton University Art Museum, 1989.

7. Inscribed in graphite below the image, lower right: Minor White; mounted on ragboard and inscribed in graphite on the verso of the mount, lower left: Two Barns and Shadow, Dansville, New York – 1955. This was the last photograph in the first version of *Sequence 10/Rural Cathedrals*, published in 1955, which included 14 photographs; it also completed the version of the series published in White's *Mirrors, Messages, Manifestations* (New York, Aperture, 1969) which included 10 images.

8. Bunnell (1991) describes how White's *Rural Cathedrals* sequence illustrated the five phases of "The Way" described by Underhill; see also Evelyn Underhill, *Mysticism: A Study in the Nature and Development of Man's Spiritual Consciousness*, London, Methuen & Co., 1911.

9. Minor White to Isabel Kane Bradley, March 7, 1956, quoted in Bunnell 1991, p. 561.

10. See *Light⁷: Photos from an Exhibition on a Theme*, exhibition catalogue, Cambridge, Hayden Gallery, Massachusetts Institute of Technology, 1968; *Be-ing without Clothes*, exhibition catalogue, New York, Aperture, 1970; *Octave of Prayer: An Exhibition on a Theme*, exhibition catalogue, Cambridge, Hayden Gallery, Massachusetts Institute of Technology, 1972.

11. White 1969.

68 — FREDERICK SOMMER

1. On Frederick Sommer (Angri, Campania, Italy, 1905–1999, Prescot, Arizona), see Keith F. Davis, Michael Torosian, and April Watson, *The Art of Frederick Sommer: Photography, Drawing, Collage*, Prescott, Arizona, Frederick and Frances Sommer Foundation, 2005.

2. See Werner Spies, *Max Ernst, Life and Work: An Autobiographical Collage*, London, Thames & Hudson, 2006; Dorothea Tanning, *Between Lives: An Artist and her World*, New York, W. W. Norton, 2001.

3. Frederick Sommer, "Six Photographs: With Reactions by Several People," *Aperture*, vol. 4, no. 3, 1956, pp. 103–17.

4. The present print is mounted on two-ply ragboard. Inscribed in graphite on the verso, upper left: Paracelsus, 1957; center: Frederick Sommer 1957.

5. For an introduction to the historical Paracelsus, see James L. Marshall and Virginia R. Marshall, "Rediscovery of the Elements: Paracelsus," *The Hexagon of Alpha Chi Sigma*, vol. 96, Winter 2005, pp. 72–76.

6. "Frederick Sommer: 1939–1962 Photographs; Words Not Spent Today Buy Smaller Images Tomorrow," special issue, *Aperture*, vol. 10, no. 4, 1962, pp. 135–72.

7. Gerald Norland, *Frederick Sommer: An Exhibition of Photographs*, exhibition catalogue, Washington, D.C., Washington Gallery of Modern Art, 1965.

8. Frederick Sommer, *The Poetic Logic of Art and Aesthetics*, with assistance from Stephen Aldrich, Stockton, New Jersey, Carolingian Press, 1972; see also Michael Torosion, ed., *Frederick Sommer: The Constellations That Surround Us; The Conjunction of General Aesthetics and Poetic Logic in an Artist's Life*, Toronto, Lumiere Press, 1992. See also Stephen Aldrich and Walton Mendelson, *Metaphysics in Jars: Collagraphs*, Tucson, Nazraeli Press, 2001.

9. Keith F. Davis et al., *The Art of Frederick Sommer: Photography, Drawing, Collage*, New Haven, Yale University Press, 2005.

69 — MARIO GIACOMELLI

1. On Mario Giacomelli (Senigallia, Italy, August 1, 1925–November 25, 2000, Senigallia, Italy), see Simona Guerra, *Mario Giacomelli. My Whole Life*, Milan, Bruno Mondadori, 2008; Alessandra Mauro, ed., *Mario Giacomelli: The Black Is Waiting for the White*, Rome, Contrasto, 2009; Alistair Crawford, *Mario Giacomelli*, London, Phaidon, 2001.

2. On Giuseppe Cavalli (1904–1961), see Anne Biroleau, Jean-Claude Lemagny, et al., *Giuseppe Cavalli*, exhibition catalogue, Rome, Palazzo del Duca/PUNCTUM, 2007; Antonella Russo, *Giuseppe Cavalli: Fotografie 1936–1961*, exhibition catalogue, Lucera, Museo Civico "Fiorelli"/Foggia, C. Grenzi, 1998.

3. This photograph was printed later, probably in the 1970s. Signed and dated in graphite on the verso; stamped in black ink: "SCANNO" / PHOTO / COPYRIGHT BY / MARIO GIACOMELLI | Via Mastai, 24 / 60019 SENIGALLIA (ITALIA) / Tel. 071/60779.

4. In 2013 Giacomelli's niece, the photography historian Simona Guerra, identified the boy as Claudio de Cola; see Simona Guerra, *Il bambino di Scanno*, Rome, Postcart, 2016.

5. See Crawford 2001, pp. 222–37.

6. Edgar Lee Masters, *Spoon River Anthology*, New York, Macmillan Company, 1915 (trans. Fernanda Pivano, Turin, Einaudi, 1948). A recording of Masters's long-popular poems, read by Paolo Carlini, Arnoldo Foa, Vera

Gherarducci and Elsa Merlini, was issued in 1959 as an LP on the Italian Cetra label.

70 — ROBERT FRANK

1. On Robert Frank (Zurich, November 9, 1924–), see R. J. Smith, *American Witness: The Art and Life of Robert Frank*, New York, Da Capo Press, 2017.

2. Robert Frank, *Les Américains*, ed. Alain Bosquet, Paris, Robert Delpire, 1958.

3. Inscribed in graphite on the verso, upper right: Camera 3; upper center: Robert Frank; lower center: | » 20,7 cm [arrow] |; lower right: FR9509-2.

4. Born and raised in County Derry, Mitchel (1815–1875) became a political journalist who advocated armed resistance against the British. Convicted of sedition in 1848, he was transported to a Bermuda penal colony but escaped to the United States in 1853. Mitchel's *Jail Journal* (New York, Office of the "Citizen," 1854) remains an important text of Irish nationalism. His reputation came into question during the 1980s, when scholars debated his public defense of the Confederacy during the American Civil War. See Bryan P. McGovern, *John Mitchel: Irish Nationalist, Southern Secessionist*, Knoxville, University of Tennessee Press, 2009.

5. Robert Frank, *The Americans*, intro. by Jack Kerouac, New York, Grove Press, 1959.

6. See Brigitta Burger-Utzer and Stefan Grissemann, *Frank Films: The Film and Video Work of Robert Frank*, rev. ed., Göttingen, Steidl, 2009.

71 — ELLIOTT ERWITT

1. On Elliot Erwitt (Paris, July 26, 1928–), see Jessica S. McDonald, ed., *Elliott Erwitt: Home Around the World*, New York, Aperture/Austin, Texas, Harry Ransom Center. 2016.

2. On Roy Stryker, see Arthur Rothstein (Cat. no. 41); Elliott Erwitt, *Pittsburgh: 1950*, essay by Vaughn Wallace, London, GOST Books, 2017.

3. Elliott Erwitt, "Recruits Share Bed and Boredom," *LIFE*, November 26, 1951, pp. 18–19.

4. Erwitt's photograph *Mother and Child*, a portrait of Louie Erwitt with their newborn daughter Ellen, was included in Edward Steichen's landmark 1955 exhibition *The Family of Man* at the Museum of Modern Art. In 1953, Erwitt also photographed his daughter Ellen with Edward Steichen in the Museum of Modern Art photography department; see Elliott Erwitt, *Snaps*, London, Phaidon Press, 2001, p. 131.

5. See William Safire, "Essay: A Picture Story," *New York Times*, July 27, 1984, p. A25.

6. Michael Kaplan, "Elliott Erwitt at Work, *American Photo*, May 1, 2014,

7. Inscribed in graphite on the verso, lower left: PF – 47.

8. *Son of Bitch*, essay by P. G. Wodehouse, New York, Grossman Publishers, 1974; *To the Dogs*, New York, D.A.P./SCALO, 1992; *Dog Dogs*, London, Phaidon, 1998; *Woof*, foreword by Trudie Styler, San Francisco, Chronicle Books, 2005; *Elliott Erwitt's Dogs*, foreword by Peter Mayle, New York, TeNeues, 2012.

9. See Elliott Erwitt, *Cuba*, Kempen, TeNeues, 2017.

10. Erwitt's documentary films include *Beauty Knows No Pain* (1971), *Red, White and Bluegrass* (1973) and the prize-winning *Glassmakers of Herat, Afghanistan* (1977). During the 1980s he made 18 films for HBO television network. He was the subject of a documentary himself, co-produced in 1986 by the BBC, PBS and German television.

11. Elliott Erwitt, *Personal Exposures*, New York, W. W. Norton, 1988; see also Elliott Erwitt, *Personal Best*, Kempen, TeNeues, 2010.

72 — JULIUS SHULMAN

1. On Julius Shulman (Brooklyn, New York, October 10, 1910–July 15, 2009, Los Angeles), see Joseph Rosa and Esther McCoy, *A Constructed View: The Architectural Photography of Julius Shulman*, New York, Rizzoli, 1994; Julius Shulman and Peter Gössel, *Architecture and Its Photography*, Cologne, Benedikt Taschen Verlag, 1998.

2. See Craig Krull and David Tseklenis, *Julius Shulman: Vest Pocket Pictures*, Portland, Oregon, Nazraeli Press, 2006.

3. Wolfgang Wagener, *Raphael Soriano*, London and New York, Phaidon, 2002; Julius Shulman, *The Building of My Home and Studio*, Portland, Oregon, Nazraeli Press, 2008.

4. Barbara Goldstein, ed., *Arts & Architecture: The Entenza Years*, Cambridge, Massachusetts, MIT Press, 1990.

5. Elizabeth A. T. Smith and John Gössel, *Case Study Houses: The Complete CSH Program, 1946–1966*, with principal photography by Julius Shulman, Cologne, Taschen, 2002; Elizabeth A. T. Smith and Esther McCoy, *Blueprints for Modern Living: History and Legacy of the Case Study Houses*, exhibition catalogue, Los Angeles, Museum of Contemporary Art, 1989; Esther McCoy, *Case Study Houses, 1945–1962*, 2nd ed., Los Angeles, Hennessey & Ingalls, 1977.

6. Inscribed in black ink on the verso, lower right: Julius Shulman, 1960 / #2980-20F.

7. Alison Martino, "We Grew Up in Case Study House #22," *Los Angeles Magazine*, May 18, 2015; Barbara Thornburg, "Koenig's Case Study House No. 22 as Home," *Los Angeles Times*, June 27, 2009.

8. See "Way Up Way of Living on California's Cliffs," *LIFE*, February 23, 1962. Stahl is shown dangling "1,000 feet above Los Angeles."

73 — LARRY BURROWS

1. On Larry Burrows (born Henry Frank Leslie Burrows, London, May 29, 1926–February 10, 1971, Laos), see Liam Kennedy, "'A Compassionate Vision': Larry Burrows's Vietnam War Photography," *Photography and Culture*, vol. 4, July 2011, pp. 179–94; Larry Burrows, *Larry Burrows: Compassionate Photographer*, New York, Time-Life Books, 1972.

2. See Jay P. Spenser, *Whirlybirds: A History of the U.S. Helicopter Pioneers*, Seattle, University of Washington Press, 1998.

3. Stamped in blue ink on the verso: LARRY BURROWS VIETNAM / THE AMERICAN INTERVENTION / PUBLISHED BY LAURENCE MILLER GALLERY INC. [in small capitals] / © The Larry Burrows Collection / Reproduction without written / consent expressly prohibited / © TIME Inc. / Reproduction without written / consent expressly prohibited; inscribed in graphite, lower right: 3B; lower left: CLBU-GLM-010. *Larry Burrows: Vietnam—The American Intervention*, a portfolio of 18 dye imbibition prints, was published by Laurence Miller Gallery in New York in 1985 to mark the 10th anniversary of the final withdrawal of American troops from Vietnam. Few photographs were printed for the projected total edition of 60.

4. Larry Burrows, "In Color: The Vicious Fighting in Vietnam, We Wade Deeper into Jungle War," *LIFE*, January 25, 1963, pp. 22–35.

5. Larry Burrows, "One Ride with Yankee Papa 13," *LIFE*, April 16, 1965, pp. 24–34; Larry Burrows, *Vietnam*, intro. by David Halberstam, New York, Alfred A. Knopf, 2002.

6. Larry Burrows, "Vietnam: A Degree of Disillusion," *LIFE*, September 19, 1969, pp. 66–75; see also Burrows's devastating *Vietnam Inc.* of 1971, now reissued by Phaidon.

7. Richard Pyle and Horst Faas, *Lost Over Laos: A True Story of Tragedy, Mystery, and Friendship*, Cambridge, Massachusetts, Da Capo Press, 2003. In 1998, an American search-and-recovery team excavated the crash site in Laos, where they recovered a Leica camera and fragments of film believed to have belonged to Burrows. In April 2008, the scant remains of Burrows and his fellow photographers who died in the helicopter crash together were interred with honor at the Newseum in Washington, D.C.

74 — DAN BUDNIK

1. On Dan Budnik (Long Island, New York, May 20, 1933–), see James Enyeart et al., *Picturing Artists (1950s–1960s): Photographs by Dan Budnik*, New York, Knoedler & Company, 2005.

2. On Peter Krasnow (born Feivish Reisberg, 1886–1979), see Michael Duncan, *Peter Krasnow: Maverick Modernist*, exhibition catalogue, Laguna Beach, California, Laguna Art Museum, 2016.

3. On Charles Alston (1907–1977), see Alvia J. Wardlaw, *Charles Alston*, Petaluma, California, Pomegranate Press, 2007.

4. See Oliver Halsman Rosenberg, ed., *Unknown Halsman*, New York, D.A.P./Distributed Art Publishers, 2008.

5. Dan Budnik, Harry Belafonte, and James Enyeart, *Marching to the Freedom Dream*, London, Trolley Ltd., 2014.

6. Inscribed in red crayon on the verso, center: Dan Budnik; inscribed in graphite, center: 61 - 9 - 11/19 / Magnum; lower left: Berlin Wall Series / December - 1961 / Dan Budnik.

7. "David's Steel Goliaths," *LIFE*, April 5, 1963, pp. 128–33; Dan Budnik and E. A. Carmean Jr., *Seeing David Smith*, New York, Knoedler & Company, 2006.

8. See Jon Meachem, "Founding Father: Martin Luther King, Jr., Architect of the 21st Century," *Time*, August 28, 2012, cover; see also Sandy Johnson, *The Book of Elders: The Life Stories of Great American Indians*, photographed by Dan Budnik, San Francisco, HarperSanFrancisco, 1994.

75 — DIANE ARBUS

1. On Diane Arbus (New York, March 14, 1923–July 26, 1971, New York), see Elisabeth Sussman and Doon Arbus, *Diane Arbus: A Chronology, 1923–1971*, New York, Aperture, 2011.

2. On Model, see Eugenia Parry, *Shooting Off My Mouth, Spitting into the Mirror: Lisette Model, A Narrative Autobiography*, Göttingen, Steidl, 2009.

3. Diane Arbus, "The Vertical Journey: Six Movements of a Moment within the Heart of the City," *Esquire*, July 1, 1960, pp. 102–7. See also Doon Arbus and Marvin Israel, eds., *Diane Arbus: Magazine Work*, exhibition catalogue, Lawrence, Kansas, Spencer Museum of Art/ New York, Aperture, 1984.

4. Stamped on the verso, upper left: Not to be reproduced in any way without / written permission from Doon Arbus; upper left: A Diane Arbus photograph / Title "TRIPLETS IN THEIR BEDROOM / N. J. 1963" / print by "NEIL SELKIRK" / "Doon Arbus."

5. Doon Arbus and Marvin Israel, eds., *Diane Arbus*, Millerton, New York, Aperture, 1972, pp. 1–2.

6. See Sarah Hermanson Meister and Max Kozloff, *Arbus, Friedlander, Winogrand: New Documents, 1967*, exhibition catalogue, New York, Museum of Modern Art, 2017.

76 — DAVE HEATH

1. On Dave Heath (Philadelphia, June 24, 1931–June 27, 2016, Toronto), see Keith F. Davis et al., *Multitude, Solitude: The Photographs of Dave Heath*, Kansas City, Missouri,

Hall Family Foundation, in association with the Nelson-Atkins Museum of Art, 2015; Richard B. Woodward, "Dave Heath, 85, Photographer of Isolation," *New York Times*, July 4, 2016, p. A18.

2. Ralph Crane, "Bad Boy's Story," *LIFE*, May 12, 1947, pp. 107–14.

3. John R. Whiting, *Photography Is a Language*, Chicago, Ziff-Davis Publishing Co., 1946 (reprint, New York, Arno Press, 1979).

4. Michael Torosian, *Dave Heath: Korea Photographs, 1953–1954*, Toronto, Lumiere Press, 2004.

5. Dave Heath, *A Dialogue with Solitude*, Culpeper, Virginia, Community Press, 1965. See a discussion of the project in Michael Torosian's *Extempore* (Toronto, Lumiere Press, 1988).

6. The present print was produced in March 1964. It is dry-mounted onto illustration board. Stamped in black ink on the verso, upper center: DAVE HEATH / 433 COLUMBUS AVENUE / NEW YORK 24 · 2-7928; center: THE ASSOCIATION OF HELIOGRAPHERS / 859 LEXINGTON AVENUE / NEW YORK 21. N.Y. / 433.

7. Organized by James Borcoman, *David Heath: A Dialogue with Solitude and Songs of Innocence*, Toronto, National Gallery of Canada, November 20, 1981–January 17, 1982.

77 — GARRY WINOGRAND

1. On Garry Winogrand (Bronx, New York, January 14, 1929–March 19, 1984, Tijuana, Mexico), see Leo Rubinfien et al., *Garry Winogrand*, exhibition catalogue, San Francisco Museum of Modern Art, in association with Yale University Press, 2013.

2. Printed and published 1978. Inscribed in graphite on the verso, lower right: 80 Garry Winogrand.

3. See Nathan Lyons, ed., *Contemporary Photographers: Toward a Social Landscape*, exhibition catalogue, Rochester, New York, George Eastman House, 1967; Sarah Hermanson Meister and Max Kozloff, *Arbus, Friedlander, Winogrand: New Documents, 1967*, exhibition catalogue, New York, Museum of Modern Art, 2017.

4. John Szarkowski, *Garry Winogrand: The Animals*, exhibition catalogue, New York, Museum of Modern Art, 1969.

5. Tod Papageorge, *Garry Winogrand: Public Relations*, exhibition catalogue, New York, Museum of Modern Art, 1977.

6. Helen Gary Bishop, *Garry Winogrand: Women Are Beautiful*, New York, Farrar, Straus & Giroux, 1975.

7. Ron Tyler, *Stock Photographs: The Fort Worth Fat Stock Show and Rodeo by Garry Winogrand*, Austin, University of Texas Press, 1980.

8. John Szarkowski, *Garry Winogrand: Figments from the Real World*, exhibition catalogue, New York, Museum of Modern Art, 1988; see also Ben Lifson, *The Man in the Crowd: The Uneasy Streets of Garry Winogrand*, exhibition catalogue,

San Francisco, Fraenkel Gallery, 1999. The archive of Winogrand's negatives, contact sheets and work prints is held by the Center for Creative Photography at the University of Arizona, Tucson.

78 — PAUL CAPONIGRO

1. On Paul Caponigro (Boston, December 7, 1932–), see Paul Caponigro, *Seasons*, Boston, New York Graphic Society/Little, Brown & Company, 1988, pp. 75–93; David Stroud, *Paul Caponigro: Masterworks from Forty Years*, Carmel, California, Photography West Graphics, 1993; Paul Caponigro, oral history interview by Susan Larsen, July 30–August 12, 1999, Archives of American Art, Smithsonian Institution.

2. On Benjamen Chinn (American, 1921–2009), see Stephanie Comer and Deborah Klochko, *The Moment of Seeing: Minor White at the California School of Fine Arts*, San Francisco, Chronicle Books, 2006; Deborah Klochko, *Ten Photographers, 1946–54: The Legacy of Minor White*, exhibition catalogue, San Francisco, Paul M. Hertzmann, 2004, p. 13.

3. Caponigro found little objective information about the Neolithic monuments and their cultural context. He was intrigued by Robert Graves's provocative essay *The White Goddess: A Historical Grammar of Poetic Myth* (London, Faber & Faber, 1948); Gerald Hawkins's *Stonehenge Decoded* (Garden City, New York, Doubleday) was first published in 1965.

4. Inscribed in graphite on the mount below the image, lower right: Paul Caponigro; lower left: Running Deer, Wicklow Ireland 1967.

5. Caponigro, oral history interview, 1999.

6. *Paul Caponigro: Recent Photographs*, New York, Museum of Modern Art, October 7–December 8, 1968; see Paul Caponigro, *Megaliths*, Boston, Little, Brown & Company, 1986.

7. See William P. Patterson, *Georgi Ivanovitch Gurdjieff: The Man, the Teaching, His Mission*, Fairfax, California, Arete Communications, 2014.

8. Paul Caponigro, *Sunflower*, New York, Filmhaus, 1974.

9. See Paul Caponigro, *Stone Churches of Ireland*, Revere, Pennsylvania, Lodima Press, 2007; Jennifer A. Watts and Scott Wilcox, eds., *Bruce Davidson/Paul Caponigro: Two American Photographers in Britain and Ireland*, New Haven, Yale University Press, 2014.

10. Paul Caponigro, *The Wise Silence: Photographs*, with essay by Marianne Fulton, Boston, New York Graphic Society Books, in association with the International Museum of Photography at George Eastman House, 1983.

79 — DANNY LYON

1. Danny Lyon, *Knave of Hearts*, Santa Fe, New Mexico, Twin Palms, 1999, p. 8.

2. On Danny Lyon (Brooklyn, March 16,

1942–), see Danny Lyon, Julian Cox, Elizabeth Sussman, et al., *Danny Lyon: Message to the Future*, San Francisco, Fine Arts Museums of San Francisco/New York, Whitney Museum of American Art, 2016; Danny Lyon, *The Seventh Dog*, London, Phaidon Press Limited, 2014.

3. See Lorraine Hansberry, *The Movement: Documentary of a Struggle for Equality*, New York, Simon & Schuster, 1964; Danny Lyon, *Memories of the Southern Civil Rights Movement*, Chapel Hill, University of North Carolina Press, 1992.

4. Danny Lyon, *The Bikeriders*, New York, MacMillan, 1967 (reprint, San Francisco, Chronicle Books, 2003).

5. Danny Lyon, *The Destruction of Lower Manhattan*, New York, Macmillan, 1969.

6. Danny Lyon, *Conversations with the Dead: Photographs of Prison Life, with the Letters and Drawings of Billy McCune #122054*, New York, Holt, Rinehart & Winston, 1971, p.13.

7. Inscribed in black felt-tip pen on the recto: Danny Lyon 1963. Stamped in black ink on the verso, lower right: Printer / Igor [in graphite], BLEAK BEAUTY / [star] 1963 [in graphite] / Picture Date / 1980 [in graphite] Print Date [in a circle].

8. In its first years, the recidivism rate at the James E. Ferguson Unit in Huntsville was 9.3%, compared to the state average of 27% and the national average of 50%; see Bob Johnson, "Record Proves Kyle's Success Warden of Youth Prison," *Houston Post*, Sunday May 2, 1965, sec. 2, p. 12.

9. See Ute Eskildsen and Terry Pitts, eds., *Danny Lyon, Photo, Film, 1959–1990*, exhibition catalogue, Tucson, Center for Creative Photography, University of Arizona/Essen, Museum Folkwang, 1991.

10. At the Library of Congress in Washington, D.C., there is a unique album that includes photographs by Danny Lyon, Ernst Lyon, Gabrielle Lyon, Stephanie Lyon and others. Formats include Polaroid SX-70, Type 55, Instamatic, Ektacolor RC, and gelatin silver printing-out paper photographs. See Verna Posever Curtis, *Photographic Memory: The Album in the Age of Photography*, New York, Aperture Foundation, 2011, p. 196.

11. Danny Lyon, *I Like to Eat Right on the Dirt: A Child's Journey Back in Space and Time*, Clintondale, New York, Bleak Beauty, 1989.

80 — ERNEST C. WITHERS

1. On Ernest C. Withers (Memphis, Tennessee, August 7, 1922–October 15, 2007, Memphis, Tennessee), see F. Jack Hurley, Brooks Johnson, and Daniel J. Wolff, *Pictures Tell the Story: Ernest C. Withers, Reflections in History*, exhibition catalogue, Norfolk, Virginia, Chrysler Museum of Art, 2000.

2. See Ernest C. Withers, *The Memphis Blues Again: Six Decades of Memphis Music Photographs*, New York, Viking Studio, 2001.

3. Ernest C. Withers, *Negro League Baseball*, intro. by Willie Mays, essay by Daniel Wolff, New York, Harry N. Abrams, 2004.

4. *Let Us March On! Selected Civil Rights Photographs of Ernest C. Withers 1955–1968*, exhibition catalogue, Boston, Massachusetts College of Art, 1992.

5. Stewart Burns, *To the Mountaintop: Martin Luther King Jr.'s Sacred Mission to Save America: 1955–1968*, New York, HarperSanFrancisco, 2004.

6. Inscribed in graphite on the verso, lower left: 13/35; lower right: Ernest C. Withers.

7. In 2013, through research made possible by a Freedom of Information Act request by *The Commercial Appeal* (Memphis), reporter Marc Perrusquia suggested that Withers had served as an FBI informant ("Photographer Ernest Withers Doubled as FBI Informant to Spy on Civil Rights Movement," *The Commercial Appeal*, September 12, 2010). Later he suggested that Withers's contribution to the strikers' signs was a deliberate provocation to the violence that led to Dr. King's assassination; see Marc Perrusquia, *A Spy in Canaan: How the FBI Used a Famous Photographer to Infiltrate the Civil Rights Movement*, Brooklyn, Melville House, 2018.

8. Dr. Martin Luther King Jr., *I've Been to the Mountaintop*, foreword by Rev. Bernice King, San Francisco, HarperSanFrancisco, 1994.

81 — JERRY N. UELSMANN

1. On Jerry N. Uelsmann (Detroit, June 11, 1934–), see Carol McCusker, *Untitled: A Retrospective/ Jerry Uelsmann*, Gainesville, University Press of Florida, 2014; James L. Enyeart, *Jerry N. Uelsmann, Twenty-Five Years: A Retrospective*, Boston, Little, Brown & Company, 1982.

2. See Ralph Hattersley, *Discover Your Self through Photography: A Creative Workbook for Amateur and Professional*, New York, Association Press, 1971.

3. See James Enyeart and Nancy Solomon, eds., *Henry Holmes Smith: Collected Writings, 1935–1985*, Tucson, Center for Creative Photography, University of Arizona, 1986.

4. Jerry Uelsmann, *Yosemite: Photographs*, Gainesville, University Press of Florida, 1996.

5. Inscribed in black ballpoint pen on the verso, lower right: "UNTITLED" 1969 / JERRY N. UELSMANN*; stamped in black ink, lower center: ARCHIVALLY PROCESSED / ORIGINAL PHOTOGRAPH / JERRY N. UELSMANN / COPYRIGHT; inscribed in black ballpoint pen: 1969.

6. For Uelsmann's description of his creative process, see Jerry Uelsmann and John Ames, *Uelsmann, Process and Perception: Photographs and Commentary*, Gainesville, University Press of Florida, 1985.

7. Michael Hoffman and Peter C., Bunnell, *Jerry N. Uelsmann*, fables by Russell Edson, exhibition catalogue, Philadelphia, Alfred Stieglitz Center, Philadelphia Museum of Art, 1970.

8. A. D. Coleman "The Directorial Mode: Notes Toward a Definition," in *Light Readings: A Photography Critic's Writings, 1968–1978*, 2nd rev. ed., Albuquerque, University of New Mexico Press, 1998, pp. 246–57.

9. Enyeart 1982.

10. See Jerry Uelsmann, *Jerry Uelsmann: Photo Synthesis*, foreword by A. D. Coleman, Gainesville, University Press of Florida, 1992; Alex Alberro and Nora M. Alter, *Referencing Art: Photographs by Jerry N. Uelsmann*, Tucson, Nazraeli Press, 2003; Jerry Uelsmann, *Jerry Uelsmann: Other Realities*, New York, Bulfinch Press, 2005.

82 — NEIL ARMSTRONG

1. See Jay Barbree, *Neil Armstrong: A Life of Flight*, New York, Thomas Dunne Books, 2014; Buzz Aldrin with Ken Abraham, *Life Lessons from a Man Who Walked on the Moon*, Washington, D.C., National Geographic, 2016; Michael Collins, *Carrying the Fire: An Astronaut's Journeys*, New York, Farrar, Straus & Giroux, 1974.

2. See Gene Farmer and Dora Jane Hamblin, *First on the Moon: A Voyage with Neil Armstrong, Michael Collins, and Edwin E. Aldrin, Jr.*, Boston, Little, Brown & Company, 1970; Robert Godwin, *Apollo 11: The NASA Mission Reports*, 2 vols., Burlington, Ontario, Apogee Books, 1999.

3. See Dwight Steven-Boniecki, *Live TV from the Moon*, Burlington, Ontario, Apogee Books, 2010; David Meerman Scott and Richard Jurek, *Marketing the Moon: The Selling of the Apollo Lunar Program*, Cambridge, Massachusetts, MIT Press, 2014, pp. 55–77.

4. Arthur T. Anderson, C. K. Michlovitz, and K. Hug, *Apollo Eleven Lunar Photography*, Greenbelt, Maryland, National Space Science Data Center, National Aeronautics and Space Administration, 1970; Mapping Sciences Laboratory, NASA, *Apollo Eleven Photography: 70-mm, 16-mm, and 35-mm Frame Index*, Greenbelt, Maryland, National Space Science Data Center, 1970.

5. This print of negative no. AS11-40-5903, published by NASA around 1970, is dry-mounted, concealing any verso inscriptions.

6. "To the Moon and Back," *LIFE*, August 11, 1969; a similar cropping appeared on the cover of *Newsweek* magazine on the same date. At that time, NASA Headquarters issued the education publications *Log of Apollo* (EP-72) and *The First Lunar Landing as Told by the Astronauts*, (EP-73), in which the cropped and edited image also appeared.

7. Eric M. Jones, "A Brief History of AS11-40-5903," *Apollo Lunar Surface Journal*, December 9, 2005, n.p.

83 — LARRY CLARK

1. On Larry Clark (Tulsa, Oklahoma, January 19, 1943–), see Swip Stolk and Mark Wilson, *Larry Clark*, exhibition catalogue, Groningen, Netherlands, Groninger Museum, 1999.

2. Ralph Gibson's Lustrum Press also published *Tulsa* as a mass-market book, one of the imprint's first productions. In 1970, Gibson began Lustrum Press to expand publishing opportunities for creative photographers. The first title for the imprint was Gibson's photobook *The Somnambulist* (1970), followed by two other volumes of his work, *Déjà-vu* (1973) and *Days at Sea* (1974). See Gilles Mora, *The Black Trilogy: Ralph Gibson*, Austin, University of Texas Press, 2017.

3. Inscribed in graphite on the verso, lower left: 41; lower right: Larry Clark.

4. Larry Clark, *Tulsa*, New York, Lustrum Press, 1973, n.p.

5. Eleanor Lewis, ed., *Darkroom*, New York, Lustrum Press, 1977, p. 26.

6. Larry Clark, *Teenage Lust: An Autobiography*, New York, L. Clark, 1983.

7. Peter Biskind, *Down and Dirty Pictures: Miramax, Sundance, and the Rise of Independent Film*, New York, Simon & Schuster, 2004.

8. Larry Clark, *Larry Clark*, New York, T. Westreich, 1992; Larry Clark, *The Perfect Childhood*, New York, Scalo, 1995.

9. Larry Clark, dir., *Kids*, screenplay by Harmony Korine, New York, Shining Excalibur Films, 1995.

10. Clark's subsequent films include *Another Day in Paradise* (1998), *Bully* (2001), *Ken Park* (2002), *Wassup Rockers* (2006), *Marfa Girl* (2012) and *The Smell of Us* (2014).

84 — MARY ELLEN MARK

1. Brett Abbott, *Engaged Observers: Documentary Photography since the Sixties*, Los Angeles, J. Paul Getty Museum, 2010, pp. 136–37.

2. On Mary Ellen Mark (Philadelphia, Pennsylvania, March 20, 1940–New York, May 25, 2015), see Weston J. Naef, *Exposure: Mary Ellen Mark, The Iconic Photographs*, London, Phaidon Press, 2005.

3. Mary Ellen Mark, *Passport*, New York, Lustrum Press, 1974.

4. Mary Simons, "What the English Are Doing about Heroin," *Look*, vol. 14, April–June, 1970.

5. See Mary Ellen Mark, *Seen Behind the Scene: Forty Years of Photographing on Set*, London and New York, Phaidon Press, 2008.

6. Ken Kesey's *One Flew Over the Cuckoo's Nest: A Novel* (New York, Viking Press, 1962) appeared during a period of examination and change in American psychology and psychiatry, and the beginning of a movement towards deinstitutionalization. Although the book is set in Oregon, where Kesey had attended college, it was based on the author's experiences as a night-shift

orderly at a mental-health facility in Menlo Park, California. As a volunteer for Project MKUltra, Kesey took psychoactive drugs, including mescaline and LSD. His psychedelic experiences helped him relate to the psychiatric patients and encouraged his later recreational use of drugs. See Tom Wolfe, *The Electric Kool-Aid Acid Test*, New York, Farrar, Straus & Giroux, 1968; Mark Christensen, *Acid Christ: Ken Kesey, LSD and the Politics of Ecstasy*, Tucson, Schaffner Press, 2010.

7. Printed on adhesive stickers on the verso, upper right: 300B 011-005 / WARD 81; [barcode] WARD 81 / © Mary Ellen Mark; lower right: Credit: Mary Ellen Mark/ Library / DO NOT CROP PHOTOGRAPH [in a box] / 134 Spring Street, Suite 5B, New York NY 10012 / Telephone 212-925-2770 & 212 925-1380; inscribed in graphite on the verso, lower center: Brenda Ward 81 Oregon State Hospital / Salem Oregon USA 1976 / Mary Ellen Mark. This photograph was recommended for acquisition by the 2014 PhotoFutures program, a curatorial seminar in which students were asked to select an original contemporary photograph revealing the complexities of mental health in our society; participants included Jonathan Baker (ND'17), Stephanie Comstock (ND'16), Ruth Cooper (ND'17), Lara Dulin (ND'16), Evan Graham (ND'15), Robert Mogollon (ND'18), Jonathan Vandenburgh (ND'16) and John Wetzel (ND'16).

8. Mary Ellen Mark and Karen Folger Jacobs, *Ward 81*, intro. by Miloš Forman, New York, Fireside Books, 1979.

9. Mary Ellen Mark, *Falkland Road: Prostitutes of Bombay*, New York, Knopf, 1981.

10. David Featherstone, *Mary Ellen Mark: Photographs of Mother Teresa's Missions of Charity in Calcutta, India*, exhibition catalogue, Carmel, Friends of Photography, 1985.

11. Cheryl McCall, "Streets of the Lost: Runaway Kids Eke Out a Mean Life in Seattle," *LIFE*, July 1983, pp. 35–42.

12. Martin Bell, dir., *Streetwise*, produced by Cheryl McCall, New York, Angelika Films, 1984; Mary Ellen Mark, *Streetwise*, intro. by John Irving, Philadelphia, University of Pennsylvania Press, 1987.

85 — RICHARD AVEDON

1. On Richard Avedon (New York, May 15, 1923–October 1, 2004, San Antonio, Texas), see Norma Stevens and Steven M. L. Aronson, *Avedon: Something Personal*, New York, Spiegel & Grau, 2017.

2. Robert M. Rubin and Marianne Le Galliard, *La France d'Avedon: Vieux monde, New Look*, Paris, Bibliothèque Nationale de France, 2016.

3. See Carol Squiers and Vince Aletti, *Avedon Fashion, 1944–2000*, New York, Abrams, 2009.

4. See Klaus Honnef and F. C. Gundlach, *Martin Munkácsi*, London, Thames & Hudson, 2006.

5. See Rubin and Le Galliard 2016, pp. 72–211.

6. See Richard Avedon and Doon Arbus, *The Sixties*, New York, Random House, 1999.

7. Richard Avedon, *Observations*, text by Truman Capote, New York, Simon & Schuster, 1959.

8. The first solo exhibition of Avedon's portraits was presented by the Smithsonian Institution in 1962, curated by Eugene Ostroff. On Avedon as a portraitist, see Maria Morris Hambourg and Mia Fineman, *Richard Avedon Portraits*, New York, Metropolitan Museum of Art, 2002.

9. Inscribed in blue/black felt-tip pen on the verso, lower center: Avedon; stamped in gray ink on the verso, lower left: Richard Avedon warrants and represents that, aside / from the signed and numbered photographs in these series (Marlborough Gallery 9-10-75) no other orig- / inal prints of these photographs will be made by him / or under his authority except for a limited number of / prints made solely in connection with museum ex- / hibitions: // This original photograph may not be reproduced, by this or any subsequent purchaser without permission of the photographer. || Copyright © 1975 by Richard Avedon / All Rights Reserved. || neg. no. 248 [in black felt-tip pen] || edition of 50 [in black felt-tip pen] number 9 [in black felt-tip pen]|| Jean Renoir, director / Beverly Hills, California, 4-11-72.

10. See the autobiography of Jean Renoir (1894–1979), *My Life and My Films*, trans. Norman Denny, London, Collins, 1974; François Truffaut, ed., *Jean Renoir*, trans. W. W. Halsey II and William H. Simon, New York, Simon & Schuster, 1973.

11. See *Harper's Bazaar*, March 1959, p. 158.

12. Nicole Wisniak, "Un portrait est une opinion: Richard Avedon," *Egoïste*, no. 9, 1985, pp. 52–53.

13. A selection of these was presented in the exhibition *Jacob Israel Avedon: Photographed by Richard Avedon* at the Museum of Modern Art in New York, May 1–June 16, 1974. See Richard Avedon, "Jacob Israel Avedon," *Camera* (International Magazine of Photography and Cinematography), November 1974, pp. 4–16.

14. Harold Brodkey, *Richard Avedon: Photographs, 1947–1977*, New York, Farrar, Straus & Giroux, 1978.

15. Richard Avedon, *In the American West, 1979–1984*, New York, Abrams, 1985.

16. Jane Livingston and Adam Gopnik, *Evidence, 1944–1994: Richard Avedon*, New York, Random House, in association with the Whitney Museum of American Art, 1994.

86 — CINDY SHERMAN

1. See Douglas Eklund, *The Pictures Generation, 1974–1984*, New York, Metropolitan Museum of Art, 2009; Susan Kismaric and Eva Respini, *Fashioning Fiction in Photography Since 1990*, exhibition catalogue, New York, Museum of Modern Art, Queens, 2004.

2. On Cindy Sherman (Glen Ridge, New Jersey, 1954–), see Eva Respini, *Cindy Sherman*, with contributions by Johanna Burton and John Waters, exhibition catalogue, New York, Museum of Modern Art, 2012; Amada Cruz and Elizabeth Smith, *Cindy Sherman: Retrospective*, Chicago, Museum of Contemporary Art/ Los Angeles, Museum of Contemporary Art, 1997.

3. Gabrielle Schor, *Cindy Sherman: The Early Works, 1975–1977; A Catalogue Raisonné*, Berlin, Hatje Cantz, 2012, pp. 122–23, 354.

4. Cindy Sherman, *The Complete Untitled Film Stills*, New York, Museum of Modern Art, 2003, p. 5.

5. Robert Hirsch, *Seizing the Light: A Social & Aesthetic History of Photography*, 3rd ed., Boston, McGraw-Hill, 2000, p. 302; Babbette Hines, *Photobooth*, New York, Princeton Architectural Press, 2002.

6. See *Andy Warhol Photobooth Pictures*, exhibition catalogue, New York, Robert Miller Gallery, 1989.

7. Schor 2012, pp. 4–47, cat. no. 2; Alexander B. Todorov, *Face Value: The Irresistible Influence of First Impressions*, Princeton University Press, 2017, pp. 151–53.

8. Inscribed in ballpoint pen on the verso: Cindy Sherman / 1975/2001. See Respini 2012, p. 68; Schor 2012, pp. 37–38, cat. no. 16.

9. Cindy Sherman, *The Complete Untitled Film Stills*, New York, Museum of Modern Art, 2003, p. 5.

10. Respini 2012.

87 — JOHN BALDESSARI

1. On John Baldessari (National City, California, 1931–), see Meg Cranston and Hans Ulrich Obrist, eds., *More Than You Wanted to Know about John Baldessari*, 2 vols., Zurich, JRP/Ringier / Dijon, Les Presses du Reel, 2013.

2. See Robert Dean and Patrick Pardo, eds., *John Baldessari Catalogue Raisonné*, vol. 1, New Haven, Yale University Press, 2012, pp. 136–39.

3. Dean and Pardo 2012, pp. 81–86.

4. Curator Willoughby Sharp conceived and organized *PROJECTS: Pier 18*, and each work was recorded in photographs on his instructions. *Centering a Bouncing Ball (36 Exposures)* was one of five Baldessari pieces for *Pier 18*, photographed by Shunk-Kender. See Dean and Pardo 2012, pp. 166–67.

5. Shunk-Kender collaborated with Yves Klein on the famous photograph *Leap into the Void* of 1960, a combination print from

two negatives, in which the artist appears to dive from a second-story window to certain disaster on the pavement below. Baldessari was impressed and influenced by an exhibition of Klein's work at the Dwan Gallery in Los Angeles in 1961. See Nan Rosenthal, "Assisted Levitation: The Art of Yves Klein," in *Yves Klein 1928–1962: A Retrospective*, by Dominique de Menil et al., exhibition catalogue, Houston, Texas, Rice Museum, 1982, pp. 126–27.

6. Among these works are *Throwing Four Balls in the Air to Get a Square (Best of Thirty-Six Tries)*, in eight photographs, and *Trying to Photograph a Ball So That It Is in the Center of the Picture (Version A)*, in 38 photographs (see Dean and Pardo 2012, pp. 232–33, 233–34). See also Sidra Stich, "Conceptual Alchemy: A Conversation with John Baldessari," *American Art*, vol. 19, spring 2005, p. 81; Kassandra Nakas, *From Fact to Fiction: Zum Funktions- und Statuswandel der Fotografie seit der Konzeptkunst*, Frankfurt-am-Main/New York, P. Lang, 2006.

7. See Herbert Molderings, *Duchamp and the Aesthetics of Chance*, New York, Columbia University Press, 2010.

8. *Throwing Three Balls in the Air to Get a Straight Line (Best of Thirty-Six Attempts)*, 1973, offset lithographs in color on coated stock paper, co-published by Edizioni Giampolo Prearo and Galleria Toselli, Milan, with title page and colophon, contained in a blue paper slipcase with letterpress title, in an edition of 2000, with 500 copies reserved for the publisher. In their original conception, the offset lithographs were meant to be bound as an artist's book. See Hunter Drohojowska-Philp, *John Baldessari: A Print Retrospective from the Collections of Jordan D. Schnitzer and His Family Foundation*, exhibition catalogue, San Francisco, Fine Arts Museums of San Francisco, Legion of Honor, 2009, p. 10.

9. See Andrew Roth, Philip E. Aarons, and Claire Lehmann, eds., *Artists Who Make Books*, London, Phaidon Press Ltd., 2017.

10. Robin Kelsey, *Photography and the Art of Chance*, Cambridge, Massachusetts, Belknap Press of Harvard University Press, 2015.

11. Kelsey 2015, p. 383, n. 65.

88 — JOEL MEYEROWITZ

1. On Joel Meyerowitz (The Bronx, New York, March 6, 1938–), see Joel Meyerowitz and Colin Westerbeck, *Joel Meyerowitz: Where I Find Myself*, London, Laurence King, 2018; Colin Westerbeck, *Joel Meyerowitz*, London, Phaidon, 2001.

2. See Colin Westerbeck and Joel Meyerowitz, *Bystander: A History of Street Photography*, 2nd ed., Boston, Little, Brown & Company, 2001.

3. Inscribed in blue ballpoint pen on the verso, lower left: Provincetown 1977 / Joel Meyerowitz; lower right: 1; upper right: 17 33 5 4/6 #582 / 3 [in a circle].

4. Joel Meyerowitz, *Cape Light: Color Photographs*, foreword by Clifford S. Ackley, interview by Bruce K. MacDonald, exhibition catalogue, Boston, Museum of Fine Arts, 1978.

5. Joel Meyerowitz and Vivian Bower, *The Arch: Photographs by Joel Meyerowitz*, Boston, Little, Brown & Company, 1988.

6. Joel Meyerowitz, *Wild Flowers: Photographs*, Boston, Little, Brown & Company, 1983; Joel Meyerowitz, *A Summer's Day*, New York, Times Books, 1985; Joel Meyerowitz, *Redheads*, New York, Rizzoli, 1991; Joel Meyerowitz, *Bay/Sky*, foreword by Norman Mailer, Boston, Bulfinch Press, 1993.

7. Joel Meyerowitz, *Aftermath*, New York, Phaidon Press, 2006.

8. Including Joel Meyerowitz and Maggie Barrett, *Tuscany: Inside the Light*, New York, Barnes & Noble, 2003; Joel Meyerowitz and Maggie Barrett, *Provence: Lasting Impressions*, New York, Sterling Signature, 2012.

9. Joel Meyerowitz and Maggie Barrett, *Morandi's Objects*, Bologna, Damiani, 2016; Joel Meyerowitz and Maggie Barrett, *Cézanne's Objects*, Bologna, Damiani, 2017.

89 — WILLIAM EGGLESTON

1. On William Eggleston (Memphis, Tennessee, July 27, 1939–), see Adam Welch, *William Eggleston: Democratic Camera; Photographs and Video 1961–2008*, New York, Whitney Museum of American Art, 2008; Mark Holborn and William Eggleston III, eds., *The Democratic Forest*, 10 vols., Göttingen, Steidl, 2015.

2. See Thomas Weski and Walter Hopps, *William Eggleston: Los Alamos*, Zurich, Scalo, 2003; Mark Holborn, ed., *William Eggleston: Los Alamos Revisited*, 3 vols., Göttingen, Steidl, 2012.

3. John Szarkowski, *William Eggleston's Guide*, exhibition catalogue, New York, Museum of Modern Art, 1976. For a selection of Eggleston's Kodachromes and Ektachromes, chosen from 5,000 slides in 10 chronological binders, from which Szarkowski selected the Museum of Modern Art exhibition, see Thomas Weski, Winston Eggleston, and William Eggleston III, eds., *Chromes: 1969–1974*, Göttingen, Steidl, 2005.

4. See the facsimile *William Eggleston: Election Eve*, preface by Lloyd Fonvielle, commentary by Caldecot Chubb, Göttingen, Steidl, 2017; see also Walter Hopps, *Election Eve: William Eggleston*, exhibition catalogue, Washington, D.C., Corcoran Gallery of Art, 1977.

5. Inscribed in black ball-point pen on the verso, lower right: Eggleston / 26/35.

6. William Eggleston, *The Democratic Forest*, intro. by Eudora Welty, London, Secker & Warburg, 1989; see also Holborn and Eggleston, 2015.

7. Willie Morris, *Faulkner's Mississippi*, photographs by William Eggleston, Birmingham, Alabama, Oxmoor House, 1990.

90 — HIROSHI SUGIMOTO

1. On Hiroshi Sugimoto (Tokyo, 1948–), see Kerry Brougher and David Elliott, *Hiroshi Sugimoto*, exhibition catalogue, Washington, D.C., Hirshhorn Museum and Sculpture Garden/Tokyo, Mori Art Museum, 2005.

2. Hiroshi Sugimoto, *Hiroshi Sugimoto: Dioramas*, exhibition catalogue, New York, Pace Gallery, in association with Damiani, 2014.

3. This photogravure, produced from Sugimoto's 1978 negative, was published by Sonnabend Sundell Editions, New York, in association with Eyestorm, London, in 2000. Inscribed in graphite below the image, lower right: H Sugimoto; colophon printed on separate card: HIROSHI SUGIMOTO / U. A. THEATER, NEW YORK, 1978 / PUBLISHED BY / EYESTORM.COM.LONDON / SONNABEND SUNDELL EDITIONS, NEW YORK / THIS SPECIAL EDITION WAS PUBLISHED IN CONJUNCTION / WITH *THEATERS*, AND DESIGNED AND CREATED BY / MATSUMOTO INCORPORATED, NEW YORK / THIS IMAGE WAS PRINTED USING PHOTOGRAVURE IN THE / UNITED STATES OF AMERICA / 0548/ONE THOUSAND / ©2000 BY HIROSHI SUGIMOTO / ALL RIGHTS RESERVED USED BY PERMISSION.

4. Hiroshi Sugimoto, *Hiroshi Sugimoto: Theaters*, Tokyo, Damiani/Matsumoto Editions, 2016; see also Peter Hay Halpert, *Motion Picture by Sugimoto*, exhibition catalogue, Locarno, Galleria SPSAS, 1995.

5. Hiroshi Sugimoto, *Hiroshi Sugimoto: Seascapes*, with essay by Munesuke Mita, Bologna, Damiani/New York, Matsumoto, 2015; see also Armin Zweite, *Hiroshi Sugimoto: Revolution*, exhibition catalogue, Munich, Museum Brandhorst, 2012.

6. Hiroshi Sugimoto, *Sea of Buddha*, New York, Sonnabend Sundell Editions, 1997.

7. See Tracey Bashkoff and Nancy Spector, *Sugimoto Portraits*, exhibition catalogue, Bilbao, Museo Guggenheim/Berlin, Deutsche Guggenheim, 2000.

8. Hiroshi Sugimoto, *Āo no kigen=Origins of Art*, Tokyo, Shinchōha, 2012.

9. Kenneth Wayne, *Rodin, Sugimoto*, exhibition catalogue, Paris, Gagosian Gallery, 2011; Jonathan Safran Foer, *Joe*, exhibition catalogue, St. Louis, Pulitzer Foundation for the Arts, 2006.

91 — ANDY WARHOL

1. Among the recent biographies of Andy Warhol (Pittsburgh, Pennsylvania, August 6, 1928–February 22, 1987, New York), are John Wilcock, *The Autobiography and Sex Life of Andy Warhol*, New York, Trela, 2010; Blake Stimson, *Citizen Warhol*, London, Reaktion

Books, 2014; Maren Gottschalk, *Factory Man: Die Lebensgeschichte des Andy Warhol*, Weinheim, Beltz & Gelberg, 2015. See also Pat Hackett, ed., *The Andy Warhol Diaries*, New York, Warner Books, 1989.

2. On Warhol as a photographer, see Reuel Golden, ed., *Andy Warhol: Polaroids 1958–1987*, Cologne, Taschen, 2015; Joseph D. Ketner II et al., *Image Machine: Andy Warhol & Photography*, exhibition catalogue, Nuremburg, Verlag für Moderne Kunst/Cincinnati, Contemporary Arts Center, 2012.

3. See Adriano Aprà and Enzo Ungari, *Il cinema di Andy Warhol*, Rome, Arcana, 1971; Stephen Koch, *Stargazer: Andy Warhol's World and His Films*, New York, Praeger, 1973.

4. *Dog*, 1976: stamped in blue ink on the verso, lower left: AUTHORIZED BY THE / ANDY WARHOL // **AW** // FOUNDATION / FOR THE VISUAL ARTS [in a serrated, round cartouche]; lower right: THE ESTATE / OF / ANDY WARHOL [in an oval]; inscribed in graphite, lower left: FA09.00994; lower right: RM. Snite Museum of Art, Gift of the Andy Warhol Foundation for the Visual Arts, 2008.026.007.

5. *Dog*, 1976, acrylic and silkscreen ink on linen, 66 × 81.3 cm (26 × 32 in.), The Andy Warhol Museum, Pittsburgh, 1998.1.204.

6. *Shoes*, 1980: blindstamped on the recto, lower right: © ANDY WARHOL; stamped in blue ink on the verso, lower left: AUTHORIZED BY THE / ANDY WARHOL // **AW** // FOUNDATION / FOR THE VISUAL ARTS [in a serrated, round cartouche]; lower right: THE ESTATE / OF / ANDY WARHOL [in an oval]; inscribed in graphite on the verso, lower right: RM / FA09.1607. Snite Museum of Art, Gift of the Andy Warhol Foundation for the Visual Arts, 2008.026.008.

7. Warhol's printer, Rupert Jasen Smith (American, 1953–1988), discovered this powdery by-product of industrial-grade diamond manufacture and used it in his own work before Warhol adopted the material; see Frayda Feldman and Jörg Schellmann, *Andy Warhol Prints*, 2nd ed., New York, Abbeville Press, 1989, p. 25.

8. Tony Shafrazi, ed., *Andy Warhol Portraits*, New York, Phaidon Press, 2007, pp. 206–7; Annette Löseke, *Andy Warhols serielle Porträts: Jackie Kennedy, Marilyn Monroe, Liz Taylor, Ethel Scull; Bildbegriff und Porträtkonzept der frühen 1960er Jahre*, Hildesheim, Georg Olms Verlag, 2013.

9. "Giorgio Armani," *Interview*, vol. 38, June–July 2008, pp. 126–29.

10. *Giorgio Armani*, 1980: blindstamped on the recto, lower right: © ANDY WARHOL; stamped in blue ink on the verso, lower left: AUTHORIZED BY THE / ANDY WARHOL // **AW** // FOUNDATION / FOR THE VISUAL ARTS [in a serrated, round cartouche]; lower right: THE ESTATE / OF / ANDY WARHOL [in an oval]; inscribed in graphite on the verso, upper right: FA05.01830; lower right:

RM. Snite Museum of Art, Gift of the Andy Warhol Foundation for the Visual Arts, 2008.026.009.

11. *Giorgio Armani*, about 1981, screenprint and synthetic polymer pigment on Lenox Museum board, diptych, each panel 122.5 × 92.1 cm (48¼ × 36¼ in.); see Feldman and Schellmann 1989, IIIC.58.

12. *Myths*, 1981, series of 10 screenprints, each 96.5 × 96.5 cm (38 × 38 in.); see Feldman and Schellmann 1989, II.258–67. Warhol's *Myths* series includes prints of Uncle Sam, Superman, the Wicked Witch, Mammy, Howdy Doody, Dracula, Mickey Mouse, Santa Claus, and The Shadow, the crime-fighting hero of pulp novels and serialized radio dramas in the 1930s. Printed on two-ply Lenox Museum board, all of the color screenprints in the regular edition of the *Myths* series have diamond dust.

13. *Santa Claus*, 1981: blindstamped on the recto, lower right: © ANDY WARHOL; stamped in blue ink on the verso, lower left: AUTHORIZED BY THE / ANDY WARHOL // **AW** // FOUNDATION / FOR THE VISUAL ARTS [in a serrated, round cartouche]; lower right: THE ESTATE / OF / ANDY WARHOL [in an oval]; inscribed in graphite, upper left: FA09.00475; lower right: RM. Snite Museum of Art, Gift of the Andy Warhol Foundation for the Visual Arts, 2008.026.010.

92 — DONNA FERRATO

1. On Donna Ferrato (Waltham, Massachusetts, June 5, 1949–), see. See Ken Light, *Witness in Our Time: Working Lives of Documentary Photographers*, Washington, D.C., Smithsonian Institution Press, 2000, pp. 132–39.

2. Inscribed in black felt-tip pen below the image, right: #2 Scenes from a Marriage Lisa + Garth Donna Ferrato 1982.

3. Donna Ferrato, *Living with the Enemy*, intro. by Ann Jones, New York, Aperture, 1991.

4. Ferrato 1991.

5. See Donna Ferrato, *Amore*, Milan, Motta, 2001; Melissa Harris, ed., *Donna Ferrato: Love & Lust*, New York, Aperture Foundation, 2004.

6. Leah Bendavid-Val, *Facing Change: Documenting America*, Munich and New York, Prestel, 2015, pp. 86–107, 247.

7. Donna Ferrato, *Tribeca 9.11.01–9.11.11*, New York, Donna Ferrato, 2011.

8. Donna Ferrato, *Holy*, Brooklyn, powerHouse Books, 2019.

93 — SEBASTIÃO SALGADO

1. On Sebastião Salgado (Aimorés, Minas Gerais, Brazil, February 8, 1944–), see Parvati Nair, *A Different Light: The Photography of Sebastião Salgado*, Durham, North Carolina, Duke University Press, 2011.

2. Sebastião Salgado, *Sahel, l'homme en détresse: Photographies*, intro. by Jean Lacouture, text by

Xavier Emmanuelli, Paris, Prisma Presse for Médecins sans Frontières, 1986.

3. Eduardo Galeano and Fred Ritchin, *An Uncertain Grace: Photographs by Sebastião Salgado*, exhibition catalogue, San Francisco, San Francisco Museum of Modern Art, 1990. See also Sebastião Salgado, *Terra: Struggle of the Landless*, preface by José Saramago, poems by Chico Buarque, London, Phaidon, 1997; Claude Nori et al., *Other Americas: Photographs by Sebastião Salgado*, New York, Aperture, 2015.

4. See Angus Lindsay Wright and Wendy Wolford, *To Inherit the Earth: The Landless Movement and the Struggle for a New Brazil*, Oakland, California, Food First Books, 2003, pp. 38–39.

5. See Leonencio Nossa, *Mata! O Major Curió e as guerrilhas no Araguaia*, São Paulo, Companhia das Letras, 2012.

6. Blindstamped below the image, lower left: © SEBASTIÃO SALGADO; inscribed in graphite on the verso, center left: Sebastião Salgado / BRASIL 1986.

7. Sebastião Salgado, "Les dernier géants du travail," *Paris Match*, August 3, 1990; Matthew L. Wald, "Sebastião Salgado: The Eye of a Photojournalist," *New York Times Magazine*, September 16, 1991, pp. 56, 59, 73.

8. Sebastião Salgado and Eric Nepomuceno, *Workers: An Archaeology of the Industrial Age*, exhibition catalogue, Philadelphia, Philadelphia Museum of Art, 1993.

9. Sebastião Salgado, *Migrations: Humanity in Transition*, New York, Aperture, 2000.

10. Sebastião Salgado, *Genesis*, Cologne, Taschen, 2013.

94 — FLOR GARDUÑO

1. On Flor Garduño (Mexico City, March 21, 1957–), see Francisco Reyes Palma, *Flor Garduño*, Mexico City, Ediciones Tecolote, 2016.

2. See Emma Cecilia García Krinsky, *Kati Horna: Recuento de una obra*, Mexico City, Fondo Kati Horna, 1995.

3. Flor Garduño and Eraclio Zepeda, *Magia del juego eterno*, Juchitán, Oaxaca, Guchachí Reza, 1985. This was followed in 1987 by *Bestiarium*, a series reflecting the everyday interactions and complex relationships of native and country people with all sorts of animals.

4. See Christopher Ornelas, Scott Skinner, and Victorino Tejaxún Alquijay, *Wings of Resistance: The Giant Kites of Guatemala*, Seattle, Drachen Foundation, 2013.

5. Printed by the artist in 1999. Inscribed in graphite on the verso, lower center: Copia imprese por la autor 1999; lower right: Flor Garduño / Canasta de luz Guatemala 1989 / 3976.

6. Matthew 1:18–22; Luke 1:26–38.

7. Manuel Álvarez Bravo, *Diego Rivera before His Mural The Calla Lily Seller (1938)*, 1945; see Andrea Kettenmann, *Diego Rivera, 1886–1957: A Revolutionary Spirit in Modern Art*, Cologne, Taschen, 1997, p. 2.

8. Flor Garduño, *Testigos del tiempo*, intro. by Carlos Fuentes, Mexico City, Redacta, 1992 (*Witnesses of Time*, London and New York, Thames & Hudson, 1992).

9. Flor Garduño and Fredy Weisser, *Mesteños: Salvage caballos indiens*, Pfäffikon, Verlag Schweizer Kavallerist, 1994.

10. Verónica Volkow, *Flor Garduño: Inner Light, Still Lifes and Nudes*, Boston, Little, Brown & Company, 2002.

95 – DAVID LEVINTHAL

1. On David Levinthal (San Francisco, March 8, 1949–), see Lisa Hostetler, Joanna Marsh, and Dave Hickey, *David Levinthal: War, Myth, Desire*, Rochester, New York, George Eastman Museum, 2018.

2. David Levinthal and Garry Trudeau, *Hitler Moves East: A Graphic Chronicle, 1941–43*, Kansas City, Sheed, Andrews & McMeel, 1977.

3. David Levinthal and Eugenia Parry Janis, *Modern Romance*, Atherton, California, Aaron Press, 1985.

4. David Levinthal, *The Wild West*, Washington, D.C., Smithsonian Institution Press, 1993.

5. Inscribed in black felt-tip pen below the image: David Levinthal 1989 I/I.

6. David Levinthal and Valerie Steele, *Barbie Millicent Roberts: An Original*, New York, Pantheon, 1998. In 1972 Levinthal created "Bad Barbie," placing this ostensibly chaste character in a series of compromising situations; see David Levinthal, *Bad Barbie*, intro. by Richard Prince, story by John McWhinnie, New York, JMc & GHB Editions, 2009.

7. See, for example, David Levinthal, *War Games*, ed. Paul Roth and Kaitlin Booher, exhibition catalogue, Washington, D.C., 2013; David Stanford, ed., *I.E.D.: War in Afghanistan and Iraq, David Levinthal*, Brooklyn, powerHouse Books, 2009; David Levinthal and Jonathan Mahler, *Baseball*, New York, Empire Editions, 2006; David Levinthal, *XXX*, interview by Cecilia Andersson, exhibition catalogue, Paris, Galerie Xippas, 2000.

8. See Hostetler, Marsh, and Hickey 2018; the retrospective *American Myth and Memory: David Levinthal Photographs* was exhibited at the Smithsonian American Art Museum, in Washington, D.C., June 7–October 14, 2019.

96 – KENNETH JARECKE

1. "I Love New York: The Rotting of the Big Apple," *TIME*, September 17, 1990.

2. Ken Jarecke, "I, Witness: The Image of War; The Story Behind a Horrific and Controversial Photo," *American Photo*, vol. 2, July/August 1991, p. 45.

3. Inscribed in black felt-tip pen on the recto below the image, lower right: Ken Jarecke; inscribed in graphite on the verso, lower center: 6 of 20 + 4 A.P. / Ken Jarecke / © Feb 1993; right center: Printed 2/93 /

by / Ctein. This print is one from an edition of dye imbibition prints, a process that the photographer selected for its accuracy of hue and its permanence. Developed in association with filmmaking and closely related to Technicolor, Kodak began marketing this as their Dye Transfer process for still color prints in 1945 (see Therese Mulligan, *Jeannette Klute: A Photographic Pioneer*, Rochester, New York, RIT Press, 2017). By the early 1990s, however, Kodak had begun to curtail production of negatives, dye and papers, anticipating the rise of digital printing. The photographer, technician and author Ctein had stockpiled the materials and was able to print the edition in February 1993.

4. Colin Smith, "The Real Face of War," *Observer*, March 3, 1991, p. 9.

5. Tony Harrison, *A Cold Coming: Gulf War Poems*, Hexham, Northumbria, Bloodaxe Books, 1997.

6. Jarecke 1991, pp. 44–46, 120; see also Torie Rose Deghett, "The War Photo No One Would Publish," *Atlantic*, August 8, 2014.

7. The photograph is among the selection of his Gulf War images in the photobook *Just Another War* (Kenneth Jarecke and Exene Cervenka, intro. by John Hockenberry, Joliet, Montana, Bedrock Press, 1992).

8. Rich Clarkson, *Notre Dame Football Today*, photographs by Kenneth Jarecke, John Loengrad, et al., New York, Pindar Press, 1992; see also Kenneth Jarecke, *Husker Game Day 2010: Farewell Big Twelve*, Joliet, Montana, EyeQ Press, 2011.

97 – MARIANA YAMPOLSKY

1. Jo Tuckman, "Mariana Yampolsky: Photographer Who Caught the Emotions of Mexico," *Guardian*, May 17, 2002.

2. On Mariana Yampolsky (Chicago, September 6, 1925–May 3, 2002, Mexico City), see José Ángel Campos Salgado, Jorge Contreras Cárdenas, et al., *Mariana Yampolsky: Mirada que cautiva la mirada*, exhibition catalogue, Mexico City, Fundación Cultural Mariana Yampolsky, Universidad Autónoma Metropolitana, 2012.

3. Pablo O'Higgins had lived in Mexico since 1924. In 1933 he studied at the Academy of Art in Moscow, supported by a scholarship from the Mexican Communist Party. See Elena Poniatowska and Gilberto Bosques, *Pablo O'Higgins*, Mexico City, Fondo Editorial de la Plástica Mexicana, 1984; Leticia López Orozco, ed., *Pablo O'Higgins: Construyendo vidas*, Mexico City, Fundación Cultural María y Pablo O'Higgins, 2005.

4. *Grafik Mexikansk*, Kungshallen, Stockholm, 1950; *Mexican Art*, National Museum, Tokyo, 1955; 20th anniversary retrospective of the work of the Taller de Gráfica Popular, Palacio de Bellas Artes, Mexico City, 1957; *Grabados mexicanos contemporaneos*, Musée Galliera, Paris, 1958.

5. Mariana Yampolsky and Elena Poniatowska, *La raíz y el camino*, Mexico City, Fondo de Cultura Económica, 1985; Mariana Yampolsky, *Estancias del olvido*, Pachuca, Hidalgo, Mexico City, Biblioteca de Cultura Hidalguense del Centro Hidalguense de Investigaciones Históricas, 1987.

6. Mariana Yampolsky and Elena Poniatowska, *Mazahua*, Toluca, Gobierno del Estado de México, 1993; variant versions traveled to Berlin and to Hafnarfjörður, Iceland.

7. Inscribed in graphite on the verso, lower left: Al Filo del Tiempo – On the Edge of Time 1992; lower right: Mariana Yampolsky.

8. Elizabeth Ferrer, Elena Poniatowska, and Francisco Reyes Palma, *Mariana Yampolsky: Imagen, memoria*, exhibition catalogue, Mexico City, Centro de la Imagen, 1999.

98 – SALLY MANN

1. On Sally Mann (Lexington, Virginia, May 1, 1951–), see Sarah Greenough, Sarah Kennel, et al., *Sally Mann: A Thousand Crossings*, New York, Harry N. Abrams, 2018; Sally Mann, *Hold Still: A Memoir with Photographs*, New York, Little, Brown & Company, 2015.

2. Mann 2015, pp. 216–20.

3. Sally Mann, *At Twelve: Portraits of Young Women*, New York, Aperture, 1988.

4. Sally Mann, *Immediate Family*, afterword by Reynolds Price, New York, Aperture, 1992.

5. Inscribed in graphite on the verso, lower left: ed(25 24 × 30 / 25 16 × 20 / 25 8 × 10; lower right: ©1995 Sempervirens "stricta" / SMann / 6/25.

6. Mann 2015, pp. 214–20; Mark Osterman, *The Wet Plate Process: A Working Guide*, Newtown, Pennsylvania, Scully & Ostermann, 1997.

7. Ellen Dugan, ed., *Picturing the South: 1860 to the Present; Photographers and Writers*, exhibition catalogue, Atlanta, High Museum of Art, 1996; Sally Mann, *Deep South*, New York, Bulfinch Press, 2005.

8. Sally Mann, *What Remains*, Boston, Bulfinch Press, 2003.

9. Sally Mann, *Proud Flesh*, contribution by C. D. Wright, New York, Aperture Foundation Books, 2009.

10. John B. Ravenal et al., *Sally Mann: The Flesh and the Spirit*, Richmond, Virginia Museum of Fine Arts, Aperture Foundation, 2011.

11. Mann 2015; Greenough, Kennel, et al. 2018.

99 – RICHARD MISRACH

1. On Richard Misrach (Los Angeles, July 11, 1949–), see Richard Misrach, *Richard Misrach: Chronologies*, San Francisco, Fraenkel Gallery, 2005; Anne Wilkes Tucker and Rebecca Solnit, *Crimes and Splendor: The Desert Cantos of Richard Misrach*, exhibition catalogue, Houston, Museum of Fine Arts, 1996.

2. Richard Misrach, *Telegraph 3 A.M.: The Street People of Telegraph Avenue*, Berkeley, California,

Berkeley, California, Cornucopia
Press, 1974.

3. Reyner Banham, *Richard Misrach: Desert Cantos*,
exhibition catalogue, Oakland, California,
Oakland Museum, 1987; Susan Sontag, *Violent
Legacies: Three Cantos, by Richard Misrach*, New York,
Aperture, 1992; Tucker and Solnit 1996.

4. Richard Misrach and Myriam Weisang, *Bravo
20: The Bombing of the American West*, exhibition
catalogue, Las Vegas, Donna Beam Fine Art
Gallery, University of Nevada, 1990.

5. Richard Misrach and Rebecca Solnit, *The
Sky Book*, Santa Fe, New Mexico, Arena
Editions, 2000.

6. Inscribed in black felt-tip pen below
the image, lower left: 2/25 11A1A98
6:43:54 A.M.; lower right: Richard Misrach
1998/1999.

7. Richard Misrach, *Golden Gate*, Santa Fe, New
Mexico, Arena Editions, 2001.

8. Richard Misrach and Kate Orff,
Petrochemical America, New York, Aperture
Foundation, 2012.

9. Richard Misrach and Leslie A. Martin, ed.,
On the Beach, New York, Aperture, 2007.

10. Richard Misrach, *11.21.11 5:40pm*, exhibition
catalogue, San Francisco, Fraenkel
Gallery, 2013.

11. Richard Misrach, Guillermo Galindo,
and Josh Kun, *Border Cantos*, New York,
Aperture, 2016.

100 — ABELARDO MORELL

1. See Martine Bubb, *La camera obscura: Philosophie
d'un appareil*, Paris, L'Harmattan, 2010;
John H. Hammond, *The Camera Obscura: A
Chronicle*, Bristol, Gloucestershire, Adam
Hilger, 1981.

2. On Abelardo Morell (Havana, Cuba, 1948–),
see Elizabeth Siegel with Brett Abbott and
Paul Martineau, *Abelardo Morell: The Universe
Next Door*, exhibition catalogue, Chicago, Art
Institute of Chicago, 2013, pp. 162–73.

3. Morell's *Lightbulb* photograph became a
signature image for the exhibition *More
Than One Photography: Works since 1980 from the
Collection*, organized by Peter Galassi at the
Museum of Modern Art, New York, May 14–
August 9, 1992.

4. Abelardo Morell, *A Camera in a Room: Photographs
by Abelardo Morell*, Washington, D.C.,
Smithsonian Institution Press, 1995, p. 7.

5. See Abelardo Morell and Luc Sante, *Camera
Obscura*, New York, Bulfinch Press, 2004;
Richard B. Woodward, *Abelardo Morell*, New
York, Phaidon Press, 2005.

6. Abelardo Morell, *A Book of Books*, Boston,
Little, Brown & Company, 2002.

7. Morell 1995.

8. Lewis Carroll, *Alice's Adventures in Wonderland*,
intro. by Leonard M. Marcus, photographs
by Abelardo Morell, New York,
Dutton, 1998.

9. Charles Simic and Jennifer R. Gross,
*Abelardo Morell, Face to Face: Photographs at the
Gardner Museum*, exhibition catalogue, Boston,
Isabella Stewart Gardner Museum, 1998.
The Gardner exhibition was closely followed
by a mid-career retrospective at the Museum
of Photographic Arts in San Diego; see
Diana Gaston, *Abelardo Morell and the Camera Eye*,
exhibition catalogue, San Diego, Museum of
Photographic Arts, 1999.

10. Inscribed in graphite on the verso, lower
left: ABELARDO MORELL; lower
right: CAMERA OBSCURA IMAGE
OF UMBRIAN LANDSCAPE OVER
BED, 2000.

11. Since 2000, Morell and his assistant,
C. J. Heyliger, have developed a portable
camera obscura to capture outdoor images.
The apparatus is set into a floorless dome-
shaped tent, pierced at its apex for a prism
and a diopter lens, which together project
an image of the surrounding landscape
onto the ground inside the tent. The prism
reorients the projected image of the outside
world right side up, while the lens renders
the image brighter and more sharply focused,
reducing Morell's exposure times with his
large-format camera to between four and
five hours. The color photographs he makes
capture an outdoor scene along with the
varied characteristics of the ground surface
at each site.

GLOSSARY

ADDITIVE COLOR is the principle by which all the colors of light are made by combining different proportions of the three primary colors: blue, green and red. Such diverse photographic processes as AUTOCHROME and color television depend on this principle. An equal mixture of the three primary colors results in white light. When white light passes through a filter for one of the primary additive colors, it transmits only that hue of light and absorbs the others. Black-and-white photographic NEGATIVES exposed through such filters are called *separation negatives* and are used in such techniques as CARBRO and DYE IMBIBITION printing.

ALBUMEN is the clear liquid of a hen's egg, used to bind SILVER SALTS to paper in albumen prints, the predominant photographic medium of the 19th century. Louis Désiré Blanquart-Evrard introduced this process in 1851 to achieve more detail than the SALT PRINT, suspending the image on the paper surface instead of embedding silver salts in the paper fibers. To make an albumen print, an artisan added sodium or ammonium chloride to egg white, infusing the chemicals by beating the mixture to a froth. The solution was strained and settled, and a sheet of very thin paper was floated on the liquid to coat one side of the sheet. When dry, the prepared paper was then floated, in complete darkness, on a solution of silver nitrate to make it light sensitive. The sensitized albumen paper was PRINTED-OUT in contact with a NEGATIVE in sunlight. To prevent the thin prints from curling, they were usually mounted on stiff cardboard.

AMBROTYPE is an American term for collodion positive, a process for producing a unique photograph on glass. To make an ambrotype, the artisan prepared a collodion NEGATIVE on glass, and underexposed the plate in the camera. After developing in a solution of silver nitrate and nitric or acetic acid, the negative image appears as a POSITIVE when placed against a dark background. This was usually achieved by placing a slip of dark paper or cloth behind the glass, and enclosing both in a protective case, like a DAGUERREOTYPE. A similar effect could be achieved by using a support of dark green or red glass. Simpler and more economical, ambrotype displaced daguerreotype in the late 1850s as the preferred process for miniature portrait photographs. The ambrotype process was developed by Boston inventor and photographer James Ambrose Cutting as a method for protecting photographic EMULSION with a glass cover sheet adhered with Canada balsam. In 1854 he was granted an American patent for this refinement and, controversially, for the process itself. He called it ambrotype, derived from the Greek *athánatos*, meaning "immortal." Later in life, Cutting changed his middle name to Ambrose to strengthen further his identification with the process.

APERTURE, from the Latin *apertura*, or "opening," refers to the hole in the body or LENS of a CAMERA through which light passes for the purpose of EXPOSURE.

AUTOCHROME is an ADDITIVE COLOR screen process, the first successful commercial medium for color photography. Louis Lumière developed this process for creating unique, direct POSITIVE transparencies on glass. He was awarded a French patent in 1903, and introduced the Lumière Autochrome to the market in 1907. His factory technicians in Paris manufactured mosaic color screens on glass plates, sized to fit popular cameras. They began by dying microscopic grains of potato starch red, blue and green. The colors were intermingled before the dyed grains were cast over varnished glass plates when wet, to adhere and flatten the grains. The plates were dusted with black carbon, filling the spaces between the grains. A second varnish layer contained a gelatin silver EMULSION sensitive to all colors of light. Having purchased an Autochrome plate, the photographer loaded it into the camera with the glass facing the lens, so that light passed through the screen before striking the emulsion. After exposure, the plate was developed, bleached and exposed to daylight, then re-developed in the same developer, transforming the negative image into a positive. Autochrome TRANSPARENCIES could be projected, or viewed with the aid of a diascope, an apparatus with a tilted mirror to reflect light through the plate.

BARYTA is a coating for photographic paper that creates a reflective surface to brighten the superimposed image. Named for its constituent compounds, barium sulfate and strontium sulfate, baryta was applied in solution to the paper surface. Different manufacturers used varied ratios of barium to strontium to coat their photographic papers, so chemical analysis can often identify paper makers, and thus help to date photographs.

BICHROMATED COLLOID is a viscous substance, like gelatin or ALBUMEN, made light-sensitive by the addition of a bichromate, usually potassium bichromate. Bichromated colloids harden when exposed to light and become insoluble in water. Many non-silver photographic processes, such as CARBON PRINTS and GUM BICHROMATE PRINTS, depend upon this principle.

BLINDSTAMP is an identifying mark embossed into paper without ink. It usually indicates a maker's name, commercial address or trademark. Blindstamps are pressed into dry paper by interlocking metal discs held in a plierslike tool or small mechanical press.

BROMOIL is a variation on the OIL PRINT process that allows for enlargements. It enables an artist to combine the image from a photographic negative with hand work with a crayon or brush. To make a bromoil print, an artisan made a gelatin silver bromide print by enlargement. It was bleached with a solution of potassium bichromate, causing the gelatin to harden in proportion to the amount of silver, leaving a clear image in relief. The enlargement was soaked in hot water, causing the gelatin became to swell and become adhesive to greasy lithograph ink. The artisan applied this pigment with a crayon or brush; the ink adhered to the photographic image while being repelled from the wetted areas. The inked sheet was placed against a piece of paper, which was run through a small printing press. In this way, an oil or bromoil transfer print could be reprinted several times, with varied inking.

CABINET CARD was a popular design for mid-sized albumen photographic prints during the 1860s. Like the foregoing CARTE-DE-VISITE, a cabinet card consisted of a thin photographic print supported by a stiff card. Their size was standardized at about 6¼ x 4¼ inches (15.9 x 10.8 cm).

CALOTYPE is the name that William Henry Fox Talbot gave to his paper negative technique, developed during the 1830s. He combined the Greek word *kalos*, meaning "beauty," with *tupos*, meaning "print." To make a calotype negative, Talbot brushed a silver nitrate solution onto writing paper, and exposed the sensitized sheet in a camera for a minute or two. He protected the paper from light while removing it from the camera, and DEVELOPED-OUT the latent image by brushing on more silver nitrate solution. After rinsing, he stabilized the image by washing the sheet in potassium bromide, or fixing its image in HYPO. Calotype negatives could be printed in contact with sheets sensitized by the same method. However, Talbot preferred the look of his earlier printing papers, prepared with silver chloride. The calotype process established the negative-positive method as the foundation of photography for the 20th century.

CAMERA, the Latin word for "chamber" was used among scientists since the 16th century to describe a device for capturing and viewing an image. In its simplest form, a photographic camera is a lightproof box pierced by a small hole or LENS at one end. Opposite this APERTURE is an arrangement for the insertion and withdrawal of a light-sensitive plate or film.

CAMERA LUCIDA, or "light chamber" in Latin, is a drawing tool that has no chamber at all. In 1806 the British scientist William Hyde Wollaston introduced this instrument, consisting of a triangular prism mounted to a telescoping stick. With one side of the prism facing a horizontal drawing surface, and another facing the subject, the artist could look into the third face and perceive the subject projected onto the drawing board where it could be traced.

CAMERA OBSCURA, or "dark chamber" in Latin, is a device for viewing natural optical phenomena of reflected light. It consists of a darkened room—or a lightproof box—with a small APERTURE in one wall. As light enters through the opening, an inverted and reversed image of the outside view is projected on the opposite wall. Employed as a drawing tool in the 17th century, the camera obscura was a direct precursor to the modern photographic camera.

CARBON PRINT is a pigment printing technique patented by Alphonse Poitevin in 1855. It is based on the light-sensitive potassium bichromate, rather than silver or metallic salts. To make a carbon print, the artisan coated a thin sheet of paper with gelatin mixed with potassium bichromate, tinted chimney soot or lampblack. Exposed in contact with a negative, the gelatin hardened in proportion to the amount of light received. Next the exposed sheet was pressed against a second piece of paper coated with an insoluble gelatin layer. These were soaked together in warm water, where the unhardened gelatin dissolved while the hardened gelatin and its black pigment transferred to the final print.

CARBRO PRINT is a color photography process named for its principal chemical constituents, carbon and bromide. To make a carbro print, the artisan pressed a wet silver bromide print against a sheet of paper prepared with gelatin and sensitized with potassium bichromate. This contact generates a chemical reaction as the gelatin print hardens, and the silver is bleached away. When the two sheets were separated, the hardened gelatin was offset onto transfer paper, a low-relief gelatin image. For color carbro prints, the photographer exposed three negatives of the same image—through red, blue and green filters—producing three separate gelatin silver bromide prints. Each was chemically and physically converted into a low-relief image transfer paper tinted with one of the primary SUBTRACTIVE COLORS—cyan, magenta or yellow—which was overprinted onto

the final print. The component separations of carbo printing were compatible with industrial offset-lithography; each constituent image could be transferred to a separate zincographic matrix and printed by mechanical presses onto paper.

CARTE-DE-VISITE, or "visiting card" in French, was the most popular format for photographic prints in the 19th century. In 1854 the Parisian photographer André Adolphe-Eugène Disdéri patented a method of dividing one large glass plate into sections, which were separately exposed and developed together, to produce several portrait photographs quickly and inexpensively. Disdéri cut the albumen prints apart and pasted each onto a separate stiff card, sized about 4½ x 2½ inches (11.4 x 6.4 cm). Variant methods of producing the small prints quickly followed, spawning an industry.

CASED PHOTOGRAPHS are fragile images, such as DAGUERREOTYPES, kept in hinged protective cases. Particularly in the United States, miniature photographic portraits were housed in small, flat boxes as painted portrait miniatures had been. Made from wood, papier-mâché or thermoplastic, the case held a photographic plate behind glass, with an embossed and gilt tin mat. The case was often lined with velvet or satin, which not only padded the glass but provided a dark, matte surface against which to view the reflective daguerreotype.

CELLULOID, see COLLODION.

CHROMOGENIC PRINT (dye-coupler, type c-print) describes one of a number of proprietary techniques for DEVELOPED-OUT color prints on complex, layered paper. Three silver EMULSION layers, sensitized to the primary ADDITIVE COLORS of light, are superimposed on the paper. These are separated by chemical compounds, known as dye couplers, that react with oxidized developer to form color dyes. During development the dye couplers bond with the exposed and developed silver halides and produce complimentary SUBTRACTIVE COLOR DYES, creating a full-color POSITIVE image. Introduced in 1942, Kodacolor print film became a dominant chromogenic product of the era. During the 1990s chromogenic digital prints superseded those made from NEGATIVES.

CIBACHROME, see SILVER DYE BLEACH.

CLICHÉ-VERRE is an image printed on photographic paper from a hand-drawn negative. William Henry Fox Talbot described the technique in the 1830s, and it was later advanced by Adalbert Cuvelier among the Barbizon circle of painters. To make a cliché-verre, an artisan coated a sheet of glass with paint or another opaque medium, and after the medium had dried, drew through it with a sharp stylus. When the plate was CONTACT PRINTED

on sensitized paper, light passed through the areas scratched away to create a reproducible linear image.

COLLAGE, French for "pasting," describes the combination of various materials, photographic or otherwise, glued to a common support to create a single image. PHOTOMONTAGE refers to the combination of multiple photographic images into one, by varied techniques that might include combination printing, collage and digital editing software. Although collage and photomontage are distinct processes, the two terms are often used interchangeably.

COLLODION is a volatile, syrupy mixture of cellulose nitrate, alcohol, ether and potassium iodide. First created by Louis-Nicolas Ménard and Florès Domonte in 1846 as an explosive, it was quickly modified for other applications. In Boston, physicians used the solution as a flexible medical dressing, calling it *collodion*, from the Greek for "gluey." In England, Frederick Scott Archer began using collodion in 1851 to adhere light-sensitive SILVER SALTS to glass to produce truly transparent NEGATIVES. The WET-PLATE COLLODION technique was inconvenient, however, because the negatives had to be sensitized, exposed and developed while the EMULSION remained moist. In 1862 Alexander Parkes used synthetic nitrocellulose to formulate the first man-made plastic, and six years later John Wesley Hyatt added camphor for a flexible material he named CELLULOID. In the late 1880s this transparent material came into use as a photographic film base. This "nitrate film" was dangerously flammable, and it was replaced during the 1930s by cellulose acetate "safety film" for X-ray stock and in 1948 for motion-picture film.

COLLODION PRINTING-OUT PAPERS (matte collodion) papers were commercial materials with a BARYTA layer, covered with a layer of collodion sensitized with silver chloride and citric acid. The first commercial collodion printing-out paper, Leptographic paper, became available in Madrid and Paris in 1866. Papers were mass-produced on a larger scale beginning in 1889 with the introduction of coating machines. Collodion printing-out papers were superseded by gelatin printing-out papers in the late 1910s.

COLLOTYPE is a planographic printing process for reproducing photographic images captured by a BICHROMATED COLLOID. Alphonse Poitevin developed the process in the early 1850s, using a lithography stone. In 1869 Joseph Albert refined the technique and brought collotype into widespread use. He coated a heavy glass plate with two layers of gelatin: a base layer containing sodium silicate was superimposed with gelatin carrying a light-sensitive solution of potassium or ammonium dichromate. These EMULSION layers were thoroughly dried in a

warming box before the plate was exposed in contact with a laterally reversed negative. The bichromated gelatin hardened in proportion to the light received. The plate was flushed with cold water, causing the gelatin to shrink and creating a microscopically reticulated pattern in its surface. For printing, the plate was flushed with water and glycerin then charged with a stiff, oil-based printing ink, which adhered to the gelatin while being repelled by the wet surface. The matrix could be reinked and reprinted on hard-surfaced paper in a lithography press.

COLOR TRANSPARENCY, see CHROMOGENIC PRINT.

COMBINATION PRINT is an integral photographic image made from multiple NEGATIVES. During the 1850s photographers used combination printing to compensate for the sensitivity of COLLODION to blue sky light. Images were combined by splicing or sandwiching negatives, and photographers like Oscar Gustave Rejlander and Henry Peach Robinson fused original images of studio tableaux into historical, literary or melodramatic compositions to approximate painting. In the 20th century, artists used ENLARGERS to combine passages from different NEGATIVES in the darkroom.

CONTACT PRINT is a photographic image made by exposing light-sensitive paper or plates against a negative, the dimensions of which the image retains. This was the only practical printing method before ENLARGERS were perfected in the 1880s.

CYANOTYPE is a photographic process invented in 1842 by Sir John Herschel. He coated paper with a mixture of ammonia, ferric citrate and potassium ferricyanide. In sunlight these chemicals shift to a bright, insoluble Prussian blue pigment. A bath in running water FIXED the image. Herschel used the process for PHOTOGRAMS, placing botanical specimens on the sensitized sheets to create white silhouette images on a blue ground. Negatives could be conveniently PRINTED-OUT in contact with cyanotype paper. In the 1870s the process came into use for printing-out copies of architectural designs drawn on translucent paper, known as blueprints.

DAGUERREOTYPE was the first practical photographic process, introduced by Louis-Jacques-Mandé Daguerre in 1839, which yielded unique POSITIVE images of incomparable precision. To make a daguerreotype, an artisan prepared a sheet of copper plated with silver and polished to a mirror surface. In a lightproof container, this plate was exposed to vapors from iodine crystals to create the light-sensitive compound silver iodide. The sensitized plate was exposed in a camera and then removed to another lightproof container, where it was suspended over a heated dish of mercury, the vapors from which created an image on the plate in silver mercury alloy. The image was FIXED by immersion in a saline solution and TONED with gold chloride. Daguerreotypes have fragile surfaces, which were protected behind glass in frames or protective cases.

DARKROOM refers to an area used for handling and processing light-sensitive photographic materials. The space is usually illuminated by a safelight that using those parts of the visible spectrum to which photographic materials are insensitive.

DIGITAL PHOTOGRAPH is a generic term describing methods of capturing an image though photoelectric cells rather than through chemical reactions on a physical surface. Digital systems detect reflected photons, translating them into electrons to be digitized and recorded electronically. Photoelectric sensors, acting as light a detector, proportionately convert light-level EXPOSURE to a number scale, to be stored and manipulated in binary form by a computer. This technology was developed for the study of astronomy in the 1960s–1980s, using charge-coupled device (CCD) image sensors that shifted the photocharge to a central charge-to-voltage converter. The first commercially available digital camera using a CCD image sensor came to the market in 1990; the device gathered and digitally downloaded images directly to a personal computer. Within a decade, swiftly advancing technology made inexpensive digital cameras popular amid the general public. The term DIGITAL PHOTOGRAPH also often describes images captured on film then digitized through scanning.

DIGITAL INKJET PRINT is the largest and most diverse technology for printing electronically stored photographic images. Images are collected through the lenses of a digital camera or scanner on arrays of photosensitive cells and converted to binary code, electronically stored and organized in pixels—or picture elements. This data can be manipulated via computer, offering previously unimagined possibilities for creating and presenting visual images. As electrical signals, the image data is sent from the computer to a printer, where it is translated into minute droplets of ink that are propelled by air onto a support. By varying the size and interval of the ink droplets, the printer controls color, to achieve a broad spectrum of hues and tones.

DRY-PLATE NEGATIVE, see GELATIN DRY-PLATE NEGATIVE.

DYE DIFFUSION TRANSFER PRINT is a process introduced in 1948 by Edwin H. Lamb, who devised a camera and film capable of producing a NEGATIVE and POSITIVE instantaneously. A specialized camera held film in multilayered packs, each including an image-receiving layer, a reagent-collecting layer, and layers sensitized to the primary ADDITIVE COLORS alternating with layers of primary SUBTRACTIVE COLOR dyes. Immediately after exposure, the film pack was removed from the camera, in an action that broke open a pod of reagent that started the development process. Exposed silver in the additive color layer blocked the diffusion of the complimentary subtractive colors upward to the image-receiving layer. The reagent-collecting layer turned opaque, masking the residual silver and dyes in the image receiving layer.

DYE IMBIBITION (dye transfer) is a technique for printing photographic images in colored dyes from gelatin matrices. The process began with three separation negatives of the same image, exposed through filters for ADDITIVE COLORS: red, green and blue. Each was enlarged and transferred to orthochromatic film coated with unhardened gelatin and developed into a relief matrix. They were separately immersed in dyes in SUBTRACTIVE COLORS: cyan, magenta and yellow. The pigment was then transferred from the matrices in exact register onto a sheet of gelatin-coated receiving BARYTA paper for a full-color print. The Kodak Dye Transfer process was introduced in 1945 and, superseded by digital inkjet printing, the production of its materials was discontinued in 1994.

ELECTROPLATING is a method of applying a silver surface to a copper plate, often employed in the production of DAGUERREOTYPES. The copper plate is wired to an electric current and suspended in a bath of potassium cyanide, along with the source metal. When the electricity is applied, molecules of silver are transferred to the plate surface by electrolysis. The technique allows for a uniform and blemish-free coat of silver on the plate.

EMULSION is a light-sensitive coating applied to a film, paper, plate or other substrate. Its basic form consists of SILVER SALTS suspended in a binding agent, like ALBUMEN or gelatin, to hold the light-sensitive materials on a support.

ENLARGER is a projection device used in the DARKROOM to increase the size of a photographic image, usually from a NEGATIVE to a print. In its simplest form the instrument consists of an enclosed light source and projection LENS. The first enlargers of the 1850s used sunlight, later to be replaced by gas, and then electricity as the light sensitivity of photographic paper improved concurrently.

EXPOSURE is the act of revealing photographically sensitive material, such as printing paper or film, to the action of light, in a printing frame, CAMERA or ENLARGER.

FIX, see HYPO.

FLASH is both a burst of light illuminating a photographic exposure and the equipment that generates the light. Photographers began working with artificial light in the latter half of the 19th century, using magnesium powder or wire to produce a brief, intense explosion of white light. The electric flash bulb was introduced in 1925, and after World War II the electronic stroboscopic flash became available for photographic applications.

GELATIN DRY-PLATE NEGATIVES (DRY-PLATE NEGATIVES) are NEGATIVES on glass or film in which gelatin is the vehicle for light-sensitive SILVER SALTS. While searching for alternatives to the WET-PLATE COLLODION process, to avoid its use of ether, the English physician and photographer Richard Leach Maddox mixed silver bromide in cooking gelatin, which he probably knew from its use as an adhesive in microscope slides. In 1871 he published his method of preparing glass-plate negatives that could be prepared in advance and developed later. In 1879 glass dry plates became commercially available, soon to be followed by machine-coated CELLULOID negatives. In the 1880s photographers also made POSITIVE gelatin dry-plate TRANSPARENCIES on glass, sensitized with silver bromide crystals or silver chloride. Transparencies were CONTACT PRINTED, reversal processed, or produced by re-photographing a negative with a copy camera. They were viewed in transmitted light, or projected as lantern slides.

GELATIN SILVER PRINTING-OUT PRINTS are made of light-sensitive silver halides bound to a BARYTA paper support in an EMULSION of refined gelatin. The process was perfected by Sir William Abney in 1882 and produced by different manufacturers in 1884. After printing in contact with a NEGATIVE in sunlight, the sheets were washed, TONED and FIXED in the darkroom. By the turn of the century, gelatin printing-out papers were used more commonly than collodion printing-out papers, although both were displaced by gelatin developing-out papers in the 1910s.

GELATIN SILVER PRINTS (gelatin silver developed-out prints, silver gelatin prints) are made with light-sensitive silver halides bound to a BARYTA paper support with a gelatin EMULSION. The latent image in the exposed photographic paper becomes visible only when DEVELOPED-OUT in chemical baths in a darkroom. By an oxidation-reduction reaction, the silver ions in the image are reduced to visible silver particles. An immediate stop bath halts the development process, then unexposed silver halides are removed in a fixing solution, usually HYPO, that dissolves silver halide crystals into a water-soluble compound. During developing, gelatin silver prints are usually chemically TONED with gold, polysulfides or selenium to control tone and color, and to increase print stability. The gelatin silver print from film was the predominant photographic technique for over a century.

GUM BICHROMATE PRINT is a pigment technique that depends upon the reaction of BICHROMATED COLLOIDS when exposed to light. To make the print, an artisan prepared a sheet of paper with gum arabic mixed with pigment and sensitized with potassium dichromate crystals. The dried sheet was exposed in contact with a negative, and the gum hardened in proportion to the amount of light received through the negative. When the paper was soaked in water, the unhardened gum dissolved away, leaving a POSITIVE image of pigmented gum. In the 1890s Pictorialist photographers adopted the technique for its aesthetic, handcrafted appearance. Since there are no light-sensitive metals susceptible to deterioration in gum bichromate prints, they are unusually stable photographs.

GUM PLATINUM PRINT is a process that combines the fine tonal gradations found in the PLATINUM PRINT process with the deep shadowed areas possible in GUM BICHROMATE PRINTS. Beginning with a lightly exposed, fully developed platinum print, an artisan applied sensitized and pigmented gum arabic before re-exposing the sheet under the same negative. With a stylus or brush, the artisan then applied pigmented gum arabic in solution, which adhered to the adhesive passages, combining the precise photographic image and hand-drawn effects.

HALFTONE is a process for transferring photographic images to printing matrices to be mass-produced on a printing press. To create a halftone, an artisan photographed a POSITIVE through a screen, which reduces the image to microscopic dots. The dot size and proximity correspond to areas of light and shadow in the original image to be reproduced. This visual information was transferred to a gravure, lithograph or even gelatin matrix, and the tiny discreet shapes were printed by mechanical presses. After the halftone process was perfected in the 1880s, photograph images began appearing along with text in newspaper and magazines.

HYPO (FIX) is a general term used to describe chemical solutions that arrest the chemical changes of development, "fix" the image, and dissolve light-sensitive photographic materials. Sir John Herschel introduced the use of "hyposulfate of soda" for this purpose in 1839. Contemporary hypo solutions are most commonly sodium thiosulfate.

INTERPOSITIVE is a POSITIVE image that is made from a NEGATIVE and printed on a glass plate prepared with gelatin silver. It serves as an intermediary stage that gives the photographer who wishes to retouch the photograph a positive image on which to work. The interpositive can be drawn on, scratched or otherwise manipulated, then used to make another negative. The final print is made from the second negative.

LANTERN SLIDE, see TRANSPARENCY.

LATENT IMAGE is an image, invisible to the eye, held on a light-sensitive material such as film or paper after photographic EXPOSURE. During the PRINTING-OUT or DEVELOPING-OUT processes, the latent image is made visible.

LENS is a disc of optical glass or polymer acrylic that directs light rays onto film or a plate. Modern lenses are shaped for desired effects, such as wide angle, telephoto, soft focus, enlarging and zoom.

MINIATURE CAMERA is a portable, hand-held camera using roll film, as opposed to the large apparatus, balanced on a tripod, that exposes plate or sheet film. The term came into popular use at the end of the 19th century when the first cameras exposing 35 mm NEGATIVES became commercially available. The first miniature camera was the Kodak No. 1, introduced in 1888, which exposed negatives for round contact prints, 2½ inches (6.4 cm) in diameter. In 1912–13 the German optical engineer Oskar Barnack developed a miniature still camera that used standard roll film in movie cameras. It exposed square negatives of less than 1⅛ inches (35 mm), which had to be enlarged in the darkroom to produce legible prints. The camera also required a specially designed lens to achieve the necessary resolution. In 1923 Barnack persuaded Ernst Leitz II to manufacture prototype cameras and ENLARGERS, and transformed the practice and aesethetics of photography.

NEGATIVE is a photographic record in which the light and shadows of the natural world are reversed. Negatives are used in CONTACT PRINTING, or in an ENLARGER to create POSITIVE prints. William Henry Fox Talbot discovered this principle and realized its potential. The ideal support for photographic negatives are transparent, and innovators progressively developed glass negatives, followed by flexible materials such as nitrocellulose—or nitrate—film, and cellulose acetate, which was superseded by polyester (polyethylene terephthalate).

OIL PRINT is a process for combining photographically derived imagery with a the touch of an artist's hand, derived from Alphonse Poitevin's experiments with bichromated gelatin in the 1850s (see COLLOTYPE). To make an oil print, the artisan coated a sheet of paper with a thick layer of unpigmented bichromated gelatin. The sensitized sheet was exposed to light in contact with a NEGATIVE, causing the gelatin to

harden in proportion to the amount of light that reaches the paper. When the exposed print was soaked in water, the soluble gelatin was washed away. Afterward the artisan, using a brush, stylus or crayon, applied an oil-based pigment, which adhered to the sticky passages of gelatin, combining the precise photographic image with hand-drawn effects. This process of modifying photographic images by hand was popularized by a description of the process published by G. E. H. Rawlins in 1904. A counterproof, or oil transfer print, can be made by pressing an inked oil print against another sheet of paper in an etching press.

PALLADIUM PRINT, is a developing-out process, similar to that of the PLATINUM PRINT, that depends upon the light sensitivity of iron salts. Images created with this process form in the fibers of the paper, creating soft, rich blacks. In the run-up to World War I, when platinum was diverted to military production, palladium was combined with platinum and used in its place in photographic papers. The Platinotype Company in London began to manufacture platinum/palladium, and palladium papers in 1916. These papers produced warmer tones in photographs with enduring stability. Technical and commercial changes to the industry ended production of these materials in the 1930s.

PAPER NEGATIVE, see CALOTYPE, SALT PRINT.

PHOTOGENIC DRAWING see CALOTYPE PHOTOGRAM.

PHOTOGRAM (PHOTOGENIC DRAWING, RAYOGRAPH) is a unique, cameraless photographic print. The process was discovered by William Henry Fox Talbot who used silver iodide and both acetic and gallic acid to sensitize the paper for the process he called PHOTOGENIC DRAWING. In the 20th century, artists like László Moholy-Nagy and Man Ray (Cat. nos. 25, 50) adapted the process to the darkroom. To make a photogram, an artisan placed objects in direct contact with sensitized photographic paper and exposed it to a light source. In areas where the object blocked or shaded the paper, the sheet remained unexposed and light in tone, while the exposed areas darkened. When semi-translucent materials were used to block the light, a corresponding partial exposure was achieved.

PHOTOGRAVURE is a technology for chemically transferring a photographic image to an intaglio plate to be printed on a mechanical press. In 1858, William Henry Fox Talbot patented his "photoglyphic engraving" reproductive process, in which steel plates were coated with potassium bichromate in gelatin, and exposed in contact with a waxed-paper POSITIVE. Talbot then covered the entire plate with powdered resin and melted its tiny grains to the surface with heat in a random pattern

of microscopic dots. He etched the plate with ferric chloride, which bit into the steel surface in the areas of unhardened gelatin and in the interstices of the resin granules. The etched steel surface was inked as an intaglio plate, which printed an unetched pattern in the dark areas of the photographic image. In 1879 Karel Klíč published a refinement of this process that came dominate several variations. He used tissue layered with pigmented bichromated gelatin to transfer a photographic image to a conventionally grounded copper aquatint plate. Klíč etched his plates in stages, using mordant of decreasing strength to control subtle tonal gradation. At the turn of the century, Pictorialist photographers embraced photogravure, particularly Alfred Stieglitz (Cat. no. 7), who mastered the medium and used it for exquisite prints illustrating his *Camera Work* magazine from 1903 to 1917.

PHOTOMONTAGE, see COLLAGE.

PIGMENT PRINT, see CARBON PRINT, GUM BICHROMATE PRINT, OIL PRINT.

PLATINUM PRINT (platinum/palladium print, platinotype) is a DEVELOPING-OUT process that depends upon the light sensitivity of iron salts. To make a platinum print, an artisan sensitized paper with a solution of potassium chloroplatinate and ferric oxalate. When dry, the sheet was printed in contact with a NEGATIVE until a faint yellow-brown image appeared. It was then developed in a solution of potassium oxalate, dissolving the unexposed iron salts and transforming the exposed areas into platinum. The print was washed in three successive baths of dilute hydrochloric acid, which removed the acid and excess iron from the paper. This was a gradual process, as the pertinent chemicals migrated out of the paper and into the developing solution. The image formed within the paper fibers, creating a soft, absorptive surface along with rich blacks. Aesthetic photographers favored platinum printing for its rich tone and sharp detail. William Willis Jr. developed platinum printing and received a British patent in 1873, and in 1879 he founded the Platinotype Company in London to manufacture commercial platinum papers. Through the 1880s he continued to refine the technique as other manufacturers came into the market with platinum papers in a range of weights and textures, sensitized to produce different colors and tones. With the discovery, in 1902, that platinum could be used to produce nitric acid, a key ingredient in explosives, it became more valuable and less available. In 1913 Willis introduced Satista paper, sensitized with a blend of silver, platinum and iron salts, and three years later he patented palladium papers, based on the same chemistry as platinum but using palladium in place of the more expensive platinum.

POSITIVE refers to a photograph in which lights and shadows are reproduced as they appear in nature. Sir John Herschel first used the term in 1840 to describe the directive opposite of a NEGATIVE.

PRINTING-OUT describes the method of creating a photographic print by exposure to light alone, and without the use of a chemical development process. Following exposure, printing-out paper requires only washing and TONING to complete the printing process. Prints on printing-out paper often appear purplish brown if untoned.

RAYOGRAPH, see PHOTOGRAM.

RECTO and **VERSO** are the terms for sides of a sheet of paper. In photography the recto, or face, carries the image, while the verso is the reverse, or back of the sheet. When a photograph is mounted, *verso* refers to the back of the mount rather than the printed sheet itself.

SABATIER EFFECT, see SOLARIZATION.

SALT PRINT (salted paper print) is a PRINTING-OUT process based on the light sensitivity of silver chloride, applied by hand to a paper support. William Henry Fox Talbot developed the technique in the mid-1830s, creating PHOTOGRAMS that he called "photogenic drawings." Talbot floated writing paper on the surface of a solution of sodium chloride; when the sheet was dry he brushed the surface with a solution of silver nitrate, causing a chemical reaction that formed light-sensitive silver chloride compounds. Using the sensitized paper immediately yielded the best results. The paper was printed in contact with a NEGATIVE in the sunshine. The print was then washed, TONED, washed again, and FIXED. Soon thereafter Talbot also developed the CALOTYPE negative, which employed a combination of silver iodide and both acetic and gallic acid, for prints that were developed-out rather than PRINTED-OUT. In the mid-1850s, unsensitized salted papers were introduced to the market, and made photography broadly accessible at a time when professional photographers were turning to ALBUMEN printing. Their simplicity and common materials made salt prints popular for a brief period.

SHUTTER is a mechanism that opens and closes the APERTURE in a CAMERA, to EXPOSE photographic film or digital sensors for a controlled period. Of many early shutter designs, leaf and diaphragm shutters proved most practical. The leaf shutter consisted of one or more tiny ovoid sheets of metal that pivoted on an axel to uncover a hole in another metal plate beneath. The diaphragm shutter used several thin metal blades sliding over each other, opening and closing a circular aperture to reveal the entire LENS. Early shutters were activated

pneumatically or by clockwork, and became electronic late in the 20th century.

SILVER DYE BLEACH (CIBACHROME, dye-destruction) is a DEVELOPING-OUT technique for creating color prints from color NEGATIVES. Prints are supported by a dimensionally stable polyester base rather than traditional cotton or lignin paper, with three EMULSION layers, each of which is sensitized to a primary ADDITIVE COLOR of light, as well as an azo dye for each complementary SUBTRACTIVE COLOR. During exposure, silver images are formed in each emulsion layer, and during development the silver and the unnecessary dyes are destroyed and bleached away. When the print is FIXED and washed, the residual dyes, viewed against the bright polyester paper, produce the appearance of a full-color image. Dr. Bela Gaspar developed the dye bleach process in Hungary during the 1930s. After his death, and the expiry of his patents, his chemist and technician, Paul Dreyfus, went to work for CIBA AG in Switzerland, which introduced the process to the market as Cibachrome in 1963. Silver dye bleach prints are characterized by clarity, vibrant color and high surface gloss.

SILVER SALTS, the chemical union of silver and halogen, are the chemical building blocks of photography. The most common silver salts used in photography these are silver chlorine, silver bromin, and silver iodine. In the presence of light, these compounds decompose into metallic silvers and darken rapidly, in a process known as photochemical decomposition.

SNAPSHOT is a term coined by photography pioneer Sir John Herschel in 1860 to describe the possibility of securing a picture in $^{1}/_{10}$ of a second. Later, the term came to describe casual, immediate photographs, usually made by amateurs with mass-produced handheld cameras. The first of these was the Kodak camera, introduced in 1889, which had a fixed-focus LENS and set SHUTTER speed, making photography fast and almost effortless. The size and shape of the first Kodak prints were based on the CABINET CARD, which they quickly replaced.

SOLARIZATION and **SABATIER EFFECT** are terms describing the reversal of tone in a photographic print. Solarization is produced by extreme over-exposure of a negative in a camera. The Sabatier Effect is produced by exposing a partially developed negative or print to light during development. Although these techniques are unpredictable and difficult to control, Surrealist photographers employed them during the 1920s, appreciating the inherent element of chance and the unusual appearance of the resulting images.

STEREOSCOPIC PHOTOGRAPHY is a method of taking and viewing photographic images based on the principle of binocular vision, the physiological basis of human depth perception. The process used a camera with two lenses simultaneously to capture images of the same subject from slightly different angles. The lenses were spaced 2½ inches (6.4 cm) apart, the average distance between human eyes. When the two resulting photographic prints were viewed side by side on the same focal plane, they created the visual sensation of depth and dimension. To accomplish this, a pair of prints were mounted together on a card measuring about 3 x 4½ inches (7.6 x 11.4 cm), standardized to fit into a stereoscope, a viewer with adjustable focal length. Affordable stereoscopic photographs—or stereographs—were enormously popular as domestic entertainment from the 1850s until the 1920s.

STROBOSCOPIC FLASH is an electronic system for illumination of photographic exposures, precisely controlled in speed and intensity. The concept and technology were invented by Harold E. Edgerton (Cat. no. 43). In multiple-exposure photography, a stroboscopic flash is either timed to pulse electronically at metered intervals or is released manually at irregular intervals to keep time with a subject moving at a variable rate. Beginning in the 20th century, the stroboscopic flash has been used primarily for studying motion and interaction between moving parts. Consequently the stroboscope is of great use as a diagnostic tool in manufacturing industries.

SUBTRACTIVE COLOR is the principle by which colors are determined by spectrally absorbing media, such as dyes and inks. These allow only selected wavelengths of light to reach the eye. In photography the perception of subtractive color is elicited by white light reflected from a support, usually paper. Microscopically superimposed layers of yellow, magenta or cyan pigment allow some wavelengths to pass through while filtering—or subtracting—others in varying proportions.

TINTYPE (ferrotype, melainotype) is a direct POSITIVE photograph on a prepared metal plate, a variant of the AMBROTYPE. To make a tintype, an artisan prepared a thin plate of copper or iron with a mixture of asphaltum, linseed oil and lampblack. Once it had dried, the plate was covered with a wet COLLODION emulsion, sensitized with silver halide crystals. The plate was loaded into the camera wet, and a very underexposed NEGATIVE image was captured. The plate was developed immediately then rinsed in water, and the image was FIXED. The areas with the least amount of silver, corresponding to the darkest areas of the subject, remained essentially transparent and appeared black against the dark lacquered background. When dry, the tintype could be hand-colored

with dry pigment, before the application of a protective varnish. Their sturdy support and surfaces allowed tintypes to be mailed or carried in a pocket, but they were often presented in a paper envelope or small case. Introduced in France in 1853, the process was later patented in Great Britain and the United States, and became popular as a portrait medium for its ease and economy. Itinerant photographers set up portable darkrooms in parks or army camps to produce tintype portraits quickly and cheaply.

TONING is a process that changes the overall color of a photographic print. Early paper prints were toned by bathing them during or after development in dyes or tea. Today the effect is chiefly used for aesthetic purposes, but toning with certain metals such as gold or platinum was used during the 19th century to increase a photograph's archival stability.

TRANSPARENCY is a photographic POSITIVE on a transparent substrate such as glass, CELLULOID or polyester. During the 1850s ALBUMEN positive transparencies on glass were used with magic lantern projectors, illuminated with reflected light from a candle or gaslight, for educational lectures and domestic entertainment; they could also be seen through a viewing apparatus. Albumen positive transparencies were superseded by commercially available gelatin silver lantern slides in the 1870s. The advent of 35 mm handheld cameras in the 1920s led to the development of reversal film processed as transparencies and mounted as slides in 2 x 2- inch (5 x 5 cm) cardboard (later plastic) frames, for use with an electrically lighted slide projector.

UNION CASE is a descriptive term applied by the inventor Samuel Peck to his patented thermoplastic photograph cases, produced from the early 1850s from shellac, sawdust and colorant. This mixture was poured into heated steel molds, carved in negative relief, to form a shell. A pair of these were attached with metal hinges and a clasp, and lined with fabric to house a DAGUERREOTYPE. Union cases were commercially available in a wide range designs and sizes.

VERSO, see **RECTO**.

VIEW CAMERA (field camera) is a large-format apparatus designed to EXPOSE large NEGATIVES. Unless specially equipped, view cameras designed to expose one photographic plate at a time. To make view cameras more portable, they were fitted with a collapsible accordion-like chamber and could be mounted on a folding tripod.

WAXED-PAPER NEGATIVE was a refinement of the CALOTYPE negative process. In 1851 Gustave Le Gray introduced the practice of infusing wax into papers for NEGATIVES, to

increase the translucency of the paper and moderate the fibrous appearance of final prints. Waxed-paper negatives could be prepared and treated two weeks in advance, which made them popular among travel photographers.

WET-PLATE COLLODION was the dominant technique for preparing photographic NEGATIVES in the latter half of the 19th century. The process involved binding light-sensitive silver halides to the smooth surface of a glass plate with synthetic COLLODION. Combined with the ALBUMEN printing process, wet-plate collodion negatives produced prints of unprecedented detail, density and contrast. However it was an involved process, for the plates had to be prepared, exposed and developed while the EMULSION was wet. If allowed to dry, the collodion became impermeable to processing solutions. To make a wet-plate collodion negative, an artisan mixed collodion with SILVER SALTS and poured the syrupy liquid onto the glass, tipping the plate to coat its entire surface before pouring off the excess. The plate was then immersed in a bath of silver nitrate for several minutes. Now light-sensitive, the plate was placed in a readied camera and exposed while still wet. Exposure times could be as short as one second in bright sunlight or as long as a few minutes indoors. The plate was developed immediately in pyrogallic acid; when the image reached the proper density, it was rinsed under running water and FIXED. A protective varnish was applied to protect the plate until it could be printed.

WOODBURYTYPE is a reproductive process invented by Walter Bentley Woodbury in 1864, creating images with the continuous tone of photographic prints. To make a Woodburytype, an artisan created a thin gelatin sheet by layering liquid bichromated gelatin on a plate of glass. Once the gelatin had set, it was peeled from the glass and was exposed in contact with a photographic NEGATIVE. The gelatin hardened in proportion to the amount of light received creating a dimensional relief. The sheet was rinsed in hot water to dissolve the unhardened gelatin and cured in a drying box. The hard, paper-thin sheet was then pressed into a plate of softened lead in the extreme force of a hydraulic press, creating a metal relief block that corresponded to the tonal density of the original image. This matrix was charged with pigmented gelatin instead of printing ink, and transferred to thin paper in a heated press. The specialized equipment required for the Woodburytype hastened its replacement by reproductive techniques that could be incorporated with text and image printing.

INDEX

Page numbers in *italics* refer to illustrations. References to notes are in the format:
page number, catalogue number; note number

PHOTO CREDITS